MOZART

Jan Swafford is an American composer and author. He earned his Bachelor of Arts *magna cum laude* from Harvard College and his M.M.A. and D.M.A. from the Yale School of Music. His teachers in composition included Jacob Druckman at Yale and Betsy Jolas at Tanglewood. Swafford is the author of biographies of Ives, Brahms and Beethoven. Among many honours, his essays for *Slate* won a Deems Taylor Award for online writing on music. He is a long-time programme writer and preconcert lecturer for the Boston Symphony and has written notes and essays for the orchestras of Cleveland, Chicago, San Francisco and Toronto. Among his liner notes for recordings are ones for the DGG Beethoven anniversary release of the nine symphonies by the Vienna Philharmonic.

janswafford.com

Further praise for *Mozart*:

'Few hearts fail to melt upon encountering his humane, joyous and ravishingly beautiful music. The challenge for any biographer is how to articulate where this elusive magic comes from . . . Jan Swafford has met that challenge head on . . . For many [Mozart's] works are dear old friends. You can come away from this book feeling that he is too.' Jessica Duchen, *Sunday Times*

'Mozart's compositions, notes this outstanding account of his life and work, display "a kind of effortless perfection so easily worn that they seem almost to have written themselves". In this telling Mozart was a fundamentally happy man, a genius with an enduringly childish sense of humour. The author, a composer himself, peppers his narrative with penetrating insights into the music.' *The Economist*, Books of the Year

'[Swafford's] composer's eye is drawn to things others miss . . . There is also a cracker of a subplot.' Paul Kildea, *The Spectator*

'[A] comprehensive and engaging biography. Swafford is thoroughly up-to-date on the latest information and controversies, debunking the still commonly held mythology about the composer, and he continually reminds us of what astounding music Mozart wrote . . . Swafford also vividly places the whole story in the context of the social and artistic life of the period, including the appalling medical conditions that surely hastened Mozart's demise.' Lloyd Schwartz, *Wall Street Journal*

'This is an excellent book on Mozart for both musicians and the general reader. The story is told in a lively, knowing style, without written-out musical examples but shot through with unfailingly erudite and impassioned discussion of the composer's work. Only towards the end do we feel the huge absence that would be left by Mozart's death – and Swafford's evocation of the moment the composer knew he was dying is appropriately terrifying.' Tim Page, *Washington Post*

'An utterly comprehensive look at Mozart's life as well as an exhaustive reference to his music. Swafford . . . is a composer first, and his keen understanding of music is his greatest strength as a biographer. This book is not just *Amadeus* for aficionados . . . Swafford contextualizes Mozart's development as a composer with helpful historical primers but keeps it interesting with countless anecdotes.' Cory Oldweiler, *StarTribune*

'It is a great pleasure to read about Mozart as a working composer in a narrative written by a working composer . . . Jan Swafford, an author whose music has been performed by the symphonies in St Louis and Indianapolis, is our guide into the composing process, aided by a dexterous use of Mozart's correspondence and a deep knowledge of how music came about during the eighteenth century . . . The result is a biography that has an immediacy, a wholly thrilling "you are there" impact.' *San Francisco Chronicle*

'If tackling an 832-page biography of anybody seems daunting for the

general reader, Swafford makes it almost effortless with Mozart, animating his genius . . . As a composer himself, [Swafford offers] an astute yet thoroughly approachable analysis, almost piece by piece, of the composer's entire canon, lingering fittingly on the composer's major operas . . . A virtually indispensable volume for the music collection.' *Booklist*, Starred Review

'The prodigious career of a musical icon . . . Composer and biographer Swafford brings expertise and insight to bear on a comprehensive, animated life of Wolfgang Amadeus Mozart . . . deftly [capturing Mozart's] brilliance in a challenging narrative that is sure to thrill classical music fans . . . An admiring, authoritative biography.' *Kirkus Reviews*

ALSO BY JAN SWAFFORD

Beethoven: Anguish and Triumph

Johannes Brahms: A Biography

Charles Ives: A Life with Music

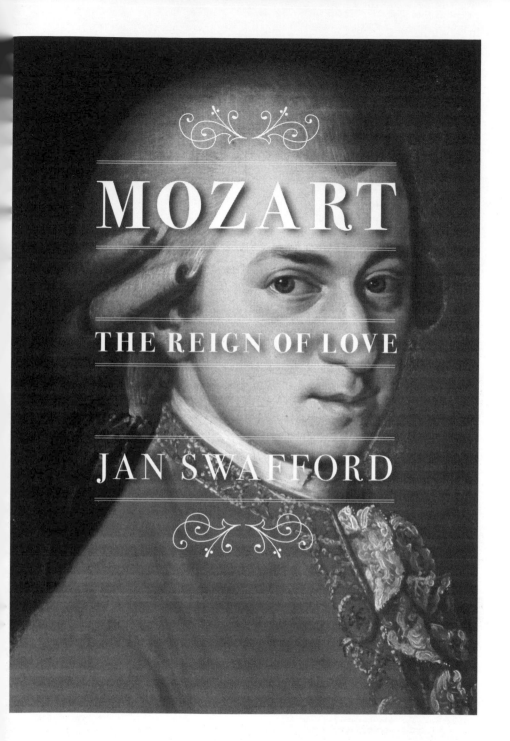

MOZART

THE REIGN OF LOVE

JAN SWAFFORD

faber

First published in the UK in 2020
by Faber & Faber Ltd
Bloomsbury House
74–77 Great Russell Street
London WC1B 3DA

First published in the USA in 2020
by HarperCollins
195 Broadway
New York NY 10007

This paperback edition published in 2021

Designed by Leah Carlson-Stanisic
Printed and bound by CPI Group (UK) Ltd, Croydon, CR0 4YY

Title page image © Imagno/Getty Images

A CIP record for this book
is available from the British Library

ISBN 978–0–571–32325–8

2 4 6 8 10 9 7 5 3 1

IN MEMORIAM

Mordicai Gerstein, 1935–2019, artist.
Friend, mentor, inspiration, you and your stories
helped teach many of us how to live.

CONTENTS

Part I

Part II

Contents

Part III

Picasso said: "Art is a lie that makes us realize truth . . . The artist must know the manner whereby to convince others of the truthfulness of his lies."

Shakespeare wrote: "The truest poetry is the most feigning."

Wolfgang Amadé Mozart was in his person a fluent liar when he needed to be because, perhaps, at that moment in his life, as at any moment in his art, he believed in everything he said. Which is to say that I find Mozart to be the kind of revelatory liar Picasso and Shakespeare were talking about. What I have come to feel in my years of living with him is that while he is, as everybody knows, the distillation of what it means to be a prodigy, beyond that he is the distillation of what it means to be an artist, at its most splendid and fundamental. Mozart is among the supreme players in the childish and sublime game of what-if, a soul made for art and for a stage even when he was writing instrumental music. On the death of his friend George Gershwin, Arnold Schoenberg wrote a definition of what I mean: "He is a composer—that is, a man who lives in music and expresses everything, serious or not, . . . by means of music, because it is his native language."

From early childhood, Mozart had the kind of innate understanding of his art that allowed him to speed past obstacles often without realizing they were there. But in the long run, even he had to overcome barriers, including his own facility and his remarkable gift for mimicry. As he came to maturity, his glorious childhood proved as much burden as an advantage. Perhaps the greatest impediment between Mozart the prodigy and what he became in adulthood was the mighty edifice of musical convention in his time. This was a barrier that he lacked the desire or the nature to skirt. He could only forge his way through

convention and come out the other side, master of convention but no longer beholden to it. In his art and in his life, Mozart took the status quo largely as a given and then went his own way.

The nineteenth century ginned up his life into a grand Beethovenian tragedy: poverty, neglect, misunderstanding, writing the Requiem for himself, the pauper's grave, and so on. That all those stories went against manifest fact was no impediment to the Romantic fancy that to be a genius, you must suffer. To that I say: the myth of the suffering genius collapses with Mozart. Compared with my previous biographical subjects' lives, Beethoven and Brahms, Mozart, I found, was by far the sanest, most gregarious, least self-flagellating. (He did, unfortunately, lack Brahms's hardheaded common sense and Beethoven's gift for the business of music.) As we will see in the coming pages, while Mozart had his share of sorrow and loss and frustration like the rest of us, he was fundamentally a happy man. He wrote for public consumption, which is to say that he was a professional in a way few composers are anymore. Still, on the whole he did what he wanted to do the way he wanted to, and when he was done he didn't worry overmuch about what the public thought of it.

At the same time, as the nineteenth century rolled into the twentieth, another myth blossomed: to be a certified genius you must be a rebel and an innovator, if not an outright revolutionary. So Mozart sometimes got painted in those terms too. Personally or artistically, the notion of Mozart the revolutionary doesn't stand, though the reasons for that are not simple. Yes, he was unusual and prophetic in being a freelancer, but he was temperamentally unsuited to being any kind of courtier, and if he claimed that he wanted a job as a court *Kapellmeister* or the like, it is a good question whether that sort of work, with its necessary subservience and bureaucratic demands, would have suited him. Politically it appears that Mozart was progressive in some degree, but we lack any details of his convictions. In any case, there is no indication that he felt rebellious toward the ruling class, among whom were a number of his friends and patrons. It was the actual job of working at a court that chafed him, and he left that kind of job early and permanently.

I am saying, then, that the Mozart we all inherited, suffering penury and writing for posterity, was an invention of biographers. At the

same time, I have to admit that as a biographer I have some sympathy with those mythmakers. Who wants to read about a happy man? We'll see.

BECAUSE I WRITE MUSICAL BIOGRAPHIES THAT ARE SCHOLARLY IN a p proach but intended for the broad public, it's part of my job to describe my subject's music. There are two problems with this endeavor. The first is that I don't believe it's possible to capture music in prose other than in technical terms. As is reflected in the title of another book of mine, I consider music to be a language of the spirit beyond words. I think most musicians feel that way. All the same, I accept the need for trying to evoke the music in a book that aspires to convey the human qualities of my subject's art.

The second problem is Mozart's art. Over the years I've written several books about music and a good many program and liner notes, and I've never found another composer who beggars language as Mozart does. Writing about Beethoven in that biography was easier because he was usually engaged in emotions and quasi-narratives that could be articulated, and I think he intended his expression to be relatively transparent. That was not Mozart's game. In his expression he was often involved in shades and subtleties. He did not play with existing formal models to the degree that Beethoven and even Haydn did. Except perhaps in some of Mozart's more or less Sturm und Drang works, there is usually not all that strong a sense of an overall story in a piece. The idea of a work of music as an implied narrative was not in the air until the next century. His works certainly hold together integrally, but it is often hard to examine why they do using the layperson's terms to which I am mostly adhering in the book.

Besides that, a good deal of his music is involved in, sometimes revelatory of, the matter of beauty. Mostly we are not taught about beauty in school because it is perceived as something vague and subjective. Among contemporary artists, beauty has often been regarded as a mushy and bourgeois quality. I believe beauty is real and significant, and central to a perception of Mozart, so I've tried to deal with it here and there in the book. But again, Mozart is perhaps the most challenging

composer of all to capture in words because his work is so intimately bound up in what music can do that is unlike what words can do. Music, to repeat, was his native language. And beauty also largely beggars language.

Once I had a conversation with the fortepianist Kristian Bezuidenhout in which he said, "We tend to listen to Mozart with ears trained by Beethoven, and that's not the best way to listen to Mozart." That was a musicianly observation, not a theoretical or philosophical one. But it's an insight I've been aspiring to understand and wield ever since. Thinking about his point, I realized that in order to approach Mozart I had to get out of my head the years I had spent studying Beethoven's music. I also had to get out of my head Beethoven's assumptions about the role of the composer in his art and in posterity. If Mozart ever thought about the career of his music after he died, there is no record of it. Trying to snare Mozart's work in prose, I searched for something more poetic to convey what is finally ineffable. But I'm not a philosopher or a poet, only a musician.

In one respect, Mozart did my prose a favor. At a certain point I noticed that my words were coming out looser, more informal, than in my previous biographies. I was glad to see this, because I try in my tone to reflect something of the personality of my subjects, and Mozart was a jolly and informal man—well, informal given that he was in his lifestyle a dandy and in his art supremely fastidious. Soon I realized why my prose was turning out that way: I was being taken over to a degree by the style of Mozart's letters, which at their most entertaining are effervescent, hilarious, sometimes so obscene that they could clear your sinuses. I laughed more while writing this book than any of my others, much of the time at things Mozart himself had written. I suppose I'll be accused of reveling in his notorious scatology, but in fact I've reveled in his wit and joie de vivre in whatever mode, and he had many modes of wit. What he reveled in, I revel in.

So as I will be noting throughout, Mozart's works are not the kind of intensely individual dramatic narratives many of Beethoven's are; they largely did not arise from his private sorrows, as the nineteenth century wanted to believe; and he did not have a sense of his work having some sort of immortality, as Beethoven did. Based again on Beethoven, the Romantics declared that art came from the inside out, from the heaven-

struck genius who sweeps aside rules and conventions. But Mozart had no sense that an artist was in the job of "expressing myself." That notion was an invention of the Romantic century. Mozart wanted to express his art and its relation to universal humanity. He did not aspire to wipe away tradition either in music or, as far as we know, in society. (At the end of this book is an appendix outlining common formal models in Mozart's time. For those who don't know them, the musical discussions in the book will make more sense if you read the appendix first.)

Mozart had some hard times toward the end of his life, but a lot of successful people have hard times, and composers do not get much more successful than Mozart in his own time. Some of his contemporaries accumulated a bigger bank account, but no composer was more respected and few better paid. What he didn't get was rich, but he did all right, better than all right in the end, and if he was never the most popular composer around, he was greatly admired by a great many people. It's worth mentioning that Haydn, his only living peer, considered Mozart his superior as an artist and said so repeatedly. I have no doubt that if Mozart had lived ten years longer, he would have been the dominating figure he became shortly after he died.

A point about my treatment of his operas: There is a tendency in writing about Mozart to treat the operas as if he wrote the libretto as well, as if the text represented his own convictions and artistic statements. This, again, is an idea reflecting the nineteenth-century cult of the towering genius in control of every aspect of his art and bending the world to his will. The reality is that the books for Mozart's stage works were written by others, who had their own concerns and agendas. In his maturity Mozart was extremely picky about what librettos he took up, but when he settled on something he took what he got and made requests and changes having to do mainly with shaping musical and dramatic matters, not the gist of the content.

I think that Mozart's attitude toward a libretto was similar to that of actors toward a script: they did not write it; their job is to bring to life whatever is there. No actor playing Iago in Shakespeare's *Othello* approves of Iago; rather he puts across a thoroughly evil character who has his reasons. In Mozart's late operas, I think this explains some of the perplexing contradictions in the approach to women and love between *Così fan tutte* and *Die Zauberflöte*: two different librettists. At the

same time, I think *Die Zauberflöte* is, to a degree, an exception to the pattern, because in that opera Mozart had a hand in the libretto from the beginning. For this reason, I consider *Zauberflöte* the most truly and thoroughly Mozartian opera, because he was involved in the shaping of the story and its implications, and in it he was working outside the pressures and protocols of court opera.

I AM PRIMARILY A COMPOSER, AND I WRITE BIOGRAPHIES OF COMPOSERS from that point of view. Because, as far as I know, no composer of my experience has written such books, I see this as what I bring to the table in the literature of music. Most people, and most scholars and performers, look at a piece of music as a finished, almost Talmudic object. That's a valid way to see a piece, especially for performers and theorists. But as a maker of music I see a work as something created, pen in hand, one note and phrase at a time, each requiring a decision by a particular person in a particular part of his life in a particular time and place, all of which contributes profoundly to the making (though not in simple or always discernible ways). I am a practical musician, less a thinker about music than a maker of it. Most of my teaching was in a conservatory, where I taught music theory and history to students who were using that training not to meditate about music but to make it. That is the foundation that inflects my treatment of composers and their works.

As a composer I also know that while there are models and formal outlines and rules and limitations and a great many things one needs to master and wield, there are at the same time no ultimate templates for creation. It does not matter if a work is revolutionary or reactionary, conventional or not, if it makes a compelling case for itself. Most of the labor of making art is done by the unconscious and by a well-trained intuition, within the trance of creation. A work, then, is a tangible realization of the voice of the inner self, but the wild horses of imagination are reined in by knowledge, experience, skill, taste, judgment, second thoughts, inevitable human frailties and imperfections, the realities of instruments and players and acoustics and money and of the great and terrible world in general. Which is to say again that a work is inflected start to finish by its time and place.

In dealing with each of my biographical subjects, I've tried to understand their particular way of working, of dealing with the world, of dealing with the traditions of their art. Charles Ives was a singular man and one of the great revolutionaries of music; Brahms an eclectic handler of traditional craft who nonetheless inspired the future; Beethoven a consummate musician in every dimension of the art who was perhaps the first composer to understand that his work was going to live in history for a long time. As I have written elsewhere, it's significant that the three arguably supreme composers in Western music—Bach, Beethoven, and Mozart—are three different kinds of artists: Bach called old-fashioned in his time for his devotion to the hoary craft of counterpoint; Beethoven called revolutionary in his time (though he never called himself that); and Mozart firmly grounded in his time and its musical and social norms. Their different stances toward tradition and innovation had a great deal to do with how their work took shape, but nothing to do with the ultimate value of their work.

It took scholars until the later twentieth century to wipe away the historical cobwebs and look at the plain facts that showed how little of the old Mozart legend was true. Recently he was the subject of a hit play and movie, but the puerile Mozart of those works was not accurate either. The myths made for a better story, but most of them aren't true.

As will be clear in the writing, I believe the only profound tragedy in Mozart's life was his early death, when he was on the verge of a new plateau in his art and, incidentally, on the verge of real prosperity. If Mozart had lived to seventy-one, he would have died the same year as Beethoven, and he would have written a great deal more music. Imagine those two titans competing, collaborating, inspiring each other. When Mozart died, having just written the magical and incomparable *Zauberflöte*, he was imagining an opera based on Shakespeare's *The Tempest*. It makes you weep to think of it.

WRITING IS A SOLITARY ACTIVITY IN THE DOING BUT COMMUNAL IN its objects, so I've always wanted people to be involved in my work during the process. I'd like to thank my three readers, each of whom helped to make this a better book: musicologist and old friend Raphael Atlas of Smith College, leading Mozartian Simon Keefe, and splendid

editor Jonathan Jao at HarperCollins. Thanks also to the aura of the café at the castle of Hohensalzburg, which gave me the beginning of the book.

Finally I'll mention that at the beginning and at later junctures in the text there are imagined soliloquies in italics that prefigure matters to come.

All books have mistakes, and for the paperback edition I've corrected a row of typos, inadvertent omissions, and inexplicable blunders, most of them noted by readers and, in one case, a critic, who in the course of a mostly pleasant review provided a list of errors with page numbers for the author's convenience. I'm grateful to them all.

MOZART

O ne can believe in miracles as a matter of faith, but one does not expect them to turn up in the living room.

It was evening in Salzburg, January 24, 1761. The Mozart home was as usual filled with music. Leopold Mozart's nine-year-old daughter Maria Anna, called Nannerl, was at the keyboard working on a little scherzo that he had given her to practice. Around her eighth birthday, Leopold had decided that it was time to see what his eldest child could do on the harpsichord. It soon became clear that she was greatly talented.

This was not a matter of teaching his daughter the family business. Music was generally not a trade for females. Their performance on instruments was restricted to private playing in the home. In the usual way of the time, Leopold had assembled a notebook of graded keyboard pieces for Nannerl to learn, starting with simple tunes in quarter notes and gradually introducing faster and harder pieces. Its cover declared, "Ce livre appartient à Marie Anna Mozart, 1759."[1] It amounted to some forty-eight pages, the pieces mostly little dances and folksongs, plus pages of exercises. Some pieces were Leopold's own, others by well-known composers such as G. C. Wagenseil, whose scherzo Nannerl was practicing

As she worked her way through the book, making quick progress, her little brother had watched, fascinated. The harpsichord in the living room had been a part of the home for as long as Wolfgangerl could remember. When you pressed the keys it emitted noises, like magic. At some point the child had probably banged on it as toddlers do, in imitation of the adults and his sister. Maybe Leopold stopped the racket, maybe he encouraged it. At some point the child discovered that if you

played together two notes two keys apart (the interval of a third), it made a pretty sound. He began to sit at the instrument and play the pretty thirds with evident delight.[2] Experimenting with thirds had apparently been the extent of his keyboard ambition.

That January night, the four-year-old suddenly insisted he wanted to try the piece his sister was playing. It was impossible, a childish notion. And the scherzo by Wagenseil was by no means the simplest piece in Nannerl's notebook; it had some fast notes in the right hand, the left hand babbling a busy accompaniment. But Leopold gave Wolfgang the seat at the clavier. Childish notion, but why not?

Like many reported miracles, this one happened in a flash. With no idea how to read music, the child not only made his way through the scherzo but also memorized it. His astonished Papa wrote on the page, "This piece was learned by Wolfgangerl on 24 January 1761, 3 days before his 5th birthday, between 9 and 9:30 in the evening." Two days later the child learned a minuet and trio, likewise in a half hour.[3] The boy began to soak up piece after piece from his sister's notebook, to fill up with music like a sponge. And somehow he played everything note perfectly, with impeccable rhythm.[4] When the tiny child sat at the keyboard, he commanded it.

A miracle is something impossible that nonetheless happens. For a pious man, it is by definition the work of God. Leopold Mozart was, in his fashion, a pious man. Maybe, he came to feel, God had chosen him to bear witness to this revelation. He also understood that beyond its intimations of a higher world, there remained the question of what to do with the revelation in this world.

PART I

It was fun to bounce on the Empress's knee. I kissed her, of course. The six-year-old could hardly remember when it had been any other way. Papa could be stern—Papa told them what to do and when to do it, but it was always things that were fun: make up a tune, play a tune at sight, name a note somebody played from across the room. It was all easy. Then you would be praised and petted and exclaimed over. Everything you did exclaimed over, even if it was not hard, just what one did.

Papa says we will make a lot of money, but I don't know anything about that. Papa says I'm known to everybody and will grow up to be a famous Kapellmeister. That would be nice, I suppose. People playing my notes just the way I want them, and then the applause. All I know is applause, which is very nice. Applause from the lords and ladies that Papa says are going to make us famous and rich. I don't know about that, but if I'm rich, I will have nice clothes. Also Sister will have nice clothes. She likes them as much as I do. And she plays as well as I do, so she deserves the applause and the clothes as much as I do. But she doesn't write her own notes like I do. Not yet anyway. Papa wants her to try and I do too. Maybe she might write notes as well as I do, but I don't think so. I write music as easy as a sow piddles. But Sister should try, maybe she'll be good. Then I'll be king of the Kingdom of Back, and Sister will be queen, and nobody will tell us what to do up there in our own world. We will wear beautiful clothes and hear nothing but our own music and lots of bravos from the lords and ladies. And in front of them all will be Papa and Mama, shouting bravo and clapping the loudest.

LEOPOLD

To wit, another boy. We christened him Joannes Chrysostomus Wolfgangus Theophilus. My poor wife had a wretched lying-in, the pain and the blood terrible, the afterbirth had to be extracted. I thought she might die. She is recovering now, he made it through the christening at least. Now we must wait and see. Five babies dead to date. The boys don't live any longer than the girls do. It will again be in the hands of God. Likewise, my violin method will be in the hands of God in making its way into the world.

His sister has gotten to age four. I think in two or three years it will be time to find out what she can do at the clavier. First, I'll teach her letters, a little of arithmetic and history and geography, enough for a girl. If she has my talent for music, she'll do well enough, grow up to play in the town's parlors and take care of her father and eventually find a husband, I suppose.

As for the boy, nothing to be gained from speculating about him at this point. Even if this one makes it past his first weeks, there are no guarantees. No guarantees anytime, no matter your labor and the heart's blood you put into rearing them. If only a name honoring God—Theophilus, Gottlieb, Amadeus, Amadé, however you put it—could ensure His favor. But it doesn't. It never does. We do what we may, but our lot is to submit.

Johann Georg Leopold Mozart was born on November 14, 1719, to a modestly prosperous family in Augsburg. His family provided him with the best education available in town, alongside children of the wealthy. He turned out an erudite and intelligent man and a gifted musician—up to a point. As fate decreed, Leopold and his eventual

wife had within them the makings of one of the most sweeping talents ever born into the art of music.

Leopold would nurture that talent brilliantly and at the same time allow it to shape itself—up to a point. At that point, the limitations of his own gifts and understanding stepped in, making Leopold, in the view of his dazzling progeny, something quite otherwise than a loving mentor: an obstruction to be dealt with. In the end, one symptom of this intelligent and erudite man's limitations would be his incapacity to understand what his son became and his incapacity to comprehend what he had become to his son. This reciprocal web of struggle and incomprehension would cause great pain to both father and son, but more to the father.

IN ITS VARIOUS DIALECT FORMS, THE NAME "MOZART" HAS A HISTORY tracing back to the fourteenth century among villages southwest of Augsburg: Motzart, Motzhart, Motzhardt, Mutzhart, Muzert, Motzet. Among the livelihoods of these families is found the usual spectrum of farmers, merchants, builders, craftsmen, and in the sixteenth century, a couple of painters. Leopold's great-grandfather David Mozart and two of his sons were designers, architects, master masons; a younger brother became a sculptor in Vienna.[1] That suggests a family inclination to precise varieties of creativity as the generations approached Leopold. In the story of this family, the matter of inborn gifts looms large.

Leopold's father, Johann Georg Mozart, took up the comfortable occupation of bookbinder in Augsburg, the town being an important publishing center. The family business was carried on in the house. Leopold grew up with the smell of leather and cloth and glue, the dressing of the books for which Augsburg was celebrated. He may have worked in the binding shop himself. Such a meticulous craft would have suited his fastidiousness. It may have been this intimacy with books that nurtured some of the far-ranging intellectual curiosity that marked him.

Augsburg enjoyed the status of a free imperial city within the Swabian region of Bavaria. The city has its roots in a Roman garrison founded in 15 BCE on the river Lech. By the sixteenth century it was one of the most powerful trading cities in central Europe. Its history includes a share of illustrious names: Augsburg was the home of the

legendary Fugger family of bankers and merchants, of the Renaissance painters Hans Holbein the Elder and Younger. At the Imperial Diet of 1518 in the city, Martin Luther refused to recant his dissenting Ninety-five Theses before the papal legate, and the Protestant Reformation followed in due course.

The Peace of Augsburg in 1555 guaranteed the rights of religious minorities, creating an unusual phenomenon in Germany: a city in which Protestant and Catholic peaceably lived and ruled together. In Leopold's youth, the city was still suffering from the aftereffects of the Thirty Years' War of the mid-seventeenth century, a Catholic-Protestant conflagration that left Germany a ruin. During a siege of the city by Catholic troops, the population had collapsed from some seventy thousand to sixteen thousand. It was not much larger or notably prosperous when Leopold was born.

The city's Mariä Heimsuchung Cathedral had murals from the twelfth century and a lower crypt from around the year 1000. The religious idiosyncrasies of Augsburg resulted in twin churches, one Protestant and one Catholic. Leopold Mozart was reared to be and remained Catholic, but he had a good deal of Protestant in his sensibilities. As in all German towns, churches and priests were woven inextricably into everyday life. Jesuits dominated education, and Leopold received a thorough Jesuit schooling, but the religious part of it impressed itself on him only up to a point: he reached adulthood thoroughly anticlerical.

Leopold's education began at age eight in the Jesuit Gymnasium St. Salvador. At fifteen he entered the Lyceum, intending to study for the priesthood. But at some point in those years, to the apparent dismay of his mother Anna Maria, he took up music, singing as a church and monastery choirboy and making himself into an accomplished organist and violinist. He also sang and acted in productions in the big theater of the Lyceum. Illustrations of the time show elaborate stage sets, implying considerable dramatic sophistication at the school. Leopold also had a hand for drawing and picked up extra cash by painting watercolors on the backs of playing cards.[2]

He was a good student; in 1736 he graduated from the Lyceum magna cum laude. In later years an old Augsburger would tell Leopold's son, "Ah, he was a great fellow! My father thought the world of

him. And how he hoodwinked the clerics about becoming a priest!"[3] Leopold was getting support from the Jesuits toward theological studies, and his mother expected him to take up the cloth. However, he seems to have had talents not only for acting but also for putting on an act. Among other reasons, he likely did not want to become a priest because he was not an admirer of them. For one example, as everybody in town knew, there were perennially dozens of young girls and boys who served as playthings of the clergy. They were called *Pfaffenschnitzls*, "priests' morsels."

When Leopold decided on a musical career (or fell into one) is not clear. After graduation he headed for Salzburg and enrolled in the Benedictine University to study law and philosophy. He was seventeen and, from that point, largely had to make his own way. His father died that year, and his disapproving mother favored his two brothers, who took up the family bookbinding trade. Eventually she gave his brothers a marriage dowry but not Leopold, at which he was outraged. Later he wrote, "I had no one to advise me and from my youth on, there was no one I fully trusted if I hadn't made sure of them first." Though Leopold was sociable enough, this is the doctrine of a loner at heart, determined to find his own way.[4]

THE CITY IN WHICH LEOPOLD MOZART LANDED AFTER HIS SCHOOL-ing, which over the next decades would supply his livelihood and eventually become his hated burden, was considered by many eighteenth-century visitors to be something of a paradise.[5] Salzburg lies in a valley surrounded picturesquely by hills and mountains. Wrote a traveler of the era:

> Conceive to yourself a vast amphitheater; the background of the picture is occupied by high rocks lifting up their heads to heaven. . . . These vast masses terminate by degrees in wooded mountains to the back . . . Precisely in the midst of the scene stands the town, which is commanded by the castle standing on a high rock . . . The town itself is very handsome—the houses are high, and built all of stone . . . The Cathedral is the handsomest building I've seen since I left Paris . . . This town contains many

more excellent buildings and statues, which remind you that the borders of Italy are not far distant.[6]

From the imposing stone pile of the cathedral and attached Residenz of the prince-archbishop, the Old Town of Salzburg spread outward in the valley along the river Salzach. On a craggy peak above town presided the hoary castle of Hohensalzburg. The occupant of the throne was one of hundreds of absolute sovereigns in the little kingdoms that constituted German lands. The rulers of most of those states were secular, but a few cities including Salzburg had ecclesiastic rulers, which meant that their positions were not hereditary. The Salzburg prince-archbishop was appointed in Vienna, seat of the Holy Roman emperor, who oversaw the hodgepodge of German states. That system, which had existed for a thousand years, was there for no other reason than it had apparently always been there. Serious questioning of such ancient status quos first occurred to people more or less in Leopold Mozart's lifetime.

Salzburg means "Salt Castle," a testament to the main resource on which the city's existence and prosperity were built. The underground Hallein Salt Mine on the nearby Dürrnberg plateau had been worked for more than seven thousand years.[7] The river Salzach made the town a natural trading center on a route stretching to Italy and France and southern Germany. Leopold and his children would be familiar with the roped-together chains of salt barges drifting down the river pulled by horses on the shore, holding fifty or more men like little villages, complete with kitchens.

In 800 CE, Charlemagne included Salzburg among the states in the Holy Roman Empire of the German Nation.[8] Eventually Salzburg became one of the most important archdioceses in German lands, from the thirteenth century onward ruled by a prince-archbishop. The town that Leopold knew was sometimes called the "German Rome" because of its wealth of churches, squares, and fountains.[9] Buildings were of stone, their eras ranging from medieval to Renaissance to Baroque. When Leopold arrived, there were some twenty thousand inhabitants in an intimate warren of streets, most of those streets about two carriage widths wide. A distinctive feature was the *Durchhäuser*, passageways cutting through buildings. The town's tightly woven arrangement gave

a certain coziness to Old Salzburg. Everybody was close to everyone else's business; as in a comic opera, gossip traveled fast.

As with most cities possessing a throne in the welter of small German states, the affairs of the town turned largely around the court and the Residenz of the archbishop: the hundreds of rooms that had to be lighted and heated; the hundreds of equerries, cooks, hunters, valets, chamberlains, ministers, string players, organists, trumpeters, drummers, composers, and other specialists who served the throne. All of them had to be fed and clothed, along with the priests and nuns and students of the churches and abbey and university. Salt was the town's prosperity; the court was the town's main employer.

In Leopold's day the atmosphere of the town was timeless unto archaic, its education old-fashioned, its society rigidly stratified.[10] Salzburgers had a reputation of being pleasure-loving, frivolous, not excessively prone to spiritual concerns. Hanswurst, the traditional German stage buffoon of the era, whose antics tended to the rabidly obscene, spoke with a Salzburg accent.[11] There were other traditional obscenities. In Leopold's maturity, there remained an official Church and state condemnation of witchcraft—confessions to it generally extracted by torture. Five years before his son was born, a sixteen-year-old girl was executed for having relations with Satan. The last witch to be burned in Salzburg was in 1762, when Leopold was in his forties and his son was six.[12]

An archbishop had ruled Salzburg since the thirteenth century. Though the throne had absolute power over its subjects, from the mid-eighteenth century the burgeoning Enlightenment in German lands questioned the authority of the ancien régime. Some rulers began to reconsider their role, departing from the idea of the state as ultimately the servant of the sovereign. Frederick the Great of Prussia declared himself "first servant of the state." The old notion of universal submission to the sovereign was being replaced by an ideal of service to an abstraction called a "state," a "nation." In Vienna, Holy Roman Emperor Joseph II would echo that philosophy with a vengeance. Even in old-fashioned Salzburg there were progressive pockets. The poor were seen to, there were schools and museums and hospitals, and a burgeoning merchant class was getting rich in international trade.[13]

IN ONE WAY AND ANOTHER, ALL BUILDINGS ARE AN IMAGE OF A SO-
cial order. The Residenz of the Salzburg archbishop was such an image
in the most intricate and categorical way. The palace consisted of 180
rooms around three courtyards. Each major room had a purpose: the
Knights' Hall, which was the political center of Salzburg; the Green
Room, where the archbishop met petitioners; the Red Room, where
foreign envoys awaited his pleasure; his bedroom, study, picture gal-
lery, chamber of curiosities, and so on. The Red Room had no chairs;
visiting ministers had to await their meetings with the archbishop and
his ministers on their feet. The outer rooms of the Residenz were in
some degree public, the inner ones absolutely circumscribed. How far
you advanced into the palace had to do with your rank, your power,
your purpose. You made your way through it via a maze of protocol.
The absolute connection of Church and state, sacred and secular, was
manifest in the physical connection of the palace to the church. The arch-
bishop had a private passage between the Residenz and the cathedral.[14]

All this amounted to a social system that had long appeared to be
written in stone. But by the later eighteenth century the old order, the
ancien régime and its artifacts, would begin to crumble, bit by bit, halt-
ingly and often violently. Yet in the lifetime of Mozart father and son,
it remained above all the Church and the nobility who allowed an artist
to live. Leopold Mozart understood minutely how your success in life
depended on attaching yourself to the powerful, and he would make
mighty attempts to teach that doctrine to his son.

Records of music in Salzburg go back to the twelfth century, when
musicians and instrument makers were noted as working in town. As
in all proper German courts, there developed a musical *Kapelle* whose
duties turned first of all around supplying music for church services,
and the trumpets and kettledrums that provided flourishes for the
ceremonial doings of Crown and court. At the same time, there were
plenty of secular occasions that required music. It was heard at ban-
quets and at concerts private and public. From early on, the schooling
of the German aristocracy generally included music or other of the arts.
In the eighteenth century, Holy Roman Empress Maria Theresa was a
well-trained singer who could passably handle an aria, and two of her
daughters were skilled painters; her son Joseph was competent on harp-
sichord and cello and a fervent patron of music.

So as courts and aristocrats competed with one another in the splendor of their architecture, they also vied in the quality of their musical forces. An archetype of the ambitious ruler was Frederick the Great of Prussia, who when not directing his armies on the battlefield played flute daily, kept an orchestra and a house composer, and for three years kept Voltaire as resident philosopher. The ruling class never took up music or art as a profession, of course; being the ruling class was their job. Many of the male nobility went into the military. Whether or not a given prince had any gift for command, the upper aristocracy provided all the generals for wars.

The multipronged musical establishment founded by the Salzburg court in 1591 had not changed significantly when Leopold Mozart arrived in town in 1736. There were four loosely related components: one group of musicians played in the cathedral, the university, and at court; some ten trumpeters and a pair of timpanists marked every court moment of any significance, also many meals and most civic functions; another group of musicians largely played and sang in the cathedral; boy sopranos and altos provided the upper parts for the choirs (women were traditionally forbidden to sing in them) and received their training from court musicians.[15] For composers, the main responsibility was to provide music for services. For big performances there might be forty players distributed among the choirs and the five balconies of the cathedral.[16] The same family names appear through the generations in court records of every department, including music. Similar musical establishments were seen in courts across Germany.

AFTER LEOPOLD MOZART MOVED TO SALZBURG, HIS STORY BECOMES puzzling for a while. In Augsburg he had been a good, even outstanding student. He was manifestly a bright, ambitious, promising teenager, and handsome as well. Now in Salzburg he became a thoroughly negligent student. In his first year at the university he somehow received a bachelor of philosophy degree, but in September 1739 he got expelled for skipping classes. He had proved himself, the university huffed, "unworthy of the name of student."[17]

Leopold did not dispute the judgment. But now, still in his teens, estranged from his mother, his father dead, he had to find something

to do. He was saved by one Johann Baptist, Count of Thurn-Valsassina and Taxis and a Salzburg canon, who found the youth impressive as man and musician and made him his valet. By then Leopold was composing; in 1740 he published a set of chamber sonatas dedicated to the count, as a gesture of gratitude. He engraved the sonatas on copper himself, a highly skilled craft in which the notes had to be incised precisely and backward as a negative for printing.

These self-published sonatas would be the only pieces of Leopold's published in his lifetime. This was nothing unusual for the modestly successful composer he became in the 1740s. Music publishing to that point was laborious and small-scale; no composer, however famous, expected all his works to be engraved. Because there were no copyright laws, any successful publication would immediately be pirated. Publishers would put out an edition and try to sell as many copies as possible before the pirates took over. A great deal of music circulated in loans and rentals in hand-copied form, which was recopied by anyone who needed it. Composers made this necessity a virtue, learning much of their craft from studying manuscripts as they copied them.

At some point in his early Salzburg years, Leopold began a long courtship of a local woman. On the face of it, Anna Maria Pertl was a surprising choice for the fiancée of an ambitious young man; she came from a family that had gone wretchedly bust. Born on Christmas Day 1720, Anna Maria grew up in St. Gilgen, some twenty miles east of Salzburg. Her father, Wolfgang Nikolaus Pertl, came from a craftsman's family and for a while taught music at the monastery school in Salzburg.[18] After schooling in law, he became a civil servant for the Salzburg court. He married late, at age forty-four, to Eva Rosina Barbara Puxbaum, then thirty-one.[19] With her music turns up again: both Eva Rosina's father and first husband had been church musicians in Salzburg.[20] As soon as Leopold's future father-in-law established his family, things began to unravel. He suffered for months from an illness involving miserable cramps, and his mind seems to have been affected. Afterward he gained a poorly paying administrative position in St. Gilgen, where he mismanaged both his family finances and those at his job. When his daughter Anna Maria was three, Wolfgang Nikolaus was in his grave and his belongings had been seized to pay off his debts.[21]

This left his wife and two little girls homeless and destitute. The

widow Pertl moved to Salzburg and scraped by on a widow's pension of eight florins a month when a salary of twice that was considered meager. She and her daughters may have taken in sewing and lace-making work.[22] Her oldest girl died at nine. In a petition for a renewal of her pension when her daughter Anna Maria was fourteen, Eva Rosina noted that this child had long been sick and bedridden.[23] The girl apparently had no formal schooling and grew up semiliterate. What Anna Maria did know was how to cook, sew, keep house, and prepare homemade medicines. These were the skills valued in a woman of the time.

So when Leopold Mozart chose Maria Anna Pertl—in adulthood she reversed her two given names—it was surely an unexpected turning point in her life. She was in her early twenties and had grown into good health. She was pretty, he good-looking. In their early years together the Mozarts would be called the handsomest couple in town.

In 1743, during their courtship, Leopold was appointed fourth violinist in the court orchestra of Archbishop Leopold Anton Eleutherius Freiherr von Firmian. Helping his candidacy may have been some Passion cantatas he wrote early in the decade. Among his colleagues in court music were composer and organist Johann Ernst Eberlin, who eventually became chief organist and Kapellmeister, and Anton Cajetan Adlgasser, Eberlin's successor.[24] A Kapellmeister was the head of a musical establishment in court or church, involved in conducting, playing (usually on keyboard), composing music for concerts and services, maintaining discipline, hiring and firing. Kapellmeisters were near the summit of the musical profession in those days, commanding the most respect and the best salary. The only musicians who were better paid—and they were far, far better paid—were famous singers and virtuosos, and those were generally attached to a theatrical company or were also Kapellmeisters. Professional freelance musicians existed, but these consisted largely of people who, for one reason or another, could not find a job. Perennially, for most artists, the freelance life tends to be precarious and often unpleasant.

An article of the next decade, possibly written by Leopold, listed the Salzburg court orchestra as ten violins; two each of violas, cellos, and basses; three oboists doubling flute; four bassoons; two horns; a trombone. Trumpets and timpani could be added as needed from the

court trumpeters and kettledrummers. The total number of players and singers in the *Kapelle* was ninety-nine, large for a court. The main reputation of the musical forces rested on its church music, which was a steady occupation.[25]

As usual for an entry position in court music, Leopold went for some years unpaid. Only in 1747 was his job declared secured, with a salary of 240 florins plus allowances for bread and wine. It was a slim but workable income. The job also brought him work teaching music to choirboys, and he gave lessons on keyboard as well. Eventually he took to calling himself Dr. Mozart, though he was no such thing.[26] Soon after his salary started, on November 21, 1747, he married Maria Anna in Salzburg Cathedral.

Leopold was now gainfully if meagerly employed. He sardonically referred to married life as "the order of patched pants." The couple settled into a four-room, third-floor flat on Getreidegasse, the building dating to the twelfth century. With them came Maria Anna's sad mother, of whom they took care until she died eight years later. Leopold rented the place from wealthy merchant Johann Lorenz Hagenauer, who lived in a grander house across the street; he became a lifelong friend and patron of the Mozarts. Leopold and Maria Anna got busy making babies, about one a year for a while. The first was born in August 1748. The first to survive, Maria Anna Walburga, called Nannerl, arrived on July 30, 1751. The couple would live in the Getreidegasse flat for twenty-six years, and all their children would be born there. Except for Nannerl and her brother, none of the Mozarts' five other children lived past half a year, a rate of survival only a little worse than average for families in those days.

Their flat was probably typical of what a modestly paid Salzburg musician could afford. There was a good-size living room with a harpsichord in residence where they had their meals, entertained, and made music. Three large windows looked out onto the street and square. On the other side of the square, a *Durchhaus* passage led out to a covered bridge across the Salzach. In winter, a big stove built into the corner was fed by servants from the corridor. (No matter how modest the standard of living, nearly everyone had servants, who were given room and board and otherwise barely paid at all.) Behind the living room was a bedroom where the whole family slept, then a study and a cabinet. The

back door looked out onto a small colonnaded courtyard. In the smoky and sooty kitchen, hung with pots and with meat and fowl, cooking was done at a waist-high hearth. For necessities there was a pit latrine that emptied into a cesspool in the courtyard, but mostly one relied on tiny chamber pots, around six inches high, that were emptied into the nearby Salzach. The Mozarts washed every day, which was unusually fastidious for the time.[27]

In Salzburg, Leopold kept his citizenship in the city-state of Augsburg, perhaps in the hope that it would help him with the legalities of inheritance. A month after he married, in a letter full of the most remarkable lies, he petitioned to renew his citizenship, declaring that his father was still alive and had paid for his education, that his wife came from a prosperous family, that he was a distinguished scholar and a valet in the Salzburg court.[28] Here and later, Leopold did not mind remolding reality when needed—a crafty practicality perhaps among the lessons he absorbed from the Jesuits.

The application for renewal was managed by his mother Anna Maria, and the petition was accepted. But the break with his mother was still final. Anna Maria did not give Leopold the dowry of three hundred florins that she bestowed on her other children when they married. He made a stab at extracting it, telling a friend that he needed it for the publication of his violin method. Finally he gave up and wrote, "It is all too true, even though she remains my mother 1000 times over, that she is wretched and has very little sense. The latter is indeed not her fault and, similarly, the former is God's will. However, it is her fault if she gradually comes to a bad end; for she doesn't trust me . . . Meanwhile, however, she let the other children do her out of what is hers." In later years, when her famous grandchildren played concerts in Augsburg, Anna Maria did not attend.

As to Leopold's marriage, it seems to have been easy and companionable. Maria Anna had no apparent ambitions beyond being a hausfrau. Her husband was not an easy man; he could be waspish and domineering. One acquaintance described Leopold as "equally discontented everywhere."[29] But Maria Anna was not intimidated by him. She seems to have had a lusty, scatological sense of humor, which her son inherited. The upper classes in those days married largely as a matter of power, prestige, and money. A middle-class bride might come with

a dowry or not, but the lower classes in the eighteenth century were free to marry not only out of economic necessity but also for intimacy, children, companionship—in short, for love.

LEOPOLD HAD ARRIVED AT HIS FIRST MATURITY AS MAN AND MUSI-cian. His schooling had made him a polymath, one well versed in literature, theology, arithmetic, and the sciences as well as music. In adulthood he had a considerable library that included several volumes of a history of the Papacy and works on music theory and history.[30] As someone who had to find his way early, he was cautious with money. In school he had picked up some of the Jesuit style: ambitious, intellectual, precise, shrewd, equipped with a sardonic temper. Not one man in a thousand can really be trusted, he would tell his son.[31] You've got to see relentlessly to your own affairs.

If Leopold maintained absolute control over his wife and family, he remained warm and loving to them, up to a point. He was sociable enough, but his closest friends in Salzburg tended to be businessmen or nonmusical creative sorts. He looked down on the run of town musicians and generally avoided them. Also, unimpressed with authority, he did not happily submit to superiors. He saw the powers that be in both state and Church as something to be maneuvered and manipulated, not groveled to.

Leopold's letters in maturity reveal his wide interests and knowledge and a dry wit here and there; he wrote incisive and vivid prose. Touchy about honor and position, he surely expected someday to become a Kapellmeister in Salzburg or elsewhere, which would have made him the leading musician in town. Certainly he had the skills, the experience, and eventually even the fame to qualify for the job. But too much worked against him—some factor of his acerbic personality, his disdain of everyday musicians, his resistance to authority. He would rise to second-chair violin and then assistant Kapellmeister, and be fixed there for the rest of his life.

In important respects, Leopold was a divided man. He hated the Jesuits' wealthy leaders and otherwise remained fiercely anticlerical.[32] In 1753 he wrote a pamphlet satirizing a Salzburg priest and a nobleman that was egregious enough to get him called humiliatingly on the carpet

for libel.[33] Yet at the same time, Leopold was a fervent and on the whole orthodox Catholic. He believed absolutely in the pope's authority over sacred matters, but not over secular ones. He went dutifully to confession. He was given to prayer, to an attitude of submission to God's will, though in his dealings he seemed to have acted on the assumption that God helps those who help themselves. In the house he kept a small shrine to the Christ Child of Loreto, the subject of a statue displayed in Salzburg and credited with miraculous cures. In 1764, on the road with his children who were ailing, Leopold wrote a patron back home: "I beg you to have four Masses said as soon as possible at Maria-Plane and one at the Holy Child at Loreto. These we promised for the sake of our children, who were both ill."[34]

And yet, and yet: Leopold was no less a man of the Enlightenment, the German version of which was called the *Aufklärung*. His literary heroes were progressive and Protestant. Epochal new ideas were making their way across Europe, their main source being thinkers in France called "philosophes." Their names are engraved on history: Voltaire, Rousseau, Montesquieu, Diderot, and their fellow revolutionaries of ideas.

IN THE SEVENTEENTH AND EIGHTEENTH CENTURIES, LIFE AND SOCI-ety were being inflected by philosophy and science in ways unseen since ancient times. In the seventeenth century there had been a series of shocks from thinkers such as Bacon, Locke, and Descartes to ancient Church-ruled dogmas. After Copernicus removed Earth from the center of the universe, the prime revelations in science had come from Isaac Newton, who, beginning in the late seventeenth century, revealed that the universe was governed by physical laws that were the same everywhere and open to human reason through mathematics and the experimental method. Philosophers declared that it remained for us as individuals and societies to exercise that reason, which required a new and absolute freedom of thought. The scientific method galvanized unprecedented progress in industry, and the middle class who commanded that industry began a long rise toward power.

The Enlightenment believed that the physics of nature and of all reality would quickly reveal itself to our understanding. While many

feared that the new science would subtract God from the equation, the core of the Enlightenment was not essentially atheistic. It rather retired God to a distance from His perfect creation, which functioned like an infinite clockwork. When Voltaire, nominally a philosopher but mainly the chief publicist of the Enlightenment, historically cried, "Écrasez l'infâme!" he meant to crush not religion but rather infamous Catholic abuses of religion. Later in the eighteenth century, Immanuel Kant declared that we can choose to believe in God, but we cannot possibly understand the ultimate nature of reality. As finite creatures we cannot know an infinite divinity; we can only know our limited selves. For that reason, all scripture, as a human creation, has no claim to absolute authority. Humanity, Kant declared, must lift itself from an ancient and self-imposed immaturity. Any religion that proposes to enforce doctrines that cannot be questioned should be forbidden. And, he wrote, the central tenet of the Enlightenment is that as reasoned beings we must think for ourselves. In Vienna, Emperor Joseph II would declare that a citizen's duty to God and his duty to the state were identical: the divine was an adjunct of the state.[35] Alexander Pope poeticized, "Presume not God to scan. / The proper study of mankind is Man."

Many things flowed from this historic rejection of spiritual dogma and upwelling of humanism. In the past, human life had been a matter of service: the serf served the lord of the manor, the lord served the local prince, the prince served the king, the king served God. Now citizens were assured that they had the right to serve their own interests and find their own happiness as individuals, and that they had a right to rational social systems and governments. John Locke, in the *Second Treatise of Government* of 1690, declared that a monarchy was a contract between ruler and ruled, and if the contract was not valid it could be revoked. Such ideas struck horror and fear into the ancien régime, and they were intended to.

None of this, of course, was simple. The Church and the ancien régime did not lie down and succumb. They fought for their privileges and, in one way and another, maintained them for many years to come. The *Encyclopédie*, an epic compendium of knowledge that was a central project of the French Enlightenment, was banned by Church and state—though it had tacit support in some quarters of Church and state. Freemasons, the international secret society that was a nexus

of Enlightenment thought, were banned by the Papacy but still prospered, its membership including any number of progressive nobles and churchmen.

In contrast to the democratic and deistic tendencies of some of the philosophes in France, the German *Aufklärung* was not anti-Church, though it was often anticlerical. It exalted enlightened strongmen who would impose reform from the top down. The most celebrated examples of enlightened princes were Frederick the Great in Berlin and Joseph II in Vienna, whom history would remember as "benevolent despots." Yet Joseph died convinced he had failed, and he ultimately backtracked on many of his own reforms. In the Enlightenment there were as many varieties of delusion as there were of hope.

ONE CRITICAL DEVELOPMENT OF THE ENLIGHTENMENT WAS THAT ART escaped from religion and into the larger world. Much of the art of the Renaissance and Baroque eras was created for the Church. In the eighteenth century, sacred art and music survived, but now it would in effect be superseded in importance by secular works addressed to a wider public. In the Baroque period, the Church had largely paid artists' rent. Now it was largely the aristocracy who bankrolled the arts, and opera and public concerts survived to a degree on the box office. The new aesthetic was accordingly popularistic, aimed at ordinary viewers and listeners no less than cognoscenti. Clarity, order, a certain modesty, and purity were the new ideals: the mean, the art that hides art.

In the later eighteenth century composers aimed for a *natural* style, meaning pieces that were new yet sounded familiar, that almost seemed to have written themselves. Nature, however vague that word, was the model and judge. The theorist Johann Joseph Fux, who historically rationalized the study of counterpoint (the Renaissance and Baroque art of interweaving melodies) in his treatise *Gradus ad Parnassum*, advised an imaginary student that originality is of course a fine thing, but only to a point: "You will strive in time with all your might for novelty and invention; but by no means overturn the rules of art, which imitates and perfects nature, but never destroys it."[36] These rules of art were perceived to be, like Newton's physics, universal and eternal.

By late in the century, musical form had become at once more com-

plex and more rationalized, laid out in outlines that connoisseurs knew how to follow: the first movement of a sonata goes in this pattern, the finale usually in another, a minuet goes like so. These forms rose partly from dance music, and much of the Classical style that was not outright dance music reflected dance in its melody and rhythm and lightness of touch. The century was, on the whole, not a great one for sacred music. It was an optimistic age, and music largely echoed that: most of the time's greatest operas would be comedies, not tragedies. In the arts novelty was blended with convention, the unexpected with the expected. There was a partial retirement of counterpoint in favor of a single melody supported by accompaniment, which was felt to be more lucid and expressive.

The same populist aesthetic enfolded all the arts: you aimed your work at everybody, from the naïve to the sophisticated. One day, Mozart would summarize this aesthetic in a letter to his father: "These concertos are a happy medium between what's too difficult and too easy—they are brilliant—pleasing to the ear and—natural without being vacuous;—there are passages here and there that only connoisseurs can fully appreciate—yet the common listener will find them satisfying as well, although without knowing why." Because it drew directly from life and nature, music that supported words, in opera and sacred music, was declared superior to instrumental music, which was more of an entertainment intended to be pleasing and easily comprehensible. Haydn, after raising the symphony from a parlor entertainment to the king of public musical genres, spent his last creative years writing vocal music, Masses and oratorios, which he considered the crown of his work.

As the scientific revolution declared that the rules governing the universe were the same everywhere, so the creative aesthetic of the time was universal—at least in theory. Christoph Willibald Gluck, the greatest of midcentury opera composers, considered opera to be properly an international style. In practice, national schools remained; for one example, there was a generally understood Italian propensity for melody, while German composers were concerned with the more intellectual matters of form, harmony, and counterpoint. Still, the old discipline of counterpoint and its allied procedures such as fugue and canon, called "the learned style," survived integrally in the music of the later eighteenth century and after.

SO IF LEOPOLD MOZART WAS A DIVIDED MAN—FERVENTLY RELIGIOUS
but anticlerical, a believer in science and reason who prayed to a
statue of the Christ child for healing—so was his age divided. His
prime literary hero was the Lutheran poet Christian Fürchtegott
Gellert, one of the defining figures of the literary *Aufklärung* and
one of the most popular German writers of the century. Leopold
disseminated Gellert's works in Salzburg and wrote to him, getting
a letter of thanks in return. Later, when his son received a volume
of Gellert from a patron, Leopold told his landlord and patron Ha-
genauer that the man who gave it had entreated the youth to "read
it often—and feel its God-like songs and lend them . . . your irre-
sistible harmonies: so that the callous despiser of religion may read
them—and take notice . . . and fall down and worship God."[37] Gel-
lert was a professor of moral philosophy; Leopold had studied that
subject in the university.

As a poet Gellert set out to raise the moral character of his country-
men. His style was celebrated for its clarity and directness—in prac-
tice, an almost childlike simplicity, wanly sentimental and didactic. A
poem about a boastful dancing bear ends with a homily about modesty:
"Your neighbor's hatred would you shun? / His talents to surpass be-
ware! / And still the higher your attainments run, / Conceal them
still with greater care." Gellert wrote extensively on the art of letter
writing. In educated circles, letters were held to be a kind of literature,
often addressed to the public. Many of Leopold's letters in his tours
with his children would be intended as public reports, to be read aloud
to friends, perhaps someday to be published. In that ambition, Gellert
was his model.

Another Protestant hero of Leopold's was the poet and man of let-
ters Christoph Martin Wieland, who in his life had evolved from ex-
hibiting a fierce piety to embracing the sensual along with the spiritual.
Wieland published the first translations of Shakespeare, an epochal
event in German letters, and wrote the first bildungsroman, a story of a
youth's education in worldly life and love and morality. His poetry was
celebrated for its grace and charm—high-*Aufklärung* virtues.

As a composer, Leopold considered himself up to date, and in its
own grace and charm, his work resembled that of many note writers
around him. Composing in those days was considered not a matter of

self-expression but rather a rule-bound craft geared for speed, the main goal of secular music being entertainment. Most of the music heard was new; people wanted to hear the latest pieces, written by their favorites. There was as yet little sense of a continuing repertoire; many pieces were expected to be played just once or a few times before listeners moved on to the next thing. Like most composers of his day, Leopold was enormously productive. In 1756, writing in the third person, he summarized his output: "He has made himself known in all forms of composition . . . [and has written] many contrapuntal and other sacred pieces, also a large number of symphonies . . . more than thirty grand serenades . . . many concertos . . . also twelve oratorios and a great number of theatrical pieces." None of these was published; most eventually were lost.

The best of Leopold's surviving works, largely symphonies, show him as a deft handler of the genres and styles of the day, the pieces vigorous, perky, tuneful, with no particular pretentions to expressive depth, originality, or strongly marked personality. One of his tunes was well known to all Salzburg from being played daily in the bell tower. Now and then he wrote novelties—his *Toy Symphony*, involving toy instruments; a *Sleigh Ride*; a drolly rustic divertimento called *Peasant Wedding*, with drums and bagpipe, shouts and whistles. His interest in symphonies was not typical of Salzburg. Although in those days composers around Europe turned out symphonies by the thousands, Leopold's town was not all that interested in them. Yet eventually he was numbered among the leading Austro-German symphonists of his generation. He also wrote many of the expansive, multi-movement pieces called serenades that were a Salzburg tradition, a feature of the *Finalmusik* heard in the ceremonies marking the end of the school year at university. Given those occasions, a serenade was an invariably cheery sort of piece; often it contained what amounted to a concerto in the middle that could be pulled out as a separate work.

Leopold was a violinist by trade, yet among his many concertos, one solo instrument he seems totally to have neglected was the violin. Musicians generally wrote concertos for themselves, but that omission shows that Leopold did not consider himself a soloist. There is no record of him playing any concertos at all.

IN THEIR BROAD APPEAL, LEOPOLD'S WORKS WERE AIMED AT THE main venue of the time: the private music room. For those who had the interest, the time, the discipline, and the money to invest in it, music was one of the prime pastimes of the middle classes and up. There were professional players and singers, but many thousands more amateurs. Some of those playing for love were highly accomplished, but the run of amateurs was, of course, more enthusiastic than accomplished. Much of the time, music was played with no audience at all, for the pleasure of the players—pianists and string quartets going through pieces alone.

Musical salons involved not only chamber music; there might be a little orchestra too. An engraving of the time shows a house orchestra, the members sprawled around one wall of a room. There are seven string players, presumably one or two of them violas, two cellos, and a bass; and for winds, two oboes, two bassoons, and two horns—the common orchestra of the mid-eighteenth century. The artist knew his music: all the instruments and performers are rendered accurately; on the music stand in front of a horn player sits waiting one of his crooks, the curled tubes that were used to change the key of the valveless instrument. In the middle of the band is another feature of the Classical orchestra, the ever-present harpsichord. This one is played by a young boy, who is leaning over his music with great concentration. Behind him, one of the bassoonists and the bassist are reading off his part, leaning to the side to get a better look. Behind the orchestra is a small collection of listeners, some of them looking over the shoulders of the players to follow the music.[38] Some of these musicians might be professionals, playing for pleasure outside their usual jobs in theater or church, but some are likely amateurs. There are no women in the picture, but in fact women were the more prominent connoisseurs of chamber music and, mainly on voice and keyboard and sometimes strings, perhaps the most frequent performers.

The programs in house concerts were a grab bag of media and genres. Most of the time the music was quite unrehearsed. One of the skills most valued in a player was sight-reading, the ability not only to get all the notes, or fake them convincingly, but also to understand the import of the music as you went. That the run of performances was catch-as-catch-can, lacking any sort of polish, goes without saying. Someone who could play a piece powerfully and elegantly at first

sight was admired extravagantly. But that was rare, and no one expected better.

If there was an orchestra at hand, a concert might begin with the first movement of a symphony. The rest of the symphony might be heard later, or not. One critic of the time opined that symphonies were rather a nuisance, not as interesting as the concertos and string quartets and sonatas and arias that might follow in the program, but given that a symphony's first movement tended to make a lot of noise, that was best to start with, to get everybody's attention. Concertos were more popular than symphonies, but connoisseurs were often more interested in how a soloist played, his polish and virtuosity, than in the music itself.

Which is to say that in the middle eighteenth century, the genre of symphony was not generally serious or ambitious; for a composer like Leopold Mozart, a symphony was the work of a few days or a week or so. The most popular instruments for amateurs were strings; the most popular genre of chamber music, the string quartet—though in Leopold's prime as a composer, the quartet was still a relatively minor genre, not yet the king of chamber music that Haydn eventually made it into. Then and for many years after, string quartets, piano sonatas, violin sonatas, and other chamber pieces were played only in private. In a few big European cities, mainly Paris and London, a public concert life that presented large works (symphonies, oratorios, concertos) developed in the eighteenth century. It was with his symphonies in the concert halls of London that Haydn found the summit of his fame in the 1790s. But public performances lagged in German lands; house music maintained its traditional dominance well into the nineteenth century.

What pictures and accounts show of musical life in the eighteenth century is that *Hausmusik* was a social occasion, carried on in music rooms and parlors mainly by and for small groups of friends and acquaintances, the music competing with food, games, conversation. People involved in music were divided into amateurs and connoisseurs. The former listened naïvely for pleasure, while connoisseurs could appreciate the craftsmanship, read the music, follow the forms and sometimes even the harmonies and modulations. By contrast, in religious music heard in church, where the audience was captive and supposedly attentive, it was expected that expression in sacred music should be solemn and weighty, the emotions sometimes tragic. Likewise in opera,

with its dramatic stories and raging emotions. Instrumental music in
the home, however, traditionally aspired to not much beyond being
pleasing, one of the main terms of critical approval.

This was the milieu for which Leopold Mozart wrote most of his
pretty little pieces, and it accounts for much about his style and the style
of his contemporaries. If you could provide a lively movement and a
catchy tune, sometimes you could even get people to give you their full
attention.

After his appointment to the court orchestra in 1743, Leopold could
look forward to the prospect of a lifetime employment in the service of
the Prince-Archbishop of Salzburg, or perhaps a step up to a musically
more illustrious court. He perhaps understood that his relatively mod-
est gifts and reputation as a composer would not qualify him for the
most prestigious German musical centers, mainly Berlin, Vienna, and
Mannheim. But Leopold had a solid reputation all the same and could
hope to be a well-placed Kapellmeister someday. There was composing
and steady work teaching. The violin method he wrote in the 1750s he
hoped would bring him some money, maybe a bit of renown, surely a
promotion. To be a celebrated Kapellmeister and pedagogue was the
summit of the career Leopold imagined for himself. That would be his
fame and fortune, God willing.

Then on January 27, 1756, Johannes Chrysostomus Wolfgangus
Theophilus Mozart was born, and everything changed in ways that
Leopold, amid all his schemes for the future, could not possibly have
imagined.

Chapter 2

PAPA

What Leopold Mozart came to call the miracle God created in Salzburg took some years to reveal itself. For a while after the birth of their first son to live more than a few weeks, his thoughts were not much concerned with the new baby. He cared about his children, but after all babies came and, mostly, went. His concern was for his violin method, with which he hoped to gain some renown, better job prospects, better security for his family. After Wolfgang had lived long enough to be christened, Leopold wrote a friend, "I can assure you I have so much to do that I sometimes do not know where my head is . . . And you know as well as I do, when the wife is in childbed, there is always someone turning up to rob you of time. Things like that cost you time and money."[1]

On its appearance in 1756, Leopold's *Treatise on the Fundamental Principles of Violin Playing* was received glowingly. The book was self-published and amounted to both a compendium of what Leopold had learned as a teacher of violin and, as it turned out, a prophecy of how he would teach his children. In a review of the book, renowned theorist and composer Friedrich Wilhelm Marpurg wrote, "A work of this kind has long been wished for, but one has hardly dared to expect it. Those who are most adept at wielding the bow are not always in control of the pen . . . How much greater, then, is our obligation towards the author of the present work. The thorough and accomplished virtuoso, the reasonable and methodical teacher, the learned musician . . . are all here revealed in one."[2]

A few years after the review, Marpurg brought Leopold into the Berlin Society of Musical Science, which gave him an opening to correspond with celebrated writers and visit them, which he did over the next years. This is when he wrote his literary hero, poet and moral philosopher Christian Gellert, who responded: "How lucky I am . . . that I can contribute something to the preservation of taste as well as good customs in my homeland."[3] Leopold's method was showing off its worth and his worth; it would ensure his place as a figure in the arts and letters, and his compositions would presumably continue to spread. All in all, Leopold could allow himself a measure of optimism.

MEANWHILE WOLFGANG SURVIVED WHEN MANY BABIES DID NOT. THE longer they lived, the more you could hope. A year, two years, three. The child was a toddler like all toddlers. He nursed, burbled, learned to recognize his parents and sister, fouled his diapers, crawled about, lisped his first words. He was healthy and well shaped except for an oddly deformed left ear.[4] Arms waving, he stumbled into walking. He played the immemorial script—until he didn't.

For years there was little to be remarked by Papa about his children's musical activities, other than how splendidly apt Nannerl was at the keyboard. Little Wolfgang banged the clavier sometimes; he sat playing thirds. (*Clavier* was the time's term for any keyboard instrument.) So it went until the miracle of January 24, 1761: out of the blue, the child not yet five years old began playing the clavier as if he had always played it. With no apparent effort, he began to memorize pieces, one after another, from Nannerl's notebook. In weeks he made the kind of progress that had taken his sister two years—and she was revealing herself as a prodigy. Like every miracle it was impossible, yet it happened. Leopold's head must have been boiling with amazement, with pride, with holy awe.

The next revelation came on December 11. Wolfgangerl was found playing something not in his sister's notebook. He was making it up. The five-year-old was *composing*. Leopold wrote the piece down in Nannerl's notebook, adding, "Sgr: Wolfgango Mozart 11ten Decembris 1761."

"Wolfgango's" perky Andante in C Major was not childish gabble;

it was an actual little piece: attractive, the harmony in the direction of correct, with a sure sense of beginning, middle, and end. It resembled, of course, the pieces in Nannerl's notebook, which was most of the clavier music Wolfgang had heard to that point. It was not just in three-beat time; it was unmistakably a minuet, with the elegant grace of that dance and the music written for it, complete with flowery trills. After four bars of minuet, the second line changes, un-minuet-like, to two-beat, but it preserves the same mood, as if the minuet has been compressed and intensified. The first four bars are static, the material AABB and each bar ending on the notes G–F, but the second line is a surprise, the melody scampering downward and, even more surprising, making a passing nod to F major in the harmony, that quasi-modulation brought off deftly en route to the final cadence. So as a composer, Wolfgang started with a minuet. He would always love the minuet, the dance and the music, because it was so like him: not so much about the ritualized outer form as how elegantly you executed it.

In writing it down, Leopold surely made some tweaks, but the unusual change from three-beat to two-beat he left untouched. This foreshadowed his teaching, his refining of his son's work from then on: responding to what the boy had done, making corrections into lessons, but leaving intact the quirks and touches of individuality.

There followed a twelve-bar C-major Allegro in two-beat, K. 1a, in which Wolfgang divided rising lines in eighths between the hands, skirting any emphasis on the home chord of C until a massive final cadence. Leopold would have explained some more matters of craft to his new student; if this second effort does not have the harmonic variety of the first piece, it has a more varied and effective melody. Next came the folksongy Allegro in F Major, K. 1b, of twelve bars, its opening tune bouncy and wry, the piece having a familiar formal outline: A / BA, each section repeated, the B section livelier. Leopold was teaching his son about form and contrast.

As Wolfgang produced piece after piece, his father wrote them down in the blank pages of Nannerl's notebook. (There may have been other early pieces that did not survive or were never written down.) On December 16 came a Minuet in F, longer and richer in material, through-composed, a bit inchoate. Minuets in G and C Major that followed in the next weeks were more elaborate in every way—there are more

harmonic excursions, and the C Major explores sonorous low-register textures on the harpsichord. Each of these miniatures goes about its business confidently, with a sure handling of melody and harmony. They also have a solid sense of style and genre and a dawning understanding of how to shape form.

Leopold was an experienced teacher, and he knew about talent. He had seen his own inner drive to music override his mother and the priests. He had watched a good many little boys struggling to find their notes on the violin, little girls fumbling at the keyboard. He had observed how talent works: this one grasps something in a fraction of the time as that one. Some, a very few, seize on what you show them as if they know it already, and take off like a skyrocket. Yet most of them, even the most seemingly talented ones, sooner or later reach a plateau and never get off it.

Now and then a student surprised him. Nannerl had been unusually quick; there was no telling how far she might go. But Leopold had never seen anything like Wolfgang. Even allowing for a father's fond imaginings, he had never seen anything like it. Maybe, he speculated, no one had. For Leopold the profession of music was less an idealistic endeavor than a trade, something that earned one's living, one's reputation, one's name and place in the world. So once again: in regard to his astonishing son, the question was what to do now.

FOR THE CHILD IT WAS A MATTER OF MIMICRY. FIRST CREATIVE EF-forts begin that way: from the inspiration of what you have encountered and loved, you want to make something of your own, but all you know is what you have seen or heard, so those become your models. There is an element of mimicry throughout the process of becoming an artist; the grown-up name for this process is *influence*. An artist devours influences, always on the prowl for new ones.[5] Eventually, with luck, one transforms it all into an individual voice.

From the beginning, Wolfgang was a phenomenal mimic. In playing pieces from his sister's notebook, he grasped how harmony and melody worked and quickly moved to making up his own pieces that rode on familiar harmonic and rhythmic and formal patterns. His father showed him the formal outlines of each kind of piece: a minuet and trio had an

A section, repeated, a B idea, and a return to the A section, repeated. In the middle came the trio section, which wanted to be lighter, and the minuet returned after the trio. A march, a scherzo—each went like so. You learned the basics of musical grammar and syntax by writing in small, mostly dance forms. Eventually in your study the formal models got larger: the first movement of a sonata goes like so.

Leopold gave Wolfgang exercises: Create a melody over a bass line, a bass line under a melody. Create middle parts between a given bass line and melody. Make sure the melodies have an elegant shape and a direction. Don't get stuck in one place. Don't let the harmony get stuck on a chord or two, either. Wolfgang seized each of these ideas with ready understanding. Meanwhile he picked up how to read and write music (more or less at the same time as he learned his letters) when he was already creating his own music. Still, for many years to come, his manuscripts would show Papa's hand in some degree or another.

Teaching in the eighteenth century was generally strict; you were taught with the stick liberally applied. In the next generation, in Bonn, Johann van Beethoven would beat music into his son Ludwig, which was probably the way Johann had been taught by his father. Punishment and tears were part of a teaching style somewhere between messianic and dictatorial. But Leopold was cannier than that. To a considerable degree he seems to have given Wolfgang free rein. *Write what you want, son. Papa will correct it, and each correction will teach you something.* But Leopold corrected with a light hand, taught his children more by example than by rule. It was only in the next century that Johann Heinrich Pestalozzi and other reformers proclaimed that the starting point of education should be the child, that the student's inner resources should be drawn out by means of activities and exercises. This appears to be the way Leopold worked with his children, by following the leads they handed him.

As for the steadiness of beat and sureness of rhythm that Wolfgang possessed from the beginning, that probably came from the clavier player he heard most in the house: his sister. Nannerl was the first significant influence on her brother as a player, and she was likely an abiding influence.

In those days composers were generally performers as well, whether virtuosic or workaday, most often playing clavier. Soon Leopold would

have taught the boy thoroughbass, the art of improvising harmony and melody over a bass line that has numbers under it indicating the chords. This was the usual way of teaching good harmonic practice. In the process, you learned the value of having a well-shaped bass to undergird your melody and harmony. Thoroughbass was practical because you often used it in accompanying soloists, and it was intuitive: the ear was trained before the analytical part was added. There were rules, of course. For one perennial example, it was not allowed for octaves or the interval of a fifth to proceed in parallel among the parts. Over time, one learned that there were assorted other faults, which the ear and fingers learned to skirt.

When one became proficient at playing chords in a key, each part moving smoothly in the texture, one could learn to change keys correctly, a more sophisticated matter necessary for harmonic variety and a fundamental element of longer pieces. Having mastered voice leading and become familiar by ear with standard harmonic practice, students were ready to invent their own music—though in practice, as with Wolfgang, composition and the technical study of thoroughbass proceeded together. Again, composition in those days was rule-bound because you needed to work fast and the rules solved many of your problems ahead of time. In an era before royalties, when you relied on commissions or sold your work outright, a professional composer had to be prolific to survive.

In all this one was ingrained in musical conventions: the right and wrong way to write harmony and melody and lay out rhythms and forms according to the taste of the time. It was all conceived and taught as matters of universal practice, on the order of scientific laws. If you wrote opera, there would be the formal and literary conventions of this and that genre, opera seria here and opera buffa there, and the kinds of music appropriate to each.

These were matters of practical craftsmanship. Making art is a dialectic among tradition, technique, and your own gifts and personality. Eventually, if an aspiring creator has any ambition, she or he will want to go beyond the proper and correct, to find a voice. This is where teaching reaches its limit, because craft and convention can be taught, but an artistic voice cannot. It comes from inside, if at all. If you are an artist, your voice is profoundly *who you are*, in the same way as your

features, how you speak, whether or not you can raise an eyebrow, whether you walk clumsily or gracefully. In every creative endeavor, some people acquire a voice, some of them sooner and some later. Most aspirants never find it.

Leopold Mozart was a skilled and highly experienced composer, but his music, even in the outings where he escaped banality, was conventional and a bit impersonal. As a teacher he was consummate, his children evidence of that, but he was not the man to prod his son to find a distinctive voice. In effect, he had never done that with himself. The aesthetics of the time presented further barriers. As noted, the celebrated Viennese composer and theorist Fux told his students that originality was a fine thing, but the eternal rules of art came first. In its quest for the universal, the later eighteenth century—what came to be called the Classical period—did not place a supreme emphasis on originality and personality. Skill came first, then taste and discretion—and audience appeal. The need to be pleasing was central too, in the musical milieus of the home and the theater with its box office.

Artists in the eighteenth century were not viewed as transcendent beings; they were working craftsmen. The word *genius* did not have the cultish aura it would acquire in the next century. The word meant something on the order of talent, aptitude, or simply one's temperament in general; that is the way the adult Wolfgang Mozart used the word.[6] A career was a matter of making your way. You were a professional; you needed people to like what you did enough to pay you for it. Often the more they liked what you did, the better they paid. And while musical connoisseurs were expected to have well-developed taste and understanding, they were outnumbered by amateur listeners who wanted to have a good time and be pleasantly or poignantly moved. When writing sacred music for church services, you had a captive audience. But if as a composer of secular music you knew what was good for you, you tried to please everybody. Only when you had found an audience and gained its goodwill could you find favor with pushing and stretching the envelopes.

At the same time, while painters and sculptors and writers had names that went down in history, their works living on in books and on walls and pedestals, music is an evanescent art, vanishing as it sounds. In the eighteenth century music was perceived to be transitory, and to

a degree its creators along with it. The notated scores on which music depended were laborious to reproduce whether by hand or in print, so the circulation of a given piece was constrained. Something like a concerto or an opera was generally too expensive to publish, especially given that pirates were always lying in wait. Most larger pieces circulated in manuscript. A music fancier wanting to develop a private music library had to work at it, often by contacting composers directly. Public music libraries did not exist. It was not until the end of the eighteenth century, with a growing audience and innovations that expedited engraving, that music publishing took off.

By and large in the eighteenth century, listeners wanted to hear the latest thing. True, here and there some music lived longer. Churches might perform repertoire going back centuries. In Leipzig, students of J. S. Bach kept his choral music alive in his old church, but elsewhere, Bach's reputation for many years was more a matter of cult and legend than widespread performance. In Wolfgang's childhood the idea that one could create work that would become part of a historical repertoire scarcely existed. George Frideric Handel, who was still alive when Mozart was born, turned out to be the first composer whose work maintained its popularity after he died. Later in Mozart's life, critics would begin to call his work immortal. If he himself ever considered such a thing, there is no record of it.

This was the musical milieu in which Mozart grew up as a creator. It was his nature not to shake his foundation in convention, but to sit firmly on it. The great artists, of course, transcended these pressures. In the later eighteenth century, composers such as Haydn and Gluck absorbed their milieu as it was but had the creative fire in the belly and the imagination to innovate and bend their audiences' expectations toward them. This was not, though, what Leopold Mozart preached to his son. Instead, he said: keep it simple, please your listeners, write things that will sound familiar to them. And in the tours of his childhood and into his teens, Wolfgang could arrive in a town, soak up the styles of local composers, and mimic those styles astonishingly.

Wolfgang Mozart was, in short, reared by his father to be a refined craftsman who would get ahead by writing what people wanted to hear. And he was remarkably good at that. His distinctive voice emerged only bit by bit, over years. Eventually he got beyond convention, but

he reached his maturity not by turning against convention but rather by going through it and coming out the other side. But here is one more surprising thing about Leopold Mozart: as far as the record shows, from beginning to end, whatever the vagaries of their relationship, he loved nearly everything his son wrote.

In September of his fifth year, Wolfgang had his first performance that history records: at the university theater he danced in the Latin play *Sigismund King of Hungary*, with Prince-Archbishop Schratten-bach in attendance—the play part of the festivities for the archbishop's name day (which was distinct from the less important birthday).[7] There is a certain prophecy in Mozart's debut before the public: in adulthood he would maintain that he was more gifted at dancing than music. That notion of his is hard to believe, but in any case dance was vitally going to shape and inform his work.

Both as player and composer, the little boy was making astonishing progress. A Benedictine monk who was a friend of the family wrote of Wolfgang at six, "He would play the most difficult pieces for the pi-anoforte, of his own invention. He skimmed the octave which his short little fingers could not span, at fascinating speed and with wonderful accuracy. One only had to give him the first subject which came to mind for a fugue or invention; he would develop it with variations and constantly changing passages as long as one wished."[8] So Wolfgang was already improvising; he knew what the contrapuntal procedure called fugue amounted to, and he could mimic that as well. With his flights of improvisation, he was at age six tossing off feats that many adult professionals could not manage.

At eleven, Nannerl appears to have been about as precocious at the clavier as her brother. In the next years some connoisseurs would prefer her playing to his. The difference was that Wolfgang improvised and composed, and Nannerl did not. Was she discouraged from it? There were women composers here and there in the eighteenth century, just as there were female painters, but it was widely alleged that artistic creativity was not natural for women. The time was obsessed with the ideal of the "natural." This required declaring what was natural and what was not, an inevitably dubious matter. Performing on keyboard, because it involved the same sort of skilled finger work as sew-ing and the like, was accepted as part of a woman's nature; a creative

imagination was not. In every part of life, gender roles were perceived as written in stone. It took a strong personality and rare support for a woman to buck them.

Nannerl did not buck them. There is no record that she ever seriously tried to compose. Given Leopold's openness in educating his children, the way he followed their cues, most likely if his daughter had expressed interest he would have nurtured her creativity in the same way he did Wolfgang's. Years later, after she sent him a song she had written, her brother would prod her to compose more, with no success. She was able to play thoroughbass accompaniments, a sort of improvisation, but as far as history knows there was only that one song from Nannerl. Beyond that, not even ingenuous little miniatures like her brother's first efforts.

The next years would only amplify the differences between brother and sister. In his letters, Wolfgang would reveal a wild imagination that Nannerl never showed. Eventually he inserted hilarious fantasies into the dry accounts of her diary, partly perhaps as a way of sending up how pedestrian her entries were. When he came of age, Wolfgang stood up to his father and went his own way. Nannerl never did. She conformed, she accepted, she stayed by Papa. All the same, for the first years of the children's life in the spotlight, Leopold usually wrote of their accomplishments together: not "my son," but "my children."

THE *AUFKLÄRUNG* PLACED GREAT IMPORTANCE ON UNDERSTANDING oneself, rationally perceiving one's strengths, one's weaknesses, one's temperament, one's distinctive *genius*. Leopold Mozart regarded himself as a violinist and composer and, God willing, eventually a Kapellmeister. He bent all his efforts and his ambitions toward those things.

Then came his two prodigies. Leopold perhaps began to understand that he was a good violinist but no soloist, an appreciated composer but not to be classed with a Haydn or a Gluck or even a Wagenseil. Leopold was superb at only two things: teaching and scheming. When his children revealed their gifts, he understood better than anyone else how far beyond him they both were, and he marveled at them. At the same time, as a practical and ambitious man, he would calculate how those gifts were to be exploited to bring his family fame

and fortune. Miracle and fame and money being for him one thing, one process.

That process, like all things, lay in the hands of God of course, but the divine omnipotence existed in a manner of speaking. Leopold believed that God had already shown his hand with his children, and while His almighty power was an unquestioned article of faith, it was Leopold's duty to do whatever he could to shape their progress to the last detail.

I will manage this marvel myself and myself alone. That is my duty to my children, to my God, to myself. Now it is wholly about the boy and the girl, but eventually there will come the payoff. I will give the children my heart's blood, and when they have found their triumph and the time comes, they will give me theirs in return.

THE RECORD IS AMBIGUOUS, BUT IN JANUARY 1762, LEOPOLD MAY HAVE taken the children to Munich to play for Bavarian prince-elector Maximilian III Joseph and his court. The title "elector" meant that he was one of the nine sovereigns of German states who voted for the man to be installed as Holy Roman Emperor. (The electors' power was largely ceremonial given that, with one exception, the emperors had been Habsburgs since the fifteenth century.) Occupants of German thrones tended to be enthusiasts for music, or to affect enthusiasm. Max Joseph was a passionate aficionado, skilled on the viola da gamba.[9] If the children did perform for him, it was their public debut.

Travel in Germany in these times was legendarily wretched: lurching coaches, rutted and muddy roads that outside of town were often unmaintained. Inns might offer lumpy pallets and bedbugs, if there were beds at all rather than a pile of straw. The aristocracy traveled with an entourage and stayed in palaces. Everybody else made do with what they could afford.[10]

A trip to Munich, a meandering route of more than a hundred miles to the northwest, took some twenty-nine hours at an average of hardly better than five miles an hour, with six station stops to change horses.[11] If the family visit there actually happened—the story comes from a hazy memory of Nannerl's late in life—it lasted about three weeks and involved both children playing for a musically sophisticated

elector, his court, and the local nobility. For Leopold the visit would
have functioned as a dry run. He knew his children's capacities as they
had surely been playing in soirées at home for family and friends. But
he had to see how they performed in front of important strangers in a
palace, whether they would do what they were told, whether they were
afflicted with nerves or failures of concentration when they were put
on the spot. If Munich happened as reported, Leopold saw with satis-
faction that his prodigies were as remarkable in front of an audience as
they were at home. From this point there is no record that either child
ever dug in their heels or got obstinate about performing.

In the next months Leopold conceived a dazzlingly audacious plan.
He would take his children to one of Europe's capitals of music, he would
see if they could make the sensation they ought to, and then the whole
musical world would be advised. On September 18, 1762, the Mozart
family set out on a trip that would take them to Vienna and into the pages
of history.

That journey of some 185 miles required more than two weeks, with
overnights at inns and some musical interludes en route. The tour had
required the approval of Prince-Archbishop Schrattenbach; here and
later, he was to prove reliably generous to the Mozarts. He may have
financed the trip, at least in part. Loans and a credit network were sup-
plied by their wealthy family friend and landlord Johann Lorenz Ha-
genauer, who was a merchant with international contacts.

The Mozarts reached the Danube at Linz on October 1. There the
children made their first well-documented public appearance together,
the program sponsored by regional administrator Count Leopold
Schlick. Gears began to turn among the aristocratic network that blan-
keted Europe. Schlick's wife the countess brought a Viennese count
to the concert; on his return home, he advised Archduke Joseph, son
of Empress Maria Theresa, about the phenomenal children who were
approaching. Joseph, the future emperor and passionately musical,
would have been fascinated at the prospect. He passed the news on to
his mother the empress. Before the Mozarts arrived in Vienna, there
was already a buzz of anticipation.[12]

At the same time, the Linz sojourn foreshadowed the kinds of de-
lays and annoyances that were going to bedevil the Mozart tours. They
were held up for five days, hosted by a couple of kind spinsters, waiting

for the nobility to receive them. When the children were finally able to play for the elector, their gift was exactly one ducat, about four and a half florins, which would pay for maybe a couple of days on the road. Still, Leopold reported, "The children are merry and behave everywhere as if they were at home. The boy is intimate with everyone, especially with the officers."[13]

From Linz they followed the river east in lovely autumn weather, the next stop Ybbs an der Donau. In a church there Wolfgang sat down at the organ and accompanied a Mass. Some Franciscan monks, enchanted by the music, rushed to see who was playing and were dumbfounded to find a tiny boy at the bench improvising away. If Wolfgang had ever played an organ before, there is no record of it. He was years from being able to reach the foot pedals from the bench. He would eventually learn to play the pedals by standing on them.

Leopold began his long collection of letters reporting every detail of their adventures—the details tidied up—back home to Johann Hagenauer, his banker and benefactor. It was expected that the news would be shared around town and the archbishop kept informed. As for Maria Anna Mozart, history would know little about her part in the early tours because Leopold's letters rarely mention his wife.

WHEN THEY ARRIVED IN VIENNA ON OCTOBER 6, 1762, THE FIRST HURDLE was to get through customs, which could be sticky: the officers were badly paid and expected generous tips, also known as bribes. But as Leopold reported to Hagenauer, "Master Wolferl" smoothed the way—he chatted up the customs officer, showed him his portable clavier, and played him a minuet on a child-size fiddle Leopold had given him.

Four days later Leopold took in the premiere of Gluck's *Orfeo ed Euridice* at the opera. This was one of the "reform operas" with which Gluck had seized the initiative in the operatic world: music solemn and restrained, resolutely at the service of the drama. The children had seen little to no opera; there was no company in Salzburg, and performances were scarce. At the performance Leopold heard the Archduke Leopold, son of the empress, raving to a nobleman in another box about this new prodigy. "All the ladies," Leopold reported home, "are in love with my boy."[14]

Leopold quickly made contacts among the musical aristocracy, aided by letters of introduction carried from home and by his children's reputation, which preceded them. They began playing in one grand parlor after another. This was not only a matter of glory; always, a gift was expected. A traveling musician, as distinct from a court musical servant, did not get a specified fee for playing for the nobility. There was a traditional myth that such tawdry transactions were beneath the notice of the great, that one performed for them as a matter of duty. But *something* would change hands: cash, a jeweled watch, a snuffbox full of coins, some sort of finery. What the gift was, how expensive it was, when it was given, whether it was given at all—it was entirely up to the patron. Musicians were expected to wait and take what they got with humble gratitude.

Soon for the Mozarts came the hoped-for coup, a summons from Schönbrunn, the suburban residence of Empress Maria Theresa. She and her family were eager to behold this freak of nature, act of God, whatever he was, and his remarkable sister.

VIENNA AS THE MOZARTS FIRST ENCOUNTERED IT WAS A DYNAMIC, fraught, patchwork culture heading toward an unknown destination, in contrast to the drowsy Salzburg they were used to. As capital of the patchwork Holy Roman Empire, Vienna had long been a place of mad juxtapositions.

The city was splendorous and it was ragged, pleasure-loving and in some ways nearly unbearable, extravagant and restrained, progressive and reactionary. It was enclosed in walls rebuilt in the sixteenth century to keep out the Turks. The walls were broad enough to walk on and a popular place for promenading. Surrounding the walls was an expansive open area called the Glacis, its avenues pleasant for strolling but its reason for being military: it provided a clear field of fire from the city walls. Beyond that lay a maze of suburbs and the Vienna Woods with its mingling of forest and vineyard.

Visitors were dazzled by the palaces of the nobility within the confines of the walled city, some three hundred residences where the nobility spent the winter months, decamping in the summer for even more imposing palaces in Hungary and elsewhere. In their seasonal moves

from city to country, the nobility hauled their apparatus of servants back and forth; among them, musical servants might make up a small orchestra. Otherwise, at the time of the Mozarts' first visit, a sixth of the city was occupied by monasteries and nunneries.[15]

The splendor of Vienna, however, was steeped in stink and grime. All cities stank in those days, the leavings of thousands of horses and tens of thousands of dogs in the walled confines making for a penetrating fetor. A visitor wrote that every street had its distinctive smell, and they were all bad.[16] Added to this was the misery of dust that billowed everywhere all the time, a compound of dirt and the desiccated filth of horses and dogs that got into your clothes, your house, your eyes, your mouth, sometimes your very soul. The dust regularly killed soldiers and serving people, but no one from highest to lowest was free of it—unless you had a country estate, one of the reasons for which was as a place to escape the damned dust in summer, when it was worst.

The city water supply was purgative enough that new visitors could expect a month or so of gastric distress until they got used to it. A visitor noted, "The streets of Vienna are not pretty at all, God knows; so narrow, so ill built, so crowded." Those streets were paved with rough cobbles that tormented the inexperienced. A British traveler said that a visitor accustomed to smooth English pavements who set out unsuspecting at night in Vienna "would speedily break his neck or his bones, put out an eye, or tear off a cheek."[17]

The gallimaufry called the Holy Roman Empire that was ruled from Vienna had nothing to do with cultural, linguistic, religious, geographic, or any other natural connections. It was a makeshift artifact of history with roots going back to the ninth century, which for the people of some of its far-flung possessions was a matter of centuries-old outrage. Revolt simmered perennially. Because of the welter of nationalities in the empire, and Vienna's position as capital, in the streets one heard German, French, Flemish, Czech, Polish, Hungarian, Serbo-Croatian, Italian, and the local dialect of German called Wienerisch, inflected by the other languages around it.[18] The streets were a fantastic caravanserai. You could behold Hungarians striding along in fur-lined dolmans and sporting pigtails; the exotic costumes of Armenians, Wallachians, and Moldavians; Serbians with their twisted mustachios; bearded Muslims in yellow slippers with murderous knives at their

belts; Polish Jews swathed in black and bearded, their hair twisted in knots; Transylvanian waggoneers with sheepskin greatcoats; Croats with black tubs riding on their heads.[19]

In 1762 the throne of the Holy Roman Empire was occupied, in practice if not in theory, by Empress Maria Theresa. Because she was a woman, her husband Franz I and eldest son Joseph were designated her co-rulers, but in fact she ran the show, with the help of advisers. The empress was in temperament conservative and resolutely Catholic, having no truck with Protestants or Jews, but she was progressive in reforming the military and bureaucracy and education. Her husband the emperor had little to do with advising or rule at all. A lot of her efforts regarding foreign policy had to do with producing children, sixteen of them in the end. Thirteen survived, and she saw to it that a number of them married royalty around Europe, thereby spreading Austrian influence. The two most famous of her children were Joseph, who became emperor upon her death, and Maria Antonia, who ended up Marie Antoinette, Queen of France, until France decided to put an end to queens and kings.

Overflowing with ideas about his coming rule that ran far beyond his mother's modest reforms, Joseph itched to inherit the throne. He was thin and quietly handsome, lacking the jutting lower jaw that had been a Hapsburg signature since the fifteenth century—a symptom of the family's long inbreeding. In Joseph's eye one found a keen intelligence and an equally keen ambition. He intended to wield the power of the throne to improve the lives of his people, to get the Church off their backs yet make them more earnest Catholics. No less, he intended to enhance the power of the throne in its perennial struggle with the nobility.

For Joseph music was a daily pleasure and recreation, and he loved opera. He would take over the running of the main venues in the city, the Burgtheater that was attached to the Hofburg (once the royal tennis court) and the larger Kärntnertortheater. Opera and theater were to be more than popular entertainment: they were to be part of the moral education of his people. Joseph was determined to raise the moral and material state of his subjects, whether they liked it or not. (Or maybe it never occurred to him that they might not like it.)

The Hofburg, the court's palace in town, was not as ornate or as

grand as the seat of government in France or other countries. It was a mélange of buildings that had accumulated over the centuries, which is to say that it was a jumble like the Holy Roman Empire itself. In the suburbs sat the Baroque summer palace of Schönbrunn, with its splendid French gardens, not on the scale of Versailles in France, but resplendent enough.

Most Austrian aristocrats were given an extensive education with a strong component in the arts. Two of Maria Theresa's daughters were accomplished painters, the empress herself a good enough singer to perform arias in soirées. Of the family, Joseph was the most skilled at the keyboard, but at one point his brother Archduke Leopold directed a performance of a Gluck opera from the harpsichord, his older sisters singing vocal parts and the younger ones, including Marie Antoinette, dancing in the ballet. Gluck himself had coached the performance; Marie Antoinette studied harpsichord with him.[20]

All this is to say that the Viennese court was one of the most musical in Europe. The city, which revolved around the court, was likewise. The court orchestra and opera in Mannheim were more acclaimed, but Vienna was a bigger and richer city and a magnet for musicians from around the Continent. It was, in short, one of the prime cities in the world for making a name in music. That is why Leopold Mozart chose it as the place to introduce his miracle.

BEFORE THE FAMILY WAS SUMMONED TO SCHÖNBRUNN PALACE, THE children had played in the houses of some nobles; word of the results would have gone directly to the highest level. The first audience before Empress Maria Theresa and Emperor Franz I came on October 13, at Schönbrunn Palace. Nannerl presumably played beautifully as usual. But the sight to behold was the tiny six-year-old boy, dwarfed by the harpsichord, who ripped through his own little pieces, his improvisations showing off his stunning dexterity at the keyboard, and likewise his unruffled confidence. Afterward he jumped into the lap of the empress, put his arms around her neck, and kissed her. She was charmed. Knowing Leopold's reputation as a pedagogue, they had Joseph's young wife play the violin for him.[21] At one point, Emperor Franz teased Wolfgang, saying that it was not such a great trick playing

when you could see the keys, but what if there were a cloth over them? Wolfgang sat down at the keyboard and archly played for a bit with one finger. Then a cloth was laid across the keys and he played impeccably. It would become a regular trick in his arsenal.

At first the child dispensed light pieces, but he knew that court composer Georg Christoph Wagenseil, whose scherzo he had learned in his first effort at the keyboard, was around somewhere. "Isn't Herr Wagenseil here? He should come, because he understands." When Wagenseil sat beside him, Wolfgang announced, "I'm going to play a concerto of yours, so you should turn the pages for me." The music he played got weightier from that point in the program.

Leading the children by the hand, Archduchess Joanna showed the family around Schönbrunn.[22] "Their Majesties," Leopold reported to patron Hagenauer, "received us with such extraordinary graciousness that, when I shall tell of it, people will declare that I've made it up."[23] Perhaps it was at this audience that Wolferl stumbled, Princess Marie Antoinette helped him up from the floor, and he declared his intention to marry her when he grew up. It was all like some inconceivable dream. Before long it passed into legend.

For that first appearance at Schönbrunn, Leopold received 450 florins, well over his yearly salary in Salzburg. The next day, presents for the children arrived from the empress: full-dress court clothes, hand-me-downs from an archduke and archduchess. For Wolfgang there was a lilac jacket and brocaded lilac waistcoat with lots of gold braiding and buttons, for Nannerl plum-colored taffeta with white lace appliqué. The young Mozarts' penchants for aristocratic finery began here. Leopold had their portraits painted in their new costumes. Wolfgang holds a hat and sports a little sword, his face plump with baby fat but his hand tucked into his jacket in the manner of a nobleman or a general. Nannerl was painted as a pretty child standing in front of a keyboard.[24]

So it went for another week, a whirl of private performances for princes and princesses and the rest of the aristocratic menagerie, in sociable settings where the guests might be attentive or might not. In these performances it would seem natural that Leopold would have played his violin with the children, but there is no record that he ever did. Nor is there any sign that his own music was ever heard during the family travels.

One Vienna occasion was attended by Johann Karl Count Zinzen-dorf, whose fifty-year diary is, among other things, a singular record of the musical life of the city. "The poor little thing played marvelously," he wrote. "He is a vivacious child, lively, charming, his sister's playing masterly and he applauded her. Mademoiselle de Gudenus, who plays the harpsichord well, gave him a kiss, he wiped his face."[25]

Leopold was no doubt staggered at what his children had wrought. But he was not going to let them rest on their laurels. He was a practical man and would have grasped a fundamental reality: if his children had dazzled the imperial court in Vienna, whom could they not dazzle?

In three years of clavier study, Nannerl had mastered the instrument as much as many adults who had been playing since childhood. Wolf-gang had reached that level in a year. Beyond this, he was improvising, a widespread art at the time, but he was doing it beyond the capacities of many grown-up musicians. And Master Wolferl was indefatigable in his absorption. If you sat him down at the clavier at nine in the evening, he would play all night if you did not order him to bed.

The little clavier numbers he was writing were light as air, but they still had ideas, real ideas, and they spoke. Of his first surviving pieces, the Andante and the Allegro in C are nimble and gay; the next piece, an Allegro in F, is courtly in tone; the Minuet in F that followed has a mellow solemnity; an Allegro in B-flat is puckish and ironic. From pieces by others that he had learned, including ones by his father, the child had begun to sense the qualities of keys: spacious and imposing C major, dark and apprehensive G minor, jolly D major, martial and dignified E-flat major, tragic C minor. These associations with keys were widely shared, even if the reasons for them were murky, more a matter of tradition than acoustic reality. Still, they had partly to do with a keyboard tuning system that gave each key a distinctive coloration, even if at the same time it rendered some keys so out of tune that they were avoided in clavier music.

So in Leopold's well-considered judgment his girl was a marvel, his boy a miracle. Leopold by nature was a calculating man. He was so-ciable with any number of friends, but ultimately his understanding of people was geared largely to how you could get something out of them. To that end, there had to be plans. He was a man of methods: a method for teaching the violin and a method for getting ahead in the

only practical way available: attaching yourself to the great and power-
ful. How to stage-manage this endeavor consumed him.

Not that he took any satisfaction in it. Leopold Mozart was never
satisfied with anything, with the perhaps single exception of his son's
music. All else was a matter of planning the next steps. As the future
would show, no matter how far it went, it was never far enough for him.

ON OCTOBER 21, THE MOZARTS WERE BACK BEFORE THE COURT AT
Schönbrunn. Soon after that second audience, Wolfgang came down
with a rash on his shins, elbows, and backside and was put to bed. Here
begins the story of the children's illnesses on the road. Wolfgang stayed
in bed for a week with what was called mild scarlet fever; at the same
time, he was miserable from cutting teeth. His illness was more likely
a rheumatic nodular eruption, later named erythema nodosum.[26] It can
recur, and with Mozart it did. Reporting home in a letter, Leopold put
the best face on it: "I was beginning to think that for 14 days in succes-
sion we were far too happy. God has sent us a small cross and we must
thank His infinite goodness that things have turned out as they have."

He did not neglect to mention that "the affair cost at least 50 duc-
ats."[27] More and more in letters to Salzburg, Leopold tended to bemoan
expenses rather than boast about profits; the profits he got into the habit
of hiding from his correspondents. He would hold to that for the rest of
his life. In any case, in October he sent 540 florins to Salzburg, nearly
double his court salary for the year.[28] In the future he would command
a higher salary, but never as high as that.

To treat Wolfgang's illness, Leopold relied on "black powder," a sort
of all-purpose remedy. It would not have helped matters. It was a pow-
erful laxative that included charcoal (which made it black), deer ant-
lers, myrrh, coral, frog's head, placenta, and powdered earthworm.[29]
It seemed as good as anything because there was not then the least un-
derstanding of the actual causes of disease. Most medicines of the time
were emetics, the principle being to rid the body of bad "humors" that
caused illness. Another way to rid the body of bad humors was blood-
letting, sometimes pints at a time. Meanwhile as with most pious peo-
ple, for Leopold a vital component of medicine was prayer and priests.
He asked Hagenauer to arrange three Masses to be said in Salzburg for

Wolfgang. Given the children's medical history as it transpired, part of the marvel of what they achieved was that they survived to achieve it at all—not because of medicine, but despite it.

ON NOVEMBER 4, WOLFGANG WAS WELL ENOUGH TO JOIN THE FAMILY for a walk around town. Next day he played at the house of Dr. Johann Anton von Bernhard by way of thanks for his advice on treatment while Wolfgang was ailing.[30] In a letter to Hagenauer, Leopold provided a list of the Viennese aristocrats who had inquired after his son's health. Plans to leave Vienna on December 26 had to be delayed because of a combination of fiercely cold weather and a days-long toothache that swelled Leopold's face. They finally set out on New Year's Day and arrived in Salzburg on the fifth. By the time they got home Wolfgang was sick again, or more likely he had not completely recovered from his Vienna troubles. The family was frightened that it was smallpox; it was probably rheumatic fever. He spent another week in bed. They were still living in the four-room flat, all sleeping in the same room.

Finding their lord Archbishop Schrattenbach incensed that they had overstayed their leave in Vienna, Leopold pacified him with a few fibs for excuses: he had had to travel slowly so as not to risk the children's health; the weather was too cold for travel; he had heard a report of smallpox in Salzburg.[31] There was good news, too: Leopold was appointed vice Kapellmeister of court music. His predecessor in the post, the Italian Giuseppe Lolli, moved to the top position.

The family's stay at home would be long enough for them to bask in their success and their takings and for Leopold to plan a grander endeavor. Word of his children was getting around. In May he read in an Augsburg paper:

I speak of the two children of the famous Mozart, Vice Kapell-meister at Salzburg. Just imagine a girl 11 years of age who can perform on the harpsichord or the fortepiano the most difficult sonatas and concertos by the greatest masters, most accurately, readily, and with an almost incredible ease, and the very best of taste. This alone cannot fail to fill many with astonishment. But we fall into utter amazement on seeing a boy aged 6 at the clavier

and hear him, not by any means toy with sonatas, trios, and concertos, but play in a manly way, and improvise moreover for hours on end out of his own head, now cantabile, now in chords, producing the best of ideas according to the taste of today.[32]

Memories of the period around this Salzburg interlude come from family friend Johann Andreas Schachtner, a trumpet player at court who was also skilled on violin and cello. On the side he produced poetry and opera librettos and translations.[33] Wolfgang had the child-size violin his father had given him. He liked the sound of Schachtner's fiddle, which he dubbed the "butter-violin." At one point the boy observed that the butter-violin was tuned a quarter tone lower than his little one. Schachtner chuckled at the notion, but he fetched his instrument and discovered that the boy was right. Leopold, noting that his son seemed actually scared of trumpets, had Schachtner aim his horn at him and play a blast. Wolfgang went pale and nearly fainted.

Another Schachtner memory was of a musicale soon after the family got back from Vienna. They were playing over some string trios by their friend Wenzel Hebelt, an inexperienced composer who wanted Leopold to critique the pieces. Wolferl interrupted, demanding to play second violin. No, said Leopold, you haven't had any instruction on the instrument; you've just fooled around with it. His son replied that you don't have to be all that good to play second violin. Leopold ordered him out of the room. An unpleasant childish scene developed: there were tears; Wolferl stamped off with his violin in hand. Schachtner, who was handling second violin, stepped in and suggested the boy play along with him. All right, said Leopold, but he must play softly so we can't hear him.

They began again. Before long, Schachtner realized that the six-year-old was covering every note of the part, and he put down his fiddle. He looked over to see Leopold playing with tears of joy pouring down his face. After going through all the pieces, Wolfgang then insisted he wanted to try the first violin part. Go ahead, they said, and the tears were replaced with laughter: the child went manfully at the part, faking like mad but somehow representing the music even though, essentially, he had no idea how to play the fiddle. Leopold added violin study to his son's daily routines.

Schachtner recalled that when Wolferl was studying arithmetic he went at it with the same obsessive intensity as he did music, chalking sums all over the walls, floors, and furniture of the house.[34] Nannerl remembered that her brother demanded musical accompaniment for every activity; carrying a toy from one room to another required march music.

Most striking of Schachtner's recollections was the time Master Wolferl was seen scratching on paper with his pen. He was making more blotches than anything else because when he dipped the quill into the ink, he plunged it to the bottom and then lifted it dripping. The page was a maze of blots with smeared notes between. Asked what he was doing, Wolfgang said he was writing a clavier concerto. Leopold picked up the page, and once again tears started from his eyes. "Look, Herr Schachtner," he said, "look how correctly and properly it is all written. Only it's of no use because it's so extraordinarily hard that nobody could play it."

"That's why it's a concerto!" Wolfgang cried. "The player has to practice until he gets it right! Look, this is how it goes." And once again he showed off his precocious skill at faking his way through a piece.[35]

Around this time began a little ceremony between father and son. On a familiar tune, Wolferl made up some nonsense quasi-Italian lyrics: "oragna figata marina gamina fa." Every night as he went to bed he sang the tune, and when he was done kissed Papa on the nose. He performed that bit of loving nonsense nightly until he was ten years old.[36]

On June 9, the Mozart family set out from Salzburg with a coach and servant on a new tour. The immediate goal was Paris, but the plan was to perform at every possible town on the way. Leopold seems to have had no firm agenda, only to visit—or rather, to enlighten—every musical center they could reach around Europe, and to return to Vienna. Other than that, he would keep the opportunities open. They would live on the road for three and a half years. Here is where the myth of the golden child began, except that many elements of this myth really happened.

DAS KÖNIGREICH RÜCKEN

When Leopold Mozart set out from Salzburg with his family and servant Sebastian Winter on June 9, 1763, it was his intention to surpass their triumph in Vienna, to conquer the European musical world. He couched that aim in exalted terms. As he wrote later, it was his duty to "proclaim to the world a miracle, which God allowed to be born in Salzburg. I owe this act to Almighty God, otherwise I would be the most ungrateful creature; and if ever I have an obligation to convince the world of this miracle, it is precisely now, when people ridicule anything that is called a miracle."[1] Here is the pious Catholic father aspiring to give a riposte to the Enlightenment scientific persuasion, in which God kept His hands off His clockwork universe. Besides his duty to God, that Leopold had also plenty of worldly ambition is clear enough in his letters, many of which are about money. In his campaign of conquest, he was to discover, however, that conquest is never simple, never complete.

A Salzburg paper gave them a swaggering sendoff:

The Vice-Kapellmeister to the Court of Salzburg, Herr Leopold Mozart, left here for Stuttgart with his two wonderful children, to continue his journey to France and England by way of the greatest German Courts. He afforded the inhabitants of his native city the pleasure of hearing the effect of the extraordinary gifts which the Great God has bestowed on these two dear little ones, . . . gifts

of which the Herr Kapellmeister has . . . taken care with such in-
defatigable zeal, as to present the musical world with a girl of 11
and, what is incredible, a boy of 7 years at the harpsichord, as a
marvel of our own and past time.[2]

Leopold's main objectives were four: to see the children, and espe-
cially his son, provoke wonder everywhere they went; to expose them
to the widest range of experiences musical and otherwise; to make
money to fill the family coffers for years to come; and to create for
Wolfgang a reputation that, when he came of age, would get him his
pick of Kapellmeister positions and secure not only his own fame and
fortune but also that of the whole family. Leopold's confidence in the
enterprise was shown in their carriage, which was their own, bought
for the tour. If the trip was long, that would be the cheapest way to
travel because you didn't have continually to hire carriages.

They were headed first for Paris and King Louis XV's palace at Ver-
sailles, over six hundred miles due west, and after that, London. Other-
wise, plans were open. Their travels would take a meandering course,
zigging and zagging in search of patrons. Leopold had with him letters
of introduction to present to prospective patrons all over the map. He
would accumulate more letters en route.

Part of the trip was financed by Archbishop Schrattenbach. From
neighbor and friend Johann Lorenz Hagenauer, Leopold had loans and
a network of trading connections from whom he could draw and deposit
funds. All the same, they needed to make money on the way because
it was going to be expensive, and Leopold intended to travel in style.
"To keep our health and for the reputation of my court," he wrote, "we
must travel 'noblement.' Moreover we only associate with the nobility
and distinguished personages and receive exceptional courtesies and
respect."[3] That is to say, if you were going to beguile the nobility, it
helped to resemble them in manner and dress.

Their luggage for the trip went far beyond clothes for four people
traveling in four seasons. Wife Maria Anna helped with the packing,
but it was Leopold's show. There were stacks of music, letters of credit
and of introduction, toiletries, stationery, tea and sugar, a first aid kit,
postcards, travel guides, language books, field glasses, prints of city
views, and calipers to calculate distances on a map.[4] Not noted but

likely, as the journey was also going to involve the children's general education, there were books that might have included history, mathematics, literature, science, and studies of art and architecture. Leopold was well versed in these subjects, and he wanted his children to be too—or at least Wolfgang; broad general knowledge was not expected from a girl. The long hours jolting along in the coach would have been filled by conversation, games, singing, lessons from Leopold in various directions. The children learned much of their Italian and French on the road; Wolfgang ended up fluent in the former and passable in the latter. To what extent Nannerl did is an open question.

Already at age seven, Wolfgang's singular imagination was churning in every direction. He hated to be bored and hated to be idle, and through his life he responded to these threats with a repertoire of antidotes mental and physical. Now to pass the time, he invented a world. Its name was "Das Königreich Rücken," "the Kingdom of Back." In this world he was king and Nannerl queen. Servant Sebastian Winter, a lively companion for the children, was required to draw up a comprehensive map of the kingdom. On it Wolfgang placed the towns and their streets and buildings, laid out the rivers and other features.[5] As when he chalked arithmetic over every surface in the house, Leopold's son seems to have had a need to place his stamp on things around him.

If there was any explanation for the name "Das Königreich Rücken," it would not survive. However remarkable, Wolferl was still seven years old; there would not be a great deal of poetic subtlety in the name. Still, it is suggestive. That it recalls Wolfgang's abiding interest in the human backside may be relevant. It might imply a private world that you could carry around on your back. Beyond that it hints at something hidden, elsewhere, lying back of the quotidian world. In the Kingdom of Back at least, Wolferl and Nannerl were sovereign; they ran the show.

AS FOR THE JOURNEY, A SNAG TURNED UP RIGHT AWAY, ONE INDICAtive of how the whole tour would go: two hours outside Wasserburg, a back wheel of the carriage shattered. Nearby mill workers came to the rescue, fashioning a temporary wheel that was small and delicate but secure enough for them to limp into town. To cut down weight, Leopold and servant Winter walked beside the carriage. When they

arrived in Wasserburg, it was decided they should replace both rear wheels, which was going to take a couple of days. As always, while they waited, there was music. Leopold took the children to examine a church organ in Wasserburg and explained to Wolferl how the pedals worked. It was assumed that the tiny child would not be able to play them until he was older. But he shoved the organ bench out of the way, stood on the pedals, and began to play them as if he did it all the time. It was, Leopold wrote home, "a fresh act of God's grace, which many a one only receives after much labor."[6]

The evening of June 12 they arrived in Munich. Next afternoon, as they walked in the garden of the elector's Nymphenburg Palace, they heard shouting. It was Prince Friedrich von Zweibrücken, an acquaintance from the Vienna visit, hailing them from a window. He asked Leopold if the elector knew they were in town. Hearing that he did not, the prince sent word to Elector Maximilian III Joseph asking if he wanted to hear these marvels. (It's possible the elector had heard them the previous year.) Right away the order arrived with a footman that they would be expected that night in Nymphenburg. Leopold gave no details but reported a great success. A couple of days later, the children played for Duke Clemens von Bayerns; three days after that, they joined the elector for a gala lunch at the palace.

Because there had as yet been no presents or payment forthcoming from the glorious and benevolent prince-elector in Munich, Leopold tried to prod him by having Wolfgang say that they were leaving the next day. The prince replied that he was sorry he had not yet heard the girl play, and Leopold pretended to let himself be persuaded to stay longer. But for the prince-elector there was royal hunting and playgoing to be done in the next days, so Nannerl could not perform until the twenty-second. And still there was no money, no money, no money. Duke Clemens hadn't produced anything, either, waiting to see if the elector would pay up and how much. Finally Leopold got one hundred florins from the elector, whereupon the duke added seventy-five. This was not bad, except for their having to hang around Munich for nine expensive days to get it. Leopold reported that another visiting musician had it worse: "The charming custom is to keep people waiting for presents for a long time . . . [Haydn colleague Luigi] Tomasini has been here for three weeks and has only just gotten paid."[7]

Their next stop in the direction of the setting sun was Augsburg, Leopold's hometown, where his mother and brothers still lived. They stayed for two weeks at a fancy inn on the main square. The children gave three public concerts at an inn because there was no court in town. If Leopold hoped for a reconciliation with his mother, who years before had cut him off financially, it was not forthcoming: she did not attend her grandchildren's performances.

His two brothers had taken up their father's trade of bookbinding, and Leopold was on good terms with brother Franz Alois Mozart. They got to know Franz's vivacious young daughter Maria Anna Thekla, whom they dubbed *die Bäsle*, "the little cousin." Eventually she would figure deliciously if briefly in the affections of her cousin Wolfgang. From the famous maker of keyboard instruments Johann Andreas Stein they bought a miniature clavichord to take with them as a practice instrument.[8] Otherwise, about which Leopold always took note in his reports, there was not much gained in gold.

After Augsburg they stopped in Ulm, where Wolfgang played the cathedral organ and where they pursued a duke to Ludwigsburg, to no effect: he had left for his hunting lodge. Anyway, "The Duke has the charming habit," Leopold wrote to Hagenauer, "of making people wait interminably before hearing them and then making them wait as long again before giving them a present." As he generally would when insufficient attention was paid, Leopold smelled a rat. In this case it was court Kapellmeister Niccolò Jommelli, who, by the way, was outrageously overcompensated:

> I regard the whole business as the work of Jommelli, who is doing his best to weed out the Germans at this court and put in Italians only. He . . . will succeed completely, for, apart from his yearly income of 4000 [florins], his allowances for four horses, wood and light, a house in Stuttgart and another one in Ludwigsburg, he enjoys the full favor of the Duke; and his wife is promised a pension of 2000 after his death. What do you think of that for a Kapellmeister's post?[9]

At that point, Leopold's salary as vice Kapellmeister in Salzburg was 354 florins.[10]

In a stop at Schwetzingen, the celebrated Mannheim court orchestra, in their summer quarters, gave a four-hour concert for them. This had widely been called the best orchestra in the world, "an army of generals," and Leopold could only agree. "The orchestra is undeniably the best in Germany. It consists altogether of people who are young and of good character, not drunkards, gamblers, or dissolute fellows."[11] With that he was comparing the Mannheimers with the usual run of Salzburg musicians, who were given to carousing and whom Leopold scorned.

On the road to Mainz, they took a look at Heidelberg with its famous castle on the heights, and Wolfgang played the organ at a church. An official there was so enthralled that he had a commemorative plate engraved and affixed to the organ. On July 19, traveling through summery fields and vineyards on the Rhine, they arrived in Mainz for what turned into a two-week stay, with a couple of concerts.

The last three weeks of August was spent in Frankfurt am Main, where interest in the children proved heated enough to support a series of concerts. Among the audience in one was fourteen-year-old Johann Wolfgang von Goethe. Late in his long career as his country's foremost man of letters, he would recall "the little fellow with his powdered hair and his sword."[12] "Wolfgang is extraordinarily jolly," Leopold reported, "but a bit of a scamp as well. And Nannerl no longer suffers by comparison with the boy, for she plays so beautifully that everyone is talking about her and admiring her execution."[13] Leopold detailed the children's recent haul, including fine snuffboxes for both of them and embroidery for Nannerl. Snuff, inhaled in pinches through the nose with a sneeze, was a widespread affectation of the day. Naturally, the splendor of your snuffbox advertised your importance. Because the Mozart children were not sniffers, and Leopold probably not either, their gifts of snuffboxes were consigned to boasting and eventual sale. In September, Leopold reported that since leaving home he had spent 1,068 florins, three times his annual salary.[14] Most if not all of it was subsidized by the Salzburg court.

Two documents show Leopold's style on this and later tours. For towns and cities of any consequence, he mailed publicity ahead, to kindle excitement before they arrived. Newspapers dutifully published the material. From a Frankfurt paper:

Lovers of music . . . are herewith apprized that on Thursday next, 18 August, at Scharf's Hall on the Liebfrauenberg, a concert will be held at 6 o'clock in the evening, at which two children, namely a girl of 12 and a boy of 7, will be here to play with incredible dexterity concertos, trios and sonatas, and then the boy also the same on the violin . . . These two children's skill not only astonished the Electoral Courts of Saxony, Bavaria, and the Palatinate, but also afforded exceptional entertainment to His Imperial and Royal Majesty during a four months visit to Vienna.

Another Frankfurt notice:

The girl, who is in her 12th year, and the boy, who is in his 7th, will not only play on the harpsichord or fortepiano, the former performing the most difficult pieces by the greatest masters; but the boy will also play a concerto on the violin, accompany symphonies on the clavier, completely cover the manual or keyboard of the clavier, and play on the cloth as well as though he had the keyboard under his eyes; he will further most accurately name from a distance any notes that may be sounded for him either singly or in chords, on the clavier or on every imaginable instrument including bells, glasses and clocks. Lastly he will improvise out of his head, not only in the pianoforte but also on an organ (as long as one wishes to listen and in all the keys, even the most difficult, that may be named for him).[15]

These press notices would be echoed in town after town over the next years. Leopold had made his children into something of a traveling circus act, a cabinet of curiosities.

In a document from years later, when Wolfgang was trying to make his own way, Leopold would advise him that when you reach a given city,

this is the way to do it. Ask your host who is the Kapellmeister or musical director of the town; or, if there isn't one, who was the best-known musician. Ask to be taken to him, or, according to his standing, ask him to come to you, and speak to him; that way you

will quickly know whether the cost of putting on a concert is too great, whether you can obtain a decent keyboard instrument—whether an orchestra can be got together, whether there are music lovers—you might even find whether there is anyone who out of love of music would play some part in the undertaking etc. . . . and this should be done in traveling clothes, without even unpacking: just put on a couple of fine rings or something, in case when you call you find a keyboard instrument there and are asked to perform.[16]

The second of these press notices mentions that the children will be playing piano as well as harpsichord. The harpsichord had long been the favored keyboard instrument for concerts because the small clavichord was too quiet to be heard by a crowd. The piano, invented early in the century, was still a small, tinkly instrument with a light touch, sometimes lighter than a harpsichord's. Those three kinds of clavier each required a particular technique. A harpsichord plucks the string with a quill, so it has no range of volume at all unless there are stops to increase the number of strings plucked for each note. The little tabletop clavichord was an instrument that one played for oneself or for a few listeners close by. Its keys are in effect levers with small metal nubs at the far ends to strike the strings, so while there is only a small range of volume, from quiet to extremely quiet, it allows for expressive effects. This element of touch control made the clavichord a good way to prepare for the fortepiano, as it was usually called in those days (fortepiano means "loud-soft"). It had hammers covered with leather or felt that struck the strings, which allowed for a range of volume and color unique for a keyboard instrument.

As an instrument, the piano was very much in flux, every country and region tending to a general sound and style, each maker equipped with his own tricks and techniques, some of which were guarded secrets. In other words, what constituted a "piano" was unpredictable. When you sat down to play one you never knew quite what it would feel and sound like. In Mozart's youth, pianos were sparse in homes, but they would not be for long. The instrument's unprecedented range of volume and color was going to be needed for the new kinds of contrasts the music of the later eighteenth century was pursuing. By the

last decades of the century, the piano had rendered the harpsichord obsolescent.

The tour continued through Bonn—they did not tarry, the elector was out of town—and Cologne, whose filthy streets and crumbling cathedral Leopold deplored. In services there, he declared, the choirboys screeched "like rascals from the alleys at the tops of their voices."[17] In Aachen at the end of September, they were hoping for good return from the sister of Frederick the Great, Princess Amalia, who was taking the cure. She heard the children play, expressed delight, and for payment gave them kisses. Reported a disgusted Leopold, "If the kisses which she gave to my children . . . had been all new louis d'or, we should be quite happy; but neither the innkeeper nor the postmaster are paid in kisses."[18] There was simply no way to predict outcomes. Viennese composer Karl Ditters von Dittersdorf recalled that after he played for some monks in Bologna, there appeared at his lodging a solemn procession bearing six pairs of white and six of black silk stockings, a half-dozen Milanese silk handkerchiefs, and twenty pounds of candied fruit.[19]

The family headed for Brussels via Liège on gnarly roads that chewed up the iron hoops of their carriage wheels. They waited out repairs over lunch in a peasant kitchen, eating meat and turnips from a pot while curious pigs wandered in through the open door.[20] Leopold had been ailing with sciatica, the gnawing pain of which did not improve his mood.[21]

Arriving in Brussels at the beginning of October, they lingered for six weeks, not by choice. At court they found something of a comic opera atmosphere. Prince Karl Alexander von Lothringen, Leopold reported, was interested mainly in lacquering, painting, hunting, eating, drinking, and laughing so raucously you could hear him three rooms away. He liked music but appeared to have no money to spare for it, and he kept them waiting for an audience for three weeks as hotel bills mounted. Leopold was not so distraught that he failed to admire a Rubens painting in the church, the court's exceptional collection of art Western and Chinese, and its natural history specimens. The children marveled at the central canal, on which oceangoing ships sailed right through the city on the way to Antwerp.[22]

There was a concert, Wolfgang received splendid swords from a couple of counts, Nannerl some Dutch lace, and that was about it.[23]

Meanwhile, the boy finished a sprightly Allegro in C for violin and harpsichord that he had begun in Salzburg. It would serve as the first movement for a violin sonata. At four and a half minutes, it was his longest effort yet. He was on the way to multi-movement pieces, his skills and ambitions as a composer growing by leaps. From there to the end, they never stopped growing.

ON NOVEMBER 18, THEY ARRIVED AT THEIR FIRST MAIN GOAL, PARIS. They would tarry there for an eventful five months. Leopold went immediately to the palace of Bavarian minister Count van Eyck; he gave them a room gratis in his house, the Hôtel de Beauvais, which included the countess's fine two-manual (meaning two-keyboard) harpsichord.[24] The children would keep the room ringing with music.[25] Immediately there was a setback. In Vienna, co-ruler Joseph's second wife died, the French court joined the official mourning, and public entertainments were suspended for the duration.

Leopold and the children spent the time practicing, studying, seeing the sights, trolling for patrons. There were the usual unpleasant discoveries of a new town and new culture. An Italian visitor observed that there was no decent cheese, fruit, or seafood to be found in Paris. The town water was drawn directly from the Seine; though mother Maria Anna boiled it, the family still came down with diarrhea. This was not the bravura Paris of the next century, with wide streets and imposing buildings. Much of it was still the medieval city, with grand carriages rushing down small squalid streets and scattering the destitute.[26] Notre Dame and the other churches were Gothic, a style largely deplored in the period, including by the Mozarts.

Nonetheless, Paris was the capital of the largest unified nation in Europe. In these years it was also a leading musical capital. The court opera was well funded and impressive; in it the vital new genre of *opéra comique* was being born. Though public concertizing was sparse in Paris, it was still more active than in most capitals; the celebrated Concert Spirituel, founded in 1725 and one of the first such organizations on the Continent, presented twenty-five public concerts a year. As part of the city's roiling intellectual atmosphere there was a great deal of patronage of all the arts.[27] One of the most

active music publishing industries in the world supplied a growing market for sheet music.

The Mozarts arrived in Paris in the midst of an epochal moment in human thought. This was the time of the philosophes, the thinkers who epitomized the Enlightenment. As noted before, the most famous of these was the sardonic and brilliant Voltaire. Other leading figures included Denis Diderot, chief editor of the *Encyclopédie*; and the incendiary philosopher, social critic, and composer Jean-Jacques Rousseau. The effective gods of the philosophes were technology and the new science. The deist Voltaire despised not so much the Catholic Church as its abuses of power, and dogmatism and fanaticism wherever he found it. (Diderot was decidedly atheistic.) Not that the philosophes preached revolution; they were pragmatic enough to be reconciled to the French throne, though they declared that it existed only by the will of the people. Still, they were hardly democrats; their ideas were not addressed to the masses but to the intellectual elite, including the occupants of thrones.

Leopold Mozart had a gift for finding the most important and powerful patrons in a given city. With the help of a letter of introduction, he befriended Friedrich Melchior, Baron von Grimm. German by birth, Grimm had been educated in Leipzig, but by now he was entirely Frenchified. He was a journalist and diplomat, at that point secretary to the Duke of Orléans. His fame was mainly owed to his hand-copied, officially banned, twice-monthly cultural newsletter of radical inclination called the *Correspondance littéraire, philosophique et critique*. At first the journal concentrated on literature and art, but reflecting its editor, it came to concern itself with the entire zeitgeist—political, social, and religious. Its circulation, mostly outside France, was somewhere under twenty-five, but those subscribers included Catherine the Great of Russia, archduke and future emperor Joseph II in Vienna, the king of Sweden, and a number of rulers of German states sympathetic to progressive ideas.

In the 1750s, Grimm had been close to Rousseau and Diderot. Rousseau introduced him to his patron and lover, the brilliant, glamorous, and pleasantly rich Madame Louise d'Épinay. A couple of years later Grimm and d'Épinay fell into a liaison, which led to a violent break between Grimm and Rousseau. Afterward Rousseau left a vindictive

portrait of Grimm and d'Épinay in his *Confessions*.[28] The connection of Grimm and d'Épinay lasted thirty years; she became his partner in the *Correspondance* but also maintained her closeness to Diderot and other philosophes. Grimm was sharply handsome, in personality stiff and imperious. He had the affectation of daubing his cheeks in white makeup, which earned him the nickname "Tyran le Blanc" (the White Tyrant). But he was a fierce enthusiast for new ideas and new experiences. In contrast, Madame d'Épinay was warmly sociable, a celebrated *saloniste* and free spirit.[29]

Which is all to say that in securing Grimm and d'Épinay as friends and patrons, Leopold attached himself to two central figures of the French Enlightenment. Grimm was not a musician, but he wrote on the subject and was an important opera critic.[30] He was quick to seize on the Mozart child for an article in his journal, becoming the first truly significant figure to proclaim this phenomenon to the world, in a publication whose influence extended far more broadly than its minuscule subscription list.

True prodigies are sufficiently rare to be worth speaking of, when you have had occasion to see one. A Kapellmeister of Salzburg, Mozart by name, has just arrived here with two children who cut the prettiest figures in the world. His daughter, 11 years of age, plays the harpsichord in the most brilliant manner; she performs the longest and most difficult pieces with an astonishing precision. Her brother, who will be 7 [actually 8] years old next February, is such an extraordinary phenomenon that one is hard put to believe what one sees with one's eyes and hears with one's ears. It means little for this child to perform with the greatest precision the most difficult pieces, with hands that can hardly stretch a sixth; but what is really incredible is to see him improvise for an hour on end and in doing so give rein to the inspiration of his genius into a mass of enchanting ideas, which moreover he knows how to connect with taste and without confusion. The most consummate Kapellmeister could not be more profound than he is in the science of harmony and of modulations . . . M. Mozart's children have excited the admiration of all who have seen them. The Emperor and Empress have overwhelmed them with kindness;

and they have already met with the same reception at the Court
of Munich and the Court of Mannheim.

For Grimm, Wolfgang performed his tricks. He played with a cloth
over the keys, which astonished everybody but for the boy presented
no challenge. Grimm gave him a minuet theme and Wolfgang supplied
a bass for it. A lady sang him a song he had never heard and he was
again asked to make a bass. At first Wolfgang faltered, so she sang it
for him once more. Now he played it back with full harmony and sang
along with her. Then he improvised ten different accompaniments for
the song.[31] Grimm saw beyond the notes to how effortless it all was for
the boy: "It means little for this child to perform with the greatest pre-
cision." If Leopold saw his son as a divine miracle, Grimm and others
involved more with science and reason than with religion were going to
view the child as a freak of nature. Still, Leopold would later boast that
he had gotten a concession from rationalistic Grimm: "Now for once in
my life I have seen a miracle."[32]

What history would not record is how far the relationship of Grimm,
d'Épinay, and Leopold Mozart went beyond music. The children were
too young to concern themselves with cultural and social matters, or
aesthetic ones either. But given Leopold's wide interests and his open-
ness to new ideas, up to a point, it is likely that there were serious con-
versations among the adults about issues of the day and that Leopold
sat in on salons. He ended the tour closer to a freethinker than he began
it.

Leopold's nebulous position between traditional Catholic and man
of the *Aufklärung* would have affected his response to Grimm and
d'Épinay and their alignments. In his letters he expressed regret when
people he respected were not Catholic, but his literary hero Gellert
was Protestant. In any case, at no point would his Catholic convictions
stand in the way of his courting the best, the richest, the most generous
patrons he could find, whatever their persuasions or peccadillos. As for
Wolfgang, the Paris sojourn of 1763–64 would not be his last encoun-
ter with Baron Grimm and Madame d'Épinay. At their next meeting,
nearly fifteen years later, he would be mature enough to listen, to talk
and judge, also recalcitrant enough to get on their nerves.

On New Year's Day 1764, the children performed at a state dinner

given by Louis XV and his family at splendorous Versailles. They had been guests in the palace for a week. These meals were ceremonial occasions when the royal family hosted assorted grandees. Upon their arrival in the banquet hall, the Mozarts were met by the Royal Guard, who led them to the royal table.[33] Having no rank they were not seated, however, but stood among a watching crowd of valets and servants. Queen Marie Leczinska, Polish by birth, spoke fluent German. She called Wolfgang over, petted him and chatted, allowed him to kiss her hand, slipped him tidbits.[34] The Mozarts stayed on for another week. Leopold naturally was thrilled at it all, but he could not help noticing that Versailles reeked of latrines and unwashed servants.[35]

Beyond the royal family, Leopold's main hope was for the children to charm the celebrated and notorious Madame de Pompadour, Louis XV's longtime, more or less official mistress. (There were a number of other, less official ones.) Though her career as Louis's lover was over and she was now designated "friend of the king," she continued to act as an adviser. Born a commoner—Louis made her a duchess—famously beautiful, liberal in politics, friend to the philosophes, and defender of the *Encyclopédie*, she was also a patroness of the arts. Voltaire wrote of her, in gratitude, "She had righteousness in her soul and justice in her heart." But though at her private mansion Wolfgang and Nannerl performed on her harpsichord covered in gold leaf, she failed to offer any patronage.[36]

Leopold was undaunted; things were going fine without her. "Madame de Pompadour," he wrote to Hagenauer, "is still a handsome woman . . . She is extremely haughty and still rules over everything . . . Yesterday my boy got a gold snuffbox from Mme. La Comtesse de Tessé and today my little girl was given a small, transparent snuffbox, inlaid with gold, by the Princess Carignan, and Wolfgang a pocket writing case in silver, with silver pens with which to write his compositions . . . My children have taken almost everyone by storm."[37] He noted that Wolfgang was finishing some violin sonatas.

Throughout the tour, Leopold faithfully continued his reports home in extensive letters that mingled news of the children, sociopolitical observations and critiques, and touristic notes of the artistic and architectural sights they had taken in. He told Hagenauer that the faces of the women of Paris were so unnaturally painted that he could not tell if

under it all they were actually pretty. He thought they looked as phony as a Berchtesgaden doll. "As for piety, I can assure you that it is not difficult to get to the bottom of the miracles of the French women saints; the greatest of them are performed by those who are neither virgins nor wives nor widows." He lamented that at court it was not common to petition royal persons as they passed in the hall, as was done in Austria, but all the same, the royal daughters at Versailles would stop for his children and fuss over them extravagantly.

Leopold gave the music at court a mixed review: the solo singing was miserable, "in a word, French," but the choirs first rate. Father and son often went to the Royal Chapel to listen to the choral singing. In regard to repertoire he noted a war between Italian and French music. As for the composers, he opined, "The whole of French music is not worth a sou." He hoped that a rising German musical influence would enlighten the scene. For Frau Hagenauer he details more gifts for the children and comments on ladies' fashions in Paris. He was amused at women who sported swords that they wrapped in fur, "an excellent idea, for the sword will not catch cold." More apropos, he reports that "four sonatas of M. Wolfgang Mozart are being engraved. Picture to yourself the furor which they will make in the world when people read on the title page that they have been composed by a seven-year-old child . . . Indeed I can tell you, my dear Frau Hagenauer, that every day God performs fresh miracles through this child."[38]

The first two of these sonatas were dedicated to King Louis's daughter Princess Victoire, the second pair to their patron Countess Tessé. The first two were presented to the princess in person; she responded with a gold snuffbox worth some eight hundred florins, more than twice Leopold's annual salary.[39] In April he told Hagenauer to expect two hundred louis d'or, about two thousand florins, to be deposited with his bankers, who would send it on to Salzburg.[40] Expenses for the trip had been high and would remain so, but this was all profit. Added to Leopold's salary, two thousand florins could support the family comfortably for ten years or more. Practically overnight, the Mozart family's standard of living had changed once and for all. And Leopold had not begun to sell off the treasure: the mounting pile of snuffboxes, swords, watches, etc.

The publication of Wolfgang's violin sonatas was prefaced by a flowery introduction by Baron Grimm, and for the princess a properly submissive dedication supposedly from Wolfgang but surely written by Grimm or Leopold: "The attempts I lay before your feet are no doubt mediocre; but since Your goodness permits me to adorn them with Your August Name, their success is in no further doubt, and the Public cannot fail to exercise indulgence for the seven-year-old Author since he appears under Your auspices." He assures the princess that "so long as Nature, who has made me a Musician as she makes the nightingales, shall inspire me, the name of Victoire shall remain engraved on my memory with the same ineffaceable strokes which mark it upon the hearts of the French nation."[41] And so forth and so on, as one humbly addressed the august rulers of the world who were thus also the sovereigns of art and artists.

As to be expected from this particular child at age seven, these violin sonatas—his first large-form, multi-movement pieces—are a mixture of immature and astonishing. Five of the movements evolved from pieces Wolfgang had written in Salzburg in Nannerl's notebook, here and there embellished and touched up. It was no great trick to add a violin part to those movements; in this genre, the violin part was considered second fiddle to the clavier; in fact it could be omitted entirely and the pieces played as piano solos. Already the boy had a solid understanding of medium and setting. Like all chamber works, violin sonatas were *Hausmusik*, often played with no listeners simply for the pleasure of largely amateur musicians. The classic arrangement would be a female keyboard player and a male violinist. Because female pianists tended to have more skill than male string players, the piano part was dominant and more challenging.[42]

Thus the character of Wolfgang's sonatas. They are decorous and winning, like everything he wrote from the beginning. The first, K. 6, is in four movements; K. 7–9, in three movements like most violin sonatas, fast-slow-fast, the finales a Minuet with trio. There is a good measure of variety in their affect, and that affect is in keeping with their keys: the stately and good-humored first movement of K. 6 is in C major; the cheery and brilliant K. 7, in D major; and so on. Maybe most surprising in material is the first movement of K. 9, in G major, which has an air of expansive grandeur. Wolfgang understands that a

first movement, regardless of its expressive quality, should be vigorous, arresting, the weightiest of the movements. A slow movement was generally expected to be pensive and/or touching, as his are, and his minuet finales are appropriately light and dancelike.

The most remarkable thing about the sonatas is how strikingly more sophisticated and elaborate they are than his first efforts of a couple of years before. There are moments in the sonatas that show that Wolfgang has begun to learn about more exotic harmonies than the usual ones—here and there a diminished seventh or an augmented sixth chord. He has a dawning understanding of the full harmonic palette— unless these were touches added by Leopold, but if they were, the child would have quickly absorbed them. His modulations are effortless and move to the correct key at the correct place in the form. Most of the movements are essentially monothematic, but he has a sense of how to vary and develop a theme by shortening, extending, making a sequence out of it.

Still, if he is a golden child, he is still a child, his taste and understanding no more at their maturity than his body is. Harmonic movement in the sonatas tends to be static, sometimes getting hung up on the home chord or a simple I–V–I alternation that wears out its welcome. Now and then melodies find themselves going in awkward directions (though more often effective if predictable directions). Wolfgang is too happy to let the left hand babble along on the conventional accompaniment figure called an Alberti bass, which was a thumbprint and often an affliction of the age's keyboard music. Mozart never entirely discarded the Alberti bass, because he never lost a sense that convention was good enough if it got the job done, but he would grow to treat it with far more imagination.

Another element might account for some of the direction of his work. As Wolfgang matured as a performer who improvised constantly, embellished whatever he played, and had to adapt himself to musicians he was playing with and writing for, his development as a composer also grew out of his life as a performer. Which is to say that in those days there was a fluid relationship between playing and composing, and that process contributed to the mounting sophistication of what he was putting down on paper.[43]

PART OF LEOPOLD'S INTENTION IN TAKING HIS CHILDREN AROUND EU-
rope was to expose them, especially Wolfgang as composer, to influ-
ences around the map: the celebrated composers and performers, the
characters of various national schools, the variations in musical life
from musical center to center, the different media and genres of mu-
sic from solo clavier to opera. It appears that the new music that most
struck Wolfgang in Paris was clavier and clavier/violin works by Jo-
hann Schobert. This composer was not the most ambitious of his time,
but in his quirky, energetic, and unpredictable works, he was among the
most distinctive. Baron Grimm was an admirer and patron. Schobert's
minor-key pieces, such as the Op. 14, no. 4 Violin Sonata in D Minor,
have a fierce, brooding, even violent quality, prophetic of the Sturm
und Drang movement in literature and music that would flare in the
next decade. Those Schobert works embody what the critical climate of
the time dubbed the *bizarre*, a quality viewed as indecorous, on an edge
between provocative and reprehensible, exciting but suspect.

Schobert's music was probably the most forward-looking Mozart
had heard to that point. Already as a child he was quick to seize any-
thing useful to him. Echoes of Schobert can be heard in his work from
the Paris sojourn onward; soon he would adapt Schobert sonata move-
ments for his first experiments with piano concertos. Fifteen years later
he was giving his clavier students Schobert sonatas to learn.[44] Among
other things, Mozart may have absorbed some of his enduring minor-
key ferocity from this early influence.

Schobert in person turned up early in the Paris visit to pay his re-
spects to the Mozarts and to give them some of his self-published pieces.
Leopold for his part had less use for the music and none for the man:
"My little girl plays the most difficult works which we have of Schobert
and Eckardt and others . . . with incredible precision, and so excel-
lently that this man Schobert cannot conceal his envy and jealousy and
is making himself a laughingstock to Eckardt, who is an honest man,
and to many others . . . Schobert . . . flatters to one's face and is utterly
false. But his [Protestant] religion is the religion in fashion. May God
convert him!"[45] (A few years later, Schobert died in grotesque fashion:
he, two of his family, a servant, and four friends were done in by poi-
sonous mushrooms.)

In that same enormous letter Leopold laments the death of their
hostess, Countess van Eyck, originally from Salzburg; she had been a
favorite of the children, and they were in tears at the loss. Grimm pro-
vided them with rooms in the rue de Luxembourg for the rest of their
stay.[46] Immediately another misery appeared: Wolfgang came down
with a high fever and a swollen throat that could have choked him. In
terms of his health, here and in the future, the child was going to have
to dodge a series of bullets. Nannerl got a cold but no fever. Leopold
wrote urgently to Hagenauer to have four Masses said for his son and
another before the Holy Child of Loreto.

In four days Master Wolferl was back on his feet. Leopold fought off
an attempt by acquaintances to have his son inoculated for smallpox.
At that point it meant implanting scabs from an infected person under
the skin and the near certainty of a subsequent illness, usually mild
but sometimes fatal. "I leave the matter to the grace of God," Leo-
pold declared. "It depends on His grace whether He wishes to keep this
prodigy of nature in the world in which He has placed it, or to take it
to Himself." This paints Leopold as a pious fatalist, which he may have
been however earnestly in lip service, but hardly in practice. Really, at
this point he was optimistic about it all: "We have tilled the soil well
and now hope for a good harvest."[47] He conceived himself to be the ar-
chitect of his children's triumph, as indeed he was. Around this time he
received 1,200 livres from the Royal Exchequer for the performances
at Versailles.[48]

Baron Grimm had been helping the Mozarts from the beginning with
his article and with advice on court etiquette.[49] With Grimm pulling
strings in high places, Leopold got permission for the children to give
two public concerts, in the middle of March and April, at the theater
of a Mr. Felix. It was a small hall, often used by the nobility to mount
plays for their own amusement. Grimm handled the tickets and helped
round up an audience, giving sheaves of tickets to aristocratic ladies
of his acquaintance, who were expected to sell them to their friends.
Around 450 people showed up for the performances, as good as could
be hoped, as was the profit. Leopold wrote home of "this great friend
of mine, to whom I owe everything here, this M. Grimm. He . . . ar-
ranged for the first concert and he paid me on his own account 80 louis
d'or, that is to say, he got rid of 320 tickets. In addition he paid for the

lighting, as more than 60 large wax candles were burnt. Well, this M. Grimm secured permission for the first concert and is now arranging for the second . . . So you see what a man can do who has good sense and a kind heart."[50]

Baron Grimm commissioned amateur artist Louis Carrogis de Carmontelle to paint a portrait of the Mozart family. This in turn was engraved in copperplate and a stack of copies printed, to be used more or less as business cards for the rest of the tour. The picture shows the musical Mozarts in profile, little Wolfgang at the clavier, his feet hanging in midair under the bench. Behind him is Papa, his legs casually crossed, playing violin while Nannerl leans on the clavier holding a sheet of music from which she appears to be singing. They are alone, making music for themselves.

ON APRIL 10, 1764, THE DAY AFTER THE SECOND PUBLIC CONCERT, THE Mozarts left Paris minus servant Winter, who had gotten a job with a prince in Donaueschingen. With Winter's replacement, they headed for their next goals: Calais, the Channel, London. They carried the usual letters of introduction, one of them from a Claude-Adrien Helvétius to Francis, tenth Earl of Huntingdon: "Allow me to ask your protection for one of the most singular beings in existence."[51]

In a very short time, the life of the Mozart family had found its abiding pattern on the road. The children performed, the boy composed, after each triumph they moved on briskly to the next. The sovereigns of Das Königreich Rücken occupied their thrones commandingly. Leopold had imagined himself a Kapellmeister and famous pedagogue. He had more or less achieved the latter and still aspired to the former. But given that he had fathered a child who boded to be a remarkable composer, and in light of his own comparatively modest gifts, Leopold largely gave up writing music. His career and his hopes for fame and fortune were now embodied irrevocably in his son.

AN INSTRUMENT AT THE
COMMAND OF MUSIC

In her diary, Nannerl wrote that at Calais, on the way to London in April 1764, they observed "how the ocean ebbs and waxes." For the Channel crossing, Leopold hired a private boat and picked up four more paying passengers. On the way the family all got wretchedly seasick; Leopold wrote home that he was champion at vomiting.[1] They reached London on the twenty-third, staying for a few days at an inn in Piccadilly before settling into cheaper rooms above a barber's in St Martin's Lane. Discovering that their Parisian attire attracted cries of "Bugger the French!" from street urchins, Leopold hastened to equip the family with English clothes, including fashionable round hats.[2] The children's reputation had preceded them: five days after their arrival, Wolfgang and Nannerl played before King George III and Queen Charlotte at Buckingham House. They would stay in London for an initially glorious, then exasperating fourteen months.

When the Mozarts arrived in London, Handel was five years in his grave; many in the city remembered his performances. At that point George III was nearly twenty-six, Charlotte nearly twenty-one. The queen was German-born, the king's family German. Besides occupying the British throne he was also elector of his ancestral Hanover, so the court had a distinctly German tone.[3] Leopold found them the warmest and most welcoming sovereigns they had yet encountered: "Their easy manner and friendly ways made us forget that they were

the King and Queen of England." During the first audience the king presented Wolfgang with sight-reading challenges, works by Wagenseil, J. C. Bach, Abel, and George's favorite, German-born Handel. Wolfgang accompanied Queen Charlotte in an aria—she was a fair singer and clavier player—and improvised melodies over Handel bass lines.[4] Afterward Leopold lamented that their gift for the performance was a mere 24 guineas (around 250 florins), but a second court appearance in May made them 24 more. Already Leopold was grousing about proceeds for an event or two that garnered more than his yearly Salzburg salary. As the Mozarts strolled in St James's Park between their court appearances, the king and queen clopped by in a carriage and George leaned out the window to give them a wave.[5] It was a sure sign of royal enthusiasm.

London at that point was the largest and richest city in the world, one of the most cosmopolitan, and a mecca for musicians. As a center of music publishing it rivaled Paris. Compared to what the Mozarts were used to, it was a seething hive of activity in the arts, with citizens on the prowl for entertainment, including concerts public and private, opera, theater, dancing, card playing. The court was highly musical, but that had little influence on the rest of the city's arts, which took shape in a maze of patrons and entrepreneurs. A fascinated Leopold wrote patron Hagenauer reports of everything from the number of streetlamps in London (55,435) to the amount of cheese consumed per annum (21,660,000 pounds) to observations on the high quality of meat and produce, the various types of beer and punch, women's fashions, Oxford students' habit of cutting their hair short so it would not interfere with their thoughts.[6]

The children took up their familiar round of concertizing. Advertisements described them as "Prodigies of Nature." Leopold scheduled their public debut for June 5, the king's birthday, when he knew the nobility would be in town. For the occasion, held in the spacious Great Hall of Spring Gardens, Leopold hired a small orchestra of London players and two singers to present arias. About two hundred people showed up—fewer than Leopold had hoped, but still bringing in ninety guineas, which amounted to more than nine hundred German florins.[7] There was a second concert at the end of the month in the rotunda of Ranelagh Gardens. Public concerts were a singular feature of

music in London, more common than most places on the Continent. During the time of the Mozarts' sojourn, two Germans, Johann Christian Bach and Carl Friedrich Abel, established London's historic first subscription series, which would be a feature the city's music life for sixteen years.

Active as was public concert life, it tended to be mainly an entrée into private performances, which were more frequent and often paid better. Grimm in Paris had recommended to Leopold a new and semi-private hub of concertizing at Carlisle House, in Soho Square. Run by Mrs. Teresa Cornelys, once an operatic singer and now society hostess, the concerts were somewhere between public and private, catering to a select aristocratic clientele.[8] It was a bit of a startling situation: the rooms, hung in blue and yellow satin, were a former brothel. They could accommodate up to six hundred attendees for concerts, cards, dinners, and masked balls.[9] Impresario Cornelys was a former (or not-so-former) procuress who notoriously had a daughter by Casanova. In 1765 the rooms became the home of the historic Bach-Abel concerts.[10] Mrs. Cornelys herself, however, did not appear interested in the Mozarts, though they may have attended her programs.

Musically, since leaving Salzburg the children had made dazzling strides. Wolfgang's playing, Leopold wrote, "has become at all points different."[11] "My little girl, although she is only twelve years old, is one of the most skillful players in Europe, and . . . my boy knows in this his eighth year what one would expect only from a man of 40."[12]

As usual Leopold made wide contacts and had boundless ambitions for the visit, but the usual tricks of fate turned up too. The first had to do with timing: they arrived in town at the end of the concert season, when the upper classes were about to leave London for the countryside. The other unexpected factor, once again, was health. For a July concert at the home of the Earl of Thanet, in Grosvenor Square, Leopold could not find a free carriage, so he hired a sedan chair for the children. As there was no room for him and the chair carriers were swift, he had to jog alongside. The exertion overheated him, which, he believed, led to a cold, which a week later turned into a miserable sore throat and fever.[13] "I have been clystered, purged, and bled," he wrote Hagenauer. "I feel like a child. My stomach does not fancy anything and I am so frail that I can hardly think sensibly . . . It depends on the grace of God

whether He will preserve my life. His most holy will be done."[14] With family in tow, he was spirited in a sedan chair out to a country house in Chelsea, three miles from London.

From a friend, Leopold got a recommendation for a doctor who turned out to be a Dutch Jew. He developed a great respect for the man, mused about trying to convert him, finally decided to leave well enough alone. In London the Mozarts got to know a number of wealthy Jews, most of them Portuguese. Leopold marveled that they dressed like Parisians and hardly looked like their coreligionists in Austria. Now he fretted that these Jews seemed too secular, neglecting their faith. He appears to have come to something like Voltaire's admiring and ironic description of England, "a place more venerable than many courts of justice, where the representatives of all nations meet for the benefit of mankind. There the Jew, the Mahometan, and the Christian transact together as though they all professed the same religion, and give the name of Infidel to none but bankrupts."[15]

While Mama took care of suffering Papa, the children had to find their own diversions. Though Leopold talked to his wife about who might take over their education if he died, the potential disaster turned out well for Wolfgang. So that Papa could have quiet and rest, the children were not allowed to touch a keyboard. To pass the time, Wolfgang decided to write a symphony for full orchestra. He was able to write the piece without a clavier because he had the inborn faculty called "perfect pitch," meaning he could hear notes accurately in his head or name any note played to him. (All the same, most of the time he composed at the keyboard.) Perfect pitch is a rare gift. Some musicians have it, most do not. Because of his remarkably precise sense, Wolfgang was pained at hearing any deviation from exact pitch.

Many years later, Nannerl described the scene as their father lay dangerously ill: "In order to occupy himself, Mozart composed his first symphony with all the instruments of the orchestra, especially trumpets and kettledrums. I had to transcribe it as I sat at his side. While he composed and I copied he said to me, 'Remind me to give the horn something worthwhile to do!'" The work later known as Symphony no. 1 in E-flat, K. 16, might be this piece, but probably not—that symphony was indeed written in London, but it does not have trumpets and drums.[16] In any case, after his first try, Wolfgang started turning out

symphonies for small orchestra designed for his and Nannerl's London concerts.

By the last week of September 1764, Leopold was well enough to bring the family back to London. They appeared for the third and last time before the king and queen on October 25, the fourth anniversary of George III's taking the throne. It may have been on this occasion that Queen Charlotte asked for the dedication of six sonatas for violin (or flute) and harpsichord that Wolfgang may have just written, or that he produced after her request.

Those sonatas, K. 10–15, are another step up in ambition and sophistication, two- or three-movement pieces with a first in sonata form, most with a minuet or two for the finale. Leopold had shown Wolfgang the formal outlines appropriate to each movement of a sonata or symphony. The first movement should have three sections, starting with a first theme or group of themelets in the "tonic," the home key, that establish the mood and main ideas of the movement. Then you modulate to the key of the fifth scale degree, the "dominant," and write a second theme or themelets that complement and contrast the first theme. You repeat that section; then there is a section in which you may modulate to more distant keys. Then you return to the opening material, now putting it all, or most of it, in the home key. (Only decades later would this pattern, already common in works of the 1770s, be named "sonata form," its three main sections called "exposition," "development," and "recapitulation," to which may be added an introduction at the beginning and a coda at the end. In practice, the pattern is a general guide that can have endless variations.)

Like all violin sonatas of the time, these of Wolfgang's are, again, mainly piano pieces with the violin along for the ride. The fast movements are confident and exuberant, and among the pieces is a nice variety of keyboard textures. The third movement of K. 14 has at the head "en carillon," and features high writing on the harpsichord and pizzicatos for the violin. The composer's youth is shown in occasionally static harmony, in the piano part still relying on babbling Alberti bass in the left hand, and in a frequent sense of inattention to the violin part; for stretches he lets the fiddle dither around aimlessly on the low strings. The violin writing, with Leopold looking over his shoulder,

works well enough, but the eight-year-old is far more involved with the clavier part.

Leopold had the sonatas engraved at the end of the year, the dedication page to Queen Charlotte necessarily obsequious, this time in French, signed by Wolfgang but surely written either by Papa or a hired writer of such things: "When the Queen deigns to listen to me, I surrender myself to thee [meaning music] and I become sublime; far from Her, the charm grows weak, her August image gives me a few ideas which art then takes charge of and completes . . . But let me live, and one day I shall offer Her a gift worthy of Her . . . I shall become immortal like Handel . . . and my name will be as celebrated as that of Bach."[17] There is a good deal more of the like twaddle. Two points: the Bach he cites is Johann Christian; and this is perhaps the only time history records Mozart (though it is not really him speaking) talking in terms of the kind of immortality for composers that Handel's enduring reputation had pioneered.

In some ways musically more interesting from that period is a series of sketches and drafts Wolfgang wrote down in a new manuscript book Leopold gave him. It would survive as "the London Notebook." Father or son signed it in the front, "di Wolfgango Mozart à Londra 1764." Here are forty-three ideas in various directions and states of completion, all of it, for a change, in Wolfgang's own hand, which by now is neat and clear and would remain so for the rest of his life.[18]

There are surprisingly few strikeouts or corrections in the London Notebook; probably he worked out the pieces at the clavier and then copied them down, relying on a remarkable memory for music, whether his own or works by others. The pieces, some incomplete, range from tentative to fascinating. Three of them may be sketches toward orchestral movements.[19] Most striking is No. 15 in G Minor, a through-composed piece that deftly develops its opening ideas throughout and en route works in a quote from Gluck's ballet *Don Juan*. Wolfgang may have looked at it as a harmonic study; its altered chords and modulations from key to key range farther than anything he had yet explored. Beyond that, there is a driving intensity to the piece that foreshadows a distinctive G-minor mood that would be with him to the end, most famously in his two symphonies in that key, one early and one late.

DURING THE LONDON SOJOURN WOLFGANG ENCOUNTERED TWO MUSI-
cians who made a lasting impression on him. The first and most impor-
tant was Johann Christian Bach, youngest of the celebrated composer
sons of Johann Sebastian. He had come to London in 1762 to write
Italian operas for the King's Theatre, and the following year he was
named music master to Queen Charlotte. He would remain in London
the rest of his life as the city's preeminent musician. Another member
of the court musical household was C. F. Abel; the two men were in the
process of organizing their concert series.

In effect, J. C. Bach and his brother Carl Philipp Emanuel, who was
then based in Berlin, were between them forging much of what history
would call the mature eighteenth-century Classical idiom. Christian's
work embodied the manner of the period called the *galant*, which re-
jected the heaviness of the Baroque in favor of light and lucid textures
without counterpoint, a tuneful and singing melodic style, a general
air of elegant, artless simplicity. This was music designed to be easy on
the ear; it could be touching and sometimes poignant, but it skirted the
gloomier emotions. Pieces were laid out in regular phrasing and clear
forms, like the dance music that constituted much of the style's founda-
tion. At its best, the galant could be entirely charming; at less than its
best, precious and banal. Christian had studied with noted theorist and
composer Padre Martini in Italy, which left a stamp of Italianate lyri-
cism on his work. His brother C. P. E. had a galant side as well, but he
was better known for a more sober and introspective music called the
empfindsamer, or "sensitive" style.

In the end the music of both Bach brothers would resonate power-
fully with Mozart, but first and most significant was Christian's galant
style, which Wolfgang absorbed in London. Among other things,
it impressed on him the Italian conviction that melody is the soul of
music—something he never lost. Already the influence is seen in the
violin sonatas of late 1764 and in Wolfgang's London symphonies. He
clearly heard a good deal of Christian's work during the visit, but the
influence was personal as well: the famous man took the new marvel
under his wing. Nannerl later described one of their appearances at
court when Christian seated himself at the harpsichord, placed Wolf-
gang between his knees, and they improvised away together, Christian
laying out ideas and her brother continuing them. It sounded like one

person playing, Nannerl recalled. Another report, probably from this occasion, said the two led each other "into very abstruse harmonies, and extraneous modulations, in which the child beat the man." Afterward as Wolfgang was rolling around on a table, somebody handed him a song of Christian's. The boy glanced at the score upside down, pointed out a wrongly copied note, and continued his roll on the table.[20]

The other abiding London influence came from the world of opera. Leopold's letters rarely mention opera performances during the tour, but they must have seen many, especially in London, where opera in Italian was the rage. For all his experience as a composer, Leopold had never written an opera, and while he was an aficionado, he was less prepared to give his son advice about that genre than he was with instrumental music. All the same, he knew he had to expose Wolfgang to a spectrum of opera. Besides being a genre that he would be expected to write in one of these days, it was a means of studying the range of expression, from gaiety to sorrow, in how music amplified a text, and also how music evoked stage movement from dramatic to dancelike.

The Mozarts came to know the renowned operatic castrato Giovanni Manzuoli, whose reputation as a male soprano was second only to that of the legendary Farinelli, who by then had retired. Leopold's first mention of the singer turns up in a letter of February 1765: "This winter nobody is making much money except Manzuoli and a few others in the opera. Manzuoli is getting £1500 for the season . . . He is the only person whom they have had to pay decently in order to set the opera on its feet again." That figure equaled a stunning 15,000 German florins.

Castratos were a familiar feature of music in the eighteenth century, but their fame did not erase the melancholy of their existence. From the sixteenth to the nineteenth century, tens of thousands of male children, mostly in Italy, were castrated before puberty to preserve their high voices, then subjected to a relentless program of vocal training. If a boy showed a hint of musical talent, his parents might send him to the knife, hoping for riches in return. As in all areas of musical education, the result was a few idolized stars like Farinelli and Manzuoli, a supply of singers for church, court, and opera, and myriad nobodies. The great majority of the victims got nowhere, sang for pennies in the street, turned to prostitution for male customers, sooner or later

disappeared into the oblivion of the outcast. As a castrato, you were a singer or you were nothing.

The tradition rose from an unholy trinity of religion, money, and art. The Church forbade women to sing in services. There was a standing ban, enforced primarily in the Papal States, on teaching women to sing professionally at all. Church choirs were staffed by boys, castratos, and adult tenors and basses. Castration was officially forbidden by the Church but sanctioned all the same—with consummate hypocrisy, reports described singers as having had an unfortunate accident in childhood.

In secular musical life, the greatest castratos, their vocal virtuosity almost superhuman and their voices uniquely beautiful, were stars of the opera stage and concert hall. As both singers and sexual toys— they were not necessarily impotent—they were favorites of royalty and clergy. In his *Mémoires*, Casanova reported an intricate orgy that could have come from de Sade: "There were seven or eight girls, all of them pretty, three or four castratos . . . and five or six abbés . . . A castrato and a girl . . . proposed to strip . . . lie on their backs . . . with their faces covered. They challenged us all to guess which was which."[21]

So the institution of the castrato was a matter of supreme cruelty and hypocrisy at the service of beauty. On the stage castratos played virile heroes and fiery heroines in opera seria, competing for fame with the female divas of the day. Their voices, distinct from that of a female soprano, were described as brilliant, ringing, even uncanny. That was the bigger-than-life role that Manzuoli was playing when the Mozarts met him in London. He befriended the family, perhaps gave Wolfgang singing lessons. He lent his voice and fame to the children's private concert at the Berkeley Square house of Lord and Lady Clive. Manzuoli was woven into Wolfgang's early experience of opera, a genre for which he was by his gifts destined. Their paths would cross again not so many years later, when Wolfgang was becoming a composer of opera.

WOLFERL CONTINUED TO BE AGREEABLE ESSENTIALLY TO ANYTHING asked of him, including being poked and prodded by various experts. One of them was pioneering British music historian Charles Burney,

who in later years recalled the child "playing on my knee, on subjects I gave him." Wolfgang added tricks old and new, as Burney listed.

> Extempore & sight Playing, Composing a Treble to a given Base & a Base to a Treble . . . as well as finishing a Composition began by another. His fondness for Manz[u]oli—his imitations of the several Styles of Singing of each of the then Opera Singers, as well as of their Songs in an Extemporary opera to nonsense words—to which were added an overture of 3 Movemts Recitative—Graziosa, Bravura & Pathetic Airs, together with Several accompd Recitatives . . . after wch he played at Marbles.[22]

Another to give the child a going-over was Daines Barrington, a lawyer, magistrate, amateur scientist, and fellow of the Royal Society, whose past fellows had included Christopher Wren, Isaac Newton, and other philosophes and polymaths. He gave the Society an extended report of his encounter with Wolfgang that was eventually printed in the Society's *Philosophical Transactions*.

> Sir,
> If I was to send you a well attested account of a boy who measured seven feet in height, when he was not more than eight years of age, it might be considered as not undeserving the notice of the Royal Society.
> The instance which I now desire you will communicate to that learned body, of as early an exertion of most extraordinary musical talents, seems perhaps equally to claim their attention.

Barrington provides some background on the prodigy's manifestations and his travels, then proceeds to a lively account of his examination. The first was sight-reading a five-part score, which Wolfgang executed perfectly, not only in the notes but in his understanding of the style. He sang one of the top two parts, with Leopold handling the lower one. Not as good a sight-singer as his son, Papa fumbled some of the notes, "on which occasion the son looked back with some anger pointing out to him his mistakes." Eventually, Wolfgang's new

experience with opera came up. As with every new experience, it had triggered his imagination.

> Happening to know that little Mozart was much taken notice of by Manz[u]oli, the famous singer . . . I said to the boy, that I should be glad to hear an extemporary *Love Song*, such as his friend *Manz[u]oli* might choose in an opera.
>
> The boy on this . . . looked back with much archness, and immediately began five or six lines of a jargon recitative [accompanying himself on harpsichord].
>
> He then played a symphony which might correspond with an air composed to the single word, *Affetto* [affection] . . . Finding that he was in humour, and as it were inspired, I then desired him to compose a *Song of Rage*, such as might be proper for the opera stage.
>
> The boy again looked back with much archness, and began five or six lines of a jargon recitative proper to precede a *Song of Anger.*
>
> This lasted also about the same time with the *Song of Love*; and in the middle of it, he had worked himself up to such a pitch, that he beat his harpsichord like a person possessed, rising sometimes in his chair . . . The word he pitched upon for this second extemporary composition was *Perfido* [perfidious].

It must have been an unforgettable scene, the tiny child pounding the harpsichord as he furiously wailed, "Perfido! Perfido! Peeeeerfidooooooo!" Barrington added that amid these and other feats, Wolfgang jumped up from the keyboard to play with a cat who had wandered in, and now and then ran around the room with a stick horse between his legs.[23]

BY THE LAST MONTHS OF 1764, THE LONDON PROSPECTS WERE STARTing to look paltry. The nobility had been largely out of town for the summer,[24] and while in October the queen bestowed fifty guineas in return for the dedication of Wolfgang's violin sonatas, expenses were eating up the Mozarts' resources. In January the children played daily

concerts at the Swan and Harp inn to try to make up some of the money lost during Papa's illness.[25] Leopold tended to see illness largely in terms of lost income; sometimes he put the children back to work before they were fully recovered.

Wolfgang was writing symphonies for a big program Leopold planned and that, after delays, took place on February 15 at the Little Theatre in Haymarket. An advertisement noted that "all the Overtures [meaning symphonies] will be from the Composition of this astonishing Composer, only eight Years old." To save money, Leopold copied all the parts for the pieces himself.[26] Which symphonies and how many of them Wolfgang wrote in London is a hazy matter, with misattributions and probably lost works involved. But there is an autograph on London-printed music paper for what history came to call his Symphony no. 1 in E-flat, K. 16. As noted, this is probably not the one Nannerl took down, thus not his first effort, but it was written in the city and surely played there.

If the violin sonatas show both the boy's precocity and his immaturity, what about his first symphonies? At age eight, Wolfgang already writes confidently for orchestra, though there would have been much advice and correction from Papa. These early symphonies were typical of the time, small in scale, intended more for a music room than a large hall. The E-flat is in three movements, strings plus pairs of oboes and horns. Like the sonatas, the piece has the galant influence of J. C. Bach all over it. Wolfgang's gift for mimicry has deepened.

The piece begins with a blustery fanfare, then calms to a quiet series of chords, striking because of their sighing suspensions and warm scoring in divided strings, but at the same time, the chords lose the energy generated by the opening. (This is the sort of thing Leopold might have noticed and known how to fix, but if so, he let it stand.) Wolfgang modulates correctly to the key of the dominant for a second theme; the development section simply runs through the opening music in new keys and ends not with a complete sonata-form recapitulation, but only the second theme in the home key.

The second movement has a quietly pulsing main theme, more atmosphere than tune, whose suspensions recall the quiet chords of the first movement. Perhaps Leopold advised his son that there needed to be rhymes and reasons for movements to cohere in a piece. The finale

is a vigorous Presto rondo in 3/8 whose beginning in octaves recalls
the mood of the start of the symphony. Its second section has a deft
contrapuntal interlude. As a whole, the piece shows a little composer
who knows how to come up with attractive material but doesn't yet
know how to vary and develop it. Instead of developing he repeats, like
a child who thinks that the third time he tells a joke will be as funny as
the first time.

There are perhaps two more symphonies from the London sojourn;
they survive only in manuscript parts in Leopold's hand.[27] One in
F major is no great advance on the earlier symphony, though there is
a sweetly lyrical and galant second movement whose emotional atmo-
sphere is beyond Wolfgang's years, part of its charm a gently undulat-
ing accompaniment. The boy has a way to go to his maturity, though
he still finds fresh ideas from piece to piece, but he does not always
realize when the ideas wear out their welcome. Symphony no. 4 in D
Major, K. 19, shows that Wolfgang knows that D major is considered
a bright and cheery key. By now he knows how to sustain a driving
energy through a movement. In any case, as he passed his ninth birth-
day in January 1765, he was a budding symphonist—incredible, for
anybody but him.

MARCH 13, 1765, SAW A CONCERT AT THE HOME OF LADY MARGARET
Clive in Berkeley Square, probably one of a number of appearances
by the Mozart children in fashionable salons. In a letter to her husband
Lady Clive described the upcoming show: "Tomorrow I shall have a
great deal of Company indeed all the people of quality etc. . . . to hear
Manz[u]oli sing here, accompanied by Mr Buron[?] on the harpsichord,
on which the little Mozarts . . . will play most completely well and this
together with two good Fidlers and a Bass."[28] It would have been the
usual thrown-together program for a house concert.

As spring blossomed, and with the novelty of the prodigious chil-
dren wearing off for the public, Leopold resorted to something on the
order of desperate measures. In April a notice appeared in the paper
that the Mozart children would be home every weekday from twelve
to two for customers to test their skills. At the end of the month, this
became three hours a day. In July there appeared another newspaper

notice prompted by Leopold, its hyperbolic tone showing a touch of anxiety:

> The greatest Prodigy that Europe, or that even Human Nature has to boast of, is, without Contradiction, the little German Boy WOLFGANG MOZART; a Boy, Eight [actually nine] Years old, who has, and indeed very justly, raised the Admiration not only of the greatest Men, but also of the greatest Musicians in Europe. It is hard to say, whether his Execution upon the Harpsichord and his playing and singing at Sight, or his own Caprice, Fancy, and compositions for all Instruments are most astonishing. The Father of this Miracle, being obliged by Desire of several Ladies and Gentlemen to postpone, for a very short Time, his Departure from England, will give an Opportunity to hear this little Composer and his Sister, whose musical Knowledge wants not Apology. Performs every Day in the Week, from 12 to 3 o'clock in the Great Room, at the Swan and Harp, Cornhill. . . . The Two Children will play also together with four Hands upon the same Harpsichord, and put upon it a Handkerchief without seeing the Keys.[29]

Finally, the British welcome manifestly petering out after a year and two months, Leopold conceded it was time to go. The Mozarts left London on July 24 and lingered for a few days at Bourne Place in Canterbury, the mansion of Sir Horatio Mann, a wealthy nobleman at that point known mainly for being mad about cricket; he had a pitch on his estate. During the visit the family took in what may have been their first horse race, an echt-British amusement. In London, a Dutch envoy had pressed Leopold to take the family to The Hague, to play for Princess Caroline of Orange-Nassau. The answer had been no, they were headed back to Paris, but the envoy showed up in Canterbury and made his pitch again, and this time Leopold agreed. His decision gained the children further glory and nearly cost them their lives.

At the beginning of August the Mozarts arrived in Calais, picked up their coach, hired six post horses, and headed for Lille on the way to Holland. Instead they found themselves mired in Lille with a flood of bad news. Wolfgang came down with an intestinal typhoid, from

which he suffered for two months.[30] In those days typhoid was fatal as often as not. Before he recovered, the typhoid hit Leopold as well, so he enjoyed his own siege of vomiting, dizziness, and vertigo. The treatment was purgatives and foot baths, one as useless as the other. (Some years later, Leopold pressed on a friend a Viennese treatment for illness: "Get some cart grease, wrap in a bit of paper and wear it on your chest. Take the bone of a leg of veal and wrap it up in paper with two kreuzers' worth of leopard's bane and carry it in your pocket. I am sure this will cure you."[31] As noted before, medicine in those days could be a patient's worst enemy.) They escaped from Lille at the beginning of September. The next days found them in Ghent and in Antwerp, where Wolfgang played the organ at the cathedral. On the road, Nannerl came down with a cold that at first seemed like nothing serious. They arrived at The Hague via Rotterdam on December 10. In a letter from The Hague, Leopold praised the cleanliness of Dutch cities and reported family encounters with Prince William and Princess Caroline of Orange.

He also reported that Nannerl's cold was improving, but he was wrong. On the twenty-sixth she came down with shivers and fever and took to bed. It was probably typhoid again. Soon the doctor announced that he could do no more; a priest was summoned to give her extreme unction. In her delirium, Nannerl babbled gibberish about their travels in a jumble of English, French, and German. In spite of themselves, Papa and Mama could not help laughing. Wrote Leopold, "Whoever could have listened to the conversation which we three, my wife, myself and my daughter, had on several evenings, during which we convinced her of the vanity of this world and the happy death of children, would not have heard it without tears. Meanwhile, Wolfgang, in the next room, was amusing himself with his music."[32]

Nannerl somehow gathered herself and recovered. But as soon as she was out of the woods, Wolfgang came down with the same frightful illness, his second bout of typhoid since August. He was in bed for a month, for eight days nearly comatose. Some of the time he could not speak; his tongue was so swollen and dry it looked like wood; his lips turned black and the skin repeatedly peeled off.[33] Leopold reported that the illness "has made him so wretched that he is not only absolutely unrecognizable, but has nothing left but his tender skin and his little bones." Leopold asked for nine Masses to be said in Salzburg: the

worse the illness, the more Masses required. By that point Wolfgang was relearning how to stand on his feet.[34] Ten days later both children gave a public concert in The Hague. Two days after that they left for Amsterdam.

There in the next weeks they gave two concerts in the hall of the Riding School, all the music on the programs by Wolfgang. They returned to The Hague to join the festivities around Prince William of Orange's eighteenth birthday. For that occasion, Wolfgang produced nine pieces, including six new violin sonatas, K. 26–31, dedicated to Princess Caroline.

As this second set of sonatas for violin and piano show, Wolfgang in his work did not often backtrack; his progress from year to year and even month to month is manifest on the page. The first sonata has three movements, the rest two, most of them cheery in tone. One striking thing is that the repetitiousness of the earlier sonatas and symphonies has receded: Wolfgang is learning to extend and develop his ideas rather than simply repeat them. The harmony is richer and more chromatic than anything he has done before. He has not entirely figured out what to do with the fiddle, which is often given simple filler under the clavier part. But there are touches of independence for the violin, occasional bits of imitation between the players.

Maybe the glory of the set is the Andante poco adagio first movement of K. 27, which has a strikingly mature affect and a touching and atmospheric tone rare for a piece in G major. Musically, Wolfgang was always beyond his years in one way and another; here is an early case where the expression is more grown-up than he was. Meanwhile at age nine he was not just a deft composer but a prolific one. At the same time, outside his musical discipline Wolferl remained his age: he would still jump up from the keyboard to pet the cat or play marbles or horsey. He apparently never had time to play with other children his age. It all had to come from his own imagination. And his child self never entirely left him. He grew up a marvelous patchwork.

The whirl continued. Back to Amsterdam in mid-April 1766, where Papa had his own moment of glory: a publisher presented him with a handsome printing of the Dutch edition of his violin method.[35] In the next weeks, by way of Utrecht, Antwerp, and Brussels, they made their way to France. The end of April found them back in Versailles.

THE FAMILY'S SECOND VERSAILLES AND PARIS SOJOURN LASTED TWO
months and proved as profitable as the first. The royal family was again
welcoming. Baron Grimm wrote a new appreciation: "Mlle. Mozart,
now 13 years of age, and moreover grown much prettier, has the most
beautiful and brilliant execution on the harpsichord . . . Her brother
alone is capable of robbing her of supremacy."[36] Their row of illnesses
had gone harder on Wolfgang than on his sister. He remained small
and pale.

In the middle of July the family were guests of the Prince de Condé,
Governor of Burgundy. Wolfgang played several times in Condé's
grand salon. There is a painting of one of those occasions, depicting the
child Mozart at the clavier in a drawing room typical of the settings of
the time's upper-class *Hausmusik*. The room is tall, the walls of elegant
stucco; there are high windows and an enormous mirror. One sees that
the program is just starting or is in between pieces. Tiny Wolfgang sits
at a spindly-legged harpsichord, perhaps giving the pitch to a man tun-
ing a guitar beside him. Present are fifteen people, aristocrats except for
the child, eight of them ladies in grand finery. In the foreground of the
painting two dogs lounge. To the right of the picture, some of the lis-
teners sample a buffet; others sit at a table chatting and passing tea and
delicacies. Perhaps later, during the music, they will sew or play cards.
At the left sits a man thoughtfully perusing some pages—a performer
looking over the score of a piece. At his feet waits a cello, its neck rest-
ing on a sheaf of music. He and the guitarist will be involved in the
program and become listeners when they are not playing. Perhaps one
of the ladies will provide an aria or a keyboard sonata.

A newspaper report describes in unctuous tones one of the concerts
before the Prince de Condé:

> Having been informed that His Serene Highness, Mylord the
> Prince of Condé wished to hear a harpsichord concert by the two
> young children of the Archduke of Salzburg's Kapellmeister, the
> music of which was composed by one of the said children aged 8,
> Messrs the Viscount Mayer and the Alderman made ready for this
> gathering the Great Assembly Hall which was decorated with cut
> glass chandeliers and ornate candelabras lit with wax candles,
> a president's chair of crimson velvet placed on a platform in the

middle of the hall for His Said Highness, and risers on all sides for seating the distinguished persons of His retinue . . . [After the concert] refreshments were offered to His Highness, along with assurances [of fealty] inspired by this prince's goodness, which he accepted, and refreshments were likewise offered to the ladies and Lords who accompanied his Highness.[37]

Such was the milieu in which the Mozarts had to make their way. If in private the aristocracy could be warm and welcoming, the distance between their place and that of the Mozarts was an unbridgeable gulf. In European society it would take a great deal of history and much violence to change that.

Wolfgang had been writing Italian arias, a step on the way toward an opera. Wrote Grimm:

I have little doubt that before he has reached the age of twelve, he will already have had an opera performed at some Italian theater. Having heard Manzuoli in London all one winter, he profited so well from this, that although his voice is excessively weak, he sings with as much taste as soul. But what is most baffling of all is the profound knowledge of harmony and its most recondite progressions which he possesses to a supreme degree.[38]

Grimm's prophecy was early by one year: Wolfgang would be all of twelve when he got his first shot at opera.

The family left Paris in July 1766. They were headed home to Salzburg, but it took them six months to get there. In Geneva the children played for friends of Voltaire and his publisher, but not for the legend himself. As Voltaire wrote to old friend (and Mozart family friend) Madame d'Épinay, "Your little Mazar, Madame, chose, I am afraid, a rather unfavorable time to bring harmony into the temple of Discord. You know that I live two leagues from Geneva: I never go out; and I was very ill when this phenomenon shone on the black horizon of Geneva. In short, he has left, to my great regret, without my having seen him."[39]

September found the Mozarts in Lausanne, Bern, then Zürich, where they were guests of poet Salomon Gessner. He gave them four volumes

of his writings with an effusive dedication: "Take, most valued friends, this present . . . and may it be worthy of keeping my memory ever alive with you! Continue long to enjoy, honorable parents . . . the happiness of your children: may they be as happy as their merits are extraordinary. At the tenderest age they are the pride of the nation and the admiration of the world. Fortunate parents! Fortunate children!"[40] This sort of tribute had become more or less routine for the family, but it was still gratifying coming from Gessner, whose sentimental *Idyllen* was at that point the most popular book in Germany.[41]

A more searching piece of writing came from a Professor Samuel Tissot, who was interested in the nervous systems of geniuses, especially prodigies. In a long essay he uses Wolfgang as a point of departure in examining the idea of inborn talent as a mental phenomenon: "What is it that lets anyone be born a Poet, a Musician, or a Painter?" Tissot finds part of the answer in some people's heightened sensitivity to a particular stimulation: "The sight of a new machine whose secret has been concealed from him worries the great Engineer until he understands it; why then should not a sound . . . force a brain keenly affected by sound to occupy itself with music?" His main example is the miraculous boy:

> Aural sensibility and justness are so keen in young Mozard [*sic*] that wrong, harsh or too loud notes bring tears to his eyes. His imagination is as musical as his ear, for it is always conscious of a multitude of sounds all together; a given single note calls up the same instant all those that may form a melodious succession . . . He was sometimes involuntarily driven to his harpsichord, as by a hidden force, & he drew from it sounds that were the living expression of the idea that had just seized him. One might say that at such moments he is an instrument at the command of music.[42]

Tissot includes an astute observation on the importance of the father, "who, far from pressing his son, has always been careful to moderate his fire and to prevent him from giving way to it." He concludes on a metaphysical note: "When I see the young Mozard with light heart creating those tender and sublime symphonies, which might be taken for the language of the immortals, every fiber of my being resounds,

so to speak, with immortality . . . I could almost imagine this child, precious to heaven . . . to be one of those pure spirits who inhabits the happy abode destined for me." Here is a thoughtful High Enlightenment treatise that attempts to come to grips rationally with a phenomenon that Tissot knows is ultimately beyond explanation.[43]

Winterthur, Schaffhausen, Donaueschingen—at the last, the Mozarts were hosted by Prince Joseph Wenzel von Fürstenberg and had an unexpected reunion with their esteemed former servant Sebastian Winter. He had begun the tour with them and now served as a retainer for the prince.[44] The family stayed in town for twelve days; on nine of them the children played four-hour programs in the evening, including some new cello pieces Wolfgang had written for the prince (later lost), and probably his droll *Galimathias musicum* (translated, more or less, as "musical gibberish"), K. 32, for orchestra. Written in The Hague, it is a hodgepodge of seventeen little movements weaving in current popular songs. When the family left the prince's, there were tears on both sides and, of course, generous gifts from their host.

From there it was "head over heels," Leopold reported, town after town in the first days of November. On the eighth they arrived in Munich for an unintended long stay. The day after they arrived, they were summoned by Elector Maximilian III Joseph, who sang a tune for Wolfgang to improvise on.[45] The child impressed, as always. That night, Wolfgang was restless in bed. It quickly became clear that he was sick again, this siege as bad as any of them. He was feverish, his joints pained him, he was paralyzed from the knees down.[46] It was likely acute rheumatic fever, which he seems to have had before.[47] The disease can return in a victim, and so it did for Mozart. One day it would return, it appears, to finish him.

YET AGAIN, WOLFGANG RECOVERED FROM A MALADY THAT COULD have been fatal, and the family was finally able to make their way home, arriving in Salzburg on November 29, 1766. They had been on the road for three years, five months, and twenty days; traveled thousands of miles by coach; stopped in eighty-eight cities and towns; and performed for thousands of usually awed listeners.[48] The children were among the famous people of the world—Wolfgang more celebrated

and scrutinized than Nannerl, but still both of them were marveled at in endless reports. When they left home, Wolfgang was not quite seven and a half; now he was nearly eleven. He had done much of his growing up on the road, everywhere celebrated but in effect living in a bubble. And he was not done with traveling.

Their tour was instantly a legend, a virtual myth, and so it would remain in history. So profound was the impact Wolfgang made that in some ways it would be impossible to top. During the tour more than one observer had noted the tendency of most prodigies at some point to hit a wall, artistically and personally. Yet the reality was that Wolfgang, already along with his sister among the finest keyboard players in Europe, had barely cleared his throat as a composer. More and better symphonies and chamber works were coming; opera loomed. Brother and sister would have a few more years of grace before the inevitable and wrenching end of a prodigy's career: growing up. Part of that would be the matter of entering the mainstream of the profession, which is to say entering the fray.

LIARS, SLANDERERS, AND
ENVIOUS CREATURES

When the family arrived back in Salzburg in November 1766, Leopold Mozart, a perennially dissatisfied man, could hardly have been unsatisfied with the results of the tour. This meant, in turn, that he was going to be steadily less satisfied with Salzburg. He was already speculating about the next move.

Leopold was quick to put the swag from the trip on display in the house. Beda Hübner, librarian of St. Peter's Abbey, reported in his *Diarium* paper that it looked like a church treasury:

> Of gold pocket watches he had brought home 9; of gold snuff-boxes he has received 12; of gold rings set with the most handsome precious stones he has so many that he [Leopold] does not know himself how many; ear-rings for the girl, necklaces, knives with golden blades, writing-tablets and suchlike gewgaws without number and without end.

Hübner noted that among the items was a snuffbox from Louis XV that the French sovereign had personally filled with 50 louis d'or, equaling 500 florins, and then added a proviso: if they should wish to sell the snuffbox, Louis would buy it back himself for 1,000 florins. Hübner estimated the entire treasure from the tour at 12,000 florins, not including the cash the children had made from their performances,

which amounted to thousands. Moreover, during the tour Leopold had bought goods that he intended to resell at a profit.[1]

The bulk of the treasure would eventually be sold off, when the bragging was done. You need only so many snuffboxes and gold rings and gold watches. By the end of 1767 Leopold had probably banked at least 15,000 florins, and there would be further profits in the coming years.[2] With his court salary now 450 florins a year, which he would collect until he died, plus the income from his teaching and dealing claviers, Leopold may now have been the most comfortably set up musician in Salzburg—though he would never admit it.

All the tour profits had been garnered by two children, under the planning and guidance of their father. The children, meanwhile, did not have a groschen in their pockets; nor would they have any money of their own for years to come. Papa ran the show, made the plans to the last detail, told them when and where to play and for how long, and Papa took care of the money. And as far as the record knows, Papa never told anybody exactly how much money there was, from this or future tours. Expenses, on the other hand, he talked about incessantly.

In his article Hübner opines that Nannerl plays with "more art and fluency than her little brother, but the boy with far more refinement and with more original ideas, and with the most beautiful harmonic inspirations." He adds:

> The boy Wolfgangl . . . has not grown very much during this journey, but Nannerl has become tolerably tall and almost marriageable already. [He means she is pubescent.] There is a strong rumor that the Mozart family will again not long remain here, but will soon visit the whole of Scandinavia and the whole of Russia, and perhaps even travel to China . . . I believe it to be certain that nobody is more celebrated in Europe than Herr Mozart with his two children, for indeed, after God, it is his children whom he has to thank for his fame and his great riches.[3]

The speculation about Scandinavia and China could only have come from Leopold, and probably the words about their fame as well. Before long these airy plans settled down to a more practical target: Vienna, already a scene of triumph for the children. But not right away—

Archbishop Schrattenbach had been patient and lenient, but Leopold needed to behave for a while like an employee of the court. The family would stay in town until autumn. They were still living in the same modest four rooms across the street from their patron Hagenauer. The maturing Nannerl, turning fifteen soon, needed her own room; but there was none available, so she got a curtain around her bed in the chamber the whole family slept in.

Now Wolfgang was to be counted among Salzburg composers. At his eleventh birthday on January 27, 1767, he was working away. As part of a previous performance of a play marking the anniversary of the archbishop's consecration, he had written an operatic-style recitative and aria for tenor, "Or che il dover." The piece impressed, and got him a far larger assignment from the court.[4]

On March 12, 1767, the Residenz saw the premiere of a sacred sung drama called *Die Schuldigkeit des ersten Gebots* (The Obligation of the First Commandment): "I am the Lord thy God and thou shalt have no other gods before me." The first of its three parts was written by Wolfgang. A sacred oratorio with recitatives and arias in the style of an opera seria, this was his debut as a dramatic composer and his first extended vocal work. He received sixty-nine florins for the music, which is to say that at eleven he was now a pro.[5] The work was heard in the Rittersaal (Knights' Hall), under a ceiling painting of young Alexander the Great as hero. For good measure, the archbishop presented Wolfgang with a gold medal.[6]

The fearfully pious story of the oratorio has the Christian Spirit inviting the spirits of Justice and Mercy to help him inspire mankind to grasp the importance of the First Commandment. Even though Wolfgang wrote only the first part of the huge work, he produced around an hour and a half of music. The other two parts were written by Michael Haydn (younger brother of Joseph, who had arrived in town four years before) and cathedral organist Anton Cajetan Adlgasser, both of them well-known composers. Given the small scale of the orchestra in Wolfgang's English symphonies, the overture is striking in its sonic richness. The band is the full Early Classical ensemble of pairs of oboes, bassoons, and horns, plus strings. The eleven-year-old wielded these forces deftly, to vivid effect. Part of the richness comes from splitting the violas into two parts, something of a Salzburg trademark in

works for orchestra. As often done in those days, the oboists sometimes double on flutes. (This is a good indication of why flutes were usually played badly out of tune in those days: the playing techniques required for an oboe reed and the open hole of a flute were antithetical. Considered a bit low class, the flute was not yet a regular member of the standard Classical wind section.)

The youth of the composer of *Die Schuldigkeit* is apparent in the relentless jangling two-bar phrases of the overture and a development section that largely just changes the keys of the opening material. The manuscript still shows steady small corrections and changes in Leopold's hand.[7] All the same, here Wolfgang is on a higher plane of skill and ambition than in his London symphonies. There is a great variety of orchestral textures, most of them painting the text. The second aria portrays the "enraged lion" of the libretto with fierce rushing figures in the strings. In the fourth aria, the Worldly Spirit talks about pastoral life and its pleasures; to conjure that atmosphere, Wolfgang provides music rustic and dancing, with some whooping roulades for the soprano. In the next aria, the Christian fearfully recalls the Day of Judgment and Last Trumpet; Wolfgang evokes that occasion with a trombone. (Traditionally in Germany, the Last Trumpet was called the Last Trombone.) Mozart would include a trombone for the same purpose in his final sacred work.

Papa would have made suggestions about how to express the text, but Wolfgang already grasped how music can limn images, actions, emotions. In their form, most of the arias are in the da capo (back to the beginning) layout (ABA), which was a traditional feature of the opera seria genre. This kind of aria can be tedious if the A material is not uncommonly appealing, because on its return that section is repeated strictly, in full (though often ornamented ad lib by the singer). Da capo arias also bring the drama to a halt while a character emotes at length to the air. It would take years for Wolfgang to extract himself from this convention.

Maybe because *Die Schuldigkeit* was well received, another commission appeared for a big work, this one nominally a comedy: *Apollo et Hyacinthus*, K. 38. It was an *intermedium*, meaning a piece to be done between the acts of a large-scale Latin drama, for the close of the school year. Plays had been a feature of universities since medieval times. This

one, a five-act tragedy by philosophy professor Father Rufinus Widl, must have been prodigious and in need of relief; Wolfgang's *intermedium* is an hour and a half long. It premiered at Salzburg University on May 13, with the female parts handled by boy sopranos and altos.[8] It's another step toward opera: five arias, two duets, a chorus, and a trio plus recitatives. The three acts were dispersed between the acts of the play.[9]

If the story of *Apollo et Hyacinthus* is classified as a comedy, it is hardly a thigh-slapper, comic perhaps only in comparison to the deep-dish drama that surrounded it. (Often in those days, you had to work hard for your entertainment.) Father Widl also wrote the libretto for Wolfgang's piece, adapting, partly from Ovid, the story of Apollo and his beloved, the boy Hyacinthus. To say the least, the good father downplayed the tale's original pederastic overtones. Apollo and Hyacinthus are amusing themselves playing discus when, in an accident, the heavy disc ricochets and fatally wounds the boy. Widl added to the ancient story a girl, Hyacinthus's sister Melia, as a new and presumably more proper love interest for Apollo. After some contretemps—Apollo is falsely accused of murdering his friend—Apollo transforms Hyacinthus into a beautiful flower, the lovers get engaged, and all ends in peace and forgiveness.

Wolfgang's music begins with a muscular intrada for orchestra. The first chorus in act 1, a hymn to Apollo, again shows his budding ability to set a mood, almost an ethos, in an introduction then to sustain that mood—in this case, one of solemn reverence. It is the first intimation of the gift that will find its greatest bloom in the choruses of his final opera and final sacred work. Apollo's first aria begins with some pastoral imagery that Wolfgang conjures with the kind of folksy music that the time associated with pastoral scenes. A duet between Melia and her father, after he has told her that Apollo was not responsible for her brother's death, has a gentle and poignantly nocturnal atmosphere, with murmuring strings and pizzicatos. That texture will be a Mozart thumbprint for the rest of his life. The whole of *Apollo* is conventional but never dull, all of it winning and elegant, perhaps more so than *Die Schuldigkeit*. Maybe Wolfgang related more directly to this troubled but finally happy tale of love's triumph over tragedy.

He is starting to grapple with what an aria involves, whether in a

concert work or an opera. Usually it is more or less a soliloquy in which
a character talks about his or her feelings. But an aria is not just about
word painting or a character: it is about *the emotions of that character
at that moment*. In the course of the whole work the character may go
from tenderness to rage, hate to love, and all these moods need to be
painted and shaped for this individual as distinct from the others in
the story. More, an aria often needs to suggest movement and setting,
something often done by means of genre and topic: a pastoral atmo-
sphere, a march, a serenade, a minuet, a furioso aria.

Opera in those days used recitative (its distinctive speech-song)
to advance the story and provide the tonal binding to join the various
numbers: arias, ensembles, choruses. Those numbers were not ex-
pected to have any tight musical relationship or progression, though
skilled opera composers paid much attention to the musical balance
of the numbers and to making a satisfying and expressive progression
of keys. In musical terms, recitatives served to modulate from the
key of one number to another. Thus the loose structure of eighteenth-
century "number opera," which also applies to a concert piece like
Apollo. In the long run Mozart would maintain this basic outline while,
in his mature work, integrating the material, keys, and musical bal-
ances more and more comprehensively—partly by carefully shaping
the musical implications of the libretto.

These are matters of operatic structure and dramatic expression,
juggling the claims of story and character and music at which the
grown-up Mozart would be supreme. In his dramatic works and operas
of the next years, Wolfgang took librettos as they were handed to him,
good or bad, and composed each number with attention to expressing the
text but with no sense of larger characterization. The characters them-
selves are pasteboard stereotypes. The music is often compelling; the
people and the drama, not so much. Not yet.

THE FIRST MONTHS OF 1767 HAD BEEN EXTRAORDINARY FOR WOLF-
gang. He had written two dramatic works totaling some three hours
for orchestra and voices; there was also a multi-movement *Grabgesang*
(grave song), another opera-like alternation of recitative and aria. He
had begun writing harpsichord concertos, though not original ones:

likely at Papa's suggestion, he took solo keyboard works and violin sonatas by various established composers, among them Schobert and C. P. E. Bach, and turned them into concertos by adding orchestral accompaniment. In all his endeavors he was nearing a point, in purely musical terms at least, where his age would not show. At eleven, after all, he had six years' experience as a composer.

During this time Leopold appears to have set his son to studying counterpoint by way of Johann Joseph Fux's legendary and formidable *Gradus ad Parnassum* (*Steps to Parnassus*). Counterpoint is the art of interweaving simultaneous melodic lines; it reached its peak of importance in the Renaissance and its summit of achievement in J. S. Bach. Fux's study is grounded in the style of the Italian sacred music composer Palestrina, long considered the purest and most sublime practitioner of Renaissance polyphony. (The term means roughly the same as *counterpoint*.) Beginning with simple note-against-note exercises in two parts, Fux progresses step-by-step to four-part free counterpoint governed by brain-breaking sets of rules. That Wolfgang could handle this grueling study at age eleven is another in his long list of childhood feats.

What Fux teaches composers is only partly to be fluent in writing counterpoint, which is the most difficult of composerly disciplines because the lines must be not only melodically independent but also harmonically interdependent. As musicians say, in counterpoint you have to reconcile two separate matters: the horizontal (melody) and the vertical (harmony). But Fux teaches deeper lessons. One learns that all music, even a song with simple chordal accompaniment, is still counterpoint, a matter of lines at every level. So the study of counterpoint breaks student composers of the habit of thinking of music as merely a series of chords and, instead, has them think of it as a series of chords rising from an ongoing interaction of lines—what musicians call "voice leading." It is impossible to do an advanced Fux exercise successfully without thinking about the whole of the piece, the whole of every line. So he also moves composers away from following their noses and toward a sense that one needs to be aware from the beginning of the direction of the whole piece. From early on Wolfgang could write counterpoint and improvise at the keyboard a contrapuntal genre like fugue, but Leopold wanted to season him with Fux, to get him

beyond mimicking counterpoint to really understanding it. As Wolfgang thrashed his way through the thickets of counterpoint study, he and Leopold also began playing through music by leading composers of the past and present, including Handel, Hasse, and C. P. E. Bach.[10]

While his son studied and composed and practiced and performed around town, Leopold plotted their return to Vienna. Once again there were letters to write, letters of recommendation to secure, routes to examine on the map, clothes and medicines and supplies to be accumulated. Maria Anna would have helped in most of it, at her husband's direction; the children would not be involved with any of the planning. Leopold knew that on this tour, publicity was no longer going to be so pressing a matter. His children, especially his son, were more or less famous around the Continent. Nearly anyone who knew about music knew about Wolfgang.

On September 11, the whole family left Salzburg for Vienna, reaching the city in four days. The immediate stimulus for the trip was the coming marriage of Archduchess Maria Josepha of Austria to King Ferdinand IV of the Kingdom of Naples, an occasion that would call for festivities, including balls and operas.[11] Leopold hoped for good pickings.

What they would find instead in Vienna was not a waiting commission, not the easy triumphs of the last visits, but rather, obstructions and near disaster. In his art Wolfgang was close to being a mature composer. Soon his career was going to resemble a mature composer's, meaning one full of frustration, in which nothing was going to be handed to him. When he was a little child, the musicians in Vienna were dazzled, petting and exclaiming over him. Now Wolfgang was reentering the most brutally competitive musical center in Europe, where he would be viewed as a rival—and the knives were out.

VIENNA IN 1767 WAS ON THE VERGE OF PROFOUND TRANSFORMATIONS. Empress Maria Theresa was still alive but had relinquished some of her power; after her husband's death in 1765, her son Joseph II ascended to the throne of the Holy Roman Empire. He would prove to be a ruler boiling with ambitions about enlightened reform, but as yet he was restrained by his still-powerful and more conservative mother. For now

Joseph waited, traveled in his kingdom, and indulged in his favorite daily pastime, playing chamber music on cello and clavier.

When the family got to Vienna, Leopold Mozart naturally had the court in his sights. But a court audience was not going to happen for a while. They had stumbled into the middle of an epidemic of smallpox, a disease deadly and feared. Those it did not kill, it often disfigured. At first Leopold did not take the danger too seriously, declaring it was not a particularly virulent strain. Then something happened that shook him and everyone else in town.

The tragedy, as it transpired, was almost operatic, an act of an opera seria. Princess Maria Josepha was preparing to wed Ferdinand IV of Naples in one of Empress Maria Theresa's strategic marriages of her many children, arranged to firm up international relations. Bride and bridegroom were both sixteen years old; he was famously ugly.[12] Wrote the empress about her daughter's betrothal, "If only she fulfills her duty to God and her husband and attends to the welfare of her soul, I shall be content even if she is not happy."

The widowed Maria Theresa had the habit of visiting the tomb of her husband in the crypt of the Capuchin church. Before her daughter left town to be married, the empress insisted that Maria Josepha accompany her one more time to pay her respects to her father. Also in the crypt was the unsealed coffin of Emperor Joseph's second wife, who had died recently of smallpox. In the next days Maria Josepha fell victim to the disease, dying on the eve of her wedding. Believing her daughter had caught smallpox in the crypt, the empress suffered gnawing guilt for the rest of her life. (In fact, given the incubation period of the disease, Maria Josepha must already have been infected.)[13]

At the same time, Leopold discovered that three children of their Viennese landlord had come down with smallpox, and the man had not told them. Leopold had been waiting for a summons to court, but now, between the death of the princess bride and this news, he was properly terrified. They had to get out of town.

What is troubling is that Leopold bolted from Vienna taking only Wolfgang, leaving Nannerl and wife Maria Anna behind. Part of this decision can be explained: he believed Nannerl had gotten smallpox earlier and now would be immune. As for leaving his wife, there is really no good explanation. What is true and perhaps sadly relevant is

that from Leopold's perspective, his son was not only a miracle of God but his meal ticket for the rest of his life, and his wife and daughter were neither.

IN THEIR FLIGHT, FATHER AND SON STOPPED IN BRÜNN, AT THE PAL-ace of Count Franz Anton Schrattenbach, brother of Salzburg's ruler. The count and countess pressed Leopold to have Wolfgang give a concert, but a presentiment troubled Leopold and he begged off, saying Wolfgang would play on their way back to Vienna, when the pestilence had eased off. In Ölmutz they came to rest in a smoky and miserable room at the Schwarzer Adler inn. There Wolfgang began complaining about his eyes. Soon he was feverish, his hands cold, pulse erratic. With a chill, Leopold realized that his son had contracted smallpox. By evening Wolfgang was delirious and raving.

Desperate, Leopold went to an old Salzburg acquaintance, Count Podstatzky, who was now rector of the university. Bring the boy here, Podstatzky said; I'm not afraid of the sickness. He summoned a doctor, Joseph Wolff, who treated Wolfgang. Leopold reported home that on the thirtieth and thirty-first, the pox came out and the boy's fever disappeared. Wolfgang looked at his swollen, pocked face in the mirror and observed, "Now I am like little Mayr," a Salzburg acquaintance who had survived the illness. Count Podstatzky's generosity, Leopold wrote to his patron Hagenauer, "will do . . . no little honor in the biography of our little one which I shall have printed later on."[14] So, he was planning a second book, to tell the world about the family miracle.

In his report to patron Hagenauer, Leopold left out the worst parts, implying that Wolfgang's illness had not been so serious. In fact he had been desperately sick, went blind for nine days and had to be careful about his eyes for weeks after he recovered. When Wolfgang was finally on the mend but still bedridden and in need of diversion, a local court chaplain taught him card tricks. After he got back on his feet, he took fencing lessons.[15] Already for his sports and entertainments, Wolfgang went for ones that involved fine physical skill. As thanks to Doctor Wolff, he sent him an arietta on a Masonic text, the doctor being a lodge member.[16]

Back in Vienna as her brother recovered, Nannerl, in usual family

style, also came down with smallpox. Hers proved a mild attack. At the end of November Leopold reported home, "Te Deum Laudamus! <u>My daughter has gotten over the smallpox safely</u> . . . You will not notice on her any marks whatever and only a few on Wolfgang."[17] In later years, though, Nannerl wrote that smallpox had wrecked her brother's once-attractive features. He grew to adulthood small and pale.

The day before Christmas father and son left Ölmutz and spent the holidays back at the palace of Count Schrattenbach, where Mama and Nannerl joined them. There Wolfgang and his sister gave the concert Leopold had promised, the forces including a scraped-together collection of local amateurs. A diarist of the town noted, "A Salzburg boy of eleven years and his sister of fifteen years, accompanied by various instruments . . . excited everyone's admiration; but he could not endure the trumpets, because they were incapable of playing completely in tune."[18] The concert would have included a concerto and probably premiered the Symphony in F, K. 43, Wolfgang's first in four movements, this being the style in Vienna. He likely began it there and finished it in Ölmutz.[19] The eleven-year-old appeared indestructible. He was not going to let botherations like near death or blindness get in his way.

The symphony K. 43 may be Wolfgang's most advanced work to date. Written for the stripped-down Classical ensemble of oboes and horns in pairs and strings, it begins vigorously before introducing a quieter and more lyrical second theme. Many composers writing more or less in sonata form in those days, including Haydn, tended to re-work the first exposition theme to make the second theme. Though there would still be contrasts of volume and tone, the pieces verged on monothematic, like a Baroque movement. (Haydn, unlike Mozart, had grown up in the last years of the Baroque.) Already Mozart was showing a preference for new second-theme material; here, the first-theme section is a series of robust riffs, the second theme a more hummable tune. For a graceful and tender second movement he reworks the affecting duet of father and daughter in *Apollo et Hyacinthus*, the oboists taking up flutes to enhance the gentle ambiance. After a flowing and beautiful minuet comes a racing galant finale that ends surprisingly on a note of quiet, sweetly sighing lyricism. In this piece, Wolfgang's old sins of repetitiousness and relentlessly four-square phrasing have

largely disappeared—and those were sins to which many adult com-
posers of the time were given.

ON JANUARY 10, 1768, THE FAMILY ARRIVED BACK IN VIENNA AND
picked up where they left off before the epidemic—which is to say,
waiting for a summons from the court. On the sixteenth, shortly before
his twelfth birthday, Wolfgang finished another symphony, K. 45 in D.
By now he had settled into the traditional sense of the D-major mood
as bright, energetic, and cheerful. To that end, besides the usual en-
semble of oboes and horns plus strings, he added trumpets for a festive
touch, trumpets and timpani being the usual accompaniment of courtly
ceremonies. This symphony is short and not particularly ambitious, its
main goal being to make a lively and happy noise. The first movement
is closer to fully fleshed-out sonata form than his earlier outings; the
finale quotes a traditional contredanse theme Papa had used in his nov-
elty piece *Sleigh Ride*.[20] It shows that as Wolfgang turned twelve he was
learning to make more out of his material, to stretch out a theme with
developing variation, the theme in effect feeding on itself. In a larger
sense, for its creator a whole work feeds on itself as it is composed.

On January 19 the Mozarts got the day in court for which they came.
It began with an audience with the empress that went well, and touch-
ingly: Maria Theresa, having suffered her own losses from smallpox
and hearing of Wolfgang's and Nannerl's bouts of it, spoke warmly
for a couple of hours with Maria Anna about the children's illness and
their tours. Eventually, Joseph appeared and welcomed them heartily
as usual. Everybody remembered Wolfgang's first visit to town, when
he was six. But from Joseph a nice welcome was about all they were go-
ing to get this time. In his account to Hagenauer, Leopold noted sourly,
"If money makes the sole happiness of man, then we are doubtless to
be pitied now, seeing that . . . we have spent so much of our capital that
there is little apparent hope of our being able to recover it. The Empress
no longer listens to concerts at home, and does not go out for them
either. The Emperor only seems to aspire to save money." Their take
from this audience was a medal, pretty but worthless.[21]

There was, however, one thing in a conversation with Joseph that
Leopold seized on. As they chatted, Joseph casually asked Leopold if

Wolfgang wouldn't compose and conduct an opera for Vienna. Leopold leapt at the prospect; this was exactly the kind of thing he was hoping for. With an Italian opera produced in Vienna, Wolfgang could go to Italy with a good chance for a commission. Of course, the emperor would have noted that he himself did not have control of the theaters in Vienna. The Mozarts must deal with one Giuseppe Affligio, the man in charge of them.

Leopold hastened to obey as if he had been given a royal command, which he had not been. At first it seemed to go well. Affligio came up with a libretto, a *buffa* (comic opera) in Italian called *La finta semplice* (usually translated as *The Pretended Simpleton* or, more accurately, "The Pretended Naïf"). Wolfgang set to composing it at a furious pace. So far, this was as it had happened over and over in the tours: an opportunity arose, Wolfgang took it on and astonished everybody, and glory and money rained from the sky. This time, however, the opportunity was prelude to a storm.

Leopold and Wolfgang did not understand that Emperor Joseph was apt to shoot from the hip, making suggestions, or threats, off the cuff with no real interest in following through on them. In any case, if Wolfgang produced the opera, Joseph would not be gambling with the court's budget; it was Affligio who would take it in the neck if the opera failed. Joseph might have pressured the impresario to act on the project, but Affligio never did and probably never intended to.

At the same time, there was Affligio himself, a piece of work largely unburdened with scruples about anything but his own advancement. Casanova described him as having "the face of a gallows bird." The impresario essentially ran all theatrical activities in town, including the appalling animal-baiting shows that were a favorite Viennese entertainment. He had been a professional gambler before arriving in Vienna, and in the next decade would be convicted of forgery and sent to jail for life.[22] Now his Vienna operation was badly in the red. At the urging of the court he had hired a troupe of French actors for the enormous sum of seventy thousand florins, and the boondoggle failed. Italian opera in Vienna, meanwhile, was about to go under.[23] Perhaps to humor Joseph, Affligio offered Leopold two hundred ducats (about nine hundred florins) for the opera, because he did not believe the twelve-year-old could manage such a thing. There was no way, in any case, for him to pay out

that kind of money, given that he was having to swallow much of the seventy-thousand-florin loss for the French actors.

In short, for contrapuntal reasons, Affligio had no use for the Mozarts. All the same, maybe in fear of disappointing Joseph, he continued the charade, going through the motions of assigning roles for the opera. As soon as Wolfgang finished the first act, Leopold assembled the singers for a run-through with an orchestra, which turned out a fiasco. The singers had not gotten their numbers ahead of time, and a couple of them actually could not read music and had to learn their notes by ear.[24] Affligio demanded changes in the score; Wolfgang obliged; Affligio was grandly reassuring; a performance date was agreed on; it was changed.[25] By the end of June, it had become apparent that the impresario had no intention of mounting the opera.

Here Leopold's paranoia stepped in: there had to be a fix on. "I was told that all the clavier players and composers in Vienna were opposed to our advancement, with the sole exception of Wagenseil, who, however, as he was ill at home, could not help us . . . [They said] that it was all humbug and foolishness . . . that it was ridiculous to think that he could compose, and so forth." To rebuff the intrigues, Leopold had Wolfgang compose a seria-style aria on the spot before witnesses.[26] When the opera was finished he arranged a run-through, with Wolfgang at the keyboard, at the home of music patron Gottfried van Swieten.[27] These demonstrations may have quieted a few wagging tongues, but they gained the Mozarts nothing.

In this case, Leopold's paranoia was justified. That was how things went in musical Vienna: when a composer got something, the composers who did not get it were capable of doing nearly anything to throw a wrench in the works. The rumor mill declared that Wolfgang's music for the opera was no good; it did not fit the words; he did not understand how to set Italian. The singers were pressured to say that the arias were too hard and the orchestra did not want to be conducted by a child.[28] The leading figure in opera at that point, in Vienna and in the rest of Europe, was Christoph Willibald Gluck, who had set opera on a reform path of fidelity to the drama and a kind of noble directness and simplicity. Leopold was at first hopeful of Gluck's support, then con-

cluded that the aging composer was also against Wolfgang, which was probably not the case. In any event, Gluck gave them no help.

Fulminating like an Old Testament prophet, Leopold framed this obstruction of his son as an offense against God: "If it is ever to be my duty to convince the world of this miracle, it is so now, when people are ridiculing whatever is called a miracle and denying all miracles . . . But because this miracle is too evident and consequently not to be denied they want to suppress it. They refuse to let God have the honor."[29] It was as if his boy were the Christ child.

In the midst of all this hullaballoo, Wolfgang finished *La finta semplice*. Its cumbersome story involves various attempts at love. The eponymous Rosina poses as a naïve village girl in order to resolve the various contretemps. Of course, she succeeds and gets her man. The text by Marco Coltellini, librettist for the Vienna court, had a distinguished pedigree: it was lightly adapted from an early work of the Italian playwright Carlo Goldoni, a major figure in the creation of contemporary opera buffa. Both buffa and seria were saddled with conventions, but those of buffa were looser and less hidebound. The principals of seria were the kings and queens, gods and goddesses, of antiquity; those of buffa were everyday people in the contemporary world.

Wolfgang had never written a buffa before, though he had seen enough of them to know how they worked. As usual he did not spend time studying or thinking about this new genre; he just started dispensing music, as he had at age eight in London when at the keyboard he improvised an operatic love song on the word *affetto* and a song of rage on *perfido*. He remained an astonishing mimic and a fearless artist. It took him four months between April and July to produce the three-act opera over two hours long, weighing in at 558 pages.[30] In the long run, Mozart showed himself as liable to procrastination as anybody else, but from early on he was capable of formidable feats of sustained labor.

The material of the opera is jolly, vigorous, Italian-style buffa music, and if it is never particularly memorable, it is attractive, and the orchestral accompaniments are nimble, rich, and accomplished. Rosina's aria "Amoretti, che ascosi qui siete" is a bit of an exception to this, touching and mature for a twelve-year-old, an observation that by now

had become thoroughly clichéd with regard to Mozart. The whole has his usual variety of material; his imagination is so fertile that he never struggles to come up with a fresh angle for each number, both in the tunes and in the accompaniment.

So it was finished, it was a manifestly impressive and appealing work, and there appeared nothing, nothing, nothing to be done. Leopold might have squelched the project, but as a matter of honor he believed that it was his duty to show the world that his son could complete the commission. But that put him in a bind: if they left town now, it would appear an admission of defeat; if they stayed around, it was only going to cost them more money and frustration.[31] Meanwhile, back in Salzburg there was no opera company that could mount such a thing.

But Leopold's blood was up, and he was not going to let go. His letters to Hagenauer verge on frothing: "By patience and perseverance one must convince people that our adversaries are wicked liars, slanderers and envious creatures, who would laugh in their sleeves if we were to get frightened or tired out and, by going off in a huff, give them the victory." He decided to make a bold move: he would go directly to Joseph II and inform him about the liars and slanderers. He wrote home, "On the morning of the 1st I had an audience with His Majesty the Emperor and handed to him my complaints about the theatrical impresario Affligio." But Leopold's massive letter of complaint accomplished nothing except maybe to annoy the emperor. Joseph received the petition graciously and then did nothing. Affligio was not reprimanded. Perhaps the court was getting a little tired of these Mozarts.

What Wolfgang did to occupy himself in the meanwhile was to write another opera, this time a buffa in German: *Bastien und Bastienne*. It too had an interesting background. As was noted, philosopher Jean-Jacques Rousseau was a composer, and his biggest success was the reformist operetta *Le devin du village* (The Village Soothsayer). He also wrote the libretto, a simple tale of rustic lovers falling into suspicions of infidelity, who are reconciled with the help of machinations by the eponymous soothsayer. In keeping, Rousseau's musical style was simple and pastoral, an intentional rebuke to the dramatic extravagances and hypervirtuosity of much contemporary opera, especially opera seria. The libretto of *Bastien und Bastienne*, by several hands, is based on Rousseau, actually something of a parody of it. The version Mozart set

was made for him by his Salzburg poet/violinist/trumpet player friend Johann Andreas Schachtner.

Wolfgang's setting, a one-act singspiel (meaning a comedy in German with spoken dialogue rather than recitative), like *La finta semplice*, did not find a public performance in Vienna. It was given in a private performance at the home of the man who may have commissioned it, Dr. Franz Anton Mesmer. A well-to-do physician and avid amateur musician, in the next decade he would become (in)famous for his role in the development of hypnotism, sometimes called "mesmerism." So far, so good. But at length the doctor went far further out on the limb, declaring that mesmerism was an aspect of an invisible astral fluid pervading the universe that joined humanity with the cosmos, that we were all vessels of this fluid, and so on and so forth. Mesmer began to treat the sick with magnets, massage, and his own magnetic touch. These shenanigans around "animal magnetism" got him thrown out of Vienna; he ended up in Paris, where he reaped enormous fame and enormous infamy. Mozart clearly kept up with Mesmer's career, because in one of his late comedies, a character flourishes a magnet to heal somebody—Mozart and his librettist engaging in some not-so-gentle ribbing of his old friend.

All this bizarrerie was in the future. Wolfgang's music for *Bastien und Bastienne* has some of the rusticity that is de rigueur for the story. (In the long run, Mozart—in contrast to his father and to Haydn, among others—was rarely given to writing folksy music.) He shaped the opera in the manner of a German singspiel, with spoken dialogue, then later made the dialogue into recitative in the manner of buffa. One of the notable things about the opera is that all the music is fairly direct, sometimes intentionally ingenuous. Which is to say that Wolfgang has learned another important lesson: an opera, despite its loose collection of numbers, needs to be an individual, to have a character of its own. This is easy to explain, not easy to do. Mozart created numbers that are nicely variegated and effective. Among the notable and amusing of them is the sorcerer's aria of bogus conjuring that begins, "Diggi, daggi, schurry, murry, horum, harum, lirum, larum"—all nonsense words (supplied by Schachtner[32]). The music for it has a droll air of the pseudo-spooky. In the future Wolfgang would remain a great lover of verbal gobbledygook. Naughty gobbledygook, even better. After all,

every bedtime in his younger years he sang Papa a song in faux-Italian before kissing him goodnight.

The airing of *Bastien und Bastienne* at Mesmer's house was surely a read-through with small orchestra or just piano, not a fully staged production. For all its charms, the opera would never be heard again in Mozart's lifetime. It is possible that *La finta semplice* ended up being played in Salzburg the next year, before it too disappeared from view. But after all, for Wolfgang these were essentially throat-clearing exercises. At twelve, he had what amounted to two big seria-style and two buffa dramatic works under his belt and was eager for anything major and public that came his way. And if he wanted to write for the stage, the best place to realize that dream was not Vienna but Italy, which was everywhere called the home of opera.

IN THE END, IT WAS EMPEROR JOSEPH II, INSTIGATOR OF THE OPERA imbroglio, who pulled the Viennese episode back from comprehensive disaster. There was going to be a consecration of a new church, the Waisenhauskirche, at the city orphanage on the Rennweg. Joseph asked Wolfgang to supply some music for the ceremony and conduct it himself. The director of the orphanage was the histrionic Pater Ignaz Parhamer, whose sermons were famously theatrical and likewise his appearance: flowing beard, cape, and pilgrim's staff. He was fond of Turkish-style military music and kept servants in Turkish dress, complete with curly-toed boots. His orphans were subjected to military drill and required to study music.[33]

In short order Wolfgang produced two more kinds of pieces he had never attempted: a trumpet concerto (later lost), to be played by one of the orphanage students, and the Missa solemnis in C Minor, K. 139, or *Waisenhausmesse*, a solemn High Mass forty minutes long, the orchestra including trumpets, timpani, and three trombones, plus oboes and strings. In the performance, the choir would be made up of orphans. It was the largest ensemble he had ever wielded, and he managed it with absolute command.

With Masses in general, the text points to much of the required musical expression from tragic to joyous, Crucifixion to Resurrection, but the opening "Kyrie eleison—Christe eleison—Kyrie eleison" ("God

and Christ, have mercy on us") implies nothing in particular, so can be set in any mood to taste. Wolfgang's Kyrie is in a darkly portentous C minor, though followed by a jubilant section on the same words in C major. In keeping with the occasion, much of the Mass is bright, grand, and celebratory, partly due to the flash of the trumpets.

The prayer for peace of the Agnus Dei begins with another of his solemn trombone solos. In his career Mozart would be sparing in using the instrument, but when he does use them it is always memorable. Trombones were the only brass instrument of the time that could play a full range of notes—trumpets and horns, lacking valves, were restricted in their available notes and could play in only one key at a time. In Germany there was the old association of trombones with church music, and that is the sort of tradition Mozart tended to honor. In the Mass one sees Wolfgang's contrapuntal studies paying off as well: the fugues in the piece are dexterous and mature. His sense of orchestral accompaniments for choir and soloists is by now masterly and imaginative.

With this assignment and its reception, Leopold must have felt a weight fall from him. Said a newspaper report, "All of the music for the orphans choir at High Mass had been from first to last newly composed for this solemnity by Wolfgang Mozart, noted for his extraordinary talent; the 12-year-old little son of Herr Leopold Mozart, Kapellmeister in the service of the Prince of Salzburg, performed himself and conducted with the greatest accuracy and to universal applause and admiration; in addition, he also sang in the motets."[34] The concert gained Wolfgang the acclaim that had so far eluded him in this Vienna visit, even if it was not with an opera as Leopold had hoped.

So much for Vienna. The Mozarts arrived back in Salzburg on January 5, 1769, and Wolfgang got busy on a Missa brevis. In three weeks he would be thirteen, one more step toward the end of prodigyhood.

The next year at home would be for him another year fertile in new kinds of genres and, for him and Nannerl, rich in performances. Meanwhile at thirteen he was approaching the trials of puberty. (Nannerl turned eighteen this year.) It is pertinent that 1769 produced the first letter of Wolfgang's that would survive, and apparently it is addressed to a girl, though her identity did not survive. The letter is a polite affair, in stark contrast to the rowdy tone of some of his later letters to the fair sex.

Dear friend, / Forgive me for taking the liberty of plaguing you
with a few lines but as you said yesterday that you could under-
stand everything, no matter what Latin words I might choose to
write down, curiosity has got the better of me and I am writing
down for you a few lines made up of various Latin words. When
you have read them, please do me the favor of sending me your
answer by one of Hagenauer's maids . . . But you must send me a
letter too.[35]

There follow a couple of lines in Latin that translate to "I should like
to know for what reason idleness is so popular with most young people
that it is impossible to draw them from it either by words or by punish-
ments." Papa himself could hardly have been more straitlaced.

As Leopold contemplated the next move, Wolfgang wrote piece af-
ter piece in his neat hand, modeled on Papa's hand, and Nannerl re-
joined the town's round of *Hausmusik*. Leopold's salary had been cut
off during their Vienna visit, and he submitted to the archbishop, as
a court clerk noted, a "most submissive and obedient Supplication by
Leopold Mozart, His Serene Highness's Vice-Kapellmeister, for his es-
pecial and most gracious Assent to supply the arrears of some Months
of his Salary."[36] Leopold received the back salary, and Archbishop
Schrattenbach welcomed the family home warmly. It is not certain, but
there may have been a concert performance of *La finta semplice* at the
Residenz. If so, it was the only airing of the opera in Mozart's life and
for many years after.

Wolfgang's Missa brevis, K. 65, seventeen minutes long and a prac-
tical item for services, is the kind of thing he would be writing a lot
in the next years. The Salzburg court was interested mainly in sacred
music from its composers. Chamber and orchestral music were mostly
the composer's business, aimed at private *Hausmusik*. Much more am-
bitious was Wolfgang's next endeavor, the *Dominicus* Mass, K. 66. This
was written as a gift to the family's patron, Johann Lorenz Hagenauer,
for the occasion of the first Mass to be celebrated by Hagenauer's newly
ordained son, P. Dominikus (Cajetan) Hagenauer. It was heard as part
of the ceremonies in St. Peter's Church. Next day, Wolfgang and Nan-
nerl played at a grand dinner party Hagenauer threw for his son.[37]

As Wolfgang settled into his court-related sacred music chores, in

the summer of 1769 he wrote for the university three outings of an-
other new kind of piece for him, works he called "cassations." These
are seven- or eight-movement pieces in the style of the university's
end-of-year works known as *Finalmusik*: simple in harmony and ges-
ture, entirely good-humored with touches of wit and irony. This tone,
quite unlike Wolfgang's more high-toned symphonic music so far, was
going to be important to his stylistic development. This development is
a different matter from his musical maturity, which by now was more
or less at hand. The next step, in some ways the hardest because most
intangible, was to find his own voice. This would take a while. What
can be said so far is that Wolfgang had reached intimations of what that
voice might be, as displayed in the fetching and gently puckish Andante
of the Cassation K. 63.

As a whole, the movements of these cassations range from the en-
tertaining to the lovable to the routine. Perhaps by now Wolfgang, as
an employed scribbler of notes, had begun to distinguish the pieces he
cared about more from those he cared about less. The latter he could
compose about as fast as he could write them down. All the same,
sometimes his quotidian pieces turned out beautifully—sometimes,
over the years, more beautifully than anything anybody else on the
planet could manage.

In finding his voice, Mozart was going to develop not in opposition
to convention—like, say, Gluck and Rousseau—but largely within
convention. His cassations were probably as much as anything mod-
eled on examples by Leopold, who had written a good deal of that sort
of thing. But in the quality of his material and the depth and subtlety of
his imagination, the son was already well beyond the father. Leopold
probably understood this better than anybody else. His son was now at
center stage, and he was himself a composer no more.

IN OCTOBER, LEOPOLD OBTAINED FROM THE ARCHBISHOP PERMISSION
for a tour of Italy, along with a generous six hundred florins toward
expenses. The next month Wolfgang got an official court title as con-
certmaster, though what that amounted to was hazy. He was capable
of conducting the orchestra from the harpsichord (the usual procedure
in those days, because the harpsichord was usually played along with

orchestral music), but in practice he mostly just sawed away, not all that happily, in the violin section. Wolfgang had become a competent violinist and eventually would be good enough to manage his own concertos, but he never cared much about playing violin or practiced it enough to satisfy his father.

The tour of Italy began on December 13, 1769. Before he left, Leopold wrote an introduction to the second edition of his violin school with an explanation for its delay:

> I have been little at home since 1762. The extraordinary musical talent with which merciful God has blessed my two children . . . was the cause of my traveling through the major part of <u>Germany</u> and my very long sojourn in <u>France, Holland</u> and <u>England</u> . . . I might here take the opportunity of entertaining the public with a story such as probably appears once in a century, and which in the domain of music has perhaps never yet appeared <u>in such a degree of the miraculous</u>.

Among his usual painstaking preparations for the Italian tour, Leopold had secured a letter of reference from noted composer Johann Adolph Hasse, who had written a glowing review of Leopold's violin method in 1756. Of Wolfgang, Hasse concluded, "I've seen compositions which appear to be his, and certainly they are not bad and not such as I would expect to find in a boy of 12 . . . That same Herr Mozard [*sic*] is a very polite man, and civil, and his children are very well educated. Moreover the boy is good-looking, vivacious, gracious and very well mannered."[38] This letter could be expected to open some doors. The reception by Emperor Joseph II in Vienna had been on the whole a disappointment, but he had given Leopold letters of introduction to various Italian grandees.[39]

There were some new elements for this tour. It was winter, and Leopold, rather than using the carriage he had bought for the last tours, rented a warmer coach and hired a coachman. He declared that this was going to be a stripped-down excursion, with more attention given to keeping expenses under tight control. Mainly, this meant that the women would be left at home. This tour was going to be for just father, son, and driver.

The women were surely not pleased with this decision. They would have to sit at home and learn about Wolfgang's triumphs in letters and newspaper articles. For one thing, Leopold reasoned, Nannerl was eighteen now and could no longer be billed as a prodigy, so she threatened to cost more than she earned.[40] As she slipped into adulthood, Nannerl was merely a fine clavier player among others, one whose musical life in the future would, as was usual for a woman, consist of *Hausmusik* and clavier teaching. Of course, at some point there would presumably be a husband and children and a household to take care of. There, essentially, is where Nannerl remained for the rest of her life, while her brother's star ascended, however fitfully, to greater and greater heights.

Chapter 6

TRALALIERA

*I*t must be planned like a military campaign. Every horse and wagon
wheel accounted for, every regiment in the right position on the field. I
know my little soldier will do his duty, as I the general will do mine. We will
find someone to ask him for an opera, a big, serious one, and he will show
these Italians that he can hold the stage with their illustrious names, write
splendid melodies in their own style. Then the great courts will fall over one
another to have him. This is the path to victory, to glory and fortune for my
son, for me, for all of us.

ONCE MORE A TOUR, THIS TIME TO ITALY, THIS TIME LEAVING THE
wife and daughter at home. With only Wolfgang to manage, Leo-
pold did not need his wife, and his daughter was no longer marketable.
Wolfgang at thirteen was also no longer an *enfant prodige* but, rather,
a young mature performer and composer ready for a position. If he re-
mained a miracle of God, would always remain so, that was no longer
so relevant. Everybody would want to hear him play, hear his music.
But he must also listen, take in church music and, above all, opera in the
land that was the home of opera and of melody.[1]

On December 13, 1769, father and son left Salzburg heading south-
west in a hired coach with a coachman engaged for the first part of the
trip.[2] Once again, towns began to unfold, each to be noted for well or
ill. Leopold reported that in Kalterl, the two "had for our lunch a piece

of preserved veal accompanied by a most fearful stinking smell."[3] From Wörgl, Wolfgang added a postscript to Mama, his first known correspondence to her, revealing his rather improvisatory German: "I feel so jolly on this trip, because it's so cozy in our carriage, and because our coachmann is such a fine fellow who drives as fast as he can when the road let's him."[4]

Now Wolfgang would add regular postscripts to Papa's letters. Mostly they would be addressed to Nannerl, in the jovial and often rowdy style the two shared with each other. At one point he got word that a Herr Schiedenhofen was interested in his sister. This sort of news always interested him. He wrote her, in Italian, "Give H. von Schidenhofen [*sic*] some gruesome greetings from me, tralaliera, tralaliera"— this being an Italian refrain indicating gaiety. He continues:

> Tell him he should learn how to play the <u>Repititer</u> minuet . . . , so he <u>does</u> not forget it, he must <u>do</u> it soon, and do me the pleasure that I <u>do</u> an accompaniment for him some day. <u>Do</u> give my greetings to all my other goode friends and <u>do</u> take care of yourselfe, and <u>do</u> not die, so you can do another letter for me, and I can <u>do</u> one more for you, and then we go on <u>doing</u> it until we are <u>doing</u> something out of us, but I am the one who wants to <u>do</u> all the <u>doing</u> until finally the <u>doing</u> is no longer <u>doable</u>, meanwhile I <u>do</u> remain, / Wolfgang Mozart.[5]

He is making a roguish play on words. In English, the word *do* can have a double meaning: you can *do* something, but you can also *do* somebody, as in bed them. In German it was the same, but there was also a third implication of *do*, which is to relieve oneself. In the letter, Wolfgang echoes Austrian and Bavarian songs that imply the naughtier implications of the verb. Nannerl was eighteen at this point, reportedly attractive, the object of a certain amount of male attention. While Leopold would not be pleased with his daughter's aspiring suitors, Wolfgang would root for them, and he was steadily amused by the whole business of men and women.

This was after all an age (like most of human history before it) when one lived closely with other people and largely without privacy: closely with lovemaking; closely with illness; closely with one's excreta, which

was usually deposited in a bucket in your room and stayed there until you or a servant emptied it; closely with death, a steady companion when life expectancy was thirty-five, at best half of children reached maturity, and you generally died in your own bed. These were matters familiar to everybody. Obliviousness was always available, but joie de vivre was not easy in these times; it was an achievement. And essentially, Mozart achieved it in the whole of his life, in good times and in bad.

From his earliest surviving letters one sees Mozart soaking up everything around him and resonating with it, whether in reportage or judgment or annoyance or, so much of the time, amusement. Like the little prodigy pounding a keyboard and crying, "Perfido! Perfido!" he would go after music and life and family and friendship with indefatigable energy and passion. Mozart was a musical being, permeated with the colors and forms of sound, but there was no distinction between his response to music and the rest of his life. They were all what he took in, what he did, what he loved, all of it wellsprings of what he put on the page. Playing clavier, dancing, riding, shooting, aiming a billiard cue with calm concentration—all of it worked together: they were beauty, movement, and above all love. Love and sex would not be a consuming passion with the mature Mozart; they would be rather a steady part of his being, like music. Like his music, too, in the end, he would prove to be absolutely in control not of his life, because no one is, but of how he consummated his love in life and in music.

AFTER A STOP IN SNOWY INNSBRUCK INSIDE ITS GARLAND OF MOUN-tains, their carriage turned south, climbing the rough and frozen Brenner Pass through the Alps, and now they were in Italy. First to Bolzano (or Botzen), then Rovereto and Verona, where they stayed two weeks and Wolfgang heard his first Italian opera in its native country. He was beginning to chatter away in Italian now, practicing the language in letters to Nannerl.[6] He would end up nearly as fluent in Italian as German and maybe more grammatical in writing it. About to turn fourteen, he remained in the world's eye the famous little prodigy, but now he was edging close to puberty and to being old news around Europe.

The Mozarts had never seen a place like Verona, which wore its long history on its face from its Roman amphitheater to its twelfth-century

Duomo. On January 5, 1770, Wolfgang played a concert at the venerable Accademia Filarmonica of Verona, founded in 1543. The glittering hall was one of those old European houses that were large yet intimate, with six stories of balconies rising precipitously above the floor, the royal box in the center of the first balcony. The balconies were strictly ranked by class from bottom to top. The number of stairs one had to climb increased as one's social rank declined. After the concert there were the usual ecstasies in the press over Wolfgang: "In the company of several distinguished professionals he was able, first, to produce a beautiful overture of his own composition, which merited all its applause. Then he played splendidly, at sight, a harpsichord concerto . . . Then, on four verses submitted to him, he composed an aria in the best of taste while actually singing it."[7]

As soon as he and Wolfgang arrived in Verona, Leopold busied himself distributing letters of recommendation. Signore Lugiati, the receiver general of Venice, directed his couriers to press Leopold to have his son's portrait painted.[8] Leopold was entirely agreeable. On the day after the concert Wolfgang had his first sitting for painter Saverio Dalla Rosa. The finished picture shows him seated before a harpsichord in an elegant red coat with gold braid. His face is impassive; he sports a powdered wig. On the music stand sits the manuscript of a Molto allegro, probably his, but it would not survive.

THE YEAR 1770 ARRIVED. IT WOULD PROVE TO BE QUIETLY MOMEN-tous in its implications for the future. America saw the Boston Massacre that helped spark a revolution, which in turn helped spark one in France. In Paris, Marie Antoinette, daughter of Austrian empress Maria Theresa, married the future king of France. In England, the poet Wordsworth was born; in Germany, the poet Hölderlin; in Bonn, the composer Beethoven.

On January 10, father and son arrived in Mantua and that night took in Johann Adolph Hasse's opera *Demetrio*. The libretto was by a Pietro Metastasio, the premier operatic librettist of the opera seria genre, who was treated as a classic in his own time. To set a Metastasio book, all of them based on ancient history, was on the order of taking a story from the Bible. In terms of both book and music, this was for Wolfgang

an experience of opera seria more or less from the horse's mouth. The same could be said of Hasse's *La clemenza di Tito*, another Metastasio setting, which they heard in Cremona soon after. That libretto had been around for decades, set by dozens of composers. It would follow Mozart to the end of his life.

From Mantua, Leopold, in a good mood reported to his wife, "Wolfgang looks as if he had been through a campaign, for his face is reddish-brown . . . This is due to the air and to the open fires. My beauty has not yet suffered."[9] In the letter he reminded Maria Anna, "I hope that you are carefully collecting all our letters." Regarding those letters, he had history in mind.[10]

In the middle of the month Wolfgang gave a concert at Mantua's Reale Accademia di Scienze, Belle Lettere ed Arti, an organization unusual in that its members came from both the aristocracy and the bourgeoisie. The huge program included one of his symphonies and assorted feats of improvisation and sight-reading.[11] At the same time, the Mozarts had rebuffs from the head of the Accademia and from Prince Michael II von Thurn und Taxis, who had a notable private musical establishment. The prince may have heard about the Affligio business in Vienna and felt that the Mozarts were getting too big for their breeches. He ordered his servants not to let them in the house. Leopold could not believe such indifference; for a while he and Wolfgang actually followed the prince's carriage around, but it did no good. There would be further illustrations of what Mozart father and son actually amounted to, which was a highly prestigious and professional pair of traveling supplicants who would pull into places, advertise their wares, and hope for attention.

Nine days in Mantua, then Bozzolo and Cremona, traveling in freezing January weather, their feet stuffed into muffs lined with wolf fur. Finally the main goal of the tour to this point: Milan, where they would rest for seven weeks, staying at the monastery of San Marco. Wolfgang arrived with his face leathery from the cold and his fingers frostbitten.[12] Milan was the capital of Lombardy, which was Austrian territory. Presiding over the city was the Gothic bulk of the Duomo, enlivened by dozens of spires large and small. In the city, opera and orchestral music flourished, much of it heard in the grand, five-tier

Teatro Regio Ducale. Milan was a good place to shop for commissions, operatic or otherwise.

On their arrival in Milan Wolfgang wrote Nannerl: "Dear little Marianne with all my arse I rejoice that you had such a frightfully good time. Tell nurse Ursula, the one, I mean, with a cold arse, that I still maintain that I sent back all her songs . . . I kiss mamma's hands 1000 times and send you 100 kisses or smacks on your marvelous horse-face."[13] He had heard about another suitor hanging around his sister and had to rib her about it: "I am truly delighted that you had such a good time at your sledding party . . . Only one thing troubles me and that is, you made Herr von Mölk sigh and suffer endlessly, and you didn't go sledding with him so that he might have a chance to toss you into the snow. I wonder how many hendkerchifs he used up that day because of you to drie his tears." He added a memento mori about Papa's beloved poet Christian Gellert, who was apparently not beloved by Wolfgang: "Herr Gelehrt, the poet from Lepzig, died and since his deathe has written no more poetrie."[14] His spelling of the poet's name is one of his trademark puns: *gelehrt* means "learned." Wolfgang's puns were not invariably rude, only most of the time.

In his postscripts, he also reported on performances and performers. He would be unforgiving in judgment, sharp in observation, catty when presented the opportunity. He described the performance of Hasse's *Demetrio* at their last stop:

The opera in Mantua was nice . . . the prima Dona's singing is good but too soft, and if you didn't see her act with her hands but only hearde her sing, you would think she is not singing at all because she doesn't open her mouth and just whines everything out very softly . . . The seconda Dona looks like a grenadier and has a powerful voice to boot . . . There was also a grotesco dancer who jumps very well but can't write like me: as sows piddle . . . The Orchestro was not at all bad. The Cremona orchestro is good . . . The prima Dona [in *Titus*], not bad, pretty old I think, and unattractive . . . A grotesco dancer was there as well; he let out a fart each time he jumped. . . . Farewell and kiss mama's hands for me a Thousand times. I remein your brother true onto deathe, /

Wolfgang de Mozart / Baron von Hohenthal / Friend of the Countinghouse.

His next postscript he signed, "Wolfgang in Germania, Amadeo in Italia de Mozartini."[15] It was one of the few times in his life he used "Amadeo" (or "Amadeus") for his middle name, and as here, it was always a joke. The next note to Nannerl ends with "a Thousand Compliments to you from ifyoucancatchhimthenyougothim and from Don Cacarella, espessially from the rear end." "Don Cacarella" being his play on words for diarrhea.[16]

Wolfgang was composing a row of arias in these months, practicing for the Italian opera commission Papa was so avidly seeking. To prime the pump, father and son took in some seven operas in Milan. Around this time Wolfgang produced a slight and folksy string quartet, his first. Showing the influence of the Italian Giovanni Battista Sammartini, who became an acquaintance on the tour, it is in four movements, beginning unusually with an expansive Adagio. It ends up a touch wearisome because there is little attempt to make it anything but an accompanied solo for the first violin, which is what string quartets largely amounted to until Haydn remade the genre.[17] Mozart was also composing symphonies on the tour, among them possibly K. 74 and 84.[18] In Vienna he wrote Viennese-style ones in four movements. In Italy he produced three-movement Italian symphonies with much influence from the local styles. The gay little K. 74 harkens back to the genre's origins in the three-part Italian overture: it has three movements that flow into one another, fast-slow-fast. In the first movement in particular, there is a new maturity of tone in contrast to his earlier symphonies: even his cheery pieces have lost some of their youthful fluff and are capable of a certain dignity and nobility. K. 84 has a manifestly puckish first theme; the symphony is in three movements, separate this time, and like most of his Italian symphonies it has a genial, opera buffa ambiance, again harkening back to the origin of the symphonic genre as an opera overture.

By now his first movements tend to be full-scale sonata form: an exposition with its two theme sections, the second section in a new key, repeated; development; recapitulation mostly in the home key. His

mimicry remained impeccable, but his own voice was edging in around the conventions he could still absorb without effort.

THE FIRST WEEK OF FEBRUARY 1770, THE MOZARTS DINED WITH COUNT Karl Joseph von Firmian, governor-general of Lombardy. As mentioned, they got to know Giovanni Battista Sammartini, Milan's leading composer, whose students had included Gluck. Sammartini had recently founded Milan's own Accademia Filarmonica, its opera house the Teatro Regio Ducale.[19] Prolific in many genres, Sammartini was particularly noted for his contributions to the burgeoning symphonic style, moving it away from its operatic foundations and toward something distinctive to the genre, bringing it to where Haydn would take it up.

Sammartini was a good man to know, his music a solid model for Wolfgang, but the really important figure of this occasion for them was Count Firmian. A man of broad influence and intellect, learned and highly sophisticated in music, he would become one of the most generous and capable patrons Wolfgang ever had. The Mozarts' entry to his ken was owed to more Salzburg connections: his brother was a high steward at the Salzburg court, and the count was also the nephew of Baron Leopold Anton Firmian, who as Prince-Archbishop of Salzburg had been Leopold's first employer in town. Count Firmian gave Wolfgang a prescient gift: nine exquisitely bound volumes of the librettos of Metastasio, the ubiquitous poet of opera seria.[20]

Leopold decided that they would stay in Milan for Carnival, the classic pre-Lent celebration in cities around Europe. In a letter, Leopold huffed and puffed about the nuisance of having to pay for a Carnival getup. "The tailor just called with cloaks and cowls which we have had to order. I looked at myself in the mirror, as we were trying them on, and thought of how in my old age I too have had to take part in this tomfoolery. The costume suits Wolfgang amazingly . . . My only consolation is that one can use these costumes again for all sorts of things and can make linings, kitchen cloths and so forth, out of them."[21] This was too much protesting; Leopold seemed in fact to have loved Carnival and rarely missed one.

Carnival in those days was more than a chance to dress up and have

fun. It was an orgy of alcohol, dancing, lovemaking, and mischief in Catholic countries before the forty-day austerities of Lent. The ancestor of Carnival may have been the Saturnalias and Bacchanalias of ancient Rome, and all lusty festivities marking the year's rebirth in January. Celebrants were costumed and masked: in theory no one knew who you were, fair or foul, noble or common, so nobody could tell anybody what you got up to during the revels. It was a license for excess, so excesses were more or less de rigueur.

Carnival days were a whirl of color and movement: masked processions, merriment and music in streets and houses and bedrooms; the nights given to balls, plays and opera in the theaters, gambling in the casinos. An observer wrote of the Carnival of Venice, "They push to the limit ordinary profligacy, they refine all pleasures; they plunge up to the throat there. The entire city is dressed up: vice and virtuousness hide as well as ever." In his memoirs Casanova recalled the time when, dressed and masked as Pierrot during Carnival, he sneaked into the convent of Murano for a tryst with the much-admired mistress of the ambassador of France. Presumably, her holy vows only enhanced her desirability, and Carnival was the time for misbehavior by anybody.[22]

The bawdy Austro-German clown Hanswurst and the masked commedia dell'arte troupes, with their raunchy, improvised street comedy and their frenetic motion and wordplay splattering around the stage, were avatars of the Carnival spirit. Each character in commedia dell'arte had a distinctive visual profile, a way of moving and talking. And the commedia character Mozart came to prefer for himself was the wily, feline, amorous servant Harlequin, with his particolored costume. To some degree, in the core of his being Mozart was the embodiment of half-masked Harlequin. And one day on the stage, he would lend a little of that spirit to a scheming servant named Figaro.

ON MARCH 14, COUNT FIRMIAN GAVE A FAREWELL LUNCH TO THE MOzarts and presented Wolfgang with a watch set in diamonds.[23] More to the point, he handed Leopold a stack of recommendations addressed to aristocratic patrons in Parma, Bologna, and Florence. This created a chain of further contacts that would pave their way to Rome. Next day Firmian sponsored a concert for Wolfgang, with 150 of Milan's high

nobility attending. For the program, Wolfgang had been assigned three arias on Metastasio texts to write on a tight deadline. Whether or not father and son knew it, this was in essence a test of Wolfgang's abilities with opera seria verses. He impressed as usual and got the longed-for reward: through Firmian's connections, he received a commission for a full opera seria to be premiered at the Regio Ducale the next Christmas. This would be more than compensation for the Vienna debacle of two years before. Now he would be heard on a stage that presented only established composers.

Leaving Milan, father and son spent a couple of days in Parma and four in Bologna, where Wolfgang played at a concert sponsored by Field Marshal Count Gianluca Pallavicini, who had been primed by Count Firmian. Among the audience for the concert was Franciscan monk Padre Giovanni Battista Martini. He was a composer but known mainly as the leading music teacher in Europe, this largely because of his command of Renaissance counterpoint in the style of Palestrina (which was also the foundation for Fux's classic *Gradus ad Parnassum*). Aged, ailing, and gimpy, Padre Martini did not get out much, but he bestirred himself to go hear the famous phenomenon, and he was not disappointed.

Leopold took Wolfgang to visit Martini twice; the old man received them kindly, surely shared with them some of his beloved chocolates, and also shared his lively wit—he was no sour pedant.[24] He and Wolfgang undoubtedly appreciated each other, musically and otherwise. On each visit, Wolfgang improvised on a fugue theme Martini gave him. In turn, Martini spread to his contacts news of this youth that, according to Leopold, went all over Italy.[25] At some point, Leopold decided that they must return to Bologna so his son could spend more time with the distinguished man.

Both father and son were exhilarated by the prospects for Mozart's commissioned opera for Milan. They had no idea what the libretto might be, but this was going to be a seria, and by tradition that required a castrato in the lead, the best they could find. This inevitably suggested an old friend from London, Manzuoli, who had been a mentor for Wolfgang. Before they left Bologna, they paid a visit to the most celebrated of all castratos, the legend Farinelli, now retired to a villa outside town.[26] With Farinelli, they touched the history of opera seria

embodied in its greatest singer, whose mentor and friend was Metastasio, its greatest librettist.

Then to Florence. Speeding ahead of them as they left was a letter from their new Bolognese admirer Count Pallavicini to his relative Cardinal Count Lazzaro Opizio Pallavicini in Rome: "Count Firmian has most assiduously recommended to me Sig. Leopoldo Mozart . . . and his son, a boy of such uncommon merit in music that at his tender age he not only equals the masters of the art, but perhaps even exceeds them in readiness of invention . . . I flatter myself he will meet with His Holiness's entire satisfaction."[27]

Weather continued to bedevil them. After a stormy trip over the Apennines, father and son reached Florence for a week's stay on March 30. The rain and wind appeared to have given Wolfgang a cold, for which Papa administered tea and "violet juice" to make him sweat.[28] Useless, but perhaps not dangerous. Coping with the cold, Wolfgang played before Grand Duke Leopold, son of Empress Maria Theresa, like his brother Joseph a future emperor of the Holy Roman Empire.[29]

In Florence Wolfgang made the acquaintance of one of the rare people in the world who were something like him. Studying in town was British prodigy violinist and composer Thomas Linley. Like Leopold, Linley's father was a well-known composer and teacher. The Mozarts met them at the house of Maddalena Morelli Fernandez, a flamboyant violinist and poet at court noted for improvising poems to musical accompaniment.[30]

The two fourteen-year-old prodigies bonded on the spot, and naturally the form their bonding took was making music together. Leopold reported that they spent the whole evening playing back and forth, embracing in the interims. The next day, Thomas brought his violin over to their rooms and played all afternoon. The day after that, the two traded off playing for another afternoon, as Leopold wrote, "not like boys, but like men! Little Thomas accompanied us home and wept bitter tears, because we were leaving [for Rome] on the following day." That morning Linley turned up with a farewell present, a poem composed upon his request by Signora Morelli: "Spirits of gaiety, / Spirits of mirth, / Quick, I invite you, / Descend to the earth, / Tribute to render / To music so tender."[31] And so forth, at length, decked out with elaborate Classical allusions. Linley accompanied their carriage

to the city gates. He and Wolfgang never met again. After a brief, brilliant career in England, Linley was to die in a boating accident at age twenty-two.

THEY ARRIVED IN ROME ON APRIL 11, 1770, AND TOOK ROOMS WITH THE papal courier. This leg of the trip was even worse than the last: five miserable days of driving rain and freezing wind battering their carriage, the accommodations dismal. "Picture to yourself," Leopold reported, "a more or less uncultivated country and the horrible, filthy inns, where we got nothing to eat but here and there eggs and broccoli."

They appeared the next day at a *funzione*, where the pope ceremoniously washed the feet of some simple clerics and served them a meal.[32] The Mozarts' fine apparel and grand bearing got them ushered through the crowd, who seem to have taken Wolfgang for a courtier and Leopold for a prince. They found themselves at the cardinal's table, near the pontiff as he served food. Curious, a cardinal asked who they were. When told, he exclaimed, "You are the famous boy about whom so many things have been written to me!" This was in fact Cardinal Pallavicini, recipient of the letter about Wolfgang from his relative, their host in Bologna.

In Rome Wolfgang added one of the final items to the mythology of his youth. Like some of the other myths, it was ginned up a little in the telling, but just the same it remained an impressive feat of memory in his most startling mode. Proud Leopold wrote home, "You have often heard of the famous Miserere in Rome which is so greatly prized that the performers in the chapel are forbidden on pain of excommunication to take away a single part of it, to copy it or to give it to anyone. But we have it already. Wolfgang has written it down."[33]

This was approximately true. Soon after they arrived in Rome, father and son went to the Sistine Chapel to hear the papal choir during Holy Week, when by long tradition the choir sang Gregorio Allegri's twelve-minute Miserere, written in the early seventeenth century. Indeed there existed a chapel regulation mandating excommunication for anyone who transcribed the piece—except in fact there were three copies outside Rome: one in Portugal, one in Vienna, and one in the possession of none other than Wolfgang's new mentor, Padre Martini

in Bologna. None of those copies had earned anyone excommunication, and that prospect would not trouble Leopold.[34] Would Martini have shown the piece to the Mozarts? Entirely possible; also possible that he did not. But it is likely that they attended that particular Holy Week service intending to hear the famous piece.

The story spread by Leopold was that Wolfgang heard the piece once, went home and wrote it down, and that was that. Actually the first attempt was provisional and possibly had Papa's help. They needed to hear it again, to make corrections. On Good Friday they went back to the chapel, with Wolfgang smuggling the manuscript in his hat. The piece was sung, he made corrections. At parties he began to sing the Miserere, accompanying himself on keyboard.

There is one other detail that went unmentioned both in the myth and in Leopold's account, though he alluded to it in his letter: "The manner of performance contributes more to its effect than the composition itself." In fact the Miserere is a fairly simple piece, interspersed with traditional Gregorian plainchant. On that foundation the choir's solo soprano castrato would improvise beautiful ornaments, and these were the main thing that made the piece beloved.[35] At one point the Viennese copy was sung in the city without ornaments and was so pale in effect that the manuscript was taken to be a fraud. To what extent Wolfgang transcribed the ornaments is not known, because his manuscript would not survive—odd in itself, given Leopold's meticulous attention to preserving his son's legacy.

But myths are not concerned with complications and ambiguities, and neither was Leopold. He spread the word about his son around Rome, delivered twenty letters of recommendation to various notables, and Wolfgang began the round of playing in the salons of nobility and clergy and collecting often lavish gifts. He made time to practice the Italian bowling game of bocce, writing Nannerl that he was going to bring a bocce set home and teach her to play.[36] Wolfgang's pattern of amusements was taking shape. He was not much interested in games involving chance or strength, preferring ones that required physical skill: shooting, bowling, billiards, horseback riding, and eventually, above all, dancing. The energy of his music was the sounding equivalent of his personal energy.

In Rome they made connections among the high clergy, but Leopold

was not preaching to them his son as a miracle of God. What he wanted for Wolfgang in his mid-teens was a high-caliber job that would support the whole family. As for the clergy themselves, as usual, Leopold was impressed neither with them nor with the spirituality he found in the home of the Church. "You cannot conceive," he wrote Maria Anna, "how conceited the clergy are here. Any priest who has the slightest association with the Cardinal thinks himself as good as he, and each Cardinal, when on business connected with His Holiness, drives with a cortège of three or four carriages, each of which is filled with his chaplains, secretaries and valets."[37]

They made good money in Rome. In the end, the Italian tour may have brought in as much as 3,000 florins, not counting the 600 the Salzburg archbishop provided to finance the undertaking. (Again, Leopold's best court salary, a good one comparatively, was 450 florins a year.) In the course of the tour he added to their coffers back home. Most important, he had secured an opera commission for Wolfgang. As it turned out, this tour was the high point of Leopold's career as impresario for his son.[38] To all these efforts, Wolfgang, his attention entirely on making music and enjoying himself, was largely oblivious. "I am well," he wrote Nannerl. "God be thancked and praised, and I kiss mama's hand and my sisters face, nose, neck . . . and her rear end if it's clean."[39]

After a month in Rome they headed to Naples, arriving there on May 14 to find the perennial bedlam of the town: crush in the streets, importuning beggars, footmen screaming imprecations at the crowd from the carriages of the rich, rampant superstition, and rampant crime. Soon after they arrived, making the usual tourist stops in Pompeii and Herculaneum, Vesuvius started to smoke on cue.[40] Wolfgang to Nannerl: "We saw the King and Queen at mass in the Court chapel . . . and we have seen Vesuvius too. Naples is beautiful, but it is as crowded as Vienna and Paris. And of the two, London and Naples, I do not know whether Naples does not surpass London for the insolence of the people."[41]

All the same, they made good contacts with the nobility, for whom they decked themselves grandly. As Leopold reported, "We drove yesterday to Portici to call on the Minister, Marchese Tanucci, and we shall drive out there again tomorrow. . . . We have . . . put on our two

beautifully braided summer costumes. Wolfgang's is of rose-colored moiré, but the color is so peculiar that in Italy it is called . . . flame colored; it is trimmed with silver lace and lined with sky-blue silk. My costume is of the color of cinnamon and is made of piqued Florentine cloth with silver lace and is lined with apple green silk."[42] If his son was shaping into a dandy, though, Leopold was never really so inclined.

As part of a series of glamorous dinners they visited British ambassador William Hamilton, whom they knew from the London visit. His wife Catherine was an accomplished pianist and played for them—with unusual feeling, Leopold reported, but she trembled visibly at playing for Wolfgang.[43] There had apparently been some worry from Maria Anna about the Miserere and excommunication. In the letter Leopold reassured his wife, "All Rome knows and even the pope himself that he wrote it down. There is nothing whatever to fear; on the contrary, the achievement has done him great credit."[44]

Another old acquaintance in town was Abbé Ferdinando Galiani, whom they had encountered years before at Versailles. Since then France had banished him to Naples for revealing state secrets. After hearing Wolfgang play, Galiani wrote to Madame d'Épinay in Paris about her old protégé that he was perhaps not as astounding as he had been as a little boy, but "he will never be anything but a miracle, and that is that." Playing a concert at the Conservatorio della Pietà, Wolfgang was suspected of something more in the direction of the occult: word went around that he got his powers from a magic ring he was wearing. He silenced this bit of superstition by simply taking the ring off and continuing to play.[45]

As usual their main ambition was to get an audience with the local ruler, in this case King Ferdinand of the Two Sicilies (formerly Ferdinand IV of Naples). This was going to prove frustrating, because this sovereign existed on some private planet of his own. He was given, for example, to showing off to all and sundry the contents of his chamber pot; he would go out fishing and hawk his catch beside the tradesmen in the harbor. In the end the Mozarts got no closer to the king than to observe him at the opera, and the queen greeted them only from a distance. Wolfgang noted that Ferdinand was shorter than his queen, so in public he would mount a stool to stand beside her.[46]

Wolfgang's reports continued to be sanguine. In a wild jumble of

German, Italian, French, and Swabian and Salzburg dialects, he waxed garrulously to Nannerl, "Hey girl, let me ask, where you been! . . . The opera playing here is by Jommelli, it's beautiful but too learned and old-fashioned for the theater. De Amicis sings beyond comparison . . . The dances are miserably pompous, the theater is beautiful, the king has a crude Neapolitan upbringing . . . The queen is beautiful and courteous, she has greeted me at least six times."[47] Anna Lucia de Amicis was one of the celebrated seria prima donnas of the day. Before long she would be singing the lead in a Mozart opera.

In the end, Naples won over hard-to-please Leopold, to a degree: "The situation of the town, the fruitfulness of the country, the liveliness of the people, the rare sights and a hundred beautiful things make me sorry to leave. But the filth, the crowds of beggars, the hateful and godless populace, the disgraceful way in which children are brought up, the incredible frivolity even in the churches, make it possible quite calmly to leave behind what is good."[48]

From Naples they returned to Rome. Each leg of the trip had produced its travails, mainly having to do with the weather. But the road to Rome, supposed to be an easy jaunt, turned out the worst. Their carriage, a two-wheeled *sedia*, hit a patch of deep sand and pitched over. Instinctively the father seized the son's hand to keep him from being hurled out of the carriage, but in the process, Leopold was tossed forward onto an iron bar that put a gash in his shin the width of a finger.[49] He arrived in Rome on the twenty-sixth in wretched shape. To add to the fun, he developed an attack of gout in his other foot. For a while he was bedridden in pain; it took him months to recover.

Still, Leopold had his wits about him enough to tell everyone en route to Rome that he was the steward of the imperial ambassador, which got them better horses and faster service. (Watching, Wolfgang would have noted the usefulness of playacting in real life.) The downside was that they traveled for twenty-seven hours with two hours' sleep and nothing to eat but bread and cold chicken.[50] The day after they arrived in Rome, the misery of Leopold's injury was at least tempered by an announcement: Wolfgang was to receive from the pope the Order of the Golden Spur, a first-order knighthood. The papal patent for the Order included a reassurance about the Miserere matter and Wolfgang's eternal soul:

We, therefore, wishing to honor thee with fitting tokens of our
grace and beneficence on account of thy sincere faith and de-
votion to us . . . together with thy other merits, hereby absolve
thee . . . from any sentence of excommunication . . . imposed by
law or man . . . We hereby make and create thee—whom we un-
derstand to have excelled since thy earliest youth in the sweetest
sounding of the harpsichord—Knight of the Golden Order, by
the Apostolate authority.[51]

The tokens of the knighthood were the Golden Cross worn around
the neck, a sash embroidered in crosses, a sword, spurs, and the right
to call oneself a knight, aka chevalier—which Wolfgang occasionally
did, with a helping of irony. The knighthood was an extraordinary
honor—to a degree. It had been given to only four composers before,
among the latest being Gluck. Still, the Papacy had been handing out
knighthoods prodigally in those years, according to a man who, in-
credibly, had received one himself: Casanova. "The Order they call the
Golden Spur," he remarked, "was so disparaged that people irritated
me greatly when they asked me the details of my cross."[52] All the same,
he habitually wore the Golden Cross. Being a papally ordained cavalier
no doubt added to Casanova's charisma with the myriad objects of his
affection.

Cardinal Pallavicini hung the Golden Cross around Wolfgang's
neck on July 5 at the Quirinal Palace. Leopold was still limping but
able to attend. On July 8, sporting his Golden Cross, Wolfgang was
received by Pope Clement XIV at the Palazzo Santa Maria Maggiore.
This added one more powerful European figure to Wolfgang's list of
eminences whose hands he had shaken or kissed.

Wolfgang wrote home that he had composed four symphonies in
Italian style. Nannerl had, of all things, sent him a song she had writ-
ten, the only time she is recorded as composing anything. Her brother
was delighted: "I was truly amazed that you can Compose so well, in
one word, the song you wrote is beautiful; you should try this more of-
ten." (Apparently she did not.) He signed elaborately, "Madamoiselle,
J'ai d'honneur d'etre votre tres humble / serviteur, e frere. / Chevalier
de Mozart." In concluding his next note to his sister he advises her,
quoting a German children's song, to "shit in your bed with a resound-

ing noise." That song was a favorite of his and of their mother's. To be ironically discreet, he translated the line into Italian.[53]

IN THREE MONTHS, THE MOZARTS NEEDED TO BE IN MILAN TO COM-pose and produce the commissioned opera seria for the Teatro Regio Ducale. They left Rome in mid-July 1770 and headed to Bologna, where they would receive the libretto for *Mitridate, re di Ponto*, an ancient Roman story by poet Vittorio Amedeo Cigna-Santi, after a play by Racine. Leopold spent most of their three weeks in Bologna with his throbbing leg propped on a chair. With Papa laid up, Wolfgang roamed around Bologna on his own and attended, as he wrote, "some magnificent functions."[54] It may have been the first time in his life that he was footloose outside Salzburg without Papa. He also took over some of the letter-writing chores. In one of these, he shows for the first time in the record the kind of minute observation of people and their quirks that would mark his maturity and fuel his painting of character in music. The voice is his own, but the meticulousness came from Leopold.

> I am still alive and very jolly indeed. Today I had a fancy of riding on a donckey, for it is costumary in Italia, and so I thought I should try it too. We have the honor of being aquainted with a certain Dominican who is said to be holy. I myself am not convinced of it, becaus he often consumes for breakfast a cup of ciocolata, right afterward a big glas of strong spanish wine, and I myself have had the honor of taking a meal with this saint, who imbibed heavily and at the end drank an entire glas filled with strong wine, in addition he ate two large slices of melooni, peeches, pears, 5 cups of Coffée, a whole plate full of birds, two full saucers of milk with lemon, maybe there is some kind of plan behind it all, but I don't think so, because for one thing it's just too much, and for another, he takes quite a few morsels with him for an afternoon snack.[55]

Leopold noted that "during the last few days Mysliveček came to see me." This was Czech composer Josef Mysliveček, famed mainly for his operas. Personable and generous, he quickly became a friend of

the family and something of a mentor for Wolfgang—until, at length, he was neither. Wolfgang seems to have studied Mysliveček's opera *La Nitteti*, on a Metastasio libretto, to good effect on his impending *Mitridate*.[56] He would keep the habit of studying everything he could find, including the competition, relevant to what he was doing.

After three weeks at an inn in Bologna they moved to the nearby country estate of their patron Count Pallavicini, who had helped spark the Rome triumph. Now they were sleeping on fine linens and eating from silver plates, and they had two servants at their disposal, one of whom had the job of daily dressing Wolfgang's hair. Leopold's injury was finally healing. Of his son's new development he reported, "I shall have to have nearly all Wolfgang's cravats and shirts altered . . . But you must not think that he is grown very tall. It is only that his limbs are becoming bigger and stronger. He has no longer any singing voice. It has gone completely. He has neither a deep nor a high voice, not even five pure notes. He is most annoyed, for he can no longer sing his own compositions."[57] The former prodigy was hitting puberty. Before long in his letters there would be intimations about girls. But as Wolfgang matured, he was not destined to grow all that much taller.

A long letter by Wolfgang during this time shows off another of his abiding qualities as a correspondent. It was to his new British prodigy friend Thomas Linley. Mozart begins,

> My dear friend, here is a letter at last! I am very late in replying to
> your charming letter addressed to me at Naples, which, however,
> I only received two months after you had written it. My father's
> plan was to travel to Loreto via Bologna, and thence to Milan via
> Florence, Leghorn and Genoa. We should then have given you a
> surprise by turning up unexpectedly in Florence. But, as he had
> the misfortune to gash his leg rather badly when the shaft horse of
> our sedia fell on the road, and as this wound not only kept him in
> bed for three weeks, but held us up in Bologna for another seven,
> this nasty accident has forced us to change our plans and to pro-
> ceed to Milan via Parma.[58]

The letter continues likewise, with none of the puckish word games and raunchy humor of his letters to Mama and Nannerl. This letter is

as sober and mature as one from a courtier. Future years would show that with each of his correspondents Mozart would adopt a particular tone, whether joking or sober, and that tone would abide in every letter to that person. Most writers of letters do something of the like: ones to parents are not the same as ones to friends or lovers. But Mozart was extreme in this quality. In a way, each of his letters was an act geared to its recipient. In those days the music he was writing in city after city varied in the same way, and to the end of his life there would remain an element of that kind of playing to a particular audience. Here is Mozart the chameleon, the actor, the Harlequin.

Part of the point of returning to Bologna may have been for Wolfgang to take counterpoint lessons with Padre Martini.[59] Now another myth took shape and soon lost its ambiguities. The lessons with Martini would have been aimed toward a particular goal: the distinguished Accademia Filarmonica of Bologna had agreed to consider Wolfgang for membership. Founded by a nobleman in 1666 in his own palace, the Accademia was what would later be called a conservatory—in this case, training composers toward the coveted title of *maestro compositore* (master composer). Its alumni included the castrato Farinelli and composers Josef Mysliveček and J. C. Bach. Padre Martini had taught there for many years. Ordinarily one had to study for at least a year and be at least twenty to receive the degree, but with Martini pulling strings and paying Wolfgang's admission fee, the panel of academics agreed that the teenager could take the final examination; if he passed he would be granted the title.

In a way, a measure of Martini's reputation was on the line if his celebrated student failed to pass the exam. And so things were not left to chance; what ensued was a bit of a confidence game. The exam involved being sequestered in a locked room and given three hours to compose new parts over a Gregorian chant bass line, and those lines had to conform to the arcane rules of formal counterpoint.

When the day came, Wolfgang was locked in one room and Leopold in another, and everybody waited. Much sooner than expected, Wolfgang's knock was heard on the door; he emerged and handed in the exercise. Leopold reported that it took him less than half an hour; school records said less than an hour.[60] But it appears the page was given not to the panel at this point, but to Padre Martini, who would immediately

have seen that it was nowhere near passable. Wolfgang had done his boning up, but this kind of thing was not really his cup of tea.[61] So Martini took the exercise home, wrote out a new and corrected version, and gave that to Wolfgang to recopy in his own hand. (All three versions of the exercise would survive.)[62] The panel examined the corrected version, and if they suspected something fishy about it they kept it to themselves. They were not likely to question their distinguished colleague and his famous protégé. The panel's voting was done with little balls, white for "accept" and black for "deny." All the balls turned out white. With applause Wolfgang was awarded the diploma, and added another entry to his legend.

THEN TO MILAN, WHERE WOLFGANG HAD LESS THAN THREE MONTHS to produce the enormous *Mitridate, re di Ponto* for the Teatro Regio Ducale. He arrived with some of the recitatives done, but it was still an outlandish demand on a fourteen-year-old whose voice was breaking. Still, Wolfgang was by then a seasoned composer with four major dramatic works to his credit, and he had never failed at any challenge in his life—at least, never failed with a little help from Papa and from his friends. Leopold's hand could still be seen on his son's manuscripts and would be for years to come.

There is no indication that Wolfgang felt anxious about the job, but as he set to work with keyboard and quill, he appeared unusually tired and serious. "My dear Mama," he wrote home in the middle of it, "I cannot write mutch because my fingers hurt terribly from writing so many recitatives. I ask Mama to pray for me that my opera will go all right and that afterward we will be happy together again."[63] With the Vienna fiasco weighing on his mind, Leopold was plenty anxious, but he vowed to his wife that he would, if necessary, "shit oranges" to expedite the business.

Mitridate was an opera seria. "Serious opera" meant, however, a great deal more than simply a sober drama. Seria was an edifice rigid in its elements and conventions, a sociopolitical ceremony, an ethos. Its stories were taken from ancient myth and history, its characters kings and nobles, its purpose to affirm the meaning and value of the ruling class by demonstrating its nobility and its ultimate benevolence. Seria

librettos were framed in neoclassical poetry, the characters scarcely human but rather symbols and archetypes.

There was little bother about fidelity to the ancient stories. The crux of all the plots was this: A king and the exalted figures around him are torn between the demands of the heart and the demands of their sacred office. Will the ruler choose love, lust, revenge, or will he choose duty and clemency? The settings of the stories are largely great halls, palaces, courtyards, battlefields.[64] Action is confined to a restricted area, usually transpiring in the course of a day. In the end, one way or another, the sovereigns in opera seria choose the path of virtue and forgiveness, order is restored, and thereby kings justify their existence. Serious opera was obliged to have a happy ending. Which is to say that opera seria was a courtly entertainment par excellence, an affirmation of absolutism, the sociopolitical edifice of the ancien régime exalted not in stone, as in an archbishop's Residenz, but instead in sound and spectacle. Wrote a librettist in 1790, "Theatrical spectacle, established on the basis of wise laws and of careful reform, can be regarded as a means always available to the sovereign power to inculcate in his subjects the most useful and important beliefs"[65]—the most important of those beliefs being faith in the sovereign's goodness and wisdom. Wolfgang's Paris mentor, the progressive social and opera critic Baron Grimm, wrote that the essence of opera seria was a belief in what has ceased to be worth believing.[66]

But the audience for seria went beyond the nobility. In practice, a good tune and a glorious voice belonged to anyone who could afford the price of a ticket, who wanted to hear some singing and also wanted from the upper galleries (the top gallery's cheap seats known as "paradise") to observe the spectacle of the beau monde below them, so near yet so far.

Productions inclined to the extravagant. One midcentury performance of a Metastasio opera involved horses and chariots, camels and lions, thirty-seven swordsmen, and sixty extras disporting themselves amid conflagrations and collapsing buildings.[67] The theater lighting of the day was a mix of candles and oil lamps, so the stage light was muted. The sets were made up of flats on the sides, mounted on tracks so they could quickly be switched for changing scenes, plus a backdrop that could be changed from the flies. Scenic designers were expert

at forced perspective, able to give the stage an illusion of vast spaces. There might be multiple trapdoors on the stage to provide magical entrances and exits. Costumes were elaborate and colorful, the players often sporting ornate headdresses that shimmered in the shadowy light.[68]

The librettos loomed large in opera seria, and as noted, the legendary author of many of the significant works was one Pietro Trapassi, known by his nom de plume of Metastasio. In a career spanning much of the eighteenth century, he produced twenty-seven seria librettos, and with him seria reached its classic form. In his stories, which embodied high-minded Enlightenment ideals, rulers overcame their selfish desires and rose to greatness. Metastasio was an elegant poet, working in many genres besides opera. His librettos had a tone of somber dignity unsullied by any hint of humor.

Musically, seria took shape as a relentless alternation of arias spaced by "simple recitative," a stylized speech-song accompanied by harpsichord. (The next century would rename it, derisively, "dry recitative," and the term stuck.)[69] The leading characters would get four or five arias to themselves; the lesser characters fewer according to their rank. The recitatives linked the arias and carried the story. In the arias a principal character would soliloquize about his or her state of mind, then ceremoniously depart the stage to end the scene. Now and then a duet or a trio might turn up, or a short aria in the middle of a scene. At crucial points there would be an accompanied recitative, the orchestra joining in to provide weight and intensity.[70] In the genre, there were traditionally few if any choruses or independent instrumental pieces, though there might be a good deal of music for ballet interludes.

Traditionally the arias were laid out in the da capo, ABA outline, the B section contrasting in emotion and material, the return of the A section generally involving the singer adding ornaments to the melody, the showier the better. But as Mozart's arias for *Mitridate* show, this static form, in which the end simply repeats the beginning with flourishes added, bringing the soliloquy back to where it started, was giving way to more varied treatments. One of the *Mitridate* arias is virtually through-composed, following no standard form but rather the expressive progress of the text. Vocally, the institution of opera seria was founded on the brilliant and tragic institution of the castrato. The superstars among these exotic performers, whose clarion voices and su-

preme virtuosity stirred both wonder and revulsion, who inspired passion in women and a pang in the groin in men, were the virile heroes of opera seria. *Mitridate* requires three castratos, a high soprano, a middle soprano, and an alto.

On the face of it the genre of seria, with its long interludes of simple recitative leading to a character emoting in an aria, usually alone, could be a tedious affair. But two things relieved the boredom. First, if the composer was doing his job, there would be splendid tunes perfectly tailored to the voices delivering them. Second, essentially nobody ever sat and listened attentively to a whole opera.

Just as in a home concert, in Italy an opera was a social event, an evening at the theater that promised contrapuntal pleasures. Other than staying home and drinking or making love, the main evening entertainment available to those eager for it was the theater. Much of the time, opera audiences ignored the stage, involving themselves instead in playing chess or cards; enjoying wine and snacks or full meals; conversing, flirting, watching, and being watched. Men scanned the theater for pretty faces; the pretty faces critically examined one another. At the same time, because seria was mounted largely during Carnival, some in the audience might be masked, which was itself an invitation to intrigue and flirtation. If an aristocrat had a private box, the flirting might get a little more serious.

In short, the show in the theater was often more diverting and even dramatic than the one onstage. An observer of a few years later at La Scala, built after the Regio Ducale burned, described the charms of evenings at the opera. From the boxes,

> young women presented to your gaze an amazing number of heavenly faces. . . . In those happy tiers can be found something to satisfy every taste. There, together, the lively brunette and the tender blonde; there, the wary lady of twenty who pleases, and knows it; and the simple girl of fifteen who pleases all the more, the less she realizes that she pleases . . . In that box you see two fortunate lovers, so pressed by the weight of their happiness that they have not the power to utter a syllable . . . There, in the neighboring box, others who are quarreling sotto voce; they are reproving each other's infidelities . . . Each angle of the theater,

in short, presents in turn new points of view, infinitely varied by cheerfulness, laughter, pleasure, jokes, and love. Delightful points of view to whoever has a heart in his breast![71]

Sometimes the commotion in the theater was enough to drown out the music, especially the recitatives that few listeners cared about anyway. It was Carnival, and people wanted to have as much fun as possible before the imposed austerities of Lent. A commentator described a Carnival day of a wealthy Italian:

> In the fashionable world, the morning is spent in a slovenly dishabille that prevents their going out . . . Reading or work takes up a very small portion of this part of the day; so that it passes away in a yawning sort of nonchalance. People are scarcely wide-awake till about dinnertime. . . . At length, the opera calls them completely into existence. But it must be understood, that the drama, or the music, do not form a principal object of theatrical amusement. Every lady's box is the scene of tea, cards, cavaliers, servants, lapdogs, abbés, scandal, and assignations; attention to the action of the piece, to the scenes or even to the actors, male or female, is but a secondary affair. If there be some actor, or actress, whose merit, or good fortune, happens to demand universal homage of fashion, there are pauses of silence, and the favorite airs may be heard. But without this cause, or the presence of the sovereign, all is noise, hubbub, and confusion.[72]

So rather than producing some sort of integral work, opera composers were concerned mainly with producing arias that were appealing enough to make the audience shut up and listen. When a favored singer stepped up to the apron of the stage, struck a stylized pose, and began warbling, the audience might suddenly go quiet and take in the music rapturously. A given opera would run nightly for a while, and many attended repeatedly, watching different parts on different nights. It was the composer's job to understand this socio-musical milieu and to supply the rapturous moments. But in practice, there were two still-more-fundamental jobs he had to satisfy: first, the proper musical expression for the feelings of each aria; second, and no less important, the

voices and egos of the singers. It was imperative to keep your principals happy. If a singer did not feel an aria suited his or her voice or would get the proper attention from listeners, that aria would not be sung. You had to write another one, and keep writing new ones if necessary, or they would resort to another composer's tunes. Wolfgang learned all about this process during the composing and producing of *Mitridate*.

The opera is a Metastasio-style seria in three acts. King Mitridate of ancient Pontus and his sons Farnace and Sifare are all in love with princess Aspasia. She has been promised to Mitridate, who is about to depart to fight their enemy Rome, but she secretly loves Sifare, who returns her feelings. After his father leaves, Farnace goes over to the enemy in an attempt to seize the throne. Having been reported as dead—this in fact a ruse to test his sons—Mitridate returns. After mellifluous convulsions of jealousy and rage and general turmoil, the Romans invade by sea, and Mitridate must exit to fight again. Farnace has a crisis of remorse and manages to burn the Roman fleet. Wounded mortally in battle, Mitridate as he dies forgives Farnace and gives Aspasia to Sifare, and the brothers unite against the Roman invaders.

The setting for the performance, the Teatro Regio Ducale, was enormous for the time, virtually heroic in itself. There were five ranks of boxes on each side. The frescoed ceiling depicted soaring gods and goddesses. The cheapest tickets were standing room. The deluxe boxes for the nobility had adjoining parlors with fireplaces, suitable for card games or assignations. In the galleries on each side were tables for the gambling card game faro.[73] The house orchestra was equally lavish, one of the largest Mozart would ever see, including fourteen each of first and second violins, six basses, doubled flutes and oboes, four horns, and two harpsichords.[74]

Mitridate is a tenor, his sons both castratos; the younger Sifare is given a high soprano part; and Farnace is an alto. (Old friend Manzuoli had been hoped for as the leading castrato, but he did not give his friends a break: he demanded 4,500 florins for the role, and that was the end of that.) The sons' beloved Aspasia is a female soprano. It was expected that the four or five arias each given to the principals would show off their voices in a variety of expressive modes: tender, enraged, and so forth. In an era that minutely classified nearly everything in art, most types of aria text were traditional; in a "simile aria," for example,

the singer compared his or her situation with some parallel: a bird in flight, a ship tossed in a tempest.[75]

The female role of Aspasia was sung by the celebrated Antonia Bernasconi, who had premiered Gluck's *Alceste*. Before the rehearsals somebody slipped her arias by other composers to sing, insisting that they were better than anything this German kid was capable of. She was tempted, but when she heard Wolfgang's arias, Leopold reported her as being "beside herself with delight." As for tenor Guglielmo d'Ettore, he rejected the first version of his opening aria and four more attempts after that, until Wolfgang came up with one he liked. This turned out to be the finest number in the opera, "Se di lauri," a mournful aria in which the troubled king hopes not to return from battle in shame.

Inevitably much of *Mitridate* is fusty and routine, but some pieces stand out. The numbers for castrato Sifare require sparkling virtuosity. In his first, the vocal pyrotechnics capture a prince enraged at his brother: "She who is able to deny me love / causes me to suffer but does not offend me, / yet he who becomes my rival inflames me with fury." The duet between the suffering lovers Aspasia and Sifare that ends act 2, "Se viver non degg'io," has a beautiful atmosphere laid out on a broad musical canvas of poignant dignity, with a touching melodic line. (In rehearsals, the *primo uomo* declared that if this duet were not a hit, he would have himself castrated again.)[76] Even more striking is Farnace's final aria repenting his betrayal, "Già dagli occhi il velo è tolto," with its heart-tugging harmonic suspensions. At the end, Mitridate cheerfully expires in recitative, and a chorus gloats over their defeat of the Romans. The curtain falls after a course of some six hours, including no fewer than three ballets lasting some two hours. (Their music was not by Mozart, and they were trimmed somewhat after the premiere.)[77]

Wolfgang at fourteen had still not learned to develop a character through the course of an opera; nor was he ready to make the static layout of seria into something musically and dramatically dynamic. But he was already adept at painting emotions in compelling music, and he was an elegant and expressive melodist grounded in the Italian operatic style. Already there is a mature conciseness, an ability to shape a musical and expressive passage lucidly that makes most other composers sound diffuse.

As was the custom, for the first three performances of the opera the composer presided at the keyboard and conducted. For the occasion Wolfgang wore his new scarlet suit trimmed with gold braid and lined with sky-blue satin, probably the one he had been painted in.[78] And *Mitridate* was a hit, running for twenty-two performances to mostly full halls, or so Leopold reported. There soon followed a commission for another opera for Milan, what became *Lucio Silla*. Leopold crowed in a letter to Padre Martini,

> I must inform you that my son's opera has been received most fa-vorably in spite of the great opposition of his enemies and the de-tractors, who, before hearing a single note had spread the rumor that it was a barbarous German composition, without form and content, and impossible for the orchestra to perform. One person had the brilliant idea of bringing the prima donna all her arias, and the duet as well, all of which had been composed by Abbate Gasparini of Turin, with a view to persuading her to insert those arias and not to accept anything composed by this boy . . . But the prima donna said that she would like first of all to try my son's arias; and having tried she declared that she was satisfied and more than satisfied. Nevertheless the calumniators kept on spreading most evil reports. But the first rehearsal with instru-ments stopped the mouths of those cruel and barbarous backbiters and not a word more was heard.[79]

After a formidable couple of months, the Mozarts could have a bit of rest. At the beginning of January 1771, Leopold reported that Wolfgang was to play a concerto at Count Firmian's, and that they had lunch with Madame d'Aste, who fed them Wolfgang's favorite dish, liver dumplings with sauerkraut.[80] Word arrived that Wolfgang had been made a member of the Verona Accademia Filarmonica.[81] In the middle of the month, just before he turned fifteen, they moved to Turin for a couple of weeks, then headed for Venice to partake in the most famous and notorious of Carnivals. There they would take in operas, Wolfgang would of course play concerts, and Leo-pold would discover something new to worry about: that his pubes-cent son might take an interest in the prostitutes who patrolled the

streets, rumored to be as expert in music as in love. Said Rousseau, "As for women, it is not in a city like Venice that a man abstains from them."[82]

The Mozarts' main patrons in Venice were the Wider family, who were fine and generous and so forth, but who posed another threat to Wolfgang's innocence in the form of six beautiful daughters. Wolfgang dubbed them the "pearls," and reported to Nannerl concerning a son of the Hagenauers, who knew the family, "Tell Herr Johannes that the pearls of the Wider family are always talking about him . . . and he should come soon to Venice again to get, Nota Bene, 'the treatment,' which is to have your bottom bumped against the floor to become a true Venetian. They wanted to do it to me too, and all 7 women [including the mother?] got together and attacked me, but they couldn't get me down to the floor." He's referring to the charming Germanic tradition of *Arschprellen*, or "ass bumping," which involved being swung by the arms and legs as your backside pounded on the floor.[83]

They made their way to Padua at the beginning of March. There Wolfgang received a commission for what became the ill-fated Lent oratorio *La Betulia liberata*. They were heading east for home—Verona, then Innsbruck in a blowing snowstorm and terrible cold. After more than fifteen months in Italy, they arrived in Salzburg impatient for the next tour and with two new commissions for Italy in hand.

Johann Adolph Hasse, receiving a report about the Mozart sojourn in Venice and Leopold's sourness therein, replied, "Young Mozard [*sic*] is certainly marvelous for his age, and I do love him infinitely. The father, as far as I can see, is equally discontented everywhere, since here too he uttered the same lamentations. He idolizes his son a little too much, and thus does all he can to spoil him; but I have such a high opinion of the boy's natural good sense that I hope he will not be spoiled in spite of the father's adulation, but will grow into an honest fellow."[84]

Leopold's hopes surely remained high. On the biggest stage yet, figuratively and literally, Wolfgang had proved himself again. Even if, still, no job. For Wolfgang's part, he had enjoyed himself thoroughly, and as his letters imply, this seems to have been his main concern. Papa talked mostly about money and plans. Wolfgang talked mostly

about fun. It was all fun, even when his fingers ached from so many recitatives. In any case, during the Italian tour he had come of age both physically and creatively. At fifteen, he was done with his fabled apprenticeship; his maturity as a composer was beginning, and with it his first enduring works.

Chapter 7

EXSULTATE, JUBILATE

A t this point Wolfgang had major commissions on his plate, one of them probably already finished the previous summer: the dramatic serenade *Il sogno di Scipione*, which may have been intended for the fiftieth anniversary of Archbishop Sigismund Schrattenbach's service to the Church. The piece was based on an old Metastasio text, which Wolfgang would have found in his set of the poet's librettos given him by Count Firmian. It is another allegory of the duties of the occupants of thrones.[1] Fate saw to it that this archbishop would not hear any of it.

When father and son arrived back in Salzburg on March 28, 1771, the presence of mother and sister notwithstanding, the city seemed less like home than ever. Since the age of six, Wolfgang had lived two-thirds of his life on the road, much of that time spent in far grander quarters than the modest flat where the family slept in one room. "The way we now sleep together, like soldiers," Leopold declared upon their return, "is no longer possible. Wolfgang is no longer seven years old." With Wolfgang now fifteen and Nannerl nearly twenty, Leopold found rooms for him and Maria Anna to sleep in, the children now had their own rooms in the flat, and at last the family could stretch their limbs.[2] They were still living like the run of musical employees in Salzburg, but this was about to change. Funds from the children's tours had been banked by Leopold, and it was time to start making use of them.

As for Mozart's music, he must now be called a mature master, if

still well short of his peak. The promise of his prodigy years was paying off, not because music still fell from his head as sows piddle, as he had recently put it, but rather because he had grown in knowledge and sophistication, a transformation fueled by his implacable drive to learn and expand himself.

Other projects were more significant, but one of them, also on a Metastasio text, would also run afoul of fate: the oratorio *La Betulia liberata*, commissioned by Giuseppe Ximenes, Prince of Aragona, for Padua. Mozart lavished serious attention on the piece and collected his fee, but at some point the prince lost interest. He was musically sophisticated for those days, unusually interested in older music, and when he finally saw it, Mozart's score may have proven too modern for him. For whatever reason, the enormous piece was not performed then or later in Mozart's lifetime. Another one to chalk up to experience.

There is no record that Wolfgang or Leopold was particularly put out about its failure to be heard. Besides, Wolfgang had bigger courses on his plate. One of them was a serenata commissioned by the Viennese court for the festivities around the October marriage of Empress Maria Theresa's son Archduke Ferdinand. This became *Ascanio in Alba*, to be written during the next Italian tour. The impetus to commission probably came from the empress, probably delivered via the Mozarts' patron Count Firmian.[3]

The main commission in hand was the second Carnival opera for Milan, which had been offered after the success of *Mitridate*. As usual the libretto would not be chosen for a while; it would turn out to be *Lucio Silla*. The commission fee of some six hundred florins was nearly a third more than what he got for *Mitridate*. At age fifteen, Mozart was in effect an established and well-paid composer of Italian opera in Italy, although this did not mean, as it proved, that he was going to be coveted by Italian employers. And certainly, established Italian composers would not welcome him as a rival. The older Mozart became, the less enthusiasm he found everywhere.

Other than opera, what he was most interested in composing in the next years were symphonies. Between December 1771 and the end of 1774, there would be some seventeen, written in Salzburg and on the road. None of them commissioned, they were heard in court and at house concerts in town, where all the Mozarts regularly played.

Wolfgang had written symphonies during the first Italian tour, all of them inflected by the style of that country. These symphonies of his later teens made a piecemeal transition to a more Viennese-oriented style—this in part meaning four rather than three movements, their tone weightier, and with less of the frothy atmosphere of Italian opera buffa. Perhaps by now he was familiar with some Haydn symphonies, though he was still influenced by ones from the likes of Sammartini and J. C. Bach.

This new inclination is shown in the Symphony in A Major, K. 114, a big, ambitious piece in four movements, grandly scored. From a gentle and earnest opening, the music gathers to a big texture, everything marked by a singularly sunny sound: two flutes, rather than the usual oboes, and A horns, which had a bright sonority. The radiant texture of horns and flutes is one of the main things striking a listener in the piece. Oboists of the time usually doubled flutes; they switch to oboes for a graceful and pensive second movement. After a vigorous, foot-pounding A-major Minuet with an A-minor trio a bit mysterious in effect, the sonata-form finale starts with a rumbustious tune and stays with that rustic, fun-and-games spirit.

In these years symphonies poured out of Wolfgang one after another, at varied lengths and levels of ambition. Only occasionally did they test the norm of little pieces written for the catch-as-catch-can orchestras of house concerts. The forms run to straightforward, the key palette is limited. His sonata-form development sections remain perfunctory to short, though they gradually extend in length and complexity. Most of the symphony manuscripts have entries in Leopold's hand; he was, after all, a highly experienced symphonist. Here and there in these pieces Mozart flexes his muscles, as in the C-major K. 128, where he expands the proportions and harmonic colors and bulks up the texture with a second pair of horns. In the F-major K. 130, a quirky piece overall, he persistently breaks out of the era's tendency to boxed-in, four-bar phrases, starting with its opening, a quietly facetious five-bar theme.

There is a question in all this: why was Mozart at age fifteen and sixteen so interested in symphonies rather than, say, the sacred pieces he was being assigned for the cathedral or for concertos for himself and his sister? One reason may have been that he had as yet no paying position as a court musician, and even if he had, under Archbishop Schratten-

bach, town composers were not required to write a lot of sacred music. As for concertos, perhaps at this point Mozart was revealing a partiality for composing over performing, though he was certainly partial to applause. In any case there was not much incentive for him to write concertos. On the whole he got no particular fees or gifts for performing at local house or court concerts, so he didn't need the bother of fronting concertos as compared to chamber works that he could easily sight-read. But Mozart would always adapt to the needs of the moment. In the next decade, when there was a great career significance in writing concertos for himself, he would write bushels of them and very few symphonies.

In his middle teens, symphonies were a good way to experiment, to find new orchestral colors in pieces of which not much was expected. What he learned would also enrich his orchestra in opera. The Romantic generation of the next century would exalt the visionary artist beyond his time, challenging listeners, pushing envelopes. As a teenager Mozart was a long way from having the inclination or the clout to push envelopes or challenge his listeners. But within this constraint (which he did not see as a constraint), he grew steadily.

ON AUGUST 13, 1771, WOLFGANG AND LEOPOLD LEFT SALZBURG FOR A second Italian trip. The Mozart women were unhappy about being left behind again, at which Leopold was only annoyed.[4] On this journey the women would serve no purpose. Leopold had no intention of tarrying in towns en route to show off his son and spread the word. Now there were big jobs to do. In good summer weather they moved fast, their two-wheeled *sedia* sometimes making fifty and more miles in a day. The first goal was Milan, where they arrived on the twenty-third. Wolfgang reported home, "My dearest sister! We suffered alott from the heat on our trip, and it was so dusty all along that we would have choked and died of thirst for sure, if we hadn't been too smart for it . . . The princess had the runs the other day—or a shit-fit. Apart from that I know nothing new, why don't you write me something new . . . I am panting it's so hot! I'm tearing open my waistcoat, right this minute! Addio."[5]

The ailing princess he mentions was probably the bride of the

occasion for their visit, Maria Beatrice d'Este of Modena. The princess clearly knew about the Mozarts: when they first ran into her she rushed up, took off her glove, and as she held out her hand to be kissed began babbling away before they had a chance to say a word.[6] In the next weeks, their patron Count Firmian would host splendid parties where Mozart played. After one of them he was presented with a gold watch set in diamonds.[7] All very nice, but by that point, Wolfgang probably had a number of them.

As soon as they arrived in Milan, Mozart received Giuseppe Parini's libretto for the serenata *Ascanio in Alba*, the commission by the Austrian Crown for the wedding of the princess to Archduke Ferdinand of Austria. Wolfgang got intensely to work on the piece, in the next month turning out some two hours of music. He wrote Nannerl that there was a violinist upstairs from his workroom, another downstairs, a singing teacher next door, and in the room opposite, an oboist. Far from being distracted, he reported the din as "all such fun for Composing! gives you lots of ideas."[8] Adding to the noise was a persistent cough from a cold.[9] Leopold for his part was struggling with dizziness that had followed him from home. In a letter he notes a dysentery that had claimed a number of lives in Salzburg and wonders if he is not suffering from some form of it: "When people are attacked both in their heads and in their arses, their condition is indeed dangerous."[10]

Ascanio in Alba was never intended to be anything but a sideshow for one of the most spectacular wedding jamborees of the eighteenth century, all of it financed by the empress in Vienna. (Now living in seclusion, Maria Theresa did not make the trip to Milan for her son's wedding.) Another item on the vast menu of events was *Il Ruggiero*, a new opera seria by the aging and increasingly tired Johann Hasse, an old friend and admirer of Leopold's. The festivities around the royal wedding would include, though not be limited to, multiple masked balls, illuminations of the city, horse races, chariot races, fountains flowing with wine, little orchestras playing all over town, a gala public wedding of 150 poor young girls to comparably poor boys, followed by the feast of their lives.[11] Thousands poured into the city to join the revels.

The libretto of *Ascanio in Alba* calls it a *festa teatrale*.[12] Librettist Giuseppe Parini, a poet famed for assaults on aristocratic tyranny, now found himself employed by the empress to write sycophantic twaddle

for her son's wedding.[13] The allegorical story is a riot of genii, graces, goddesses, shepherds, and shepherdesses, the whole pastoral gamut singing and dancing away. Its eponymous hero is Trojan prince Ascanio (Prince Ferdinand), son of Aeneas and Venus (Maria Theresa). Ascanio is betrothed to the nymph Sylvia (Princess Maria Beatrice). Sylvia anticipates his coming in dreams, but she does not at first realize that this ardent suitor is her destined lover—and so forth and so on. It goes without saying that there is a happy ending.

As for the music, Mozart understood perfectly well what he was supposed to do. This was a hosanna for the ruling class, in a genre long associated with royal celebrations. Accordingly, he kept it relentlessly cheery, celebratory, high-minded, and impersonal. It amounts to a miniature opera in concert, a parade of flowery solos, recitatives, ballets, and staunchly joyful choruses. There were two parts for castratos, the role of Ascanio handled by Mozart's old mentor Giovanni Manzuoli, then at the end of his performing career. Wolfgang had not forgotten or forgiven Manzuoli's demand for an outlandish fee, which had kept him out of singing in *Mitridate*. "Herr Manzoli, who has always been thought of as the brightest among the Castrati," Wolfgang wrote Nannerl, "has now, in his old age, shown a bit of stupidity and conceit."[14] Manzuoli had refused an extravagant fee for the new opera and after the performances left Milan in a huff. A few days later Wolfgang reported that he had taken a break from his labors for some entertainment, which was watching four men get hanged in the Piazza del Duomo. He reminisced to Nannerl that it was just like a hanging they saw in Lyon in childhood.[15]

In its four performances, the first the day after the royal wedding, *Ascanio* seems to have had a nice success, while Hasse's opera manifestly did not. He had written it reluctantly, only because the empress pressed him to take the commission. "It really distresses me very greatly," Leopold wrote home with hushed satisfaction mixed with genuine regret for a friend, "but Wolfgang's serenata has killed Hasse's opera."[16] There was a ghastly postscript at an *Ascanio* performance on October 24, when before the Mozarts' eyes a scaffolding collapsed and more than fifty people in the audience were injured or killed. If Leopold and Wolfgang had not arrived late, they would have been on that scaffolding.[17]

Leopold's great hope was that the newly married Archduke Ferdinand would hire Wolfgang for his court in Milan. The archduke had given them an audience and indeed was considering it—until he got a letter from his mother. Ferdinand had written Empress Maria Theresa about the idea; after all, she would be paying for it. In Vienna, she had once bounced little Wolfgang on her knee, allowed him to kiss her, commiserated with the family about their illnesses. Now she appeared fed up. "You asked me to take the young Salzburger into your service," she wrote her son in her rambling style that had little use for punctuation, "I do not know why, not believing that you have need of a composer or of useless people if however it would give you pleasure, I have no wish to hinder you what I say is intended only to prevent your burdening yourself with useless people and giving titles to people of that sort if they are in your service it degrades that service when these people go about the world like beggars besides, he has a large family."[18]

"Useless people," "people of that sort"—the empress was inexplicably wrong about the Mozart family's being large, but more or less accurate in saying that they went around the world like beggars. Her letter squelched Mozart's best chance in those years for a court position. Probably Leopold never knew about it; he knew only that his hopes for a position for his son had come up short again, despite yet another shining success for Wolfgang.

Leopold and Wolfgang left Milan on December 5, 1771, and made the 325 miles northwest to Salzburg in ten days. It must have been hard on Leopold, who was suffering with rheumatism and, at fifty-two and starting to feel his years, not so completely on top of everything—though his backstage managing was no longer so necessary. He still controlled the purse strings, in any case. They got home expecting the celebration of Archbishop Schrattenbach's fiftieth anniversary of service and the performance of Wolfgang's *Il sogno di Scipione*. But the pious old ruler who had always been so generous and accommodating with the Mozarts died the day after they arrived. To general consternation, the town learned that his successor was to be Archbishop Hieronymus Colloredo. This well-placed aristocrat was, in his way, a progressive and well-intentioned man, but nowhere a well-liked one.

Colloredo made his ceremonial entry into Salzburg at the end of April.[19] Relations between the Mozarts and the new archbishop began

well enough. On May 3, part of *Il sogno di Scipione* may have been performed as a welcome for the new sovereign. The Metastasio text is a semi-staged cantata, another genre designed to acclaim the wisdom and generosity of the glorious rulers of court or Church. In the story the Roman general Scipio dreams of the rivalrous goddesses Fortune and Constancy, there are visits to the Elysian Fields, et cetera. Mozart's score is another big one, but if any of it was performed in honor of Colloredo, it would have been an excerpt. The new archbishop did not approve of elaborate ceremonies with extensive music.[20]

In one of his first actions related to court music, Colloredo appointed Mozart, now sixteen, as *Konzertmeister*, with a yearly salary of 150 florins. (He had for a couple of years held the title honorarily, without salary.) There were few exact requirements, mainly that he would play violin in the court orchestra and take over its direction if needed, which it rarely was.[21] It was hoped that he would compose something useful now and then for court or Church. At the same time, Colloredo was agreeable to Mozart father and son once again heading for Italy to mount *Lucio Silla* in Milan.

As Nannerl later recalled, there was a new health scare in 1772: Wolfgang looked sickly and yellow for a while. It was probably jaundice, not a small thing, but it was his last significant illness for years to come.[22] In any case, sickness did not much affect his composing. One effort of early 1772 was three pieces for strings in four parts, K. 136–38. On the score, he labeled each of them "divertimentos," a general title not implying much other than something light and pleasant. Likely they were intended for *Hausmusik* around town. Later they picked up the nickname "Salzburg Symphonies," but it's not certain whether he intended them for four single strings or an ensemble. Why these pieces should be more sure-handed and original than the string quartets he would be writing in these years is curious. Perhaps writing for a quartet of strings not exactly in the genre of string quartet, he was less distracted by influences.

These divertimentos are, perhaps, the first pieces Mozart wrote to make a claim on immortality, though he would hardly have thought of them in such grand terms. He would have thought of them as pieces of work that were fun and, come to think of it, turned out pretty well. Mozart as a teenager was accomplished at producing things facile and

attractive in fashionable styles, but in these divertimentos, there is a kind of effortless perfection so easily worn that they seem almost to have written themselves. And they are fresh, incomparably his own. As an example, the F-major K. 138 has nimble and tuneful outer movements, with a delightfully wry finale and an inner movement of a trancelike, nocturnal beauty unique to Mozart. It is like a yearning dream. In music of this concentration, the whole must flow as inevitably as water; not one note can be out of place, or the spell is broken. At sixteen, Mozart was already one of the finest of melodists, but more important, he was creating art capable of making life sweeter, more poignant, more intense.

The Mozarts left Salzburg for Milan on August 13, again traveling fast, but there was still time for Wolfgang to play organ for admirers in Innsbruck and to report home: "We are now already in Botzen," he wrote his sister. "I'm thirsty, I'm sleepy, I'm lazy, but I am well . . . Botzen is a shit hole . . . Before I come back to Botzen—ugh / I'd rather smack myself in the mug."—except the term he uses for "mug/face," *d'fozen*, is another of his puns. *Fotzen* is also a German vulgarism for the female parts. So an equally valid translation would be: "Before I come back to this Botzen spot / I'd rather smack myself in the twat."[23]

Father and son reached Milan on November 4, and Wolfgang plunged into *Lucio Silla*, written, like *Mitridate*, for the Teatro Regio Ducale. There were no worries about the deadline. This was more or less his seventh opera, and he could manage formidable feats of work. During the preparations for the premiere there would arise the expected surprises, for well and ill. He had done some of the tedious but exacting business of writing the recitatives in Salzburg, but now he wanted to make alterations on them. The libretto became troublesome, shifting around on him. Author Giovanni de Gamerra had sent it to the master Metastasio in Vienna, for approval and suggestions. The old man made a great many changes and added a new scene in the second act, which Wolfgang now had to work in.[24] While he waited for the libretto to settle down and the principals to arrive, Mozart tinkered with recitatives and wrote the overture.[25]

Once again he was sitting up into the night, moving between keyboard and writing table, his quill scratching away, his fingers aching, inking tens of thousands of notes, every one of them a choice, a de-

cision, that would finally add up to an opera. Yet he still had time for puckish notes to Nannerl. In December just before the premiere, he wrote her a letter headed by one of his rough drawings, showing a backside from which emerges a billowing cloud of flatulence and a little bird flying away holding in its beak a banner reading, "Fly to my child and suck from front or behind." After each line of the letter, he rotated the page and wrote the next upside down, so it had to be read likewise. The letter verges on hallucinatory:

> I hope you are doing well, my dearest sister. By the time you re-
> ceive this letter, my dear sister, on that evening my opera will go
> on. Think of me, my dear sister, and imagine, my dear sister, as
> hard as you can that you are seeing and hearing it as well, my dear
> sister . . . tomorrow we are eating at Herr v. Mayer's, and why do
> you think? Guess. Because he invited us . . . We left today to go
> home from Count Firmian's place, and when we came into our
> street, we opened the door to our house, and what do you think
> happened? We went inside. Farewell, my little lung. I kiss you,
> my liver, and remain at all times, my stomach, your unworthy
> brother Wolfgang, frater, please, please, dear Sister, something is
> biting me, come and scratch me.[26]

Does this letter suggest some unhealthy intimacy between brother and sister? Most likely not. It was Wolfgang's habit to be inappropriately flirtatious with various people, later including their sixty-something-year-old landlady. And at sixteen, he was showing his age when it came to girls in general. In another letter to Nannerl, he asks her to give his best to a damsel in town, and in a later one he thanks her for the favor. Now as in the midst of big projects in future years, his wit could some-times become childish to an alarming degree. It is as if matters in his head were boiling so hard that all he could summon for human com-munication was surface froth, his inner Hanswurst breaking through.

AS *LUCIO SILLA* NEARED COMPLETION THERE AROSE ASSORTED ACTS of God. The experienced tenor contracted for the title role fell ill and there was a scramble to find another one, who in any case would

arrive precariously late. The only tenor who could be secured was one Bassano Morgnoni, a church singer with little stage experience.[27] The prima donna, the celebrated Anna de Amicis, was delayed for days by flooded roads on the way from Venice. Of course the arias for both principals could not be composed until they arrived and Mozart could hear them sing. It remained absolutely necessary to tailor the music to each singer's voice, to accentuate their positives and paint over their negatives as musicians and actors. As it turned out, the dramatic abilities of tenor Morgnoni were one large, hefty negative.

Another potential snag emerged with de Amicis, over whose singing Mozart had raved after hearing her in Naples in 1770. She apparently did not know much if anything about Mozart, so when she saw this diminutive teenager, it appeared preposterous to her that he was the composer of the opera. She decided to be gracious with the child. The story runs that she took Mozart gently by the hand and asked him to explain to her his ideas about the arias and the scenes in which she appeared, and she would take care of composing her arias herself. Mozart smiled agreeably. Then he went home and started writing her arias. At the first rehearsal he apologized to the soprano, saying that he had somehow written her first number already, and here it was. De Amicis seems to have had good instincts. She looked over the music, quickly realized what she was dealing with, and apologized profusely. Afterward there were no more problems from that quarter. Wrote Leopold, "De Amicis is our best friend. She sings and acts like an angel and is extremely pleased because Wolfgang has served her extraordinarily well."[28]

More good news came with the arrival of the *primo uomo*, twenty-six-year-old castrato Venanzio Rauzzini , who was to sing the part of Cecilio. As per his reputation, he turned out to be a splendid musician, with a sweet and flexible voice of considerable range, also an able harpsichordist and composer. On the other side of the ledger, Rauzzini would prove something of a wily backstage schemer. Still, he and Mozart hit it off, and the younger man had a new castrato to admire to replace the aging and disappointing Manzuoli.

Lucio Silla was the first new libretto with which Mozart worked. (J. C. Bach set it two years later.)[29] It has a motley plot, even for an opera seria. There are murderous schemes and counterschemes, the usual

thwarted lovers, the usual king failing on the job for bad reasons. The gist is this: Lucio Silla, a Roman tyrant, has banished his enemy Senator Cecilio from Rome. In secret, Cecilio returns to Rome to marry his beloved Giunia, for whom, wouldn't you know, Lucio Silla has a seething passion. Lucio leans heavily on Giunia, everybody wants to kill Lucio, nobody succeeds. In the last minutes of the six-hour opera, Lucio suddenly and inexplicably decides to turn into a good egg, blesses the union of Cecilio and Giunia, and gives up the dictator business. This sort of happy turn, however dramatically improbable, was a necessity of opera seria: the king must relent, and the result must be peace and happiness in the kingdom because that is the purpose of kings, and the happy ending leaves the audience to go home cheerfully whistling the tunes.

Mozart's music for *Lucio Silla* is not so much an advance on *Mitridate* as a settling in of his maturity. The melodies are sure-handed, the orchestral sound rich and varied beyond most of the time's composers. There is an indefatigable—call it wholly Mozartian—rhythmic energy in the accompaniments. Mozart still does not have much sense of developing a character through an opera, but his skill at expressing a text and a character at a given moment is reliably deft.

The first aria, for Lucio Cinna, the second castrato, conjures a jubilant atmosphere to convey the main sentiment of the text: "Come whither love would guide thee / Come, already I sense in my breast / The lofty aspirations / Of thy approaching joy." In his earlier dramatic work, Mozart had already mastered one of the great challenges of opera: writing music that minutely evoked the feelings of the text from moment to moment—no less the imagery, the setting, and the action—while at the same time shaping music that was coherent and logical in its own terms. Which is to say that an operatic number should make musical sense even if the words were removed. Mozart had also begun to attack the static recitative/aria, recitative/aria pattern of opera seria. At times he used—as did Gluck—orchestrally accompanied rather than simple recitative to link arias, diminishing the distinction between recitative and aria and so smoothing the flow of the music.

The musical high point of the opera is the graveyard scene that ends the first act. It is set in subterranean chambers filled with monuments to Roman heroes. Cecilio has a haunted recitative accompanied

by chilling strings, "Morte, morte fatal"—"Death, thou that shapest man's destiny, / Those whom thy chill hand has seized / Slumber in these cold vaults." In its richness of harmony and expressive orchestration, including trombones in their lugubrious mode, this scene could have been written fifty years later. The number also makes good use of Rauzzini's ringing soprano. It segues seamlessly into a recognition scene, starting with a chorus. Cecilio's love, Giunia, enters and sings to the spirit of her late father. When Cecilio reveals himself, at first Giunia takes him for a phantom. For this scene, prima donna de Amicis got a gorgeous aria to show off her lyrical gifts; at the same time, the music piercingly paints her mournful address to her father. After a chorus, the two sopranos, female and castrato, sing a brilliant duet, their voices ascending together into the heights.

This extended scene, made of a great variety of elements, adds up to a striking end for act 1. As an opera composer Mozart is homing in on the ends of acts as points of climactic intensity, something at which he will become the greatest of masters. And now, within the constraints of an hours-long "number," opera made up of separate parts that can be shuffled, omitted, replaced as needed, he is beginning to think more about the shape of the whole: the first act ends with the extended grave-yard scene climaxing in a duet; the second act ends with a trio, the third act with a quartet and chorus.[30]

Another challenge of opera for a composer is the way practical problems invariably contend with musical ones. With stand-in tenor Morgnoni being manifestly limited both vocally and dramatically, Mozart had to write his deficiencies into the music no less attentively than he did the dazzling singing and elegant acting of de Amicis and Rauzzini. Ultimately Mozart took an expedient route and trimmed Morgnoni's arias from four to two. As a result, the tyrant for whom the opera is named comes off as rather more stolid than menacing, and is mostly offstage anyway.

Lucio Silla did not get an easy launch at its premiere on December 26, 1772. To begin with, the show could not commence until the arrival in the hall of the glorious and benevolent archduke and archduchess. But the archduke had felt moved to write some New Year's greetings to the emperor and empress in Vienna. This occupied him for no fewer than three hours, while the audience in the hall sweltered and stewed and

swore. During the performance itself, Morgnoni's deficiencies were exposed. When Lucio Silla was supposed to make a gesture of aggravation to Giunia, he overacted so absurdly that the audience cracked up. De Amicis had no idea why they were laughing or at whom, and for the rest of the night she was thrown off her form. Meanwhile, *primo uomo* Rauzzini, perhaps determined to take the prima donna down a peg, had informed the archduchess that he was terribly nervous and needed encouragement from the royal family. So when Rauzzini made his entrance onstage, the archduchess, whom he had primed for this moment, made a great show of applauding to reassure him, which naturally the audience echoed. Rauzzini thereby got a grander ovation than the prima donna, at which she was most displeased. Finally, because of the delay at the start, the opera, with its three huge ballets, did not end until 2 a.m.

Somehow in the end, these contrapuntal cockups did not sink *Lucio Silla*. Next day the royals had de Amicis to the palace and spent an hour royally buttering her up one side and down the other. From then on she was in top form. What finally took shape was an even bigger hit than *Mitridate*. *Lucio Silla* ran for a total of twenty-six performances to full houses, with the prima donna's arias regularly encored. (This happened often in those days; leading singers expected encores as their due.)[31]

And then, like *Mitridate*, *Lucio Silla* sank from sight in Mozart's life, never to rise again. This in fact happened to most operas of the day. There is no evidence that he ever tried to revive either work, though later he did pull out a couple of arias from *Lucio Silla* to impress a girl.

IN JANUARY 1773, JUST BEFORE HIS SEVENTEENTH BIRTHDAY, MOZART tossed off another gem, this one for castrato Rauzzini , clearly a tribute to him. Rauzzini was the kind of singer who gives a composer good notes. The piece was the three-movement *Exsultate, jubilate*, K. 165, on an ad hoc Latin text of general jubilation: "Rejoice, resound with joy, / O you blessed souls, / Singing sweet songs, / In response to your singing / Let the heavens sing forth with me." Rauzzini premiered it at Milan's Theatine Church on January 17, two days after Mozart finished it. The accompaniment is strings and pairs of oboes and horns. It's a

tough assignment, to write something that lives up to the poem's image of heavenly collaboration, but the first movement does the job. Mozart wanted to show off Rauzzini's virtuosity in florid passages, but once again, he turns virtuosity into expression, conjuring holy joy spilling over. In the outer movements, there is a place near the end for an improvised cadenza, where the castrato could strut his stuff as extravagantly as he liked. After a brief recitative and a sweetly lyrical slow aria comes a resplendent, unforgettable alleluia. The world, and the world's sopranos, never would forget it. Here once again, Mozart is at his most inspired in melody, the art he learned from the Italians and made his own, outdoing his models.

The manuscript of *Exsultate, jubilate* is grandly signed, "Cavaliere Amadeo Wolfgango Mozart Accademico [*sic*] di Bologna." This sounds like baloney, and it was intended to. As often the case with Mozart, in a piece likely written quickly, the manuscript still has not a single revision or miscopied or unclear note. As a copyist, as in every other aspect of his art, Mozart had an uncanny precision. In the notation as in the music, there is nothing but certainty.

At the end of January father and son took in the second Carnival opera of the season, Giovanni Paisiello's seria *Sismano nel Mogol*, with its then-unusual action finale of act 2. This likely gave Mozart something to ponder in regard to future work. He pondered other matters, too. "In this opera," he wrote Nannerl, "there are to be 24 horses and a great crowd of people on the stage, so that it will be a miracle if some accident does not happen. I like the music." It was not common that he liked a competitor's music, and of course he would have been gleeful if the horses relieved themselves onstage.

At the same time, Leopold sent a sad report home: he had rheumatism so bad he had to stay in bed.[32] Except, as he reported in code to Maria Anna, he was actually feeling dandy and had invented the travail as an excuse not to come home. Salzburg was beginning to wear on both father and son, and they had heard that the new archbishop was hard to get along with. Moreover, Leopold had contacted a grand duke in Florence offering his son and perhaps himself for the duke's service. Leopold assumed his letters to Salzburg were being perused in official circles before being delivered, so he used a code for things he didn't want the archbishop to know. These codes would be used increasingly

in the next years as the family had more and more things to hide from their employer. Still, the code was a simple letter substitution and probably easily figured out at the Salzburg Residenz. That Archbishop Colloredo may have seen through the Mozarts' coded plans and opinions of him in intercepted letters, could explain a lot about his behavior toward them in the coming years. His predecessor Archbishop Schrattenbach had never figured out that on their tours, Leopold was trolling for jobs. Colloredo did.

Leopold's rheumatism excuse was followed by another one claiming that their departure had been delayed by ice in the Tyrolean mountains. Mainly they were waiting for a reply to their offer to Florence. None arrived.[33] Finally they left Milan on May 4, getting to Salzburg on the twelfth. Wolfgang brought home six string quartets he had written in Milan. He had no idea of it, but this time his departure from Italy was final. It had been the scene of some of his most impressive feats and historic triumphs. But no job prospects had turned up, and *Lucio Silla* was the last opera Italy would want from him. He never saw the country again. Its music, meanwhile, had found a lasting place in his art.

After spending two-thirds of his last eleven years on the road, Mozart was now going to be moored in Salzburg for most of the next seven and a half years.[34] Through that time he would be living under, coping with, and increasingly loathing the regime of Archbishop Hieronymus Colloredo.

After a triumphant career as a prodigy, Mozart was now a mature artist with a string of successes to his credit. But when all was said and done, in 1773 where was he? He was writing works a later time would call immortal, but he could himself have had no idea of such a thing. He wrote this and he wrote that, sometimes hitting his best, sometimes not. But to what end? This had been Leopold's concern all along, but more and more it would become Wolfgang's. From his angle of view, where was he, and what was he going to do? In front of him he saw a bit of road, this or that piece to write, but no road stretching into any sort of future. Where was he?

PART II

We need to get out of this place. Our fortune is not here, only frustration and stagnation. I am scorned by a pack of dissolute court musicians and suffer under a ruler who has no respect, no respect for any of us. My boy with his head in his music paper and girls on his mind, will he ever do anything to help our cause, his own cause? No, it still falls on me. How can I get us out of this place?

INERTIA

When Leopold and Wolfgang returned from Italy in March 1773, Wolfgang had no commissions in hand from there or anywhere else. What he had was a low-salaried, largely ceremonial job as a Konzertmeister for the Salzburg court. His salary went to Leopold, who still kept him on an allowance. Leopold for his part was weary of the four-room flat they had been living in for so many years. Now, thanks to the children, he had the means to get something better. For some time he had held off on moving, hoping Wolfgang could find a job at a court in Italy, or anywhere other than Salzburg, with its sleepy court and society, its dissipated musicians and mediocre orchestra. Although the place was hardly a backwater—it was a fairly prosperous city with an active musical life—in practice it had started to feel to Leopold like a cage. All the same, he had been thinking about a bigger residence, which would be at once a relief and a concession that they were stuck in Salzburg for the foreseeable future.[1]

Their frustration would be amplified by the new archbishop, Count Hieronymus Joseph Franz de Paula Colloredo. Colloredo took the throne already with a reputation, and not a cheerful one. His distinguished family had gotten its name from their castle, built in northern Italy in the fourteenth century. His father had been Austrian vice-chancellor of the realm, and Hieronymus had served in capacities including Prince Bishop of Gurk.[2] As a ruler he was ambitious and his ideas progressive: his hero was Joseph II, who as co-ruler with his

mother and then as emperor would prove one of the most enlightened sovereigns in Europe.

When Archbishop Schrattenbach died, Salzburg expected the new ruler to come from among the local nobility. But Vienna wanted Colloredo, son of a vice-councillor of the imperial court, a Viennese who would be close to the throne there. Maria Theresa's son and vice-councillor Joseph stuck to that determination through forty-nine ballots by the electors, until they got what they wanted.[3] When Colloredo became archbishop, he had a long list of things he intended to do and, in the end, largely achieved them. All were in the direction of bringing enlightened Josephinian reforms to his realm. He was one of the few subscribers to the more or less radical newsletter *Correspondance littéraire, philosophique et critique*, put out by the Mozarts' Paris patron Baron Grimm.[4] In his study, the archbishop kept busts of Rousseau and Voltaire.[5]

Colloredo's political convictions might have made him popular in liberal circles, but his personality made him disliked unto hated by Salzburgers of all persuasions, and he scorned them back. As a ruler he was obsequious to superiors, with underlings aloof, haughty, and acerbic. He addressed everyone of lower rank than he as *er*, "he," the third person one used with servants and children. The portraits of Colloredo in the Residenz portray a man sharp and inflexible, hiding behind a smile of forced geniality.

His predecessor Schrattenbach had been conservative and also lackadaisical about finances; he left the court treasury virtually empty. Colloredo intended to deal with that too. Perhaps sensing that he would never win over his people, he did not bother to try, enacting his reforms and austerities by decree. He took steps to protect small farmers from large estate owners, improved medical care, introduced vaccinations, ordained prison reform and shorter trials, promoted secular education over religious, and improved the roads in his territory. Surprisingly, he turned out by no means a puppet of the Viennese throne.

None of it made him popular. Colloredo opened a public theater for productions by traveling troupes, but then closed the university theater, which had employed musicians regularly.[6] In his church reforms he managed to outrage nearly everybody. Over time he banned pilgrimages, decreed shorter Masses, cut back the population of monks by

a third, trimmed all sorts of extravagances in services and weddings, and cut back the number of feast days. As a result, everybody had to work more days in the year, and church services became more austere and less entertaining. Salzburg gossip dubbed him a "secret Lutheran."[7]

Even though the archbishop was personally a music lover and a competent fiddle player who liked to sit in with the orchestra, he discouraged instrumental music in church, decreed shorter concerts in the Residenz, and ordered that music for Masses not exceed forty-five minutes. These moves in the name of piety and frugality went hard on Salzburg musicians, who had to scramble to find new sources of income. In short, the archbishop wanted a cheaper, smoother-running musical establishment, and he did not want his musicians, namely the Mozarts, trotting around Europe looking for jobs.

His tastes in music were Italian, and soon he installed an Italian Kapellmeister, passing over Leopold. Perhaps Colloredo's most egregious early insult to Wolfgang was to opine that he needed to spend some time studying at a conservatory in Naples.[8] He did not mean that he thought Mozart lacked competence, but rather that he wanted this servant to provide more Italian-style music for his court. Wolfgang was of course livid at the suggestion. He came to associate Colloredo's progressivism, his admiration for Voltaire and Rousseau, with the archbishop's oppression. As a result, Mozart would not come out of Salzburg a devotee of the Enlightenment. Eventually, Vienna would teach him otherwise.

For his keep in his last Salzburg years, Mozart wrote some dozen Masses and other sacred music—litanies, choral works, church sonatas for two violins and organ.[9] Most but not all of the Masses conformed to the archbishop's forty-five-minute rule, and they were written for the cathedral orchestra, which had no violas. These efforts cost him little. With the rest of his time, he wrote symphonies and chamber music for use in salons around town, and on some of these he lavished his full attention. He played steadily in private houses, most of the time improvising.[10] In his prodigy years he had simply emitted music, all of it at about the same level of attention and ambition. Now he was a busy professional turning out things to help pay the rent. Some of those pieces worked out splendidly all the same, but often he needed something to prod him, to get the juices fully flowing.

THE SIX STRING QUARTETS K. 155–60 THAT MOZART BROUGHT HOME from Milan in late 1772 and early 1773 are more a matter of potential than maturity, which is to say that they are not at the level of the symphonies he was writing in those years. All these quartets follow the Italian three-movement pattern and are centered on the first violin, the cello playing a simple bass line, the second violin and viola largely filler. As with his piano-centric violin sonatas, this was partly a concession to practicality: at an amateur salon, you couldn't count on finding two good violinists and a good violist. In his use of sonata form, Mozart still tends to treat the development section as a brief harmonic palate cleanser before the recapitulation, and he doesn't embark on the kind of contrapuntal elaboration by then often found in his symphony developments. What attractiveness these pieces have is due largely to his gift as a melodist, and much of that appeal is found in the slow movements; there as in other works around that time, he can be touching beyond his years and is sometimes at his most original.

In the spring of 1773, Mozart was unproductive by his extravagant standards—a short Mass, a light divertimento, four symphonies that break no new ground, though they have a certain weightiness of tone on the verge of his full maturity as a symphonist, which as it turned out was only months away. At some point a restless Leopold decreed another trip to Vienna, to see if Wolfgang could find some entry into a job there at court or Church. Anything but Salzburg. He may have gotten word from Vienna that court Kapellmeister Florian Gassmann was failing; when he died, the position would surely go to a composer in town, but that person's ascent might leave a post to be filled. If Leopold had known that Empress Maria Theresa had dismissed the Mozarts to her son as traveling beggars, he might not have bothered returning to Vienna. In any case, from the beginning a certain air of desperation hung around this trip.

Archbishop Colloredo agreed to the Vienna trip in part because he was going there himself to visit the royals and his indisposed father.[11] Leopold and son left Salzburg on July 14, heading east on familiar roads; in Vienna, they roomed with a friend they had known in Salzburg.[12] At an audience Colloredo allowed them to extend their visit. There was also an audience with the empress. Having been warm and

generous to the child Wolfgang, now she gave them nothing but a politely chilly reception.[13]

Mainly they spent time with old friends, the families of Franz Anton and Joseph Mesmer, who had been patrons for Wolfgang's childhood visit. Anton had not yet begun his notorious experiments with animal magnetism as a cure for all ills, but he was already, as a physician, moving in occult directions. His Vienna estate, provided by his splendidly rich wife, had a fabulous garden decked out with statues, an aviary, a theater, and a belvedere looking out over the trees of the Prater park.[14]

Franz Anton Mesmer was highly musical, skilled in, among other things, the glass armonica. This instrument, invented by Benjamin Franklin, consisted of a series of sideways-nested tuned glasses inside a box partly filled with water. One turned the glasses with a treadle and played with a delicate touch of the fingers. It produced, in other words, the familiar effect of a wet finger run along a crystal glass, but from an instrument that could play whole pieces. Its otherworldly tones were well suited to the moony Mesmer. Naturally Wolfgang tried his hand at the instrument; Leopold wrote home that he wished he could buy one.[15]

Concerning his hopes for this tour, Leopold played cagier than ever in his letters home; he knew they were likely to be read in the Residenz. He did not write about what had to be his mounting frustration at turning up nothing in Vienna for his son. Meanwhile Wolfgang, as usual, appeared cheerfully oblivious to the practicalities, busy studying Viennese scores, writing a new series of string quartets, and dispatching puckish letters to his sister. In contrast to his childhood letters detailing and critiquing music he had heard, his later epistolary leanings ran to sometimes rabid obscenity and deadpan satire. In the latter mode, he wrote Nannerl in the middle of August, his tone skewering the didactic rhetoric of the Enlightenment:

> I hope, my queen, that you are enjoying the highest degree of health and yet now and then or rather once in a while or better occasionally or still better qualche volta, as the Italians say, you will sacrifice for me some of your deep and important thoughts, which always issue from that reasoning mind of yours, which is both pleasant and penetrating and which you possess in addition

to your beauty, although you are so tender in years and so little
is expected of the aforementioned things from members of your
sex.[16]

A week later, he is still in this mood:

If one contemplates the benevolence of Time while not com-
pletely ignoring the high esteem rendered by the sun, it becomes
rather evident that I am well, god be praised and thanked. How-
ever, the second part of this sentence could also be written quite
differently; instead of sun, let's put Moon, and instead of benevo-
lence, art; now, anyone who is endowed with even a minimum of
natural reason will have to conclude that I am an idiot, especially
since you are my sister.[17]

The latter he concludes in retrograde: "oidda,—gnagflow Tra-
zom / neiw ned 12 tsugua 1771." He knew the contrapuntal device of
retrograde, in which a theme is turned backward—as he termed it,
"arsewise." Often he applied musical principles to his prose, to some-
times startling, sometimes hilarious effect. He was writing Nannerl in
1772, but with cunning subtlety he dates the letter as 1771, which is
nonretrogradable—the same backward as forward.

During the Vienna visit Leopold made sure to secure some fash-
ionable corselets, caps, and the like for Nannerl.[18] If his daughter was
no longer a traveling prodigy, she still dressed like one, including
hairstyles in the manner of aristocratic French ladies, which got piled
higher by the year.

In his early travels, Mozart, upon arriving in a town, would soak up
work by local composers. Now in Vienna the composers he studied in-
cluded Johann Baptist Vanhal and possibly Haydn.[19] Mozart was about
to make a decisive turn in his music, and various models helped spark
it. Another anticipation of the future took shape when he apparently
saw and liked the opera La fiera di Venezia, by Antonio Salieri, well
established in Vienna at age twenty-three, and wrote some variations
on a tune from it.[20]

Six string quartets Mozart produced in Vienna on this visit are a
mixed bag like his symphonies of the time, but among them are the first

of his quartets that can claim to be taken seriously. We find the new sophistication right away in the first of the quartets, K. 168 in F Major: a leading tune supported by three real contrapuntal parts, in an opening nine-bar phrase. The ensuing phrases keep skirting the standard four bars, and they involve steady imitation of ideas among the upper three players. There is a wryly worrying second theme like the buzzing of a fly. A longer development than usual for him is consistently contrapuntal and approaches what later Haydn developments amount to: not a short harmonic palate cleanser but a longer quasi-improvisation on themes of the exposition. Next comes an Andante in F minor, all four instruments with mutes on, which begins with a four-part canon that verges on eerie in effect. After a strutting, banish-cares Minuet, the quartet's finale takes shape as a short but full-throated and dashing fugue. If it can be argued that harmony is the heart of music and counterpoint the soul, in his quartets Mozart is becoming more soulful.

The last quartet, in D minor, K. 173, crowns the set. Again, in music the later eighteenth century was a major-key age, not all that given to tragedy, melancholy, or the dark side in general. A minority of pieces were in minor keys; on average, a set of six quartets would have just one in minor. While the driving and demonic tone characteristic of Mozart's works in G minor is apparent all the way back to pieces in his childhood, his D minor seems dark in another way, as heard in the brooding opening of K. 173. It moves quickly to a repeated-note figure that will persist. For Mozart and his time, dancing repeated notes were a mark of energy and exuberance; here they are something otherwise: a kind of pounding obsession.

In these works he is beginning to pay more attention to overall moods and relationships in multi-movement pieces. The tone of brooding and obsession that marks the first movement abides through the rest of the D Minor. The repeated-note obsession figure that ends the first movement is taken up on the same pitch by the second movement, in D major and Andantino grazioso, but its gracefulness is tempered by an undercurrent of—call it uncertainty, a sense of a fly somewhere in the ointment. More striking is the third-movement Minuet, back in D minor, still with a touch of obsessive pounding but more a shadowed take on the old elegant dance. Its trio seems to provide some F-major relief, but an aggressive F minor intrudes. The D-minor finale has

another vision of obsession: it is a fugue whose theme is a chromatic scale slithering fatefully downward, which never departs. For virtually the first time in Mozart's quartets, here the cello is a melodic voice in full standing with the others.

The question is whether the advances of these quartets had to do with Mozart studying Haydn quartets in general, and in particular Haydn's revolutionary Op. 20 set. There the older master first laid out the future course of the string quartet: instead of more or less an accompanied solo for the first violin, it is now what was called a conversation among four equals. There is a freer treatment of form, moving away from steady adherence to regular sonata form and regular four-bar phrasing; more intensity of expression; more counterpoint.

All these elements are found in Mozart's six Vienna quartets of 1773, in some degree or other, but whether they really came from Haydn is another matter. Haydn's Op. 20 was written in 1772 but not published until two years later, in Paris. Mozart did not meet Haydn on this Vienna visit. He could only have seen Op. 20 in manuscript—possible, but unlikely.[21] It is more likely that, on his own, Mozart was moving in Haydn's direction, so when he finally did get to know Haydn in person and on the page, he was primed for the impact. But that impact would not arrive until his next set, nearly a decade later.

Probably trolling for work in Vienna, Leopold arranged a couple of church appearances for Wolfgang and his music. On August 8 he was to play organ at St. Cajetan's monastery, but the instrument was out of sorts, so he borrowed a violin to play a concerto, possibly his own, possibly K. 207.[22] The next day, Leopold conducted Wolfgang's *Dominicus* Mass K. 66 at the Jesuit church. But no job leads appeared, and Leopold gave up. At the end of September, father and son straggled back to Salzburg, once again nothing accomplished. Wolfgang would be mired in Salzburg most of the next four years.

STILL, WOLFGANG ARRIVED HOME ABSOLUTELY FULL OF JUICE. WHILE his son settled down to work, Leopold acted on the plan he had been contemplating for a year: he secured a spacious second-floor apartment on Hannibalplatz (later Makartplatz), a neighborhood favored by the aristocracy. The building was known as the Tanzmeisterhaus because

it had once been the home of a French dancing master who taught his students in the main room, which sported elaborate plasterwork on the ceiling and was big enough to function as a ballroom. In his early Salzburg years Leopold had played violin at masked balls in the house.[23] The Mozarts rented the Tanzmeisterhaus from an Anna Maria Raab, who had inherited it from a cousin who also taught dance.[24]

After years of sleeping in one room in a plain flat, the family now had an eight-room apartment with eight woodstoves, some of them the ornately tiled ones called *Kachelöfen*. Parents and children each had a warm and roomy bedroom to themselves. The children, after all, had largely paid for it. There was a kitchen and a room for two servants. Leopold installed his library, which included histories of the Papacy, the comedies of Plautus in Latin, a huge European travel lexicon, and books of music theory and history.[25] In the back was a garden suitable for shooting matches and the bowling game of skittles. The house lay across the Salzach from Old Salzburg. Walking to the covered bridge over the river, they could look up to see the spreading castle of Hohensalzburg on its crag, presiding over the town.

The big central room of the Tanzmeisterhaus served multiple purposes. Leopold used it as a showroom to deal in harpsichords and clavichords. (Pianos were still rare in Salzburg.) It made a perfect space for music making among friends and became the setting for the family's various amusements: dancing, card and board games. Sundays and religious holidays were given to the popular Austrian pastime called *Bölzlschiessen*, "bolt shooting." In Salzburg, the sport was usually pursued on Sundays and holidays because in the name of piety, Archbishop Colloredo had banned on those days any sort of public or private entertainment before 4 p.m., which included all games and music but for some reason did not include target shooting.

Bölzlschiessen involved an iron-barreled air rifle some four feet long, pumped up with an accompanying gadget, and metal bolts with pig bristle fins. The rifles were not all that accurate, so the shooting was from a range of nine or so yards, at a homemade target, so it could be done both outside and in. The painted targets, made of wood or paper, ranged from family portraits—one depicted Nannerl at the harpsichord and at her feet Bimperl, the family's beloved fox terrier—to assorted ribbing and ribaldry, often with accompanying

prose. Wolfgang's contributions to the targets might involve bare backsides.

Of course, with *Bölzlschiessen* people did not just assemble ad hoc and fire away. This was the late eighteenth century, which wanted to rationalize and codify just about anything. *Bölzlschiessen* was carried on with the most remarkable rigmaroles. Each family had a formal shooting society, with enrolled members. The rules and ceremonies involved a pecking order: turns were taken as *Bestgeber*, or "best giver," who organized the event, supplied the prize money, saw to the target, and provided snacks and drinks. (Each member kept a kitty for the purpose.) Outcomes of each contest were dutifully entered into a book, necessary partly because, as with all games, there was money at stake. The winner of a round was called *Die Beste*, and the prize was a remarkable one florin at a time when two hundred florins per annum could put you on the verge of middle class.

At one point Wolfgang had a hundred florins in his own shooting kitty, more than the annual rent on the Tanzmeisterhaus. The schedule of shootings was strictly upheld; if you were not present to shoot, somebody would be deputized to stand in for you, but you still had to pay if your substitute lost. For all his manifest physical coordination, Wolfgang seems to have been not such a great shot; there are few records of his winning a match. And there would be an extensive record: in his letters and his sister's later diary, one finds over a hundred mentions of shooting afternoons, far more than mentions of music.[26]

The intricate malarkey of *Bölzlschiessen* was one on a long list of things one pursued in the daily round of Salzburg life, in which you had to work for your fun. The diary that Nannerl began in 1775 details the routines of the days for herself and the family. In the evenings there was often theater, convenient because the town theater, established by the archbishop, was across busy Hannibalplatz from the Tanzmeisterhaus. It was on the small side, with some seven hundred seats, but big enough for Salzburg.[27]

Because Colloredo's court supported no theater or opera company, as some thrones did, shows were mounted by visiting dramatic and operatic troupes. In drama, Nannerl most liked weepers that would keep her in tears throughout. Her diary records daily attendance at Mass in the morning, walks with Bimperl and with friends, balls, the visit

of an elephant to the town, and the details of shooting matches: "On Sunday we had Bölzlschiessen, Papa was Bestgeber, I shot for Mamma and she lost 9 florins, [Maria Gilowsky] shot and won Die Beste."[28] The family was making music regularly, but Nannerl rarely mentions it in her diary.

Near the beginning of the diary she notes that "my brother fell in some filth." This appears to have involved cow leavings. After that note, another voice appears: her brother's. From the diary's beginnings, Wolfgang was in the habit of writing in it, usually as if in his sister's voice, but with his distinctive concerns. Here to gloss his sister's notation, he appended a little poem,

In his red-bordered duds;
My heart is sore.
Nannerl was not around
Nearby or in the pasture.

A later diary entry is entirely his, beginning in his sister's voice and in an imitation of her hand: "7 a.m. mass, afterward with the little fräuleins and fr. v. maÿer . . . at 6 a walk with Papa and Pimperl." (They spelled the dog's name variously.) Bit by bit he turns the scene eccentric: "The sun is sleeping in a sack, at ten it rained with a pleasant smell—the clouds lost themselves, the moon allowed itself to be seen, a fart allowed itself to be heard."[29]

In short, the family had a busy, pleasant, sociable life centered in a spacious and comfortable residence. Leopold was at least in part resigned to being stuck in Salzburg, Wolfgang composing away more for private performances than for Church or court. The Colloredo regime only slowly began to get on his nerves. As for Nannerl, then and later she did what Papa told her to do.

Mozart proved brilliantly productive in the months around the beginning of 1774. Among the works of the period was his first string quintet, K. 174, modeled after some recent quintets of Michael Haydn and as such something of a hybrid.[30] Its material is more attractive than memorable, but in some respects the piece is more adventurous than his recent Vienna quartets. The extra viola makes for richer textures and colors. The upper three parts of the quintet are busier than in his

quartets—trading off ideas, doubling in octaves, breaking into coun-
terpoint. As if in deference to his betters above, the cello largely sticks
to the bass line. There is a sense that, for whatever reason, Mozart
feels freer and more adventurous in string quintets than quartets. He
always would be. In these years, he wrote two pieces for clavier four
hands, presumably for himself and his sister, in D and B-flat major. The
D-major K. 381 might be called a product of the teasing relationship he
and Nannerl had in those days, a pretty slow movement framed by two
movements filled with nose-thumbing tunes.

Wolfgang's maturity at age seventeen had been demonstrated in
October of the year before, when he produced his first unforgettable
symphony, No. 25 in G Minor, K. 183. From the driving syncopations
of its opening, outlining a stark theme, and the stabbing four-octave
figure that follows, this is an atmosphere new to him in its sound and in
its gravity. A vital part of the atmosphere is four horns, arranged in two
keys so the instruments can together manage more notes of the scale,
and so play more melodically than usual with open horns. In the eigh-
teenth century, orchestral horns mostly played drones as a sort of tex-
tural glue, supplied rhythmic figures, or played stately or folksy themes
in their characteristic "horn fifth" harmony. In the G-minor Symphony
the horns are strident and something on the order of alarming.

Where did this tone come from? For one thing, from Mozart's
sensitivity to his time's ideas about the character of keys. This is his
first symphony in minor. That alone makes it distinct, but this is also
G minor, which moved him in particular ways. Later comment would
say that this symphony shows the impact on Mozart of the German
Sturm und Drang, "storm and stress," movement that flared in the 1770s
to trouble the balance and rationality of the Age of Reason. A response
to a mélange of impulses that included Rousseau's back-to-nature ideas
and the new translations of Shakespeare, Sturm und Drang proclaimed
the primacy of the transgressive and irrational. "Steep yourself in
chaos!" cried a character in the Friedrich von Klinger drama that gave
the movement its name.

Sturm und Drang affected a number of composers of the 1770s and
'80s, most notably Haydn. His music in that direction turned to more
minor keys, more intense emotion, gestures that threatened the form
and the integrity of the work itself. An example is the end of Haydn's

Farewell Symphony, in which the musicians, one at a time, pack up their instruments and leave the stage until only two violins are left. This was a hint to his employer that it was time for the musicians' vacation, but the effect comes off as bizarre as it is funny. Whereas balance, restraint, universality were fundamental to the late eighteenth-century Classical style, the disturbing, uncanny, and defiantly individual were fundamental to Sturm und Drang: Goethe's novelistic hero in *The Sorrows of Young Werther*, who kills himself from frustrated love for a friend's betrothed; the bloody denouement of Schiller's play *The Robbers*, which at its premiere had men in the audience screaming and women fainting.

Was Mozart's first G-minor symphony—there would be a later one in the key, even more haunted—inflected by Sturm und Drang? In fact, probably not. Whether by that point he knew Haydn's works in that direction is moot, but Goethe's *Werther* did not appear until the next year, Klinger's play *Sturm und Drang* premiered in 1776, and Schiller's *Robbers* not until 1781. True, when Mozart wrote the G Minor in 1773, there was likely a whiff of Sturm und Drang in the zeitgeist, but it was not fully developed, and there is no real record of his contact with it.[31]

Did the piece reflect some personal anguish of his at the time? If so, there is no account of it, nor of an event that might have distressed him. The reality is that Mozart did not require tragic feelings at the moment to write a tragic work, or any other territory of emotion. What the G-minor Symphony more likely involves is what that tonality did to Mozart's personal tonality. He did not impose his feelings on the piece; the key and the ideas imposed their feelings on him.

Arguably this could be a model for most of his art. In his operas it is the characters and situations that evoke their music, not a drive to heap his own feelings on them. Artists in Mozart's day were not trying to express themselves. Mozart's G-minor mood was already in place in one of the London Notebook sketches he produced at eight years old. From that point on, his sense of the key was steady. It was as if G minor had invaded his sensibility, taking him to places in his personal and creative consciousness that were acquainted with obsession, tragedy, sorrow, wrath.

The G-minor Symphony has further advances, but not necessarily ones that finally settled into his work. He was certainly aware that there needed to be relationships between movements in multi-movement

pieces, but how and why his pieces fit together in this period is some-times ineffable, the answer to the question "As a whole, what makes this piece this piece?" hard to pin down. In this symphony, though, the mood of G minor tempers the whole. It is a work of rage and pain from beginning to end, with one stretch of relief: the demonic first move-ment is followed by a gentle Andante in E-flat major that provides a stretch of solace. (It features the first soloistic bassoon parts in his sym-phonies.)[32] The Minuet returns to G minor and comes off as startlingly aggressive and foreboding for that old courtly dance. The finale begins nervously and builds to towering fury. At the end, there is no hopeful turn to G major, rather a final G-minor chord marked "fortissimo," a rare and extreme indication for Mozart.

Also holding these movements together are thematic echoes that are not always evident in his works of those years. It was later, when he studied Haydn intensely, that he fully grasped the technique of unify-ing a work by taking a motif, or two or three, and using them as seeds of a whole work. (His later G-minor Symphony would be a case in point.) Perhaps the connections in the earlier G Minor are unconscious, but they are there in, first, the way the baleful four-octave turn figure of the fifth measure is reflected in the rest of the piece, and second, in the lashing syncopations of the beginning that return in the finale.

Finally, with this symphony Mozart began his true escape from three forces that had held him back. First was the elegant but often shallow posture of the galant, incompatible with the kind of ardor heard in this symphony. Mozart would wield the galant tone for the rest of his life, most often in workaday pieces, but his more ambitious ones might use the galant as in effect a baseline from which to depart. (Haydn did like-wise, and maybe that is where Mozart learned how to do it.) The second escape was from the buffa atmosphere of Italian symphonies, including his own in that style. The final escape was from the limited world of the salon. The G-minor Symphony could be played by a little *Hausmusik* orchestra, but the emotions are too big for those forces and too stormy for that milieu.

The symphonies before and after the G Minor are perfectly amiable, but they gain no particular ground. Some of them return to the obsoles-cent three-conjoined-movement pattern of the Italian opera overture. Mozart knew well enough when he was boiling the pot and when he

was not, when he was suiting himself and when suiting others. As he once put it, in characteristic terms, "If necessary, I go in the direction circumstances demand; when I have diarrhea I run, and when I can no longer contain myself, I shit in my pants."[33]

In April 1774 came another of the early great works, the four-movement Symphony in A Major, K. 201. Call it a gentle riposte to the furies of the G Minor. It begins just as memorably, but softly and with a lilting and rising theme of marvelous grace, like a lover whispering in your ear. The theme in the first violins is supported by warm counter-point in the lower strings. This is a work bathed in summer sun, with a big, lyrical second movement, a staunchly striding Minuet, a spirited 6/8 finale in the mode of a "hunt" piece. In this symphony, develop-ments are back to the short side; there are no overt thematic echoes—other than that big sections tend to end with some kind of single-voice afterthought, the one in the finale being a jokey and inexplicable forte, upward-dashing scale that erupts here and there all the way to the last bars. Mozart was eighteen when he created this symphony. He never wrote anything more warmhearted and amicable.

MUCH OF WHAT MOZART PRODUCED IN THE FIRST MONTHS OF 1774 WAS works for Church and court—serenatas, short Masses, small sacred works. Whether he was impatient with these duties at this point would not be recorded, but Leopold's unhappiness was. The aged court Kapellmeister Giuseppe Francesco Lolli was slowing down, so the archbishop appointed an assistant who would be in place to take over—Domenico Fischietti, another Italian. Leopold had been sure that this time he would get the nod. What else could he have done, he thought, to make him worthy of being Kapellmeister? To surmise some reasons he was passed over: Leopold was not Italian, and Colloredo wanted Italians and Italian-style music; he had not composed in years; he had spent much of the last dozen years out of town; he could hardly hide his scorn for most of the other town musicians. Colloredo probably knew that Leopold had been fishing for another job for his son and possibly for himself. From the archbishop's point of view, these were reasons enough. Leopold nursed a sense of injury about it for the rest of his life, his disgust aimed squarely at the archbishop.[34]

In the spring or summer of 1774, a new offer appeared for Wolfgang: an opera, not for Salzburg but rather the second opera for the next Carnival in Munich. The first Carnival operas were generally serias, like the ones he wrote in Italy. This commission was for the second offering, generally a buffa.

Mozart had no idea yet and may never have admitted it, but buffa was going to be his main métier on the stage. His wit, his often-mordant scrutiny of people and their foibles, his fascination with the frenzies of love and lovemaking—all this made him the consummate composer of buffa; likewise his indefatigable energy on the page and in person, his deft painting of character and incident and movement. The characters and settings in buffa were not from the past but were instead contemporary, usually with an upstairs/downstairs conflict of classes involved. And there were none of the obstinate musical conventions of seria; in buffa, the handling of aria and recitative could be as free as you liked, as long as it was expressive and coherent. When it came to the singers, in buffa there was less emphasis on vocal display, which in seria had to supply some of the excitement the fusty stories lacked. The music for singers in buffa was mainly about character and melody, and Mozart was one of the greatest of tunesmiths.

In September he got the libretto, *La finta giardiniera*, and took the requisite time to digest it before he began to compose. That would have taken him a while, because the tale is vertiginous. In stories of all time, the arrows of love have rarely flown more wildly. It's not clear who perpetrated the libretto, but it had been set before by one Pasquale Anfossi, whose work would create some nuisance for Mozart in the next decade.

The title (another of a number of comic *fintas* of the day, and Mozart's second) means "The Pretend Gardener." The person seeing to the garden is Violante, who in real life is the Countess Onesti, now calling herself Sandrina. She had once been the passionate lover of Count Belfiore, but things hadn't worked out so well, she aroused his jealousy, he stabbed her. But Violante survived and is now on the lam, incognito in her picturesque gardening clothes. By the way, she is presumed dead, so the authorities are hunting for Belfiore, who's on the lam too. Violante is also looking for him, for some reason. Violante/Sandrina is hiding out chez Don Anchise, the mayor of Lagonero. To her annoy-

ance, he's in love with her, which annoys his servant Serpetta because she's hot for the mayor. Sandrina/Violante has a servant, Nardo, also disguised as a gardener, who's sighing for chambermaid Serpetta.

Then there's Ramiro, who was dumped by Arminda, who is now engaged to, of all people, Count Belfiore. With that, *la ronde* is complete. As Belfiore is about to visit Arminda at the mayor's, she innocently tells Violante about her engagement to him, whereupon Violante faints away. She recovers to find herself looking into the very eyes of her bête noire, beloved, whatever: Belfiore. Complications ensue. At one point, and no wonder, Belfiore and Violante appear to have gone insane, imagine they are Greek gods, and break into dance. As it plays out, Sandrina/Violante discovers that, come to think of it, she still loves Belfiore, and never mind the little dagger incident. As buffas must, come what may, all ends well. There's a slight reshuffling of alliances, and nearly everybody ends up content except for the mayor, who has lost his longed-for inamorata, and as if things couldn't get worse, he has to find a new gardener.

In short, this is a most peculiar state of affairs for a comedy, everyone suffering extravagantly from unrequited love or lust, unwelcome discoveries, attempted murder, and what-all. Mozart had to find a tone to accommodate all this trouble and somehow turn it in the direction of funny. It's a buffa, and so he made it a bit antic, with opportunities for singing in comical voices and the like, but more important, there is an underlying essence that makes it all work: things are bad all around, and the music paints that loss and yearning and rage, but most of it with an indefinable musical tongue in cheek. They suffer, they are ridiculous, curtain.

Call *La finta giardiniera*, Mozart's ninth dramatic work, a transitional effort. It is musically mature but not quite operatically so; the libretto is outlandish, and he either didn't know what to do about that or didn't try. He would not make that mistake again. If some of the music borders on routine, there are great moments. Violante, in her first aria, "Noi donne poverine," laments the fate of women to be tortured by love, but perhaps because she is singing in her gardener's disguise to bereft Ramiro, the song is more lyrical than tragic, with exquisite wind fluting that foreshadows the luminous scoring of Mozart's last opera.

Unusually for a buffa, one of the characters is a castrato, the part

of Ramiro. It was sung by Tommaso Consoli, who must have had a fine voice, because Mozart wrote him two powerful arias. The first is "Dolce d'amor compagna," where he sees love as a sweet companion; second, the furioso aria "Va' pure ad altri," where he finds himself on the other side of the coin, raging at the treachery of his love, Arminda. Not to be outdone, Arminda has an aria that is not so much furioso as berserk, and Mozart accompanies the text right over the top as she froths at Belfiore: "I would like to tear out your heart!" She's a feisty gal.

The long, multipart finale of act 2, when Violante and Belfiore go around the bend, is something of a marvel, the music mocking their madness and building to a soaring frenzy, the couple crazy and the others bewailing their craziness, all at the same time. The penultimate number in the opera is a quite beautiful duet that takes itself entirely seriously, Violante and Belfiore deciding during its course that they can't resist what's between them, whatever in the world that might be. There's a short, jolly finish with everybody embracing their beloved and crying, "Long live love, which makes everyone happy!" As Mozart's later operas would more pointedly ask: does it really?

IN THE SECOND WEEK OF DECEMBER, FATHER AND SON ARRIVED IN Munich to finish *La finta giardiniera* and prepare the premiere. As usual Wolfgang was deep in the work and Leopold fussing. Nannerl was to join them for the premiere, and it was expected she would do some performing. Mama was not invited. Papa wrote home that he was having trouble finding lodging for his daughter, or maybe for reasons of his own he kept putting off her arrival. Finally he found a place where Nannerl could have a room with a harpsichord to practice on. There followed Leopold's usual pages of advice. At home Nannerl was accustomed to having her face and hair elaborately done every day by some helper or other; in fact she was incapable of doing it herself. This raised Leopold's impatience. "I suppose that Nannerl will realize how silly it is," he wrote his wife, "not to be able to put on one's makeup or perform other necessary duties by oneself . . . Nannerl must acquire the habit of putting on a negligée [meaning her hair down] very neatly and of making up her face. She should also practice the clavier most diligently."[35] Nannerl was at this point twenty-three.

Besides his opera, Wolfgang had other matters on his mind. He wrote Nannerl before her arrival, "I beg you not to forget to keep your promise . . . I mean, to pay the call we both know of . . . For I have my reasons. I beg you to convey my greetings there—but in the most definite way—in the most tender fashion—and—oh, I need not to be so anxious, for of course I know my sister and how extremely tender she is. I am quite certain that she will do her utmost to do me a kindness . . . But we shall quarrel about this in Munich. Farewell."[36] This is not Wolfgang's first or last letter to his sister asking her to remind a Salzburg girl of his existence. (The names of these lady friends would be lost to history.)

Soon he acquired a miserable toothache that kept him at home for days with a swollen cheek and eye, some of that time able to ingest only soup.[37] The pain did not stop his work on the opera, and his wit soon recovered. "To Miss Mitzerl[,] I send all sorts of regards," he wrote Nannerl, "and tell her she must not doubt my love, I see her always before my eyes in her enchanting negligée; indeed, I have seen quite a few pretty girls here, but I have not found a beauty such as hers." This would appear to be an even more ardent appeal to Nannerl to give his best to a girl, but in fact Miss Mitzerl was his pet name for their landlady, Anna Maria Raab, age sixty-four.[38]

Nannerl finally arrived in Munich on January 4, a pile of music in her luggage for her and her brother, but as it transpired she apparently did no performing at all. Instead she and Leopold got caught up in Carnival and seeing the sights. At a ball she appeared in the costume of an Amazon, which Leopold reported suited her well.[39] Nannerl seems to have had few concerns in her life by this point other than *Hausmusik*, a bit of clavier teaching, dressing up, and taking in amusements.

The premiere of *La finta giardiniera* had been intended for December but was put off a couple of times so that, according to Leopold, the singers could learn their parts better. The year 1775 arrived, which was not going to be an epochal one for Mozart, but very much so for Western civilization. America saw the first battles of a revolution in Lexington and Concord, and George Washington was appointed commander in chief of the rebel army. Paris saw the premiere of Beaumarchais's *Le Barbier de Séville*, the first of his historic dramas about a randy count and his wily barber.

La finta giardiniera premiered on January 13, 1775, in Munich's old court theater. Leopold reported it home as another ringing success, but hints between the lines suggest it may have been otherwise. One sign of something not quite right is that Wolfgang wrote his mother a long boasting letter about it, something that to date he had rarely done to anybody, usually letting Papa do the crowing. "<u>Praise to the Lord!</u>" he wrote Mama. "My opera was performed yesterday, the 13th, and it was received so well that I can't possibly describe to Mama all the applause. First of all, the whole theater was so crammed full that many people had to be turned away. Then, after each Aria, there was a tumultuous storm of applause and shouts of 'Viva Maestro.' Her Highness, the Electress, and the one who is widowed [her sister], who were both sitting vis-à-vis from me, also called out bravo to me."[40] The letter goes on likewise at length, sounding quite like one of his father's glorious accounts.

The scheduling proved a disappointment. Unlike the Italian pattern of keeping each Carnival opera around for a week or so and offering the performances for free, in Munich the audience had to pay, so a new work would be done only twice in a row because attendance might suffer. After a couple of weeks, the opera might be heard again, or not.[41] *La finta giardiniera* was done once more after the first two performances, and that was it. Later Mozart had a German libretto fashioned for it, with dialogue rather than recitative, making it in effect a singspiel, and in that form it found some performances.

A Munich reviewer of the opera opined floridly, "Flames of genius quiver here and there; but it is not yet that still, calm altar-fire that mounts toward Heaven in clouds of incense—a scent beloved of the gods." A review in Mainz called it "a motley business . . . more for the connoisseur who knows how to unravel its refinements than for the dilettante."[42] In the future, Mozart would read a great many reviews echoing the latter: he's too complicated, he's for connoisseurs but not the common listener.

Though the Munich critic declared himself an admirer of "that wonderful genius *Moʒart*," he did not stop at dismissing *La finta giardiniera*. Mozart had appeared in a keyboard duel with a Captain Ignaz von Beecke, and the critic concluded that "Beecke surpasses him by a long way."[43] If Mozart read that comment, he would have been livid: as a performer he simply did not get reviews like that. The problem

may have been that this contest was carried out on a fortepiano. Mozart had played piano here and there, but this is one of the first accounts of a performance. The techniques for playing harpsichord and piano are distinctly different. It may have been that Mozart did not yet have a developed piano technique. Pianos were rare in Salzburg, his own final transition to the more modern instrument years away.

During the Munich sojourn there was another annoying matter beyond the tepid reception of his opera. His Serene Grace Archbishop Colloredo was actually visiting the city. Naturally the Mozarts assumed he would take in his famous servant's new work, but his visit fell between the performances, and he did not wait for the final one. Leopold was incensed, writing, "Picture to yourself the embarrassment of His Grace the Archbishop at hearing the opera praised by the whole family of the Elector and by all the nobles, and receiving the enthusiastic congratulations which they all expressed to him. Why, he was so embarrassed that he could only reply with the bow of the head and a shrug of the shoulders, we have not yet spoken to him, for he is still too much taken up by the compliments of the nobility."[44]

There was also, Leopold continued, a rumor to be squelched: "That the gentlemen of Salzburg are gossiping so much and are convinced that Wolfgang has entered the service of the [Munich] Elector, is due to our enemies and to those whose conscience tells them that if he had done so, it would have been with good reason. You know well that we are accustomed to these childish stories and that such talk leaves me quite cold."[45] Between the lines of this letter is the reality that nothing would have pleased Leopold more than his son's getting an offer from Munich. Maybe these words were actually directed toward prying eyes at the Residenz, to cover his tracks.

Yet again, a grand premiere followed by nothing. Leopold had hoped the success of *La finta giardiniera* would be enough to generate a commission for a seria for Munich. One would come, but not for nearly six years. At the beginning of July, Leopold and his son were back to the grindstone in Salzburg.

Chapter 9

BREAKING

B ecause there are no letters to document the period, the record of
the Mozarts' Salzburg years, 1775–79, is largely the music Mo-
zart wrote during them. On his return from Munich he found a large
order on his plate, or maybe he already knew about it: a commission
for something in the direction of an opera seria from none other than
Archbishop Colloredo. The occasion for it was the visit of the em-
press's youngest son, Archduke Maximilian Franz. He and Mozart had
met as children on the latter's first visit to court in Vienna, and Max
Franz had been an admirer ever since. In the next decade, he took over
the elector's throne in Bonn, where one of his musical stable would be a
promising youth named Beethoven.

The libretto for the opera was *Il re pastore* (The Shepherd King), a
Metastasio production that had been set some twenty times earlier by
composers including Gluck.[1] The libretto was shortened for Mozart by
local abbé Giovanni Battista Varesco, a poetizing priest and the arch-
bishop's confessor.[2] He and Mozart would have further collaborations.
The resulting two acts ran only about an hour each, compared to the
four to six hours of Mozart's earlier serias.

In *Il re pastore*, once again a king is disguised as a commoner, in
this case a shepherd who is of course in love with a shepherdess. He
proves the rightful heir to the throne of Macedonia, now held by Al-
exander the Great, so once again we find the seria conflict of love and
duty—though, at least at the end, after assorted contretemps, he gets

the girl. The piece is nominally an opera but is also described as a sere-
nata, meaning a dramatic cantata, because it was likely not intended to
be fully staged. The premiere came at the Salzburg Residenz in April
1775, the story from the life of Alexander played out under one of the
palace's Alexander murals. The day after his opera, Mozart supplied
some improvisations in a concert in honor of visitor Max Franz.[3]

Il re pastore is one more paean to the ruling class. There is no record
of what Mozart's political convictions were at this time; impossible to
say whether at nineteen he had any thoughtful convictions about the
world outside music. If he had problems with the ruling class, they
would have had to do with Archbishop Colloredo personally. So here
was something on the order of a routine opera for a ruler he did not
think so much of (and the feeling may have been mutual) and for a vis-
iting stranger—though at that point Mozart seems to have liked Max
Franz. (By the time Max Franz took the throne in Bonn and vaguely
aspired to get Mozart for his court, Mozart had decided that becoming
a priest had turned him into an idiot: "Stupidity peers out of his eyes."[4])
Meanwhile this opera was not likely to get anything beyond one per-
formance, for a small audience. The result is another piece that was for
Mozart a workaday affair, with occasionally appealing music when a
felicitous musical idea happened to hit him. To put it another way, lit-
tle was expected for the occasion, and as usual he provided more than
expected.

FOR TWO YEARS FROM EARLY 1775, MOZART MADE MUSIC ON KEYBOARD
and on paper, socialized with friends, went to Mass, played at cards and
shooting, strolled with the family and the dog, wooed girls, watched
sunsets, complained when it rained, cracked jokes, teased the servants,
and so on. All quite convivial, really, and Mozart was a convivial soul,
but he was getting steadily more restless and bored. What to do about
it? In the last years he had contributed little to his father's initiatives to
get him another job. At that point all Wolfgang knew to do by way of
improving his condition was to keep his head in his work, hope for bet-
ter, and wait and see. He was to spend years in Salzburg on that course,
with one luckless intermission.

His musical development in 1775–77 had much to do with a change

of focus in his large works away from symphonies and toward concertos for violin and keyboard. History has left a certain haziness around his early efforts in both these genres. Was he writing the violin concertos for himself? He probably could have played them, but there is little indication whether he actually did. He may have written them for one of the local virtuosos. His father the famous violin pedagogue did not appear to play concertos. As for clavier concertos, Wolfgang was curiously tentative about these pieces that would appear to be critical for him as a performer. His first violin concerto was K. 207 in B-flat, probably written in 1773 rather than the year of the others, 1775.[5] It adds up to an appealing and reasonably fresh piece, more so than his first keyboard concerto.

As his career took shape it was Mozart's destiny to perfect a concerto form that would last well into the next century. This task took all his gifts, not only his instincts but his technique. The early eighteenth-century idea of a concerto, in the hands of say Bach and Handel, was simple in outline: the first movement starts with a tutti, usually a string group playing a theme that will be the basis for the whole movement. Then one soloist or a group of them enters with a solo section, and the movement continues in a simple pattern of tutti-solo-tutti-solo-tutti for as long as you like, ending with a return of the full opening tutti. Mostly but not always, the strings accompany the soloists in their sections.

By the second half of the eighteenth century, this pattern was no longer amenable to composers. Among other things, they wanted more variety of material and more contrasts within a movement, and this increased diversity needed more sophisticated forms. Where those patterns were headed was, yet again, in the direction of what a later time would call sonata form, a model so logical yet malleable that it invaded nearly every kind of music including, in ad hoc permutations, insinuating itself into the numbers of operas. The problem for the late eighteenth century was that a concerto still needed to be fundamentally a dialogue between a soloist and orchestra, so still an alternation of tutti and solo. But how to reconcile that with sonata form and its exposition and development and recapitulation, with which the pattern of tutti-solo-tutti, etc., has nothing to do?

The Violin Concerto no. 1, K. 207, is written for a basic band of two oboes and horns each, and strings. This and all his later concertos have

three movements. K. 207 shows that for Mozart a solution to the first-movement question, which would involve a substantial first exposition by the orchestra with the solo silent, was well in the future. This concerto's first movement begins with a jaunty theme that is quickly taken up by the soloist—more or less the pattern of an aria, with a short introduction before the singer begins. After the violin enters on the main theme, there is a bit of a quieter second theme in the key of the dominant, followed by some fancy fingering in a sort of passage that would later be called the "display section." There follows the usual lively finish of an exposition, but where usual sonata form would at that point have a repeat of the exposition, there is a development section, after which the violin leads the return to the home key and main theme. At the end there is a place for the usual improvised cadenza. Other Mozart concertos of this time involve smaller cadenzas within the movement.

After the jolly opening movement of K. 207 comes a quiet nocturne of a slow movement, luxuriously scored. In his concertos as in the chamber music of his teens, Mozart is often most original and most beautiful in his middle movements. Here as in later slow movements the orchestra leads with an extended section that is less an introduction than a section in its own right. The soloist enters with a new theme, hazy and lovely. This movement also has a cadenza; eventually his concertos will have them mostly in the outer movements. To call these slow movements his most original means that while he stays within the orbit of convention, he has in some degree escaped standard emotional representations and the insubstantial pleasantries of the galant.

Large works of these days were front-weighted, meaning the heaviest and most extensive movement was the first, the finales usually shorter, lighter, gayer: what came to be called a "last dance." Neither Mozart nor Haydn would challenge this pattern. (The challenge would come in the next generation, with Beethoven.) Accordingly, the finale of K. 207 has a lusty jabbing theme and dashes and dances throughout, with a third cadenza at the end. The whole concerto shows a general simplicity of material and form that recalls his serenades of the time, which in their five to seven movements often contain what amounts to a violin concerto of modest dimensions.[6]

In 1775 Mozart wrote four more violin concertos, after which he put the genre aside. As with his earlier symphonies, these are pieces of

varying ambition and impact, but also like the symphonies, they trace a path toward deeper engagement and sophistication. Of these, the most ambitious, breaking the most ground, are Nos. 3 and 5.

No. 3, K. 216, is in G major, with the spacious good humor that key often summons. Accordingly, the symphony recycles a melody from an aria in *Il re pastore*: "Quiet air." In this piece the soloist begins to have more individuality, likewise the orchestra. The opening orchestral section is marked by dynamic accents and changes of volume; it meanwhile moves away from a simple introduction and toward a more substantial orchestral exposition. For the first time, the soloist introduces new material that he continues to own exclusively. The development is one of Mozart's longest to date, most of it in minor, with an undercurrent of tension striking in a major-key piece. For the second movement, the oboes switch to flutes and the strings put on mutes, helping to paint another of Mozart's exquisite misty nocturnes, the violin singing long, beautiful, aria-like melodies. The orchestra part is lavishly developed, supporting the solo with gently throbbing textures.

The finale, a Rondo, begins with a lusty three-beat folk dance and gets increasingly curious as it goes. The traditional form of a rondo was based simply on a theme that keeps coming around—thus the label—alternating with other material: A B A C A D A E A, and so on to taste. By Mozart's time, however, sonata form had invaded rondo as well, creating the hybrid *sonata-rondo*: something on the order of A B A C A B A. (What follows the C section is variable.) The Rondo finale of K. 216 is more unruly than that. In 3/8 time, its form amounts to an A B A C A D E A—there the theme falls into G minor—cadenza, then a final A section (in major) as coda. The D section is a sudden andante in G minor and 2/2 time, the E section something like a folk dance in 4/4 before the final return of the jovial 3/8 A theme. This kind of cavalier handling of a standard form, offbeat and unexpected, will before long recede in Mozart's work.

If the fourth violin concerto, K. 218, is a touch on the routine side, K. 219 in A Major, the last violin concerto of 1775 and as it turned out the last of his life, rises to a higher plane, starting with its first page, tremolo strings creating an air of breathless anticipation. The orchestral beginning is a real exposition with two themes. After that, in Mozart's mature concertos, follows a question: will the soloist enter on

the orchestra's first theme, or present a new one of her own? In this case, the answer is sort of "neither": the orchestra builds to dramatic octaves to open the curtain for the solo, but with the entry of the soloist the tempo changes from allegro to adagio, and the violin sings a kind of operatically soulful little aria (which never returns) before an allegro strikes up and the soloist introduces a soaring new theme. Mozart thus makes the soloist a distinctive individual, who from her first appearance takes charge of the music as its leader, though the dialogue of solo and orchestra will be steady and intricate, the orchestra often supplying opulent figuration. Meanwhile the soloist's new allegro theme has the effect of a first theme proper, as if she were saying to the ensemble, "You've had your say. Now here's my idea." The first movement, always led by the solo, is no ordinary Allegro. The soloist struts here, falls into searching moments there. We are arriving at the mature eighteenth-century concerto, in which the soloist is the leading character and the orchestra is the world he or she lives in, and their relations are intricate.

Mozart could always coast on his incomparable gift as a tunesmith, but now he is thinking more about how themes (and nonthematic matter as well) function in the architecture of the movement as a whole. Each moment of a movement announces clearly to the listener what it is doing in the form: here is a theme, here is a transition, here is the retransition to the recapitulation. There you have the achievement of the late eighteenth-century, musical syntax on the small scale adding up to architecture on the large scale. The pattern was consistent, well understood by connoisseurs, yet infinitely flexible. This predictability underlying unpredictability in sonata form, its effectiveness in organizing material no matter how variegated, created a formal model that stayed around for much of the next two centuries.

Part of the flexibility of sonata form was this: a familiar pattern as a baseline, ultimately a rule to be creatively bent and broken. A rondo, with its repeating tune, is an easy form to hear, so a composer can play games with listeners, flirting with the return of the rondo theme, putting it off, launching into a false return: here's the tune back at last, but, oops, it's in the wrong key. Haydn more than any other composer knew how to play the game of setting up expectations in the listener. Just when you think you know what he's up to, he's sneaking around to kick

you in the pants. As example, Haydn's *Joke* Quartet: it ends, the audience applauds, it starts up again and ends again, the applause is a little tentative now, and indeed it begins yet again. After the true ending, which does not sound like an ending, the audience is left expectantly with hands suspended in air; then everybody dissolves in laughter. In his life and in his art, Mozart was a man devoted to fun, but he was more artistic aristocrat than older master, not much given to Haydn's rough jokes. In his musical humor, Mozart is subtle as in all else.

To return to his last word in violin concertos, K. 219: The middle movement is a long, gently lyrical Adagio that despite its key of E major, usually a bright tonality, strays into poignant and sorrowful places, the violin singing a kind of endless melody that at times verges on heartbreakingly lovely. This mood is broken by a Rondo finale whose A theme is a forthright minuet, a bit precious, entirely danceable. It kicks off another complicated rondo pattern: A B A C A D A B A. The D section is the wildcard: here for the first time, Mozart takes up the exotic Viennese style called "Turkish," featuring wild roulades from the solo fiddle. The conventionality of the Rondo's minuet theme is thereby confirmed as tongue in cheek, because the excursion into exotic Turkish territory renders the return of the minuet a bit silly. The highly popular Turkish style, based on that country's military music but really a Viennese invention, will be with Mozart from this point on.

Why Mozart never wrote another complete violin concerto is an open question. The answer may be as simple as his not getting a commission and/or not having anybody at hand for whom he wanted to write one. At least at age nineteen, he finished that train of thought with the A Major, his finest violin concerto because it is the richest and most appealing in material, enormous fun here and heart-tugging there. Like so much of his greatest music it posits a little world, a little summary of life itself. The bulk of his concertos after this, though, would concern his own instrument and his own career.

ONE THING TO UNDERSTAND ABOUT CONCERTOS IN MOZART'S TIME IS that musically, little was expected of them. In an era when most composers were also performers, players largely wrote concertos for themselves, as part of their performing portfolio. You wrote them to show

off your strong suits, mainly your nimble virtuosity and tender expressiveness and, if necessary, to mask your weak suits. For connoisseurs, virtuosity was a competitive sport, with rabid partisans. By and large, listeners were less interested in what you were playing than in how impressively, brilliantly, movingly you played it. Connoisseurs would swoon over a pearly touch and glittering fast passages. In effect, for a virtuoso the showing of wares was more the game than the notes serving that purpose. If Mozart's first concertos for violin and piano more or less submit to this model, his mature ones would put it aside with an unprecedented vehemence, yet at the same time still show off his technique. Which is to say that his mature concertos were going to have the depth and ambition of his finest music.

Between the ages of eleven and sixteen Mozart had written what amounted to practice harpsichord concertos based on music by other composers. Not until he was seventeen did he produce his first original one. Why he waited so long is a puzzle. It could hardly be that he felt uneasy about the genre; from childhood, he fearlessly attacked nearly every genre in sight, and anyway, as a performer he needed concertos at hand. So far, when he needed one for a concert it would often be by another composer.

His first original keyboard concerto, K. 175 in D Major, from late 1773, is, despite its showy scoring with trumpets and drums, a middling affair on the whole, not as ambitious as his first violin concerto of that year, and he didn't produce another one for three more years. He did play K. 175 around, into the next decade in fact, and it seems to have been popular.[7] Eventually, he wrote a new finale that, he reported, created a furor in Vienna.[8] The lack of any dynamic markings in the piano part implies he was thinking of a harpsichord here, but the solo could readily be covered by piano. In this time, when the pianoforte was gradually supplanting the older instrument with its absolutely limited range of volume and touch, most things written for keyboard were expected to serve for both instruments. It was not until the next generation that pianists from childhood appeared on the scene, among the first of them Beethoven.

Clavier Concerto no. 6 in B-flat, K. 238, is dated January 1776. Three more followed in the next three months. If none of them makes much progress, all of them have winning music. No. 6 features a blissful slow movement that amounts to a prophecy of the sublime nocturne

of No. 21. No. 7 in F, K. 242, is for three keyboards and came to be dubbed the *Lodron* because he wrote it for a local countess of that name and her two daughters, ages fifteen and eleven. The countess on the top part got most of the hard bits, and he went easy on the youngest. The interest of the piece is not so much in the material as in listening to Mozart revel in the orchestral and antiphonal effects he can get out of this solo group—trading off ideas, big tuttis, the aviary effect of stacking up trills. The clavier parts have dynamic markings, so he was probably thinking of pianos even though the premiere was on three harpsichords.[9] Piano Concerto no. 8 in C Major, K. 246, written and named for a Countess Lützow, a clavier player of apparently limited technique, amounts to another workaday item marked by a certain galant preciousness.

If that aristocratic lady inspired him little, at the beginning of the next year, another woman apparently inspired him considerably on her visit to Salzburg. History would remember her surname as Jeune-homme, but she was in fact Louise Victoire Jenamy. (Part of the historical confusion is that letters show that neither Mozart, father or son, knew how to spell her name.) She was the daughter of celebrated choreographer Jean-Georges Noverre, whom the Mozarts had known in Vienna, and she seems to have been a first-rate pianist. For her Mozart wrote not just a first-rate concerto, but arguably the finest work of his career to that point.[10]

The name-amended *Jenamy* Concerto, K. 271 in E-flat Major, announces its novelty at the beginning: a fanfare-like motto from the orchestra, then the piano, rather than sitting out the orchestral exposition, enters with a perky answering phrase. After this routine is repeated, the orchestra proceeds with an elaborate exposition while the piano waits patiently as usual. To add to the flavor of this piece, the opening orchestra-piano dialogue is three-plus-three bars, followed by a five-bar phrase. This concerto jettisons the galant tone, the regular phrasing, and the by that time usual pattern of the piano waiting through an orchestral exposition before entering.

This early entrance of the soloist accomplishes several things at once. The question-answer between orchestra and piano establishes what will be a steady dialogue, but not exactly a dialogue of equals: the piano is in charge from the beginning. So the opening also estab-

lishes the soloist as a distinct character more decisively than any other
of Mozart's concertos to date. Accordingly, after the orchestra's fully
developed two-theme exposition, the solo enters with a new idea before
working back to a recall of the opening question and answer. She will
continue to toss ideas into the movement.

What is her personality? Inclined to lyricism, not as bravura as in
some of the other concertos; even the fast passages have a gentle profile,
and she is seductive in the silken second theme. Everything is more de-
veloped, more elaborate: more unaccompanied piano than before (and
extensive dynamic markings, real piano music); a development section
that is one of Mozart's longest and expressively most far-ranging to
date; a whole movement generally good-humored but free of rote gai-
ety. Our soloist, in short, is arguably more feminine than in Mozart's
other concertos, whatever that term might mean. Here it means less of
a showoff, more considered, emotionally more open.

While the *Jenamy* may be his most mature, most ambitious, rich-
est, and generally finest work to date, the middle movement may
be his first single movement that can be called haunting. Its key
of C minor says it is something outside his usual paths. He had
written poignant and atmospheric slow movements before, going
at least back to the F-major Divertimento, K. 138, but nothing like
the brooding opening of this movement, where the echoing muted
strings seem to share a mournful parable. The piano passages that
follow, the middle part of an ABA movement, are gently consoling,
like a hand laid on a fevered brow, but the consolation is shadowed
by sorrow. The return of the A section appears not as a formal re-
quirement but rather as the return of sadness.

There is another subtlety in the movement: several periods finish
with the unmistakable downward fourth that ends a recitative. Call the
spirit of those endings something in the direction of a resigned *So be
it*. There is a cadenza left to be improvised; it must be anything but
gay and showy. Instead of culminating in the usual orchestral outburst,
the cadenza flows into a written-out phrase for piano with an echo of
the opening orchestra-piano question-answer. The orchestra's final en-
trance, now the strings with mutes off, is on a harmony called the Ne-
apolitan, always a special effect, a chord out of the key that in its effect
can be colorful or tragic or weird. Here it sounds like a cry of anguish,

the piano's quiet unaccompanied answer like the end of a heartbroken recitative.

How Mozart resolves the expressive issues of a piece in a given finale, both technically and emotionally, is always something to contemplate. If the material of a piece is essentially tragic, he does not generally like to end on that note. In some of his works this results in a finale too light to do the job. The *Jenamy* finishes with a Rondo, and ending rondos are usually dashing and gay. This one is not, because it is inflected by what came before. Call its main theme, laid out in a long passage by the solo unaccompanied, a matter of hard-driving determination. The virtuosity is there in the solo, but generally soft, understated. It comes to rest in a remarkable excursion in the middle: suddenly a minuet appears, and it has a quality of something like quiet wisdom. Maybe the wisdom of one wounded by life, expressed in the form (here is the contribution of convention) of a courtly dance. There are little cadenzas, the piano sinking into contemplation. In all his operas, Mozart rarely wrote a stronger, deeper, more involving character than the soloist in this movement, which is also to say that he was bringing his operatic gifts to his instrumental music. There is no final cadenza; nothing further needs to be said. The *Jenamy* ends not in gaiety or triumph, but in whispered affirmation before two brisk finishing chords.

OTHER WORKS THAT MOZART TURNED OUT IN 1775–77 WERE MOSTLY more occasional sorts of things. There were practical items such as marches and minuets. Besides the requisite church pieces and some concert arias written for a particular artist and/or to keep his hand in operatic issues, he produced lighthearted works going under the generic titles of cassation, divertimento, and serenade. Which constitutes which of those genres can be a hazy matter; the title on the score may have had as much to do with its occasion as with the nature of the music.[11] A divertimento, for example, was generally considered to be background music to accompany dining, games, and the like, and intended for one player on a part—but this applies to some serenades too.

The most settled of these genres was the orchestral serenade. By Wolfgang's day it had grown into a genre far from its roots as a song sung by a lover in the evening, under his love's window. It was still

understood to be night music associated with the outdoors, though not usually played there. Otherwise, the serenade had evolved into a multi-movement occasional piece, light in tone but not in size—a Salzburg serenade meant seven to ten movements and could last up to an hour. Leopold had made a specialty of them, writing more than thirty, which became models for his son's early ones. The more important requirements were that they be tuneful, pretty, witty, folksy, those kinds of moods suited to one of the common settings of serenades: as *Finalmusik* to celebrate the end of a school term at the university.

Four of Mozart's serenades were commissioned specifically as *Finalmusik*. They needed to be carefree, imbued with prospects of the end of school and summer at hand. So it was by definition an occasion for delight, and Mozart could dispense delight by the yard. The movements of a serenade were not rigidly prescribed, but tended to include an opening movement often in sonata form, a couple of slow movements interspersed with minuets, and a fast finishing movement.[12] Again, all of Mozart's serenades have two or three movements featuring solo violin, amounting to sort of a violin concerto.

He could dash these pieces off, coast on his melodies and his indefatigable inspiration, and enjoy himself. The result was the expected blend of less and more inspired pieces, few of which were expected to be heard more than once. At the same time, for Mozart they constituted an ongoing laboratory in writing for orchestra. There are features not often found in his symphonies: more elaborate horn writing, folk music movements, galant stretches, whatever turned up. And there was another factor: as when the visit of a brilliant lady pianist galvanized the *Jenamy* Concerto, a particular occasion might supply a spark. One of these occasions was the marriage of a daughter of the Haffner family, rich merchants in Salzburg. Commissioned by father Siegfried, the piece was first played in July 1776, the night before his daughter's wedding, at the family's summer house.

The *Haffner* is the seventh and more or less the distillation of Mozart's Salzburg serenades. A quick summary of the movements might run: (1) rather grand; (2) a mellifluous Andante with solo violin, suitable for thoughts of marital bliss; (3) a quasi-staunch Minuet with some yearning stretches, much solo violin, and a folksy trio heavy on the horns; (4) a dashing Rondo with solo violin fiddling madly;

(5) a syndromic *Menuetto galante*; (6) a lilting and lyrical Andante; (8) another Minuet, this one a hearty folk dance with drones here and there and hunting horns in the trio; (9) a long and solemnly beautiful introduction for a dashing and droll Allegro assai finale with episodes of mock-furioso.

If serenades were something for Mozart to toss off for fun and money, they had a part to play in the formation of his mature symphonic approach, because there was no heavy line between the two genres. A symphony was expected to be more substantial and organic, but even there a dose of optimism and fun was always welcome, and serenades gave Mozart practice in those indispensable qualities.[13] At the same time it assembled all he knew about writing for the orchestra and took it to a new plane of imagination. He fashioned a five-movement symphony from K. 250, and in the next decade wrote another serenade for the Haffner family and extracted four of its movements for one of his finer symphonies.

THE YEAR 1776 REVEALED FURTHER SIGNS OF MOZART FEELING AT loose ends. He was not producing much of major import, the *Jenamy* Concerto and *Haffner* aside. At some point he had begun tinkering with a project that would occupy him off and on for years: incidental music for a play by the Viennese Tobias Philipp Baron von Gebler: *Thamos*. As early as 1773 Mozart scored two of the choruses in the play. It is set in ancient Egypt, and there are Masonic overtones. Something seized him about the story, though not quite enough to compel him to sit down and see it through. Still, he returned to it repeatedly over the next years, revising and adding pieces, never entirely finishing it. Those first two choruses (later revised) were heard in productions of the play in Vienna and at the Laxenburg Palace in spring 1774.

In September 1776 Mozart dispatched a long, fawning letter to his old mentor Padre Martini in Bologna, sending him the new Misericordias Domini. He knew the Padre would appreciate its elaborate counterpoint and archaic atmosphere. "Most beloved and esteemed Signor Padre Maestro! I beg you most earnestly to tell me, frankly, and without reserve, what you think of it. . . . Oh, how often I have longed to be near you. For I live in a country where music leads a struggling existence . . . Meanwhile I am amusing myself by writing chamber music

and music for the church." As for his father, "He has already served this court for 36 years and as he knows that the present Archbishop cannot and will not have anything to do with people who are getting on in years, he no longer puts his whole heart into his work."[14] Martini replied kindly, praised the piece, and issued some boilerplate: "Music," he concluded, "is of such a nature as to call for great exercise and study as long as one lives."[15] In fact Wolfgang's ostensible letter is in Italian and in Leopold's hand, so his father probably wrote it.[16] Most likely it constituted yet another cast into the waters hoping for a job or at least a commission from Italy.

At age fifty-seven Leopold felt disgusted and desperate for a way out. He wrote another letter in that period, this one to Archbishop Colloredo, asking permission for another tour for Wolfgang. The letter did not survive, but whatever it was, it began a process that tumbled toward disaster. Colloredo turned down Leopold's request. He was tired of these servants gallivanting around like beggars and intended to put a stop to it. Accordingly, in July the archbishop received a letter signed by Wolfgang that began, in light of his father's request being denied, "Your Princely Grace, will You graciously permit that I ask Your Highness submissively for my discharge from service . . . Your Princely Grace will not, I trust, take this submissive request amiss, since Your Highness graciously declared already three years ago, when I sought permission to travel to Vienna, that I had nothing to hope for and would do better to seek my fortune somewhere else." In fact this letter is also in Leopold's hand, and has his concerns all over it:

> Parents make great efforts to enable their children to go out and win their own bread; they owe that to themselves . . . And the more children are blessed with talent by God, the more they are obliged to make use of it and improve their own as well as their parents' lives . . . The Gospel teaches us to take advantage of our talent. Therefore, before God and my conscience, I owe it to my father, who has untiringly given all this time for my education, to be thankful to him with all my strength, to ease his burden, and to take care of myself as well as my sister, for it would be a pity for her to have spent so many hours at the harpsichord without making good use of it.[17]

These are not Mozart's hopes and dreams and ideals; they are his father's. Not only does he owe something to his own gift, the letter declares for Wolfgang, but he owes everything to his father and family. This was Leopold's perennial obsession: his son must get a good job and support them. All his efforts and pains must be repaid, in full (even though he was hiding and hoarding the proceeds of the children's tours). As the above shows, Leopold does not neglect to give a little lecture to the archbishop about the duties of parents and children.

The whole production was utterly misconceived. Why Leopold, with all his practical shrewdness, made a blunder like this is hard to imagine. If Wolfgang had a job offer in hand, such a letter of resignation would have been appropriate. But there was no offer or any suggestion of one. One guess is that Leopold had gotten so outraged at losing his likely last chance to be Kapellmeister that his usual considered judgment went up in smoke. It was more or less inevitable that Archbishop Colloredo would take the letter very much amiss. He let them stew for a month, then sent a curt, sardonic reply to these people who presumed to instruct him about his duty to the Gospel: "To the Exchequer with the observation that father and son have permission to seek their fortune elsewhere, according to the Gospel."[18]

When the reply came, Leopold was suffering from a bad cold. Reading that he appeared to have been fired, he took to his bed in a panic. If both he and his son were out of a court job, he could only imagine ruin. It may have been here, at age fifty-seven, that something broke in Leopold Mozart. In his youth he had been a talented and promising student; as an adolescent, clever at making his way; as an adult, a celebrated pedagogue and father of a miracle, a man of magisterial confidence in his wisdom, his cunning, his understanding of the world. Now all at once Leopold was looking and feeling like a frightened old man. From this point on, rather than the commanding and benevolent paterfamilias, he would as often be angry, vindictive, waspish, and scared.

Leopold begged Colloredo to keep his job and succeeded, with this humiliating proviso: "His Grace desires that there should be real harmony amongst his musicians. In gracious confidence therefore that the petitioner will conduct himself calmly and peaceably with the Kapellmeister and other persons appointed to the court orchestra, His Grace retrains him in his employment and graciously commands

him to endeavor to render good service both to the church and to His Grace's person."[19]

In August 1777 Wolfgang gave an academy, perhaps in the big room of the Tanzmeisterhaus. He and Nannerl played a keyboard duet, and a new scena (solo vocal composition) of his was sung by the young Czech soprano he wrote it for, Josepha Duschek. She was newly married and visiting Salzburg, where her grandfather was a rich merchant and former mayor of the town.[20] She and Mozart began a long friendship and collaboration.

A month later Wolfgang left town once again in search of greener pastures. The ultimate destination would be Paris, where he had triumphed in childhood and where old friends and patrons were ready to welcome and champion him. The immediate goal would be Mannheim, to see about prospects in that musical capital. Surely something, something would happen.

This time Leopold did not go along. He was perhaps exhausted, perhaps worried that leaving Salzburg again would lose him his job once and for all. He trusted his wife to deal with the practicalities of travel, but she was also to keep an eye on the boy and send her husband regular reports. The "boy," twenty-one at this point, was charged with taking his father's lessons to heart and making his fortune.

Before Wolfgang left, Leopold commissioned a portrait of him that had been requested by Padre Martini. It shows him sporting his Golden Spur Cross. The painting may have been done on the cheap. It is strikingly crude, Wolfgang looking stiff and cross-eyed, though Leopold insisted it was a good likeness. Actually Martini had requested portraits of both father and son, but Leopold replied, "I do not think my snout merits being put in the company of men of talent."[21] The man whose company he says he does not deserve to be memorialized in is his son.

Leopold and Maria Anna packed up for the trip and Leopold said his farewells to his son and his wife. She and Leopold had enjoyed a good, loving union in its way. Maria Anna never challenged her husband's will, kept to her wifely duties with good humor, did as she was told. That Leopold sent her along with their son showed that he trusted her to be his stand-in.

Inevitably, one farewell to a loved one turns out to be the last. Often the last farewell is like any other farewell. This was theirs. Leopold

had just averted professional disaster in Salzburg; his son would avert the same, barely, on this journey. For Maria Anna Mozart, the journey would turn out to be the final disaster. Leopold never saw his wife again, and he never ruled his son's life again. The family was breaking apart.

NO VACANCY HERE

From the beginning, it was nothing like the old tours. When Wolfgang and Maria Anna Mozart departed Salzburg in September 1777, heading for Munich and Augsburg, they left a good deal of unhappiness in their wake. Family friend Franz Firmian observed to Archbishop Colloredo, "Your grace has lost a great virtuoso. Mozart is the greatest clavier player I've ever heard in my life . . . and he is a first-rate composer." The archbishop's answer was silence.[1] After playing a Mozart violin concerto at a concert in Salzburg, Herr Kolb declared to the audience, "You have been hearing the compositions of a good friend who is no longer with us." The musicians responded in their fashion: they got drunk, banged disconsolately around the room and smashed a priceless chandelier.[2]

Mother and son traveled for much of this tour in a chaise Leopold had recently bought; horses would be hired at inns en route.[3] In the first of his letters that followed Wolfgang and his mother around the map, Leopold described the reactions at the Tanzmeisterhaus. He was still hoarse from his cold and said that in the rush of packing and their departure he had forgotten to give his son a proper blessing. He ran to a window and delivered it to the air. Nannerl fell ill with a headache and violent vomiting and spent two days in bed with Bimperl beside her.

Then Leopold got down to his endless well of advice. "When you're in Augsburg," he wrote Wolfgang, "you should stay in the 'Lamm' in the Heiligkreuzgasse, where the tariff is 30 kreuzer for lunch, where

the rooms are comfortable, and where the most respectable people, both Englishmen and Frenchmen, put up. From there it is quite a short distance to the church of the Holy Cross; and my brother, Franz Aloys, also lives close by . . . the 'Drei Mohren' is far too expensive." Soon he was giving personal and spiritual directives: "You know that you soon get hot and that you prefer cold to warmth, which is a clear proof that your blood, which has a tendency to heat, immediately boils up. Strong drinks therefore and too much wine of any kind are bad for you."[4] At a distance, Leopold was straining to direct this tour down to the last detail as he always had, his wife serving as deputy. "I could not let you travel alone," he wrote to Wolfgang, "because you are not accustomed to attend to everything or to be independent of the help of others and because you knew so little about different currencies and nothing whatever about foreign money. Moreover you have not the faintest idea about packing or about the innumerable necessary arrangements which crop up on journeys."[5]

Wolfgang would follow some of his father's advice, usually give at least lip service to it, and ignore it increasingly. Now and later there was to be no break between father and son, not exactly. But Wolfgang was no longer under his father's thumb. Though his mother was serving as his father's stand-in, she had no thumb for him to be under. Maria Anna did not direct things; she had always done as she was directed. Wolfgang left Salzburg with the same intense relationship with Leopold he had always had. But on this journey he was going to find out who he was without his father standing over him. He would return home, as the saying goes, sadder but wiser, by which point their relationship had settled into a volatile truce.

The story of the next months would be told in letters among father, son, mother, and sister. They document a journey and a process of growth by Wolfgang, the only one of them to grow. Call the story something on the order of a bildungsroman, the long-delayed completion of one.

Mother and son arrived in Munich on September 24, lodging at an inn owned by friend and musical connoisseur Franz Joseph Albert.[6] Mozart was well remembered in the city from the recent production of *La finta giardiniera*. He got busy looking up contacts. The first was Count Joseph Anton von Seeau, supervisor of entertainment for the

Munich court, who advised Mozart to get an audience with the elector right away. Wrote Leopold, "You could find an opportunity of showing the Elector everything you can do, especially in fugues, canons and counterpoint compositions. You must play up all you can to Count Seeau and tell him what arias and ballets and so forth you are prepared to compose for his theater." In fact Count Seeau, who appeared entirely cordial, was no admirer of Mozart, had found nothing good about *La finta giardiniera*, and claimed, falsely, that it had received hisses from the audience.[7] To those who knew him better, Seeau was a glutton, a drinker, a libertine, and thoroughly two-faced.[8] At length Mozart would learn that about him the hard way.

In her occasional addendums to letters on this trip, Maria Anna Mozart reveals herself as bright, funny, well informed, and as submissive to her son as she was to her husband. She also reveals herself as a prime source of not only her son's scatological inclinations, but also his raunchy poetizing. "We lead a charming life, early to rise, late to bed, all day we have visitors," she wrote her husband. "We live a life of princely clout / until the knacker comes to put it out. adio ben mio. Stay well in body and mind / and try to kiss your own behind. / I wish you a good night / shit in your bed with all your might."[9] Her humor was aided, it appears, by a considerable enthusiasm for wine.[10]

Nannerl's first letter to her brother continues in the vein of their ironic and affectionate, sometimes alarmingly affectionate, relationship:

> I am delighted to hear that Mama and Jack Pudding are cheerful and in good spirits. Alas, we poor orphans have to mope for boredom and fiddle away the time somehow or other. That reminds me, please be so good as to send me soon a short preambulum. But write me this time from C into B♭, so that I may gradually learn it by heart. I have no good news to send you from home. So I kiss Mamma's hands and to you you rascal! You villain! I give a juicy kiss and I remain Mama's obedient daughter and your sister who is living in hope—Marie Anne Mozart / Miss Pimpes too is living in hope, for she stands or sits at the door whole half hours on end and thinks every minute that you are going to come in. All the same she is quite well, eats, drinks, sleeps, shits and pisses.[11]

Another acquaintance Mozart renewed in Munich was with Czech composer Joseph Mysliveček, who had befriended the Mozarts in Italy and had been kind and helpful toward Wolfgang. But he was no longer the same man. Mysliveček was a well-known womanizer, and it had caught up with him: he had contracted syphilis, the scourge of the age. Wrote Goethe in this period: "Whom love does not deter, apprehension does. Nowhere does one in security lay one's head in a woman's lap. Neither the marriage bed nor adultery is safe any longer."[12] The treatment, useless like most medicine of the day, had disfigured Mysliveček's face and destroyed his nose. Everybody knew about that too.

Leopold was disgusted, and advised Wolfgang to stay away from the man: "If . . . Mysliwecek [sic] hears or has heard that you were in Munich, your excuse, if you do not wish to visit him, will have to be that your Mamma forbids you to do so and that other people have persuaded you, and so forth. It is indeed a pity. But . . . where does the blame lie, but on himself and on the horrible life he has led? What a disgrace he is before the whole world! Everybody must fly from him and loathe him."[13]

Mozart did not loathe or shun this friend, instead visited him in the hospital. Mysliveček's explanation for his disfigurement was a carriage accident and bad doctors. Nobody believed this, and if Mozart did at first, he soon learned better. This was no small matter for him. Mozart saw in the most graphic way, on the face of a friend, what can happen from venereal disease. It horrified him. He had promised to visit Mysliveček again the next day, but, he wrote Leopold, "I thought it beyond my powers to come to him. I had eaten close to nothing and been able to sleep only three hours . . . In the morning I was like a man who had lost his reason . . . He was always before my eyes."[14]

As far as the record knows, Mozart truly fell in love only twice in his life. It is entirely possible that he had affairs here and there, and during this trip he was going to have some sort of dalliance. But for a man as manifestly devoted to women and sex as he was, there is a surprising lack of evidence for an affair or even of his visiting a brothel, which was usual for bachelors of the time. If Mozart's collection of lovers was as limited as the record implies, the reason for that may have been Joseph Mysliveček. As man and artist, Mozart was instinctively self-

protective. Now he knew the risks, and it could be that, on the whole, he steered clear.

In Munich at the end of September, Mozart had an encounter, scarcely an audience, with Elector Maximilian III Joseph. This elector had studied music seriously, with a number of compositions to his credit, and had appreciated *La finta giardiniera*. Munich was among the places at the center of Mozart's hopes for a court position, and he knew the elector from his visits to the city going back to 1763. Their meeting this time, however, was on the order of a polite humiliation.

Mozart's friend Franz Woschitka, a cellist in the court orchestra, positioned Mozart in a room through which the elector and his party were to pass on the way to a hunt. They duly appeared, decked out in hunting attire. Count Seeau gave Mozart a friendly greeting. Seeing the familiar face, the elector paused, and Mozart recited, in proper form, "Your Highness will allow me to throw myself most humbly at your feet and offer you my services."

The elector had been informed of the situation. "So you have left Salzburg for good?" he asked.

Yes, Mozart said.

"How is that? Have you had a row with him?"—meaning the archbishop.

"Not at all, your Highness. I only asked for permission to travel, which he refused. So, I was compelled to take this step, though indeed I had long been intending to clear out. For Salzburg is no place for me, I can assure you."

"Good heavens!" the elector exclaimed. "There is a young man for you! But your father is still in Salzburg?"

Mozart began to talk fast. "Yes, your Highness. He too throws himself most humbly at your feet. I have been three times to Italy already, I have written three operas, I am a member of the Bologna Academy, where I had to pass a test, at which many *maestri* have labored and sweated for four or five hours, but which I finished in an hour. Let that be a proof that I am competent to serve at any court. My sole wish, however, is to serve your Highness, who himself is such a great—"

He was not allowed to finish. The elector was impatient to get to his hunt. "Yes, my dear boy, but I have no vacancy. I am sorry. If only there were a vacancy."

The moment was slipping. "I assure your Highness that I should not fail to do credit to Munich!"

"I know," said the elector, walking away, "but it's no good, there is no vacancy here."[15]

So much for that. Elector Maximilian was a sophisticated musician, and he knew Mozart's worth. Privately he told a patron of Mozart's, "It's too early yet. He ought to go off, travel to Italy and make a name for himself. I am not refusing him, but it's too soon."[16] Anyway, for the moment there was no post available, and after all, this young man was another in an endless line of petitioners waiting in anterooms. Perhaps Mozart had been ill advised to impugn one ruler in front of another, but in any case, Maximilian was not going to do anything for Mozart—the elector would be dead by the end of the year.

It was only the first disappointment. Each of Mozart's hopes and plans during this trip was going to blow up one after the other, for a row of reasons. It would take a while, though, for discouragement to set in. He was enjoying his freedom, come what may. At the end of his account of being brushed off by the elector, Wolfgang appended a note to Nannerl, "My greetings to A. B. C. M. R. and other such letters," these presumably being the initials of friends and/or girls. He ended with one of his bits of doggerel apropos of nothing: "When I built my house I was very glad, / when I knew its cost, I got very sad. / . . . Building a house takes a lot of loot, / and you should have known it, you nincompoop."[17]

A scheme he embraced from his innkeeper friend Albert was to collect ten of the Munich nobility who would agree to give him a mere ducat a month for support, which would add up to some forty-five florins and a workable living. Leopold was quick to discourage the idea. "I have no great hopes of anything happening in Munich. Unless there is a vacancy, the Elector is bound to refuse to take anyone and, moreover, there are always secret enemies about, whose fears would prevent your getting an appointment. Herr Albert's scheme is indeed a proof of the greatest friendship imaginable. Yet, however possible it may seem to you to find 10 persons, each of which will give you a ducat a month, to me it is quite inconceivable . . . To me it seems far more likely that Count Seeau may contribute something."[18] From

a distance, it did not occur to Leopold that Count Seeau might be one of those secret enemies.

In his account of his abortive conversation with the elector, Wolfgang goes on to describe a court councillor in one of the sharply and cattily observed passages that would mark his letters and, eventually, his operas.

> A certain Court Councilor Effele sends his humblest Regards to Papa. He is one of the best court councilors here and could have made chancellor long ago, if it wasn't for one thing: the bottle. When I saw him for the first time . . . I thought, and so did Mama, Ecce! What a perfect Simpleton! Just imagine a very large man, strongly built, Corpulent, with a ridiculous face. When he walks across the room to greet people . . . he puts both his hands on his stomach, pushes in, then thrusts his whole body upward, produces a nod with his head, and when that is accomplished, he jerks his right foot backwards and he goes through all this motion anew for each Person. He says he remembers Papa for a thousand reasons.[19]

Court Councillor Effele is like a character in one of Mozart's operas to come, his description of the man like a phrase of music in one of those operas. It could also be a description of a character in a novel by an author to come named Dickens. In another letter Wolfgang describes a meeting with Leopold's adored poet Christoph Martin Wieland, with whom his father had corresponded. Wieland was in town for the premiere of an opera set to his libretto. Wolfgang did not find the old man overly impressive.

> I . . . have finally met Herr Wieland. He doesn't know me as well as I know him, because he hasn't heard anything about me. I would never have imagined that he would be the way he was when I saw him. His speech is somewhat stilted; he has a somewhat childish voice, and is constantly scrutinizing you through his glasses, he has a certain learned rudeness and yet, now and then, an air of stupid condescension. But I'm not surprised that he acts in such

a way here, he may be different in Weimar or elsewhere; for the people here stare at him as if he came straight down from heaven; they are actually embarrassed to be in his presence, no one says a word, everyone is hushed; all play close attention to each word he utters; it's a pity they often have to wait so long because he has a speech defect and, because of it, speaks very slowly and can hardly say six words without coming to a halt. Apart from that he has, as we all know, a superb mind, though his face is really ugly, full of pockmarks, and he has a rather long nose.[20]

Leopold and Wolfgang were each writing two or more times a week, many of the letters voluminous, with additions from Nannerl and Maria Anna. As was proper for the time, in his letters to Leopold Wolfgang used the formal *Sie* for "you," whereas Papa used the intimate *du* one used for a child.[21]

After the elector waved him off, mother and son did not dally in Munich. In mid-October Mama reported her struggles at packing: "I'm sweating so that the water is running down my face . . . The devil take all this traveling. I feel like shoving my feet into my mouth, that's how tired I am." She noted without apparent rancor that Wolfgang gave her no help at all. Wolfgang reported that Mama had gone out for coffee with friends but downed two bottles of wine instead. For his part he had gone to the theater for a pantomime, the name of which sounded like one of his own neologisms: *Girigaricanarimanarischariwari*.[22]

On the eleventh, they departed Munich for Papa's hometown of Augsburg. It would be an eventful visit, though not because of music. (That would be the story of most of this journey.) At twenty-one, Mozart was learning fast in his understanding of the world and of himself. But fundamentally he remained an innocent abroad, stumbling from one boondoggle to another. All the same, as the miles grew between him and the father who had always run his life, he was becoming, month by month, more his own man.

IN AUGSBURG, HIS FATHER'S BOOKBINDER BROTHER FRANZ ALOIS MO-zart introduced his nephew to the city's governor, Jakob Wilhelm von Langenmantel, who received this visitor, wrote an annoyed Wolf-

gang, like "a reigning King of Diamonds . . . speaking down from the height of . . . his niggardly throne."[23] Langenmantel's name means "long coat"; in letters, Mozart took to calling him Longotabarro, "long beard." Wolfgang wrote of his visit to the governor, "I had the honor of playing for about three quarters of an hour upon a good clavichord by Stein in the presence of the dressed-up son and the long-legged young wife and the stupid old lady. I improvised and finally I played off at sight all the music he had."[24]

Besides Langenmantel, Franz Mozart reintroduced his nephew to his daughter Maria Anna Thekla, known to the Mozarts as *die Bäsle* (the little cousin). Wolfgang had presumably met her as a child on their visit in 1763. Now she was nineteen, a sparkler, highly interested in men. Wolfgang and the Bäsle hit it off very well indeed.

Taken by a son of Governor Langenmantel to visit clavier maker Johann Andreas Stein, Mozart on his entrance introduced himself as "Trazom." Having heard the child at age six, the older man was at first confused, then surprised and delighted to encounter this marvel grown up and out in the world. In his excitement, Mozart reported, Stein "kept crossing himself and making faces and was as pleased as punch."[25] For his guest Stein proudly showed off his wares: clavichords, harpsichords, pianos.[26] Stein was the most celebrated and innovative clavier maker in Europe, and he knew it. (Later, in Vienna, his daughter Nannette would be the same.) Mozart's enthusiastic letter home about Stein is the first indication of his involvement with musical technique and technology.[27]

Mon très cher Père! / Let me start right off with Stein's Piano forte. Before I had seen Stein's work, I favored Spät's Claviers. But now I must give Stein's Claviers preference because they have a much better damper than the Regensburg instruments . . . No matter how I play the keys, the tone is always even . . . What distinguishes his instruments from all others is that they are built with an escapement. Not one in a hundred will bother about this, but without escapement action you cannot possibly have a Piano forte that will not have a clangy and vibrating after-effect. When you press down on the keys, the little hammers fall back the moment they have struck the strings . . . He told me himself that after

he has finished a Clavier, he will first of all sit down and try all sorts of passages, runs and leaps, and then he goes on filing and fitting until the Clavier does everything he wants it to. . . . When he has finished a soundboard for a Clavier, he puts it outside and exposes it to the weather, to rain, snow, the heat of the sun . . . so that it will crack; then inserts a wedge and glues it in to make it all strong and firm.[28]

He goes on to describe the damper lever below the keyboard that was operated with the knee. His letter amounts to a summary of where the piano stood in 1777. The instrument's range was about five octaves. It was made and painstakingly voiced by hand; its timbre projected the wood from which its body was entirely made. On the whole, the slim build and the sound were closer to a harpsichord than to pianos of the next century. Rather than an overall evolution of the instrument in this period, each region had its own style, individual makers their own proprietary tricks and techniques. Nothing about the piano, in short, was standardized, and would not be for more than a century to come.

Mozart had grown up a harpsichord player and became one of the finest in the world. Surely he understood by this point that the harpsichord was on its way out and the piano was the clavier of the future. He had played pianos here and there, whenever he came across one. But if there was a moment when he began to be a true pianist, his encounter with Stein in Augsburg was surely that moment. His mother heard the change in his playing. At the end of 1777 she wrote her husband, "Everyone thinks the world of Wolfgang, but indeed he plays quite differently from what he used to in Salzburg—for there are pianofortes here on which he plays so extraordinarily well that people say they have never heard the like."

Another of Mozart's letters from Augsburg describes another new acquaintance, Friedrich Hartmann Graf, the town music director and a well-regarded composer and flutist, who largely wrote flute concertos. Mozart liked the man, his music not so much; he described it sardonically and also incisively to Papa, as one composer to another:

What a Noble Gentleman he is indeed. He was wearing a dressing gown . . . He pronounces his words as if they were sitting

on stilts, and, for the most part, he opens his mouth before he knows what he wants to say—and sometimes it falls shut again without anything having emerged from it. He performed . . . a concerto for 2 flutes . . . The concerto was like this: not good for the ear; not natural; he often marches into his keys with too much—Heaviness; and everything without the slightest bit of charm. When it was over, I paid him many compliments because he actually deserved it. The poor Fellow must have had plenty of trouble writing it all.[29]

The key word is *natural*, which Mozart used as a term of praise in the same way his future friend and mentor Haydn did. It meant something that lies well in the ear and under the fingers; that does not show off whatever effort may have gone into making it; that does not strain for effects; that sounds on first hearing (whatever surprises may arise) like something familiar, as if it had written itself. The ideal of the eighteenth century was an art that modestly veiled its artistry and respected rules and conventions, though not slavishly: originality was prized, within bounds. One of the great achievements of the period, what eventually came to be called the Classical style, was to make even the unexpected logical, such as the famous movement that gave Haydn's *Surprise* Symphony its name. It is based on an ingenuous little tune that has a sort of quiet *ahem* at the end. Haydn teaches us to expect that *ahem*. Then, when we're accustomed to it, he lets us have it with a forte explosion. The surprise is *prepared*, it is *logical*, it is, in a word, *natural*, even if it shocks the pants off us. This sort of logic was instinctively ingrained in Mozart well before he met Haydn, but Haydn would sharpen those instincts significantly.

Leopold replied to his son's reportage with endless prompting. Let Herr Stein open doors for you, have him arrange for a newspaper article. Set a high price on your talent. Do not neglect your immortal soul, be faithful to your religious duties, use the Latin prayer book: "You should sometimes for a change say your morning and evening prayers out of it. These are easy to understand and you might add some confession and communion prayers."[30] Wolfgang was playing violin here and there on the trip, and Leopold prodded him about that, too: "You yourself do not know how well you play the violin, if you will only

do yourself credit and play with energy, with your whole heart and mind, yes, just as if you were the first violinist in Europe. You must not play carelessly, or people will think that from some foolish conceit you consider yourself to be a great player . . . Say these words first: 'I really must apologize, but I am no violinist.' Then play with your whole mind and you will overcome all difficulties."

At the same time Leopold also dispensed his wisdom about the world and its denizens, always in terms of what could be expected of people for one's benefit. "All men are villains!" he instructed Wolfgang. "The older you become and the more you associate with people, the more you will realize this sad truth. Just think of all the promises, flatteries in the hundred circumstances we have already experienced, and draw for yourself the conclusion as to how much one can build on human aid."[31] And again, "Mark it well, my son, if there is just one man in 1000 who with no element of self-interest is your true friend, he is one of the greatest wonders of this world."[32] These were bitter maxims that Leopold lived by. For well and ill, his son did not.

On the whole, in Augsburg Mozart at first found the kind of welcome he considered his due: "In no place have I been overwhelmed with so many marks of honor as here."[33] As usual, he was dining and playing in various houses, including that of Governor von Langenmantel, who had become a touch more agreeable and, after Mozart protested, no longer referred to him as *er*, "he," the pronoun one used with servants.[34] His son proved to be another matter. Young Langenmantel understood that his privilege gave him license to make sport with musicians and their sort. As Leopold had instructed him, Mozart wore his Golden Cross to dinner at the house. Young Langenmantel and his brother-in-law quizzed Mozart about it; he explained that it came from the pope. My, my, they said. They must send away and get one for themselves, so they could be in the same league as a Mozart. They started addressing him, with a smirk, as "Signor Cavalier." What does such a cross cost, anyway? Of course, it's not really made of gold, it's only tin. Say, if I send a servant over, can I borrow your cross tomorrow? But can I leave off the spur?

Finally Mozart snapped, "You don't need a spur, you already have one in your head!" After a few more words in that direction he doffed his hat and left, to general embarrassment. Shortly Herr von Langenmantel Jr. ran into Mozart on the street and invited him nicely to play

at a concert. Mozart politely declined. "I decided not to go and let the entire Patrician lot kiss my arse," he wrote Leopold. He was suddenly sick of Augsburg. Well, not entirely. Before ending the letter, he added, "I must tell you something about my dear Mademoiselle Bäsle. But I will wait till tomorrow because one should be in a cheerful mood if one wishes to praise her as she deserves."

IN MID-OCTOBER 1777, FRANZ MOZART'S DAUGHTER MARIA ANNA Thekla, the Bäsle, wrote Leopold, "My particularly lovable uncle, It is impossible for me to express the great pleasure which we have felt at the safe arrival of my aunt and of such a dear cousin and indeed we regret that we are losing so soon such excellent friends, who showed us so much kindness . . . Please give my greetings to my cousin Nannerl and ask her to keep me in her friendship, since I flatter myself that I shall one day win her affection."

Things had been transpiring. Around the same day Mozart reported to Papa, "I write and declare that our Bäsle is pretty, sensible, charming, talented, and jolly . . . The fact is, the two of us are just made for each other, because she too is a bit of a rascal." They play tricks on their hosts, giggle together behind their hands. Presumably she was present at a concert where he played and, as he reported, "a goodly number of high Nobility was present: the Duchess Kickass, the Countess Pisshappy, also the Princell Smellshit with her 2 daughters, who are married to the 2 Princes of Mustbelly von Pigtail. Farewell, everyone, everywhere. I kiss Papa's hands 100,000 times and I embrace my sister, the rascal, with the tenderness of a bear."[35]

Leopold took all this in stride. For whatever reason, his son's sexuality never seemed to trouble him, though a given woman might trouble him greatly. Leopold grasped soon enough that his son and his niece were engaged in some sort of fooling around beyond the public hijinks. What their private activities amounted to, how far they went, was never specified. On the whole, in those days one was frank about sexual matters in general but did not tend to provide the details (unless one was a professional voluptuary, like Casanova). But clearly Leopold had been getting other reports from Augsburg that his son was not privy to, including ones about the Bäsle. "I am altogether delighted to hear that my

niece is beautiful, sensible, charming, clever and gay," he wrote his son mildly, "and so far from having any objection to make, I should like to have the honor of meeting her. Only it seems to me that she has too many friends among the priests." The charming and gay Bäsle, it appears, had a reputation. But Wolfgang was having none of it: "My dear Bäsle, who sends regards to both of you, is not at all a Pfaffenschnitzl," he declared to Papa, using the familiar Augsburg expression "priests' morsel."[36]

As it tended to be with Mozart and other people, his relations with his cousin struck a chord at the beginning and stayed in that tonality for the duration. He appreciated the Bäsle greatly but did not take the relationship unduly seriously. It was a matter of exploration and delight as if between two naughty and lusty adolescents. How seriously the Bäsle took him—they exchanged letters, only his would survive—is impossible to say. But did she hope to win Nannerl's affection as her sister-in-law?

Mozart had courted and flirted with Salzburg girls before this, maybe fooled around with them intimately. He was making the immemorial discoveries of youth and sexuality, which are profoundly vibrant and new, a discovery of yours and another person's body as if in an Edenic garden—which is to say that every generation believes it invented lovemaking, just as every dog believes it invented barking.

If Augsburg soured for Mozart, the town still felt on the whole warmly toward him. Perhaps prompted by one of his patrons, a local paper crowed, "An honor for us, dear Patriot! To have a composer, a compatriot here with us whom the whole of England, France and Italy envies . . . This can be nobody else than Herr Chevalier Wolfgang Amadee [sic] Mozart, who did such great wonders before the above nations in his tenderest youth."[37] This was the introduction to a story detailing his grand concert at the Fugger concert hall that included the Concerto K. 242 on three new Stein pianos.[38] Cathedral organist Johann Demmler handled the first solo part, Mozart modestly taking the second, Stein the easy third.[39] The audience was large and delighted, the local critic in ecstasies: "Everything was extraordinary, tasteful and admirable. The composition is thorough, fiery, manifold and simple; the harmony so full, so strong, so unexpected, so elevating; the melody, so agreeable, so playful, and everything so new; the rendering on the forte piano so neat, so clean, so full of expression, and yet at

the same time extraordinarily rapid, so that one hardly knew what to give attention to first, and all the hearers were enraptured."[40] Among the audience was his old Paris champion Baron Friedrich Melchior von Grimm, who happened to be in town. Mozart did not spot him—he was shortsighted but refused to wear spectacles—and as Grimm recounted to Leopold in a letter, he did not have time after the concert to greet Wolfgang.[41] They would meet again soon enough.

There was also an informal concert connected with a lunch at the Holy Cross Monastery, of which Mozart reported,

> Everyone praised my beautiful, pure tone. Then they brought in a small Clavichord. I played a Preludium, after that a sonata and my Fischer Variazionen. Somebody whispered into the Dean's ear that he should really hear me play in the organ style [meaning more learned and contrapuntal]; so I asked him to give me a theme, he didn't want to, but one of the clergymen did. I took the theme for a walk, then in the middle of it—the fugue was in g minor—I changed it to major and came up with a very sprightly little tune, . . . then I played the theme again, but this time arsewise [retrograded]; in the end, I wondered whether I couldn't use this merry little thing as a theme for the fugue?—Well, I didn't stop to inquire, I just went ahead and did it, and it fit so well as if it had been measured by Daser [a Salzburg tailor]. The Herr Dean was quite beside himself with joy . . . "I would not have believed what I just heard, what a man you are!"

Clavier maker Stein asked Mozart to give some keyboard lessons to his cherished eight-year-old daughter, Nanette. This was a potentially sticky matter, as Stein was a famous master of his craft and a generous patron. Mozart managed to be amused, a bit horrified, but encouraging—at least concerning a child. Around her father he could be a touch discreet with his opinions. But with Papa he could be candid.

> Whoever can see and hear her play the piano without laughing must be like her father—made of *Stone* [*Stein* meaning "stone" in German]. You must not place yourself in the middle of the piano, but way up at the treble, for in this way you have a better chance

of flinging your body around and making all sorts of grimaces. You roll your <u>eyes</u> and smirk. When a passage occurs twice, you play it slower the 2nd time; if it comes around a 3rd time, you play it slower still . . . She has a chance of getting somewhere, for she has real talent; but she won't succeed if she continues this way, she simply won't get the necessary rapidity, because she does everything she can to make her hand heavy.[42]

Mozart was going to do a good deal of teaching in his life, and if the quality of his students is any indication, he was like his father a first-rate teacher—he could even be patient sometimes, if other times on the sarcastic side. Mozart appreciated and praised talent when he found it, but he was a hard man to impress. He was supremely aware that there had rarely if ever been a more impressive talent than himself.

To Leopold he added another technical matter, one that speaks volumes about his playing: "I always keep correct time. They are all wondering about that. They simply can't believe that you can play a Tempo rubato in an Adagio, and the left hand knows nothing about it but goes on playing in strict time."[43] With nearly everybody else, he complained, when the right hand drifts, the left drifts along with it. So in Mozart's playing the left hand kept the tempo steady while the right ranged freely around the beat—but this sort of rubato, he implied, was mainly for slow music, which tended to be more rhapsodic and ornamented in the playing.

Finally they had lingered long enough in Augsburg. In contrast to Munich, the stay had brought in the kind of earnings it was hoped would finance the tour en route. At the end of October Wolfgang and his mother left for Mannheim, where they arrived on the twenty-eighth hoping for a long and fruitful stay. "To some extent Augsburg has made up for your losses," Leopold wrote. "Now you must be well on your guard, for Mannheim is a dangerous spot as far as money is concerned. Everything is very dear."[44]

They had departed a town with a solid musical life and the finest clavier maker in Europe. Now they would be in a town whose court was one of the glories of European music, its orchestra the most celebrated in the world, and both court and orchestra would make an enduring impression on him.

Chapter 11

LOVE AND MONEY

The day after Wolfgang and his mother arrived in Mannheim in October 1777, Mozart called on orchestra director Christian Cannabich, who had first met the wunderkind when the family visited the town in 1763. Mozart considered Cannabich the finest conductor he ever saw. On the other hand, though the reputation of the older man's symphonies stretched around German lands and into Paris, Mozart was less impressed with Cannabich's galant, perky, manifestly pleased-with-themselves works—say, like Leopold in his symphonist years, if at a higher and orchestrally more colorful level.

Wolfgang and Maria Anna would spend four and a half months in Mannheim, whose court and musical forces were in their prime. The prosperity and power of a state and its capital had much to do with the proximity of navigable rivers, and Mannheim lay near the confluence of the Rhine, Germany's main artery, and the Neckar. By the middle of the eighteenth century the town had the largest Baroque-era electoral palace in Germany and a musical establishment of fifty assorted artists. The ruler of the state was called the elector Palatine, his office as one of the four original electors of the Holy Roman Emperor, giving him considerable clout.

Elector Karl Theodor took the throne in 1742 on the death of his father. Personally he was devoutly Catholic, close to the conservative Jesuits, but in his policies he proved tolerant and enlightened. A statue of Voltaire, then still alive but already a legend, stood outside

the electoral library. If not a dynamic reformer like Frederick in Berlin and Joseph in Vienna, Karl Theodor still founded academies for the arts, physics, economics, and sciences. All the same, his main interest was in music. He was an able flutist, played the cello a bit, composed a bit, and he expanded the Mannheim court's musical forces to a position supreme in their time.[1]

Much of how Karl Theodor accomplished this had to do with money. In Salzburg and Vienna, the royals were concerned with how much music they could get for the least outlay. In contrast, Karl Theodor wanted the best and was ready to pay for it. Kapellmeister Ignaz Holzbauer made 3,000 florins a year; Director Cannabich, 1,800. A singer could start at 400 to 600 florins. By way of comparison, Leopold Mozart in those days was getting around 450; Joseph Haydn at his court around 1,000.[2]

Mannheim was brimming with music. In 1753 Voltaire's secretary reported to his master: "The electoral court was at that time perhaps the most splendid in Germany. Fêtes followed up on fêtes, and the good taste developed thereby constantly gave them fresh charm. There were hunts, operas, French dramas, musical performances by the leading virtuosos of Europe. In short, the electoral residence offered the most pleasant sojourn available for every person of fame and merit, who could always count on the most heartfelt and flattering reception there." There was also incidental music for hunts, water pageants, parades, processions, military exercises. A lot of these featured the court ensemble of twelve trumpets and two drummers, who also played at receptions, banquets, dinners, balls, ballets, pantomimes, and on through the endless calendar of amusements.[3]

The Mannheim orchestra had risen to acclaim in the middle of the eighteenth century under Johann Stamitz, who wrote for it some of the most influential symphonies of the time—if by the standards of later masters they were on the pale and mannered side. Among other things, Stamitz helped establish the idea of a minuet as the third of four movements in a symphony. His orchestra was more than twice as big as most court bands of the time, on the order of twenty violins, four each of violas and cellos, two basses, two each of flutes, oboes, bassoons, and horns. Clarinets began to appear in the late 1750s, and by the time Mo-

zart arrived they were a regular part of the wind section—unusual for those days. To that, as always, could be added trumpets and timpani.

The orchestra played amid the statues and frescoes and opulent chandeliers of the Knights' Hall in the Electoral Palace. A program would typically begin with a symphony, then a string of concertos interspersed with vocal arias and duets, and conclude with another symphony or a larger vocal ensemble. Concerts were events as much ceremonial and social as artistic. Card tables were set up beside the orchestra. With the grand entrance of the elector and electress and their family and retinue into the Knights' Hall, the card games and conversations and flirtations and the orchestra commenced together. During the music the elector would circulate among the tables and join in the talk.[4]

The Mannheim symphonic style was as distinctive as its orchestra. Its greatest innovation had to do with musical dynamics, the handling of volume. Baroque music rarely had dynamic indications on the score. The main Baroque keyboard instrument, the harpsichord, could change its volume only by adding another rank of strings. Instrumental players of the Baroque might contribute modest dynamic effects to taste, but the main effect was the blocky volume change of a small versus a large collection of instruments, as in a concerto's alternation of solo and tutti, or the effect of adding stops on an organ. One of the reasons for the rise of the piano is indicated by its original name, *fortepiano*, which means "loud-soft." It was the first keyboard instrument that could play both loud and soft and gradations in between: it could execute a crescendo from soft to loud or a decrescendo in the other direction.

The new possibilities for controlling keyboard and orchestral volume were embraced by the composers of the mid-eighteenth century, who made them part of new kinds of expression and of form: a surge of volume could evoke a surge of feelings. The Mannheim orchestra led in that evolution. A Mannheim symphony tended to begin with forte hammer strokes in unison, followed by a sudden piano passage. At some point would arrive the famous "Mannheim crescendo," the orchestra swelling in volume together, an effect new and thrilling for the day. (In practice, the dynamic novelties helped gloss over the often flimsy musical material.) In addition to the dynamic effects was a series of conventions that included the "Mannheim rocket" figure, a brisk zip

upward through the notes of a chord, and the "Mannheim sigh," a falling two-note figure.

None of this would have been as impressive without the quality of the musicians, which the British music writer Charles Burney dubbed "an army of generals." One connoisseur described the band this way: "Its *forte* is a thunderclap, its *crescendo* a cataract, its *diminuendo* a crystal stream babbling in the distance, its *piano* a breath of spring."[5] Cannabich sharpened the orchestra to an unheard-of level of precision; the generals moved as one. In contrast to the usual thrown-together house orchestras that often read pieces at sight, the Mannheimers carefully rehearsed the music. The wind players in particular were some of the finest in Europe. In other words, in Mannheim the Classical symphonic forces and style of the later eighteenth century took shape; it only awaited better composers to provide better notes. Wolfgang Mozart, taking in the orchestra with the greatest attention in 1777–78, would be one of those to absorb its virtues and pay them off. In particular it was the winds that caught his ear. He befriended two of them: flutist Johann Baptist Wendling and Friedrich Ramm, called the premier living oboist, whom Mozart quickly provided with a concerto he had written in Salzburg. Mannheim would broaden exponentially Mozart's sense of orchestral possibilities. (He would, however, write no symphonies in Mannheim and by his standards not a lot else either.)

The instrumental renown of Mannheim's court music was rivaled by its theatrical side. A gala performance on the elector's name day began the season, which would average two operas a week. Opera seria, with its connection to myths of royal benevolence and clemency, was the preferred genre, although a new seria style, partly imported from France, added more color and spectacle to dazzle audiences: choruses, big crowd scenes, special effects, ballets and battles, camels and elephants.[6] The audience came from the court, the nobility, the high bourgeoisie.

All Mannheim's musical endeavors were integrated into a ceremonial framework that blossomed on major feast days. A description of one of those days:

On the fourth [of November], the feast of St. Charles Borromeo, there will be a large gala at court in honor of the high name day

of his electoral highness, our most gracious ruler and lord . . . On this high feast-day the entire nobility, ministers and cavaliers, as well as all [officials of the] law courts, will most graciously be allowed to appear in the electoral apartments to congratulate and kiss the hand [of the elector], after which at about 11 o'clock his electoral highnesses and the entire court will process between the electoral bodyguard and the Swiss Guard . . . to the High Mass . . . Finally at the last sign of the cross, cannons will be fired from the ramparts. Thereafter [there will be] an open banquet . . . That evening toward 5 o'clock an opera will be performed.[7]

These kinds of holiday ceremonies were familiar in courts around German lands. The scale of a given court's spectacle amounted to an indication of its importance, or self-importance, among the German states in their hundreds. There was nothing in Salzburg like the splendor of Mannheim's holidays. After Joseph took the throne in Vienna, there was nothing like it there, either. Ceremony did not exist simply for entertainment, however, any more than churches existed only to encourage piety: both were the visible manifestation of the traditions of the ancient thrones, their wealth, their unchallenged powers.[8]

MOZART ARRIVED IN MANNHEIM FULL OF HOPES FOR A COURT POSI-tion or, failing that, to make his way by teaching and performing in the most musical of German cities. "One must . . . always have a plan in view four months ahead," Leopold cautioned, "but a plan that one can alter at a moment's notice if circumstances change."[9] Wolfgang's planning was diffuse, but indeed he could change at a moment's notice and did, or attempted to.

In early November he played for Cannabich six piano sonatas, K. 279–84, that he had written in Munich for Thaddeus Dürnitz, a bassoonist and clavier player. They amount to his first mature piano sonatas, but they are not particularly ambitious, mostly satisfied to be galant and pretty. Here and there they stretch further, like the Adagio of Piano Sonata No. 2 in F, K. 280, which is one of his memorably introspective and touching slow movements, yet not beyond the skills of a young pianist. He was starting to look for students and may have intended to publish

the sonatas as teaching pieces, keeping the difficulties down while bringing together musical material that would educate the fingers.[10] His first truly significant piano sonatas were just over the horizon.

But performances in Mannheim did not turn up quickly, in the end hardly at all. He secured a few students, some of them from among the elector's natural children with his mistress. None of it shook Mozart's jaunty mood. He was traveling as much as anything in search of good times and some modest wild oats. The Bäsle had much to do with his frame of mind; under her influence he lit up to his full potential of unruly imagination, far-reaching satire, randiness, obscenity, bad poetry, and unquenchable joie de vivre. In early November, he wrote her one of the most manic letters of his life.

> Dearest cuz buzz!
>
> I have received reprieved your highly esteemed writing biting, and I have noted doted that my uncle garfuncle, my aunt slant, and you too, are all well mell. We, too, thank god, are in good fettle kettle. Today I got the letter setter from my Papa Haha safely into my paws claws . . . You write further, indeed you let it all out, you expose yourself, you let yourself be heard, you give me notice, you declare yourself, you indicate to me, you bring me the news, you announce unto me, you state in broad daylight, you demand, you desire, you wish, you want, you like, you command that I, should could send you my Portrait. Eh bien, I shall mail fail it for sure. Oui, by the love of my skin, I shit on your nose, so it runs down your chin.

So far in the letter he has invented a zany system of word echoes and then gone off on what appears to be a parody of a language dictionary. The rhythms and phrases are virtually musical, leading to an unexpected yet musically logical climax concerning her chin. Then he turns to more relevant matters:

> Apropós, do you also have the spuni cuni fait?—what?—whether you still love me?—I believe it! so much the better, better the much so! . . . Oh my <u>ass</u> burns like fire! What on earth is the meaning of this!—maybe <u>muck</u> wants to come out . . .

And so forth. What about the *spuni cuni* matter? Here we meet Mozart's proclivity for neologism, his new words generally having mischievous overtones, in this case probably genitalia and/or their various roles. (In another letter he reports suggestively to the Bäsle that "I have not taken off my pants since I left Augsburg, except at night before going to bed.")[11] In this letter he is just getting warmed up. For a finale he launches into a comic aria of epic dimension:

Now, where was I?—oh yes, will come,—yes, yes, they will come—well, who?—who will come?—oh yes, now I remember: letters, letters will come—but what kind of letters?—well now, letters for me, of course . . . I want to make sure that you send these to me . . . Now Numero 2: I'm asking you, why not?—I'm asking you dearest numbskull, why not?—if you are writing anyway to Madame Tavernier in Munich, please include regards from me to the two Mad.^elles Freysinger, why not?—Strange! why not?—and to the Younger, I mean Fräulein Josepha, tell her I'll send my sincere apologies, why not?—why should I not apologize?—Strange!—I don't know why not?—I want to apologize that I haven't yet sent her the sonata I promised, but I will send it as soon as possible, why not?—what—why not?—why shouldn't I send it? . . . Strange! I wouldn't know why not?—Well, then you'll do me this favor . . . why not, it's so strange! After all I'll do it to you too, if you want me to, why not?—why shouldn't I do it to you?—strange! why not?

The word games he's playing in the letter are partly musical in effect, partly an implied pun, if one chooses to notice: the *send* that keeps coming up is in German *schicken*, in sound a close ally of *ficken*, "to fuck." Therefore, the *schicken/ficken* he's riffing on suggests what he's ready to do with her, if she wants him to.[12] Why shouldn't he? Strange! Mama probably read the letter and got a laugh out of it. It's her style. He ends the letter noting a fart and a finger up his backside to make sure it was his, as Mama insisted it was.

Again, what exactly he and the Bäsle had been up to is impossible to say. Her letters might have revealed more, but he did not save them. There had been some fooling around, surely, but there were also the

looming threats of venereal disease and, of course, pregnancy. But after all, there are a variety of delights to explore for the young and eager. Why not?

THEIR ACCOMMODATIONS IN MANNHEIM WERE AT FIRST PLAIN AND chilly, and they had to economize on food—except when Mozart was dining with nobles and patrons, when he generally left Mama in the flat alone. From all the traveling and the cold rooms her health was suffering; she had acquired a persistent cough.[13] But in December, Maria Anna was able to report that a patron had supplied them with much improved quarters. A court councillor gave them a room in his home gratis in return for Wolfgang giving clavier lessons to his teenage stepdaughter.[14]

Musical opportunities did turn up in Mannheim in an at least encouraging way, for the moment. Some of them, in one way or another, Mozart fumbled. He needed to be friendly with vice Kapellmeister Abbé Georg Joseph Vogler, but he couldn't stand the man or his music. Vogler, he wrote Papa, is "a dreary musical jester, an exceedingly conceited and rather incompetent fellow. The whole orchestra dislikes him."[15] Mozart's distaste became public when he walked out of a rehearsal of Handel's *Messiah* when Vogler pulled out a piece of his own; soon after that Mozart exited a rehearsal of a Mass of Vogler's. "I have never in my life heard such stuff," he wrote Leopold, in the process providing a thumbnail sketch of his own aesthetic.

In many places the parts simply do not harmonize. He modulates in such a violent way as to make you think he's resolved to drag you with him by the scruff of the neck, not that there is anything remarkable about it all to make it worth the trouble; no, it's all clumsy plunging. . . . It is impossible that a mass of Vogler's should please any composer who is worthy of the name. To put it briefly, if I hear an idea which is not at all bad—well—it will certainly not remain not at all bad for long, but will soon become— beautiful? God forbid! Bad and thoroughly bad; and that in two or three different ways. Either the idea has scarcely been introduced before another comes along and ruins it; or he does not

round it off naturally enough to preserve its merit; or it is not in the right place, or finally, it is ruined by the instrumentation.[16]

Vogler's music that survived is not uninteresting, at times verging on Sturm und Drang, but it also shows the failings Mozart reported: rather than sustaining ideas Vogler tends to drop them, and there is a straining for effect and general self-consciousness a long way from Mozart's effortless spinning out. In other words, Mozart saw that Vogler's ideas were better than his skill in handling them. At the rehearsals Vogler of course noticed Mozart's scorn—everybody noticed—and among court musicians, countermeasures were probably initiated behind the scenes. Vogler could see Mozart only as a rival and respond accordingly. This was not the only time in Mozart's attempts at a career that he would come up against a figure with a settled position and the clout to go with it, and rub him the wrong way.

In Mannheim Mozart made the acquaintance of celebrated tenor Anton Raaff, whom he quickly saw was past his prime. Wolfgang reported home, "When you hear him begin an Aria and you don't think right away that this is Raaff, the once so famous tenor . . . if I didn't know that this was Raaff singing, I would bend over with laughter. As it was—I just pulled out my handkerchief and giggled. Besides, he has never been, as people here tell me, a good Acteur."[17] After seeing him in an opera, Wolfgang added, "He had to die and while dying sing a very very very long aria in slow time; well, he died with a grin on his face, and towards the end of the aria his voice gave out so badly that one really couldn't stand it any longer."[18] With Raaff at least, Mozart managed to keep his amusement to himself; the two were destined to be friends and colleagues. The aging singer's voice did not get better, but Mozart got more forgiving about it, and he liked the man.

With Elector Karl Theodor, Mozart managed only a passing audience. At a concert with a noisy audience, the elector and electress sat close to the clavier to listen. Afterward Mozart kissed the elector's hand and the old man observed, "I think it is about fifteen years since you were here last."

"Yes, Your Highness, fifteen years since I had the honor of—"
"You play admirably."
That was it for the elector. Mozart turned and kissed the electress's

hand, and she cooed, "Monsieur, je vous assure, on ne peut pas jouer mieux" (I assure you, sir, no one can play better.) Soon came rumblings that the elector might be considering something for Mozart, raising his hopes again.

In December a commission appeared, a significant one in terms of money at least. Ferdinand Dejean was a physician rich enough not to have to practice, an amateur flutist, and something of an eccentric. Once employed by the Dutch East India Company, he now spent his time traveling about for pleasure. Court flutist Wendling told Wolfgang that "our Indian" was ready to pay two hundred florins for some concertos and flute quartets.[19] Leopold kept prodding Wolfgang to get the pieces done, and Wolfgang, unenthusiastic about the whole business, began to obfuscate, make excuses, and outright lie about it. In one of the letters to his father his equivocation took this form: "Of course, I could scribble all day long, and scribble as fast as I can, but such a thing goes out into the world; so I want to make sure that I won't have to feel ashamed, especially when my name appears on the page; besides, my mind gets easily dulled, as you know, when I'm supposed to write a lot for an instrument I can't stand."[20]

Was he making excuses, or could he really not stand the flute? It could have been either or both. In the later eighteenth century there were sophisticated schools of string playing (one of them Leopold's), but not of wind playing. There were lots of flutes around, mostly heard in the street and the parlor, usually played badly. At its best the instrument, a simple wooden tube with open holes and a key or two, was wretchedly difficult to play in tune. It was built in D major; every other key involved tricky cross-fingerings. By this point, as noted before, when flutes were called for in an orchestra, they were mostly played by oboists who could double. Given that the fingerings and playing techniques of the two instruments were radically different, the flute got short shrift. In Wendling at least, Mozart heard a specialist and one of the best players in Europe. He told the flutist's brother, "Well, you know, it's different with your brother. In the first place, he is not such a doodler, and then you don't always have to be afraid with him when you know a note is about to come that is going to be much too low or too high—it's always right. His heart is in the right place and so are his ears and the tip of his tongue."[21]

In the end Mozart supplied Dejean with two flute concertos—not mentioning that one of them was the recycled and lightly revised oboe concerto—and probably two flute quartets. For all his protests about the instrument, these pieces would endure as some of the finest of their kind. The first flute quartet, K. 285 in D Major, begins with a vibrant flurry of melody in high-galant mode, with the charm of that atmosphere but not its limp preciousness. In the whole quartet the melodic writing is irresistible—Mozart seems to be glorying in the flute, which he actually was not at all. The heart of the piece is the Adagio, a long-breathed soliloquy for the flute accompanied by pizzicato strings that is sort of a serene interior lament; it segues into an energetic and darting finale. The other flute quartet that seems authentic is 285a, in two movements, pleasant enough, if not on the same plane of inspiration, maybe a sign that Mozart was running out of interest.[22] The more appealing of the two flute concertos is K. 314, the one originally for oboe: fresh-faced and tuneful in a generally galant tone, with a particularly perky finale evocative of, say, summer and an amour of the moment. At any rate, that was what Mozart himself had been enjoying with the Bäsle.

In January 1778, Wolfgang wrote Mama a long, exceedingly rude poem from Worms, where he was visiting. He ends, "I will . . . write the 4 quartets without any sass, / So he has no reason to call me an ass." As for the remaining concerto, "The Concerto I'll write him in Paris, it's fitting, / For there I can dash it off while I'm shitting."[23] None of that came to pass. Dejean had by then left town. Mozart dispatched to him two flute quartets and two concertos, one of them not actually new, and collected ninety-six florins, a notch less than half the commission. From there on he put off Papa about the remaining pieces. When Mozart truly did not want to do a commission it tended not to get done, regardless of how much he needed the money.

Leopold had begun to push his son to head for Paris, scene of his childhood triumphs, where there were old friends and patrons to help him. Wendling and Ramm were planning to go there soon and invited him to come along. Mozart was at first receptive to the idea, especially if he could dispatch Mama back to Salzburg and go on by himself. "Once a man has written a couple of operas in Paris," he wrote home, "he is sure of a settled yearly income. Then there is the *Concert Spirituel* and

the *Académie des Amateurs*, which pay five *louis* d'or for a symphony."[24] Still, he lingered in Mannheim. "I am thinking of staying on for the winter. I am only waiting for a reply from the elector."[25] As he waited for word from on high, he was also partying heartily, as he implied in a mock-confessional recitation to Leopold.

> I, Johannes Chrisostomus Amadeus Wolfgangus Sigismundus Mozart, am guilty of not coming home until 12 o'clock midnight, the day before yesterday and yesterday, and often times before, and that from 10 o'clock until said hour at Canabich's I did some rhyming in the presence and company of Canabich, his wife and daughter, the Treasurer, and Messrs. Ramm and Lang,—nothing too serious but rather light and frothy, actually, nothing but crude stuff, such as Muck, shitting, and ass licking, all of it in thoughts, words—but not in deeds. I would not have behaved so godlessly if our ringleader, known as Lisl, namely Elizabeth Cannabich, had not inspired and incited me to such high degree; I must also confess that I thoroughly enjoyed it all. I confess all these my sins and transgressions from the bottom of my heart, and, in the hope that I can confess them more often, I'm fully committed to perfecting the sinful life that I've begun. I, therefore, beg for holy dispensation if it can be obtained easily; if not, well, it's all the same to me because the play must go on.[26]

Papa was not in the least amused. "You must have other, more important thoughts in your head than tomfoolery; you must be busy anticipating a hundred things . . . Even if . . . you give a hundred lessons, compose sonatas, and, instead of attending to more important matters, concern yourself with smut every night . . . Then ask for credit! . . . Good God! Solely on your account I am . . . in debt, and you think that perhaps you can coax me into good humor with a hundred stupid jokes."[27] And so it transpired that that was the last merry letter Wolfgang ever wrote to his father.

IN THE FIRST WEEK OF DECEMBER MOZART GAVE A LESSON TO ROSA Cannabich, daughter of the Kapellmeister, who was thirteen. He de-

scribed her to Leopold as "a very beautiful and well-mannered girl; she is very thoughtful and self-assured for her age . . . she is serious, doesn't talk too much, but when she speaks she speaks with graciousness and friendliness."[28] The lesson was on the C-major Sonata K. 309, which he had written for her. Beyond that, he declared that the second movement was a portrait of her (something that, as far as the record shows, he never did again).

The C Major seems to present itself in the opening exposition as a simple and galant affair, sounding rather like a piece for students, complete with lots of routine Alberti bass accompaniment. Then it moves into a development section entirely in minor—not mock-serious but truly serious, perhaps already an evocation of serious young Rosa. The minor mode lingers, clouding the main theme in the recapitulation. The second-movement Andante, his portrait of the girl, is singular not only in being a portrait but also in its atmosphere and form. The main theme is hesitant, a series of little gestures separated by silence, perhaps suggesting a young girl who does not speak readily. The form is likewise unusual: an A section repeated with ornamentation, then a BA handled likewise. The B section still manages to be thoughtful unto solemn. The finale returns to a galant-with-Alberti mode for the Rondo theme, the minorish elements of the previous movements coloring the secondary sections. The sonata adds up to a fabric of emotional subtleties.

Mozart reported that during one lesson, as he listened to Rosa play her Andante portrait quite beautifully, he wept. Perhaps it was not entirely a matter of being moved by his own music. After putting him off for weeks, answering queries with a shrug, Elector Karl Theodor had concluded that there would be no position for him at court. When Mozart told his friend Wendling, the flutist turned red with anger—or so Wolfgang reported—and declared, "We'll have to find another way; we have to keep you here, at least for two months, until we can go to Paris together."[29]

Leopold welcomed the Paris idea, but he continued to harangue Wolfgang relentlessly. The boy was distressingly devil-may-care.

That you, my son, should tell me <u>that all planning is needless and useless, since after all we do not know what is going to happen,</u> argues indeed a scattered brain; and you must have written that

quite thoughtlessly. No sensible man, I need hardly say, no Christian will deny that <u>all things will and must happen in accordance with the will of God</u>. But does it follow therefore that on all occasions we are to act blindly, . . . make no plans and barely wait until something drops down from the sky of its own accord?[30]

This was Leopold's style of piety in a nutshell, embodied in a familiar cliché: all is the will of God, but God helps those who help themselves. Unfortunately, his son was more inclined to wait until things dropped from the sky.

Sober as were Leopold's letters to his son on the road, there were splinters of his dry wit here and there, especially in reports of goings-on in the house and around town. One report was tragicomic. Composer and cathedral organist Anton Cajetan Adlgasser was an old acquaintance of the family. Like many of his colleagues including Michael Haydn, Adlgasser was fond of his wine and, like Haydn, not always abstemious on the job. Leopold reported that Adlgasser had been playing organ at a service when the notes suddenly turned into gibberish. As Adlgasser groped around it sounded, Leopold wrote, "like a dog running over the keys." By a third number he was playing the left hand with his fist. Everybody assumed Adlgasser was drunk again, but in fact he was dying. He was only forty-eight, but it appears a stroke had hit him, and he kept fingering the keys at random until Leopold coaxed him from the bench; he expired soon after.[31] This description probably drew a rueful chuckle from all the Mozarts. Adlgasser's death, meanwhile, left the leading organ position in town usefully vacant.[32]

IN MANNHEIM, WOLFGANG'S TEARS AT THE DASHING OF ANOTHER JOB prospect did not last. He remained determined to amuse himself until it was time to go to Paris. Perhaps contributing to his high spirits, the Bäsle remained firmly lodged in his mind. "Write her a sensible letter for once," Mama advised. "You can still write all that funny stuff, but be sure to tell her that you have received all the mail." Her son sort of concurred, but the funny stuff had to come first. The Bäsle had prom-

ised to send him her portrait, but she had not enclosed it with her latest letter. "Ma trés chére Niéce! Cousines! Fille!," Mozart began,

> Mére! Sœur!, et Epouse!
>
> Heaven, Hell, and a thousand sacristies, Croatians, damnations, devils, and witchies, druids, cross-Battalions with no ends, by all the elements, air, water, earth, and fire, Europe, asia, affrica, and America, jesuits, Augustins, and dignified Holy-Crucians, Canons regular and irregular, and all hairy brutes and snitches, higgledy-piggledy castratos and bitches, asses, buffaloes, oxen, fools, nitwits, and fops! What sort of manner is this, my dear? 4 soldiers and only 3 gear?—such a Pacquet and no Portrait?

He concluded, veiling his suggestion modestly in French, "I kiss your hands, your face, your knees, and your _____, in a word, whatever you permit me to kiss."[33]

TO MOZART THE BÄSLE WAS TO BE INDULGED IN WITH UNBUTTONED silliness. At the same time as he was dispatching pages of madness to his cousin, though, another girl came into his ken who was something quite otherwise. The first hint came in a letter to his father in January 1778. Wolfgang wrote that he was going with a soprano and her father to Kirchheimbolanden, north of Mannheim, to meet and hopefully impress the Princess of Orange, whom he had met years before in The Hague, and who liked to sing. During this visit, he would play the part of the famous virtuoso, pay most of their expenses with Leopold's money, and split the fee with the singer.[34] He wrote Leopold that he was having some of his arias copied to bring with him.

> The copying of the arias didn't cost me much either, because it was done by a certain Herr Weber, who will accompany me on the trip. I'm not sure whether I have mentioned his daughter to you—she sings superbly and has a beautifully clear voice. The only thing she lacks is some experience in acting, but once she has mastered that she can be a Prima donna in any theater. She is only

sixteen. Her father is a good, honest German who is raising his children properly . . . She sings my aria, the one I wrote for De Amicis, with those horrific Passages, exceedingly well.[35]

Her name was Aloysia Weber. She was lovely to behold and likewise to hear. Paintings show ripe lips, plump cheeks, a self-possessed air. She arrived in Mozart's life as a piano student, but she was primarily a soprano with operatic ambitions not in the least fanciful: she was as gifted as fetching. Her family was intensely musical, her father Frido-lin, the son of a musician and brother of another (who later became the father of composer Carl Maria von Weber). Fridolin had studied law and began his career in a government job, but gravitated to music. When Mozart encountered him he was a lowly bass singer, theater prompter, and music copyist for the Mannheim court.[36] He and his wife Cäcilia had four daughters, all of them budding singers, three of them destined to become prima donnas. But Aloysia was then, and always would be, the shining star of the family.

So it began with keyboard lessons. Aloysia appears to have been a capable clavier player, good enough to hold down one of the solo parts when Mozart mounted his three-piano concerto in Mannheim, but at sixteen, she was already an exceptional soprano whose admirers included Elector Karl Theodor.[37] As she sat on the piano bench close beside him, running through her pieces while his gaze strayed from her hands to her delightful young face, Mozart was smitten quickly and hard. Why should he not have been? He knew the real thing when he saw it, and Aloysia was in every sense the real thing.

How Mozart responded to people had to do not only with how much he liked them and the particular way he liked them, but also with how he sensed the way they responded to him. Which is to say, this was not going to be a heated courtship as with the Bäsle (who didn't really require courting anyway). Aloysia he handled with gloves on, his approach cautious and chaste. He was one person with Papa, another person with Mama, another with Nannerl, another unlike any other with the Bäsle, and utterly otherwise with Aloysia. With each of them he assumed a role that he played with near-perfect consistency. Now his role was of the undeclared lover maneuvering nervously just outside her orbit. Mozart rarely

seemed to be scared of anything or anybody, but maybe he was a little scared of Aloysia.

In any case he kept a lid on his feelings. The main symptom of his affection was, naturally, that he composed arias for her, gave her ones from his operas, and coached her in arias by J. C. Bach, to which he added embellishments to show her off.[38] They became a musical team. As she welcomed him into her life, her father welcomed him into the Weber family, eager to have this famous young man interested in his daughter and perhaps able to do something for them all.

Aloysia would have been well aware of the figure Mozart cut in the world, also aware how unsettled and ambiguous was his current position in the world. There were men around of better means, and many men better looking. Aloysia was the sort of girl who could have her pick, and she was ambitious. There is no record of what she thought of Mozart at this point. Young Aloysia just sang beautifully as he coached and accompanied her. It only made him love her more.

Love does not announce itself as a matter of convenience; it rushes in imperiously whenever it chooses. This was more or less the worst time for Mozart to fall. He was nominally a marriageable adult, but a man did not tend to marry in those days until established in some sort of profession. Mozart was then about as much at loose ends as a musician could be, and where he might come to rest was impossible to imagine. Which is to say that a crisis loomed.

For the moment communication went on as usual. In January Leopold wrote his son,

> My heart is heavy indeed, now that I know you will be still farther away from me. True, you can realize this to some extent, but you cannot feel the burden of grief which is weighing down my heart. If you will take the trouble to remember what I undertook with you two children in your tender youth, you . . . will admit, as others do, that I always have been and still am a man who has the courage to dare all. Yet I managed everything with the greatest caution and consideration that was humanly possible.

This was preparatory to advising Wolfgang that to finance the trip Leopold had now gone into debt for the first time in his life, to the tune

of seven hundred florins—some two years' salary in his job.[39] From this point on, Leopold bemoaning his finances was going to become a steady drumbeat in his letters. True, he had borrowed money. Once again: what he did not mention, never mentioned or admitted, was the comfortable amount he had stashed away from the children's travels.

Leopold's coming protests of poverty, ranging from furious to anguished to pathetic, must be seen in that light: he was lying.[40] For years he lied relentlessly, heaping the burden on his son, demanding to be repaid for all his pains and expenses. He loved his children and had done everything in his considerable powers to give them the tools to realize their gifts and find a place in the world. But stronger even than that was the drive to achieve his own comfort and security as he aged. That is one of the reasons he never pushed Nannerl to leave the nest or do more performing. She stayed home and took care of him. Whether Wolfgang or his sister ever suspected the truth about their father's finances cannot be said. The truth lay open in front of them in later years, but they may never have added up the simple evidence: Leopold lived a comfortable existence to the end in the spacious and elegant Tanzmeisterhaus.

ALOYSIA WAS MOZART'S FIRST TRUE LOVE, AND AS IT OFTEN GOES with first love, it inflamed and inspired him and also at times made him stupid. With Aloysia and Fridolin he had gone to the court at Kirchheimbolanden to play for the singing princess. It went well. "In the evening," he reported,

> we were received at court . . . Mlle. Weber sang three arias; I don't want to go into details about her singing—just this one word: excellent!— . . . The following Monday we had another evening of Musique, Tuesday as well, and then again Wednesday. Madamoiselle Weber sang altogether 13 times and played the Clavier twice; her playing is not bad at all. . . . Just imagine, she played my difficult sonatas at sight, slowly but without dropping a note.[41]

On his return to Mannheim, he announced a plan for something more ambitious—far too ambitious. He begins with a sanguine ob-

servation about Dejean's flute pieces that he was in fact apathetic about
and, in any case, only half finished.

> I propose to remain here and finish entirely at my leisure that
> music for De Jean, for which I am to get 200 gulden . . . In the
> meantime Herr Weber has endeavored to get engagements here
> and there for concerts with me, and we shall then travel together.
> When I am with him, it is just as if I were traveling with you.
> The very reason why I am so fond of him is because, apart from
> his personal appearance, he is just like you and has exactly your
> character and way of thinking . . . I have become so fond of this
> unfortunate family that my dearest wish is to make them happy;
> and perhaps I may be able to do so. My advice is that they should
> go to Italy . . . As far as [Aloysia's] singing is concerned, I would
> wager my life that she will bring me renown. Even in a short time
> she has greatly profited by my instruction, and how much greater
> will the improvement be by then! I am not anxious either about
> her acting. If our plan succeeds, we, M. Weber, his two daughters
> and I will have the honor of visiting my dear Papa and my dear
> sister for a fortnight on our way through Salzburg. My sister will
> find a friend and a companion in Mlle Weber, for, like my sister
> in Salzburg, she has a reputation for good behavior, her father re-
> sembles my father and the whole family resembles the Mozarts.[42]

He has decided to go to Italy with half the Weber family in tow
and establish teenage Aloysia as a diva on the stage there, at the same
time establishing himself in a land of his childhood triumphs. It will
be almost like the old tours, so much are the Webers like the Mozarts!
As for the Paris plan, to go there with his dear friends Wendling and
Ramm . . . well, suddenly he had realized some disturbing things about
those two, disturbing to himself and surely to Papa.

> My mother and I have talked about it and agree that we don't like
> the conduct of the Wendling family. Wendling is an Honest and
> good man, but he has no Religion and neither does his family. It
> is enough said when I tell you that his daughter was a mistress.
> And Ramm is a good person but a libertine. I know who I am,

I know that I have enough religion in me that I would never do anything that I could not do before the whole world; just the idea to be alone on a trip with such men whose way of thinking is so different from mine and different from that of all honest people, is scary to me.[43]

At least one part of this was true: Wendling's daughter Elisabeth Augusta had once had a lover, who was in fact Elector Karl Theodor, and apparently that was agreeable to her parents.[44] Otherwise, from this point the mendacity of the son was beginning to compete with that of the father. But it would never be a simple matter. In the letter, Wolfgang followed the Italy idea with some entirely sensible and worthwhile thoughts about love and marriage. The reason, of course, was that his thoughts were now turning to marriage.

Herr von Schidenhofen [*sic*] could have let me know through you long ago that he was planning to get married soon. I would've Composed some new Minuetts for the occasion. I wish him the very best with all my heart. It is, of course, a money marriage, nothing more. I wouldn't want to enter into this kind of marriage. I wish to make my wife happy and not make my happiness through her. That's why I want to stay away from it all and rather enjoy my golden freedom until I am able to support a wife and children. For Herr von Schidenhofen it was necessary to choose a wealthy woman; after all, he is a nobleman. People of noble birth cannot marry out of inclination or love, they have to marry out of material interest and other such motives. It wouldn't fit the image of such high and noble Personages if they loved their wives in addition to having fulfilled their obligation of bringing a Plump scion into the world. But we poor common folk not only have to take a wife we love and who loves us, but we are permitted, able, and willing to take such a wife precisely because we are not aristocratic, highborn, Noble, and rich, but indeed low born, humble, and poor, in other words, we are not in need of a rich wife, for our riches die with us because we carry them in our heads;—and no one can take that away from us, unless someone chops our head off, in which case—we won't need anything anyway.[45]

Here Mozart is perceptive on two fronts. Most aristocratic marriages in those days were a matter of position, money, and breeding, not love. Often it was not a matter of choice, either, especially for women, who were commonly told whom they were going to marry and were sometimes exhibited to available aristocrats like broodmares. In this situation it was predictable that extramarital affairs among the high-born were more or less expected. In Mannheim, the elector's various mistresses were nothing unusual. For aristocratic wives, affairs were more fraught because of the risk of getting pregnant, but they were still common.

In the past the lowborn had married for practical reasons having to do with labor and childbearing. But in the eighteenth century Enlight-enment grew the idea of companionate marriage, a matter of individual choice, the impetus coming from romantic love. A vital part of that was the joys and satisfactions of the marriage bed.[46] When it came to his father, Wolfgang was learning that a good deal of the time he must talk through his hat and to punch Papa's buttons, especially concerning family honor and religion. But the credo he articulated about marriage was serious, and it stayed with him. For Mozart, between husband and wife, love and sex, the spiritual and the delightful were fundamental and indivisibly wedded.

When Leopold received Wolfgang's letter about Aloysia and the proposed tour of Italy, he did not have time to notice perceptive obser-vations about love and marriage. Rather he saw his hopes going up in smoke around him. It was as if he had discovered his son reaching into his pocket and withdrawing piles of cash. Panicked and outraged, he splashed over the page at his usual exhaustive length, pulling out vir-tually every stop at his command. He begins with an overview of what Wolfgang's betrayal does to him and his own hopes.

> I have read your letter of the 4th with amazement and horror. I
> am beginning to answer it today the 11th, for the whole night long
> I was unable to sleep and am so exhausted that I can only write
> quite slowly, word by word . . . Up to the present, thank God, I
> have been in good health; but this letter, in which I only recognize
> my son by that failing of his which makes him believe everyone
> at the first word spoken, open his kind heart to every plausible

flatterer and let others sway him as they like, so that he is led by whimsical ideas and ill considered and impractical projects to sacrifice his own name and interests, and even the interests and the claims of his aged and honorable parents to those of strangers— this letter, I say, depressed me exceedingly, the more so as I was cherishing the reasonable hope that certain circumstances which you had to face already, as well as my own reminders, both spoken and written, could not have failed to convince you that not only for the sake of your happiness but in order that you may be able to gain a livelihood and attain at length the desired goal . . . it was imperative for you to guard your warm heart by the strictest reserve.

His reckless son had ignored his wise counsel, taken the bit and galloped off with no idea what he was doing or where he was going. This was, to be sure, true. Leopold recalls the happy days of their past together, which Wolfgang threatens to negate.

Merciful God! Those happy moments are gone when, as child and boy, you never went to bed without standing on a chair and singing to me Oragna fiagata fa, and ended by kissing me again and again and again on the tip of my nose and telling me that when I grew old you would put me in a glass case and protect me from every breath of air, so that you might always have me with you and honor me.

He returns to his abiding lie, on which he will play variations for the rest of his life.

Listen to me therefore, in patience! You are fully acquainted with our difficulties in Salzburg—you know my wretched income . . . The purpose of your journey was twofold—either to get a good permanent appointment, or, if this should fail, to go off to some big city where large sums of money can be earned . . . It now depends on you alone to raise yourself gradually to a position of eminence, such as no musician has ever obtained. You owe that to the extraordinary talents which you have received from a beneficent God.

Leopold raises the specter of poverty and disaster if his son fails to realize his God-given gift and reach the height of a musician's ambition: to secure a position as Kapellmeister and become the breadwinner of the family.

Now it depends solely on your good sense . . . whether you die as an ordinary musician, utterly forgotten by the world, or as a famous Kapellmeister, of whom posterity will read,—whether, captured by some woman, you die bedded on straw in an attic full of starving children, or whether, after a Christian life spent in contentment, honor and renown, you leave this world with your family well provided for and your name respected by all.

He does not neglect to hold over his son the episodes of childishness, the frivolous amours.

In Augsburg you had your little romance, you amused yourself with my brother's daughter . . . When you were at Wallerstein [Leopold had been advised] you caused the company great amusement, you took up a violin, and danced about and played, so the people described you to absent friends as a merry, high-spirited and brainless fellow . . . Suddenly you strike up a new acquaintanceship—with Herr Weber; all your other friends are forgotten; now this family is the most honorable, the most Christian family and the daughter is to have a leading role in the tragedy to be enacted between your own family and hers!

Then Leopold arrives, at last, at the common sense of the matter. The idea of an Italian tour with the Webers is worse than hopeless; it is ridiculous and will only earn ridicule for the whole family.

You are thinking of taking her to Italy as a prima donna. Tell me, do you know of any prima donna who, without having first appeared many times in Germany, has walked onto the stage in Italy as a prima donna? . . . As for your proposal (I can hardly write when I think of it), your proposal to travel about with Herr Weber and, be it noted, his two daughters—it has nearly made

me lose my reason! My dearest son! How can you have allowed yourself to be bewitched even for an hour by such a horrible idea, which must have been suggested to you by someone or other! . . . Quite apart from your reputation—that of your old parents and your dear sister? To expose me to the mockery and ridicule of the Prince and of the whole town which loves you? Yes, to expose me to mockery and yourself to contempt, in reply to repeated questions, I have had to tell everyone that you are going to Paris.

He concludes, "Off with you to Paris! . . . Though half dead, I have managed to think out and arrange everything connected with your journey."[47] And Mama is absolutely to accompany him.

Leopold's letter would have struck Wolfgang and Maria Anna like a bolt from a thunderhead. Wolfgang's lovestruck schemes had been bluntly slapped down. Some words from home could be resisted, ignored. Sometimes Mama was more or less complicit. Not this time. In a secret postscript to another letter, she reported that Wolfgang was ignoring her. "In a word, he prefers being with others to being with me. I take exception to one and another thing not to my taste, and that annoys him."[48] His tendency to push aside Mama and her needs and opinions was going to have its consequences. When she complained, it was to her husband, not her son.

Wolfgang's reply to Papa was a chastened backtrack, almost as if he had not really written what he wrote. Here begins a pattern of unruffled, respectful, canny responses to his father's screeds.

I hope you received my last two letters safely. In the last one I discussed my mother's journey home, but I now see from your letter of the 12th that this was quite unnecessary. I always thought that she would disapprove of my undertaking a journey with the Webers, but I never had any such intention—I mean, of course, in our present circumstances. I gave them my word of honor, however to write to you about it . . . In the intoxication of the moment I forgot how impossible it is at present to carry out my plan.

Some of the blame he shuffles off on Mama. Wendling and Ramm had already left for Paris. "If my mother had not first raised the point,

I should certainly have gone with my friends; but when I saw that she did not like the scheme, then I began to dislike it myself."⁴⁹ Leopold had reported that when she heard about Wolfgang and the Webers, Nannerl had cried for two days. In regard to that, Wolfgang noted, with a chilly want of sympathy, "I embrace my sister with all my heart, but she shouldn't cry about every little sh[it], otherwise I'll never come back."⁵⁰

Both the children tended to respond bodily to bad news. When Wolfgang left Salzburg, Nannerl vomited and spent wretched days in bed; she wept over his letter about Aloysia. After his father's response, Wolfgang developed a cold, headaches, a sore throat, aching eyes and ears. He pleaded with Papa less for forgiveness than for faith: "I beg you, think of me whatever you like, but don't think anything bad. There are people who believe that it is impossible to love a poor girl without having bad intentions; and that pretty word maitress, wh-re in German, oh, it's so charming and convenient!—but I am no Brunetti and no Misliwetcek [*sic*]! I am a Mozart, a young and decent-minded Mozart; therefore, I hope you will forgive me if I get carried away sometimes in my excitement."⁵¹

Maria Anna added postscripts backing up her son:

We are both awfully sorry that our letter horrified you so. On the other hand, your last letter of the 12th distressed us greatly. I implore you with all my might not to take everything to heart the way you do, for it is bad for your health . . . You say . . . we ought to have told you at once about Herr Wendling's way of living. The reason why we didn't do so is that for a long time we knew nothing about it. . . . Herr Wendling is the best fellow in the world, only the whole household knows nothing about religion and does not value it . . . I do hope that Wolfgang will make his fortune in Paris quickly, so that you and Nannerl may follow us soon.⁵²

To all this Leopold replied to his son, "The Prince's conduct can only bend me, but yours can crush me. He can only make me ill, but you can kill me."⁵³

Did Wolfgang believe that his father's very life depended on his obedience and his earnings? As it would play out, he did not. And he was correct.

There was another issue bearing heavily on Mannheim, the court, and the Webers. In Munich, Elector Maximilian III Joseph, who had given Mozart a brushoff the previous autumn, died of smallpox at the end of December 1777. His successor on the Bavarian throne was his cousin Karl Theodor. Karl eventually decided it was imperative to move his court from Mannheim to Munich and occupy the throne, because Joseph II of Austria had manifest designs on Bavaria. Joseph's claim to the throne was founded on his late wife, who was Maximilian Joseph's sister—plus the situation that all Karl Theodor's children were, as the saying went, illegitimate.

A chain of events unfolded to create what became known as the War of the Bavarian Succession. Hoping to calm the waters, Karl Theodor signed a treaty to give Lower Bavaria and other territory to Joseph. This gained the attention of Frederick the Great, the fighting king of Prussia, who supported the Bavarian claims of the Duke of Zweibrücken, but who in fact mostly wanted to restrain Austria's power. Frederick marched an army into Bohemia, where Joseph stood at the head of his army to oppose him. From that point, the conflict slipped largely into a war of maneuver, with skirmishes over supplies and communications. It was soon sardonically dubbed the "Potato War," because the Prussian Army seemed to be occupied mainly with digging potatoes for their sustenance. Over the protests of her son Joseph, Empress Maria Theresa brokered a peace with Frederick; in 1779 Austria got a small slice of Bavaria, and that was the end of it.

As his court hastily packed up for a departure to Munich on the first day of 1778, Karl Theodor gave his musicians a choice of whether to move with him or to stay in Mannheim.[54] In the next months, the majority went with him, including the Webers. Munich would provide a bigger stage and better opportunities for Aloysia and the rest of them. So Wolfgang's love was leaving town, and so was he. As for Mannheim, its musical glory days were over. Some but not all that glory would reemerge in Munich, and Karl Theodor would not forget about Mozart.

Naturally, Mozart gave Aloysia a parting gift. He had written concert arias since childhood, as well as more elaborate scenas that set a chunk of text from an opera with recitative and so on. The telling recitative and aria he wrote for Aloysia, one of the most significant prod-

ucts of his time in Mannheim, was "Non so d'onde viene," for which he supplied an orchestral accompaniment, its text from Metastasio.

He continues mildly, "At first I had intended it for Raaff, but the beginning seemed to me too high for his voice . . . It seemed to me better suited to a soprano. So I decided to write it for Mlle Weber." No. This was a love song from the beginning: "I do not know from whence comes / That tender affection, that unknown vibration which is born in my breast." The music is warm but not overtly ardent, a touch formal in tone. Even on the page, Wolfgang was keeping his passion under wraps. Call "Non so d'onde viene" a love song to Aloysia's voice, crafted to make it shine. "I like an aria to fit the singer as perfectly as a well-made suit of clothes," he wrote Papa. Much of the song shows off the beauty of Aloysia's voice in the middle range, but she clearly had a spectacular high register: at the end, he takes her up to a breathtaking high E-flat. "This is now the best aria she has," he wrote, "and it will ensure her success wherever she goes."

His letters after Leopold's blast are going to be nothing but submissive, optimistic, reassuring, and bland. He concludes, "Do rely on me. I shall do my very best to bring honor to the name of Mozart and I have not the slightest fear . . . I do entreat you never to allow the thought to cross your mind that I can ever forget you, for I cannot bear it . . . Let us place our trust in God, Who will never forsake us."[55]

That day, that very same day, perhaps moments after his letter to Leopold, he wrote another of his improvisations to the Bäsle.

> You may perhaps believe or even think that I am dead!—that I Croaked?—or kicked the bucket?—not at all! Don't think of it, I beg of you; for thinking and shitting are two different things! . . . But now I have the honor to query how you are and whether you are weary!—whether your bowels are solid or thin?—whether you are still a little fond of this here gawk?—whether you sometimes write with a chalk?—whether you now and then think of me?—whether at times you'd like to hang yourself from a tree?

On the one hand this is simply another installment of how Wolfgang writes to the Bäsle, in boggling contrast to how he writes Papa. On the

other hand, this one has between the lines a detectable touch of hysteria, with its jokes about death and hanging oneself. On paper and in person, Wolfgang played his variegated roles to the Bäsle, to Papa and Nannerl, and to Aloysia, and they seemed each a distinct and integral world. But because Mozart was after all human, the roles could seep into one another. A character in his last buffa will propose to hang himself from a tree, and it is at once a joke and no joke.

In his letter to the Bäsle, he invents a shaggy-dog fable about a shepherd and a dog in the village of "Tribsterill, where the shit runs into the sea, or Burmesquick, where they make the crooked arseholes." The shepherd falls asleep and dreams he has lost his sheep, awakes and finds joyfully that his sheep are all there, all eleven thousand of them, and he has to get them over a bridge. Then . . . well, Wolfgang doesn't know if the sheep got over the bridge and doesn't actually care. Enough of that "shitstori." To close with the Bäsle, he sends his best to his Augsburg friends, "and who doesn't believe it can kiss my rear end, from now until eternity, or until I regain my sanity, in which case he will have to lick and lick." From there his sanity seems unrestored: "I am, I was, I were, I have been, I had been, I would have been, oh if I were, oh that I were, I wished to god I were, I would be, I shall be, if I should be, oh that I would be, I might have been, I shall have been, oh if I had been, oh that I had been, I wished to god I would have been, what?—a numbskull."[56] What he wished to God was that he could be Aloysia's husband and mentor, from now until eternity, amen.

Even in his wildest flights, as per the aforementioned, Mozart retains his propensity for mimicry, so even here his words reflect influences: mainly the traditions of commedia dell'arte and Hanswurst performances, ratcheted up to a screaming pitch. In those partly improvised street performances, audiences were treated to displays of flying excrement, urination, farting in the face, endless bawdy jokes. Male characters often wore an erect phallus made of leather. Hanswurst ingested the most amazing things, and even more amazing ones came out his other end. Goethe may have studied with the ever-so-upright poet Gellert, but he once wrote a Hanswurst sketch that included characters named Jack Arslet, Cuddle-pussy, Snot-spooner, Dogturd, Dr. Bonnyfart, and a poet named Drivelshit.[57] This was eighteenth-century

entertainment for the whole family, and Mozart drew on it with all his considerable energy and imagination.

FOR MOZART MANNHEIM HAD BEEN A MOMENTOUS VISIT IN PERSONAL terms, but professionally, it had not produced much of anything tangible. As he got ready to leave the city, Leopold sped him on his way with advice about Baron Grimm and other Paris contacts and leavened it with sad tales of his poverty: "I look like poor Lazarus, my morning coat is in tatters . . . My flannel vest . . . is so torn that it can barely stay on my body . . . Since your departure I had no new shoes made."[58]

Leopold felt divided about Paris, nervously shuttling from confidence to anxiety. Grimm had written him a letter welcoming a visit and observing, "I believe your son's conduct to be sufficiently good to have no fears for him from the dangers of Paris. If he were inclined to libertinage, he might no doubt run some risks; but if he is reasonable, he will take precautions against all trouble, without thereby leading the life of a hermit."[59] Leopold seconded that hope, and when Wolfgang sent him a new French aria he replied reassuringly,

> Your aria has made me breathe a little more easily, for here is one of my dear Wolfgang's compositions and something so excellent that I'm sure it was only some very persuasive tongue which must for the moment have driven you to prefer a knockabout existence to the reputation which he might acquire in a city so famous and so profitable to the talented as Paris. Everyone is right who says that your compositions will be very popular in Paris; and you yourself are convinced, as I am too, that you are able to imitate all styles of composition.[60]

Yet shortly before, Leopold had written to the contrary:

> Count Kühnberg, Chief equerry, who, as is well known, lays no claim to saintliness, talked to me a few days ago . . . and expressed extreme anxiety about Paris, which he knows thoroughly. He said that you should be on your guard against its dangers and that you should refrain from all familiarity with young Frenchmen, and

even more so with the women, who . . . run after young people of talent in an astonishing way in order to get at their money, draw them into their net or even land them as husbands. God and your own good sense will preserve you. Any such calamity would be the death of me![61]

In his reply to Baron Grimm in Paris, Leopold blundered when he reported Wolfgang's qualms about Wendling's lack of religion. Grimm knew and respected the flutist, and Leopold's letter only succeeded in leading the baron to conclude that these Mozarts were a pack of provincials.[62] It would be through that lens that he viewed the grown-up Wolfgang.

Before they left for Paris there was a farewell concert at the Cannabich residence, made up of Mozart's music and largely Aloysia's singing and playing—two arias from *Lucio Silla*, her new aria with orchestra, and the three-piano concerto with Aloysia covering one of the solo parts and Rosa Cannabich another. It was the climax of Mozart's sojourn in Mannheim. Tears all around, fervent avowals of gratitude from the Webers. Aloysia gave Wolfgang two pairs of mittens she had knitted for him. Her father Fridolin presented him with four volumes of Molière's comedies, which Mozart would read eagerly and keep by him for a long time.

In Salzburg there had been a commemoration, whether sardonic or cruel, of his imminent leave-taking from the Bäsle. For a session of *Bölzlschiessen*, somebody—Leopold? Nannerl?—made a shooting target representing the Bäsle weeping and drying her eyes with a cloth that dragged on the ground, crying to Wolfgang beside her, "Accursed fate! Alas! It seems you did but come and now you are on your way. Who would not weep?"[63]

It was presumably with a mingling of despair and hope that, with his mother and his new mittens, Wolfgang left Mannheim for Paris on March 14, 1778, in search, yet again, of his fortune. As for his fame, that had been established sixteen years before. Paris would confirm that by now it was more burden to him than blessing.

ASHES

M aria Anna Mozart and her son reached Paris on March 23, 1778, after a demoralizing journey of nine and a half days. They made the trip in their own carriage, which had conveyed them since Salzburg. At the end the hired driver bought the carriage for himself, finding it necessary to replace the chassis that the roads had beaten up. "Never in all my life have I been so bored," Wolfgang wrote home about the trip.[1] If there are omens, these were omens.

In Paris they found some dim upstairs rooms in the rue du Bourg-l'Abbé, and Mozart got busy seeing to connections. At the top of his list were his childhood admirer Baron Friedrich Melchior von Grimm and the Duchesse de Bourbon, a well-known patron to whom Grimm provided an introduction. Mozart was quick to make the acquaintance of Joseph Legros, the city's leading impresario and director of the Concert Spirituel, one of the pioneering public orchestral series in Europe. He introduced himself to the Palatine ambassador to France, Count Karl Heinrich Joseph von Sickingen, for whom his Mannheim friends had provided letters of introduction.[2] Sickingen's home would serve as the setting for daylong music-making sessions. After his first visit, Wolfgang wrote home that he found the ambassador "a charming man, a passionate lover of music, and a true connoisseur."

At Baron Grimm's side remained his partner, the celebrated writer and *saloniste* Madame Louise d'Épinay, whom he had stolen from Voltaire decades before. So before Mozart lay a row of prospects and of

patrons who had their hands on the highest levels of influence artisti-
cally and, in the case of Grimm and d'Épinay, socially and politically.
Above all, Grimm, with his advice and his circle of aristocratic con-
tacts, was vital to Mozart's ambitions. Leopold wrote his son, "I now
urge you very strongly . . . to preserve <u>by a complete and childlike trust</u>
the favor, affection and friendship of Baron Grimm, to consult him in
all matters, not to act on your own judgment or preconceived ideas, and
constantly to bear in mind your interest and in this way our <u>common
interest</u>."[3] With that Leopold says that his son must look out not only
for his own welfare but for that of his family in general and, by implica-
tion, his father in particular.

 Also visiting in Paris were Mozart's virtuoso friends from Mann-
heim, flutist Johann Wendling and oboist Friedrich Ramm. In his effort
to put off leaving Mannheim and Aloysia, he had deplored their lack
of religion to his father as a reason to avoid traveling with them. They
presumably did not get wind of that, and they soon had a jolly reunion
with Wolfgang. He wanted nothing more than to write something to
show off these virtuosos and himself. Here was yet another pleasant
prospect.

 One of his prime ambitions in the French capital was to write an
opera, but that was going to be a foredoomed hope. He had arrived in
the middle of a boiling operatic feud between the partisans of Niccolò
Piccinni and Christoph Willibald Gluck. Piccinni had been brought
to Paris to uphold traditional Italian opera seria against the reforms of
Gluck, who championed a more text-oriented and naturalistic style. At
the moment when it came to opera, Paris was interested in little else.
Mozart probably heard a lot of opera during the visit, likely including
Gluck's newly commissioned *Iphigénie en Tauride*, one of the towering
works of the new style, which had its premiere two months after he
arrived. Mozart would never be committed either to tradition or to re-
form in opera seria; he was on his own tack. But these men were impor-
tant figures, and he was ready to learn from both of them.

 The population of Paris was growing toward six hundred thousand
by the end of the next decade. It remained one of the financial centers
of the Continent, a city abundant in wealth and no less in the squalor
Voltaire memorialized in 1749: "We blush with shame to see the pub-
lic markets, set up in narrow streets, displaying their filth, spreading

infection, and causing continual disorders . . . The center of the city is dark, cramped, hideous, something from the time of the most shameful barbarism." The center of the city was getting steadily more cramped, buildings climbing higher for lack of land to build on. There were no streetlights and no sewers; waste was directed into the Seine, which was also the source of the city's drinking water. Travelers could expect to enjoy some weeks of gastric distress, as indeed the Mozarts suffered even though they carefully boiled their water.[4]

The age of the philosophes and Encyclopédists found its conversation in the city's hundreds of cafés and dozens of salons. The arts thrived as the aristocracy bought art along with their finery and flocked to the theater to laugh at Pierre de Beaumarchais's comedy *The Barber of Seville*, which skewered their class. Around Europe, French fashion, French taste, and the French language were the standard for cultivated society. In Berlin the court of Frederick the Great spoke French. German, said Frederick, is for peasants and horses.

When Mozart arrived in Paris, musical patronage was as robust as ever but had expanded from the court to the aristocracy at large. The city had become a center of music publishing, partly because of innovations in engraving on copper and pewter plates that expedited the laborious process, and partly because an increase in performances produced an increase in demand.[5] While the city's philosophy, literature, theater, and dance were thoroughly French, musical tastes leaned toward Italian and, lately, German composers. In the Tuileries Palace the venerable institution of the Concert Spirituel thrived under famed tenor and impresario Joseph Legros. Haydn symphonies were a regular feature of his programs, as were works by J. C. Bach and Cannabich and other international luminaries. On the Continent the orchestra Legros directed was second only to Mannheim's in skill and size, the strings numbering over forty.[6] In comparison, the private orchestras Mozart was used to had on the order of twelve or so strings plus pairs of oboes and horns, maybe a bassoon or two, and trumpets if available. As far as Mozart was concerned, when it came to orchestras, the bigger the better. His mature ideal of the orchestra would come first from Mannheim, second from Paris.

While her son busied himself making the rounds, Maria Anna Mozart was left in their rooms. She was feeling poorly, had been coughing

since their first stop in Augsburg. There was no question of Wolfgang using his valuable time to nurse or amuse his mother. When he headed out, he left her to stare at the walls. To add to her isolation, Maria Anna spoke no French. "As far as my life is concerned, it's not very pleasant," she wrote Leopold. "All day I sit in my room alone as if it were a prison cell; the room is dark and faces a little courtyard . . . I don't see [Wolfgang] all day and may just forget how to talk." Their living situation would improve, Madame d'Épinay finding them a cheerier place near the opera house, but Maria Anna's health would not improve with their lodgings.

As in the tours with his father, Mozart came equipped with a collection of letters of recommendation, and had Leopold been managing the situation there would have been a menu of introductions, schemes, and stroking of every contact in sight. Now on his own, Wolfgang proceeded to bungle nearly every opportunity that presented itself.

One of the first incidents involved Joseph Legros. For Mozart the Concert Spirituel was central to his hopes of making himself visible. Founded in 1725 and now the premier concert series in Europe, it featured programs heard on the upper floor of the Tuileries Palace, called the Salle des Cent Suisses.[7] At first Mozart and Legros hit it off, and the director proved to be generous. Because Mozart's first flat was at the top of a staircase too narrow to get a clavier up, Legros offered to let him come to his house every day to practice and compose at the keyboard.[8] It was at the home of Legros that Mozart met the violinist and composer Giuseppe Maria Cambini. Mozart observed to him that he had heard some of Cambini's string quartets in Mannheim, and he complimented them. Well enough, but then Mozart sat down at the clavier and began to play bits of the quartets from memory, claiming he couldn't exactly remember them, and archly amended and improved them as he went. "What a marvelous head!" Cambini exclaimed. But in fact he was offended, and Legros annoyed.

This incident may have weighed on the first big piece Mozart finished in Paris, a sinfonia concertante for flute, oboe, horn, bassoon, and the Concert Spirituel orchestra. Its inspiration was a quartet of brilliant musicians visiting in town: on flute and oboe, his Mannheim friends Wendling and Ramm; on horn the celebrated virtuoso Giovanni Punto ("Punto blows magnifique," Wolfgang reported home), and bassoonist

Georg Wenzel Ritter. Prospects appeared rosy for the sinfonia concertante; that genre, involving two or more soloists, was popular in Paris. Legros promised to play it, then somehow it kept not getting played. For a while on visits, Mozart saw the score sitting on a table at the director's house, then noticed it had disappeared. He searched around in Legros's music and found the score hidden away. Before long the intended soloists had left town, there was nobody else around at their level, and that was the end of it. The piece never got heard and eventually was lost.[9] For a while Mozart made himself scarce with Legros.

Another potentially important patron was the Duchesse de Bourbon, a connection arranged by Grimm. She invited Mozart to call and he turned up at her palace expecting something on the order of a warm welcome and attentive listeners. In a furious letter he reported to Leopold what had happened instead. The duchess kept him waiting a half hour in an unheated room, finally appeared and asked him to come in and play, apologizing for the decrepit clavier. Mozart asked for a warmer room. The request was ignored. Instead some gentlemen appeared, the duchess sat down at a table with them, and they began to draw while over the next hour Mozart played as best he could, getting steadily colder and angrier. He stayed, he said, only because walking out might have annoyed Grimm. As he played the duchess and the gentlemen stuck to their drawing, apparently ignoring him completely. At length he jumped up in disgust, and was surprised to receive a shower of compliments from the table.

Restraining himself, Mozart said he could not do himself justice on that instrument and maybe should come back another day. The duchess would not hear of it, telling him to wait for her husband. The gentleman arrived after another half hour, sat down by the clavier, and listened attentively as Mozart resumed. With that audience of one, Mozart reported to Leopold, he exerted himself. All he required was a little attention. When he finally escaped the duchess's palace he hastened to complain to Grimm.[10]

This only took Grimm's opinion of him down another notch. As his patron understood and Mozart did not, the Duchess of Bourbon's drawing circle was a well-known and much respected academy, its teachers including the famous court painter Fragonard. Mozart had been invited to accompany one of the group's regular drawing sessions.[11]

His fulminations further convinced Grimm that with the Mozarts father and son, he was dealing with provincials who had no idea how to get ahead in the artistic and social maelstrom of Paris. Grimm was a fractious man, easily ruffled, and this youth, for all his talent, was getting tiresome.

The need for discretion was not going to mollify Mozart's aversions, which quickly extended to everything French, including its music. "If I were in a place where people had ears to hear, hearts to feel, and had some small understanding of Musique, if they had a modicum of taste, I should heartily laugh about all these things; but as it is, I am living among brutes and beasts as far as Musique is concerned; but how can it be otherwise; after all, that's precisely what they are in their behavior, sentiments, and Passions."[12] And further: "What annoys me most of all in this business is that our French gentlemen have only improved their goût to the extent that they can now listen to good stuff as well. But to expect them to realize that their own music is bad or at least to notice the difference—Heaven preserve us! And their singing! Good Lord! Let me never hear a Frenchwoman singing Italian arias. I can forgive her if she screeches out her French trash, but not if she ruins good music! It is simply unbearable."[13]

In other words, from early in his stay Mozart was disgusted with French music and most of the musicians. He did not generally include the Concert Spirituel orchestra in his fulminations, because, really, they were quite good when they took the trouble to be, but he never particularly complimented them either. Meanwhile it is one thing to feel superior to the people you need favors from, quite another to display your feelings in smirking and satire. And that Mozart could not help doing. In Paris as in town after town before, it was noticed and resented.

For her part, in her lonely flat Maria Anna cooked largely for herself. In letters and newspapers she and her husband followed the news about the War of Bavarian Succession and the American Revolution. Leopold wrote, "In Prussia and Austria people are being whipped off the streets and pulled from their beds to be turned into soldiers."[14] He expressed hope that in Paris she and Wolfgang might meet Benjamin Franklin.[15] But no summons arrived from Versailles or other high places. Finally Maria Anna began to get out and do some people watching, at which

she was shrewd (another quality she passed on to her son, along with her rough humor).¹⁶ Her letters included gossip about Marie Antoinette's pregnancy and fashion notes for Nannerl, who perused them eagerly. Mamma noted that, of late, fashionable Frenchwomen were carrying fancy walking sticks when they strolled, and she advised her daughter to get herself one. More important, "The <u>friseur</u> they wear is extraordinarily high, not a heart-shaped toupee, but the same height all round, more than a foot." Determined to look the part of a Parisian noblewoman, Nannerl acquired a walking stick, and her friseur ascended dramatically.

THERE WAS A TRACE OF HOPE AND OF REGULAR INCOME WHEN MOzart acquired three pupils. Maria Anna reported that he could get many more, but he did not want the bother.¹⁷ The most prominent was the teenage harpist Marie-Louise-Philippine, daughter of the Duc de Guînes, a music lover and able flute player. Hearing this news, Leopold went on full alert: "My dear son! I beg you to try and keep the friendship of the Duc de Guînes and to win his favor. I have often read about him in the papers. He is all-powerful at the French court. As the Queen is pregnant, there will surely be <u>great festivities later on</u>, and you might get something to do which would make your fortune."¹⁸

Mozart complained perennially about having to take pupils, but in practice he was a patient and attentive teacher in the vein of his father, who arranged his pedagogy around the gifts and personalities of his students, including his children. It helped if the student was a young and charming female, as many of Mozart's would be. He reported of Marie-Louise-Philippine, "She plays the harp <u>magnifique</u>. She has a great deal of talent, even genius, and in particular a marvelous memory, so that she can play all her pieces, actually about 200, by heart. She is, however, extremely doubtful as to whether she has any talent for composition, especially as regards invention or ideas. But her father who, between ourselves, is somewhat too infatuated with her, declares that she certainly has ideas and that it is only that she is too bashful and has too little self-confidence. Well, we shall see." He noted that she had a good command of the rules of composition and harmony, and he gave her exercises in the direction of composing, such as filling in a bass

under a melody. But Mademoiselle got bored and complained that she could find no ideas of her own. Doggedly Mozart tried starting pieces and asking her to vary or continue them, and for a while she managed that.

In the end, for all her talent, Marie-Louise-Philippine got nowhere with composition.[19] What she and her father did get was a place in the annals of music: for them Mozart wrote the splendid Concerto for Flute, Harp, and Orchestra in C Major, K. 299. Here was another important piece involving the flute, which Mozart had told his father he disliked. The harp of the time was midway in its development but had simple pedals, so one did not have to stick to one key. (Mozart never wrote for the instrument again, probably only because no occasion presented itself.)

Mozart referred to the Flute and Harp not as a double concerto but rather a sinfonia concertante. Either designation will do. The orchestra is the common Early Classical one for *Hausmusik*, strings plus pairs of oboes and horns. That he wrote it quickly, as a practical piece for a student and her father, might betoken a workaday outing. But the concerto is no such thing. All the movements are expansive—it's nearly half an hour long—and are laid out in the usual outlines, the first movement in a fully fleshed-out concerto sonata form: an orchestral presentation of two theme sections before the soloists arrive.

The orchestra begins with a big C-major arpeggio in octaves, establishing a genial mood that will mark most of the concerto. The first theme is more given to vigorous gestures than tunes, the second theme more melodic. For much of the piece the flute handles most of the lyricism while the harp supplies accompanying filigree. The andantino second movement is one of those stretches unique to Mozart, music of ineffable heart-tugging warmth that foreshadows some of the gorgeous romances of his later years, some of its warmth coming from divided violas. It features a refrain-like phrase that would melt listeners in perpetuity. The dancing finale has a bit of an outdoorsy atmosphere, the horns and oboes providing little fanfares, the music overflowing with themes and unflaggingly good-humored. All in all, here was a work whose existence, and in the intimacies of its unfolding, had to do with his interaction with the people for whom it was written.[20] As Mozart

had said in another similar situation: it fitted them like a well-tailored suit of clothes.

The concerto presumably was played privately. If the duke and his daughter were true connoisseurs, they had to have had some idea what a treasure Mozart had given them. All the same, in keeping with how the Paris sojourn was going, the ever-so-musical and generous Duc de Guînes apparently never condescended to pay Mozart for the piece, and paid him for only half of the two dozen lessons he gave the gifted but diffident Mademoiselle.[21]

IN EARLY SUMMER MOZART TOSSED OFF SOME FRENCH-FLAVORED MU-sic for a ballet, *Les petits riens*, as a favor for its choreographer, Jean-Georges Noverre, whom he had encountered possibly in Milan during the *Ascanio* production and later in Vienna.[22] He had written his finest piano concerto so far, the *Jenamy*, for Noverre's daughter. In the next weeks the ballet had several performances at the Paris Opéra, but Mozart was not paid for the music, and his name was not mentioned on the program.

For a while Maria Anna felt better as the summer warmed up. In town was Mozart's old colleague, tenor Anton Raaff; he squired Maria Anna, affectionately called her Mama, visited every day and sang to her. Wolfgang wrote Leopold that during a lunch, Raaff joked, "Herr Mozart is not a hundred percent here to admire all the local beauties— half of him is still where I just came from [Mannheim]—of course, there was a good deal of laughter . . . but in the end Herr Raaff said in a more serious tone . . . I can't blame you—she deserves it; she is a well brought up, good-looking, Honorable Girl, and she has great skills and lots of Talent."[23] Mozart did not have to be reminded of all that regarding Aloysia.

Brass player and publisher Franz Heina, an acquaintance of the family, took Maria Anna out to lunch and to a picture gallery. But she found the exertion exhausting, and on June 11 a doctor was called to bleed her.[24] He took two plates' worth, which would have involved cutting a vein. This was a long-standing procedure intended to get disease-causing blood out of the body; in fact it did nothing but harm. Maria

Anna felt uneasy about French doctors and did not like them attending her. Her feeling amounted to a bad idea in theory, but in practice it made no difference. One was perhaps more often saved *from* doctors than *by* them.

Spring and early summer saw a small surge in production for Mozart. He wrote two violin sonatas to complete a set of six begun in Mannheim, K. 301–6. His intention was to dedicate the set to the Electress Palatine and present it to her when he could get back to Munich. In returning to this genre he had been writing since childhood, he took another step toward freeing the violin from its conventional subservience to the piano—which is to say, these were not for "piano with violin accompaniment." In historical terms, this set laid out what from that point would be considered a violin sonata.[25]

If the sonatas are not notably ambitious in scope, they are conspicuously attractive. All but the last are in two movements. The glory of the K. 301–6 set is the E Minor. Again, minor keys tended to be special in the late eighteenth century, exceptions in an optimistic age. This is Mozart's only piece in E minor. If the sonata reflects his feeling about that tonality, it does not have the gnawing tension and tragedy that G minor drew from him, but rather something more subtly fraught. It begins quietly, like an aria full of lonely apprehension, a moment of C major providing a brief relief from the inner overcasts. Next is an E-minor Minuet of dark hue, the courtly dance made into something like a ritualization of heartache. Its trio turns to E major, but it is a shadowed, minorish major, the violin singing a melody filled with yearning.

The violin sonatas were written on speculation, a gesture toward getting a foothold with the Electress of Bavaria and therefore perhaps a foothold at her court. Another project fell into his lap from a perhaps unexpected quarter. Mozart had been avoiding Joseph Legros since the embarrassing episode with Cambini and the failure of the sinfonia concertante to get played. But while calling on Anton Raaff, he ran into the director of the Concert Spirituel and they had an awkward but productive encounter.

As Mozart reported with his usual vivid evocation, Legros was welcoming if a bit fluttery (or maybe he was always so): "It is really a miracle to have the pleasure of seeing you again—Yes, I have a great deal to do—Will you stay and join us at our table today?—I must ask to

be excused . . . M. Mozart, we must spend a day together again soon—
That would give me great pleasure (a long pause—eventually) A pro-
pos. Will you not write a grand symphony for me for Corpus Christi!
Why not!—Can I then rely on this? . . . It will not go the same way as
my sinfonia concertante."[26] By the last remark, Legros meant that he
would actually play this one.

If the meeting went as Mozart recounted, it's possible that Legros
came up with the symphony proposal on the spot, by way of a peace
offering. That he gave Mozart only a month or so to compose it was not
out of line for the time. Even major orchestras did not plan programs
far ahead. Composers wrote symphonies fast and hoped they would be
played right away.

Mozart finished the Symphony in D Major, K. 297/300a, comfort-
ably a week ahead of the June 18 premiere. It was played at the home of
Count Sickingen, to general appreciation.[27] With the Concert Spirituel
orchestra, however, he had an unpleasant time of it in the piece's sin-
gle rehearsal. (Mozart had hoped for a second, but even one rehearsal
was more than symphonies often received in those days.) "You can't
imagine," he wrote Leopold, "how they bungled and scratched their
way through the Sinfonie—twice in a row.—I was truly worried." He
felt so upset that he considered skipping the concert. Finally, with the
encouragement of nice weather, he dragged himself to the hall deter-
mined "that if things went as poorly as during rehearsal, I would walk
straight up to the orchestra, snatch the violin out of the hand of Herr
Lahousè, the first violinist, and conduct it myself." Whether he would
actually have done something so scandalous is unlikely, but to his re-
lief, in the performance the Concert Spirituel orchestra more or less
pulled it off.

The symphony is a big Mannheim-style piece in the festive key of
D major. Mozart reported that the first movement went so well, with
cries of rapture during the splashier bits, that at the end there were
shouts of *Da capo!* "Once again!" He did not mention if the opening
movement was encored on the spot, as was not unusual. He said the
finale pleased the crowd even more, and the middle movement went
well enough. To celebrate afterward, he told pious Leopold, he treated
himself to an ice cream at the Palais Royale and prayed a rosary before
going home.[28]

What came to be called the *Paris* Symphony was written for the largest orchestra Mozart had ever had at his disposal.[29] At that point, the band seems to have been enormous for the time: twenty-one violins, five each of violas and basses, eight cellos; the high winds in pairs including clarinets, plus four bassoons; pairs of trumpets and horns.[30] The symphony shows them off with music grand, showy, and extroverted, even if in the end it comes off as a work that Mozart's heart was in less than his craftsmanship. For all the ruckus it's on the impersonal side, with little in the way of memorable melody or tender interludes.

He made sure to open the symphony with a *premier coup d'archet*, the big start in octaves that the French liked, though as he wrote home, "What a fuss the oxen here make of this trick! The devil take me if I can see any difference! They all begin together, just as they do in other pieces. It's really too much of a joke."[31] All the same, he began with those octaves, forte, long-short-short-long, then a scale ripping up an octave. Both ideas will be recurring motifs in the movement, though the *coup* figure is usually shrunk to twice as fast. In a sort of sonata form, but with no repeat of the exposition and only a hint of a development section, the opening movement is long and loud, the material gestural rather than melodic, with a lot of vigorous striding up and down arpeggios.

The handling of the form and of the orchestra come off as arguably more interesting than the contents. In some ways the dynamics are the most striking feature of the symphony: in most of his music Mozart sticks largely to the markings "forte" and "piano," leaving the nuances to the performance, but here there are "fortissimo" and "pianissimo," quick juxtapositions of loud and soft, and the dramatic full-orchestra crescendos that were a Mannheim trademark. With this group, Mozart had the clarinets he had long yearned for, but in practice he does little with them other than to use their rich timbre to thicken woodwind chords. The clarinets have no solos and only a few exposed moments; there is a sense that he has not quite decided what to do with them, though he would figure this out soon enough.

French symphonies tended toward three movements, and Mozart conformed to that. The Andantino middle movement, in a slow 6/8, has a wistful appeal but in the end is about as impersonal as the first movement. The Allegro finale shows some wit, beginning with a quiet pas-

sage of racing counterpoint and an off-kilter theme designed to make the audience sit up and listen before he hits them with a forte on the *coup* rhythm of the first movement. The second theme is a sort of faux fugue; then comes, for him, an elaborate development—following, as in the first movement, an exposition that does not repeat.

Was the *Paris* Symphony important in Mozart's own development? As a creative advance, no, though it foreshadowed the big Viennese-style symphonies he would produce years later. It may have expanded his orchestral palette to a degree, though Mannheim had had more to do with that. (For whatever reason, he had written no symphonies in Mannheim.) In fact, after the *Paris*, his thirty-first symphony, Mozart produced only three more before he moved to Vienna three years after. More to the point, in the next years, what advances he made in his orchestral palette were going to benefit his operas more than his symphonies.

THE TROUBLED E-MINOR VIOLIN SONATA WAS PROBABLY WRITTEN BE-fore July 1778, but if prophecies exist it could stand as another one, given what that month brought. Maria Anna had been ailing since the beginning of the trip but had managed to maintain some of her good cheer and her sociability, when the kindness of friends gave her the opportunity. In addition to the endless cough, she had been afflicted since Augsburg with a toothache, a sore throat, and an earache.

In June she fell into an alarming decline. Diarrhea, headaches, fever and shivers, hoarseness; then her hearing failed. From Baron Grimm Wolfgang borrowed 15 louis d'or, about 150 florins, to pay medical expenses. A doctor sent by Grimm gave her rhubarb powder in wine, but he saw that she was not likely to pull through.[32] On June 26 the doctor told Mozart that she might not survive the night.[33] She did, barely. She probably had typhus, against which the medicine of the time stood helpless.[34]

As the death watch began, a priest was called on June 30 to give her extreme unction. As his mother slipped away, Wolfgang could only watch helplessly, unable to go out, unable to work. In his life he would write plenty of sad music, but he did not usually compose when he himself was sad. As he sat watching his mother die, among the gnawing

questions in his mind was *How do I tell Papa? In a letter, in words on a page, how do I tell my father what has happened to the love of his life, the mother of his children, the companion with whom we have all lived without thought as with something as comfortable and enduring as a parlor sofa? How do I tell Papa that he will never see his wife again on this earth?*

On July 3, as Mozart, a nurse, and family friend Franz Heina watched, Maria Anna fell into delirium, the death rattle began, and she breathed her last at 10:21 p.m. In his report home, Mozart was precise about the time. She was fifty-seven.

In the hours after his mother died, he wrote not one but two letters to Salzburg. Maybe the body had been removed, maybe it still lay before him. The first letter went to his father, the next to a family friend, Abbé Joseph Bullinger. They would be the most careful and considered letters of Mozart's life.

To his father he wrote a loving lie, hoping to prepare him and soften the blow: Mama is very sick and she might not make it. He reports her decline in detail. In his letters of the past weeks, he had given his father no hint. Perhaps he had not realized how serious it was, which is to say that he was not truly paying attention.

> Monsieur mon trés cher Pére! I have to bring you some very distressing and Sad news . . . My dear Mother is very ill—she was bled, just as she always had it done . . . afterward she felt somewhat better—but a few days later she complained of chills but at the same time she seemed to have a burning fever . . . As her condition grew steadily worse—she could hardly speak anymore and lost her hearing . . . Baron Grim [*sic*] sent his physician . . . They are giving me hope, but I don't have much—I have been between fear and hope for several days and nights now . . . I am comforted, come what may, because I know that god, who arranges things for our best—even if we don't always understand it fully—wills it so . . . those are the consoling thoughts I like to engage in after I pray to god for the health and life of my dear mother; I find myself uplifted, calmer, and consoled afterward.[35]

In citing God as the arbiter of life and death, Wolfgang knows he is striking a powerful chord with his father. If his wife dies it is the judg-

ment of God, of which there can be no questioning. Then in the letter, without pause, Wolfgang goes blandly on to describe the rehearsals and premiere of the D-major Symphony, with the intention of distracting Papa from the news.

Near the end of the long letter Mozart includes, in passing, something more shocking than his scatological transports elsewhere: "Now I have an item of news that you may have heard already, namely that the godless Arch-culprit Voltaire has kicked the bucket—like a dog, so to speak—like a beast—so that's his reward!"[36]

This was presumably something he figured Papa would like to hear, some reassurance that his son had not taken up impious modern ideas. In practice this little paragraph is the nadir of Mozart's letters in this period, maybe of any period. To the degree that it truly showed his feelings, it may have to do with his antipathy not toward Voltaire but toward two echt-Enlightenment figures who had personally provoked him: Archbishop Colloredo and now Baron Grimm. In any case the idea that Voltaire died in agony was a lie spread by the Church, which had intended to throw his corpse in a lime pit, as was the rule for non-believers. But Voltaire's friends stole the body, propped it up like a drunken friend in a coach, and spirited it to Champagne for a decent burial.[37]

In the other letter Mozart wrote the night of his mother's death, to Abbé Bullinger, he vented his anguish, then went on to detailed directions concerning what Bullinger must do to prepare Leopold.

My very dear friend! for you alone / Mourn with me, my friend!—This was the Saddest Day of my life—I am writing at 2 o'clock in the morning—and I must tell you that my Mother, My dear Mother, is no more! God has called her to Himself . . . Just imagine all the turmoil, the anxiety and worries that I endured these last 2 weeks—she died without regaining consciousness— she went out like a light . . . At this time, I am asking you for only one service as a friend and that is to prepare my dear father very gently for this sad news—I have written him today as well—but only that she is gravely ill . . . I have been able, by a special act of god's grace, to bear it all with fortitude and resignation. When her condition got serious, I prayed to god for only 2 things, namely

a peaceful last hour for my mother, and strength and courage for
myself—and our gracious Lord heard my prayer and granted me
both blessings in rich measure. I beseech you now, dearest friend,
watch over my father, inspire him with courage so that, when he
hears the worst, the blow won't be so hard and unbearable. I also
commend my sister to you with all my heart . . . I beg you,—don't
tell them yet that she is Dead, but just prepare them for the news
as best you can.[38]

These two letters were not dashed off in the throes of mourning;
they were drafted and then carefully copied out. The one to Bullinger
is impeccable in penmanship. There are no hesitations or strikeouts; the
margins on the page are sharp. Wolfgang surely wept for his mother,
but there is no mark of tears on his letters.[39]

When Leopold got Wolfgang's news, he was in the middle of a let-
ter, sending his wife greetings on her name day. He and Nannerl were
of course thunderstruck. Pessimistic as always, he did not allow himself
much hope.

I have received your distressing letter of July 3. You can imag-
ine what we are both feeling like. We wept so bitterly that we
could scarcely read the letter—and your sister! Great God in Thy
mercy! Thy most holy will be done! My dear son! Though I am
resigning myself as far as possible to the will of God, you will
surely find it quite humanly natural that my tears almost prevent
me from writing. And after all, what conclusion am I to draw?
Why none other than this, that this very moment as I write, she
is probably gone.

He surmises that Maria Anna tended to put things off, and probably
had done so with the bleeding. He tells Wolfgang that if she is gone, to
ask Grimm for help. Beware of people trying to take advantage of you
in your grief! Then, just as Wolfgang did, he goes on to business, con-
gratulates his son for the success of the symphony in the Concert Spi-
rituel, and thank God he did not actually charge into the orchestra and
take the violin away from the concertmaster, as he had threatened. He
notes that Nannerl has vomited and gone to bed. Then as Leopold bent

over his letter came the visit, as Wolfgang had directed, from Abbé Bullinger. "You may be quite easy in your mind about me," Leopold concludes after that news. "I shall play the man. But do not forget how tenderly loving was your mother—and you will only realize now how she cared for you—just as later on when I'm gone you will love me more and more."[40]

Maria Anna Mozart was buried in the churchyard of Saint-Eustache on July 4. Apparently, the only mourners were her son and friend Heina.[41] When he received his father's response, Mozart had probably already decided how to proceed in the next letter, the one that would give Papa the real story. Over and over in this letter he returns to boilerplate about the will of God.

> I hope you are now ready to receive this Saddest and most painful news with fortitude . . . on the 3rd, at 21 Minutes after 10 o'clock at night my Mother passed on peacefully to the Lord.—When I wrote to you she was already partaking of the Heavenly joys . . . I hope that you and my dear sister will forgive me for this small but necessary deception . . . You can easily imagine what I went through—what courage and fortitude I needed to endure it all with composure . . . and yet, god in his mercy bestowed on me the grace I needed . . . Now, His divine and most holy will is fulfilled—let us pray a deeply felt Paternoster for her soul . . . A big help for me in regaining my tranquility would be if I could hear that my dear father and my dear sister are facing the will of the Lord with calmness and fortitude,—that they trust in him with all their heart and in the firm belief that he arranges everything for our best![42]

This letter mingles piety and narcissism in a way unique in Mozart's correspondence. He begs his father and sister not to grieve too much because it will disturb his tranquility. This amounts to an attempt to calm them down, but a dismal one. Then his letter goes on to news and gossip. He is now living with Baron Grimm and Madame d'Épinay; the quarters are pleasant: "As much as my emotional condition permits, I feel quite cheerful." He chuckles over Papa's report about Michael Haydn being too drunk to function in a church service. "It's a

real shame when such a talented man incapacitates himself by his own folly to the point where he can no longer fulfill his duties—during a church service in God's honor."[43] He goes on and on about the lack of discipline in Salzburg musicians. He notes that Raaff is leaving Paris tomorrow. He brags about how much Legros is taken with him.

Wolfgang's intention was to reassure Papa that Mama's death was an act of God, then to distract him with chatter. Did he sincerely mean all the pious slogans? To surmise: yes and no. There is much less of this in the letter to Abbé Bullinger. Mozart was a practicing Catholic and a believer, perhaps more conventionally so in these years than later. He seems to have gone to Mass regularly with the family in Salzburg; elsewhere, that is not so certain. He reasonably insisted that his mother's death was God's will, that nothing could have been done.

But Mozart was still, characteristically, irresistibly, putting on an act for Papa. By now his letters home were mostly bland—again and again he had found his wit being slapped down. In any case this sort of letter to his father had to be sober, pious, and reassuring about how things were going in Paris. Did Mozart have the triumph he reported with the D-major Symphony? Maybe, or at least a good success. But Legros asked him to write a simpler slow movement, and he did.[44] (Legros had the symphony published, so he must have liked it.)

So three letters in the days after his mother's death, two to Papa and one to a family friend. His next letter home begins, "Let's not talk about their main subject anymore—it's over now—even if we were to write pages and pages about it, we cannot change things anymore!"[45] With that he attempted to wipe his mother's death out of their correspondence. But Leopold would not be placated so easily.

Mozart's letters to Salzburg after the calamity speak volumes about his emotional world. He suffers; at the same time he is detached and in command of his emotions. For all his neglect of Maria Anna, he loved his mother, but he also understood that death was always waiting in the wings. On the page, in his anguish he examines every detail of her end like a jeweler turning over a stone. He is self-involved, seeing the loss mainly in terms of its impact on him. Professional matters, struggles with performance, and his relations with local musicians are always at the front of his mind.[46] At the same time he is sincerely concerned with the feelings of his father and sister. He tries to the best of his powers—

not succeeding, but he tries—to soften the blow on the people he loves. With his father he takes one tack and tone, with Bullinger another.

In his relations with others, Mozart often lacked empathy, viewing the recipients ironically from a posture of superiority, but at the same time, he was aware of the reality of other people even when he was scorning them. He fills his fulminations in letters with real people, not caricatures. More than any other composer of his level, Mozart viewed human life and behavior almost as a novelist would, but in his case, this insight finally emerged as music—not just in opera but in all his music, founded on a fascination with the world and the people in it. All of which, for him as for all artists, is called "material." His own suffering he saw as material likewise. His angle of view is founded on a mature awareness of pain and death, and also detached from them. In all this Mozart is a man of the *Aufklärung*, the Age of Reason, in which death itself was food for thought and action. No less was he the bone-deep artist, absorbing material wherever he found it, for the purpose of putting on a show. Before long he would be writing an opera much concerned with death, and to it he would bring everything he had learned as artist and man.

On this journey that began at age twenty-one and would end at twenty-four, Mozart escaped from under his father's thumb. A letter of Leopold early in the Paris sojourn defines what this amounted to, the father binding the son to his happiness and well-being: "I feel that your active endeavors and your anxiety to drag me out of this miserable situation [in Salzburg] are really bringing me back health and strength. Once you have made your father's happiness your first consideration, he will continue to think of your welfare and happiness and to stand by you as a loyal friend."[47] Your father's happiness, Leopold wrote, *your first consideration*.

If that had ever been Wolfgang's first consideration, it was no longer. With the death of his mother and his response to it, he completed the shaping of his posture in regard to his father as one not of serving but of mollifying and manipulating. He had learned the latter from Papa. The main means of handling his father would be on the one hand boasting of his triumphs, and on the other hand mendacity, a fabric of fantasies and half-truths and lies. This too he had learned from Papa. Wolfgang's lies were often transparent, often contradictory, but so

were his father's. Like his father, the son often believed in his fabrications as he was telling them. Some of Wolfgang's lies were loving, as Leopold's rarely were. Nor were Wolfgang's lies cynical, as Leopold's often were. By this point neither of them trusted the other to tell the truth, and they never would.

The frustrations of Paris and the death of his mother can be called the penultimate stage of Mozart's maturity, near the end of his particular bildungsroman. He had one miserable chapter to go, in Munich. Some lingering immaturity and a lack of simple empathy are shown in one shocking detail: after Maria Anna died, Wolfgang removed her wedding ring and sold it to get some cash. Leopold would be shocked and outraged when he found out.[48]

So Mozart was making a quick if thorny transition from overprotected son and into his own as an adult. He loved Papa and his sister, he knew very well what kind of personal debt he owed them both, but he was on his own now, and he had to see to his own concerns. Wolfgang could no longer joke unrestrained in letters to his father; that was not received well. Nor could he unburden himself from the heart. Early in the Paris sojourn, he had written Leopold, "I often wonder whether life is worth living—I am neither hot nor cold—I don't find much pleasure in anything." His father responded to this confession, "I don't like it," and gave him a lecture on his God-given gifts and his youth and his luck, "Whereas I in my 59th year have to tear my hair over five pupils, and for a wretched pittance!"[49] They had become something bordering on two solipsists competing in their miseries, neither listening sympathetically to the other.

Whatever came from home, Wolfgang now knew how to put on a show of being loving and forthcoming while coolly maintaining his distance. He would keep to that path raggedly but doggedly for the rest of his father's life.

At the end of July Mozart wrote Fridolin Weber in Mannheim with a scheme to have him and Aloysia come to Paris so she could sing with the Concert Spirituel. It was another unlikely to impossible fantasy, Wolfgang's yearning for Aloysia disguised as promoting her career. In any case, by autumn she and her father would have jobs with the elector's relocated court in Munich.[50]

Mozart had been writing to Aloysia as well, and presumably she to

him for the moment. Only one of those letters survives, one of his from the end of July. This has none of the raunch and randiness of his letters to the Bäsle. It is, in fact, one of the more restrained, proper, humorless letters of his life, in that regard an indication of his respect for Aloysia on one hand and his anxiety about her on the other. This letter from one German to another is written in Italian, as if their native language seemed to him dangerously intimate. He was continuing to approach Aloysia with utmost caution.

> Dearest friend! I beg you to forgive me for failing to send you at this time the variations that I have composed for the aria you sent me—but I thought it was necessary to reply as quickly as possible to your esteemed Father's letter, so I did not have time to write them down . . . You shall also have the "Popolo di Teßaglia," which is already half completed—if you are as pleased with it as I am—I shall consider myself very happy . . . I desire no other Praise but yours—I must admit that this scena is the best I have composed in all my life.

Flattering Aloysia and himself, he continues with some coaching at a distance about performing the new piece, revealing a good deal about his sense of the relation of music and words and drama: "I particularly advise you to pay attention to the expression marks—to think carefully about the meaning and the force of the words—to put yourself with all seriousness into Andromeda's situation and position!—and to imagine yourself to be that very person. By doing this, with your beautiful voice—your beautiful way of singing—you will become unfailingly Excellent within a short Time!"[51] There in essence is Mozart's conception of the union of singing and musical and dramatic expression: don't just go through the motions; *imagine yourself to be that very person.* For the true musician, there is no divide between technique and expression. It was the same kind of advice his father gave aspiring violinists in his method. More to the point, here is one secret of Mozart's singular brilliance in shaping character on the stage by means of music: *Imagine you are that man.* Or that woman.

His mind was fixed on Aloysia, but always there would be Papa to deal with. Leopold wrote asking for details of his wife's death. He

floated his own theories, recalled that she had chronic constipation, that her cough was peculiar, that she put things off, that surely the doctor was called too late.[52] The last was in the direction of an accusation that Wolfgang had neglected his mother in her extremity, an implication that would lie between them more or less for the rest of his father's life, though Leopold would also spread the blame. Wolfgang responded with details of Maria Anna's death,[53] to which Leopold replied, "Had your mother returned from Mannheim to Salzburg, she would not have died . . . she sacrificed herself for her son." This was outrageous, given that it was Maria Anna's own idea to continue on to Paris with Wolfgang, and Leopold had agreed. Elsewhere he shifted his wrath to Archbishop Colloredo, calling him "the fatal instrument" that caused the death of "the most honorable of wives and finest mother."[54]

Wolfgang continued to manage Papa with a steady stream of subterfuge. He wrote Leopold that he was working on a "declaiming opera" for Paris, meaning a "melodrama," a stage work with music accompanying spoken text. There was no such opera sketched or possible. (Mozart had seen a melodrama by Georg Benda and liked the idea, saying that he thought all recitative could be replaced by spoken recitation.) He implied a second new symphony had been performed; there was none, though the Concert Spirituel may have played one of his earlier symphonies, and they repeated the D-major Symphony with the new slow movement.[55] He said he had been asked to write a French oratorio for the Concert Spirituel for next Lent; if that was true, it never happened.[56]

Palatine ambassador Count Sickingen was a generous patron and host throughout the Paris sojourn, Mozart's visits to his house full of music, his host full of plans for the famous youth. None of them worked out. There had been an offer to become organist at Versailles, with a middling salary but a good opportunity for making contacts, but Wolfgang declined it. He gave his father various reasons, but probably the real one was that it would keep him away from Aloysia. Mozart had produced a fair amount of music in Paris—the list deceptively slim because some of it, including a sinfonia concertante, would be lost.[57] The surviving big Paris pieces, the D-major Symphony and the Concerto for Flute, Harp, and Orchestra, are major works, the concerto arguably the finer and fresher of the two.

But there is another piece from the sojourn that is striking indeed:

the Piano Sonata in A Minor, K. 310. It may have been played some-times on harpsichord in those transitional times for keyboard, but this is truly piano music, full of sudden changes of intensity that demand the piano's range of volume and articulation to make its point. The surges of sound are an image of surging emotions. The sonata demonstrates why the piano was indispensable to the new intensity of musical and emotional contrasts composers were pursuing in the late eighteenth century.

The A Minor, Mozart's first keyboard sonata in minor and one of only two, begins on a note of urgency, with an obsessive theme over hammering chords in the left hand, the volume jolting from loud to soft and back. Soon driving sixteenths emerge, and from that point to the end of the exposition they will not cease, giving a nervous energy even to the C-major second theme. Once again Mozart's developments to this point have tended to be short, more or less harmonic palate cleans-ers before the return to the home key at the recapitulation. This de-velopment is fiercely dramatic, a restless chain of mostly minor keys, his rare uses of fortissimo and pianissimo amplifying an obsessive en-ergy that ends in a phrase of pealing dissonances over a churning left hand. Here Mozart is moving further toward more elaborate and pen-etrating development sections. In the recapitulation, the exposition's C-major second theme comes back in an intense A minor. The opening movement is not exactly furioso, not exactly tragic; call it rage under restraint: an aria by a troubled character who does not want to lose himself.

The enormous second movement (ten minutes) redefines that mood, taking it inward. In a minorish F major, it adds up to one of the most affecting major-key stretches in Mozart. The movement is in sonata form, the second theme in a charged C major as in the first movement. Then rises one of the longest and most passionate developments of his early maturity, mounting to a feverish phrase founded on the pounding chords of the first movement accelerated in the right hand, while the left hand sings a defiant theme. After that development, the first theme returns as a sorrowful consolation. A driving 2/4 finale amounts to just under three taut minutes, marked by an unflagging nervousness that ends not in a turn to hopeful major, as so often in Mozart, but in curt A-minor chords. For all the finale's energy, most of its dynamics are

piano, which only enhances its simmering tension. The few fortes seem
to pounce on us.

In his art Mozart showed a habitual detachment from the circum-
stances of his life. As noted before, in those days the point of art was not
to express yourself but to express everybody and to express art itself.
For an artist the abiding goal was to earn a living by providing enter-
tainment, with the proviso that entertainment can be as moving and
profound as anything. The heart will make itself heard.

There might be Sturm und Drang influences in the A-minor Sonata,
but they're not necessary to explain it. That tonality, one Mozart used
rarely, struck him that way. And it's hard not to see the loss of Maria
Anna Mozart in the restrained rage and melancholies of the A Minor.
The manuscript itself speaks: Mozart usually wrote with a quite neat
hand, but this sonata has notes jammed in and overflowing the staves.
The page speaks of urgency.[58] Mozart was an artist, and the death of his
mother was more material—in this case maybe material for one of his
finest piano sonatas. But he felt the loss no less deeply for that.

After his mother's death Mozart was invited to stay with Baron
Grimm and Madame d'Épinay. This was a pleasant prospect, until it
became one more prospect that fell apart in his hands. At the end of July
Mozart and Grimm had a set-to. The baron saw that nothing promising
was happening with this protégé, or whatever Mozart was to him now,
and the youth's efforts were not likely to get him anywhere in bru-
tally competitive Paris. Grimm was going to make a report to Leopold,
and his report would not be papered over like his son's were. Wolfgang
wrote Leopold of their conversation:

> Monsieur Grimm said the other day to me, what should I write to
> your father?—what are your plans now?—will you stay here, or
> will you go to Mannheim? I couldn't keep from laughing—what
> should I do in Mannheim now?—if I had never come to Paris—
> but as it is, I am here now and have to try as hard as possible to
> make my way—I know, he said, but I can hardly believe that you
> can make it here—why?—I see a lot of Miserable bunglers who
> can make a living here, and . . . should I not be able to do so? . . .
> Well, he said, I'm afraid you are not active enough here—you are
> not getting out and about enough.

In Wolfgang's letter there follows a list of explanations and excuses, some of them real enough. The Duc de Guînes had stiffed him disgracefully: "the Duc wanted to pay only one lesson for 2, and this although he has had a Concerto for flute and harp." Wolfgang declares he's going to go to the Duc's housekeeper and demand his money. "What annoys me most is that these stupid Frenchmen think I am still just seven years old . . . Mad. D'Epinai [*sic*] told me so herself." His childhood fame was now one more obstruction in his way. He ends the letter with bootless fantasies about writing an opera.[59]

Grimm's letter to Salzburg confirmed to Leopold everything he had suspected about his son's inability to make his way.

> He is too trusting, too inactive, too easy to catch, too little intent on the means that may lead to fortune. To make an impression here one has to be artful, enterprising, daring. To make his fortune I wish he had but half his talent and twice as much shrewdness . . . He might give all his time to [composition rather than teaching]; but in this country the great public knows nothing about music . . . You see, my dear *maître*, that in a country where so many mediocre and even detestable musicians have made immense fortunes, I very much fear that your son will not so much as make ends meet.[60]

That amounted to a requiem for father and son's Paris hopes. Relations between Grimm and Mozart declined from this point. Still, Madame d'Épinay remained warm and reassuring. There would have been long, amiable conversations between her and Mozart, and what came from her would be ideas from the heart of the French Enlightenment, from her personal relationships with Voltaire, Diderot, Rousseau, and other philosophes, and from the ideas of illustrious men and women at her salons.[61] Mozart had crowed to Leopold about Voltaire's death, but over time he would move decisively, historically, into the Enlightenment in his life and in his work. Likely Madame d'Épinay had something to do with galvanizing this process, and perhaps there would be echoes of her in the vibrant and wise women who populated Mozart's operas to come.

At the end of August Mozart had a delighted reunion with one of

the prime mentors and friends of his childhood, J. C. Bach, visiting from London to see to the premiere of his new opera, *Amadis de Gaule*. (Bach had fallen out of fashion, however, and the opera flopped badly.) "You can imagine his joy as well as my joy in seeing each other again," Wolfgang wrote home.[62] Leopold for his part had some good news that month. Following the departure of Kapellmeister Domenico Fischietti after a six-year reign, Leopold had assumed some of the position's duties, as it would take a while to find a new Kapellmeister. In light of that and his long service, Leopold petitioned the court for a raise. He had given up hope that he would ever get the top job, though he never lost his bitterness about being passed over. But he got the raise, a substantial 100 florins, adding up to a comfortable 500 a year. And there was another development that led him, after Grimm's disheartening letter about Wolfgang's prospects, to change course in regard to his son.

In a conversation with Countess Maria Antonia Lodron—Wolfgang had written the Triple Piano Concerto for her and two of her daughters—Leopold mentioned that Wolfgang had been offered the job of organist at Versailles. Lodron was close to Archbishop Colloredo and at that point the most influential woman at court.[63] Soon she returned to Leopold with an idea. Presenting the Versailles position as something that might take his most famous musician out of town, she had gotten Colloredo to offer Wolfgang an enhanced position of Konzertmeister, presumably someday to ascend to Kapellmeister. He would receive a salary of 600 florins a year.[64] (By the time Mozart got back to Salzburg, the salary had become 450.) So their combined incomes would make them nicely prosperous, to which would be added income from Leopold's and Nannerl's teaching and Wolfgang's composing and performing. His only duties would be playing organ at the cathedral, some composing and teaching, sitting in on the violin section of the orchestra now and then. An assistant would take care of routine church services. Mozart would be allowed to travel for opera projects every couple of years. There would be plenty of time for his own work.

Leopold's initial hopes had been for Wolfgang to find a job or at least prosperity in Paris or some other capital, to the benefit of them all. Now he wanted his son back in the Tanzmeisterhaus, the family enjoying the fruits of his labor, Leopold the paterfamilias. At least until one or both children married, life would go on as before, but with a good

deal more money coming in. All that was necessary was to be resigned to staying in Salzburg. This was exactly the sticking point, mainly for Wolfgang but really for both of them.

Wolfgang for his part was torn about the idea, lurching from resignation to resistance. He wrote Abbé Bullinger heartfelt thanks for his help in seeing to Leopold when Maria Anna died and then, as usual, went on in the letter to practical considerations. He had gotten wind of the Konzertmeister offer. As for that, "You know, my dear friend, how I hate Salzburg!—not only on account of the injustices that my father and I have suffered there . . . Salzburg is no place for my talent!— First of all, the court musicians do not enjoy a good reputation, second, there's nothing going on musically; there is no theater, no opera!"

From that point in the letter, Mozart goes on to a cogent analysis of problems with the court musical establishment—an analysis that would be appropriate for a prospective Konzertmeister and Kapellmeister. When he gets into it, though, his wit takes over.

It is more useful and reasonable to look for a Kapellmeister, since they really have *none* at present, than to write all over creation, as I've been told they are doing, to hire a good female singer . . . when we have so many already!—and all of them first-rate; if they went after a tenor, I could understand it, although we don't really need one either . . . but a female singer, a Prima donna!—after all, we have a castrato now!—It's true Mad. [Magdalena] Haydn is sickly,—she has gone too far with her austere religious life . . . I'm surprised that she hasn't long since lost her voice with all her constant flagellations and whippings, her posturing in a hairy shirt, her unnatural fasting . . . But let me take my argument to the extreme [regarding the need for sopranos]: let's just imagine that, apart from the weeping Magdalena, we had no other female singers, . . . that one of them suddenly gets pregnant, another one is taken to jail, the 3rd is going to be flogged, the 4th perhaps beheaded, and the 5th— snatched up by the devil!—what then?—well, nothing!—after all, we still have the castrato!—he can sing in the high register and would, therefore, be excellent in a woman's role . . . In the end, because I know at Salzburg they love variety, change, and

innovation, I can see before my eyes a large field of opportunities whose realization can truly make History.

Toward the end of the letter, Mozart has slipped into irony. Did he really think Salzburg loved innovation? Did he really believe he could make musical history there? He goes on to imagine bringing Metastasio himself to Salzburg to write dozens of librettos "in which the male lead and the female lead never encounter each other on stage, for in this way the castrato can play both the male and the female lover . . . and the piece would be found especially interesting because it allows us to admire the virtuousness of the two lovers, which goes so far that they deliberately avoid speaking with each other in public."[65] He may have gotten a report that the new Italian castrato at the Salzburg court, Francesco Ceccarelli, was an excellent musician. He would become a friend of the family, a violin student of Leopold's, and a regular at *Bölzlschiessen* matches.[66] Mainly Mozart's letter reveals that despite himself, he enjoys turning over details of managing court music, and the idea that Salzburg could be made into an important center is maybe not entirely a joke—whether realistic is another matter.

At the same time he wrote a reassuring letter to Papa about the job that was largely rubbish: "I am satisfied and that settles it. There is one place where I can say I am at home, where I can live in peace and quiet with my most beloved father and my dearest sister, where I can do as I like, where apart from the duties of my appointment I am my own master, and where I have a permanent income."[67] Only, he continued, he will not play violin in the orchestra. "I will no longer be a fiddler. I want to conduct at the clavier and accompany arias." Nonsense, Leopold replied. You have no reason to complain, and you will play the fiddle when required to.

There is another matter in this letter: Mozart's rising disgust with Baron Grimm. "Monsieur Grimm is capable of helping <u>children</u> but not adults," Wolfgang fumed to Leopold in September. "Were it not for Mad. d'Epinay, I wouldn't be in their house . . . I would have moved out next month and gone to a place where they are not as smug and dumb as in this house—where they don't always rub it in when they have done you a favor." Grimm was now leaning on Mozart for the fifteen louis d'or lent to him during his mother's illness. "Is he perhaps worried

about getting it back?—if he has any doubt, he really deserves a kick in the rear, because he is doubting my Honesty, which is the one thing that can really make me angry—he is also doubting my Talent . . . because he told me once to my face that he didn't think I was capable of writing a French opera."[68]

By now all these words were products of impotent rage. Mozart had made little impression on Paris, and he was not going to. It only remained for him to cut his losses and get out. He wrote home that he was waiting to get paid by Guînes and Legros (he never got fully paid) and to receive the published violin sonatas (which did not happen until after he left town). His father had borrowed seven hundred florins for Wolfgang's journey, and insisted he be paid back. He wrote Wolfgang at one point that Nannerl had contributed all her savings as well, but that may have been a lie, and in any case it did not appear to come up again. Leopold was, in any case, protecting his secret nest egg.

Toward the end of November interesting news came from home: "Your desire that the Webers should have 1000 gulden a year has been fulfilled, for a letter from Munich of September 15 informs me that Count von Seeau has engaged Mlle Weber for the German theater at 600 gulden. So if you add her father's 400 they will have 1000." (Actually, Aloysia would soon be getting 1,000 and her father 600, which added up to a grand income.)[69] Leopold still had wide-ranging informants. To his relief, Wolfgang finally was going to leave Paris. In regard to Baron Grimm, he cautioned in stern underscores, "be sure not to play any impudent prank on him."[70]

This was good advice, which apparently Mozart had already followed in another scene with Grimm. He told his host that he was going to move over to Count Sickingen's to expedite the engraving of his sonatas. With "his eyes sparkling with rage," Wolfgang reported, Grimm barked, "If you leave my house before you leave Paris, I shall never look at you again as long as I live. In that case you must never come near me, for I shall be your worst enemy." Their relationship had come to wrath and threats. To this Mozart responded diplomatically, for the moment, writing his father, "Well, self-control was indeed very necessary. . . . I only bowed and went off without saying a word. Before I left Paris, however, I did say all this to him—but he answered me

like an idiot—or like some wicked fellow who now and then prefers to behave like one."[71]

Mozart left disastrous Paris on September 26, 1778. He was not heading directly for home and a new job, however, but rather to Mannheim, where he may have thought the Webers were still in residence. There he could congratulate Aloysia and her father on their good fortune and find solace, he fervently hoped, in her arms at last.

It is no surprise that Mozart was not in a hurry to get back to Salzburg. Brushing aside his father's protests, he would take months to get home. But for whatever reason, he seemed likewise in no hurry to get to Mannheim and Aloysia. As much as he yearned for her, putting off the visit may be a sign of apprehension about how she would receive him.

Going by way of Nancy, he reached Strasbourg and dallied there for nearly two months. Shortly after he arrived in Strasbourg he gave a concert entirely solo, to save money, then two accompanied ones. The solo concert amounted to what later would be called a piano recital, but the idea had not been invented yet, and in the eighteenth century such a program was nearly unheard of. But few people showed up to this historic event, or to the other concerts, either.

For a time in Strasbourg, Wolfgang neglected his correspondence home. Leopold responded with panic: "A most frightful blow! I had written to the brothers Frank at Strasbourg on October 1, telling them of your arrival and of the money order on Herr Scherz. They replied on the ninth, saying that you had not yet arrived . . . Well, seeing that six days later you had not reached Strasbourg, must we not all think that you have fallen ill? . . . Whenever Bullinger appears, I watch his features with the greatest attention, lest he should be bringing my sentence of death. I have now spent four sleepless nights—such ghastly nights, my son!"[72] Wolfgang hastened to reply, but ignored his father's hysterics.

Mozart finally made it to Mannheim on November 6, to discover that the Webers had departed, but he had a warm reunion with Madame Cannabich—her husband had gone on to Munich—and other friends there.[73] "Mannheim loves me as much as I love Mannheim," he wrote Leopold, and went on to prod him to ask the archbishop for more money: "Indeed the Archbishop cannot pay me enough for that slavery in Salzburg!"[74]

Leopold remained in a swivet, desperate to have his son and meal ticket back home: "I will either lose my mind or die of exhaustion . . . Your whole intent is to ruin me so you can build your castles in the air . . . I hope that after your mother had to die in Paris, you will not also burden your conscience by expediting the death of your father."[75] It was another veiled implication that Wolfgang had killed his mother. It would not be the last. Again, Wolfgang ignored it.

Desperate, and not realizing the Webers had departed, Leopold tried another tack to dislodge Wolfgang from Mannheim: "I trust that, if you are still there, you will leave by the very first mail coach. Two things seem to be turning your head and altogether preventing you from thinking out matters sensibly. The first and chief one is your love for Mlle Weber, to which I am not at all opposed. I was not against it when her father was poor, so why should I be so now, when she can make your happiness—though you cannot make hers? I assume that her father knows about this love, as everyone in Mannheim knows about it." He says Wolfgang should invite Aloysia and Fridolin Weber to visit Salzburg. This was one of Leopold's rearrangements of reality. "Not at all opposed"? Earlier he had been rabidly opposed to Wolfgang's courtship of Aloysia.

In the letter Leopold goes on to say that he has installed a new chest in Wolfgang's room for his clothes, and that the clavichord is waiting for him. "If it is God's will, I want to live a few years longer, pay my debts—and then, if you care to do so, you may have your own obstinate way. But, no, You have too good a heart! You have no vices. You are just thoughtless!" There he reveals his current scheme: Wolfgang is to live in Salzburg until he has paid his father back for the Paris jaunt, then he can go his own way. Before he closes, Leopold cannot resist one cynical parting shot at Fridolin: "I am inclined to think that Herr Weber is a man like most of his type, who make capital out of their poverty and, when they become prosperous, lose their heads completely. He flattered you when he needed you—perhaps he would not even admit now that you had shown her or taught her anything."[76] That is not necessarily one of Leopold's exaggerated surmises. In any case, as it turned out, Fridolin did not have long to live, and his widow would prove far more calculating than he was.

If Wolfgang felt yearning and anxiety over seeing Aloysia, he had

not forgotten the delightful Bäsle, now that he was back in her vicinity. "Dearest cozz, don't be a buzz," he wrote her in his hyperbolic mode, his emotions in all directions perhaps made manic by his uncertainty about Aloysia.

> I would've loved to come to Augsburg, I assure you, but the Herr Imperial Prelate wouldn't let me leave, still I don't have a beef, be- cause it would be against God's law and that of nature even more, and whoever doesn't think so is a wh-re, and that's what is in store galore.—Maybe I'll be able to hop over to Augsburg from Mu- nich for a few days; but that's far from certain.—But if you are as glad to see me as I am to see you, then please come to Munich that splendiferous city—make sure that you get there before the New Year, so I can look at you from afar and from near—I will show you around town, if you don't mind, and if need be I'll clean your behind . . . But all jokinggg aside—it's precisely for this reason that I need you to come and stay—for you might have an impor- tant role to play;—so be sure to come even for a bit, otherwise I'll be in deep shit. I shall greet you high and nobly with pizzazz and put my personal seal on your ass, I will kiss your hands and have such fun shooting off my rear-end gun, I shall Embrace you with a smack and wash you down front and back, I shall pay up all I owed you from the start and then let go a resounding fart, and perhaps even drop something hard—well, adieu, my Angel, my heart, I'm waiting for you with a smart, please send me right at this moment a little note of about 24 pages to Munich . . . But don't tell me where in Munich you will be so I won't find you and you can't find me;—votre sincere Cousin / P.S. Shit-dibitare, shit- dibitate / the pastor of Rodempl, / he licked the ass of his kitchen maid, / to set a good example. / Vivat—vivat—[77]

It is impossible to know just what he was thinking at this point, hard not to wonder. He loved Aloysia helplessly, but she was so far untouch- able. The Bäsle was fun and games—not, as it proved, a backup for him if Aloysia did not work out. For the moment he just wanted them both at the same time, each in her respective role. Did his cousin un- derstand this at all? He invited her to Munich, told her she might have

"an important role to play" there. What could that important role have been other than some kind of accomplice in his courtship of Aloysia? If this is not self-involved manipulation, it is hard to say what else to call it. If the Bäsle understood what Wolfgang was up to, how did she feel about it? There is no evidence beyond this: she came to Munich, stayed by him through what transpired there, journeyed back to Salzburg with him, and stayed as long as a month. Whether the Bäsle had lingering hopes concerning him at that point, there is no record.

Comparing Mozart's letters to one person and another, such as to the Bäsle and to Leopold, seeing how the content and style of each is radically different yet consistent in letters to each person, we see something essential about Mozart as an artist, and about accomplished artists in general: each piece of work is its own world with its own personality and even its ethos; and within the work, that personality is consistent and unmistakable. A sentence that is right in a letter to Leopold would usually be wrong written to the Bäsle, and vice versa. In the same way, a phrase that is right and beautiful in the Concerto for Flute Harp, and Orchestra might compromise the intensity of the Piano Sonata in A Minor.

How to achieve that distinctive and integral personality is the question. For an artist, an understanding of the voice and the integrity of the work at hand, what makes this piece this piece and no other, involves too many elements to be marshaled consciously. It is more an irreplaceable part of artistic intuition, called "inspiration." Mozart did not plan how he would write to the Bäsle; he simply did it based on how he felt about her, and she about him, and his instinctive response to those feelings. Later the same would be true of the Andante of the Piano Concerto no. 21, in which a single note out of place could break the spell of a sui generis atmosphere. When something was not going well, Mozart did not fret and labor over it; he dropped the piece and started another, even if it was a movement of a larger work. For an artist of supreme fluency and inspiration like him, the creation of a work with its distinctive voice and logic floats on its own, unfolding like butter on a hot pan.[78]

Mozart left Mannheim on December 9 and dallied in Kaysersheim for over a week as a guest of the town abbot. There he received a package from Grimm with the newly engraved violin sonatas, which he was

going to present to the electress.[79] He arrived at the Webers' new place
in Munich on Christmas Day 1778. It would have been a day of joy in
the season and of satisfaction in the good fortune of Aloysia and her
father. It would not be a day of rejoicing for Mozart. It would be the
climactic disaster of the journey.

He arrived at the Weber family celebration dressed in French-style
mourning for his mother, a red jacket with black buttons. What hap-
pened was something in the direction of his worst nightmare. Aloysia
could have taken any number of routes to tell him she had moved on—
tears, a heartfelt talk, a brusque dismissal. What she did was colder
and stranger than that: she pretended she didn't recognize him. After
moments of what could only have been confusion and dismay, her be-
havior sank in. He was being jilted. Mozart responded in his mode: he
sat down at the piano and improvised a song, the operative line being
"Let the wench who doesn't want me kiss my arse."[80]

That would have presumably ended the party, and it would seem
to have ended their relationship. Whether Aloysia had ever viewed
it as more than an artistic partnership is not discernible. The passion
may have been entirely on Mozart's side. She was talented, beautiful,
ambitious, and at seventeen remarkably self-possessed. As with some
people, there was an aura around her; she was marked for fame and
well aware of it. She was going to go for a lover or mate of the same
cloth, and soon enough she found him. However talented and ambi-
tious, Wolfgang was not beautiful. And maybe with Aloysia, out of
fear and respect he had not utilized one of his principal charms: he had
failed to be amusing.

Mozart had never been so stricken, not even, it appears, by the death
of his mother. He reported to Papa that he had arrived in Munich, but
"I'm saving my full report . . . for today I can do nothing but weep . . .
I simply can't write—my heart is on the verge of tears all the time! I
hope you will write to me very soon and console me."[81] A Mozart fam-
ily friend in Munich had a talk with Wolfgang and reported to Leopold,
"For a whole hour I hardly succeeded in staying his tears: he has so
good a heart . . . He is assailed by some fear lest your reception of him
may not be as tender as he wishes."

Wolfgang had not explained to his father what he was weeping
about. After the friend's report, Leopold concluded that it was because

he missed his Papa and was worried about his father's loyalty to him. Leopold wrote tenderly, "If your tears, your sadness and heartfelt anxiety have no other reason but that you doubt my love and tenderness for you, then you may sleep peacefully . . . You have no reason to fear a cool reception or disagreeable days in the company of your sister and myself. But what plunges me into a state of anxiety . . . is your prolonged absence."[82]

The apprehension over his father was probably real enough. After one rejection, Wolfgang feared another, following months of disappointing his father and snubbing his advice and his pleas. But Aloysia was the real source of his tears. Rejections from the person most important to you, your fondest hope, is nothing but devastating. Yet, hard as it is to believe, Mozart spent the rest of his Munich stay in the Weber house. He was close to Fridolin, but he and Aloysia would have seen each other every day. Somehow he endured this abrasion of a raw nerve. Was it a sign of some desperate hope that she would relent, or was it another indication of his ability to distance himself from distress, even in the presence of its cause?

At the beginning of January Mozart and Cannabich had an audience at the Munich court, where Mozart presented the six violin sonatas, K. 301–6, to Electress Maria Elizabeth. She received them graciously, and that was the end of it. She apparently bestowed some sort of gift for the sonatas, but nothing on the order of a job. Mozart was gearing up to leave. "I am burning with desire to embrace you and my sister," he wrote home, "if only it were not in Salzburg . . . I must hurry now because the mail coach is about to leave.—My Bääsle [*sic*] is here— why?—To please me, her cousin? . . . However—well, we'll talk about it in Salzburg;—and because of that I wished she would come with me to Salzburg!—You will find something written by her own hand and nailed to page 4 of this letter."

The Bäsle had agreed to go to Salzburg with him. Perky and shaky in literacy, her letter to Leopold has no sign of disappointment or anything but good humor. "Monsieur mon trés cher oncle / I hope you are in good health and also my cousin, I had the honor to meet your son in Munich in excellent good health, he wants me to go with him to Salzburg, but I do not yet know whether I shall have the honor of seeing you: but my kinsman is a regular fool, you see: I wish you all happiness,

mon cher oncle, and 1000 compliments to ma cousine. Je suis de tout mon coeur / Mozartin."

There is no record of what sort of farewell the Webers gave Mozart when he left Munich, though it could not have been as warm as the last one. Maybe the inner and outer chill of the winter was warmed a bit by the presence of the Bäsle. When he reached Salzburg on January 15, 1779, after sixteen months away and just before his twenty-third birthday, he left behind him a trail of hopes and dreams and schemes, all of them blown away like ashes in the wind.

A SCOUNDREL, A LOUSY ROGUE

I f in Paris Wolfgang made a covert declaration of independence from his father, his return to Salzburg in January 1779 still amounted to doing what Leopold wanted: to pull the family together again (without Maria Anna), the men working for the court and enjoying a comfortable income in a spacious flat, all earnings going to Papa, who kept his adult children on an allowance. This was not a concession on Wolfgang's part; he had no choice. His sixteen-month jaunt had been a demoralizing failure.

On his return Wolfgang was welcomed by a feast of capons.[1] On the face of it, life in Salzburg was agreeable enough. With Wolfgang now making 450 florins and his father 500, the Mozarts were more prosperous than ever. They had a busy social life, with guests regularly in the house; they lived across the square from the town theater and took in productions regularly; they entertained visiting theater people and got free tickets. The Johann Böhm troupe was in residence in the 1779–80 season, offering every sort of show: operas, tragedies, comedies, ballet, singspiel, assorted hybrids.[2] Theater was new in Salzburg, and citizens were not yet savvy about it. During a play they were known to scream at the villain and after the show to chase the actor back to his inn with threats.[3]

Wolfgang had fairly light duties for the court and could compose and perform as he wished. There were court concerts to attend three nights a week, though by order of the archbishop they were kept to

just over an hour.[4] His main duty was playing organ in the cathedral, which cost him no effort, and he had an assistant for menial tasks. If he stuck it out, he could look forward to being court Kapellmeister someday.

To ease his return there was the presence of the Bäsle, who may have come back in the carriage with him. They would have found some quiet corners to amuse themselves and, in company, resumed their game of giggling together at the rest of the world. With the Bäsle, Mozart began to call his sister "Zizibe" behind her back, this being a nickname for a prudish and affected girl.[5] After the Bäsle left, Mozart for a while squired Therese Barisani, daughter of the court physician, with whom he had been friendly for a long time, but nothing came of it.[6]

Mozart soon settled in as cathedral organist, composer, and teacher for the court. The post had been seized on by Leopold to tempt him back to town, but Wolfgang still had to apply formally to the archbishop for the job in appropriately groveling terms. Leopold probably handled the letter: "Your Serene Highness was most graciously pleased after the decease of Cajetan Adlgasser most graciously to take me into your service: I therefore most submissively beg that I may be graciously assigned the post of Court Organist in your Exalted Service; to which and, as for all other high favors and graces, I subscribe myself in the most profound submission."[7]

He found composing for the cathedral tiresome, especially given the time constraints Colloredo had imposed on the music for Masses. He was meanwhile expected to give lessons to cathedral choirboys.[8] All the same, as he did with the teaching that he also didn't much like, he went about the job thoroughly. He made a study of what he considered the best of Salzburg sacred music, mainly works of Michael Haydn and Johann Ernst Eberlin, copying out some 150 pages of excerpts. (Copying was how you studied pieces in those days.)[9] Mozart never lost his respect for Haydn's work. For all his love of the bottle sometimes publicly on display, this younger brother of Joseph Haydn was a prolific and masterful composer. His sacred music is old-fashioned for the time, much of it contrapuntal, as much Baroque as later eighteenth century, but it is not fusty. Mozart's Salzburg church music would follow suit, and there would be echoes of the older man in his sacred work to the

end. Mozart knew Michael Haydn's secular works as well: the exqui-sitely wistful slow movement of Haydn's Flute Concerto in D Major, P. 56, may be a predecessor to the same in Mozart's early Divertimento K. 138, and Haydn's atmospheric nocturnes an influence on as late a work as the Piano Concerto no. 21.

The Mozarts were a sociable family, with old friends such as the Bullingers, Hagenauers, and trumpeter/violinist/poet Johann Andreas Schachtner. New friends included court castrato Francesco Ceccarelli, whose name appears in the ranks of *Bölzlschiessen* players. The favored card game these days seems to have been a widespread one called *Ta-rock*, played with a tarot deck—the same as was used for divining, but this a game with tricks and bidding. As with all games, there would have been money on the line. The family's socializing was worked in around the court schedule of Wolfgang and his father's and Nannerl's teaching in the morning.

Mozart resumed writing in his sister's diary, no less whimsically. There were signs of boredom: "7:30 to Hagenauer's to watch the horse take a shit . . . at 7:30 mass or something like that, then with Lodron, or something like that . . . Afternoon at the countess Wicka's played cards or something like that, then back home with Katherl, she deloused me a bit—finally we had a game of Tarock."[10]

The most elaborate of Wolfgang's entries in Nannerl's diary is sim-ply bizarre, until its secret is discerned: "About shitting, my humble self, a jackass, a hernia, again a jackass, and finally a nose, in church, staying at home due to the whistle in my arse, the whistle in my arse a little evil. In the afternoon kathrl [Gilowsky] stopped by and also Herr Fox-tail, whom I afterwards licked nicely in the arse. O, price-less arse!"[11] If one is paying attention, in the German one notices that the capitals of the nouns spell out one of Nannerl's mundane entries: "Around 7 o'clock went to church. Papa stayed home, feeling a bit out of sorts . . ." and so on.[12]

After the Bäsle departed back to Augsburg, Mozart's letter to her in May implies there had been some friction, which he tries to tease her out of. This time, though, rather than his usual Hanswurst raunchiness in writing to the Bäsle, he is more forthrightly romantic and erotic, with a dash of irony in both.

Dearest, best / most beautiful, most charming / most enchant-
ing, / little bass / or / little Violoncello, / so enraged by worth-
less / fellow. // Salsbourg, 10th of May / 1709er / blow into my
rear. /—:—/ Nothing could be finer / bon appétit! / Whether I,
Joannes Chrisostomus Sigismundus Amadeus Wolfgangus Mo-
zartus will be able to calm, soothe, or soften your anger, which
has increased your enchanting beauties (visibilia and invisibilia)
by the full height of the slipper heel, that is a question I am pre-
pared to answer right off:—to soften means as much as car-
rying Someone softly in a soft chair—I am by nature soft and
mild, and I also like to eat mild mustard, especially with roast
beef . . . Yes, my dear little violoncello! [in a postscript] A Tender
Ode!— / Your picture sweet, O Bäsle, / hovers before my eye /
but each sad tear will tell me / that you are—nowhere nigh. /
I see it in the setting sun, / I see it in the rising moon, / I see it
and I weep inside / that you are—nowhere nigh. / In the flow-
ers of the Valley / which I've gathered for her, / and each of the
myrtle branches / which I twist and twine for her, / I conjure
up her image, I implore her to appear; / if only by some magic /
I could bring Bäsle here. / finis coronat opus, Baron von Pig-
tail . . . Adieu—Adieu—Angel! / My father sends his Uncle-ish
blessings and my sister sends you 1000 Cousine-ish kisses. And
this here Cousin gives you something he is not supposed to give
you.[13]

For a graphic touch, the letter includes a rough drawing of the
Bäsle, her face in profile and below it her petite bare breasts, nipples
proudly erect.[14] The fooling around had continued in Salzburg, and
he seems to have had hopes for more, but in fact, his letter essentially
says nothing, studiously nothing. He mentions her anger: Did she
leave in some heat? Did she have some lingering hopes about him that
he dashed? In any case, there appears to have been no overt break.
He ends with a promise that he'll write something more sensible by
next post, but it appears that he didn't. The record would only show
one more letter to the Bäsle, one not in his rowdy mode, but rather
tellingly sober.

IN THIS PERIOD OF PLEASANT SOCIALIZING AND LOOSE ENDS IN SALZ-
burg, Wolfgang was not all that prolific by his standards, though what
he did produce was entirely up to his standards. For the moment there
were no wrangles with the archbishop, even though Wolfgang was
more fed up than ever. He had traveled halfway across Europe in the
hope of getting something better and had ended up where he started,
in the same stagnant society, the same stagnant life surrounded by the
same carousing musicians. At the end of summer 1779 he heard that
Aloysia Weber, at nineteen, had found a job as a prima donna at the
Burgtheater in Vienna, the most important opera house in Europe. The
rest of the Webers followed her there. During the season she married
leading actor Joseph Lange; when they wed in October, she was two
months pregnant. The Vienna position was a plum of plums for Aloy-
sia and her family, though father Fridolin would not have long to en-
joy it—he died shortly before the wedding. He and Mozart had been
fondly close.[15]

Within the Mozart family there were new tensions. Responsibility
for Maria Anna's death was an issue that never went away, and Leopold
still expected to be paid back for the cost of Wolfgang's journey. Papa
had written bluntly to Wolfgang in Mannheim, "I am <u>absolutely deter-
mined</u> not to remain covered with disgrace and deep in debt on your
account; and still less to leave your poor sister destitute." Possibly when
his son took the new position, his salary paid to his father, Leopold held
back some of it toward the debt. There is no sign that Wolfgang, in the
dark about his father's actual resources, objected to these demands. But
he felt no pressing obligation either.

Mozart's Salzburg music of 1779–80 ranges widely, with large sa-
cred works now part of the mix. Probably for himself and Nannerl,
he wrote an amiable Concerto in E-flat for Two Pianos, K. 365, and a
grand and attractive Vesperae solennes de Dominica in C, K. 321, for
choir and orchestra, which features the style of Baroque counterpoint
he had picked up from Michael Haydn. Symphony no. 32 in G Major,
K. 318, is an odd beast, a single movement in three short sections,
the middle part slow, recalling the three-part Italian opera overture
that originally gave rise to the genre. It may have been intended
for the theater, which suits its vigorous temperament. There's nothing

arbitrary about the form, eccentric as it is: the first section has an expo-
sition and development that is interrupted by the slow music; the final
section recapitulates material from the opening in reverse order. The
Böhm theater company had arrived in the summer of 1779; the director
may have asked for an overture, and the G Major may have been Mo-
zart's response.[16]

His next symphony, No. 33 in B-flat, K. 319, originally had three
movements; Mozart later added a minuet. It has little apparent ambition
beyond being agreeable, harkening back to the lightweight atmosphere
of the galant. After writing a lot of symphonies in Salzburg and with so
far middling exposure to Viennese symphonies, Mozart for the moment
seems to be marking time in the genre. Still, both these symphonies
found widespread performances around German lands. Since he left
Paris, meanwhile, the Concert Spirituel had played some of his sym-
phonies.[17]

For another university *Finalmusik* in 1779, Mozart produced the
most substantial of his Salzburg serenades, K. 320, amounting to seven
movements and nearly fifty minutes of mostly joyful noise to celebrate
the end of the school year. It acquired the title *Posthorn*, from that in-
strument's lusty solo in the second trio of the second Minuet. (The first
trio of that movement features the peeping little *flautino*.) In those days
post horns announced the arrival of the mail rider or coach, and its calls
were taken up in concert works as a touch of realism. The part could
be played by trumpet, but the hoarser little post horn would preferably
have made an appearance. The first movement of the serenade is close
to a sustained fanfare, with lots of festal horns, trumpets, and timpani.
The winds change movement by movement, two bassoons often in a
solo role rather than doubling the bass; the Rondo features some liq-
uid dialogue between solo flute and oboe. The surprising element is a
dark-toned Andantino fifth movement, its somber air in keeping with
Mozart's accustomed D-minor mood.

Soon after his return from Paris, he wrote the most enduring of his
early church works, the *Coronation* Mass, K. 317.[18] The traditional ti-
tle probably came from its later being used at a Holy Roman Empire
coronation; the first performance was probably at the Salzburg Cathe-
dral in April 1779. This is a Missa brevis, conforming to Archbishop
Colloredo's decree of no church Mass of over forty-five minutes, but

it manages to be substantial and memorable in its movements of seven minutes or less.

The key of C major and the presence of trumpets and timpani in addition to the usual oboes and horns suggests the *Coronation* is going to be a gala affair. In fact the opening Kyrie is spacious and solemn, even in the vocal solos, with a weightiness that marks the whole Mass. There are stretches of fiery energy in the Gloria and Credo, flights of lyricism in the solos. (There are no fugues in the piece and little counterpoint.) This is one of the rare Masses describable as "virile." Mozart's attention to the drift of the words is steady: in the hushed stillness of the Et incarnatus a muted violin flutters like the holy dove to evoke the Immaculate Conception. The unflagging intensity continues into an elevated Sanctus, which gives way to a gently lyrical Benedictus, which erupts into a driving Osanna in excelsis. In most Masses the Agnus Dei, a prayer for peace addressed to the Lamb of God, is going to be tender with a touch of pastoral atmosphere; so it is here, its pastoral key of F major the only departure from C. The fundamental dynamism of the Mass reasserts itself in a final Allegro con spirito setting of Dona nobis pacem (Give us peace): this is a surging, dancing prayer.

Throughout the *Coronation* there is a sense of personality and of engagement with the ancient text unusual among the often-impersonal sacred music of the time, including much of Mozart's. The style remains on the archaic side, which was Salzburg style. Mozart at this point had perhaps heard little of the manifestly operatic sacred music being written in Vienna by Joseph Haydn and others, and in fact that approach would never interest him. He wanted a distinctive sacred voice, and it would be some time before he discerned what that could be.

Another major sacred work of this period is the *Vesperae solennes de confessore* in C, K. 339. This is a more joyful C-major work than the *Coronation* Mass, more contrapuntal, with a learned fugue on Laudate pueri complete with inversions of the theme. It amounts to one of Mozart's most substantial and compelling sacred works, most of it, again, in an archaic mode, with little "Mozartian" about it—until the exquisitely gentle and graceful Laudate Dominum for solo soprano. That movement is absolutely sacred music, deeply devotional, not at all operatic, utterly Mozartian. Here is perhaps the first glimmer of the sacred voice he would arrive at a decade later.

IN THE COURSE OF HIS CAREER MOZART WOULD LEAVE A GOOD MANY incomplete pieces among his drafts and sketches. Many were beginnings that he kept as a fund of ideas he could pick up and finish as needed, so a number of completed works rose from things that had been lying in his drawer. Two pieces of these years got far but were never entirely done. Both have appealing music and also significance beyond that.

One of them is the better part of an hour's music, two acts, of an unnamed work that was discovered only after Mozart's death and came to be called *Zaide*. The German libretto was made by his old friend, musician and poet Andreas Schachtner, based on an earlier libretto. The story is a Turkish yarn of a sort popular at the time. Zaide, harem favorite of Sultan Soliman, has fallen in love with the slave Gomatz, about which the sultan is most unhappy. Allazim, the wise captain of the slaves, entreats Soliman to view Gomatz as a human being rather than a slave. Also involved is a bumpkin slave dealer named Osmin, whose sole aria concerns being hungry, and who is given to scornful laughter. He would turn out to be a study for a later character of Mozart's named Osmin. At the point where the score breaks off, the end of the second act, things are not going well: the sultan vows nasty revenge on both lovers. Little of the libretto survives, but presumably all would resolve agreeably in the third act, and Zaide would get her man.

On the face of it, as a work in German with spoken dialogue, *Zaide* would seem to be a singspiel, that comic genre, though there's not much comedy in it, and the threat of violence in the story is quite real. As a whole it resembles, in short, neither singspiel, buffa, nor seria. Accordingly, Mozart gets away from the old static da capo (ABA) aria of seria tradition and explores a new variety of formal approaches responding to the drama that will serve him well in coming works. And because the characters are not the stock figures of seria, the music can delve deeper into their individuality.[19]

Within the work are two more features of particular interest. First, this amounts to Mozart's only experiment with a genre he'd been speculating about for a while: melodrama, spoken dialogue accompanied by music, which he had found appealing in the work of Georg Benda. The two sections of melodrama in the *Zaide* draft largely involve highly

charged orchestral fragments interspersed with monologue. In these numbers, Mozart manages to shape a sense of continuity even when the music is constantly interrupted by spoken monologue. So even in this unwonted situation—he never returned to melodrama—his sense of continuity is unsurpassed. The second notable element is an aria for Zaide, "Ruhe sanft," exalted in tone, with warm oboe and a bassoon doubling strings and voice on a particularly handsome melody, accompanied by pizzicatos. The whole score has a dramatic voice unlike any other Mozart stage work.

Why did he take on *Zaide* and then not finish it? It appears to be one of his works written on speculation. He probably hoped to bring it to Vienna and impress Emperor Joseph II, who might order a production at the National Singspiel.[20] In Vienna a couple of years later, Mozart would make a stab at a commission and production, but it would be superseded by a more promising story, though one in the same direction: a Turkish tale. In any case, he had faith in the piece. Still, at a distance, in the company of his finished works, much of the music for *Zaide* is not all that inspired. That's arguably because he was writing on speculation, not for flesh-and-blood singers, who on the whole galvanized him more than anything else.

The same can't be said about the inspiration for another substantial fragment of a theatrical piece he took up again in 1779–80: *Thamos, King of Egypt*, choruses and incidental music for a play of that name that had been based partly on a French novel of ancient Egypt called *Life of Sethos*, by Jean Terrasson, which had Masonic undertones and partook of the order's quasi-Egyptian lore. This piece, like *Zaide*, is in a distinctive style, but here the music is fresher and weightier.

Mozart seems to have been drawn to the play's exotic setting and perhaps its Masonic side—he had known members of the order here and there, and set some Masonic texts. It may be that he wrote two choruses for *Thamos* in 1773–74, in his teens, and apparently returned to it twice, revising and adding music, doing the last work in 1779–80, but none of its genesis is certain.[21] The plot concerns Thamos, who has inherited the throne of Egypt from his father Ramesses, but discovers that his father had usurped the throne from its rightful owner, Menes, who is now disguised as the high priest Sethos. There is of course a girl involved, the priestess Sais, with

whom Thamos is of course in love. The story ends happily as usual, with the enemies defunct and Sethos/Menes ceding the throne to Thamos and Sais.

The *Thamos* music ended up as five choruses and four interludes. The opening chorus, a prayer to the sun, has a solemn grandeur that Mozart never wielded again, and that quality colors the rest of the music. Some of the interludes have a blistering intensity likewise singular in his work, as exciting as anything he created later—perhaps because, again, this music is independent of seria conventions and has a level of threat and violence that he never had available in his comedies. The No. 7a Interlude features hair-raising string and oboe quasi-glissandos. As a musical dramatist Mozart could depict violence as well as anything else, but he rarely again got a chance to.

Of all his works that never quite got finished or established, *Thamos* is one of the most regrettable. If this music had been the basis of a full opera, it could have been a tremendous one—though that is hard to imagine, because at the time there was little precedent for a serious opera outside the conventions of opera seria. To what extent it was heard in public is uncertain. Two of the choruses made their way to Vienna for a production in 1774, and a couple of choruses were repurposed later. The Böhm company produced *Thamos* in Salzburg during their residence and may have used all the music.[22] (Böhm also mounted *La finta giardiniera*, translated into German, in Salzburg and Augsburg.) But soon the play *Thamos* sank out of sight, and the music with it.

Yet, some ideas of great significance for Mozart came from these two ephemeral efforts. With *Zaide*, he probably worked on shaping the German libretto with friend Schachtner, something he had never been able to do before and that he would do from now on. It gave him experience in adjusting form and expression to character and drama outside the narrow boundaries of seria. The intense musical interludes in the melodrama numbers carried over into his recitatives in the next opera. As for *Thamos*, he would return to Egypt, to Masonic themes, and to the novel *Sethos* again, at the summit of his powers. And in the next decade when he took up a scene of an uncanny and ominous dinner guest, he would return to the doom-laden atmosphere of the last number in *Thamos*.

IN THE END, THE MOST MEMORABLE PRODUCT OF MOZART'S LAST Salzburg sojourn was an instrumental work, the Sinfonia Concertante in E-flat Major for Violin, Viola, and Orchestra, K. 364. The next century would tend to take Mozart most seriously in his dark and poignant moods, meaning mostly the minor-key works. In other words, the fraught unto demonic Mozart was held to be more significant than the sunny and delectable. As much as anything he wrote, this sinfonia concertante takes issue with that supposition.

In Paris Mozart produced in effect two sinfonias concertante, the one for four winds that was lost and the light and genial one for flute and harp. The idea of the genre was a work for two or more soloists modestly accompanied by orchestra. Unlike the concerto format, with its long orchestral introduction laying out the basic material before the soloist enters, the sinfonia concertante tended to have a vivacious but not all that tuneful introduction, the soloists soon arriving to dispense the main thematic material. The mood of these pieces was generally breezy and light, so they usually sported major keys. With his usual adaptation to place and genre, Mozart absorbed these rules in Paris and then remade them. It's what fills up the familiar conventions that takes this sinfonia beyond its models. It turned out to be one of the more ineffably charming and touching instrumental works of his life.

The first movement is marked "Allegro maestoso" and begins in keeping, with a grand tutti. The ensuing introduction issues a stream of themelets that prepare for a further stream when the soloists enter. The orchestral sound is enriched by divided violas and passages with violins in octaves. Mozart's concertos tend to be profuse in themes, this one even more than usual. The soloists slip in with a high E-flat in octaves that crescendos into the foreground, then breaks into a soaring theme of breathtaking élan and charm; from there they find one new idea after another. The soloists sometimes become a virtual single voice, sometimes join in octave lines, sometimes trade off ideas in chains of echoes. The generally bright mood is marked by the occasional shadowy intrusion of C minor, which is going to be the key of the second movement. The viola itself is brighter than usual because Mozart directs it to be tuned a half step higher, a device called *scordatura* that was a Salzburg specialty.

The middle Andante in C minor is one of the most evocative of Mozart's early maturity; he would rarely surpass its plaintive beauty. It is more or less in the vein of a deeply sorrowful operatic aria. There is an orchestral refrain of heart-filling yearning. This is one of the rare minor movements in his major-key concertos; its depth of feeling would bring some in later times to call it a memorial for his mother. The rondo finale does not so much banish care as forget about it entirely, in a darting and laughing presto that again tosses around ideas in abundance. From the soloists there is a recurring little refrain in triplets that might be described as a moment of dancing, transcendent elation.

Where did the joyousness of this work come from? At the time, Mozart was disgusted with his hometown; he later endured great sadness and disappointment. But through it all there was a streak of bubbling joie de vivre that never entirely left him. Joie de vivre is all over the sinfonia, along with the sadness. Thus his music, thus his life. The sparkle of the sinfonia is another occasion of a life-avowing quality unique to Mozart. Part of its magic is its inexpressibleness outside itself, its sense of skirting time and place and language into a territory of sheer sound and delight.

During this period Mozart also produced an ambitious violin sonata, K. 378 in B-flat Major, the only mature one he wrote in Salzburg. It is a rich and expansive outing. Mozart did not tend to play Haydn's game of starting with something ingenuous and then turning it into something impressive, but the opening theme does have a forthright and earnest quality, perhaps ironic. The piano leads on the songful tune, answered by the violin—this sonata is not going to be "piano with violin accompaniment," but a real partnership. There is a transition to what would seem a second theme, but then a quiet but startling detour to G minor, the violin singing a gently touching melody. There is the essential dialectic of the movement. The second theme proper arrives with a perky march figure, but that again diverts to G minor: there is a shadow inflecting the earnest opening material. This intensifies with a development beginning in F minor that is fairly long and harmonically unsettled, all of it in minor. The harmonic intensity persists through the recapitulation, which gets into G minor again and as far afield as B-flat minor. None of the minor-key episodes is driving or Sturm und Drangish but rather a bit worrying.

The piano leads in the second movement with a songful and elegant theme, inward and with a subtle hint of melancholy surprising for E-flat major. The form is ABA, though the second section stays in E-flat for a while, its theme more striding. At the return of the A, the violin leads on the songful tune. The Rondo finale has an outline of A B A C A D A / coda, the D section being a sudden dashing intrusion of 4/4 triplets in a 3/8 movement. The A theme is the usual gay and jaunty sort for a rondo, but the C section returns yet again to G minor, the surprise key of the first movement, here with perhaps some irony in the pathos. Before the C section ends, the A theme pops up in G minor as a pseudo-return before the actual return in B-flat. The final return of A is reworked into a coda in solid B-flat. In terms of expression, the whole sonata amounts to a study in subtle shades of feeling.

Sometime in 1780 there arrived a commission for an opera seria for Munich. It may have been lobbied by Count Seeau, who must have been in one of his periods of appreciating rather than deploring Mozart. Friend Cannabich, conductor of the Munich orchestra, would have supported the offer, likewise the conductor's good friend Countess Paumgarten, currently the paramour of Elector Karl Theodor, and old tenor friend Anton Raaff. The elector had known Mozart since childhood and admired him, even if he was skeptical that this young man was ready for a Kapellmeister position.

Soon Mozart received the story, *Idomeneo*, an old French libretto that would have to be redone in Italian. The elector would have selected it himself, or been advised to. This was the most significant commission Mozart had landed since the opera projects of his teens. It represented another chance for a toehold in the most musical court in Europe, which had been transplanted from Mannheim.

Mozart would become a supreme opera composer, and his supreme works opera buffas. In fact, if anything he preferred seria, for all its limitations. By the time he took on *Idomeneo*, he had learned to work more freely around seria's rigmaroles of form and character and story. Again, Mozart never felt constricted by convention but instead worked comfortably within it, stretching and bending it as needed. He took what the world offered him, digested it, and gave it back in his voice. In this creative submission to the found and the given, he revealed his particular individuality.

In the next century, artists would begin to see their work as emerging from inside, from their singular ego and genius. Again: artists aspired to *express themselves*. In practice, artists of earlier times did the same, but that was not their goal. They were trying to express some universal essence pertaining to humanity or nature or God. Artists of the future would write *from inside out*. Mozart and artists of his time and earlier wrote *from outside in*.

Part of what was outside was emotional and expressive: the human condition and so on. Part of it comprised forms, rules, conventions, genres, expressive devices. Your mastery of these added up to skill and taste, which were in large degree also imposed from outside. The necessity of interiorizing these matters from outside was never in question. Originality, an individual voice, was prized, but within the context of structures and strictures. In reality these structures and strictures were anything but universal and eternal, but they were assumed to be. Your success as an artist had in large part to do with how well you interiorized the rules and conventions and melded them with your personality as an artist. Few if any musicians of Mozart's time questioned this, and neither did he.

This process in the eighteenth century had a particular flavor, because the aesthetics and the creative life of the time were being inflected by the new science. As science proposed to understand the eternal logic and harmony of the universe, from outside in by way of experiment and mathematics, one's mastery of artistic conventions was the foundation of one's art in the same way as experiment was the foundation of science. To repeat: Joseph Haydn's favorite word of praise for a work was *natural*, which is to say that it reached something universal, came off almost as if it had written itself. Mozart used the word the same way. For Mozart, what a later time would call sonata form was not a template to be trimmed and bent to the needs of a particular work; it was in large degree a given, natural, even if within it one had a great deal of flexibility. (Haydn in his later years had a freer relationship to the sonata form he himself had perfected than Mozart ever did.)

Mozart interiorized sonata form just as, in an opera, he interiorized characters and their behavior, trying in how he painted them to reach an essence. *Now I am Susanna. Who is she, what is happening to her, how is she feeling at this moment?* Which is to say that he interiorized a

libretto as an actor does a character. Like an actor, he saw a figure on-stage in terms of universal emotions and responses, he took that in, and he gave it out in his voice, which was at once singular and characteristic of his era. In childhood, he had been a remarkable mimic, able to pick up techniques and styles effortlessly. In his maturity he had digested what the time gave him, forged his way through convention, and come out on the other side into his own.[23]

IN OCTOBER 1780 MOZART COMPLETED HIS THIRTY-FOURTH SYM-phony, in C major, K. 338. This was a return to an expansive and weighty vein, anticipating the four-movement ones he would be writing in Vienna in the next decade—but this one is in three movements, all of them long. The music is on the whole genteel, not among his most memorable, though the finale has a dashing brio that raises a smile.

That month, Nannerl came down with an acute bronchial infection that bedeviled her for weeks. Leopold meanwhile was coping with back trouble. So neither of them was able to do their sittings for an endeavor of Papa's, a large family portrait to show Wolfgang and Nannerl side by side at the clavier and Papa standing at the other end, violin in hand. In autumn the painter, possibly one Johann Nepomuk della Croce, did his portrait of Wolfgang; it would be the end of the year before the entire picture, with Nannerl and Papa and a portrait of Maria Anna hanging on the wall, was finished.[24] Later Nannerl would call it the best likeness of her brother she knew; it became a model for many portraits after.

Another significant occasion that autumn, though one that would not bear fruit for some years, had to do with a new theatrical troupe that appeared in town. It was headed by actor, director, playwright, and impresario Emanuel Schikaneder, who was adept in all those elements of theater. His troupe numbered thirty-four players; for his pit band he hired local musicians. Like his predecessor in town, head of the Böhm troupe, Schikaneder was befriended by the Mozarts and became a frequent guest of the family, joining in card games and shooting, and again the Mozarts got free tickets to shows in the theater across the square. Schikaneder's productions ranged from serious to popular; his triumph as Hamlet in Munich had sparked the formation of his troupe. Among his ninety-three productions in town that season were more

Shakespeare, Gozzi, Metastasio, plus a sprinkling of singspiels and music dramas. Between Böhm and Schikaneder, the Mozart family had been able to take in, up to four times a week, the most prominent stage works of the time presented by two of the leading directors.[25] Schikaneder's later connection to Mozart, though, would be more direct than simply an influence on his growing theatrical intelligence.

AT THE BEGINNING OF NOVEMBER MOZART HEADED FOR MUNICH TO finish *Idomeneo* and see to the production. It was to be his eleventh completed dramatic work. With him he brought the libretto and probably drafts of a good deal of the music, perhaps most of the first act. This was possible because he was already well acquainted with the principals in the cast except for one, the castrato who would handle the leading role of Idamante. Mozart settled into a place near the massive electoral Residenz. His flat had a spacious living room and an alcove with two beds, and unlike too many rented rooms in his experience, the heating was good. There was no kitchen, so he took his meals out. A barber appeared every morning to shave him and do his hair. Mozart would stay in the place for five months.[26]

The libretto of *Idomeneo* had been adapted by Salzburg priest Giovanni Battista Varesco, who served as court chaplain and confessor to Archbishop Colloredo.[27] Five years earlier he had adapted Metastasio's *Il re pastore* for Mozart.[28] Mozart chose Varesco for the simple reason that he was the only man in Salzburg who could manage an Italian libretto. A forced choice like that is unlikely to prove ideal, and Varesco was not. But he was competent, with a good sense of dramatic structure, and critically, when it came to working with Mozart, he proved pliable if sometimes peevishly so. In those days an opera librettist was taken more seriously, generally considered to be of a higher class than the composer, the great example being the celebrated Metastasio. Mozart would become the composer who changed this dynamic. He and Varesco split the commission, which means Mozart probably got in the vicinity of 225 florins for his work,[29] around half his yearly Salzburg salary, so not bad in that respect, but nowhere close to his value. He was paid for the grunt work, not the brilliance.

The plot of *Idomeneo* amounts to another of the ancient history stories

familiar in opera seria. In the aftermath of the Trojan War the Greek king Idomeneo is sailing home to Crete to rejoin his son Idamante when a terrible storm erupts. Idomeneo entreats the sea god Neptune for mercy, and Neptune consents, but with a nasty catch: Idomeneo must sacrifice the first person he encounters when he reaches Crete. Desperate, Idomeneo agrees. These sorts of bargains do not tend to turn out well. The first person whom Idomeneo meets will be his son Idamante. From there the story makes its way through various trouble personal and supernatural, the characters involving Ilia, daughter of the late King Priam of Troy, inconveniently in love with her enemy's son Idamante; and Elettra, fierce and vindictive daughter of Agamemnon, who is still more inconveniently betrothed to Idamante.

Thus the usual tangle of obligations and desires of opera seria are in play. But the crux of *Idomeneo*, what sets it apart from the tradition of opera seria as a paean to the glory and wisdom of the ruling class, emerges after Neptune, furious at Idomeneo balking at his vow, raises a storm and dispatches a sea monster to ravage Crete. The question at this point is not whether the ruler will choose his kingly duty over his passions, but rather will the king choose his vow to a god or his connection to his people and his beloved son. Which of his choices is morally *right*, family and love and nation, or the will of a god?

Varesco adapted the libretto of *Idomeneo* from one by Antoine Danchet that had been set by André Campra for the Paris Opéra in 1712. This would have been the French version of serious opera, *tragédie lyrique*, which had its own tradition going back to the spoken drama of Racine and the Greek Revival.[30] Whether Mozart had a hand in Varesco's work from the beginning is not clear, but the Salzburg cleric, while keeping most of the original in direct translation, had much work to do. For one thing, the original ended tragically, with Neptune getting his sacrifice, and that was not to contemporary taste. There must be a happy ending. This in turn had significant implications, taking the opera in a direction that suited the *Aufklärung* temperament of the times, more specifically the temperaments of Mozart, Karl Theodor and his court, librettist Varesco, and Mozart's employer, Archbishop Colloredo.

Traditional opera seria presumed that the will of the gods was absolute, likewise their earthly representatives, the ruling class. In *Idomeneo*,

great Neptune is all-powerful but not absolute, and his presence is much reduced from the original story. In the end the principals choose reconciliation and self-sacrifice over obedience to the divine, and the power of that choice moves even the almighty god. Which is to say that natural law and social harmony (the good, the true, and the right) are equal to the divine.[31] This is fundamental Enlightenment territory. The essence of earthly order is love, embodied in the holy couple. All this in turn places greater significance on the character of Ilia, whose conflicting loyalties begin the opera, whose offer of sacrifice saves the day, and who represents the force of reconciliation between enemies and between father and son.

These changes from the original did not happen entirely out of *Aufklärung* optimism. Here enters in the jumble of practicalities and ideals that determined how the story was going to unfold. The happy ending did not originate as a matter of *Aufklärung* convictions; it came to pass because in that court, a tragic ending was not going to happen in any case. Much of the remaining changes had to do with Mozart's understanding of what he had to work with in Munich, his gift for turning necessity into art, for making a virtue of limitation.

FOR THE LATER STAGES OF THE OPERA'S COMPOSITION, HISTORY would inherit a singular record: a series of letters between Wolfgang and Leopold that detail its shaping. This account of creation and collaboration was unique not only in Mozart's life, but also in music to that time and for some time after.

The first of Wolfgang's letters came soon after he arrived in Munich. The trip was all fine and pleasant, he reports ironically, except that "the kind of carriage we had jolts your very soul out of your body!—and the seats!—hard as a rock! From Wasserburg on I thought that I couldn't bring my rear end to Munich in one piece!" That out of the way, he goes on to more apropos matters. He has touched base with Count Seeau, for the moment his most powerful champion at court. More to the point in the letter, Mozart wants Ilia's first aria in act 2 to lose some spoken asides, which he says are natural enough in a monologue but artificial in an aria. Otherwise there is "a real pain in the rear" to report: his Idamante, castrato Vincenzo dal Prato, has been known to run out

of breath in the middle of an aria, and he has zero stage experience. And onstage his Idomeneo, famous tenor and old friend Anton Raaff, bless his heart, "stands around like a statue," and his voice was showing its age.[32] Raaff's dramatic limitations were not simply a function of age—he was now sixty-six—but of talent. Years before, Metastasio had called him "a block of ice" onstage.[33] So two of Mozart's principals had serious vocal limitations; they also couldn't act.

There was nothing to be done about that, so Mozart had to adapt. This he did brilliantly, both as composer and as editor of the libretto. The librettos of his earlier operas had been largely routine, and he hadn't been able to improve them. Now he could, and without serious resistance from his librettist.

If the two male principals were his weak suits, he had some strong ones. His Ilia, Dorothea Wendling, wife of his flutist friend Johann Baptist, was one of the finest operatic sopranos in Europe, both vocally and dramatically. He knew her voice intimately, having written some concert arias for her. Wolfgang reported to Leopold that Dorothea was "Arci-Contentißima with her scene [presumably her opening one]— she wanted to listen to it 3 times in a row."[34] Her aria that he wanted Varesco to revise features a wind quartet of flute, oboe, horn, and bassoon. That group included three old friends supreme on their instruments, for whom he had written the lost sinfonia concertante in Paris: Wendling on flute, Friedrich Ramm on oboe, Georg Wenzel Ritter on bassoon.[35] Dorothea's sister-in-law Elizabeth, also a gifted singer and actor, was given the fiery part of Elettra.

Here were more consequences for the final shape of the opera. The required happy ending threw more importance onto Ilia; the need to limit the damage threatened by Raaff and dal Prato and play to the strongest member of the cast redoubled her importance; and the idea of a heroine who serves as mediator and savior was entirely to Mozart's taste. Ilia became the soul of the opera. Now begins Mozart's run of strong, wise women.

Mozart knew ahead of time that he was going to have to adapt to Raaff, who even in his decline still had his virtues. Beyond that, Mozart genuinely liked and admired the man. Raaff had been a good friend to Maria Anna in Paris, keeping her company when her son was away. "Raaff," he wrote Leopold at that time, "has totally mastered the

bravura aria Passages and Roulades—and then there is his precise and clear articulation—that is beautiful."[36] So that is what Mozart wrote for Raaff in *Idomeneo*, music that played to these strengths—meanwhile, trimming away at the length of his arias and recitatives and his time onstage. In the opera the eponymous king, helpless in his remorse and foreboding, is often notable for his absence, turning up here and there to bemoan his fate.

As for "my molto amato castrato dal Prato," as Mozart sarcastically dubbed him, Mozart was wrong about his lack of experience. Dal Prato was then twenty-four and had been onstage since age sixteen. But Mozart's grievances with the singer were unrelenting: in a concert he sang "most disgracefully"; he will "never get through the rehearsals, still less the opera"; "I have to teach him his whole part as if he were a child"; "he has no intonation, no method, no feeling"; he and Raaff are "the most wretched actors that ever walked on a stage."[37] Mozart was probably comparing dal Prato to castrato Francesco Ceccarelli, and in fact made an abortive attempt to get Munich to replace dal Prato with his Salzburg friend. But dal Prato went on to a long career in Munich, and seems to have worked hard at the role.[38] Mozart's complaints about him eased off after a while, even as he trimmed his arias.[39] Idamante's arias are detectably stiffer than most of the others, but they still have some showy passages necessary for his status as a leading man.

There were more elements Mozart could rely on. As an opera center, Karl Theodor's court was second only to Vienna's. Following the taste of the elector and court, both of whom spoke French in daily life, the local operatic style mixed French and Italian elements in a singular way—French in a preference for choruses, big scenes, and showy spectacle that was foreign to the seria tradition and in general was cognizant of Gluck's reforms, meanwhile prizing Italian lyricism and amenable to simple recitative. All this was written into the libretto and the music of *Idomeneo*. Meanwhile Mozart was working with the Bavarian court orchestra, the finest in the world, the "army of generals" based on the Mannheim band. For icing on the cake, the winds included a pair of clarinets. *Idomeneo* has the most elaborate and colorful orchestral writing among Mozart's operas. The house chorus was first-rate, so the same would apply to his choral parts, which range memorably from tender to joyful to terrified. He had a decent tenor for the part of Ido-

meneo's councillor, Arbace, so he expanded the role. Stage designer Lorenzo Quaglio and ballet master Le Grand were acclaimed in their fields. Mozart had, in short, been dealt a mixed hand and knew how to play it.

The final work rises from the archaic tradition of opera seria, but Mozart took it in contemporary and personal directions. Here as well as anywhere is shown his mature gift for going through convention and coming out into a territory he owned. It is relevant that since he completed his last opera, he had himself experienced love, rejection, and tragedy. These experiences, as with all artists, went into his toolbox.

Mozart's letters home about composing *Idomeneo* mostly concern the critical issue of pacing and the singers—mainly singers he is unhappy with. Pacing in a stage work is simple to describe, not simple to achieve: How long is long enough but not too long? At what point do listeners start to get bored with, say, a simple recitative or an aria that overstays its welcome? These matters must be treated ruthlessly in creating a work. Usually much of the fine-tuning is done in rehearsal, as it was with *Idomeneo*. Cuts and revisions would continue to the end; the conducting score has revisions large and small in ink and red crayon, including an entire duet for Idamante and Ilia struck out.[40]

Mozart also writes to his father about the effect of a scene onstage, and its sense of realism: he wants to escape the conventional hyperstylization of opera seria. On November 13: "The 2nd Duetto is going to be omitted altogether . . . for if you read the scene over again, you will see that if we put an Aria or Duetto in there the scene will become bland and uninspired—and very awkward for all the others onstage who just have to stand there."[41] On the twenty-ninth: "Don't you think that the speech of the subterranean voice is too long? Just think about it!—imagine yourself in the theater; the voice has to convey a feeling of terror . . . one has to think it's real—how can you get such an effect if the speech is too long . . . If the speech of the Ghost in 'Hamlet' were not quite so long, it would be much more effective." In the same letter: "Raff [*sic*] is not happy with his Aria [by Varesco] that you just sent, and neither am I . . . it's supposed to transmit a feeling of peace and contentment, but that isn't conveyed until the second part."[42]

In the letters Raaff comes up repeatedly, Mozart's affection for the man contending with his frustration at Raaff's woodenness onstage and

his constant demands. Mozart handled the old man's wishes as best he could, but when Raaff complained about the incomparable third-act quartet, where the principals each speak of their particular anguish, he dug in his heels.

> I've had a lot of trouble with Raaff about the quartet.—The more I try to imagine how the quartet will sound onstage, the more I know it will be effective;—everybody who heard it with the piano accompaniment liked it.—The only one who thinks it will not be effective is Raaff; he told me privately: . . . it is too Tight [for the voice]—as if in a quartetto one shouldn't speak the words more than sing them . . . I only said to him, dearest friend!—if I knew of one single note that I could change in this quartetto, I would do it immediately. But nothing in the entire opera pleases me as much as this quartet; and after you hear it all together, I think you'll change your mind.—I have made every effort to serve you well with your two arias—and I shall do the same with your third aria—but as far as Terzets and Quartets are concerned you have to leave things up to the Composer—at which point he said he was satisfied.[43]

Mozart is not only becoming practiced at managing stage music and action, but he was also learning to manage primas. And like most artists he is not mainly concerned with issues of technical perfection, with showing off for the connoisseurs, with immortality: he is concerned with what is *effective*, which is to say, what *works* here and now. What works to his taste, the singers' tastes, the audience's taste, are three different questions, and Mozart had to juggle them all. In the end, Raaff did come around regarding the quartet, and he was entirely happy with his arias, which showed off his bravura and expression and avoided the attrition that time had inflicted on his voice.

In the midst of all the shop talk with Leopold, Mozart did not omit relevant gossip and teasing. He had lunched with Cannabich at the house of the conductor's friend Countess Paumgarten. (She sang, and he had written a concert aria for her.)[44] He would have been informed of her intimacy with Elector Karl Theodor, and he could not resist reporting this to Papa by way of one of his bizarre acrostics: "She is

the lady with a Foxtail sticking out of her Ass, and she has V-shaped chains dangling On her ears, and a beautiful Ring. I saw It myself, even if death should Take me, I, unfortunate man, without a Nose." The underlined letters spell out *Favoritin*, "favorite." He knew Papa would understand of whom the countess was a favorite. He also joked to Papa, "You must accustom yourself to kissing a little. You could practice in the meantime on Mme. Maresquelle. For here whenever you call at Dorothea Wendling's (where everything is rather in the French style) you will have to embrace both mother and daughter—but in the chin, of course, so that their rouge may not become blue."[45] The Wendling daughter in question was a beauty, and in due course she became, at eighteen, the new *Favoritin* of the elector.[46]

To Papa fell the task of conveying Wolfgang's orders to librettist Varesco, which would not always prove smooth going. Librettists were not used to being ordered around by composers. At one point Wolfgang threw out an aria for Idomeneo, asking for a recitative instead because it would be too much coming between two choruses: "An aria at that particular point would cut a poor figure—and moreover there is the thunderstorm, which is not likely to subside during Herr Raaff's aria, is it?"[47] Mozart promised Varesco that his uncut text would be put into the libretto book that was provided at the performances. It would have the Italian and a German translation on facing pages.[48] Handing out the whole libretto was done not just to placate the author, who was seeing his work sliced and diced; some of the cuts had removed so much exposition that the full text was needed to understand what was going on. (This shows that the audience in Munich was not like the Italian audiences of Mozart's youth, who barely cared about the story or the recitatives, and who talked and flirted and played cards through much of the performance. It appears that the Munich crowds stayed quiet and followed the story.)

Leopold's letters included the usual prods and demands. He insisted that Wolfgang pay seventy florins for a French silk dress Nannerl would wear to the premiere. This was nearly a third of his fee for the opera, but Wolfgang paid up.[49] And before he left for Munich he had promised Schikaneder an aria for a production in Salzburg. Now with his son plunged up to his ears in the most important project of his life to date, Leopold wrote peevishly, "What on earth are you thinking

of? The way you are treating Herr Schikaneder is really shameful. On my name day, when we had our shooting, I said to him: 'The aria will certainly be here tomorrow . . . I really do not know what story I shall tell him when he comes to our shooting tomorrow. As you know, I am not much good at telling lies." He then details the lies he's going to tell Schikaneder: the postage was too much, Wolfgang missed the mail coach, and so forth.[50] Mozart produced the aria. It probably cost him no more than a couple of hours, but finding space in his mind to deal with it, under the gun as he was, amounts to another example of his prodigious creative energy and concentration. In the letters the peevishness went both ways: after Leopold had reported Nannerl's serious bout of illness, Wolfgang wrote back, "I beg you, don't send me such sad letters anymore—because—right now I need a cheerful spirit, a clear head, and good inspiration for my work."[51] Leopold was flabbergasted at the reply.

More important, his letters to his son were full of suggestions that could include anything from disquisitions on the proper accentuation of an Italian word to full-scale ideas about the music. This was, after all, a dialogue between two composers, both of whom knew intimately how the other thought. It is the only real record on paper of the collaboration the two had pursued from the beginning. If Mozart by that point was essentially ignoring his father's screeds about his life and behavior, it was quite otherwise with Papa's musical suggestions. Some Wolfgang ignored, some he adapted, some he simply followed.

One piece of fatherly advice the son ignored was another entreaty to be simple and pleasing: "I advise you when composing to consider not only the musical, but also the un-musical public. You must remember that to every ten real connoisseurs there are a hundred ignoramuses. So do not neglect the so-called popular style."[52] Leopold sometimes took the librettist's side on a disputed passage: "I sent for Varesco at once, for I received your letter only at 5 o'clock this evening . . . We have considered the first recitative in all its bearings and we both find no occasion to shorten it . . . If you consult the draft, you will see that it was suggested that this recitative should be lengthened a little, so that father and son should not recognize one another too quickly. And now you want to make it ridiculous by making them recognize one another after

they have exchanged only a few words." He expounds on the point for quite a while. Wolfgang let the recognition scene linger.

The most striking advice from Leopold concerned the subterranean voice of Neptune declaring the enthronement of Idamante, which marks the denouement of the story. Leopold wrote, his excitement visible on the page,

> I assume that you will choose very deep wind instruments to accompany the subterranean voice. How would it be if after the slight subterranean rumble the instruments <u>sustained, or rather began to sustain, their notes piano and then made a crescendo such as might almost inspire terror, while after this and during the crescendo the voice would begin to sing?</u> And there might be a terrifying crescendo at <u>every phrase uttered by the voice . . .</u> The attention of the audience is aroused; and this attention is intensified by the introduction of a quiet, prolonged and then swelling and very alarming wind instrument passage, and finally become strained to the utmost when, behold! <u>a voice is heard</u>. Why, I seem to see and hear it![53]

Wolfgang heard it too, essentially writing the passage just as Leopold described it, using trombones for the only time in the opera, plus two French horns. Their stark harmonies swelling and fading to silence makes for one of the most striking moments in *Idomeneo*. (As father and son may or may not have been aware, it recalls the Oracle scene in Gluck's *Alceste*.)[54] But the matter of trombones sparked a scene with Count Seeau. As overseer of the production, Seeau did not care for the expense of hiring trombonists for a few bars of music, and he had other issues concerning expenses. In response Mozart pitched a calculated fit. "I had to be coarse with him," he wrote home, "or I would have gotten nowhere."[55] In the end he did get nowhere: the trombones were apparently not used, and Seeau once again got fed up with Mozart, this time for good. If Seeau had done Mozart a favor in helping to get the commission, there would be no more favors in Munich. With Mozart having placed much of his hopes in that court for years, it would end up being another city he saw again only in passing.

BY THE END OF DECEMBER 1780 MOZART REPORTED HIMSELF NEAR THE end of his labor. "My head and my hands are so full of the third Act that it's a wonder I'm not turning into a third Act myself—This Act alone cost me more trouble than the whole opera—because there's almost no scene in it that isn't extremely interesting."[56]

The year 1781 arrived, one historic in and out of art. It saw Haydn's epochal Op. 33 String Quartets; Friedrich Schiller's searing Sturm und Drang play *The Robbers*; Immanuel Kant's *Critique of Pure Reason*, which spawned a revolution in philosophy; and the tide-turning British surrender to the American rebels at the Battle of Yorktown.

In the second week of January visitors from Salzburg began arriving for the premiere of *Idomeneo*. Before he and Nannerl left, Leopold penned a letter to Breitkopf und Härtel, the leading music publisher in Europe: "I have been wishing for a long time that you would print some of my son's compositions. Surely you will not judge him by the clavier sonatas which he wrote as a child? True, you have not seen a note of what he has been composing for the last five years . . . You might try what you can do with a couple of symphonies or clavier sonatas, or even quartets, trios and so forth."[57] Leopold was still working for the cause, but it was another bootless initiative. Breitkopf was not interested.

Leopold and Nannerl arrived in Munich on January 26, in time for the dress rehearsal next day on Wolfgang's twenty-fifth birthday. Nannerl was doubly excited about the trip because she had not been out of Salzburg for five years. Now she could show off both her playing and her outfits, and the family would stay in town for the rest of Carnival, which in Munich would be on a grander scale than the festival at home.[58] Salzburg visitors did not include Archbishop Colloredo, who had departed with his entourage for Vienna to see to an ailing father.[59]

The premiere on January 29 was a grandiose affair, this being the first and most important Carnival opera. Excitement was high, the auguries good. Elector Karl Theodor had heard some of the music in rehearsal and declared his satisfaction. The court attended in full regalia. Mozart directed forces that included the greatest of orchestras and one of the greatest of living sopranos. There would be three performances; then after a pause, two more were planned.

Built in the 1750s, the main theater of the electoral Residenz, eventually called the Cuvilliés Theatre for its architect, was one of the most

splendid rococo halls in Europe. Decorated in blood red and seething with gilded ornamentation, the theater had three ranks of loges above the ground floor and seated about a thousand. Stucco drapery fell from the aristocratic loges in the middle and from above the small stage. The richly bedecked elector's box, in the middle loge, above the entrance, was supported by two muscular Atlases in stucco.

Like many theaters of the day the proportions of the Cuvilliés ran more to vertical than horizontal. The result was a small but tall theater, notably intimate, the whole audience feeling close to the stage.[60] The acoustic was subdued but lucid. Theater lighting of the time meant candles in chandeliers and oil lamp footlights—these could have hundreds of wicks—the candles usually of beeswax or spermaceti because these smelled less bad than cheaper tallow. This kind of lighting was one of the reasons theaters of the time regularly burned down; it also tended to make them stuffy. On candles and lamps could be fitted filters of fabric or glass to color a scene. The light was dim in any case, the stage usually only marginally brighter than the hall.[61] Partly for that reason costumes tended to be showy, with ornaments and headdresses to catch the light. Idomeneo's costume at the premiere was in vivid red, with billowing skirts and stylized armor and a helmet with a big shimmering plume.

Theaters had intricate machinery to produce whatever effects might be required: battles, storms at sea, flying gods and chariots, magical appearances via trapdoor, what have you. Scene changes were managed quickly with flats on tracks that could be shuttled quickly on- and offstage from the wings. The flats got closer to center stage toward the back, creating effects of depth and perspective; they led to an elaborately painted backdrop.[62] The orchestra sat in front of the stage in a shallow pit, the conductor in the middle, leading from a harpsichord or piano.

There were no professional directors. Stage direction might be handled by the librettist; for *Idomeneo*, ballet master Le Grand oversaw the movement. Much of it, though, was determined by convention: the rank of the characters determined by their placement onstage, the most distinguished occupying stage right, the strongest position, and in crowd scenes, the middle. A premium was placed on acting, though then as later, a mediocre actor with a glorious voice was tolerated. So

it had always been with Anton Raaff, especially in his prime when his voice was unequivocally glorious. In any case, acting in opera seria was stylized, a repertoire of gesture representing the various qualities and emotions and also representing rank and character. Originality of movement was less valued than how elegantly and naturally one went through the expected motions. (Opera buffa acting was generally looser and more informal than in seria.)[63]

So the evening arrived: January 29, 1781. Mozart entered the orchestra pit to a burst of applause. He bowed, turned, sat at the keyboard, and lifted his hands to begin what he hoped would prove to be one of the most momentous performances of his life.

OPERA OVERTURES IN THOSE DAYS HAD NO PREDICTABLE RELATION to the works they began. It was not unusual for an overture from one opera to be grafted onto another. The reformer Gluck had declared that the overture must imply and introduce the drama, and so it is with *Idomeneo*. Also following Gluck, Mozart's overture is in one sonata-form movement (a customized sonata form, nearly half of it exposition) in a symphonic vein rather than the three-movement Italian style.[64] The key of the overture and home key of the opera is D major, that tonality usually bright and cheerful. But here the tone is weighty and stern, geared for the big Munich orchestra, foreshadowing momentous events to come. Many of the arias in the opera will be in binary form—like a sonata form without development, the second stanza in a new key with a return to the home key.

Recitatives in opera seria were largely simple, accompanied only by keyboard. Gluck had turned to more colorful and expressive recitative accompanied by the orchestra. Ilia begins *Idomeneo* with an anguished recitative supported by strings: "When will my bitter misfortunes be over? Miserable Ilia! Wretched survivor of a raging tempest, bereft of father and brothers, pitiful victims whose noble blood is mixed with that of the barbarous enemy!" She mourns for her father Priam, and the fall of Troy. Her heart is further torn by her helpless attraction to Idamante. The intensity of her accompanied recitative is partly thanks to the example of Gluck, whom Mozart would have heard and studied in Paris and earlier, but also to his own familiarity with melodrama,

accompanied spoken dialogue, with which he experimented in *Zaide*. Orchestrally accompanied recitative also makes for smoother transitions, giving the whole a more fluid continuity than seria's usual stark alternation of clavier-accompanied simple recitative and aria.

As for Ilia, her essential dilemma, torn between love and loyalty, has been quickly defined, but she has a long way to go. The opera will turn around her journey of mounting wisdom, courage, and love. Her recitative segues into an aria in G minor, here, as usual for Mozart, a key of restless pathos. For the next recitative, an encounter between Ilia and Idamante, Mozart turns to simple recitative for a scene more of exposition than emoting: Idamante declares he will free the Trojan captives and confesses his love for Ilia; she recoils from this declaration by a man who has been enemy of her people. In his first aria, Idamante declares his own dilemma: "I am innocent, yet you blame me."

Soon comes the first chorus, Greeks and Trojans rejoicing in the coming of peace and the freeing of the prisoners. Again it was Gluck who elevated the chorus beyond its spare use in opera seria, making it a dynamic character in the drama. In a simple recitative Elettra denounces Idamante's release of the Trojan prisoners; this segues into an agitated accompanied recitative, then into a furioso aria in D minor. These moments define Elettra's volatile and vengeful character, and Mozart's means of painting her are unusually passionate for him. The orchestra provides explosive accents and unsettled harmonies, including a wrenching modulation from D minor to C minor.

Once again the question rises about Mozart's relation to Sturm und Drang. In fact, the Mannheim and Munich courts of Karl Theodor were centers of that spirit, which roiled at its height during the 1770s and early '80s—the decade of Goethe's epoch-defining *Sorrows of Young Werther* and Schiller's *The Robbers*, which had its turbulent premiere in Mannheim in 1782. If Mozart's forays into these kinds of agitated sentiments in his earlier music (often involving wrenching contrasts) could be explained by his feeling for certain minor keys such as D minor, in painting the overwrought character of Elettra, maybe he edged beyond that into full Sturm und Drang.

These episodes in *Idomeneo* go beyond the influence of Gluck, whose plainspoken restraint was not Mozart's style. Mozart was more Italian in his lyricism than Gluck, more sensual in his treatment of

the orchestra. The powerful choruses he wrote for *Thamos* had their
influence on *Idomeneo*. Mozart had no use for Gluck's declaration that
the drama and the words were more important than the music, and
the music must be the humble servant of the story. For Mozart the
music was supreme; it was the job of the libretto to be its formal and
expressive underpinning. Which is all to say that well before the end-
ing of *Idomeneo*'s first act, Mozart has shown that he is a student of
Gluck and his reforms but not beholden to them, and from a foun-
dation in opera seria he intends to go beyond it with his chorus and
his characters: the denizens of this story are more individual than the
chilly archetypes of seria, more emotional—in short, more real. All
this will be woven into his operas to come.

After an agitated chorus of men caught in the storm, Neptune calms
the sea, exacts his terrible price, and Idomeneo takes the stage with
recitatives expressing yet another divided character: he is grateful to
have survived, horrified by his vow that he has sworn to sacrifice some
random innocent. His appearance begins two hundred bars of contin-
uous music weaving together simple and accompanied recitatives and
an aria, a continuity remarkable for the time and prophetic of opera's
later innovations.[65]

Idomeneo's "Vedrommi intorno" is in a gentle and beautiful C major,
but its sentiments are tormented: "Before me I see / His mournful
shade, / Night and day by me." A god has demanded an arbitrary sac-
rifice; Idomeneo's humanity reels at the thought. The opening, where
he pictures his victim standing before him as a shade, is in a pulsing
C major verging into minor, trancelike, strangely beautiful, until Ido-
meneo and the music erupt into anguish: "O the horror of it all!" From
here until the end, Idomeneo will suffer from his vow in one way and
another. In this aria there is profuse lyricism but no vocal showing off,
which with Raaff had to be handled carefully. (Mozart wrote Leopold
that if he'd had a better tenor, he'd have written a better aria.) Here
Mozart shows how he is going to make a virtue of necessity, portraying
Idomeneo as a helpless and often absent king who can only grieve, not
actually do much of anything.

Typically for *Idomeneo* as distinct from most opera seria, instead of
a big finish and exit, Idomeneo's aria slips into a simple recitative that
prepares a scene where he pushes Idamante away. The scene between

them ends with another intense accompanied recitative, then Idomeneo flees from the son he is supposed to murder, and Idamante, with no idea of his father's vow, laments in an aria that Mozart makes fraught despite its F major. There, with the modest bravura singing dal Prato could manage, the act ends.

The second act begins with a march as soldiers return from their brush with death on the sea; there is a chorus of thanks to Neptune and some dancing—the corps de ballet needs its exercise. In the next scene Idomeneo confesses to Arbace his vow that lies behind his treatment of Idamante. His old adviser expresses his sympathy in an aria with an old-fashioned seria tinge—the part was done by a court tenor who seems to have had some technique but not so much expression. After an encounter with Idomeneo, Ilia sings to him "Se il padre perdei," which marks her transformation from an exile to a woman embracing her fate in a new country: "Though my past was taken from me, / You are now my native land. / My father, my tranquility, / Crete, by your benevolent hand, / Is now my blessed haven." Here Mozart made deft use of Dorothea Wendling, a soprano who did not need to show off to demonstrate how brilliant she was, and who was enough of an actress to give the scene the emotional clout it requires.

Unfortunately for Idomeneo, when Ilia leaves he realizes the reason for her change: she loves his doomed son. In renewed distress he cries, "Neptune will have three victims punished on his altar—one killed by the sword and two by sorrow!" In "Fuor del mar," he laments that the sea did not claim him. Here Mozart gives Raaff some modest roulades to express his character's racing emotions.

Enter Elettra. Idomeneo has ordered his son to flee to Argos with her, which suits her perfectly, both in her love for Idamante and her ruthless agenda for homeland, family, and herself. She sings "Idol mio," an aria calm for her at least, about her love for Idamante and her triumph over rival Ilia. But her music is tinged with self-conscious complacency here, malice there: Elettra sings as if into a mirror. A march intervenes, the chorus enters, the Trojans departing for home sing a lilting evocation of calm seas and gentle zephyrs.

In a trio of three characters voicing opposed sentiments, Idomeneo says a hopeful farewell to his son, Elettra voices her hopes for their union, and Idamante laments the fate taking him away from Ilia and

homeland. These sorts of ensembles were common, but Mozart raised them to an uncommon level of expression and drama, conflicting characters voicing the same musical gestures to different ends, sometimes climaxing with a ringing figure on the same words, the words meaning something different to each of them, all of it adding up to a whole. Mozart is weaving music and character and drama into a seamless fabric.

The trio is answered by alarming music, thunder on the bass drum, terror from the chorus: Idomeneo's attempt to elude the sacrifice of his son has enraged Neptune; the god's devouring monster has risen from a stormy sea and begins devouring Cretans. Act 2 ends with the populace fleeing, the sea impassable, nothing resolved. As Wolfgang told his father, act 3 will be a busy one.

It begins, naturally, with Ilia. After a recitative accompanied by strings, she asks the breezes to carry her love to departing Idamante. Her quietly and yearningly beautiful "Zeffiretti lusinghieri" is in E major, a rare key for Mozart and one a touch shaded in the orchestra because it has few open strings. Here, for the first time in the opera, is true music of love. The home key of *Idomeneo* is D major, which is the tonality of the overture and ends every act; otherwise, Mozart appears to have chosen his keys mainly to suit the singers and get particular colors from the orchestra.[66] In later operas he will be more concerned with large-scale patterns of keys, which is to say that he will bring the same kind of attention to the logic of key choices that he does in his instrumental music—though with its competing exigencies, opera would always tend to be looser than instrumental music.

Idamante appears, and despite all that separates him and Ilia, the two confess their mutual devotion. What follows is the quartet Mozart called his favorite number in the opera: Idamante declares that if he cannot have Ilia, he will wander in search of death; Ilia vows to share his grief; Idomeneo despairs at what Neptune has brought them to; Elettra thirsts for vengeance because she has lost Idamante to Ilia. *Primo uomo* Raaff, despite his decades of experience, did not like the quartet at first because he did not understand that it had nothing to do with showing off voices. The points were its dramatic novelty, the extremes of character and passion it wove together into a taut fabric with transports of emotion at the climaxes: "A sorrow so great is worse than death!" they cry together, each from a different sorrow. The quartet is

in E-flat major; as so often in the opera, Mozart gives to a major key the kind of surging expression usually the domain of minor keys. The quartet shows the kind of innovation he brought to convention, which lies not in the conception but in the brilliance of the execution.

From there, things happen fast. The Cretan people cry for relief from the monster; Idomeneo capitulates, tells them he will sacrifice his son; Idamante departs to attack the monster, expecting death, then returns in triumph to offer himself to his father for sacrifice. In these moments the High Priest of Neptune defines the dilemma of the story: the god's demands must be honored, and yet, and yet: "Heaven most clement! / The son is innocent, / The vow merciless. / Stay the hand / Of a father so pious." It is Ilia who finds the way out of a moral labyrinth. Out of selfless love and duty toward her former enemy Crete, she falls to her knees and demands to be sacrificed in Idamante's place. Her gesture is so prodigious that it moves the god. From within the earth, the voice of Neptune is heard in an uncanny atmosphere of trombones and horns: "Idomeneus shall no longer be king. Idamante shall reign, and Ilia be his bride." Idomeneo the warrior will be replaced by his son the peacemaker.

And so Ilia becomes the soul of the opera, the reconciler of enemies, the savior of her love and her adopted country. It remains only for Elettra to spew her venom in a blistering aria and depart. At the end the lovers are crowned, and the chorus of citizens who have participated in the drama, in joy and terror and rage and now in relief, sing to the pair, "May Cupid, Hymen, and Juno / Descend to this royal pair. / May the goddess of marriage bear them / Years of peace, we implore."

Cupid the god of love, Hymen the god of fertility, Juno the sympathetic queen of the gods—these are evoked as a blessing for the earthly pair not only who are crowned as rulers, but whose crowns are shared by love itself, an earthly love that can move even the gods. Here for the first time in Mozart's operas arrives the theme that will mark him as a dramatist and also as a man: the triumph of love.

IT HAD BEEN GRUELING WEEKS FINISHING THE OPERA, COPING WITH the stresses imposed by cast and budget, yet in later years, Mozart would call his time with *Idomeneo* the happiest period of his life. He

would never again enjoy such relatively unobstructed control over a production, at the height of his powers, surrounded by admirers and with no significant enemies, with audiences eager to hear what he would give them.

Apparently the performances were a respectable success, though there is no firm record of the reception. For the Mozarts, after the first run of three evenings it was time to turn to Carnival and to fun. Two more performances were expected, but there were conflicts with court events, a banquet and a ball; the later performances may not have happened.[67] Mozart knew that relatively few operas in those days had more than one run: wealthy courts paid lavishly for them, audiences cheered if you were lucky, then everybody moved on. Wolfgang and Leopold hoped the success would finally inspire Elector Karl Theodor to give Wolfgang something, at least a foothold, in Munich.

This did not happen. Perhaps by then the elector had been advised that in Salzburg Mozart had not been a dutiful and submissive servant to the archbishop; perhaps Count Seeau, once again an enemy after their row, worked against him. Mozart had hopes for further productions of *Idomeneo*, especially in Vienna. But Empress Maria Theresa had died in November, and her son Joseph took the throne determined to pursue reform in every direction, including in the theaters, of which he was a passionate devotee. But Joseph did not like opera seria, which *Idomeneo* was. This attitude in one of the most important centers of opera hastened the obsolescence of the genre, especially ones not permeated by Gluck's reforms. In Vienna and elsewhere, opera buffa was the future. In Mozart's lifetime, *Idomeneo* would not be seen again in a theater.

At Carnival the Mozarts likely did a lot of relaxing in the usual modes, dressing up in costume and dancing, wining and dining. At one point in a ballroom, perhaps to annoy Papa, Wolfgang gave a few whirls to a prostitute.[68] There was a side visit to Augsburg, where Wolfgang and Nannerl played a lot of two-piano music. If he had a reunion there with the Bäsle, there is no record of it, and he never saw her again. When Leopold and Nannerl headed home, they took with them a twelve-year-old violinist named Heinrich Wilhelm Marchand, son of the director of the Munich theater company, whom Leopold intended to make his new project and, as it played out, proxy son. Later he also

took in Heinrich's sister, a singer. He wanted to turn them into prodigies, which they were not up to, though both went on to respectable careers.[69]

Wolfgang meanwhile had been summoned by his lord and master to hasten to Vienna to take his place in the archbishop's retinue. Mozart's latest flash of glory was done, Nannerl's vacation from Salzburg was done, his and Leopold's last musical collaboration was done, and there was no sign of further interest from the Munich court. With a metaphorical groan, Mozart left Munich on March 12, 1781, to resume his role as servant. Once again it appeared that after a moment of glory he was going to end up back in dead-end Salzburg serving a man he loathed.

The trip to Vienna was 250 miles. Getting there took five days.[70] Mozart arrived at 9 a.m., on the sixteenth, and in the afternoon, at the palace of Colloredo's father, he played a concert with the Salzburg court musicians before Viennese high nobility.[71] Colloredo wanted to show off his musical stable. The next day Wolfgang wrote Leopold a report about his doings. He had been given a servant's room in the house of the Teutonic Order, along with the rest of the archbishop's retinue in their dozens. He continues with sour irony:

I have a charming room in the same house in which the Archbishop is lodging . . . We take our meals at 12 o'clock noon . . . Seated at the table are the two gentlemanly valets who are the archbishop's body-and-soul attendants, the Herr Comptroller, Herr Zetti, the pastry chef, the 2 cooks, and then [musicians] Ceccarelli, Brunetti, and—poor little me;—N.B., the two Messieurs valet are sitting at the head of the table—I at least have the honor of sitting above the cooks . . . there's a lot of crude and silly joking at the table; but not with me, for I don't say much and if I must say something, I do it always with great seriousness—and as soon as I am finished with my meal, I get up and leave—No meals are served in the evening, instead we each get 3 ducats—and boy, you can really go to town with that.[72]

Mozart at twenty-five felt more disgusted than ever with his position as a servant, a sentiment represented graphically in the obligatory

seating order at lunch, the all-important personal valets of the arch-bishop at the head of the table. Mozart had grown up in music with astonishing speed, but as he entered maturity, his professional life had been utterly stagnant. At table he was more than capable of crude humor himself, but at these humiliating meals he could only try to preserve his self-respect by playing a part, putting on a mask of seriousness—which is to say, of superiority.

He desperately wanted some outside-paying work in Vienna, above all at occasions that would give him exposure to music lovers and the court. "My main goal right now is to meet the Emperor in some agree-able fashion," he wrote Leopold. "I am absolutely determined that <u>he should get to know me</u>."[73] One of the prime opportunities was the Soci-ety of Musicians, which yearly gave gala concerts for the benefit of the widows and children of musicians. Even though performers donated their services, these were some of the most prestigious events in the musical life of the town, and most of the best musicians pitched in.

Mozart secured an invitation to the coming concert, assuming the archbishop would give his consent. But Colloredo refused. As Mozart fell into outrage, some of the nobility pressured the archbishop to let him play, and Colloredo grudgingly conceded. So Mozart made his public debut as an adult in Vienna, the large audience, including Em-peror Joseph II, hearing a symphony of his played by an orchestra of eighty-five, plus some variations from Mozart at the keyboard.[74] He wrote home, "I already wrote to you about the applause in the theater, but let me add that what delighted me most of all . . . was—the aston-ishing silentium—and the shouts of Bravo in the middle of my playing. In Vienna, where you have so many good clavier players, that is cer-tainly a great honor."[75]

He intended to ask the archbishop for leave to stay on after the rest of the court members left, so he could give some concerts for ready cash and, of course, nose around for opportunities. "If it weren't for you," he wrote Leopold, "I swear on my honor, I would not hesitate for a minute to quit my service, give a major concert here, take on four pupils, and do well enough to earn at least one thousand thalers a year." He asks Leopold for advice in that direction, though in fact he wants Papa to certify what he already intends to do. With rage smoking on the page, he accuses Colloredo of doing him out of big-paying jobs.

To a degree Mozart talked through his hat with all this. His fury was real, his complaints less so. He complained about getting only three ducats for dinner expenses, presumably for a week, but that is around eleven florins and not bad when dinners cost between one and two florins. Colloredo did not actually mind his players appearing in outside concerts as long as they were available for his, and Mozart, after all, was drawing his full court salary. The archbishop lingered in town, hoping for an audience with Joseph, but the Kaiser snubbed him. Mozart crowed that Joseph hated Colloredo.[76] In any case, the archbishop expected him to hang around in the mornings in the hall to receive orders. Either Mozart did not realize that expectation or he simply refused to do it. "I just want to set down the chief accusation which was brought against me in respect of my service: I did not know that I was a valet— and that was the last straw."[77]

Which is all to say that a confrontation was brewing. Mozart had a general idea that court ministers would be intercepting his letters and reporting their contents to the archbishop. For a while he and Leopold had been putting the riskier bits of their letters into code, but in fact Wolfgang was arbitrary about what he encoded and did not, and the code was a simple letter substitution easy to figure out. Colloredo's ministers probably had a chuckle over it. The gist of the letters was unmistakable in any case: Mozart was in rebellion and planning to quit at the first opportunity. Here is his letter of April 11. The coded bits are between carets.

Sunday week, April 22, Ceccarelli and I are to go home. When I think that I must leave Vienna without bringing home at least 1000 gulden [florins], my heart is sore indeed. So, for the sake of a <malevolent Prince> who <plagues me> every day and only pays me a <lousy salary of 400 gulden>, I am to <kick away 1000>? For I should <certainly> make that sum if I <were to give a concert>. When we had our first grand concert in this house, <the Archbishop sent each of us four ducats>. At the last concert, for which I composed <a new Rondo for Brunetti>, a <new sonata> for myself, and <also a new rondo for Ceccarelli>, I received <nothing>. But what made me almost <desperate> was that the very same <evening> we had this <foul>

concert I was invited to Countess Thun's, but of course could not
go; and who should be there but <the Emperor>! Adamberger
and Madame Weigl were there and received 50 ducats each! Be-
sides, what an opportunity! I cannot, of course, arrange for <the
Emperor to be told that if he wishes to hear me he must hurry
up>, as <I am leaving> Vienna in a few days . . . I <neither can
nor will remain here unless I give a concert>. Still, even if I have
only two <pupils>, I am better off here than in Salzburg but if I
had 1000 or 1200 gulden <in my pocket, I should be a little more
solicited> and therefore <exact better terms>. That is what <he
will not allow, the inhuman villain>. I must <call him that, for he
is a villain and all the nobility call him so>. But enough of this.
Oh, how I hope to hear by the next post whether I am to go on
<burying my youth and my talents in Salzburg, or whether I may
make my fortune as best I can, and not wait until it is too late>.[78]

So the archbishop would have read that this servant had called him
a villain, said the emperor hated him, declared that the whole Viennese
nobility considered him the same. The latter may have been not com-
pletely wrong—Colloredo was widely disliked—but the sums Mozart
says he would earn if he stayed in Vienna were imaginary. He says he
earns a lousy 400 florins a year; it was 450. While he may have missed
an outside opportunity or two, for the first concert at his father's house,
the archbishop paid more than 40 florins, not bad for a couple hours'
work.[79]

Leopold's responses to these letters would not survive, but it is clear
that he was horrified. He may have understood that his son might go
off on his own someday, but he thought it madness for Wolfgang to
burn his bridges with Colloredo before he had a job offer in hand. In a
Vienna filled with experienced composers and virtuosos scrambling for
attention, to expect to get by teaching and concertizing was a potential
disaster in the making.

Those fears were reasonable enough. But equally, Leopold wanted
more money out of Wolfgang, was still talking about getting paid back
for the disastrous Paris tour—even though in the two years since,
he had probably reclaimed those losses by siphoning his son's salary,
which was still paid to him. Leopold cried in a letter that Wolfgang had

no understanding of money. Wolfgang replied, in one of the more insightful moments in his letters, "Where might I have learned the value of money since to this day I have had so little of it in my hands?"[80]

In response to Leopold's increasingly feverish objections, Wolfgang once again resorted to zigging and zagging, backing and filling, nearly every letter taking a new tack. He hates the idea of returning to Salzburg; he will return to Salzburg: "I will return home for sure and with the greatest of joy; because I'm truly convinced that you would never stand in my way if I want to make my fortune."[81] "Return home . . . with the greatest of joy," Leopold likely read while shaking his head. At this point he had absolutely no idea what his son might do and, despite all his efforts, no control over it.

At the beginning of May, Mozart was ordered to leave his lodgings. He had been visiting the Webers, his old friends from Mannheim. Now he moved in with them. In the middle of all this trouble, he did not forget to buy some fashionable items for Nannerl and send them on, or to get a portrait of his mother from its painter, who had brought it to Vienna, and send it back to contribute to the family portrait that was still in progress. In it Maria Anna would preside as a picture on a wall above her husband and children.[82] Nannerl would be the last added to the painting, sporting her clothes of a French aristocrat and a hairdo that towered over her head. She notified her brother the day before the painter arrived for her, "I am writing to you with an erection on my head and I am very much afraid of burning my hair. The reason why the Mölks' maid has dressed my hair is that tomorrow for the first time I am sitting for the painter."[83] In other words, somehow Nannerl was going to sleep overnight without wrecking the edifice crowning her head.

After the recent death of father Fridolin, mother Cäcilia Weber was making ends meet by renting out rooms. She had also extracted a yearly stipend from actor Joseph Lange, Aloysia's new husband. The three younger daughters were still unmarried and living at home: Josepha, Sophie, and Constanze. All were sopranos, two of them destined for operatic careers nearly as grand as Aloysia's. When Cäcilia Weber looked at Mozart she saw a highly marriageable bachelor and a famous musician who could do a good deal for any of her girls, as he had in his coaching of Aloysia. He was also, as she would have seen, an overprotected son and something of a naïf in the ways of the world.

Cäcilia was the opposite, a virtuoso schemer, always with irons in the fire. Her principal irons were her daughters.

As for Archbishop Colloredo, he had swallowed enough of the sulking and insults of this mid-level court servant. The youth's brushes with fame had gone disgracefully to his head; he had forgotten who was buttering his bread. So the archbishop summoned Mozart to audiences and reamed him out. "I'm still boiling with bitterness!" Wolfgang wrote Papa. "I'm sure that you, my best and dearest father, feel just like me . . . I am no longer so unfortunate as to be in Salzburg's service—today was that happy day for me; listen! Twice before,—this—oh, I'm at a loss for words what to call him—has thrown the greatest insults and impertinences into my face, which I did not want to tell you, in order to spare your feelings . . . He called me a knave and a slovenly fellow, told me I should get out of here . . . I had to move out of my lodgings instantly." When Mozart was expected to book a carriage back to Salzburg, he was summoned and ordered to carry with him an important package. It was a test, and he failed. He doggedly put off his departure, was summoned to the presence again. "Well, young fellow, when are you off?" Colloredo demanded. The carriage tickets were sold out, Mozart lied. Then,

> At that moment [Colloredo] burst into one unstoppable tirade: I was the most worthless fellow he knew, no one has served him as poorly as I have . . . I couldn't get a word in, his words came out like a blaze of fire . . . I listened to it all patiently, although he . . . called me a scoundrel, a lousy rogue, a cretin! . . . Finally, as my blood began to boil, I said—so Your Highness is not satisfied with my service?—what, are you threatening me? You cretin, oh, such a cretin!—there is the door, right over there, see it? I don't want to have anything to do with such miserable scum anymore.[84]

Here as elsewhere in his life, Mozart however indignant seethed but did not tend to erupt in fury. But if his feelings had been on simmer, now he was utterly fed up. The next day, April 5, he handed a letter of resignation to Count Karl Joseph Felix von Arco, Colloredo's chamberlain/councillor and master of the kitchen.[85] The Arco family was among the

highest Salzburg nobility and active musical patrons. Various members of the family had always been kind to the Mozarts, who treated them with friendly deference.[86] A resignation from a servant was not always a simple matter; like everything else, it had to be approved by the lord of the manor. This could take time. Count Arco stalled, refused at first to accept the petition; it had to be redone; it had to be approved by Mozart's father, who was assistant Kapellmeister and therefore his superior. Eventually Arco sputtered, absurdly, that if Leopold approves, "you can request your discharge, if not—you can request it anyway."

By this point Mozart's blood was on steady boil. At a performance, "all these lofty remarks the Archbishop had uttered during the three audiences I had with him . . . and all the subsequent things this splendid servant of god dished out, had such a terrific effect on my body that in the evening I had to leave the opera in the middle of the first Act and go home so I could lie down.—I felt quite hot and feverish—my body was trembling all over—and I staggered about in the street like a drunkard."[87] With Papa, he was reduced to almost pathetic begging: "If you are worried—then pretend to be angry with me,—scold me in your letter [for the sake of the court eavesdroppers], just as long as you and I understand how things really stand."[88]

These are some of the most heated letters of Mozart's life, and among the most hyperbolic. Once again he took on a role, this time of an artist whose integrity and honor have been unforgivably insulted. All that was true enough, and his accounts of Colloredo's fits of abuse ring true—that was why a lot of people did not like the archbishop. But there is a theme behind the letters that, like a theme in his music or a character in an opera, determines their tone and direction.

Mozart's outrage is real enough, but more important he desperately wants out, and everything he writes, true or false, he fashions in that direction as consistently as he fashions a movement of a sonata. At the same time, there is a telling aspect to his response: he does not say, "I am a great artist superior to these aristocratic fools, and I cannot be treated this way." Instead, his position is that the fools are what they are, and the problem is how to escape. Here and later, when life slapped him down, as happened to him like everybody else, he never said, "I am Mozart! They can't do this to me!" Instead, he said the equivalent of "This is what happened, and this is what I am going to do to fix it."

Instead of arrogance, Mozart's usual response is optimism: when I get
past this mess, it will get better. As it proved, even if many of his fixes
amounted to fantasies, he was right. He simply considered himself too
good for the world to fail to understand his significance. He was right
about that too. Things always did get better, even at the end, when the
getting better came too late.

FOR THE MOMENT THE ARCHBISHOP'S MAN COUNT ARCO TRIED TO
smooth things over and keep Mozart in Salzburg. Arco summoned the
prodigal for a talk and tried some avuncular advice. Mozart reported
that they had a calm and friendly talk, and Arco promised to hand on
the petition. By that point, Mozart had presented his resignation four
times, having revised it twice. But Arco advised Mozart, "Look, you
allow yourself to be dazzled too easily;—a person's fame is of short
duration here—in the beginning one is given a lot of accolades, and
one earns good money, that's true—but for how long?—after a few
Months the Viennese will want something new." You're right, Mozart
replied, but I don't really plan to stay long in Vienna. Where else he had
in mind, if he really did, he did not mention. The archbishop considers
you thoroughly conceited, Arco observed. "I believe it," Mozart said,
"because that's how I behave toward him; I treat people the way they
treat me;—when I see that Someone is contemptuous of me and puts
me down, I can be as proud as a Baboon."[89]

With that, Mozart ignored the reality that one's aristocratic em-
ployer in those times was not *someone*. He held your life in his hands.
Even at best, even if he liked you and your work and treated you as a
sort of esteemed house pet, he remained your unquestioned lord and
master. Rulers were known to clap recalcitrant servants in jail, and in
any case all a prince had to do was spread the word of your disloyalty
and your career could be finished. That was Leopold's all-consuming
fear, for himself even more than for his son. But while Leopold had
always adapted to that situation—which is to say, adapted to reality—
there was something fundamental in Wolfgang that resisted being a
servant, even if he never seems to have challenged the legitimacy of
princes. In that attitude he put himself into a kind of limbo, and he
would pay the price for it.

Once again, stewing helplessly in Salzburg, Leopold discharged every weapon in his arsenal. The letters would not survive, but their drift is clear in Wolfgang's responses. If Wolfgang quit, Leopold was going to lose half the family income, all of which went into his pocket. This sort of thing, up to and including Papa's declarations that his son was killing him, by this point simply made Mozart weary. Yet he always responded, parrying his father's hysteria and accusations. He had his own habitual refrains: "I beg you, I beg you by all you hold dear in the world, strengthen me in my Resolution rather than try to dissuade me from it, for it makes me miserable and uncreative;—it's My Wish and hope to gain Honor, Fame, and Money, and I have reason to believe that I can be of better help to you in Vienna than in Salzburg." Concerning the pursuit of fame and money, he is speaking Papa's language. He promises that he will send money home from Vienna, as Leopold expected. That promise Mozart would allow to wither on the vine.

Wolfgang was ready to concede some things, though not Leopold deploring the Weber family. (Leopold understood soon enough what the formidable Cäcilia Weber was up to, something Wolfgang resolutely refused to see.) "What you're saying about the Weber family, I can assure you it's not what you think—I know I was a fool about Frau Lange [Aloysia], that is true, but that's the way it is when you are in love!—and I really loved her, and even now she is not indifferent to me—it's luck for me that her husband is a jealous Fool and won't let her go anywhere, so I see her very rarely."[90]

In his next letter he takes on some remarkable accusations his father has made. "I have not recovered from my Bewilderment and, in fact, will not be able to do so ever if you continue to think and write as you just did;—I must confess that there was not a single sign in your letter by which I can recognize my father! . . . Perhaps it was just a dream—and now you are awake."[91] If Wolfgang really felt floored by Leopold's response, his prose does not show it. His tone is hurt but calm. He gives a point-by-point rebuttal to Papa's grievances and accusations: Leopold will never approve of Wolfgang resigning precipitously in Vienna; Wolfgang can only save his honor by giving in and staying on; his son will not sacrifice his own pleasures and needs for the sake of his father.

After brushing away those complaints, Wolfgang goes on to paint

a rosy picture of his prospects in Vienna the coming winter: publishing, plans for an opera, a big concert at Advent. On both sides of the correspondence, a blizzard of reason and unreason (this opera plan was no fantasy—it became *The Abduction*). Through it all, on Wolfgang's side amid his random tackings and fantasies, one solid truth remained: in Vienna he would be free, with grander prospects, and in any case, he was damned if he would go back to Salzburg. By this point the plan may have been to stall the archbishop as long as possible while collecting his salary, then make his escape.[92] And if Vienna was his road to wealth and fame, it was also his road away from Papa. Now for the first time he could live as he wished unencumbered, and what he earned would go into his own pocket.

There things stood at the end of May and into June, Wolfgang boiling and Leopold stewing, likewise Count Arco and Archbishop Colloredo. Mozart busied himself courting wealthy patrons and trolling for students. He knew that he would stand out as composer and clavier player in a city full of the species, and he was confident that there were sophisticated connoisseurs who would understand his value—and among those connoisseurs was Emperor Joseph II. Mozart was not wrong about that, but the effort of establishing himself would never be as simple as sitting down and playing for powerful people. He would have to cope not only with established competitors but with active enemies.

It came to a head on June 8, 1781, a date that in the history of music would live in legend. All right, said the archbishop to Count Arco, send the scoundrel on his way. It was only necessary for Arco to announce the decision and show Mozart the door. What Arco did, probably an improvisation on his part—his family was known for their temper—was to have Mozart thrown out and speed him on his way with a kick in the rear.

It was a shocking humiliation, to be sure. But Arco's kick resolved in one blow every misery and frustration that had been hanging on Mozart for years. *Years.* In effect, Count Arco booted Mozart into his glory.

PART III

I am in Clavierland, and the emperor knows who I am.
Soon he must understand what I am.

Chapter 14

RETURN

S o it transpired that in June 1781, Mozart found himself where he be-
longed. All the same, returning to Vienna had been a muddled and
wrenching process. To do it he had been obliged, as Papa portrayed it,
to insult his powerful employer and betray his father and his family.
Leopold had always expected to be paid back for the herculean efforts
and expenditures he had laid out in rearing his miracle, and now that
hope appeared to have escaped the close grasp in which he had always
held his son. The funds he commanded from the children's tours he
would keep concealed to the end.

It was not that Mozart could not have found, eventually, another
productive situation outside Salzburg. He might well have ended up in
the Munich court, then as important a musical center as Vienna, and
where Elector Karl Theodor had long had an eye on him. He could
have been summoned to Bonn, where in 1784 his admirer Maximilian
Franz took the throne and created a progressive and highly musical
court, among whose servants was a prodigy named Beethoven. Again,
a Kapellmeister position with a leading court was both Leopold's and
Wolfgang's goal. Few if any musicians aspired to the perennially inse-
cure situation of a freelancer, though a leading virtuoso could expect
well-paying engagements in public and private venues, if he was pre-
pared to stay on the road. A few leading opera composers lived like-
wise, traveling from city to city for commissions and performances.
But Mozart was not mainly interested in being a virtuoso, though he

was an incomparable one, and he had seen enough of the road, having been on it since he was six.

How he landed in Vienna had not been a calculated campaign as it would have been with his father. He had more or less stumbled into the place, leaving everybody incensed and resentful. In the city he would begin and end largely a freelancer. (This was a prophecy of future composers' careers, but that hardly did him any good.) Yet it is an open question as to whether it was in Mozart to submit to the life of a court composer, who was essentially a servant ranking somewhere above a cook and somewhere below a councillor. Even Haydn, the quintessential court Kapellmeister, wrote after he had left his three decades in the Esterházy palaces, "I did not know if I was a *Kapelle*-master or a *Kapelle*-servant . . . It is really sad always to be a slave."[1] Moreover, a Kapellmeister's job required patience and tact with employers and employees, and Mozart was not much gifted with either patience or tact.

If Mozart ever sat down and thought critically about this reality of an artist's life in his time, there is no record of it, no indication that he questioned the circumstances he was expected to submit to. It simply seems that it was not in him to submit. He felt superior to the run of musicians, and would stay true to who he was even if he never fully thought out where he belonged. Mozart's resistance to the status quo was not public or theoretical. It was private, instinctive, and dogged.

WHEN LEOPOLD HEARD THE NEWS OF WOLFGANG'S EXPULSION FROM Salzburg service (in practice with the kick on the backside, though the dismissal was never put in writing), he reacted predictably, with outrage and panic. For Leopold it was as if he himself had been kicked onto the street. If his letters to Wolfgang from this point largely do not survive, presumably because his son threw them away, Wolfgang's letters do survive, because Leopold still considered them material for history. From this point it is mainly Wolfgang's responses to Papa that record the grief coming at him from Salzburg.

At this moment Mozart was roiled. He was furious at his treatment, at the same time relieved and optimistic. He already had powerful patrons and admirers in town: Countess Wilhelmine von Thun, as musical as she was wealthy and influential; Russian ambassador Prince Dimitri

Alexievich Gallitzin; Baroness Martha Elisabeth von Waldstätten, who corresponded with Leopold and would help mediate between father and son.[2] Soon Mozart secured a student, Countess Marie Thiennes de Rumbeke. She had a relative in the inner circle of Joseph II, she became a friend, he spent much time at her house. He charged over two florins for a lesson, and they might have been three times a week. Before long, annoyed at cancellations, he would demand payment in advance for a dozen lessons a month, whether or not the student appeared, and that earned him enough to let him take on only four students at most.[3] It also allowed him to ride out the summer months when his aristocratic students tended to be in the country.

So, four students and he would be making a serviceable living. Before long he had them, and by that point he was a leading virtuoso in a town rife with the species. The Viennese nobility of this period were a largely superficial sort, given to pleasure rather than thought, not much involved in literature or ideas; their one imaginative involvement was with music. Mozart's new patrons were sophisticated and influential. They knew all about his fabled childhood and forgave him for it, because they had the ears to understand what he had become.

Mozart's letters home of these weeks detail the fallout with the archbishop, but mostly are a matter of trying to calm his father's anxiety. There was another matter greatly troubling Leopold now: Wolfgang was living at the Webers', where scheming, hard-drinking, newly widowed Cäcilia still had three daughters she intended to marry off and in the process profit from. In dealing with Papa, Wolfgang had to address this matter as well. Here his dissembling reached new heights of fantasy and obfuscation—which is to say, new heights of playacting.

> Mon trés cher Pére! Now Count Arco has really done it!—so that's the way to persuade people, draw them closer to you: by refusing to accept a petition because you were born dumb, by not informing your master because you lack the courage to do so and because you love being a pedantic bureaucrat; for all these reasons you keep a fellow dangling for four weeks and, finally, as this fellow is forced to hand in his petition himself instead of <u>at least</u> granting him access, you throw him out the door and give

him a kick in his Behind.—And that's the Count who, according to your last letter, has only my interests at heart . . .

[Your] comparing me to Mad. Lang [*sic*] has caused me much bewilderment and depressed me all day.—[Aloysia] lived off her parents when she didn't have any income of her own—but by the time when she was able to show some gratitude to her parents—NB: her father died. Before she had yet earned a penny—she left her poor mother, took off with an actor, married him—and her Mother doesn't get—a penny—from her. Good god!—heaven knows that my only goal is to be of help to you and all of us . . . [D]o I have to tell you a hundred times that I can be more Useful to you here than in Salzburg.

He goes on to detail his efforts to appeal to Arco and the archbishop, the account more or less accurate, but Leopold would not have cared about all that. He cared only about the result. Wolfgang strained to calm his father's anxiety, an effort that neither now nor later would have much effect.

I'm so tired of the whole thing that I really don't want to hear about it anymore. Considering the <u>causes</u> of my quitting, which you know all too well, no father would think of being angry with his son about something like that, rather the opposite . . . I assume you have to act like this on account of the court.—I beg you, my dearest father, don't crawl too much.—The archbishop cannot really harm you.

The reality was otherwise. When Aloysia was hired by the Munich Opera, her father got a comfortable job there as well. As for Cäcilia not getting a penny: when Aloysia came to the Vienna Opera and married actor Joseph Lange, her mother, wielding the club that Aloysia was pregnant at the time, extracted from him a stipend of seven hundred florins a year. Cäcilia set her sights on something comparable from Mozart. And Leopold perceived her and her agenda excruciatingly clearly.

Wolfgang finished his first letter after the break with what had become his ritual plea to Papa: get off my back, I need my peace of mind.

"I beg you, my dearest, most beloved father, don't write this kind of letter to me anymore, I beseech you, because they are of no use, except to fog up my brain and disquiet my heart and spirit,—and I, who am now constantly called upon to Compose, need a clear head and peaceful spirit.[4]

He ends on a promising note: Count Rosenberg, overseeing the theater for the emperor, has ordered a libretto to be found for him. This would have been Joseph II's doing. The emperor had a very good idea of what this catch for Vienna amounted to, and he wanted to reel it in without delay—preferably at a reasonable cost. So unlike the chimerical opera and oratorio and symphony about which Wolfgang had written Papa from Paris, this prospect happened to be real, and it was going to bear great fruit.

As for Councillor Arco, who had administered the final and literal blow, Mozart fantasizes revenge:

It is the heart that ennobles man; and though I am not a count, I have probably more Honor in me than many a count; and whether I am dealing with a lackey or a count, if he insults me, he is a scoundrel.—I shall make it clear to him from the beginning how badly and miserably he has handled this matter;—but in the end I may have to make sure in writing that he understands he can still expect a kick in the ass and a couple of slaps in the face from me.[5]

All the same, in the letters of these weeks Mozart's fantasies of revenge (which if acted on, a commoner attacking a nobleman, would have landed him in jail) are overwhelmed by reports of plans and glittering possibilities in Vienna. If they were fantasies for the moment, they were grounded, and would on the whole come true. Within a short time he would have little to complain about—except Papa. I'll be sending money home, Wolfgang insisted. I'll be more useful to you here than in Salzburg. In fact, whether he ever sent any of his earnings home is uncertain. Leopold probably feared what in fact came to pass, that his son would end up sending little to no money home, and he would be of no further use to the family back home except as glory reflected from a distance.

THE VIENNA THAT MOZART HAD RETURNED TO WAS FAMILIAR TO HIM in many respects from his sojourns in childhood. He found the same city of hundreds of palaces and dozens of churches, the same jumble of languages and costumes and boots and beards and mustachios from a far-flung empire, in the streets the same dust and offal and stench. But now Joseph II had taken the throne of the Holy Roman Empire determined to transform his kingdom into a modern progressive state. This reformist fury from the top down was changing the city and the empire. It would likewise change Mozart. As man and artist he owned a driving energy, and in the 1780s, the vitality and the opportunities of Vienna would spur him far more than the drowsy rhythms of Salzburg.

Vienna was the seat of one of the great empires of the age, but it resembled less a capital than a cultural and commercial center with a growing bureaucracy and a rising middle class. The court was the main business of the town, as in any town with a court, but this was blurred by a city life burgeoning in every dimension.[6] The thick walls and ramparts of the inner city had been built to keep the Turks at bay. In the inner city were packed some 52,000 souls, while about three times that many lived in the suburbs. The 3,000 or so members of the Viennese nobility were sustained by 6,000 lackeys and 34,000 servants.[7] Of foreigners, there were some 25,000 residing in greater Vienna; of military, more than 12,000; of clergy, 2,000; of Jews, around 500 (they had to be specially permitted to live in the city[8]).[9] At one point, besides the crowd of churches, a sixth of Vienna was occupied by monasteries and nunneries. Joseph would prune their number radically.[10]

Vienna throbbed and groaned in daily patterns. The city woke up early, first light full of church bells drawing worshippers to Mass. Meanwhile the street vendors opened up, old women laying out fruit, vegetables, poultry, and herbs in baskets and raising their raucous cries, calling forth a legion of cooks, wives, and daughters looking for the day's sustenance. By midmorning the cobblestone streets were crowded with the carriages and clopping hooves of the wealthy; with commercial wagons full of wood, cloth, meat, and the other needs of the day, mingling with legions of clerks, secretaries, adjuncts, and the like on foot. These were followed by a wave of judges, chancellors, vice-chancellors, and other bureaucrats headed for government offices.

Aristocratic ladies generally spent their mornings in their boudoirs

with servants, taking hours to dress and arrange their coiffures. How one rated in Vienna, male or female, had much to do with how one dressed. This was something Mozart understood well; he dressed like a courtier so he would be pictured as one, and because he was a dandy by nature. Traditionally, women's fashions came from Paris; wealthy ladies had clothed manikins and drawings imported to tell them what to wear this season.[11] Johann Pezzl, a Joseph II disciple and sharp-eyed chronicler of the city, noted that a proper male dandy needed to know the best wines, the cost of a game of billiards, the best places to bowl, the best dogs at the baiting ring. For this sort, "deadly sins are: a sensible discussion.—A useful book.—Hard work.—A bad meal." The female dandy was required to know the latest fashions, the best German dances, the favored ices, how to size up a prospective lover by the decorations on his chest. "She loves any man who pretends to be a count or a baron, everyone who wears boots and spurs, and understands horses; and every male hand bearing a diamond ring." The main fears of these women were an unmade face, or occupying a sofa where she was not the most important person.[12]

When Mozart arrived in Vienna in 1781 there was a rampant Anglomania in dress and style. Men sported British round hats and dark frock coats with high collars, boots and spurs, a rough walking stick. Many women put aside the stiff fashions and hooped skirts of the past for lighter fabrics. Pezzl rhapsodized over the "girls with their white summer dresses and a ribbon around their waists as they flowed across the promenade . . . and the furs in winter . . . What Grecian simplicity they have! How they complement the charms of a round bosom!" Many Viennese of those years affected speaking English, drinking whiskey, talking about jockeys.[13]

Around noon the high-class prostitutes appeared around the central Graben and Kohlmarkt; at dusk the streets would give way to the cheaper variety. (Mozart's Don Giovanni would happily accommodate both sorts.) By midday the idle swells of the town were lounging in front of coffeehouses eying the ladies coming out of church, or waiting to pick up their girlfriends for afternoon assignations. In the afternoon much of the nobility lined up in their four- and six-horse carriages along the wooded paths of the great parks, the Leopoldstadt and Prater. Middle-class ladies promenaded atop the city walls or in the spreading

glacis outside the city, laid out to provide a clear field of fire from the walls in time of war. Joseph II planted the paths with chestnut trees for the times of peace.

This was not on the whole a puritanical era, and Vienna was less inhibited about the passions than many places. The nobility married for power and status, not for love, and neither they nor the high clergy were generally required to bother themselves with the morality of the lower orders. Wealthy men tended to keep mistresses on the side, setting them up in flats that could cost thousands a year. Wrote Pezzl, "All these kept girls are passed from hand to hand. After a time, either their lover has had enough of them, or another comes along with promises of several more ducats each year and . . . is given preference."

As for the commoners, men needed to be established in a profession to start a family, so they tended to marry late, and most bachelors frequented prostitutes. As for those women, wrote Pezzl, while the daytime ones could be nice-looking, they descended to "brutal whores who haunt the beer houses of the suburbs, get drunk on mugs of beer and then lie in wild thrashings with soldiers, coachmen, and rough manual workers."[14] When it was suggested to Emperor Joseph that brothels should be required to have roofs, he quipped that they would have to put a roof over the whole city.

Given the extramarital amusements of aristocratic men, it was largely the wives who had to make the accommodations. Still, for many women of the nobility there was the institution of the cicisbeo, a gallant who served as her companion at entertainments and at church. Some of these men were bedmates, some not; some were homosexual but happy to take the arm of a grand lady.[15] This scene, and the contrasts of moralities upstairs and down, were the setting of any number of plays and operas, including Mozart's. A boyish character of his named Cherubino would grow into something on the order of a cicisbeo, assuming that role in a part of the story Mozart never got to.

The climax of the day's hubbub in the city came at around six, when the whole populace poured into the streets voracious for amusement, for theater and opera and soirées, and for the rougher pleasures of gambling, animal baiting rings, and street theater.[16] Music and opera were growing passions, but prices in the main theaters were still stiff for ordinary citizens, even the cheapest seats in the top-balcony "par-

adise." Theaters made much of their income from renting boxes to the nobility, which could cost upward of a thousand florins and which the renters maintained year after year. For many, a theater box amounted to a second parlor, where they could entertain, flirt, dine, play cards, or discreetly make love.[17]

As a leading musical capital, Vienna was stocked as well as anywhere with first-rate musicians from professional virtuosos to skilled amateurs. As Wolfgang wrote his father, "This is here a true Clavier land!"[18] But the city was not yet *the* musical capital of Europe, partly because the homes of the aristocracy were still the dominant venue. Besides mounting chamber music, some nobles maintained small orchestras, the players sometimes doubling as house servants.

In Vienna there were no dedicated public concert halls; a music-loving bourgeoisie was just beginning to take shape. A tangle of rules constrained performances in the two big halls, the Burgtheater and the Kärntnertor: no performances on Friday, nothing on Advent before Christmas, none on major religious holidays or memorial days for Empress Maria Theresa's husband and parents.[19] There was nothing like the thriving public concert life of London or Paris, which was based not on courts but on entrepreneurs. For his concerts, Mozart like other virtuosos would have to be his own producer and rent the available venues, such as the Mehlgrube room over a restaurant in the Neuer Markt, or the casino in the Trattnerhof, where he lived for a while.[20]

Stage productions were banned in the big theaters during the weeks of Lent and Advent, but instrumental performances were allowed, so most of those concerts were stuffed into Lent's forty days. Of course, theater was available to all in the streets, where little companies laid out boards for a stage and put on anything from serious drama to rowdy improvised comedy in the vein of Hanswurst and commedia dell'arte. (Even in Joseph's nominally liberal Vienna, the antics of Hanswurst were banned from court theaters, in the name of maintaining moral uplift on the stage.)[21]

The principal amusement of most Viennese, however, was dancing. This passion climaxed during Carnival, when the doors of the large and small ballrooms in the Hofburg were opened to all, with thousands cramming in to dance all night there and in any other available room in town. Wrote British tenor and Mozart friend Michael Kelly, "The

propensity of the Vienna ladies for dancing and going to Carnaval [*sic*] and masquerades was so determined, that nothing was permitted to interfere with their enjoyment of their favorite amusement—nay, so notorious was it, that for the sake of the ladies in the family way, who could not be persuaded to stay at home, there were apartments prepared, with every convenience for their accouchement, should they be unfortunately required."[22]

This was the grand milieu that became the setting for Mozart's climactic works. For all its kaleidoscopic energy, meanwhile, much of the tenor of Vienna flowed from one person, the man at the top.

AFTER SERVING AS CO-REGENT WITH HIS MOTHER FOR FIFTEEN YEARS, Emperor Joseph II took full command of the Hapsburg monarchy and the Holy Roman Empire in 1780, when Empress Maria Theresa died. As a woman she had not been permitted to hold the throne, but in practice, her power had outweighed her son's. (The thrones of the monarchy and the empire were separate, the lands not exactly the same, the relationship between the two arcane.) The empress had been in some ways progressive in Enlightenment terms, secularizing education and abolishing judicial torture and the death penalty, but in other ways the opposite: she loathed Jews and Protestants and Freemasons, and she did not seriously challenge the power of the nobility.

To a degree that frightened his mother, Joseph II was a product of the German *Aufklärung*, determined when he took full power to make his realm a model of enlightened reform. The ancient myth of the divine right of kings he wiped off the slate: "All men are equal at birth," he wrote: "We inherit from our parents no more than animal life, hence there is not the slightest difference between the King, Count, bourgeois and peasant. I find nothing in divine or natural law to contradict this equality." He was king because he happened to be, but this imbued him with a supreme responsibility. From that foundation, Joseph acted in a single-minded direction. But the ways in which he acted and reacted would be another story, partly due to what he was up against, partly due to his own inner contradictions.

On taking the throne, Joseph gave the public symbolic notice of the new order. In the name of simplicity and austerity he largely emptied

the Hofburg, the old Hapsburg palace in the center of town, and terminated most of its ceremony and much of its staff. Unused rooms were boarded up. He did likewise with most of the grand summer palace of Schönbrunn, outside town, only now and then opening the large Orangery hall for parties and performances. He and his mother turned their hunting estates and gardens, the Augarten and Prater, over to the public. Joseph spent much of his time touring his realm; at home he generally lived in modest rooms in the Augarten. In town he could be seen hailing citizens from a simple two-wheel carriage with one servant, or on foot. Sometimes, to the shock of visitors, he was found wearing a worn military coat with patched elbows.

Rather than lavish ceremonies and banquets and the like, Joseph did most of his socializing in the palaces of the nobility. He explained to a countess:

> It would be hard indeed, if, because I have the ill fortune to be an Emperor, I should be deprived of the pleasures of social life, which are so much to my taste. All the grimace and parade to which people are accustomed from their cradle, have not made me so vain as to imagine that I am in any essential quality superior to other men; and if I had any tendency to such an opinion, the surest way to get rid of it, is the method I take, of mixing in society, where I have daily occasions of finding myself inferior in talents to those I meet with.[23]

Joseph's essential conviction was that he could shape his people into a progressive and integral society by dictate. In the last decade of his mother's life the throne issued under 100 decrees; in his less than a decade on the throne, Joseph issued 6,206.[24] To the task of reform he brought a burning determination and an absolute obliviousness to the practical and human consequences of what he was doing. As Casanova said of Joseph after meeting him, "No one ever denied his claim to great courage; but he had no idea whatever of the art of government, for he had not the slightest knowledge of the human heart, and he could neither dissemble nor keep a secret; he had so little control over his own countenance that he could not even conceal the pleasure he felt in punishing."[25] An aristocratic diarist wrote, "It looks as though the

Emperor believes . . . that he alone loves his country and knows what is right, and that all his officials are knaves and fools."[26]

These appraisals were not exaggerated. Joseph declared himself a *Volkskaiser*, an emperor of the people. But he intended to elevate his people into the enlightened future he imagined for them whether they liked it or not, and his stated method was the exercise of despotism. Regional traditions and institutions meant nothing to him; he saw himself as an agent of universal truth and universal good. He believed that when his empire absorbed the results of his edicts, a new freedom and energy and prosperity in action, his people would love him for it. As it played out, many did love him; for others, he was chaos incarnate, and the forces that despised him had far more power than those who embraced what came to be called Josephenism.

Portraits of Joseph show a slim, handsome, bright-eyed figure of military bearing. He liked to consider himself a soldier first, though he would prove to be ungifted as a commander in the field. In company he was studiously genial and unregal. A British visitor recalled, "His manner . . . is affable, obliging and perfectly free from the reserved and lofty deportment assumed by some on account of high birth . . . He is regular in his ways of life, moderate in his pleasures, steady in his plans and diligent in business." When Mozart arrived in 1781, Joseph was a confirmed widower. His beloved first wife had died of smallpox in 1763, followed later by their daughter. Joseph was devastated by both losses. He dutifully married a cousin, but despite her best efforts he hated and belittled her. His description: "short, fat figure; no youthfulness; a common face; on it, some little pebbles with red spots; bad teeth." His second empress was good enough to die after enduring two years of his cruelty. Joseph never remarried and unusually for his class never kept a lover. He came to describe himself as "made neither to give nor to receive love."[27] His abiding love was for the state.

Which is all to say that Joseph made a relentless show of making no show, of clamping down on courtly extravagance, of a personal modesty and simplicity. Beneath all this, in the pursuit of his ideals he was a fierce autocrat ready to ride roughshod over any person, tradition, or institution no matter how venerable.

Many of his most far-reaching reforms had to do with religion. His mother the empress had been firmly against giving full rights to Jews

and Protestants. Joseph's Toleranzedikt of 1782 eradicated state discrimination against Lutherans, Calvinists, and the Greek Orthodox, and relaxed some of the old and oppressive restrictions on Jews: now they could attend state schools and universities, own businesses, and live where they wished, though the numbers allowed to reside in the inner city were still strictly limited.[28] Joseph's mother had tried to suppress the Freemasons, whom she feared as a hotbed of progressive thought (this even though her husband was a Mason). Joseph, though he said of the order that he had "never experienced any curiosity about their mumbo-jumbo," in practice protected them while keeping the lodges under wary observation.[29] The Masons had reviled Maria Theresa; for a time, at least, they called Joseph their champion.

When it came to monasteries and nunneries, Joseph eliminated every institution and order that he felt was doing no service to the society at large, confiscating their property, turning the buildings into businesses and schools and selling the land to benefit education. The number of monks in the empire was reduced from 25,000 to 11,000, the number of monastic institutions reduced by 530.[30] He mandated simpler church services with less music, ordered the traditional adornments of religious statues removed, limited the numbers of pictures and statues and candles and altars, and curtailed the number of feast days and religious processions.

Pius VI, fearful of what he saw as the worst threat to Church power since the Protestant Reformation, made the Papacy's first trip out of Italy since the sixteenth century to come to Vienna and remonstrate with Joseph.[31] The Viennese received the pontiff in rapturous thousands, but Joseph refused to budge in any matter or even to meet with the head of his Church. "I was a good Catholic before his arrival," Joseph declared, "and he had no need to convert me."[32] This was true: Joseph was an entirely faithful Catholic. He believed that if he relieved some religious restrictions on Jews and Protestants and turned the Church away from superstition and show, there would be a new earnestness and piety in the people's religion that would, in its authenticity, serve as a means of conversion. The effect, though, was the opposite: Protestants and Jews thrived in the new freedom.

Joseph's overriding goals were to reduce expenses and excesses, to force the Church to serve the people, and no less to bring the Church

under the control of the throne. He intended to erase the line between service to God and to the state. Papal bulls were no longer admitted in Austrian lands. The government took over running the seminaries. As one satirist observed, "The Emperor has [decided] that Jesus Christ . . . having given useful service to the house of Austria for many centuries, deserved, in accordance with the guidelines laid down, to have his salary reduced and to be placed among the Quiescenti," these being the forcibly retired and pensioned-off clergy.[33]

The emperor's attention to the aristocracy was no less draconian. He passed laws to mitigate serfdom, decreed that the nobility had to pay the same land taxes as everybody else and submit to the same laws. One of the results of his legal reform was that one of the common sights in Vienna, petty criminals in chains forced to sweep the streets and endure the taunts of passersby, now sometimes included aristocrats clad in prison shifts and wielding brooms. Joseph raised funds by selling off patents of nobility to the rising wealthy class: twenty thousand florins made you a count, six thousand a baronet.[34] For all its cynicism, this engendered a dynamic new nobility whose power and influence challenged the position of the old aristocracy. At the same time, a new upper-middle class, including a Jewish middle class, rose from the economic reforms, giving commoners more power and influence than they had ever known.

Joseph's tide of initiatives was a product of high-*Aufklärung* sensibility, a determination to make the lives of his subjects better and his state more disciplined and rational. This was the idealistic part, in which he was absolutely sincere. Yet from top to bottom, his reforms were ambiguous, compromised, and fiercely resisted by the Church and the aristocracy whose wealth and privilege he attacked. The nobility could not fail to notice that Joseph's initiatives to curb their power in the name of progress invariably enhanced the power of the throne. On the whole the lower classes and Jews and Protestants idolized the emperor for his reforms, but all the same his elimination of many religious holidays meant that everybody had to work more, and his curtailing of show and ceremony did not appeal to the Viennese, who liked extravagance in their rulers and in their religion.

If Joseph loosened censorship, he also maintained a network of police informers who kept a close eye on the citizenry. He might not have

you hauled in if you denounced his regime, but he wanted to know about it. If his mother had abolished the death penalty, he instituted punishments that were crueler than simply being hanged. Condemned men were sentenced to haul boats along the Danube Canal, slogging through mud and given one meal a day until they died, which usually did not take long. Joseph was fond of the lash, prescribing floggings for many prisoners. Torture had been abolished in legal proceedings, but he saw to it that one aristocratic murderer, who had wooed and killed a rich widow to pay his gambling debts, was sentenced to a prolonged and brutal public execution. (More than thirty thousand Viennese turned up to enjoy the show. Living some two hundred yards away from the execution, Mozart was working on Piano Concerto no. 25. If he was home that day, he heard the roars of the crowd and possibly the screams of the victim.)[35]

Joseph created a new class of bureaucrats intended to bring the whole of government into more professional shape. This would prove to be another of his abiding but ambiguous legacies to Austria. The regime did become far more efficient and effective, and the new bureaucrats grew into another class rising in the economy, and they devoted some of their attention and their fortunes to the arts. This new officialdom, formed to serve the cause of progress and efficiency, would in the long run prove equally adept at serving the cause of tyranny.

As early as 1761, Joseph wrote, "Everything exists for the state; this word contains everything, so all who live in it should come together to promote its interests."[36] When he came to power his determination to turn Austria into a unified modern state on the model of his chief rival, Prussia, was doomed from the start because the Austrian state had no foundation or meaning at all. It was a patchwork of mutually indifferent or hostile cultures, lands, and languages stretching from parts of the Netherlands to Belgium to Hungary to Italy, which over the centuries had been randomly accumulated by the Habsburg Empire. Even the Hapsburg monarchy and the Holy Roman Empire were two separate institutions uneasily cohabitating, their interests sometimes conflicting. Austria was in theory one of the most powerful kingdoms in Europe, but there was no common ground on which to form a cohesive country. Meanwhile Joseph's tactic of promoting a free and enlightened state by dictatorial means with no element of

democracy was a contradiction that could not be reconciled. Eventually the price would have to be paid.

And yet amid the hit-and-miss effects of Joseph's decrees, a new tone of openness percolated from the top to the bottom of society. The stage was reopened to banned authors. Dozens of coffeehouses became places to debate and read and learn; floods of journals and pamphlets exploited the relaxed freedom of speech. And if one was freer to write and speak, one was also free to criticize and even denounce the regime, which in practice remained an elite, absolute power unanswerable to the populace.

Part of what added up to a colossal social impasse in the making, a progressive yet antidemocratic despotism ready to turn into a reactionary one, was the speed and arbitrariness of the process. Joseph was not a systematic thinker; he acted on impulse in unpredictable and contradictory ways, even as he aspired to have a hand in everything from the largest matters of government, to the plays and operas and actors and singers in the theaters, to the diet and dress of his subjects and how they were buried. For reasons of public health, to get cemeteries out of the city, Joseph decreed radical procedures for common burials: after memorial ceremonies in town, bodies were to be sewn in a sack, hauled out to the countryside, and tossed into common graves. These burial regulations were universally despised and soon rescinded, though an echo of them persisted in third-class burials to the end of Mozart's life. In the long run, in his welter of initiatives, Joseph managed not only to outrage the aristocracy and the Church, but often to disappoint and distress his supporters: the peasant who now had more workdays in the year, the performers who lost jobs from the reduction in church music.

Most of these matters might appear to be of little bearing on the life of a composer and virtuoso, but they had great bearing. Even from a ruler proclaiming benevolence and freedom of thought, Joseph II remained an absolute ruler, and the whole of society turned around him. His career as emperor, his successes and failures alike, bore directly on Mozart, and not only because Joseph became his patron and eventual employer. As Joseph's policies and patronage and popularity rose and fell, so to a degree did Mozart's career. From the new nobility and middle class, meanwhile, including leading Jewish businessmen, Mozart

would draw his circle of friends, much of his audience, and many of his convictions.

In the spectrum of how he and Joseph would relate in the coming decade, there is a telling matter: Mozart was a steady and lusty complainer about life and people, but there is no record of his ever complaining about the emperor. There may have been protests later destroyed or never written down, but the implication remains that Mozart approved of Joseph and his agenda—politically and even, on the whole, musically.

THOUGH THE MYTHS OF HISTORY WOULD LEAN HARD ON THE EMPEROR for his treatment of Mozart, as if Joseph had little understanding of what he had before him, in an aristocratic society that was often involved with music he excelled most of his class as a connoisseur and enthusiast.

Music was Joseph's prime recreation. When he was in residence in the city he played chamber music three afternoons a week in his rooms with a group of palace musicians who were kept on call.[37] He was a capable player of clavier and cello, able to read through an opera score at the keyboard and sing the parts in his mellow bass voice. He attended nearly every opera in the court theaters and he often took in rehearsals as well. (As part of his austerity program, the aristocracy paid for their seats.)[38] After some years of independent management of the two court halls, the Burgtheater attached to the Hofburg and the larger Kärntnertortheater, in 1776 Joseph reclaimed control and in nominal charge of court theaters placed Count Franz Xaver von Orsini-Rosenberg. Here was another figure who would have significant weight in Mozart's life. Rosenberg was Joseph's gatekeeper of opportunities for composers, and he would prove less enamored of Mozart than his employer.

Rosenberg's official duty was to hand the emperor his shirt in the morning. Perhaps he did so, but their mornings were given to ongoing plans about the opera and other matters musical and theatrical. In 1776 Joseph created a German National Theater. Ending the domination of French and Italian productions, he hired German actors and playwrights and formed an opera company devoted to singspiel. For the old courtly genre of opera seria, Joseph had no use; its static drama and general tedium bored him. He wanted comic German singspiel and

Italian opera, as long as it was buffa. Eventually he dispatched scouts around Italy in search of the brightest talents, and he was prepared to pay what it took to bring them to Vienna. This inclination of the emperor's was in its effect historic: it turned Mozart in his prime—who for his part was as happy to write seria as buffa—into the supreme composer of Italian comic opera. In the same way, Joseph's trimming of elaborate music in the churches is the main reason Mozart wrote little sacred music in Vienna.

Count Rosenberg had his influence, but mostly he was there to do Joseph's bidding regarding the theaters, including whom to hire and fire and what repertoire to take up. To foster German theater was in Joseph's mind a matter not of mere entertainment but of uplift and edification: the theater existed to promote morality, elevate the language, and thereby help make audiences useful citizens of the state. For this reason his censorship bore down harder on the stage than on books, because Joseph considered theater the more powerful moral influence. Nothing was allowed on the stage that was deemed "morally offensive." No violent or unpunished crimes, no divorce. Also no criticism of thrones, even if the setting was ancient Rome. Shakespeare was allowed, but readjusted: *Coriolanus* ended pleasantly; the principals of *King Lear* were alive and smiling at the end. Fortunately for playwrights and opera composers, women could still be seduced onstage, only, for some reason, never in their own boudoirs.[39]

Inevitably, Joseph's musical passion was going to be brought to bear on Mozart. Composer Karl Ditters von Dittersdorf recalled a conversation with the emperor that began with Ditters observing of Mozart, "I have never yet met with any composer who had such an amazing wealth of ideas. I could almost wish he were not so lavish in using them. He leaves his hearers out of breath, for hardly has he grasped one beautiful thought, when another greater fascination dispels the first, and this goes on throughout, so that in the end it is impossible to retain any one of these beautiful melodies."

Joseph replied, "He has only one fault in his pieces for the stage, and his singers have very often complained of it—he deafens them with his full accompaniment."

They went on to compare Mozart and the poet Klopstock: him you have to read more than once, as you have to hear Mozart more than

once, while Gellert is clear at first glance.[40] This was already a common refrain about Mozart from critics and connoisseurs: too many ideas to take in, too many instruments, too many notes. In his time these perceptions would prevent Mozart from being as popular as other and lesser composers, but in history they would also fuel myths of neglect and misunderstanding that were not true in the least. If Joseph II was a representative connoisseur of the time in his reservations, he was also representative in grasping Mozart's stature.

In any case the history of Joseph's tastes, foibles, and enthusiasms is also part of the history of Mozart's career in Vienna, his greater and lesser successes. When it came to opera, there would be in that regard one presence and obstacle that Mozart had to be concerned with from the beginning: Joseph's favorite opera composer, and a wily and powerful fixture in the musical life of the city, one Antonio Salieri.

This was the setting for which Mozart had, as it happened, prepared for his whole career. And in its fickle and extravagant fashion, Vienna was prepared for him. His circle of friends and patrons would be wide, from merchants to the high nobility, Catholics and Protestants and Jews, anyone who appealed to him in his boundless appetites for music and company and dancing and games and all things pleasurable and fun.

Those friends came to know an inexplicable force of nature who could rise from a luminous improvisation at the clavier for a round of meowing like a cat and leaping over the furniture. They would remember the myriad fancies and gaieties of the little man with an overlarge head and a pale pockmarked face who was forever drumming on things, tapping his feet, jabbering away, but who might also grasp your hand and look at you with something profound, searching, and melancholy in his eyes. Even in company there was often an air about Mozart of being in his mind not quite there. At table he might sit silently and unseeing in the hubbub, clutching a napkin to his face and grimacing.[41] In Vienna it was as if he lived onstage and off at the same time, a character in life's tragicomedy but also outside it, watching, studying, gathering material from the world around him for the fabric of his art.

GNAGFLOW AND ZNATSNOC

A fter his limbo years in Salzburg, Mozart came to Vienna in 1781 to find things suddenly happening fast, due less to his own efforts than to his patrons and his reputation. Even as his break with the archbishop was unfolding, an offer from the court fell into his lap to write a singspiel, the uniquely German comic opera using spoken dialogue rather than recitative. Emperor Joseph II had ordered his theater director Count Franz Xaver von Orsini-Rosenberg to find a libretto for him, and the count settled on Johann Gottlieb Stephanie to provide it. In letters home Wolfgang attempted to fix Leopold's attention on his prospects rather than the distress he seemed to be causing everybody. About this opportunity, Mozart wrote,

> I must now explain why we were suspicious of Stephanie. I regret
> to say that the fellow has the worst reputation in Vienna, for he is
> said to be rude, false, and slanderous and to treat people most un-
> justly. But I pay no attention to these reports. There may be some
> truth in them, for everyone abuses him. On the other hand, he is
> in great favor with the Emperor. He was most friendly to me the
> very first time we met, and said: "We are old friends already and I
> shall be delighted if it be in my power to render you any service."
> I believe and hope too that he himself may write an opera libretto
> for me. Whether he has written his plays alone or with the help of

others, whether he has plagiarized or created, he still understands the stage, and his plays are invariably popular.[1]

Stephanie was an actor, a librettist, and a greatly fashionable playwright, if an otherwise dodgy character. At this point he was stage manager of the singspiel company in Vienna, established by Joseph II to promote all things German.[2] Mozart initially attempted to ply Stephanie with his sketches for the melodrama *Zaide*, but was brushed aside. The court was interested only in comic opera now, Stephanie said; maybe he could find something more suitable. This became the new commission.[3]

Wolfgang continues to Papa, trying to involve him as son to father, composer to composer:

> I have not the slightest doubt about the success of the opera, provided the text is a good one. For do you really suppose that I should write an opéra comique in the same style as an opera seria? There should be as little frivolity in an opera seria and as much seriousness and solidity as there should be little seriousness in an opera buffa, and all the more frivolity and gaiety. That people like to have a little comic music in an opera seria I cannot help. But in Vienna they make the proper distinction on this point.[4]

Leopold had raised some sort of objection, and Wolfgang is trying to reassure him that he will keep his genres straight: no comedy in seria, no seriousness in buffa. As to the latter, though, whether or not he was earnest about this notion at the time, it has nothing to do with what would be his approach to writing comic opera, which would invariably incorporate serious characters and serious matters. Before long he would be writing home declaring the need to have a *mezzo carattere* in buffa, a character between comic and serious, which is a question not only of drama but of style: seria music placed in a buffa context.

Grievances kept erupting from Salzburg, Leopold brushing aside the cheerful reports just as Wolfgang tried to brush aside his father's complaints. It was a dialectic between them that over time would ebb but never entirely go away, Leopold sinking toward a posture of

simmering bitterness. Gleaned from his replies, Papa's current darts took assorted forms, including spiritual accusations. Wrote Wolfgang,

> You need not worry about the salvation of my soul, dearest father!—I know I am still a young man, capable of errors, but it were to be wished . . . that others had erred as little as I.—You may well be believing things about me that are not true;—my main fault is that I give the appearance of not always behaving the way I should—and it's not true that I bragged about eating meat on every feast day; what I said was that it was not a big concern of mine, and that I didn't think it was a sin . . . I go to Mass every Sunday and holiday and, if I can, on work days as well . . . Be assured that I am holding fast to my religion.[5]

Mozart may not have realized yet that there were slanderous rumors about his behavior going around, and they had reached Salzburg. In coming weeks this would add to the thicket of obstructions he was trying to thrash out of, all of it the wages of his presumed sin in striking out on his own. A sign of the strain it produced is in the tone of his letters, which had lost the antic quality of his younger years. No jokes of the privy, little about his amusements. Mostly, instead, business and smoke and fog.

In any case his situation was improving. He soon found a second piano student, one not as simple a matter as an aristocratic lady who liked to play and could afford a famous teacher. This one was a commoner, daughter of a court official, and she was as gifted as she was annoying. In that respect, this student illustrated a fundamental duality of Mozart's temperament: he was nicely generous in recognizing talent as long as it represented no challenge to him (which he assumed was barely attainable in any case), but intolerant of foibles, pretentions, incapacities of any sort.

Her name was Josepha Barbara Auernhammer. As a pianist, she was able and ambitious; as a female, chubby and unattractive. To Papa Wolfgang reported both sides of the equation:

> I spend almost every day after lunch at the house of Herr von Auerhammer [sic].—The young lady of the house [Josepha] is

hideously ugly!——Her playing however, is enchanting, even though she lacks the true, delicate touch, that singing quality in the Cantabile . . . She let me in on a plan that she keeps a secret, namely that she wants to study hard for two or three more years and then go to Paris and make piano playing her profession.—— She says: I am not beautiful, au contraire, I am ugly; and I don't want to marry some petty clerk in the chancellery . . . and I don't have a chance of getting anyone else; so I'd rather stay single and make a living off my talent. And she is right; she asked me to help her realize her plan.[6]

But it soon became manifest that Josepha did aspire to find a good catch as husband: him. This could have roused Mozart's pity, but it only roused his ire. If he was aesthetically pleased with her playing, he was aesthetically offended by the rest of her. To Leopold he paints Josepha in bold colors, as if a character in an opera buffa: the homely, pathetic, love-drunk buffoon:

If a painter wanted to portray the devil to the life, he would have to choose her face. She is as fat as a farm wench, perspires so that you feel inclined to vomit, and goes about so scantily clad that really you can read as plain as print: "Pray, do look here." True, there is enough to see, in fact, quite enough to strike one blind . . . So loathsome, dirty, and horrible! . . . Well, I have told you how she plays, and also why she begged me to assist her. I am delighted to do people favors, provided they do not plague me incessantly. But she is not content if I spend a couple of hours with her every day. She wants me to sit there the whole day long— and, what is more, she tries to be attractive. But, what is worse still, she is *sérieusement* in love with me! I thought at first it was a joke, but now I know it to be a fact. When I perceived it . . . I was obliged, not to make a fool of the girl, to tell her the truth very politely. But that was no use: she became more loving than ever. In the end I was always very polite to her except when she started her nonsense—and then I was very rude. Whereupon she took my hand and said: "Dear Mozart, please don't be so cross. You may say what you like, I am really very fond of you." Throughout

the town people are saying that we are to be married, and they are very much surprised at me, I mean, that I have chosen such a face. . . . She is nothing but an amorous fool.[7]

It appears that the rumors of their marriage going around town had been spread by Josepha herself. This delusion would not have pleased anyone: not Mozart, nor likely her parents, certainly not Cäcilia Weber. Yet in the end, Mozart was enormously generous to Josepha the pianist. He taught her devotedly, performed with her, wrote for and dedicated pieces to her, and gave her the foundation of what became a career, within the confines of what that meant for a female pianist. His respect for her judgment was shown in his letting Josepha edit and supervise some of his publications in Vienna.[8]

MOZART'S FIRST VIENNA SUMMER, IN 1781, WAS HOT AND HUMID, PUNC-tuated by thunderstorms. By his standards he composed little, spending his time looking desultorily for an apartment, strolling in the Prater, socializing and salonizing, and waiting for Stephanie's libretto to appear.[9] In early July he reported to Salzburg from the country home of Count Johann Karl Philipp von Cobenzl, where he had been invited: "The little house is not much, but the surroundings!—the woods—where he had a grotto built that looks as if it'd been done by Nature herself."[10] It was one of the few mentions of nature in his correspondence, and he mainly cites a man-made grotto that agreeably mimics nature.

He had learned from some source that sister Nannerl had a suitor, and this interested him highly. His letters to her remained affectionate but now came out subdued, with little of the old playfulness and quasi-flirtatiousness. "I'm so glad that the ribbons were to your liking . . . Frau von Auerhammer [sic] was kind enough to get them for me, would not let me pay for them and instead asked me to send you her best regards . . . Now I would like to know how things stand with you and a certain good friend. Please write me about it! Or do I no longer have your confidence in such matters."[11] The good friend was Franz Armand d'Ippold, director of a school for boys of the nobility and a councillor for the Salzburg court.[12] Mozart encouraged the connection as best he could, turning it into an opportunity to reunite the family—not in Salz-

burg, but in Vienna. "I feel certain that you and d'Yppold [*sic*] have . . . no future in Salzburg. But could not d'Yppold do something <u>here</u>? . . . Were things thus arranged, you would no doubt marry, inasmuch as, believe me, you could earn money enough here . . . by giving private concerts and lessons. You would be much in demand and well paid." Beyond that, "My father would have to resign and come too, and we could live together again with much contentment . . . Even before I knew you had become serious about d'Yppold, I had something like this in mind for you. Only our dear father had become the stumbling block, for I wanted the man to be untroubled and not torment and vex himself. Pursuing this path might bring the desired end, for with your husband's income, yours, and mine, we could get along and provide him with a tranquil and comfortable life."[13]

Here he sounds more than a little like his father, issuing plans for the family. But did he mean it? Did he really want Papa in Vienna, looking over his shoulder again? There is no indication that the offer was discussed or considered. For her part, Nannerl clearly welcomed the attentions of d'Ippold, but to Wolfgang's disgust, Leopold put an end to the match. He wanted, if anybody, somebody richer and better titled as husband for his daughter. As always, Papa ordered and Nannerl obeyed.

In short order another point of contention broke out with Leopold, one having to do with rumors of courtship on Wolfgang's part. Mozart wrote home that he was looking for a place to live away from the Webers, "because people are gossiping . . . I would dearly like to know what kind of joy certain people derive from spreading groundless rumors all day long;—just because I am living with them, people assume I'm marrying the daughter." The daughter in question was Cäcilia's second youngest, Constanze, then nineteen. Mozart had gotten to know her in Munich around the debacle with Aloysia and had given her some piano lessons and voice coaching.[14] Despite his protests Mozart was spending time with her; they were going for walks in the Prater and generally pursuing something that resembled a courtship, whether or not he admitted it to Papa or to himself. He continued,

If I've ever thought about <u>not</u> getting married, it's definitely now!—The last thing I wish for is a rich wife, but even if I could

make my fortune by marriage right now, I could not oblige, because I have too many other things on my mind—God has not given me my Talent so that I should hitch it to a woman and waste my Young life in idleness . . . I have nothing against the state of matrimony, but at the moment it would be a disaster for me . . . if I had to marry every lady with whom I've been joking around, I would easily have collected 200 wives by now.[15]

This is reasonable enough; he was just beginning to feel his way into a new and promising situation, and he resisted the idea of getting attached at this point. But he was by no means the master of his fate and his feelings that he supposed himself to be. He may not have realized yet to what degree Vienna was a rumor mill by definition. He probably also did not suspect that a prime source of the marriage rumors was Constanze's mother. As soon as he arrived to room at Cäcilia's house, she had begun spreading a nice little net for him. Now, it appears, she had made a show of indignantly ordering him out of the house, citing compromising rumors about him and Constanze that in fact she had fomented herself.[16]

When Wolfgang and Constanze were alone, at least, they could act like lovers, he in his puckish fashion: he wrote in Constanze's prayer book a riddle about "Trazom" receiving a keepsake, "and from whom does he hope to receive it? From Znatsnoc. Don't be wholly too devout. Good night."[17]

At the end of July the new singspiel libretto arrived, and Mozart pounced on it. He wrote,

Well, the day before yesterday Stephanie . . . brought me a libretto . . . I must tell you frankly that, unpleasant as he can be at times to other people . . . he is a good friend to me.—The libretto is good. The subject is Turkish and the play is entitled: Bellmont und Konstanze oder die verführung aus dem Serail. I'm going to write the overture, the first act chorus, and the final chorus in the style of Turkish music . . . I am so excited about working on this libretto that I have already finished the first aria for Cavalieri and one for Adamberger as well as the trio that will conclude the First Act.[18]

In other words, at first look, having had no inkling of the libretto's story or setting, he dashed off two arias and a chorus in a couple of days, over three hundred bars of music.[19] The occasion for the opera was an important one for the court. The year before, Joseph II had met with Empress Catherine the Great of Russia about a threat brewing with the Turks. Between Austria and Russia, an alliance was taking shape that would turn out a fateful one for Joseph and his kingdom. Empress Catherine had gained the throne by deposing her husband the tsar, father of Prince Paul Petrovich, who was now being kept on a short leash. Paul was due to visit Vienna in mid-September with his German wife, Princess Sophia Dorothea of Württemberg, and the opera handed to Mozart was to be premiered by the National Singspiel as part of the festivities. So the commission was a considerable honor for a new composer in town. Rival composers would have been fuming.

A Turkish subject was apt for the political moment, not only because of the current Turkish threat, but also the coming one-hundredth anniversary of the defeat of the Turks outside Vienna in 1683. The exotic setting also, as Mozart well knew, played into a current Viennese mania for all things Turkish: fashion, military uniforms, music. As sometimes happens, a culture had developed a fascination with the trappings of a former, and perhaps future, enemy. Which is to say that a Turkish opera at this point was going to have a fashion trend behind it. Oddly, in the letter when referring to *The Abduction from the Seraglio*, Mozart calls it the *Verführung* (seduction) rather than *Entführung* (abduction). This was probably a simple word switch in haste, but the image of seducing one's lover out of captivity is intriguing and, in a word, Mozartian.

As with seria librettos, buffa stories were promiscuous. Stephanie adapted his from one by popular librettist Christoph Friedrich Bretzner. The plot turns around a character familiar to fiction and stage in those days, the supposedly barbarous Oriental potentate who turns out to be a munificent soul. In this case it is Pasha Selim—originally Spanish, as it turns out, but occupying a throne in Turkey. As usual, with this project Mozart was going to be working with a set of conventions: the German comic genre of singspiel with its spoken dialogue (looser in layout than opera seria, but still with predictable elements); the exotic or rather pseudo-exotic Turkish setting (which had relatively little to do with the reality of the country's actual culture, or its music for that

matter); Pasha Selim the enlightened Oriental potentate; the buffoon Osmin amounting to Hanswurst in a turban; and the lovers who will be rescued after suitable contretemps.

Mozart was also going to be working with singers he was familiar with, who happened to be some of the finest voices available: hero Belmonte sung by leading tenor Johann Valentin Adamberger; heroine Constanze, by the Vienna diva Caterina Cavalieri; and as Osmin, Ludwig Fischer, the premier buffa basso of the day. All of them would have a future with Mozart. That the heroine of the story was named Constanze (sometimes spelled with a *K*) was a coincidence, but one he would embrace in the music. He set to work with his usual fervor, but the opera would not be done by September, Paul's visit was delayed until November, and the court decided to postpone the opera in any case. The gestation would stretch well into 1782. It would turn out to be one of the few times Mozart had a chance to compose an opera at his leisure.

AT THE BEGINNING OF SEPTEMBER HE ESCAPED FROM THE WEBER house and moved first into the Auernhammers' for a couple of weeks, then into a rat-infested flat they found for him, then to a cramped third-floor room on bustling Graben Street, a minute's walk from St. Stephen's Square in the center of town—and still close to the Weber house.[20] He stayed there for most of a year. There were shops on the ground floor of the building and lodgings of assorted sizes. The building was owned and most of it occupied by imperial court purveyor Adam Isaac Arnstein and his wholesale business. Arnstein was Jewish, and his importance as a businessman had elevated him to the only one of his persuasion allowed to select and lease his own place in the inner city. (At that point Jews were not allowed to buy property.)[21] Adam, his son Nathan, and Nathan's wife Fanny, eventually to become a celebrated saloniste, were the first of several Jewish friends and patrons Mozart acquired in town.[22]

Getting out of the Weber house did not spare him Papa's accusations. One Peter Winter, a Munich violinist who knew Mozart and had studied with Antonio Salieri, had written to Leopold advising that his son was involved with Constanze Weber, and the girl was a scheming slut. This was seconded by Salzburger Franz Gilowsky, supposedly a

friend to Wolfgang, who was outraged to find him gossiping to Leopold. In Vienna, meanwhile, a Herr von Moll was declaring Mozart a philanderer whose arrogance and tactlessness had turned everybody against him.[23] This is how Vienna played the game, when it came to rival artists. In September, weary of it all, Mozart wrote Leopold in heat, "I can see . . . that you put more credibility in the gossip and scribblings of others than in me—as if I were an arch-scoundrel or a dummy or both—and that, in fact, you have no confidence in me at all. But I can assure you that this doesn't really bother me—let the people write until their eyes pop out of their heads."[24]

In short, Mozart was falling in love though not yet ready to declare it, and he was dismayed to be hearing about it from every quarter. Jerked back and forth by Cäcilia and his father and the subject of hostile public gossip, he was being put through the wringer for what should have been a simple matter of love and courtship. Loving and losing Constanze's elder sister Aloysia had taught him that romance can be a tricky business, but that experience, from a blissful high to a wretched low, had none of the paroxysms of this current distress around Constanze and her family. His lies and obfuscations about the situation, meanwhile, only fanned the flames.

He kept trying to get Leopold involved with his work on *Die Entführung aus dem Serail*, hoping for the kind of exchange of ideas they had so agreeably indulged in with *Idomeneo*. At the end of September he sent some musical excerpts home. Copied on the reverse of his letter was the text of Constanze's aria, "Ah, I love you," in the hand of Constanze Weber.

Still, it did no good. In the weeks after the break Wolfgang wrote eight letters to Salzburg and apparently got only one or two in return.[25] Leopold had declared something on the order of a silent treatment, pursuing a distant and pathetic resistance to his son's defection. But Wolfgang tried, tried, tried to get him interested in the opera, in the process revealing a great deal of how he thought about and worked with music and character. Once again he was looking over his librettist's shoulder, adding this and cutting that.

The original text began with a monologue, but I asked Herr Stephani [*sic*] to make a little arietta out of it,—and create a Duett

instead of these two prattling with each other after Osmin's little song.—Since we gave the part of Osmin to Herr Fischer—who has an outstanding bass voice . . . we had to take advantage of such a man, especially since he is a great favorite with the public here . . . I gave him an aria in the First Act and will give him one in the 2nd Act as well.—I described to Stephani exactly what I needed for the aria;—in fact, I have finished most of the Music already before Stephani even knew anything about the change.

Now he is asking a librettist to do something novel, write verses to a number he has already written, the music setting the tone and direction of the text. There is no indication in the letters that Stephanie resisted any of this. He was a highly experienced theater man and would have understood how thoroughly Mozart knew his business. Mozart continues,

Osmin's anger will be rendered comical by the use of Turkish Music.—In composing the aria I made Fischer's beautiful deep tones really glisten . . . The passage <u>Therefore, by the beard of the Prophet</u>, etc., is, to be sure, in the same tempo, but with quick notes—and as his anger increases more and more, the allegro assai—which comes just when one thinks the aria is over—will produce an excellent Effect because it is in a different tempo and in a different key. A person who gets into such a violent rage transgresses every order, moderation, and limit; he no longer knows himself.—In the same way the Music must no longer know itself—but because passions, violent or not, must never be expressed to the point of disgust, and Music must never offend the ear, even in the most horrendous situations, but must always be pleasing, in other words always remain Music, I have not chosen a tone foreign to F, the key of the aria, but one that is friendly to it . . . the more remote A minor.

It is as if this passage is following his creative process as he pens the music on paper, phrase by phrase setting the text, *acting* the text, while shaping a lucid "abstract" musical line with a progression of keys at once expressive and logical—and no less, something that will make the

celebrated Ludwig Fischer look good. Call the end of that account, the need to be "pleasing," a bit of hyperbole for the sake of Leopold's sensibility. Yes, Mozart is insistent on the musicality of everything he does, but he also wants to reassure Papa that he is not going to do anything disruptive that might offend his audience.

He goes on more specifically about expressing images and action in music:

Now about Bellmont's [*sic*] aria in A Major. "Oh how anxious, oh how passionate?" do you know how I expressed it?—even expressing the loving, throbbing heart?—with two violins playing in octaves.—This is the favorite aria of everyone who has heard it—it's mine too.—And it was written entirely for Adamberger's voice; one can see the trembling—faltering—one can see his heaving breast—which is expressed by a crescendo—one can hear the whispering and the sighing—which is expressed by the first violins with mutes and one flute playing unisono.[26]

Finally Leopold deigned to comment on the text of the *Entführung*, to which Wolfgang responded with relief, "As far as Stephani's work is concerned, you are quite right, indeed.—Yet, the poesie is totally in tune with the character of this stupid, coarse, and malicious Osmin.— and I am well aware that the kind of verse used here is not the best—but it agrees so completely with the musical ideas that had been wandering around in my head . . . I couldn't help liking it." He goes on to stake a claim contra Gluck, whose reform was founded on the conviction that the text, the drama, was the master in opera and that music must be its servant.

This was a long-standing assumption, especially when it came to seria, which is what Gluck was writing. As he (or his forceful librettist Ranieri de' Calzabigi) wrote in the preface to *Alceste*, "I determined to strip [opera] completely of all those abuses, whether introduced by the mistaken vanity of the singers, or by the excessive obligingness of the composers, that have long been disfiguring Italian opera and have turned the most magnificent and beautiful of all the spectacles into the most ridiculous and boring. I determined to restrict music to its true function, namely, to enhance poetry in terms of the expression and the

situation it relates."[27] Mozart subscribed halfway to these ideals at best. But now, perhaps for the first time among composers of opera, he reversed the equation:

> The Music reigns supreme . . . where words are written expressly for the Music and not merely to suit some miserable rhyme here and there . . . I'm talking about creating words . . . which ruin the composer's entire concept—Verses are probably the most indispensable element for music—but rhymes—created solely for the sake of rhyming—are the most detrimental . . . It is so much better if a good composer, who understands something about the stage and can make a suggestion here and there, is able to team up with an intelligent Poet and create a true Phoenix.—In such a case one need not worry about the applause even of the ignorant![28]

Mozart had spent his youth setting Metastasio texts that were considered illustrious literary works in themselves, many of them set by multiple composers who were happy to attach their names to the famous writer. Now Mozart shoved that tradition aside: A libretto was not really a work of literature and not just a vehicle for the music. It needed to be fundamentally *shaped* for musical effect, and so as composer he needed to have a hand in it. His complaints about rhyming as a literary device would recede when he found a librettist who could rhyme fluently and musically, but mainly he was interested in what a text evoked and in its rhythms: the musical expression, color, character, movement, and structure had to be implicit in the words.

Of course, this did not mean that Mozart was cavalier about story and character; no composer ever acted story and character in tones more consummately than he did. And he would not touch a libretto that had no literary value. But he refused to allow his music to be subservient to anything. His attention to abstract musical values within opera, how he addressed the eternal challenge of conveying action and drama moment by moment while creating music coherent in its own terms, was going to prove supreme among composers of opera.

At age twenty-five, Mozart was finally putting his earnings in his own pocket and making his own decisions however dicey, luxuriating

in his freedom even as he fended off attacks on it. How he had matured emotionally is apparent from what appears to have been his last letter to the Bäsle, the little cousin with whom he had first explored his sexuality, to whom he had once written letters of sparkling naughtiness that echoed their amusements in person. He may have seen her in Augsburg in March, on a visit after the premiere of *Idomeneo*. Now he wrote, soberly and vaguely,

> I've been eagerly awaiting a letter from you, dearest cousin, for quite some time now . . . In the meantime, as you probably know, a number of significant changes have occurred in my life that have given me a lot to think about but also cause me annoyance, vexation, worry, and a troubled mind, all of which can serve as an excuse for my long silence.—As for all the other things, let me say that the gossip that people like to circulate here about me is in part true and in part—false . . . Let me add for your peace of mind that I do nothing—without a reason—and in fact—without a well-founded reason.—If you would have shown me more friendship and trust and had turned directly to me rather than to others—I mean!—but quiet!—If you had turned directly to me, you would probably know more than everyone else—and, if it were possible, more than I know myself!

There was some trouble concerning the Bäsle that she had not confided to him. He knew too that she had heard rumors about Constanze and maybe was not happy about that. He does not detail what he means by the true and false, but that probably has to do with Constanze as well. No doubt his cousin would have understood from the tone of his letter, more than the content, that the fun and games were finished. The cousins' connection was likely finished too. He ended, "keep me in your friendship, which is so dear to me," but there is no record they ever met or corresponded again.[29]

There is also no record of how the Bäsle dealt with it. Three years after Mozart's last letter to her she would have a daughter by a canon of Augsburg Cathedral. It seems that the Bäsle became a *Pfaffenschnitzl*, a "priests' morsel," after all. She was hardly alone. A visitor to Augsburg wrote, "The freedom of most of the citizens of Augsburg is as cheap as

the virginity of their daughters, who were bought in dozens every year by the gentlemen of the Cathedral here."[30] In the register of births, she listed her name as "Trazin," an echo of her onetime playmate's joke of reversing his name: Trazom. In a long life, the Bäsle never married.[31]

Another rebuff from Salzburg fell on Mozart's name day. It was routine for family members to salute one another on the day, but nothing about it came from the Tanzmeisterhaus. Wolfgang celebrated the occasion with a midday dinner at Baroness Waldstätten's. He had fallen into a warm friendship with this noblewoman in her late thirties.

A few days later he and Josepha Auernhammer played in a concert at her family house, the listeners including new Mozart patrons Countess Wilhelmine von Thun and Baron Gottfried van Swieten, who was involved in educating Viennese musicians about the glories of Handel and J. S. Bach. (The baron and Mozart had first met back in 1768.)[32] Mozart and Josepha played the Concerto for Two Pianos, K. 365, which he had produced a couple of years before for himself and Nannerl. More significant was the premiere of a new Sonata for Two Pianos in D Major, K. 448, written for himself and Josepha and for this occasion. For Mozart pieces like this were intimately bound up in social occasions and in relationships. He had written a collection of four-hand and two-piano pieces for himself and his sister, most delightfully the other D Major for Piano Four-Hands, K. 381, from a decade earlier.

The Vienna D Major is a high-spirited outing as well, but quite another matter: richer, more expansive, made not for a sister or a lover but for a skilled pupil one wants to show off. To that end, in the premiere he gave Josepha the first part and himself the second.[33] The music celebrates a relationship—or rather the relationship galvanized the music, which manages to be something at the door of a major work without showing its hand trying to be. Mozart's four-hand pieces tend to be orchestral in effect, involving big textures that resound on the walls of a music room and are watered down in a larger hall. K. 448 begins with a mighty stride down a D-major chord, dissolving into music of dashing and intricate tracery, the two soloists tossing ideas back and forth as equals, their interaction foreshadowing his Vienna piano concertos.[34] The quietly thrumming beginning of the second movement echoes the placid lyricism of the older D-major duo; the two pianos call to each other with little figures like birdsong. The finale jumps off at Allegro

molto and exercises the fingers of the players, building from intricately intimate moments to grand congregations of tone. The music makes manifest that Josepha was as good a pianist as Mozart reported her to be.

Russian grand duke Paul and wife showed up in December, but rather than the original idea of premiering *The Abduction*, it had been decided to honor the royal visit with a celebration of the aged and failing Gluck. Duke Paul visited the master and gallantly assured the old man that no one's music moved him more. Several Gluck productions were mounted, one a festive performance of the great reform opera *Alceste*, at the Schönbrunn Palace. Ailing and near death as he was, Gluck supervised the productions. Mozart attended some rehearsals and studied both the music and the principal singers, for whom he was writing his singspiel.[35]

During the festivities Mozart also, at Joseph's request, wrote and improvised some variations on Russian songs, and he was invited to entertain the visiting grandees in the rooms of Joseph's brother Archduke Maximilian. Mozart obliged, found the duke and grand duchess charming, but in writing home he dismissed the archduke as "an eighteen-year-old stick and truly silly." In connection with the performances, there was something of a bungled ball at Schönbrunn that Mozart, who was not present ("No lover of crowds, digs in the ribs, and blows," he wrote, "Herr Ego did not attend"), reported that tickets ended up being distributed randomly to all and sundry, barbers and chambermaids crowding into the hall with the nobility, and in the middle of things "the Viennese mob . . . pressed forward to the point of pushing the Grand Duchess free of the Emperor's arm and into the middle of the dancers. The Emperor began to stamp, cursed like a street beggar, pushed back a crowd of people, and vented his rage right and left."

He also reported home the rumor going around town that the emperor was enamored of the grand duchess and, for good measure, her fetching younger sister Elizabeth. The rumor was unlikely; Joseph had buried one wife he adored and one he loathed, and by this point he had sworn off wives and women entirely. But Mozart loved to investigate gossip as, among other things, grist for the mill. He speculated with manifest glee about the emperor's rumored attentions to the teenager, "It hangs in the balance whether this morsel is to be for himself or for a Tuscan prince; more likely the latter. All the same, in my eyes

the Emperor shows himself entirely too affectionate with her, without cease kissing her hand, first one, then the other, and often both at once. I am really astonished because she is, you might say, still a child. But if what people allege is true . . . I shall, in respect to this affair, return to the belief that charity begins at home."[36]

That same December, an Italian named Lorenzo Da Ponte turned up in Vienna. More or less on the run from authorities, he was a poet, scholar, and adventurer looking for work as a librettist for the singspiel company, even though by that point he had never actually written a libretto. A grandly enterprising sort, Da Ponte knew how to get the ball rolling: he visited the retired and venerated Metastasio, with a laudatory poem as calling card, and received a blessing from the master of opera seria. (Metastasio died the following spring.) Connections would soon lead Da Ponte to Salieri, to Joseph's court, and eventually, historically, to Mozart.

For Mozart December 1781 was eventful in several dimensions. On the eighth, Artaria, the leading Viennese publisher, announced six violin sonatas from him. A mix of four written that year and two earlier, they were dedicated to Josepha Auernhammer, who prepared them for publication.[37] Mozart was not particularly concerned about leaving the editing to her; mainly he wanted to send them into the world in the hope of securing some cash.[38]

Call the set, K. 296 and 376–80, a mixed blessing, from routinely charming to splendid. Four of them are among his ambitious violin sonatas, even though one of those, the G-major K. 379, was produced between eleven and midnight the day before it was premiered—he only had time to write down the violin part, and at the performance played the accompaniment out of his head.[39] It is a striking piece both in expression and form, beginning with an expansive and songful Adagio introduced by rich rolled chords on the piano—music strikingly poignant for G major. This leads to an Allegro in G minor—for Mozart often a key touched by Sturm und Drang, and so it is here, a movement of propelling energy verging on obsession. Sometimes what holds a Mozart piece together in this period is as elusive as it is unmistakable, but part of what draws the G Major together musically and expressively is a consistent presence of half steps in that interval's lamenting mood. In his later music Mozart would pay more discernible attention to gen-

erating themes in a work from small motifs. His eventual association with Haydn, who by now did this reliably, would strengthen him in it.

K. 377, in F major, begins on a bit of a hectic note, the violin giving chattering triplets, and triplets will persist unflagging through the movement. It has an unusually long, intense, contrapuntal development section that in effect drives right into the recapitulation, still developing. In simplest terms, a sonata-form development can take three tacks: a short palate cleanser between exposition and recapitulation, with a new key or two for variety, which is what Mozart had done more often than not in his sonata-form movements; or a new idea in the development, contrasting with what came before; or a kind of improvisation on material from the exposition. In the next generation, Beethoven would concentrate on the latter, expanding his developments to new ambitions and lengths. Here in the F Major, this is what Mozart is doing as well, foreshadowing more expansive developments in his later work.

The Sonata K. 378 in B-flat Major is the most expansive of the group, starting with a first movement nearly twice as long as those in the other sonatas. It begins with a little galant tune that amounts to a feint, because it initiates a movement of wide-ranging color and expression, tending to pensive. As in the F- and G-major works, the slow movement is the soul of the sonata, something on the order of a song of solace. The piece ends with a dashing, waggish Rondo.

The last entry in the set is K. 380 in E-flat Major, another key that will have a particular resonance in Mozart, in the direction of powerful and noble—those kinds of sentiments, aimed not at the jugular or at the dancing feet but at the heart. Here is the expressively widest-ranging entry of the set. Its first theme is largely a series of bold gestures; its second, a skittering and thrusting tune. The movement has another long development, bringing in new ideas that add almost a sense of apprehension to the whole. Rather than the usual A-flat second movement for a piece in E-flat, he picks G minor for a sustained lament that barely departs from its keening and atmospheric theme. The Rondo finale begins as gaily as rondos usually do, the form A B A C A, the C section a long and passionately propelled stretch of C minor.

These sonatas were nothing radically new for Mozart, but they added to what he had already achieved, which was to set the course of the violin sonata for generations to come. As he would manage again

and again, he took a genre of which not all that much was expected, in this case a *Hausmusik* piece traditionally aimed toward reasonably expert lady pianists and often less expert male violinists, "clavier with violin accompaniment," and made it into a model that would endure.

IN DECEMBER 1781, WOLFGANG FINALLY CAME CLEAN WITH LEOPOLD about Constanze. Why had he waited? Was he anxious about Papa's response? Indeed he was, and had every reason to be. He may also have been waiting for his own feelings to come clear, and they had to have been tangled up with practical apprehensions. For all the attention Mozart was receiving in Vienna, he was not yet firmly established, which is to say that he had no job, so no reliable means of supporting a family. At the same time he was proposing to join a family presided over by a scheming mother-in-law he could not trust, and to marry the sister of a woman he had loved and lost, Aloysia, for whom he likely had lingering feelings.

His letter home about Constanze was the most careful and thought-out of anything Mozart had written to his father since his mother died in Paris. In it he not only announces his intention; he formulates an ethos of marriage. In his previous letter he had written vaguely that he "was unable to fulfill all your wishes in the manner you had expected of me." Leopold sensed something was up, and demanded to know. What he learned confirmed yet another of his fears.

> Dearest father, you're asking me to give you an explanation of the words I wrote to you at the end of my last letter! Oh, how happy I would've been to open my heart to you long ago; but the fear of reproaches you might have made to me . . . kept me from telling you . . . It has become my endeavor in the meantime to secure a small but sure income—which, together with what opportunity might provide, will allow me to live here reasonably well—and then—well, get married!—You are taken aback by this thought?—I beg you, dearest and best father, listen to me! . . . The voice of nature speaks in me as loud as in any man, louder perhaps than in some big, robust brute of a fellow. It's impossible for me to live as most young men live nowadays.—First of all, I

have too much religion in me, second, I have too much love for my neighbor and too great a sense of decency that I could seduce an innocent girl, and third, I have too great a horror and disgust, dread and fear of diseases, in fact, I like my health too much to be playing around with whores; I swear that I never had anything to do with a woman of that sort.[40]

In contrast to so much of what Mozart wrote to his father, this letter rings true. He's finally confessing his courtship of Constanze, and he places his foundation of marriage first on "the voice of nature," by which he means sexuality: a powerful sense of it that is not "brute" but a matter of nature, which is God's nature. He protests that unlike most young men of the time he does not frequent whorehouses, out of religious scruple and fear of disease: "No matter how strong such a drive is in me, it is not strong enough to tempt me." If Mozart never frequented prostitutes, he was indeed an unusual young man in those days, yet it's possible that this was the truth as well. (His horror of venereal disease originated long before, when in Mannheim he encountered old friend Josef Mysliveček disfigured by treatment for syphilis. If Mozart did keep a rein on a passionate sexual appetite, it was another example, perhaps the most telling of all, of how relentlessly self-protective he was.) To these ideas can be added words he wrote Leopold earlier about the likes of him, commoners, marrying not for money or status, as the nobility did, but for love, companionship, family—sexuality an integral part of it all.

However Leopold judged this letter's relative truth, he would have not gotten far into it without wrath and despair. What he had dreaded all along had come to pass: Cäcilia Weber had foisted one of her daughters on his son. Constanze had been reported to Leopold as a scheming slut. In the letter Wolfgang declares her "the Martyr of the family, the most kindhearted, the most skilled, in one word, the best of them all." He builds up Constanze by putting down her sisters: the oldest sister Josepha is "a lazy, coarse, deceitful person, not to be trusted"; his old flame Aloysia "a false, malicious person and a Coquette"; the youngest Sophie "all too frivolous."

He paints Constanze as an unassuming sort with no bewitching charms or excessive high spirits, a modest maiden suited for domesticity: "she is not ugly, but also not really beautiful—her whole beauty

consists of two little black eyes and a graceful figure. She has no great wit but enough common sense to fulfill her duties as a wife and mother. She is not extravagant in her appearance, rumors to that effect are totally false—to the contrary, she is in the habit of dressing very simply." And just imagine, "she does her own hair every day." A portrait of the young Constanze by her actor brother-in-law Joseph Lange, who was a skilled amateur painter, shows her as not possessing the sort of beauty Aloysia had, but attractive enough, with a suggestion of a voluptuous figure.

"I could fill pages with my description of all the stormy scenes that have happened in that house on account of the two of us," Wolfgang added, referring to Cäcilia. On the face of it, from the raging mother onward the auguries for this marriage appeared meager. Soon it got worse. In a letter Leopold read to his horror that Mozart had himself drawn up and presented Cäcilia with a marriage contract, declaring that if within three years he did not marry Constanze—whom Cäcilia declared to be compromised by his attentions—he would pay the family three hundred florins a year for life.

The idea for the contract surely came from Cäcilia, enforced by Constanze's guardian, one Johann von Thorwart. As if he had no idea how it would affect his father, Wolfgang reported, "This guardian filled the mother's ears with stories about me for so long until she finally told me about it and asked that I have a talk with him myself . . . He came—I spoke with him—the result was . . . that he told the mother to forbid all association between me and her daughter until I had settled the matter with him in writing."[41] Thus the contract. The resources Cäcilia actually commanded she made sure Mozart did not hear about: the annual seven hundred florins she had extracted from Lange in order for him to get her permission to marry Aloysia, and she had also obliged him to pay off nine hundred florins she had borrowed. She likewise hid the fact that Aloysia was helping support the family.[42]

The situation had become operatic, virtually opera buffa in plot if not in the least amusing. Now into the mise-en-scène had entered Thorwart. Widows were required by law to have a male guardian for their children, but Thorwart was more than just the overseer of Mozart's intended; he was also the imperial and royal court theatrical supervisor, therefore someone an opera composer could not afford to

cross. Mozart handled him with care. Rich and high placed as he was, Thorwart was not above essentially blackmailing Mozart on the basis of compromising rumors propagated by Cäcilia Weber.[43]

So, abetted by a well-placed guardian, Cäcilia was treating her daughters as commodities to be dealt to someone ready to pay. For his part, Mozart would refuse to acknowledge that he was being gamed. In a fury, Leopold wrote that she and Thorwart should be treated like Viennese convicts: put in chains and made to sweep the streets with signs around their necks reading, "Seducers of Youth." Wolfgang replied, "Even if what you say were true, namely that they intentionally opened all doors to me and allowed me the run of the house, thus giving me all the opportunities, etc., etc., even then such a punishment would go too far;—at any rate, I don't need to tell you that it wasn't like that—I am hurt enough by your insinuation that you think your son would frequent a place where such things were going on." Moreover,

> Don't suspect my dear Constanze of having such conniving thoughts—you must believe me that I could not possibly love her if she were a schemer. She and I—both of us—became aware of her mother's plans already some time ago—but she is deceiving herself—because—it's her wish to have us after we're married, in her house, for she has an apartment to let—but nothing will come of it,—for I would never want to do that and my Constanze even less.—au contraire—it's her intention to visit her mother very rarely, and I'll do my best to see to it that it won't happen at all.[44]

In truth, Constanze was being run as ragged by her mother as was Mozart. Her first declaration of independence from Cäcilia was a dramatic gesture: she took the marriage contract from her mother and tore it up, telling Wolfgang, "Dear Mozart! I need no written assurance from you. I believe what you say."[45] This hardly daunted Cäcilia. Desperate from the uproar, Constanze fled the family house (which, with fine irony, was called Zum Auge Gottes, "The Eye of God") to the palace of Mozart's friend Baroness Waldstätten, returned home, then fled to the baroness again, whereupon Cäcilia threatened to call the police to drag her back. Sister Sophie tearfully sent word through a Weber housemaid begging Mozart to persuade Constanze to come home.[46]

This pathetic situation may finally have prodded him to take the only available solution, his father notwithstanding. Of course all this was played out in large degree in the public eye, in the buzzing whirl of Viennese gossip. Some of Mozart's friends, observing from the sidelines, began calling *The Abduction from the Seraglio* by a more germane title: *The Abduction from the Auge Gottes*.[47]

In the midst of these tribulations of life and love, art continued on its course. If Mozart had a tremendous sense of self-protection concerning himself and his work, he also had relentless concentration. At the end of December he was summoned by Joseph II for an occasion of great moment for his reputation in Vienna: at the Hofburg on the day before Christmas, he was to engage in a piano duel with an Italian virtuoso whom many called the finest pianist alive, Muzio Clementi.

As noted, connoisseurs in those days, at least the narrower of them, tended to be more interested in how glitteringly a virtuoso played than in what pieces he or she happened to be playing. This was reflected in the disdain of more discriminating connoisseurs for the musical value of concertos, which they considered a mere excuse for showing off. But showing off was what many aficionados wanted to hear, so duels of virtuosos were carried on like a sport, before militant partisans of both sides. Clementi, four years older than Mozart, had also been a celebrated child prodigy. He was visiting Vienna at the height of his fame as a virtuoso and composer, part of a European tour that had included an appearance before Marie Antoinette in Paris.[48]

Before an invited audience, the duel was presided over by Emperor Joseph and the wife of Russian prince Paul, the Grand Duchess Maria Feodorovna, a fervid Clementi partisan. In public Joseph maintained neutrality, but privately he made a bet with the duchess that Mozart would claim the prize. Mozart's patron Countess Thun had provided him with her Stein piano, which he was familiar with, but Joseph decreed that he could use it only when playing solo. In the parts of the duel where they were playing together, trading off passages, he required Mozart to play a clavier that Wolfgang reported to Leopold as being out of tune and having sticking dampers. It was as if Joseph had, for his own devious reasons, given his favorite a handicap.

Clementi knew all about Mozart, who claimed to Leopold that he had never heard of his opponent. The two first met in Joseph's music

room before the duel. At first sight, Clementi recalled, from the way Mozart was dressed he took him for a high court official. It was not until they started talking about music that he realized whom he had before him. The meeting was genial enough. On Mozart's side, it did not stay that way.

He reported the details back home to Salzburg. After they had exchanged sufficient pleasantries, Joseph told Clementi to go first; he played a prelude and sonata. All right, said Joseph to Mozart, fire away. He supplied a prelude and some variations. The duchess handed them manuscript sonatas by Giovanni Paisiello ("poorly written out in his own hand") and they played them, alternating movements; then each was asked to improvise on a theme from the piece.[49] Finally Joseph gave them a theme on which they improvised back and forth.[50] This spectacle of two of the greatest musicians of the day contending at the height of their powers would have been an overwhelming experience for the connoisseurs, on the order of Mozart's fabled feats in childhood. Afterward the emperor presented Mozart with 225 florins, half his old Salzburg salary for an evening's work. Publicly Joseph declared the duel a draw. Privately, with Countess Feodorovna, he claimed he'd won the bet, Mozart was the winner, and she paid up. Joseph apparently talked obsessively about the duel for months afterward.[51]

As a composer Clementi was not in Mozart's league, but he was of comparable brilliance as a pianist and improviser. In reporting the duel to Leopold, Mozart was at his cattiest: "He is a very solid Cembalo player.—but that is all.—He has great facility in his right hand.—his best passages are Thirds.—Apart from that he doesn't have a penny's worth of taste or feeling—he is a mere Mechanicus"—by which he meant a technician, not an artist.[52] And Mozart did not give up his venom toward this rival: a year later, he wrote home, "Clementi is a Ciarlattano [charlatan] like all Italians . . . what he does well are his passages in thirds . . . apart from that he has nothing to offer—nothing whatever."[53] For his part Clementi was entirely generous, recalling of the encounter, "Until then I had never heard anyone perform with such spirit and grace. I was particularly astonished by an Adagio and some of his extemporized variations."

Mozart could be kind to musicians who were not in his league, as long as they were not getting what he considered undue credit. To

these latter, he could be haughty and insulting. In regard to Clementi he was unusually peevish, even for him. Clementi may have been the most serious keyboard rival he had ever encountered, and his pride was pricked by it. Beyond that, Clementi may have been more of a pure pianist than Mozart. His piano music would be one of the first bodies of work to concentrate intensely on finding idiomatic ways of writing for the instrument as distinct from the harpsichord. When in the 1780s the young Beethoven went looking for models for his piano music, he turned to Clementi, not to Mozart or Haydn.

Speaking with Mozart after the duel, Joseph had added one more kind word: he wished him and Constanze the best for their upcoming marriage.

MOZART HAD REPEATEDLY BEGGED HIS FATHER FOR A BLESSING FOR the marriage, and it had not arrived. Finally he and Constanze decided to go ahead with it. Soon after, Constanze wrote a sisterly note to Nannerl in Salzburg, introduced in a distinctly cautious letter by Wolfgang:

> My dear Constanze has finally plucked up her courage and followed the dictates of her heart—that is to write you, my dear sister, a letter.—If you should honor her—which I dearly wish you would so I could read her pleasure of receiving a letter from you on the forehead of this good creature—if you wish to honor her with a reply, please enclose it in a letter to me . . . I am including here a Prelude and fugue for three parts [Fantasy and Fugue in C Major, K. 394]. . . . The reason that this particular fugue came into being has to do with my dear Constanze.—Baron von Suiten [sic], whom I visit every Sunday, lets me take works by Handel and Bach home with me, after playing them for him at his house.—When Constanze heard these fugues, she fell completely in love with them—now she wants to hear nothing but fugues, particularly, in this kind of composition, Handel and Bach.—So she asked me, because she had heard me play some fugues out of my head recently, whether I had written any of them down?— When I said no—she really scolded me, saying that I didn't want

to compose the most artistic and beautiful things in music; and she did not relent until I composed them.[54]

Constanze's note to Nannerl is appropriately fawning:

I should never have been so bold as to follow the dictates of my heart and to write to you, most esteemed friend, had not your brother assured me that you would not be offended by the step which I'm taking solely from an earnest longing to communicate, if only in writing, with a person who, though unknown to me, is yet very precious, as she bears the name of Mozart. Surely you will not be angry if I venture to tell you that though I have not the honor of knowing you personally[,] I esteem you most highly, as the sister of so excellent a brother, and that I love you and even venture to ask you for your friendship.[55]

The prelude and fugue that Mozart sent home with his letter is an odd item, singular for him in being written as a manifest imitation of J. S. Bach, the prelude melodramatic, the fugue echoing the first one in Bach's *Well-Tempered Clavier*. The fugue goes through some familiar Baroque devices, under the names of augmentation (stretching out the theme) and stretto (quicker entries of the theme), but in the end it comes off as stiff and constrained, sounding almost like a work in quotes. Around this time Mozart started and abandoned more fugues. He was quick to understand the significance of Bach, in whom Baron van Swieten was tutoring him. In the baron's music room, invitees would gather around Mozart at the piano to sing through a Handel oratorio, a Bach cantata, and the like. Mozart arranged a number of preludes and fugues from the *Well-Tempered* for instruments, probably for use at Swieten's soirées, and began playing Bach in private performances.[56] But his late-century musical sensibilities were too ingrained to let him absorb the old master directly into his work as a model. Mozart's response to Bach's counterpoint recalls his teenage effort to join the Italian musical society with an exercise in archaic counterpoint, which was not really his forte and had to be cleaned up backstage by Padre Martini. Bach was to become another in Mozart's amalgam of influences, broadening his sense of counterpoint and its

possibilities, but Bach's voice would not overly affect Mozart's, even when he wrote fugues.

It was in April 1782, soon after this interlude of musical domesticity around fugues, that after the months of struggle to pursue their courtship on their own terms, it all but went up in smoke, yet again in something of a buffa mode. It appears that Constanze was not exactly the unobtrusive domestic soul Wolfgang had painted to his father. Their friend Baroness Waldstätten was something of a notorious figure in the spectrum of Viennese nobility, an amateur pianist who may have studied with Mozart. She was separated from her husband and well known in town for both her sociability and her amorous adventures. She threw parties as boisterous as her lifestyle, and at one of them Constanze, the baroness, and other ladies engaged in a jolly game of forfeits that involved men measuring their calves with a ribbon. Constanze came home to give a giggling report of the affair, at which Mozart was scandalized. He protested, Constanze would have none of it, and in a fit of anger she declared the engagement over.[57]

Immediately she received from Wolfgang a letter of mingled remonstration and pleading, amounting to the kind of minute examination of an issue that he had inherited from his father. Here is Mozart consumed by jealousy, waspish and obstinate, but still meticulous. It is another singular entry in his record of correspondence, in its way as considered as his letters home about his mother's death, if more heated than those.

> Dearest, most beloved friend!—Surely you will still allow me to address you in this manner?—And surely you don't hate me so much that I cannot be your friend anymore and you—no longer mine?—And—even if you don't wish to be my friend any longer, you can't really forbid me to think highly of you, my friend, now that I have become so used to it.—Please consider carefully what you said to me today.—You have, regardless of all my pleas, turned me away three times and told me straight to my face that you wish to have nothing to do with me anymore.—I am not as careless as you in giving up the object of my love and I am not as emotional, unthinking, and unreasonable to simply accept your refusal.—I love you too much to take such a step.—So I call on you once more to think and reflect about the cause of

this unfortunate incident, namely the fact that I voiced my disapproval that you had been so impudent and inconsiderate as to tell your sisters—Nota bene, in my presence—that you allowed some Chapeaux to measure the calves of your legs. No woman intent upon her honor does that sort of thing.—I do understand the <u>maxime</u> that when you are with others, do as others do—but one has to think about certain related matters—whether it is a gathering of good friends and acquaintances?—Whether I am a child or young woman of <u>marriageable</u> age—but especially, whether I am already engaged to be married?—Important too, is whether the people present are of my social standing or of the lower class—or, which is of particular importance, whether there are people present of superior rank?—if it's true that the Baroness permitted the same thing to be done to her, well, that's something entirely different because she is a woman past her prime who cannot possibly excite anybody anymore—besides, she is known to be a connoisseur of the Et cetera . . . If you cannot possibly resist playing along with the others, although the <u>playing along</u> does not look good in a man and even less in a woman, you should have, in God's name, taken the ribbon and measured your calves <u>yourself</u>; that's what I saw <u>honorable women</u> do in similar situations, you should not have had it done by some chapeau.[58]

The letter's mingling of reasoning and wounded lover's outburst more or less served its purpose; their squabble cooled off. This may have been a model for future quarrels, but they would leave few traces. In this case, Constanze had staked her ground and they moved on. They were, after all, heatedly in love and eager for the fruits, if they had not been enjoying them already. Constanze was fed up with her mother and her family and ready to make a home with Mozart, who for a musical girl was an incomparable catch in nearly every way other than the matters of his current lack of a job and his pale plainness. Some reported Mozart as having powerfully seductive eyes that appealed to women, but nobody ever said his face did.

By 1782 Mozart's career was becoming hectic in a way he had never experienced and few musicians ever have. Fewer still would have been able to manage it as he did, out of a surfeit of brilliance, fearlessness,

and energy. For his father he wrote an outline of his daily schedule; and for good measure he sent another copy to Nannerl. The schedule was perhaps a touch idealized, but not by much. His days began with a knock on the door from his hairdresser, who also shaved him.

> At 6 o'clock in the morning I'm already done with my hair; at seven I'm fully dressed;—then I compose until 9 o'clock; from nine to 1 o'clock I give lessons.—Then I eat, unless I'm invited by someone who doesn't eat lunch until two or 3 o'clock as, for instance, today and tomorrow at the Countess Zizi and Countess Thun.—I cannot get back to work before five or 6 o'clock—and quite often I can't get back at all, because I have to be at a performance; if I can, I write until 9 o'clock. After that I go and visit my dear Constanze;—however, our pleasure of seeing each other is often ruined by the galling remarks of her mother . . . I get home around 10:30 or 11 o'clock at night . . . Since I can't depend on being able to compose in the evening, because of the concerts that are taking place but also because of the uncertainty whether I might be summoned elsewhere, it has become my habit to compose a little before going to bed . . . Often enough I go on writing until 1 o'clock—and then of course, I begin at 6 o'clock.[59]

During Lent, when only instrumental concerts were allowed, Mozart was able to secure a hall for himself, probably the prestigious Burgtheater, attached to the Hofburg. His March 3 program was the first in a legendary series of concerts he was to give in Vienna over the next years. It featured numbers from *Idomeneo*; the Piano Concerto K. 175, with a new finale geared to Viennese taste, and some improvisation. He sent the new finale to Papa with a proviso: "Please guard it like a gem—don't give it to anyone . . . I wrote it specially for myself—and no one may play it, except my dear sister."[60] On April 5 he gave another concert at the big Augarten pavilion in the Prater. That program included the Concerto for Two Pianos in E-flat, with him and Josepha Auernhammer soloing; a symphony of his, perhaps No. 24 in B-flat; and another by an amateur, Baron van Swieten, who occasionally indulged in composing.

The letter with his schedule has a postscript by Constanze that, in

a translated approximation, gives a sense of the sort of education she had been provided, which was patently limited. She may have been more proficient in music than in writing her language. "Your dear son has jusst been summoned to the Contessa Thun and hasn't had time to finnish his ledder to his deare father, for which he's verry sorrie, he has given me Comision to let you know this, becaus today is poste day and he don't wish you to be without a ledder from him."[61]

By spring of 1782 the months of tinkering with the singspiel were done. Mozart had been showing the acts to Countess Thun as they were finished; on May 30 he played the third act for her and Constanze.[62] That summer would see two enduring landmarks in his life. The first was the premiere of *Die Entführung aus dem Serail* at the Burgtheater, on July 16. The performance was tumultuous, rocked by racket from cabals hired by some rivals or other to disrupt the music. But the protests were in vain. The opera, calculated with all Mozart's craft to appeal to the Viennese in its fashionable Turkish setting no less than in its music, made a sensation.

On July 27 he wrote Leopold, "I must implore you, implore you for all you hold dear in the world: please give me your consent so that I can marry my dear Constanze . . . I feel that it is absolutely necessary on account of my honor as well as that of my girl, but also on account of my health and peace of mind.—My heart is in turmoil, my head confused—how can one think and work intelligently under such circumstances?"[63] A father's consent for marriage was not legally required in those days, but it was considered obligatory as a matter of custom. Constanze's guardian Thorwart had given the consent on her side. In fact the couple was going to go ahead with the ceremony anyway. Mozart had made his plea as a son; he would never fail to make a show of humble respect for Papa, but he would also never fail to take a path he intended.

Wolfgang and Constanze were married at St. Stephen's Cathedral on August 4. The few witnesses included a well-satisfied Cäcilia Weber and daughter Sophie and guardian Thorwart. The best man was Mozart's surgeon friend Franz Gilowsky. Baroness Waldstätten gave the couple a wedding feast that Wolfgang said was more princely than baronial—princes being higher on the ladder of nobility.[64] Leopold's capitulation, his grudging consent, arrived the day after the wedding.

He soon spelled out in a letter to Waldstätten that "all I can do is to leave him to his own resources."[65]

The auguries of this marriage had been worse than unpromising. They had been pathetic, shabby, farcical. Leopold would never give up his resentment about Constanze. Nannerl sided with Papa to the end; in reminiscences after her brother's death, she wrote that he had made a bad marriage, that she didn't even know how many children he had. Leopold may have viewed Constanze and her mother as gold diggers, but it is an open question what he actually wanted for his son. For both his children Leopold had conventional expectations of getting them married, because in many ways he remained conventional in his attitudes. Yet Leopold Mozart was eternally divided in his attitudes as well—in this case, compulsively jealous of anyone who intruded on the deep-rooted connection between him and his children, whom he had reared up and made famous. What sort of bride would have satisfied him for Wolfgang? His son was not going to marry an aristocratic lady; law and custom put up powerful barriers against that. Maybe Leopold imagined a rich middle-class mate for his son. Just as likely, no match for Wolfgang would have been good enough for him.

As it proved, for all the mess and bad omens, the marriage of Wolfgang and Constanze would turn out splendidly. There is sparse record from this point of what she said and did, but the record shows that he was deeply, uncomplicatedly in love with his wife—and equally in love with love, in all its dimensions, from the marriage bed to children and domesticity and pets and wining and dining and parties and games. And given that Mozart was in the business of making life into art, the presence of love became as essential to his work as it was to his happiness. He would endure sorrow and pain and defeat like everybody else, but Mozart was a man geared for happiness. Love was the chief revelation that bestowed it on him.

MONSTROUS MANY NOTES

In taking up a project what an artist needs to do is to believe in its value and its premises. This may involve some sort of philosophizing. Whether that indulgence contradicts what one believed for the last project, or might proclaim for the next one, is not so important. In their ideals artists are permitted to be promiscuous. The art justifies its ethos, or renders it irrelevant. So the meaningful aesthetic and philosophy is not necessarily the credo that presides over your life's work, but rather the one that best gets done the job at hand. There is no better demonstration of this than Mozart, whose convictions depended on whom he was talking to and when, and what project he was talking about.

He took up *Die Entführung aus dem Serail, The Abduction from the Seraglio,* first because the commission was handed to him and he understood that he had a story whose exotic setting would appeal to the Viennese. More important, he had a libretto that could be made to work, after some judicious tinkering. Moreover, he wanted to write opera in German, partly out of cultural loyalty, partly perhaps because it offered him a path into a different kind of opera than he had been writing in Italian.

German singspiel had contemporary characters and settings, and greater freedom in its layout and the structure of its numbers. Its dramatic foundation came not from ancient history but from the life Mozart observed around him every day, inside the house and on the street, upstairs and downstairs in the palaces of the nobility. So characters in

comic opera could rise to a level of realism and complexity that seria characters, locked into their conventional roles, could not. At the same time, Mozart could apply to this project what he had learned from the experience of *Idomeneo*, when he first began to shape not only the music but the libretto. Now he could bring to comedy what he had learned in opera seria; later he would bring to seria what he had learned in buffa.

He hoped *The Abduction* would establish him as a composer in Vienna and a fixture of Joseph II's National Singspiel, and perhaps open stages to him elsewhere in Europe. As it played out, the opera turned out as much of a success as anyone could wish, but it succeeded too well. For the rest of his career Mozart never managed to write another work for the stage nearly as popular. More immediately, *The Abduction* was so commanding that it helped kill off Joseph's singspiel company by revealing how paltry were most of the rest of its offerings.[1] For Vienna and for Mozart, Italian opera would return to the stage, and he would re-embrace that genre just as fervently.

THE PERSONALITY OF *THE ABDUCTION* REVEALS ITSELF IN THE FIRST seconds of the overture. There is a bit of rustling tune, then the Turkish battery breaks out in a burst of gleeful energy: bass drum, cymbals, triangle, and piccolo leading the fray in a lusty two-beat theme. Soon we hear a quick little three-note fillip that will ornament much of the music to come. From the first bars we have been told a good deal about the style and ethos of the opera. The key is C major, which is at once the home key and the "Turkish" one: though it will range widely, the opera is grounded on that style and in that tonality. The overture also reveals that whether or not a given number is Turkish-flavored, the music will consist of melodies that stick in the ear, that are designed for ready popularity. As a tunesmith, Mozart never wielded his gift for engaging melody more forthrightly. In the overture and later, while the harmonies are mostly straightforward, with few exotic excursions, the orchestral sound is vivid and rich, what would prove to be in its instrumentation the most elaborate of any of his mature works for the stage. Here is one of the few works so far in which Mozart incorporates the full Late Classical wind section of pairs of flutes, oboes, clarinets, and bassoons; clarinets will play a distinct part in the instrumental flavor.

The winds are parceled out variously depending on the character of a given number; only occasionally will he use the full wind and brass contingent.

The *Entführung* overture's second theme is a variant of the first, now in G major, and instead of a development section, in the middle comes a change of meter and tempo. We are presented with a lilting three-beat tune that, expanded, is going to be the first aria in the opera. In the recapitulation of the opening material the Turkish music builds to a frenzy, as it will tend to do in music to come. There will be a good many thematic recalls in *The Abduction*, both overt, such as with the tune of the overture's middle part, and covert, such as with the three-note fillip in various guises.

The musical style that German lands called "Turkish" and "Janissary" had a long and polyglot history. Janissaries were a special contingent of Turkish troops going back to the fourteenth century, made up of children of Christian slaves abducted from their families, indoctrinated into Islam, and formed into an elite corps with distinctive uniforms and a tradition of fanatical loyalty. Their music was distinctive, played in the midst of battle to inspire the troops. Accordingly, Janissary music was noisy and rhythmic, with bass drums to pound out a heavy two-beat, shrill shawms called *ʒurnas*, timpani, cymbals, bells, and trumpets. In 1665 the Grand Envoy Mehmet Pasha marched into Vienna accompanied by the racket of a big Janissary band, which electrified the onlookers. It was the sounding image of the exotic.

From the seventeenth century, Europeans began to form their own versions of Janissary bands with their own instruments, adapting the style into something basically European—less noisy, but still hearty marching music with a cachet of the foreign. The signature instruments were bass drum, cymbals, triangle, and piccolo, added to the usual winds and brass of military bands. Though the style was associated with the military, it was played not in battle but in parades, ceremonies, concerts. Sometimes to quasi-ethnic effect, the percussion was handled by Africans or by whites in blackface. The distinctive musical signature involved duple meter heavy on the downbeat, pounding repeated notes, quick runs, simple harmonies, sometimes minor keys, sometimes major with a raised fourth degree: Lydian mode, exotic to European ears.[2] The total effect of the instruments and the musical style

made it instantly recognizable—channeling the sort of virile energy that pounces on us in the overture to *The Abduction.*

The overture segues into Belmonte's opening number, which despite its C major is a mournful aria that he sings outside the palace of the Turkish pasha Selim. After a shipwreck his love Constanze, her maid Blonde, and his servant Pedrillo have been abducted by the pasha, Constanze headed for his harem. Belmonte has come in the hope of somehow getting her back. Palace servant Osmin lusts for Blonde, whose boyfriend, Pedrillo, in his captivity now sees to the palace garden. So we have the familiar elements of a rescue plot with two pairs of lovers, one couple of the upper class and the others servants. These social divisions will in turn have musical implications: a servant does not sing the same sort of music as his or her master, nor a Turk the same as a Spaniard. In their music the lower-class comic characters will be in the general range of singspiel style, Turkish or otherwise. The aristocratic Constanze and Belmonte sing in opera seria style, with bravura passages for Madame Cavalieri, who originated the role.

Belmonte first encounters Osmin, who is picking figs and not interested in being bothered by this infidel. Osmin was the central element Mozart shaped in his reworkings of the libretto, expanding considerably the character's dramatic and musical role from Stephanie's original version. On the face of it, Osmin is an exotic buffoon, a cliché Turk: stupid, lustful, and cruel, Hanswurst with an overlay of the barbaric. But in Mozart's hand he is no longer a simple character; he has his follies and his flaws. That is to say he is another example of how Mozart took up a convention and tugged and twisted it for his own purposes and for the gratification of his performers. If he made use of convention, he was not interested in clichés. Osmin ended as one of his great creations for the stage, a more dynamic and idiosyncratic character than any other in the cast.

We first hear Osmin singing, as he picks his figs, a ditty about lovers and sweethearts. For a while he ignores Belmonte's attempts to hail him. His melody is crooning and folklike; like all his tunes it rings in the ear as distinctly as a coin in a tin bucket, and Mozart decks it out with lavish orchestral underpinning. There follows an animated, multi-section duet, Belmonte trying to extract information about Constanze and Osmin increasingly annoyed and suspicious. The Turk finally

works himself into a fury, spewing threats sadistic and silly: "First be-headed, then hung like a hound, / What's left can be put on a skewer. / Then burned, and bound, and drowned." Basso Osmin, first sung by Ludwig Fischer, has a signature passage that will be heard several times more: a moaning descent into his lowest register. As Mozart put it to Leopold, he wanted to give "full scope now and then to Fischer's beautiful deep notes." The need to show off a performer thereby creates a motif, a musical thread to mark this character and most of his music.

Soon follows an Osmin aria addressed to Belmonte's servant Pe-drillo. "You dandies, so sham and so shady," is no lyrical flight but rather is laid out in bits and pieces that give a master buffo basso, as was Ludwig Fischer, lots of room to clown vocally and physically. It takes Osmin a while to reach full boil, at the verse "By the beards of the Prophets." This was the number for which Mozart wrote the music first and asked Stephanie to provide the words after.

After his solo Osmin takes his leave, and Pedrillo meets up with his master Belmonte for some urgent consultation. Constanze is well and still loves him, Pedrillo says, but the pasha is pressing himself on her. Here enters the other necessary element of these stories: lust, in this case the threat of rape and miscegenation. In one way or another, sex licit and illicit was central to most comedy plots in these days. If anything, Mozart and his librettists plunge into desire and its outcomes with more gusto than most—not just for titillation, but also to examine to entertaining effect what desire does to people.

The news upsets Belmonte deeply, which occasions one of the finest arias in the opera. As Pedrillo leaves, Belmonte sings the name of his imprisoned beloved, "Constanze! Constanze!" in a moment of breath-taking beauty of a kind singular to Mozart, that springs up as suddenly as a breeze with the smell of flowers. If one wants to see this moment as Mozart calling to his own Constanze, one is welcome to. This was one of the three numbers Mozart wrote as soon as he got some of the libretto, which set the style and approach of the opera in three dimen-sions: a comic number for Osmin, a serious one for Belmonte, and the eventful trio that concludes the first act.

Belmonte sings of his heart throbbing at once with love and with an-guish at their separation. Mozart had written to Leopold, "You feel the trembling—the faltering—you see how his throbbing breast begins to

swell; I have expressed this by a crescendo. You hear the whispering and the sighing—which I have indicated by the first violins with mutes and the flute playing in unison."[3] He means the softly shimmering violins for "whispering," the sagging figures for "sighs." The aria is in A major, a key associated with light and happy moods. In fact, much of the sad music in *The Abduction* is in major keys. Perhaps this adds a touch of brightness to the sorrow, suggesting that despite the qualms, this is after all a comedy, nobody we care about is going to die, and the lovers will win the day.

Belmonte is a grieving aristocrat, so his aria is not in buffa mode but rather a stretch of Italian-style seria music in a comic setting. There are several of these numbers, and unlike the other elements of the singspiel, nominally a genre with spoken dialogue, a couple of them are introduced by accompanied recitative. And while every number minutely expresses the text in the kinds of ways Mozart describes to his father, he is equally attentive to musical values. This involves a prevailing sense of continuity through music that shifts to follow changing feelings while paying attention to abstract form. By this point Mozart had long since discarded the traditional ABA outline that marked the arias and inhibited the drama in traditional opera seria. Instead, the shadow of sonata form hangs over Belmonte's first aria and other numbers in the opera: here, after the A-major first theme, comes a quasi-second-theme section in E, the key of the dominant, as is usual in sonata form. After a bit of tonal excursion, there is a recapitulation of the opening theme in A; the second theme section is expanded and developed as Belmonte's emotions surge.

So the pattern of sonata form (minus a development section) and the demands of drama coincide. But the outline later named "sonata form" already had an innately dramatic quality: its contrasting-theme exposition in two or more keys, often dramatic development in various keys, and recapitulation in the home key were often compared to a story, to the tension and resolution of drama. In a sonata-form instrumental piece the effect of the recapitulation is to return to the central idea after a period of exploration and to resolve the movement's harmonic journey into the home key. In a sonata-like opera number, the effect of recapitulation is the same, but added to it is a sense of reaffirming and underlining a feeling or perception in the text: "How fearfully, wildly, it beats, / The loving heart in my breast!"

Exit Belmonte, enter Pasha Selim and Constanze, preceded by an-
other expected feature of a Turkish tale, a stalwart chorus of Janis-
saries singing the pasha's praises. From the beginning the pasha was
planned as a speaking role, one possible reason being that he is an-
other seria character, not part of the comedy, and a collection of arias
for him would threaten the musical and dramatic balance. Selim's part
in the story is to court Constanze for his harem. She resists his ad-
vances, tells him she has a lover, and naturally, this blooms into an
aria about Belmonte and their bitter separation, full of a pathos and
stillness that rings a touch strangely within a show full of broad and
physical comedy. But Constanze is also a seria character, grieving
and under threat from what would appear a brutal captor determined
to have his way with her. As for the comedy, most of it will be the
business of the servants.

Unmoved by her pleas, the pasha gives Constanze a day to decide
to accept him, or else. She leaves sighing Belmonte's name. Now in
a soliloquy, Selim begins to reveal himself as more than a tyrant—
rather a man who in some degree recognizes his captive's feelings:
"Her anguish, her tears, her steadfastness have bewitched my heart
all the more . . . Who would use force on such a creature? . . . —No,
Constanze, no, even Selim has feelings. Even Selim knows love." He is
divided, and here again is a first step in humanizing a figure who would
otherwise be a narrow cliché: the heartless Muslim threatening rape
and violence to his helpless Christian captive.

Belmonte enters with Pedrillo and puts the rescue plot in motion
by pitching himself as an experienced architect who is at Selim's ser-
vice. The pasha takes the bait and exits. Osmin turns up with his usual
threats, and the first-act finale begins in a vein of physical comedy, with
Osmin brandishing a whip and ordering these rogues to begone. The
ensuing trio, in style something between two-beat Turkish and buffa-
like clownish, builds rhythmic energy to a full-throated finish to bring
the curtain down.

The second act starts with Blonde's first aria, a meditation on men
and maidens addressed to Osmin, who is hungering desperately for her.
Bluster and threats won't capture a girl's heart, she tells him, her music
folklike in style and form: two strophic verses and a coda. In the en-
suing dialogue, Osmin declares her his slave, and she responds with

scorn. "Girls are not cattle!" Blonde cries. "I am a freeborn English-
woman, and I defy anyone who wants to force me to do anything!"
She cows Osmin, who has never seen the like: "She is the very devil!"
In the ensuing duet Blonde succeeds in chasing him off. If Constanze
is a seria character, Blonde the maid is very much a buffa girl. Beyond
that she is the first appearance of the true Mozart heroine in his mature
comedies: a strong young woman wise in the ways of the world and in
the wiles of men, no less sharp and sexy for that. She likes men fine, but
understands them too well to be much impressed with them. In Mo-
zart's next opera that kind of woman, another maid to an aristocratic
lady, will be the leading female role.

Constanze takes the stage to further lament her fate. Here Mozart
turns to a recitative and aria, longer and still more poignant than her
last solo. He acts the pain of "Sorrow has become my fate / Because
I was torn from you," the pathos in high gear, the aria amounting to
another long interlude of twilight emotion in the middle of rowdy com-
edy. To enhance the shadowed atmosphere, Mozart has the clarinets
take up basset horns, an instrument that, despite its name, is a tenor
clarinet, pitched a fourth lower than a B-flat clarinet. He will return
memorably to these dark-toned winds in later works. In this number
he goes for the sorrow of the moment, the tears of the character, even
though in context there is not much chance of tears from the audience.
In the later operas, the joking and serious elements will be more inte-
grated and more moving—in part because Mozart by then will have a
better librettist.

Blonde tries to give Constanze hope for a rescue, but then Selim ap-
pears, again demanding that she become first among his wives. Again
she resists him, and this time he threatens the worst: "tortures past en-
during." He leaves Constanze to her big aria, the showpiece Mozart
provided for prima donna Caterina Cavalieri, whose beautiful voice
and spectacular virtuosity had gained her the adoration of the Viennese
despite her lack of physical charm. One critic observed coldly, "Mlle
Cavalieri is incomparably stronger [than her rival Aloysia Lange],
but . . . apart from that she is frightfully ugly, has only one eye, and
both of them act pitiably."[4] Besides her dazzling voice, Cavalieri had
another ace in her hand: she was the one-time student and eventually

the lover of the most powerful opera composer in town, Antonio Sa-
lieri. To cross Cavalieri was to cross him too.

Constanze's bravura aria addressed to an astonished Selim is "Mar-
tern aller Arten" ("Tortures most surely await"), in which she responds
to him with defiance: "Rant and rage and shout! / Your threats are all
in vain." Once again, Mozart sets a lyric full of horror and bravado
in a major key, in this case C, grounding it in the opera's home to-
nality. It begins oddly with a full-scale military march, during which,
onstage, Constanze and Selim have little to do but pull faces at one
another. In the orchestra a quartet of soloists—flute, oboe, violin, and
cello—add their voices to the texture, sometimes playing alone in a
quasi-concerto vein, sometimes blending their roulades with the sing-
er's virtuoso turns. The major key and bright scoring give a lightness
to this music in which Constanze contemplates a nasty death. After
virtually laughing at her fate in glittering passages up to high C, she
storms off. Perhaps this is the point of the C major: Constanze hopes
Selim will be impressed by her courage, a tone traditionally proper to
that key, and indeed he is. Still divided, Selim wavers: "Where threats
and pleas have failed, cunning may succeed." In Mozart operas, as in
Casanova's memoirs, as in actual persons' lives, people go to the most
extraordinary lengths for a roll in the hay. As it transpires, none here
will get the opportunity. Nor will Selim get to display his cunning.

Now the rescue scheme takes over the action, the music a parade of
topics. Pedrillo has to tempt Osmin into drinking some drugged wine,
despite alcohol being forbidden to Muslims. This is a situation delicious
with comic possibilities, and the libretto and the music deliver them.
The duet begins with a nimble tune in Turkish mode and C major, Pe-
drillo belting out, "Viva Bacchus!" Osmin dismisses the temptation,
Pedrillo flourishes the bottles, Osmin wavers, Pedrillo raves over the
taste, Osmin has qualms: "Can Allah see everything?" Finally, of
course, he capitulates. Soon Osmin and Pedrillo are drunkenly belting
out together, "Here's to the girls! Blondes and brunettes!" The drug
having done its job, Pedrillo leads Osmin out to his rest.

At last Constanze and Belmonte unite; he sings her a tender aria full
of hope for their liberation. Blonde and Pedrillo join them for a quartet
to end the second act. This was another Mozart addition to the original,

Bretzner's muted end to the act turned by Stephanie into a romp of re-
gret, jealousy, forgiveness, and joy.[5] In a singspiel as in an opera buffa,
the second-act finale was a matter of great dramatic and musical import,
where the principals gather to mark a turning in the plot toward the de-
nouement. It needs to generate excitement that will carry into the final
act; the funnier and more frantic, the better. Musically it will be laid out
in a series of contrasting segments that gather energy and exhilaration, or
turmoil, to a climax at the curtain.

The key of their quartet is a bright D major. The tone at the begin-
ning is staunch, Constanze and Belmonte proclaiming their love, the
servants concentrating on their imminent freedom. All come together
on a proclamation: "At last the hopeful rays of sun / Shine through
the dark and clouded sky!" Indeed there is a lingering cloud. The
tempo slows, and the specter of unfaithfulness and miscegenation rears
its head. Belmonte confesses to his secret anxiety about Constanze's
honor, and Pedrillo echoes. In response, the ladies are too outraged
even to proclaim their innocence. Blonde responds with a slap to her
lover's face. This is answer enough with servants; Belmonte must sink
to his knees and beg for forgiveness, which is given by both ladies af-
ter due finger shaking. Then allegro! Tutti! Strings racing ecstatically!
"Well, now that's behind us!" the lovers cry. "Long live love!" Libera-
tion awaits! Except, of course, it won't be so simple.

The third act begins in darkness, the plans in place, the escape ladder
and the boat ready. Once again Mozart pours on opera seria pathos in a
recitative and aria for Belmonte in which he declares that the power of
love will save them. This aria seems a touch rote in its grieving posture,
revealing little new about the story or the character. For Belmonte it
is perhaps an aria too far, though it does serve to make us anticipate
what we know is coming and are eager for. In dialogue Pedrillo tells
Belmonte that he will scout things out around the palace and sing a folk
song as signal if all looks clear. Soon after Pedrillo voices his signal,
the rescue falls apart. A groggy Osmin discovers the escape and erupts
in murderous rage, despite his delight that once again he can contem-
plate the gory ruin of these infidels: Turkish music in D lydian mode,
with piccolo: "Oh, my gloating will run amok / When you're on the
chopping block!" Selim appears, learns of the plot, leaves in a rage to
arrange the death of the plotters by unpleasant means.

Love has not triumphed. Facing a dreadful end, the lovers can do nothing but sing a regretful duet. Belmonte laments that he has doomed his beloved, while Constanze declares that it's all her fault but at least they can endure their fate together: "To die beside your love / Is a blessed happiness!" In a singspiel, this suffices as comfort. Pedrillo and Blonde appear, their despair more flippant: "I hear that I'm to be boiled in oil," Pedrillo groans. "That's some treatment!" Blonde gamely professes indifference to how she's going to be dispatched. But everybody in the audience knows the lovers really aren't going to die, and many probably already know why: this pasha will surely turn out to be one of those enlightened Oriental despots wonted in stories in those days.

Selim takes the stage, it would seem, to exact his revenge. Then the twist required for the happy ending. He had learned that Belmonte's father was the man who ruined him in his native Spain and drove him to Turkey as an exile. Now he tells Belmonte, "I loathed your father too much ever to follow in his footsteps. Take your freedom, take Constanze, sail to your homeland. And tell your father that you were in my power and that I set you free." Helpless at his master's inexplicable act of forgiveness, Osmin is again beside himself with fury. (In the original libretto, Selim turned out to be Belmonte's father. Stephanie and Mozart changed this, seeing that showing clemency for his own son would not have the dramatic and moral impact of doing it for his enemy's son.)

Here is a High Enlightenment denouement that echoes the end of *Idomeneo*. Law, custom, and the power of the Turkish throne say the lovers must die. But right and justice say they must live, and right and justice are not bound to time and place, but are universal.[6] Selim's hard-won decision to put aside his feelings and his desire for revenge and do the right thing recalls the forgiving kings of Mozart's opera serias, the clemency of Idomeneo and Titus. With his action, Selim places himself in the line of European benevolent despots, who act—in theory, at least—not out of emotion or whim but from an enlightened sense of the good. In moral terms, Selim's clemency raises him above the Westerner who did him evil. Besides, not to put too fine a point on it, he actually is a Westerner, Spanish born.

The closing number takes shape as a vaudeville, a formal outline in which each character emotes to the same tune interspersed with tutti

refrains. Because Selim doesn't sing, it's a quintet of two pairs of ec-
static lovers and a fuming Osmin. The lovers shower the pasha with
praise, joining again and again on the refrain: "The man who could
forget your reign / Should be looked upon with disdain." Pedrillo's
relief is more graphic: "How could I ever, ever forget / How close I
came to strangulation / And other forms of emasculation!" There is
a final explosion from the disillusioned Osmin, who returns to his fa-
vorite fancies and to his earlier tune: "First beheaded, then hung like
hounds, / What's left can be put on skewers," and so forth. The Janis-
saries enter and, echoing their earlier chorus, join their voices in praise
of Pasha Selim in a racing and bracing finish.

In later years Mozart would not have much good to say about *Die
Entführung aus dem Serail*, considering it more a practical than a serious
item in his catalogue. That it outstripped any of his other operas in pop-
ularity probably annoyed him. But it did a good deal for his evolution,
artistically and practically. It taught him much about shaping comic
opera, about how to integrate humor and sorrow. It is relevant that
since the operas of his teens he had personally experienced love and
loss, victory and humiliation, and this gave to his portrayals of feeling
a new gravity. *The Abduction*, meanwhile, made the public around Eu-
rope aware of him as a mature composer and brought him close to some
exceptional singers, some of whom would be with him from then on.

Before Mozart, the singspiels heard in Vienna tended to be loose
concoctions, comedies with songs thrown in. With *The Abduction*, even
written as it was for ready comprehension and popularity, Mozart from
his wealth of imagination lifted the genre to a new level of unity and
impact. It may have been the first singspiel in which the music was su-
preme. And it worked as hoped. Despite miserable summer heat and
dust, the house was packed every night.[7] It was the only real artistic
success Joseph's National Singspiel ever managed in an original work,
and it quickly spread around Europe.

Out of nationalist sentiment and to enlighten his people, Emperor
Joseph II had wanted a German theater for its own sake, both in plays
and operas. Joseph as co-ruler had ended overall court control of
Vienna's theaters, keeping only the Burgtheater, which was attached
to the Hofburg, and the larger Kärntnertortheater. This allowed sub-
urban theaters to flourish under private management, leading to a

boom in theater and in jobs for musicians. All this would eventually affect Mozart.[8] In opera and spoken theater, the National Singspiel in 1781–82 mounted four times more comedies than tragedies. The most performed operas included Gluck's drama *Iphigenie auf Tauris* and Salieri's *The Chimney Sweep*, before the popularity of *The Abduction* edged the latter from the stage.[9] But when it came to a regular diet of singspiel, when all was said and done the Viennese aristocracy, who were buying most of the tickets, preferred opera buffa in Italian, and Joseph would be obliged to give it to them.[10]

The first recorded response to *The Abduction*, probably backstage at the Burgtheater premiere, came from the most important member of the audience: Joseph II. Legend has him saying to Mozart, approximately: "Too beautiful for our [Viennese] ears, my dear Mozart, and monstrous many notes!" To which Mozart, in legend, replied: "Exactly as many as necessary, Your Majesty!" This encounter and those words may or may not have happened, but Joseph's complaint rings true. It would not have been the first time he said that Mozart wrote too many notes, that his orchestra covered up the singers, that his music was too prodigal with ideas to be taken in on first hearing, that he was writing only for connoisseurs. (In fact, as Mozart wrote Leopold, just before the premiere he made a lot of cuts after having given "free rein to my ideas." The cuts would have had to do with anything from the demands of the singers to the expression of the text to the overall timing and shape.)[11] A Berlin critic admitted that the opera had "an extraordinary amount of happily inspired song, and was very prettily performed," but the effort should "have been employed on a better product."[12]

Mozart would hear these veins of criticism for the rest of his life. The music is splendid but the libretto weak or, worse, insulting to morality. And too many notes. The latter complaint helped preclude him from being the most popular of opera composers. Of course, not long after Mozart died, he became the prime model for all opera composers to come—which is what he would likely have been in his lifetime if he had lived long enough to write more operas and for all of them to sink in. Did this bother him? Not all that much, it appears. When asked a couple of times, he essentially shrugged and observed that they'll get it eventually. Besides, there was something to Joseph's complaint. Some of the arias in *The Abduction*, especially the seria-style ones of

Constanze and Belmonte, arguably linger past their welcome for the audience, though not for the singers, for whom the more the better.

In one respect, Mozart failed to capitalize on the success of *The Abduction*. The composer of a successful opera had to bestir himself to make arrangements of the music for keyboard and various instruments, this being the main way of earning more money from a hit in an age with no royalties and no copyright. If you didn't get your own arrangements out, pirates would do it for you. And Mozart, who never promoted himself with the kind of care his father once had, failed to do his keyboard arrangement of *The Abduction* before a pirate in Augsburg issued an edition, and that was the end of that.[13] By failing to produce his arrangements in time, Mozart lost a solid source of income.

As for the premiere, what really agitated him was not the emperor's complaints but rather the machinations, real or imagined, of Antonio Salieri. Mozart wrote home announcing a great success, crowded on the first night and the reserved boxes soon sold out, the audience everyone from the nobility to the middle class. After the second performance Wolfgang wrote more in disgust than pleasure,

> Can you imagine that yesterday there was an even stronger cabal against it than on the first night?—throughout the first act people were hissing—but they couldn't silence the shouts of Bravo during the arias.—So my greatest hope was the trio at the end, but as luck would have it Fischer was off—which threw Dauer (Petrillo) off too—and Adamberger alone couldn't pull it together; so the effect of the trio was lost, and this time there was no repeat.—I was beside myself with anger and so was Adamberger—And I told them immediately that I would not allow another performance until we had a brief rehearsal for the singers.[14]

Though Salieri's name does not come up in regard to the cabal at the premiere, shortly it would: Mozart suspected him of standing in his way, here and on later occasions. Salieri was the most established opera composer in town and Joseph's favorite. Was it actually he who organized and paid for the hisses that nonetheless failed to damage the premiere of *The Abduction*? Not likely. More likely, it had to do with singers and supporters of Italian opera who begrudged the German

troupe.[15] Cabals were an institution in Vienna; the men required were available for hire.

In any case, there is no way to tell for certain if Salieri was involved, because he was a consummate careerist who played his cards close to his chest. Six years older than Mozart, Salieri had been active in Vienna for fifteen years when this potential rival arrived on the scene. He was not a new name to Mozart. They may have met in Vienna in 1768, amid the debacle with *La finta semplice*. In his 1773 visit Mozart probably heard a Salieri opera, and he used a theme from another one for some keyboard variations.

Salieri was born in 1750 in a small town between Venice and Mantua, to the family of a well-to-do merchant who encouraged music for his children. His first teacher of violin and singing and piano was his brother. His parents died as he reached his teens, and in the first of the characteristic pieces of good fortune that marked his career, he was taken up by an aristocratic patron who oversaw his study in Venice with the assistant Kapellmeister of San Marco. There Salieri got to know the leading Italian opera composer Florian Leopold Gassmann, who became his teacher and mentor. Gassmann took the teenaged Salieri with him to Vienna in 1766.

Quickly he revealed an aptitude for making his way up the ladder, though in practice he began close to the top and stayed there. Through Gassmann he met Joseph II, then co-regent, and soon he was playing clavier in Joseph's private chamber music afternoons. The emperor took the promising young man under his wing and nurtured his career. Meanwhile Salieri ingratiated himself with old Metastasio, though as it turned out, following his mentor Gassmann, he was going to become one of the leaders in the reform camp that Gluck created. He got to know Gluck as well, played harpsichord in the historic premiere of *Alceste*, became a rehearsal keyboard player at the opera.[16] When Gassmann died in 1774, Salieri slipped into his position as imperial chamber composer, even though he largely wrote opera and not much instrumental music.[17]

In 1770, at around twenty, he produced his first ambitious work, *Armide*, which he described as involving "Magic, heroes, and love, which also touches on the tragic." By then Salieri was Viennese in his style and Gluckian in his approach, and he had distanced himself from

opera seria.[18] In the next decades he wrote some forty operas for Vienna, Italy, Munich, and Paris. He had his share of flops and successes, but nothing shook the supremacy he gained early in Vienna, founded on the patronage of the emperor. This is where Mozart found Salieri when he arrived in 1781.

In person Salieri was on the compact side, dusky in complexion, choleric in temper but quick to recover, witty, and wily. He drank only water but had a weakness for sweets of all sorts. One of the stories told of his cleverness was how he handled a singer who believed he sounded good only in E-flat major and refused to sing in any other key. Salieri wrote for him an aria in B-flat but made the key signature three flats— implying E-flat. The singer was fooled only for a while. Arriving at a rehearsal to find the man steaming, Salieri threw himself at his feet and declaimed an aria that ends, "a guilty man before you." Everybody laughed, and the problem went away.

The assumption of history would be that Salieri was a mediocrity jealous of Mozart's brilliance. He may or may not have felt jealous to some degree, though in fact during Mozart's lifetime his operas never achieved anything close to the popularity of Salieri's. And in any case, Salieri was, at his best, a consummate professional and a splendid composer of opera. If he did not have Mozart's melodic gift, he knew how to shape a story and how to make voices shine, and he had an orchestral imagination at least the equal of Mozart's, maybe beyond. Prima donnas knew that if Salieri was writing their showpiece, it would likely be something dazzling.[19] His masterpiece, the tragicomedy *Axur*, from the later 1780s, was Joseph's favorite opera.[20] Salieri did have a weak suit: an indifferent taste in librettos. He tended to set what was in front of him, without the discrimination in selecting and reworking librettos that was essential to Mozart.[21] Many of Salieri's duds were a matter of weak librettos that his music could not salvage.

In short, Salieri had no reason to see Mozart as a rival or to engage in plots against him. No artist's position in Vienna was entirely secure, but Salieri's was as secure as it got in Joseph's reign. Mozart blamed Salieri for doing him ill, but he gave no particular evidence. The hard reality was that Salieri was Joseph's long-standing favorite, with a decade and a half of seniority over Mozart, and Joseph believed in seniority. All the same, Joseph well understood Mozart's importance and his value to the

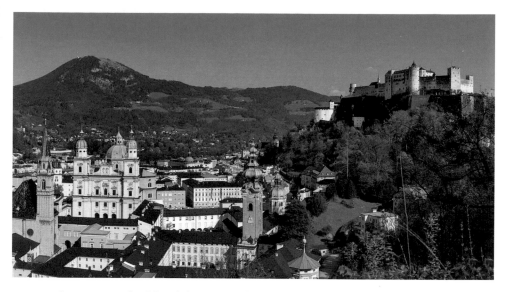

A modern view of Old Salzburg, with the cathedral and Residenz on the left, and the castle of Hohensalzburg on the right

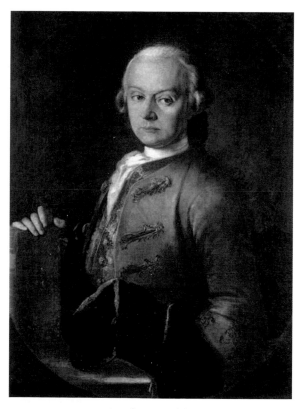

Portrait of Leopold Mozart
and his violin method

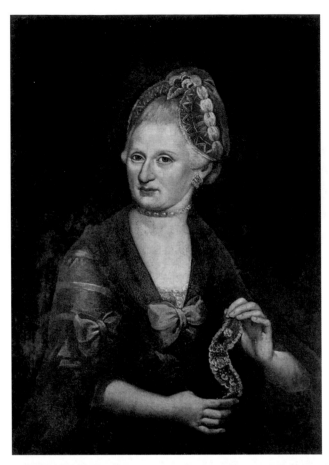

Wolfgang's mother,
Maria Anna Mozart

A house concert, with
Frederick the Great of
Prussia as the flutist

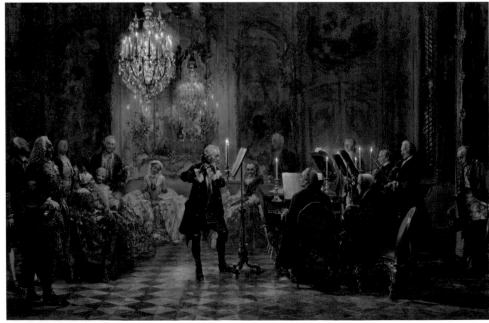

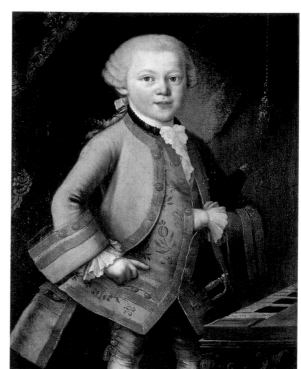

Wolfgang and Nannerl
during their triumphant
stay in Vienna in 1762,
wearing outfits given
to them by Empress
Maria Theresa

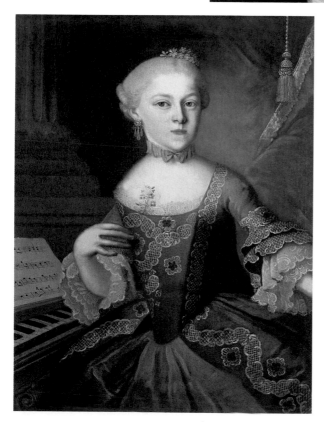

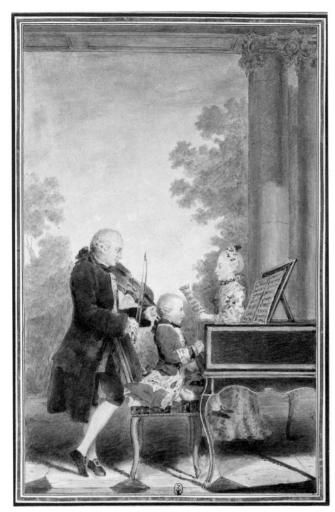

The painting commissioned by Leopold during the Paris sojourn of 1764, an engraving of which would serve as their calling card for the rest of the tour

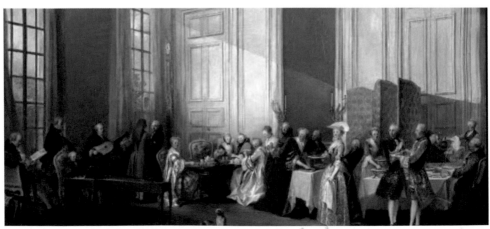

Wolfgang at the clavier on the left during a Paris soirée

Friedrich Melchior Baron von Grimm

Madame Louise d'Épinay

Johann Christian Bach,
by Thomas Gainsborough

Mozart at thirteen in
Verona, 1770

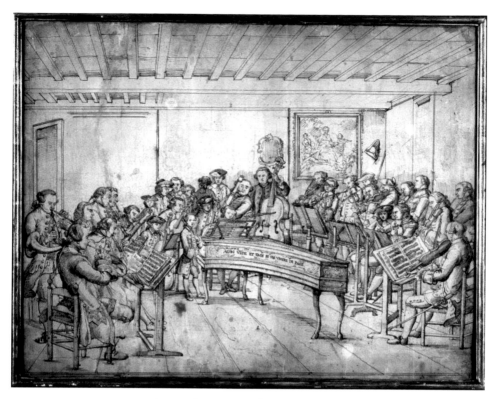

An orchestra at a house concert

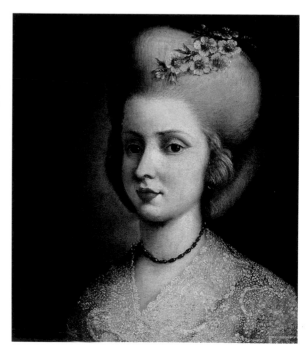

Aloysia Weber at around
the time Mozart met her

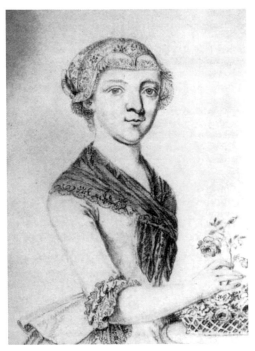

Maria Anna Thekla Mozart—
the Bäsle

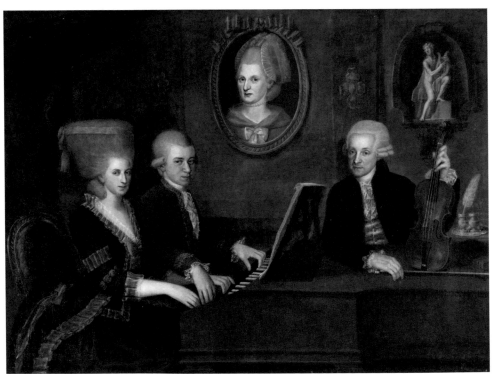

The Mozart family portrait of 1780

Royal box at the
Cuvilliés Theatre
in Munich

Constanze Mozart,
by her brother-in-law
Joseph Lange, 1782

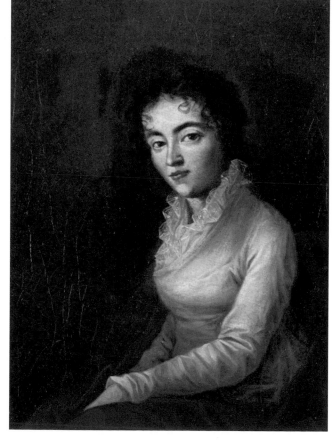

Emperor Joseph II

The Burgtheater on the right

The nimble and amorous
Harlequin, from the
commedia dell'arte

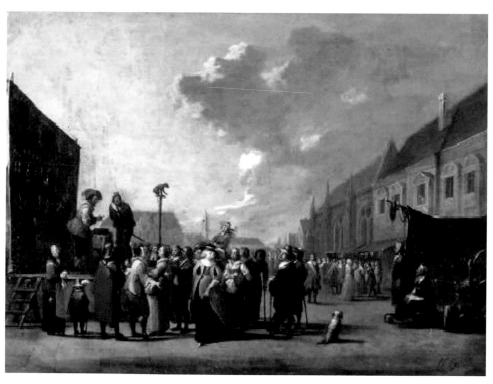

A street theater company

A modern incarnation
of Hanswurst

Joseph II making
music with his sisters

Aloysia Weber
Lange in her diva
years as Zémire

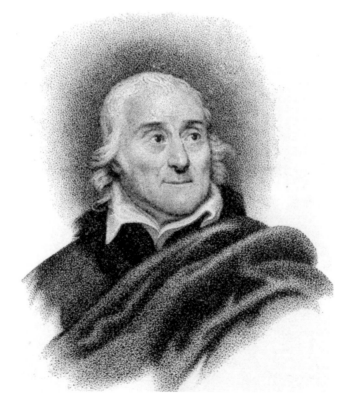

Lorenzo Da Ponte

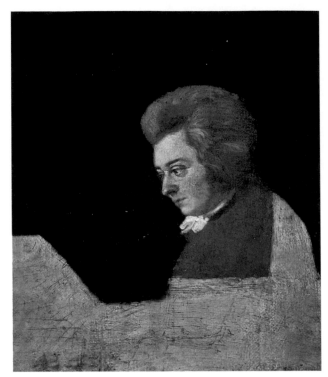

Mozart, by his
brother-in-law
Joseph Lange,
unfinished

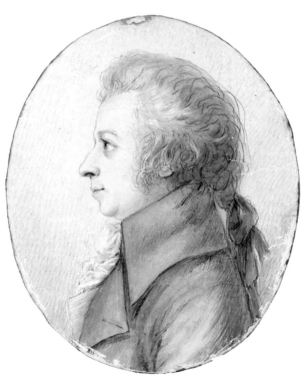

The last Mozart portrait, by Doris Stock, 1789

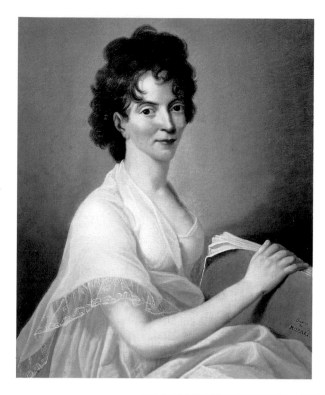

Constanze Mozart in 1802

Nannerl Mozart
in her later years

First choral entrance of the Requiem

court, and he treated him accordingly. Mozart may have wanted more from Joseph, but he did not complain overmuch about what he got, which was more than any other composer did—except Salieri.

In the end, Salieri's main sin may have been that he was simply the man ahead of Mozart in line. This may have aggravated Mozart more than the greater number of productions Salieri got—which after all was partly because Salieri was so prolific. In 1788–91 he would have ninety-seven performances of six different operas at the Burgtheater; during those years Mozart had fifty-four performances of three operas.[22] In the long run, each man studied the other's work with profit, and the two ended cordial if a bit wary colleagues and friends. Neither ever said much about how he regarded the other as a composer, but some degree of mutual respect was manifest.

All this is to say that it made no sense that Salieri would have been jealous enough to stand in Mozart's way. But human life makes no sense. Were years of suspicions on Mozart's part and gossip around Vienna all mistaken? Salieri had no need to strike at Mozart, but that does not mean he never did. After all, *The Abduction* had a much greater success than Salieri's comedy *The Chimney Sweep* of the year before, whose premiere Mozart had heard.[23] What is certain is that if Salieri did plot and organize cabals against the young lion, none of them succeeded. What problems Mozart had with the public had to do with his overwhelming imagination, his too many notes. Rivals bristled at his ability to toss off without apparent effort things most composers would have given a limb to conceive. These were Mozart's chief sins in the eyes of the public and rivals—not his careerist efforts, at which Salieri was a master and Mozart was not.

SUNK IN HIS RESENTMENT, LEOPOLD IN THIS PERIOD SHOWED HIS DIS-pleasure in various ways, including a studied lack of response to Wolfgang's efforts to get him interested in *The Abduction*. When Mozart sent him the score, Leopold made no comment. He could only vent his feelings to Nannerl and, as it happened, to Baroness von Waldstätten, with whom he formed an epistolary friendship. Soon after his son's wedding he wrote her a letter whose courteous tone does not conceal its bitterness.

I thank your ladyship most warmly for the very special interest you have taken in my circumstances and for your extraordinary kindness in celebrating my son's wedding day with such liberality. . . . Having done my duty as a father, having in countless letters made the clearest and most lucid representations to Wolfgang on every point and being convinced that he knows my trying circumstances, which are extremely grievous to a man of my age, and that he is aware of the degradations I am suffering in Salzburg, since he must realize that both morally and materially I'm being punished for his conduct, all that I can do now is to leave him to his own resources (as he evidently wishes) and pray God to bestow on him his paternal blessing and not withdraw from him his divine grace. For my part I shall not abandon the cheerfulness which is natural to me and which in spite of my advancing years I still possess . . . On the whole, I should feel quite easy in my mind, were it not that I have detected in my son an outstanding fault, which is, that he is far too patient or rather easy-going, too indolent, perhaps even too proud . . . on the other hand, he is too impatient, too hasty and will not bide his time. Two opposing elements rule his nature, I mean, there is either too much or too little, never the golden mean. If he is not actually in want, then he is immediately satisfied and becomes indolent and lazy. If he has to bestir himself, then he realizes his worth and wants to make his fortune at once. Nothing must stand in his way; yet it is unfortunately the most capable people and those who possess outstanding genius who have the greatest obstacles to face. Who will prevent him from pursuing his present career in Vienna if only he has a little patience?[24]

Here, with due politeness to the baroness, Leopold accuses his son of laziness, but more spitefully, of contributing to his father's "degradations." By this he probably means that he blames Wolfgang for his being passed over again as Kapellmeister. This is a fabricated complaint: Leopold knew perfectly well that negotiations with the new Kapellmeister, Luigi Gatti, had been going on for years.[25] Now Leopold will leave his son "to his own resources," which means that he intends essentially to disinherit him—as, in the end, he essentially did. But

Leopold was not in "trying circumstances," instead likely well set up on the proceeds of his children's tours. He still had a good job at court and private students, the archbishop did not take any revenge on him, and his failing to be named Kapellmeister probably also had to do with his well-known scorn for most of the Salzburg musical establishment, who scorned him back. Meanwhile a Kapellmeister was expected to provide original music, and he had long since retired from composing. In any case, Leopold's last years in the Tanzmeisterhaus were comfortable, the big flat always full of friends and students.

IN VIENNA THINGS WERE TAKING SHAPE NOW. THE WIDE CIRCLE OF friends Mozart would accumulate ran from the emperor and the high nobility to the middle class and the new nobility—largely wealthy businessmen who bought their titles. There was a certain relaxed atmosphere with the high aristocracy, though one could never really bridge the divides between the old nobility and the new, or the nobility and the middle class. In May 1782, Mozart and a partner mounted the first of a dozen subscription concerts in the Augarten. Among other things he and Josepha Auernhammer played the K. 365 double concerto.[26]

Among the aristocracy, Mozart was closest in these years to Baroness Waldstätten. She was musical and admired him, she was unconventional and notorious for it, she served as a go-between for Wolfgang and Leopold. Mozart could talk to her as he wished, which was not the case with most of the high nobility. For example, he consulted with the baroness about his cravings as a dandy, writing her in September 1782:

> As for the beautiful red jacket that is tickling my heart so mercilessly, please let me know <u>where it can be bought and how expensive it is</u>, for I completely forgot to check how much it was; my attention was totally drawn to its beauty and not to its price.—I simply must have such a jacket, so it will be worth my effort to get those buttons, which I can't get out of my mind.—I saw them some time ago in the Brandau Button Shop . . . when I bought some other buttons for a suit. They are made of mother-of-pearl with several white stones around the edge and a beautiful yellow

stone in the middle—I would like to have all things that are good, genuine, and beautiful!

This may have been a hint to Waldstätten to give him the finery as a gift. In their relations, his puckish side reemerged, less bawdy than with the Bäsle, but with the same verbal playfulness. "When Your Ladyship graciously invited me yesterday to dinner for tomorrow, Sunday, I did not remember at the time that I had already accepted an engagement for dinner at the Augarten a week ago . . . So I hope Your Grace will find the inspiration to make a new accommodation so we can bring our complementation and veneration, say, next Tuesday, together with some purification to keep us from vexation if Fräulein von Auernhammer makes a presentation."[27]

He could flirt with the baroness too, something he got a kick out of and was good at.

Let me say to you that I am both a happy and unhappy man!—Unhappy ever since I saw Your Grace at the ball with that exquisite coiffure!—So—gone was my peace of mind!—Nothing but sighs and groans!—The remaining time at the ball I wasn't dancing—I was jumping—and when the supper came—I didn't eat my food—I wolfed it down—and during the night, instead of slumbering softly and peacefully—I slept like a dormouse and snored like a bear!—And, without taking too much credit for my insights, I would almost be willing to wager that Your Grace had a similar experience—à proportion—of course!—You are smiling?—you are blushing?—Oh yes—I am such a happy man! My fortune is made!—But woe! Who is tapping me on my shoulder?—And who is peering into my writing?—auweh auweh auweh!—It's my Wife!—Well, in God's name, she is here, and she is all mine, and I must keep her! What's to be done?—I must give her a little praise—and pretend that it is true!—My wife, who is an angel of a woman, and I, a model of a husband, kiss Your Grace's hands 1000 times and we shall always be your faithful vassals.[28]

To a degree even with Emperor Joseph, Mozart could joke, and vice versa. Shortly after their wedding, Wolfgang and Constanze were

strolling in the Augarten with her dog when she observed to her new husband that if he pretended to hit her, the dog would leap to her defense. Mozart could not resist the challenge. He pretended to belabor her, the dog growled, and at that moment Joseph emerged from his summer residence in the park. Seeing the dramatic scene in front of him, the emperor quipped, "Well, well, married just three weeks and fisticuffs already?" It made for a laugh all around.[29]

In spite of how well things were going for Mozart at the end of 1782, he found himself feeling restless and neglected. To Leopold he wrote,

> These Viennese gentlemen, by whom I mean mainly the Emperor, had better not think that I am on this earth alone for the sake of Vienna.—There is no monarch in the world I'd rather serve than the Emperor—but I shall not go begging for a post here. . . . And if Germany, my beloved fatherland, of which I am Proud . . . will not have me, then, in God's name, let France or England to become richer by another talented German—to the disgrace of the German Nation . . . Countess Thun—Count Zitschy, Baron von Suiten [*sic*]—even Prince Kaunitz, they are all very unhappy with the Emperor for not placing greater value on people of talent . . . Prince Kaunitz said recently to Archduke Maximilian, when they were talking about me, such people come into this world only once in 100 years, and they should not be driven out of Germany—especially when one is fortunate enough to have them right here in the Capital.[30]

Remarkably, he speculated about going back to Paris and getting involved again with the Concert Spirituel, even though his last sojourn there had accomplished little but to frustrate and enrage him. He kept trying to impress Papa with his schedule, writing at the end of the year,

> I must write to you in greatest haste because it's already 5:30 and I've asked some people over for 6 o'clock to play a little Musique;— I'm so busy these days that at times I don't know whether I'm coming or going anymore;—the entire morning, until 2 o'clock, is taken up with music lessons;—then we eat;—and after lunch I have to grant my poor stomach a short hour of digestion; only the

evening is left for composing—and not even that's a sure thing, because I am often asked to take part in a concert.[31]

In late August he wrote that he was waiting for the second visit of the Russian grand duke and his wife, for whom he was expected to perform. In November he returned to the pit of the Burgtheater to direct *The Abduction* from the harpsichord, for a performance in honor of the Russian visitors.[32] Having heard nothing from Leopold about the opera, he wrote that he was glad Papa had said he liked the new symphony, one in D major he had written in July and August, in the middle of the long gestation of *The Abduction*. History remembers it as No. 35, K. 385, the *Haffner* Symphony. Leopold had managed to be polite about the piece, but after all he had asked Wolfgang to write it to celebrate the ennoblement of Wolfgang's childhood friend Sigmund Haffner the younger.

Mozart agreed to do it, but the symphony emerged only slowly in the next weeks, amid a row of excuses having to do with the premiere of *The Abduction* and with his marriage. It may have arrived too late for his friend's ennoblement ceremony, but Leopold seems to have had it performed in Salzburg. At that point it was a six-movement piece, more like a serenade than a symphony. When in December Wolfgang wrote asking his father to send the score because he needed it for a concert in Vienna, Leopold sat on the request for weeks before forwarding it. When Mozart finally received it, in February, he dutifully thanked Papa and observed, "My new Haffner symphony has positively amazed me, for I had forgotten every single note of it. It must surely produce a good effect." All the same, for an upcoming concert he made significant revisions, including adding pairs of flutes and clarinets to the outer movements and deleting two movements to make a symphonic complement of four.[33]

True to its original function to mark a happy occasion, the *Haffner* Symphony declares a festive atmosphere with the violins' exuberant two-octave leaps of its opening. Mozart wrote his father, "The first Allegro must go really fierily, the last as fast as possible."[34] One of the changes Mozart made from the original first movement was to take out the usual sonata-form repeat of the exposition; the development section is harmonically restless but short. All this makes for a

compact movement that is largely monothematic, turning around the opening theme and glittering passagework. The slow movement is gentle and galant through the course of a two-theme sonata form. After a staunch minuet, the finale is a dashing and droll Sonata-rondo. The whole of the *Haffner* has a straightforward and engaging disposition, with nothing particularly unexpected. It has a precursor in the *Paris* Symphony, also in D major and geared for maximum brilliance. Those two are the only Mozart symphonies with the full wind complement of the late-eighteenth-century orchestra: pairs of flutes, oboes, clarinets, bassoons, horns, and trumpets.[35]

His Lent academy of March 23, 1783, amounted to the first of a generally triumphant series of concerts he would mount in Vienna in the next few years. The program was enormous, with ten pieces old and new, in a variety of media. As often done in those days, he broke up the *Haffner* Symphony, the first three movements at the beginning and the finale at the end. Aloysia Lange sang two concert arias, and Johann Adamberger one; Mozart played two piano concertos, one old (K. 175 with a new finale) and one new (K. 415). There were two movements of the *Posthorn* Serenade and variations on operatic themes of Paisiello and Gluck. Because Emperor Joseph was present and because he liked fugues, there was short one to make him happy.[36] The hall, Mozart reported, "couldn't have been fuller, and all the loges were occupied." After the concert, Joseph sent Mozart 25 ducats; his overall take was an enormous 1,600 florins, nicely promising for his future in Vienna— though as it turned out, this would be the best take Mozart ever had from a concert.[37] As important, now he realized that if he wanted to truly get ahead in Vienna, he could not rely on random freelancing and Lent concerts, those available at best once a year. He needed to become an impresario, to produce public subscription series wherever in town he could find to contain an orchestra and an audience.[38]

HE HAD BEGUN WRITING PIANO CONCERTOS FOR HIS ACADEMIES, A collection that eventually would comprise one of the greatest bodies of work in the long history of music. In the process he more or less invented the idea of playing in public what had traditionally been a fixture of private music making.[39] Concertos were the sort of items

virtuosos produced to show themselves off to a gift-bestowing audi-
ence, but Mozart brought to the genre a symphonic approach unique for
the time, which became a model for the future. With the just mentioned
two concertos and the next one, K. 414, he made extra money by sell-
ing manuscript copies to subscribers—common practice at the time for
pieces that were not going to sell enough to make engraving profitable.

When he finished K. 413 in F and K. 415 in C, he wrote Leopold
about them in terms that succinctly defined the musical ethos of his
time: "These concertos are a happy medium between what's too dif-
ficult and too easy—they are brilliant—pleasing to the ear and—
Natural without becoming vacuous;—there are passages here and
there that only connoisseurs can fully appreciate—yet the common
listener will find them satisfying as well, although without knowing
why."[40] Again, composers of this era aimed to please all sorts of listen-
ers, each at their level, the music being "natural," both predictable and
unpredictable without descending to galant blandness on the one hand
or to convolutions on the other. As a discipline for composers, this was
as difficult as any, and it helped to have a gift for melody, as did Mozart
incomparably. He wrote tunes that could be whistled and sung on the
street—and soon enough, they would be.

The new concerto Mozart played at his March academy, No. 12 in C
Major, K. 415, begins with a quiet stretch of counterpoint. Always he
picked the winds and brass for a concerto depending on the tone of the
music. Here they are pairs of oboes and bassoons, plus horns, trumpets,
and timpani. Overall this amounts to a comparatively low-key outing.
Its beginning foreshadows a piece more involved with counterpoint
than most concertos—perhaps what Mozart was talking about in the
letter to his father, the sort of thing connoisseurs will appreciate.

The first movement is less tuneful than highly varied in material,
with contrapuntal episodes. The soloist's display sections, the usual
quick scales and arpeggios, are more liquid than brilliant. There are
assorted reminiscences of a C. P. E. Bach concerto, starting with the
soloist's entrance in movement one, where the material is distinct from
the orchestra's opening theme (which the soloist never plays). The sec-
ond theme of the solo exposition is also new, owned by the piano. So the
personality of this soloist is distinctly as an individualist. Next comes
a pensive Andante, the form ABA, with two moments for the soloist

to provide a cadenza whether practiced or improvised. Its atmospheric main theme is again based on a C. P. E. Bach concerto.[41]

Mozart had started and abandoned a second movement in C minor because it might dilute the effect of that key's appearance in the finale. The finale is a Sonata-rondo, a common choice, but this one is quirky. A typical sonata-rondo outline would be A B A C A B A. This one starts off with the usual A and B sections in a dancing 6/8, but instead of the usual move to the dominant key, G major, for the B section, it stays in C. Then comes a small cadenza for the soloist, and we are plunged into the rondo's C section, a moody C-minor Adagio. (This is an unusual tempo change in a finale.) There follows the usual return to A, the rondo theme, the B theme now in G. Theme A returns, but with the entry of the soloist it veers into A minor. The B theme follows. Things are already curious, and they get more so. After another little cadenza, the C-minor Adagio turns up again, now lavishly ornamented by the soloist. Finally the Allegro-rondo theme returns to set things right, but not to provide a showy finish: the music subsides to pianissimo, an uncommon marking for Mozart, and the concerto makes its exit with a murmuring whisper. The whole movement has an exploratory quality rare for the usually jaunty and predictable rondo genre.

Neither in its time nor later did the comparatively easygoing K. 415 get much attention. Non-connoisseurs did not find in it the glittery virtuosity and charming tunes they liked, and it is not one of Mozart's most grandly conceived mature concertos, one sign being that it lacks the rich wind writing of his later ones. Trying to sell the group of three concertos to a publisher in Paris, he said they could be done with strings only. His ambitions for the genre had not yet ascended to their peak. Whether he realized it yet himself, however, the C Major suggested a new and climactic period in his concertos where the model was symphonic, meaning pieces longer and richer in material and orchestral forces.[42]

JUST BEFORE CHRISTMAS 1782 MOZART WROTE LEOPOLD, "COUNT Rosenberg talked to me at Gallizen's [*sic*] and suggested that I compose an Italian opera;—I am already trying to get the latest libretti for opere buffe from Italy so I can make a choice, but I haven't received any yet."

Mozart had gotten wind that Joseph was about to close down what had turned out a failed experiment, his Burgtheater singspiel company, and form a troupe to specialize in Italian opera buffa. He did not have far to look for singers, because the leading ones in the singspiel had studied in Italy and made their names in buffa. Mozart, for all his sermonizing to Leopold about wanting to write German opera, would take up the Italian variety with equal enthusiasm. It would carry him to the heights of his achievement on the stage, which is to say among the heights of all achievement on the stage.

Around the same time he completed a string quartet in G major, K. 387, that would be the first of an eventual set of six marking his full maturity as a composer of quartets and, in that genre, a confessed student of Haydn. And at the beginning of January he wrote Leopold that he had "half a mass that is lying here waiting to be finished." This was an ambitious sacred work he had solemnly promised to Constanze as something of a wedding present.[43]

There would be no more letters to Leopold about his determination to write German opera. The Italian libretto he was looking for would turn up in due course, by way of Paris and a gifted collaborator. As for his position in Vienna, Mozart by the end of 1782 was at the gateway of his greatest period. Over the next four years he would be heard in at least seventy performances public and private, part of a burgeoning Viennese concert scene in which he was the leading figure.[44] And in the next decade he would compose an extraordinary amount of extraordinary music. It would add up to a time of wide-ranging opportunity and incomparable success that sometimes required killing labor, all of which he would embrace joyfully, until it killed him.

LAST RETURN, LAST DEPARTURE

In January 1783 Wolfgang wrote in high spirits to Papa. In December he and Constanze had moved to a building on the Hohe Brücke owned by Baron Raimund von Wetzlar, a friend and patron whom he described to Leopold as "a wealthy converted Jew," and their flat as "1000 paces long and one pace wide." They had just thrown a party. "We started at 6 o'clock in the evening, and ended at seven; what, only one hour?—No, No!—We ended at 7 o'clock in the morning." Among the guests he listed for this epic revelry were Baron Wetzlar and wife; "Gilowsky, that old gasbag" (a surgeon and witness at their wedding); Baroness Waldstätten; Aloysia Lange and husband; and tenor Johann Adamberger and wife. These were among his expanding circle of friends, patrons, and performers in Vienna.

Parties were not a casual matter for a man as sociable as Mozart and who loved dancing as much as he did. His favorite was the courtly minuet, a dance in which there was no improvisation. It was all as laid out and ritualized as a court ceremony or a Fux counterpoint exercise, though in its subtle, elegant little bows and sidesteps and gliding motions and circlings, there was room for individuality.

The name of the dance came from the French *menuet*, meaning "fine, delicate." In executing the prescribed steps a premium was placed on skill that was the opposite of ostentatious. Bows, moments of a man and woman moving hand in hand and then alone. The carriage must be upright but not stiff; the dancer should regard his or her partner with

a gentle smile. The better the dancer, the easier the dance appeared.[1] Nothing touched but hands. You went through much of the dance at enough of a distance from your partner to admire her grace, her figure, her clothes. Only later, when the waltz arrived, did partners embrace, and that was of course called scandalous. Until then the minuet reigned as the queen of dances: you gazed at each other, made shuffling steps, looked into each other's eyes, smiled, joined hands, essayed little stylized motions of flirtation and movements as if of pursuit and capture. To be good at the minuet was to be attentive to minute subtleties.

Mozart was a fine dancer, or fancied himself to be—a dancer in his person and in his music, so much of which is in dance forms and rhythms and spirit. If you are skilled in dance it is something you give yourself to, which takes over you and you become the dance. To the Greeks this sort of thing was a matter of possession by Dionysus, god of wine, of sexuality, of theater, of all things that sweep you into ecstasy and into another mode of being. In the minuet love and sex were stylized but not really suppressed. All social dance is in some way, covert or overt, a fertility ritual. And sometimes sexual suppression is intensely erotic, and so the minuet's association with the aristocracy that made a public show of dignity and restraint while often, in private, pursuing unrestrained indulgence.

All this suited Mozart well. The minuet required skill and subtlety and passion under restraint, all masked in grace and charm and elegant, feline movement. In some ways, this could serve as a definition of his art. He told Constanze that he believed his real gifts were more for dance than music. This was absurd, but for him understandable.

In the letter recounting the party, Mozart entreated his father to send a Harlequin costume Leopold had worn at Carnival some years before, which Wolfgang required for an upcoming ball—a masked one, like all Carnival events.[2] It was preordained that he would want to assume that persona from the commedia dell'arte: Harlequin, with his checkered costume signifying the patchwork of a poor gentleman's valet; who was wily and indefatigable in his pursuit of food, wine, fun, and love, and particularly in pursuit of the delicious maid Columbina. Light-footed Harlequin, who would as soon turn a somersault as stroll; who sometimes wore a catlike mask reflecting his feline nimbleness; who might brandish a slapstick to apply to the backsides of his compatriots.

Harlequin was a pure creature of theater, no existence outside it, yet a distilled human archetype. He was the eternal survivor at the bottom of the social ladder, an amoral trickster yet not really malicious, always getting himself in trouble with his insatiable appetites but always finding a way to squirm out of it. Those appetites lay behind his mask with wrinkled forehead and eyebrows arched with delight and desire. All this was Mozart, his desire and his feline physicality, his attachment to emotion behind a mask, his foundation in traditions and conventions on which he could improvise. Harlequin was one of the ancestors of the lusty German clown Hanswurst. His subsequent avatars in Mozart's life would bear the names Figaro, Leporello, and Papageno.

AT A MARCH PUBLIC MASKED BALL IN THE REDOUTENSAAL, THE BIG ballroom in the Hofburg, during a half-hour break Mozart and company performed a pantomime "Masquerade" to his music and with a program of verses by actor Johann Müll. (Little of the music and text would survive.) Among the friends accompanying Mozart's Harlequin were Aloysia Lange, as his flighty inamorata Columbina (the aptness could not have escaped them both), and her husband Joseph Lange as the sad clown Pierrot, who never got the girl. (This irony would not escape them, either.)³ An old dancing master who went by the name "Merk" played Pantalone and coached the dancing. "I can tell you, we played quite charmingly," Mozart reported.

Soon after this theatrical effort, he noted his part in a concert of Aloysia's where the house was full, he played the C-major Concerto K. 415 and his *Paris* Symphony was heard, and the applause sounded "like a regular cloudburst." Aloysia sang a recitative and aria, revised for the occasion, that he had written back in the days when he was besotted with her. Gluck was present at the concert and much pleased; he invited the Mozarts and Langes to lunch. Mozart noted that this was all a good omen for his upcoming subscription concert on March 23, and so it proved.⁴

In February Wolfgang and Constanze moved temporarily to a flat on the Kohlmarkt, "rather uninspiring" he wrote, but the move and the rent had been paid for by their landlord Wetzlar because he needed their flat in his place to house a lady. In their first years the couple

would move a lot—a new flat on Judenplatz in April, two more moves
in 1784. In the letter with news of the move, Mozart insisted to Leo-
pold, not for the first time, that they were eager to visit Salzburg. He
had been putting off his father with various excuses, perhaps justified:
he was getting more in demand and so highly busy, and he was con-
cerned about his resignation from the court in 1781 never having been
formally approved. He did not put it past Archbishop Colloredo to have
withheld the discharge in order to clap him in jail if he turned up in
Salzburg.[5] In reality, for Colloredo he was a dead issue, but for Mozart
this was not an entirely outlandish notion. Who knew what the acerbic
Colloredo was capable of?

Actually Mozart really did intend to go to Salzburg, mainly to in-
troduce Constanze to Leopold and Nannerl, presuming that this would
set their minds at ease about his marriage. Given the repeated delays,
Leopold was predictably skeptical of his son's intentions, as can be seen
in a testy reply from Wolfgang: "If you choose to call me a fool for
something I consider a real threat [of being arrested], I can't prevent
you from doing so; . . . but is it right?—That's another question.—
Have I ever given you the impression that I have no desire or eagerness
to see you? . . . It's not necessary for me to tell you that I care little
about Salzburg and nothing at all about the Archbishop, and that I shit
on both of them."[6] He knew the court would probably intercept the
letter and so Colloredo would read that sentence, and this appeared to
be fine with him. At the same time, for Papa, he resorted to such as this
concerning a visit: "When Herr von Dubrawaick left us for Salzburg
from here, my wife could hardly be restrained, she wanted absolument
to jump into a carriage with me and follow him."[7] Leopold would have
seen through this twaddle in a second.

In April came a long-expected change in the court opera: Em-
peror Joseph scrapped the failing singspiel troupe in the Burgtheater
and moved it to the Kärntnertortheater as part of a spectrum of shows
there, and established a troupe in the Burgtheater to do Italian opera
buffa. The Burgtheater was smaller, but Joseph wanted the two compa-
nies to compete.[8] The new troupe debuted the next month with Salieri's
The School of Jealousy.[9] The change marked the ascendancy of Italian
opera over German in Vienna, which is to say that it also marked a
disappointment to the emperor's hopes for a German theater. If Joseph

was a thorough autocrat, in the end he still had to submit to the public's judgment. Now he plunged into the new situation at full tilt. He was fluent in Italian and would attend the new opera regularly.[10] Already he had on his payroll first-rate singers who had been part of the singspiel troupe but whose background was in buffa and seria: tenor Johann Adamberger and prima diva Caterina Cavalieri. The splendid buffa bass Ludwig Fischer, the first Osmin, did not get a contract and departed to Paris. Aloysia Lange was something of a problem, having acquired a reputation as a prickly prima donna. Eventually she would wear out her welcome in the Italian opera and was moved to the Burgtheater.[11] The next year, to oversee the singspiel productions at the Kärntnertortheater, Joseph hired from Pressburg the well-known and also notorious Emanuel Schikaneder. He and the Mozart family had become close when the impresario brought his troupe to Salzburg in 1780–81. They had a jolly reunion and sooner or later would naturally begin to speculate about projects.

Joseph dispatched scouts to Italy to find the best singers available, and despite his tightfisted approach to court matters, he was prepared to pay them extravagantly. The troupe would be joined by three baritones from Italy—Stefano Mandini, Francesco Benucci, and Francesco Bussani—plus Irish-born tenor Michael Kelly and half-British soprano and comedienne Nancy Storace. These singers would be not just performers for Mozart; through their voices and their stage presence, they would also help shape the momentous roles he wrote for them. The Italian troupe as it finally took shape was perhaps unrivaled anywhere. The first season began with Joseph's favorite, Salieri, and the dozen productions that followed included Paisiello's wildly popular *The Barber of Seville*, based on a French play by Beaumarchais.[12] In the next seven years 59 different opera buffas would be staged at the Burgtheater. Most popular would be Paisiello's, with 166 performances; next came Salieri, with 138. Mozart would have 35 at most, though he had far fewer works to offer than his competitors, who were largely opera specialists.[13] In 1785–91, Vicente Martín y Soler's works were performed the most; in performances, Mozart came in seventh.[14] (As a comparison, in Vienna the greatest German playwrights of the age, Goethe, Schiller, and Lessing, were skimpily performed in comparison to popular sentimental authors.)[15]

At the time, Mozart was not happy with the end of the singspiel company. He wrote Leopold just before its demise that while *The Abduction* had seen its seventeenth performance, "It's as if they were determined to kill the German opera . . . And it's the Germans who are doing it . . . Every nation has its own opera—why shouldn't we Germans have one as well!—Is the German language not as singable as French and English? . . . Well now;—I'm going to write a German opera just for *myself.*"[16] He proposed to have a well-known Italian libretto by Carlo Goldoni, *The Servant of Two Masters*, translated into German and to write it on speculation. This was a bootless scheme and got nowhere beyond a couple of arias. It would not be his last attempt at a German opera that year. At the same time, he was not so impractical as to flout the new state of affairs. He wrote that "I have gone through at least 100—probably more—[Italian] libretti—but—I found almost nothing acceptable."

He decided that his best bet was to solicit a new libretto, and for that he approached the new librettist of the court opera, Lorenzo Da Ponte. Mozart may have first encountered this curious creature among the group of converted Jews who congregated at Raimund Wetzlar's.[17] The Italian newcomer had been struggling with his first project, *Rich Man for a Day*, for Salieri. In fact Da Ponte had never in his life written a libretto and was learning on the job—a job that Salieri, impressed with his poetic skills, had secured for him. (This first collaboration would turn out a fiasco that soured Salieri on the writer for years.) Mozart reported skeptically that Da Ponte "promised to write me something New after [the Salieri project]—but who knows whether he will keep his word—or even wants to!—You know, these Italian gentlemen, they are very nice to your face! . . . And if he is in league with Salieri, I'll never get a text from him—and I would love to show here what I can really do with an Italian opera."

He prodded Leopold to talk to Giovanni Battista Varesco, librettist of *Idomeneo*, about trying a buffa. "It has to be on the whole very comical; and, if possible, include two equally good female roles,—one would have to be a seria, the other a *mezzo carattere*—but in quality— both roles would have to be absolutely equal.—The third female character can be entirely buffa, and so could the male parts."[18] In citing these characters, he is more or less prophesying his buffas of future years:

a suffering seria female, a *mezzo carattere* between light and serious, a comic female who is probably going to be a servant, and likewise her male counterparts. Meanwhile, Mozart is talking about his requirements in the abstract: first come the kinds of characters he wants, which implies the kinds of music he will write for them, and the comic context. Actual story and characters with names and personalities come after that, similar to the requirement for a multi-character, frenetic second-act finale comes before the dramatic reason for it.

These are musical patterns imposed on drama, in the same way as instrumental forms were shaped partly by conventional outlines and expectations, and in their expressive course they followed patterns of contrast, light and shade, tension and release, like those in opera. In the record of how Mozart considered these practical elements, he never mentioned sociopolitical aspirations—which is not to say that those matters never concerned him or that he never mentioned them. But sociopolitical matters were to become steadily more precarious with artists in Vienna, and they needed to be played close to the chest.

THERE WERE OTHER MATTERS WEIGHING ON MOZART IN THE LATE winter and spring of 1783. His exposure and income were ascending, but he had still fallen behind on a loan from bookseller Johann von Trattner, used to cover the cost of copying some of his piano concertos for a public subscription. There was little interest in the concertos, Mozart had no money on hand, and a threat of legal action loomed. From among his well-set-up friends, he turned to the one most likely to be sympathetic, Baroness Waldstätten. "I got myself into a fine predicament!" he wrote her in February.

> Herr von Trattner and I talked about getting an extension for two weeks . . . I was quite relaxed about it and thought, if I couldn't get the money together myself, I would be able to borrow the sum!—Now Herr von Trattner sends me word that the man in question is absolutement [*sic*] not willing to wait any longer, and if I don't pay between today and tomorrow, he will <u>sue</u> me for the amount.—Just think, your Grace, what unpleasantness this would mean for me! . . . I beg Your Grace, for Heaven's sake, help

me not to forfeit my honor and good name!—My poor little wife is a bit indisposed; therefore, I cannot leave her alone, otherwise I would have come to ask Your Grace in person.[19]

Presumably he received help from the baroness. Friends often lent and borrowed among themselves in those days. In the letter Mozart shows that he knows how to entreat a friend for money, to paint his and his family's situation with due pathos. He would refine those skills later, when the debts were bigger and more critical. The letter shows another ill-omened pattern he would repeat: borrowing to pay off a debt. It did not help his situation that early in the year, when he sent Leopold the score for *Idomeneo* to be copied for a possible Berlin production, he sent money and music paper for the job and apparently included some extra funds as a sort of gesture toward doing what Leopold had long demanded, to be repaid for his old expenditures for the children. Leopold duly thanked Wolfgang and probably expected more, but that may have been the only money he ever received from his distant son.[20]

There was more weighing on Mozart. As he implied in the letter to Waldstätten, Constanze was pregnant with their first child. Also, in the spring he fell sick more seriously than he had in years, with a wretched sore throat and headache that seem to have afflicted him through June.[21] In July he reported himself well except for a lingering cold, and made a dutiful son's request to Papa:

According to the midwife the baby should have come on the fourth of this month—but I don't think it will happen before the 15th or 16th.—If you ask [Constanze], she'll say: the sooner, the better! so she and I can enjoy the happiness of embracing you and my sister in Salzburg that much earlier.—As I didn't think it would get serious so quickly, I kept postponing what I meant to do all along, namely to go down on my knees, fold my hands, and ask you, my dearest father, in all humility, to be the child's godfather!—As there is still time, I am asking you now. . . . We'll call it either Leopold or Leopoldine.[22]

This would have warmed Leopold's heart, but he did not respond to the offer until it was too late, and anyway, at that moment, his re-

sentment still simmering, he had no intention of coming to Vienna.[23] So when the baby was born on July 17, Wolfgang reneged both on the godfather and the first name. The child would be christened Raimund Leopold, named after the Mozarts' landlord, Baron Raimund Wetzlar, who also served as godfather to what Wolfgang reported as a "fine, sturdy boy, round as a butterball." With his usual punctiliousness he wrote Papa the details of Raimund's birth, including their use of a birthing chair, common at the time. Soon he was doing the father's job of giving Granddad regular updates: "Thank God, my wife has weathered the two most critical days, yesterday and the day before yesterday . . . The baby is also quite lively and healthy, he has a tremendous amount of things to do such as drinking, sleeping, crying, p . . . , sh . . . and spitting up [*sic*]."[24]

To everybody's surprise, the baby brought about a reconciliation with Cäcilia Weber, for whom a grandchild was a realization of the sort of hopes she had for her daughters. She proved more helpful than expected for the new mother and child. "My mother-in-law," Wolfgang wrote, "is now making up for all the bad things she did to her daughter when she was still *single*." From that point harmony was restored between them. Constanze's sister Sophie would recall that Mozart took to turning up at Cäcilia's house with coffee and sugar for her under his arm, which delighted her. Often she would caution him that he was working too hard, to which he would answer, "Ah, mamma, I can't change my nature."[25] His nature was to compose at every opportunity, and sleep and health had to accommodate to it. This worked for him very well, until it didn't.

The blessed event did not slow his composing and performing. He could not afford for it to. In later life Constanze said that he worked on the D-minor String Quartet while she was in labor and incorporated her cries into the second movement. Maybe, maybe not, but it would have been like him. In any case, whatever the distractions this was a prolific time for him, foreshadowing a period of dazzling productivity. Around here he finished two more string quartets of an eventual collection of six, the K. 387 in G Major and the D Minor, K. 421. A quartet in E-flat followed in the summer of 1783. There were meanwhile vocal pieces and a quintet and concerto for horn, written for old Salzburg friend Joseph Leutgeb, now making his living in Vienna as a horn

soloist and cheesemonger. Their closeness can be seen in Wolfgang's elaborate teasing on the manuscripts of pieces he wrote for Leutgeb: on the concerto K. 417, "Wolfgang Amadé Mozart has taken pity on Leutgeb, ass, ox and fool, at Vienna, 27 March 1783."[26] Mozart was also working this year on a Mass in C Minor, the first big sacred work he had taken on since the *Coronation* Mass of 1779, near the end of the Salzburg years. This is the Mass he had promised to Constanze as a gift.

Some occasional works that turned out better than they should have managed to set the Viennese scandal machinery in motion. In early July Wolfgang wrote Leopold, "Mme. Lange was here trying out her two arias, we also discussed how we could outshine our enemies, for I have plenty of them, and Mad. Lange, too, has had enough of Storace, the *new singer.*" Nancy Storace was Aloysia's new rival in town, and the mutual enmity of the two prima donnas would enliven the musical scene for years. Mozart had written the two arias for Aloysia, plus one for Johann Adamberger, as inserts for the opera *The Imprudent Curious Man*, by Pasquale Anfossi. The verses for the arias were provided by Lorenzo Da Ponte—a step toward a serious collaboration with Mozart.[27] Aloysia wanted something more bravura than Anfossi had provided for her. This was routine; composers regularly wrote inserts for other composers' operas, usually to accommodate a new leading singer with something more specific and agreeable. The problem was, he did the job too well: Anfossi's opera proved a flop, Mozart's arias widely declared the only good thing about it (or so Mozart reported to Salzburg[28]).

So his enemies cooked up a scandal. Despite Mozart's exaggerated paranoia, he did have enemies. This time, the only time actually documented, Salieri was involved to a degree. Wrote Mozart, "My enemies were malicious enough to start a rumor beforehand, saying that *Mozart wants to improve on the opera by Anfossi* . . . so I sent a message to Count Rosenberg to the effect that I won't give my [numbers] to anyone unless the following text will be printed in the libretto in both German and Italian." This referred to a blurb attributing the arias to Mozart, to be put into the public libretto. And, he added, "It had all been a trick by Salieri." Joseph's theater manager, Count Rosenberg, never a wholehearted Mozart partisan, had declared the inserts an insult to An-

fossi. Salieri seconded the charge, advised Adamberger not to include Mozart's aria, and Adamberger complied.[29]

All this was aggravating, certainly, but Mozart's paranoia over the matter was hyperbolic. The flap was short-lived; Anfossi's opera quickly sank out of sight, and now Mozart had three new arias in hand to use as he wished. And the arias he wrote for Aloysia are some of his finer ones. In "Vorrei spiegarvi, o Dio!" he wove her voice and a solo oboe into the kind of piece one writes lovingly for an old flame. It was another in a chain of works that came into being because of Aloysia, all of them marked by their history in all its convolutions. In later life she declared that Mozart had loved her to the end. Whether he did or not, he never ceased to respond to her as he responded to everything that moved him, in effusions of sound.

AT LAST MOZART AND CONSTANZE MADE GOOD ON THEIR PROMISE TO visit Salzburg, arriving there on July 29, 1783. Intending at that point to be gone only a month or so, they left six-week-old Raimund behind in the care of a nurse in the suburbs.[30] Many in those days were wary of breast milk, believing it curdled in a baby's stomach. Commonly parents fed their babies on "water," a pap of bread boiled in wine or beer with added sugar and meal, mixed with water.[31] Wolfgang and Constanze had been reared on the same. It was in fact a disastrous regimen and likely played its part in the time's frightful level of child mortality. This was what Mozart intended to do with their baby, but he was talked out of it: "I wanted the child to be brought up on water, like my sister and myself. However, the midwife, my mother-in-law and most people here have begged me and implored me not to allow it, if only for the reason that most children here who are brought up on water do not survive, as the people here don't know how to do it properly."[32] It was more likely a sign that medicine in Vienna was at least marginally less primitive than in Salzburg.

Constanze would have understood that this visit to the Tanzmeisterhaus was made to show her off to Leopold and Nannerl. The details of how she handled that ordeal are not recorded. As it transpired, she was received politely and tolerated politely for what turned out to

be the three months of their sojourn. In their luggage Wolfgang had brought the unfinished Mass in C Minor. He would work on that and other pieces during the visit. Once again, his productivity proceeded serenely regardless of setting or situation.

Back in the Tanzmeisterhaus, he resumed his puckish relationship with his sister. He arrived the day before Nannerl's birthday and for the occasion wrote her one of his effusions of doggerel: . . . "I know you love the English, / and that's what I had thought, / For if you liked Parisians, it's ribbons I'd have brought . . . / What you need is a drink, my dear, / punch of the strongest brew, / So prosit, and enjoy the day! / That is my wish for you." He signed it "W. A Mozart poeta lauratus [*sic*] of the Shooting Club."[33] He had rejoined the family rounds of *Bölzl-schiessen*, now with Constanze trying her hand at plugging the rude homemade targets. Mozart also resumed writing in Nannerl's diary, lampooning her monotonous entries: "Went walking in the Mirabell-garten at 7 o'clock as one goes walking in the Mirabellgarten, as one goes walking, went walking as one goes. Looming threat of rain, but never rainfall, and gradually—the heavens smiled!"[34]

He and Constanze joined the music making in and out of the house. Leopold now had three students in residence, violinist Heinrich and singer Gretl Marchand and their singing niece Maria Brochard.[35] Constanze knew the family from her Mannheim days, and some of their relatives came to visit during the couple's stay. Leopold had picked up the Marchands as budding talents when he came to Munich for *Idomeneo*, and made them a project: he intended to make them into celebrated soloists.[36] Mozart would have seen soon enough that these teenagers were not in such a league, talented but nothing that remarkable. A couple of years earlier, when Leopold had taken up Heinrich, Wolfgang did, with perhaps a degree of jealous cattiness, relay some juicy gossip: Heinrich and his brother were notorious for having been caught "helping" each other (meaning mutual masturbation), and for that reason, "in Mannheim no one ever allowed their boys to go where the Marchands were." But, he concluded with smirking false assurance, "You, my father, will be able to reform him completely, of that I am quite sure."[37]

Tensions simmered during the Salzburg visit, but it appears that only once did they break out. Years later Constanze recalled a distress-

ing scene. Some English visitors were around when Mozart produced the quartet from *Idomeneo* and the family gave it a whirl. The quartet is from the moment when Idamante has to leave his father, who has been behaving inexplicably, and meanwhile he is in love with Ilia, his father's enemy.[38] Leopold had presumably been singing the part of the father, Constanze Ilia, and Wolfgang the son. To general consternation, in the middle of the piece Wolfgang burst into tears and dashed from the room, Constanze running after him. He was moved easily to tears, but usually recovered quickly. This time it took Constanze a while to calm him down. It was as if the years of parrying his father and the months of defending his marriage had all come down on him. If in his letters he had settled into a posture of quasi-dutiful detachment, in his heart the strain of his revolt was eating at him. Maybe it always would, and Papa would give him no chance to forget.

For Leopold and Nannerl, there was more strain than the disturbing presence of Constanze, whom they would never truly accept into the family. Beyond that there was no family left anyway, as it once was, as Leopold had imagined it to be. Wolfgang's presence could only remind his father and sister that his career was burgeoning and they were sharing none of it, not the prestige, not the money. Everything Leopold had labored for since his brightly promising youth in Augsburg—pulling himself up by his bootstraps to a respectable position, the book that made him a famous pedagogue, this being certified by his training of his two domestic miracles; his sermon to the world about his children, and the world's embrace of them—all of it had come down to this: a placid, monotonous life in a backwater town, his wife dead, the same underappreciated court functionary he had always been, busy with job duties and students, comfortable in income but having to hide from everybody, including his family, the sources of that income. The fantasy of all of them living together on Wolfgang's earnings, or of his sending money regularly home—all that was no longer imagined or discussed.

Nannerl was dutiful as ever but had sunk into spinsterhood and likely into a fog of quotidian despair. She had once played in palaces; now she played in the parlors of rich locals and minor nobility and taught their usually talentless children. Her gift had not deserted her, but the world's interest in it had, and her lack of imagination, creativity, and

resourcefulness had caught up with her. Papa had once been resource-ful enough for the whole family, but he had taught his children none of it, and his own ambition had trickled away, his book still in print but his fame gone stale. At the end of all his dreams, Leopold was stuck in place now, and he knew it. Above all he blamed his son for that.

AMONG THE PRODUCTS OF MOZART'S SALZBURG VISIT APPEAR TO HAVE been three piano sonatas, a cycle published together.[39] They may have been written with his Vienna piano students in mind; none is partic-ularly hard on the fingers.[40] Mozart had never taken this genre quite as seriously as others. As noted, piano sonatas were for amateurs to play alone or for friends in the parlor. But at this point in his evolution, anything he took up might be touched with enchantment. These three works would loom large in the history of sonatas.

The C-major K. 330 is in his warm-hearted vein, beginning on an endearing little galant tune, a mood he sustains through the course of the opening movement. The texture is delicate, almost harpsichordish. A four-note descending figure marks the leading theme; in the next two movements, it will return in various guises. An ABA slow movement comes off as introspective but no less winning, its middle section falling into a pensive F minor. This temper subtly colors an otherwise jaunty finale. Mozart has deepened and refined his jauntiness.

The middle sonata of the group, the A-major K. 331, would become one of the most beloved of Mozart's solo piano works, mainly because of its first and last movements—one limpidly beautiful, the other driv-ing and dynamic, all of it within the reach of players of modest skill. In a way, here he exemplified what Leopold attempted to drum into him years before: write simply and well for a broad amateur audience. By no means did Mozart always work in that vein, but in general he never intentionally set out to challenge his audience, to scorn the unsophisti-cated listener. When it turned out he did challenge somebody or other, on being informed of it he generally responded with a metaphorical shrug and went on to the next piece.

The A Major begins with six variations on a lilting folklike tune in 6/8, the theme a pastoral *siciliano* with a serene grace beyond any con-vention. It is something on the order of artless elegance and prayer uni-

fied, a prayer not to God but to human affection embodied in a familiar genre. Unlike most sonatas, this one has no movement in sonata form. The central movement is a sort of virile minuet, its trio a murmuring *musette*, this being a topic imitating a pastoral folk tune on bagpipes. In his maturity Mozart is paying more overt attention to interrelations in the whole of a work: the trio's parallel thirds and hand crossing recall Variation 4 in the first movement, and the trio also foreshadows some double octaves in the finale. That finale was destined to be perhaps Mozart's most famous movement on piano—a dashing and irresistible Rondo alla Turca march that returns to the exotic vein he had mined in *Die Entführung*. In the militant eruptions of the movement one almost hears the clashing cymbals and pounding drums of Viennese Janissary bands. By the end of the century some pianos would have a "Turkish stop" with a bell and an imitation of a drum, invented as much as anything to play this movement.

The last sonata of the set, K. 332 in F Major, is the richest of the three in material and scope. In its first half minute it moves from a lyrical galant opening to a little buffa-like fanfare to a sudden dramatic, virtually Sturm und Drang phrase in D minor. The second-theme section begins with another divergence, starting with a delicately lapidary phrase and going through two more distinct subthemes, the middle one a vigorous and insistent harmonic sequence. The development section starts on a new and, again, contrasting theme before lapsing into the insistent phrase from the second theme. The development itself is short, but the recapitulation develops the ideas of the exposition further. His treatment of sonata form is becoming freer and more variegated, his developments more variegated as well.

After the first movement's wide-ranging topical and expressive journey, the second movement, in form ABAB, begins on a gentle phrase in B-flat major that soon darkens into B-flat minor. The B section is a stretch of elegant tracery, then both A and B return intricately ornamented, rendering the ideas more intimate and yearning. What next, in this wide-ranging journey? A whirling romp of a 6/8 finale, with the same kind of contrasts as the first movement, including its intense D minor and a sort of playfully triste C-minor episode. That key returns to begin an expansive and developmental middle section. The whole sonata demonstrates that unity in a multi-movement work is a matter

not just of recurring motifs, but also of harmony, color, general personality. The personality of the F major involves a dynamic interplay of contrasts.

Another Salzburg effort was a favor to an old and admired friend. Michael Haydn had received a commission from the archbishop for six violin/viola duos. Perhaps mindful of Haydn's fondness for the bottle, Colloredo had threatened to dock his salary if the duos were not finished by the deadline. Then the composer fell ill and could complete only four of them. Learning of his friend's predicament, Mozart sat down and quickly wrote the two missing duos, an expansive one in B-flat and an effervescent one in G, both in three movements, both with gently lyrical, aria-like slow movements.

Of course, Archbishop Colloredo was not informed of all this. The six duos were elegantly copied out and presented to the archbishop under Haydn's name, complete with effusive dedication, and premiered under his name. They amount to another case of Mozart taking on a minor task and making something major out of it—here, the supreme contribution to a tiny repertoire. The duos also amount to another testament to Mozart's affection for the viola, which in the duos he elevates to equality with the violin: they alternate on melody and accompaniment, trade off ideas, and with their steady double stops, sonically enrich what would seem to be an innately scrawny medium. (Later Mozart had the duos sent to Vienna and planned to publish them under his name, but he did not live to see them in print.)

THE SALZBURG VISIT AMOUNTED TO A RETURN TO THE HOME LIFE MOzart had experienced, or rather endured, during his later years there: theater, church, shooting matches, music making, walks around the intimate little town with the family and Bimperl the dog, visits to and from friends, composing into the night. He had hated it before; maybe for him now it was a nostalgic reprise. There is no indication whether by the end he felt his mission had been accomplished, that Constanze had been fully accepted into the family. Perhaps they convinced themselves that she had been. If during the visit she had been treated with studious courtesy, the bitterness of Leopold and Nannerl over his marriage would simmer on uninterrupted.

The finale of the visit was a performance at St. Peter's of the still-unfinished C-minor Mass. All that is known about the inception of the work was the promise Mozart had made to Constanze before they were married that he would write it in her honor, and his intention to include in it some solos for her. He may have planned the Mass for a Salzburg premiere after the wedding. In any case, it turned out to be another of his at the time fervent but unfulfilled vows. To Salzburg he brought about half a complete setting of the ordinary of the Mass (the text included in every service), planning to finish it there. But though he composed a good deal of music in Salzburg and worked on the first half of the Credo and the Sanctus, he never finished the Credo and never began the concluding Agnus Dei.[41] It is not recorded whether the August 26 premiere at St. Peter's used a substitute Agnus Dei, or if the piece was performed as it lay. Then he put the piece aside, perhaps figuring that if he ever needed a big Mass in Vienna, he could complete it then. But the Mass, in scope the most ambitious sacred work of his life, would in the end remain unfinished. The promise to Constanze was neither here nor there, in abeyance or just forgotten.

In its material the Mass is in essence a one-off. His earlier Salzburg sacred works had been influenced mainly by local composers, most significantly Michael Haydn. The C Minor has a new element, gleaned from his soirées at Baron van Swieten's: the impact of J. S. Bach in the counterpoint in general and of Handel's oratorios in its imposing choruses. (At some point Joseph Haydn acquired a copy of Bach's B-minor Mass, though it is not certain whether Mozart ever saw it.) Partly because of those influences, this is, for Mozart, an unusually weighty piece, not just in size but also in sound, owing to the presence in the orchestra of four trombones added to pairs of trumpets and horns. As for woodwinds, except for a single appearance of flute he forgoes all but pairs of oboes and bassoons. (The omission of clarinets may have been due to their absence in Salzburg.)

The voices form a double choir, for which he wrote some of the densest counterpoint of his life. There is a solo vocal quartet including two sopranos, at the premier one of them his wife and the other his castrato friend Francesco Ceccarelli. It's not entirely certain which soprano solos were intended for Constanze; when there are two sopranos in duos and ensembles, she would have sung the top part. While

none of the soprano solos is operatically virtuosic, there is no sense in them of concession to Constanze's amateur status, which is to say that her husband knew her to be a dependable soloist. (Constanze after all had come from a remarkably gifted group of sisters, all of them largely trained by their father, and in some degree she surely shared their gift. Choosing not to become a professional may have had more to do with a lack of ambition than of voice and talent.)

The Mass begins with a solemn, dark-toned Kyrie in C minor based on a keening melodic figure, the orchestral sound marked by the solemn voices of trombones, in German lands long associated with church and funeral music. Here as always, Mozart's sense of instruments rose in large part from custom and convention. The middle Christe eleison, the music ascending into warm sunlight for the image of Christ, is led by a soprano solo. Its theme resembles some vocal exercises Mozart had written for Constanze the year before, so this was likely intended for her—it would have suited him for his wife to be the first-heard solo voice in the Mass.[42] The next section of the ordinary, Gloria in excelsis, is appropriately glorious, the choral parts heavily contrapuntal. It includes a refrain manifestly lifted from Handel's *Hallelujah* in *Messiah*. The gently joyful Laudamus te is a soprano solo still redolent of the Baroque, perhaps geared for the richer voice and the bravura of a castrato. After a Gratias in manifestly Handelian style, a grave D minor with striding dotted rhythms, comes a soprano duo in the Domine, where Constanze had to hold her own with the brilliant Ceccarelli.

The G-minor Qui tollis is so Baroque in its dotted rhythms that it sounds almost like another quote from Handel, but it is also Bachian in its double choirs calling to each other. The Quoniam vocal trio is close to the manner of a Bach solo vocal movement, a thin texture over a strong bass with violin obbligato, the two sopranos trading florid sorties. After a massive Jesu Christe ringing with trombones comes a solemnly contrapuntal Handelian fugue on Cum sancto spiritu that gathers to a massive Amen. The Credo announces its proclamation of faith with vigorous fanfares, the chorus declaiming in staunch rhythmic unisons. Then arrives the longest movement, Et incarnatus, in Masses often mystical in tone because it evokes the descent of the divine into humanity. Here it is a stylistic departure, a soprano solo closer to opera than Baroque oratorio, also the most exquisite number in the Mass and a foreshadowing of Mo-

zart's late sacred music—which is to say, direct and from the heart. It involves a delicate openwork of soprano with a trio made of flute, oboe, and bassoon. The quartet of trombones added to pairs of oboes, bassoons, horns, and trumpets makes up the rich wind choir passage that begins the Sanctus, a color unique in Mozart's work. The movement resolves into a dashing fugue on Osanna in excelsis.

The Mass winds up with a return to neo-Baroque in the Benedictus, starting with a vocal quartet. Here is the end of a larger pattern: the Mass begins with vocal solos, then a duet, a trio, now a quartet. The chorus enters with some galloping counterpoint to make a big finish, but the Benedictus at the end still does not sound like a conclusion: the last pages are terse, seeming more on the way to the expected Agnus Dei than the finale of a mighty undertaking.

So the Mass in C Minor ends up a truncated undertaking, with stylistic issues arguably not entirely settled. Its debts to Handel and Bach are undisguised, less assimilated than in any other major Mozart work. In the end the Mass seems less integral than his sacred music earlier and later; it jumps movement to movement between Handel oratorio grandiosity, complete with big fugues, to more nearly Bachian and/or operatic solo movements. An Agnus Dei might have given Mozart the chance to draw things together more at the end, but that did not come to pass.

The C Minor is a vigorous, colorful work. But if with this Mass Mozart was striking out on a new path for sacred music, the path immediately petered out. Again, sacred music was a problem in the late eighteenth century. The grandiosity of the High Baroque was distant from the more modest and intimate High Classical voice, and the tragic vein of much sacred music was distant from the generally optimistic tone of the era. In his late Masses and oratorios, Joseph Haydn would submit to the Viennese operatic style, but that never seemed to interest Mozart. He wanted something else, but the C-minor Mass suggests that he did not yet know what that might be. Eventually, he would find his own way in sacred music, but he would have little time to explore it.

All this is to say that for Mozart, finding a distinctive sacred style had eluded him in his Salzburg youth, and it still eluded him in the C-minor Mass. The material is entirely powerful and imposing. These days he was still capable of routine pieces, but not in a big work like this. But

with the Mass something stood in the way. Some of that was stylistic and some practical. If he had finished it in the same spirit, it would have been well over an hour long. That would have made it unwieldy for any service, more so given the restrictions placed on church music in Joseph's Vienna as in Colloredo's Salzburg. So, this may be another reason he put it in a drawer, leaving it a splendid unfinished conception, an imposing profile like the ruins of a castle on a mountain peak.

THE DAY AFTER THE MASS PREMIERE WOLFGANG AND CONSTANZE took their leave of the Tanzmeisterhaus, probably to the relief of everybody concerned, and set out east toward Vienna. Just before they left Constanze asked Leopold for a keepsake from the collection of baubles that remained from the children's early travels. It was a simple, even touching request. Leopold refused.[43] Wolfgang would see his father only once more. His sister he never saw again.

On October 29 the couple arrived at Linz on the Danube for what turned out to be a three-week stay in that venerable town with its grand views of mountains and river.[44] They expected to take an inn there, but they were summoned to the palace of old Count Johann Joseph Anton von Thun und Hohenstein, the patriarch of Mozart's Viennese patrons. "It is hard to describe the wealth of courtesies that are being showered upon us in this house," he wrote Leopold.

> On Tuesday . . . I will give a concert at the theater here.—And as I didn't bring one single Simphonie with me, I'll have to write a new one in a hurry . . . I must close now, for I have to start work at once . . . Give our greetings to Gretl and Heinrich . . . and to Hanni;—and please tell Gretl from me, she should not strike such coy poses when she sings in performance; kisses and flattery are not always appropriate.—Only dumbasses fall for such tricks.—I myself would prefer a simple peasant lad who is not ashamed to shit and piss right in front of me to such insincere cajoling, which is so thick that you can grab it with your hands.[45]

The symphony he indeed wrote in a hurry: five or six days it appears, though he may have already had ideas for it on paper or in his

head. It is to be noted that in those few days the piece was composed, then the parts had to be copied and presumably given to the orchestra for at least a run-through before the premiere at the Ballhaus in Linz.[46]

This is Symphony no. 36 in C Major, K. 425, which history would dub the *Linz*. It begins with a weighty and solemn passage, his first slow introduction, which was a feature of Viennese symphonies. It prefaces, however, an Allegro spiritoso that strikes out on a blithe and galant note, telling us that this symphony is going to be affable in disposition. There will be few signs of haste in it, least of all its length, some thirty-five minutes. Three of the four movements are in sonata form, and it has a big sound, even though the woodwinds are restricted to oboes and bassoons. Pairs of horns and trumpets flesh out the texture.

There is no certain record of whether Mozart had yet gotten to know Joseph Haydn personally, or how thoroughly versed he was so far in Haydn's mature symphonies, but in any case he was moving stylistically toward Haydn. The *Linz* was written not for a palace music room but for a probably medium-size orchestra in a spacious hall. Again, Mozart is becoming freer in his treatment of sonata form, his themes proliferating in expositions, his developments expanding. His keys are becoming less predictable: the chugging second theme of the first movement would conventionally be G major in a C-major movement, but this one begins in a surprising E minor before slipping into G. He wields a subtle motif through the course of the piece: the opening bar outlines a sixth, C up to A, and the melodic material beginning to end will tend to turn around that interval; for one example, the gentle first theme of the Allegro sighs up from E to C, then back down to E. These kinds of connections give an air of familiarity to new material as it turns up, just as our sense of new faces we encounter may strike us, often unconsciously, as recalling faces we have known before.

For the second movement Mozart issues a gracious Siciliano in F major, with the placid 6/8 lilt of the genre, the rare inclusion of trumpets and horns in a slow movement contributing to some intense passages.[47] The opening of the main theme stretches from C up to A, echoing the beginning of the first movement. After a swinging *minuetto* with a breezy trio, the finale, again in sonata form, dashes around like a child on holiday. Which, in a way, is what Wolfgang and Constanze were enjoying in Linz, oblivious to terrible news awaiting them at home.

Another apparent product of this period, though its provenance is hazy, is the Piano Sonata in B-flat Major, K. 333. More than its predecessors, this sonata demonstrates the ways a work feeds on itself as its goes. It begins in a genially galant mode, laying out the scale-wise descent of a sixth that will turn up steadily in the piece. Another abiding feature will be the first bar's downbeat appoggiatura, an underlined dissonance. In the rest of the work this motif will be turned upside down, linked into chains, developed steadily. After a first section concentrating on the opening theme, turning its elements around as if examining a gem, the second-theme section blossoms into three distinct themelets, the third preceded by a striding and a bit mysterious interlude that briefly interrupts the lively rhythm. (The integral quality of the thematic work is shown in how the second bar of the second theme section is a melodic recasting of the rhythm of the sonata's first full bar.) The development is not long, but starting with a driving bit of F minor it adds an unsettled note, a bit of cloud over a generally sunny outing. In the recapitulation, the exposition's mysterious interlude with thirds is expanded into a suggestion of the coming middle movement, with its parallel thirds.

The Andante cantabile, in a compact sonata form, is quiet and meditative, with moments of yearning washing through it. Its development is short but fraught from its beginning on a downbeat appoggiatura, this one making a strange, wrenching harmony. The Sonata-rondo finale begins with a wry little theme that rather lampoons the first theme of the first movement, playing with the G that begins the piece, that note ordinarily occupying a modest role in the key of B-flat. In the second bar the G comes off almost as a hiccup, or a missed F. The general mood is breezy and a touch ironic, with a central section that begins in the rich middle of the keyboard. Before the end there is a muscular episode leading to a concerto-like little cadenza. A return of the wry A theme assures us that the concerto-ish showing off wasn't too serious, all in fun.

ON THEIR RETURN TO VIENNA AT THE END OF NOVEMBER 1783, WOLF-gang and Constanze were greeted by the discovery that their little Raimund was three months in his grave. He had died of dysentery.[48] The mature knowledge that only about half your children were going to survive beyond the cradle was quite apart from the devastation of

the experience with a first child. After that death, you never again had the same kind of hope. Wolfgang wrote home, "We are both very sad about our poor, bonny, fat, darling little boy."[49] In the next weeks they dragged themselves through a fog of sorrow and loss.

At the end of the year nothing appeared all that promising. Mozart was working desultorily on a couple of buffa librettos; he finished a forceful, almost alarming Fugue in C Minor for Two Keyboards (years later he added an ominous Adagio introduction to an arrangement for strings); just before Christmas he played in a Society of Musicians concert at the Burgtheater.[50] For the moment there was little to indicate the splendors the coming year would bring. He was entering a period of stupendous creativity that he would mount in response to relentless demand. It seemed not to be in him to say no to anybody, either as composer or performer, though in practice the two were connected: his concertizing would require a steady supply of new works, mainly concertos. In the coming thirteen months he would write eight concertos and sketch another, and some of those pieces would be historic.[51]

Meanwhile, that year in Paris there appeared a play called *The Marriage of Figaro*. It had already made a scandalous sensation before Mozart took it up and made it immortal.

LONG AND LABORIOUS EFFORTS

The beginning of 1784 found the Mozarts moving again, to the massive new Trattnerhof, which fronted on the Graben, the busiest street in Vienna. The building had some six hundred tenants, but Mozart did not seem to be bothered by noise and bustle inside his building or outside. Owner Johann Thomas von Trattner had made much of his ample fortune publishing reprints of Enlightenment works, schoolbooks, and the like. His wife Maria Theresa, over forty years younger than her husband, was a piano student of Mozart's. Businesses on the ground floor included Trattner's luxurious bookstore.[1]

Mozart's taking an apartment in the Trattnerhof had partly to do with the rent, a bargain at 150 florins a year, and partly with the central location and the advantages of the building. It incorporated a multipurpose casino open all hours that served coffee and drinks and provided newspapers and gaming tables. That space was also a workable venue for the subscription concerts Mozart was planning.[2] Because the Burgtheater was available for concerts only during Lent, and there were no dedicated concert halls in town, he had to look to restaurants and anyplace else that could hold enough people. The quality of the acoustics was not something he could afford to worry about. Anyway, the sound was not so good in the Burgtheater or Kärntnertortheater either.

In February he began to keep a systematic thematic catalogue of his works, starting with the Piano Concerto in E-flat, K. 449. The entries have short descriptions of each piece on the left page and a few opening

bars of each on the facing page. He maintained the book faithfully from then on, not as a source for history but as a record for himself. He was writing so much in these days, was so busy in general, that it strained even his remarkable memory to keep up with what he had done. After all, when his father sent him the score of the quickly written *Haffner* Symphony, he had found that he didn't remember a note of it.

For all his productivity, Mozart was finding composing more recalcitrant. He was determined to find fresher and more personal ideas, and that took time and effort.[3] Such effort applied above all to a series of string quartets that had been occupying him for over a year. He had written plenty of quartets in the past, and clearly he was not satisfied with them—which is to say that now he had the example of Haydn's quartets before him as a goad and a judgment.

Still, as composer and performer, Mozart was white-hot in 1784, in a state of tremendous nervous and creative energy, with a public clamoring to hear him. He became accustomed to taking bows in splendid finery to thunderous applause from full houses, to being lionized in the palaces of the nobility. It suited him well. Mozart loved applause, loved having money and fine clothes and a grand apartment. His composing and performing were reinforcing one another more than ever, but in the long run he loved composing more. His income and his fame from performing did not distract him from placing that first.

The frenzy of activity he had fallen into may have strained his body, but it did not strain his mind or his creative energy. So he was in fine spirits, of the sort reflected on the manuscript of the Horn Concerto in D Major, K. 412, one of a series of works written in the Vienna years for his old Salzburg friend, the horn virtuoso Joseph Leutgeb. The manuscript of the rondo has running teasing from Wolfgang, a sign of the intimacy and sociability of this music, and to a degree of all his music:

For you, Mr. Donkey—Come on—quick—get on with it—like a good fellow—be brave—Are you finished yet?—For you— beast—oh what a dissonance—Oh!—Woe is me!—Well done, poor chap—oh, pain in the balls!—Oh God, how fast!—You make me laugh—help—take a breather—go on, go on—that's a little better—still not finished?—You awful swine!—how charming you are!—dear one!—little donkey—ha, ha, ha—

take a breath!—But do play at least one note, you prick!—Aha!
Bravo, bravo, hurrah!—You're going to torture me for the fourth
time, and thank God it's the last—Oh finish now, I beg of you!—
Confound it—also bravura?—Bravo!—oh, a sheep bleating—
you're finished?—Thank heavens!—Enough, enough![4]

Otherwise, since autumn he had been working with little enthusi-
asm on two opera buffa projects, both on speculation. One was a li-
bretto he had solicited from Abbate Varesco in Salzburg called *L'oca
del Cairo* (The Goose of Cairo). The eponymous star of the show was
a large mechanical goose. The plot concerns a Spanish nobleman who
keeps his beautiful daughter locked up in a tower, and her lover who
wangles his way into it, à la the Trojan horse, by hiding himself inside
the goose. This played into the era's fascination with automatons, such
as the famous French duck by Jacques de Vaucanson that appeared to
be capable of eating from one's hand at one end, digesting the food, and
excreting it at the other. (The duck was a clever fake. Vaucanson also
built humanoid flute and tambourine players.)[5] If the plot of *L'oca* was
fashionable, though, it was also outlandish and dramatically clumsy,
which Varesco himself suspected and Mozart knew perfectly well.
What would survive of the *L'oca del Cairo* drafts was the better part of a
first act, some forty-five minutes of music attractive and instrumentally
colorful, at the same time sketchy and not particularly memorable. The
libretto was too rambling and thin to provide either drama or char-
acters to sink his teeth into. Fortunately for everybody, Mozart never
picked up the project again.

Around the same time, he worked on another buffa, called *Lo
sposo deluso* (The Deluded Bridegroom). Later the libretto would be
attributed to Lorenzo Da Ponte, but that seems unlikely. This got as
far as some twenty-three minutes of music, including a droll overture
beginning with a fanfare for trumpets, an instrument of which Mozart
was usually neglectful; the fanfare returns as a striking segue into the
opening aria. The real significance of both these abortive projects was
to return Mozart to writing Italian opera buffa at a musically and emo-
tionally more mature level than his last effort, *La finta giardiniera*. This
would prove highly useful in his next project, one with a splendid li-
bretto from Da Ponte.

IN EARLY 1784, BESIDES PERFORMING CONSTANTLY AND COMPOSING prolifically, Mozart was overseeing a stream of publications, a grueling task in itself: every one of the myriad marks on the page has to be carefully proofed. During Lent, between March 4 and April 11, he played twenty-three concerts, four for his benefit and others in the houses of nobility with grand names: Esterházy, Galitzen, Palffy, and the like. The next year, his public concerts would for the first time outnumber private ones.[6] That spring he performed with a young Italian violinist named Regina Strinasacchi.[7] He wrote Leopold, "We have the famous Strinasacchi from Mantua here right now; she is a very good violinist, has excellent taste and a lot of feeling in her playing.—I'm composing a Sonata for her [K. 454] at this moment that we will be performing together Thursday in her concert at the Theater." For the Mozarts father and son, words on the order of *taste, feeling, expression*, were the highest terms of praise. Precision and virtuosity counted little for them. Wolfgang later wrote Nannerl about Strinasacchi, "She plays not a note without feeling . . . she played everything with expression, and no one can play the Adagio with more feeling and more touchingly than she. Her whole heart and soul are in the melody that she performs. And her tone is just as beautiful and powerful."[8]

The piece Mozart wrote for Strinasacchi, Violin Sonata in B-flat Major for Violin and Piano, K. 454, shows off his admiration. This is the violin sonata of the future, a real partnership of the instruments. Actually only half the partnership was on paper at the time of the first performance, in April in the Kärntnertortheater, with Emperor Joseph in the audience. Mozart had composed the sonata so fast that he didn't have time to write down the piano part, so he played it from memory.[9]

The sonata begins with a stately Largo that is mostly lyricism from the violin, to which the piano adds some flowery figuration while the violin accompanies. That introduction sets up a little three-note ascending figure that will mark the first theme and an arpeggio figure that will mark the second theme. A new theme ends the exposition with what comes off as the goal of the preceding, so the expansion of the exposition into more than two themes amounts to an expressive expansion too. The development is short, but in the recapitulation the first theme is extended in a further development. Mozart's thematic treatment is spreading out of the development section.

If the sonata's first movement is in tone tender but a bit reserved, the slow movement is songful and moving, a testament to Strinasacchi's expressive playing.[10] Its development is not only expansive but one of his most striking to date, because it deepens and intensifies the soulfulness of the exposition. The movement ends with one of his rare pianissimos. Neither as fast nor as gay as most of its sort, the Rondo finale is more expressive than usual, as if the poignancy of the middle movement has lingered into the next one. The middle C sections of most rondos are in minor key and intense; this one is quiet, inward, yearning. It is as if the whole sonata is captured in what Mozart wrote about this performer: "she plays not a note without feeling." So it was composed, as a gesture of intimacy between two people, and so it asks to be played.

ANOTHER PRODUCT OF THE SPRING WAS THE QUINTET IN E-FLAT FOR Piano and Winds, K. 452. The ensemble is oboe, clarinet, horn, and bassoon plus piano. Mozart may have been fonder of winds than a composer had ever been, and this may be the first piece ever written for this combination.[11] Part of his mature orchestral style was founded on an increased presence of the wind choir; he had been producing a lot of horn music for Leutgeb; he championed the clarinet as part of the orchestra, writing much of his clarinet music for friend Anton Stadler. Here his affection for winds plus his own instrument is brought to bear in one of his supreme works. Certainly he thought so, writing Leopold, "I think of it myself as the best [work] I have yet written in my life . . . I wish you could have heard it! And how beautifully it was performed!"[12]

To contemplate this piece is to contemplate why Mozart would say this, how it demonstrates the terms in which he viewed his work. First, melody was central for him, and this is an unflaggingly tuneful piece, the melodies taking the music on a journey through subtle shades of feeling. The piano has the occasional virtuosic flurry, but on the whole there is nothing flashy—rather a steady dialogue of equals calling to each other, supporting each other, sometimes joining in a rich tutti. In its material the Quintet is tight: the first bars present us with two central motifs, a three-note bit of scale that might fall or ascend; and in the piano's second bar, a figure of a descending fifth and a step upward.

For the rest of the piece Mozart will play kaleidoscopically with those bits of material.

The piece begins with a long Largo introduction that unveils the essential approach: dialogue and lyricism. Winds were usually considered vigorous and perky, not given to deep expression; here they are often songful and affecting. This applies even to the first movement's Allegro moderato, the main theme made of the two central motifs, the tone not zippy and bright but rather tending toward lyrical, much of it like an intimate dialogue among friends. The music revels in both the unity and individuality of the four instruments, arranging them in a constantly transforming palette—and likewise the whole piece, the piano a full partner but not the dominating voice. The beginning of the big slow movement sets a pastoral tone led by the oboe, the lines stretching out in long, languid, exquisite periods. This may also have been part of Mozart's affection for the piece: the way it sustains ideas beyond the crisp dancelike periods that dominated most of the time's music.

A group of winds usually implied a light divertimento, but there is none of that style here. It is more like a concerto for five instruments in a concerto-like three movements. The finale is an exuberant but unhurried Rondo, a bit oboe-centric but still involving the whole group in dialogue and companionship. The connection to concerto style is cemented finally in a written-out cadenza for the winds, at the end of which each instrument steps to the fore to doff a hat in farewell before the coda. So there is another seal of approval from the composer: an unconventional group of instruments playing in unconventional ways, the music laid out in the usual formal outlines, but which still come off as particular to this piece. Again Mozart accepts convention in one dimension, brushes past it in another.

A newspaper notice for the Burgtheater concert that premiered the Quintet gives the flavor of his programs:

Today, Thursday 1 April, Herr Kapellmeister Mozart will have the honour to hold a great musical concert for his benefit at the I. & R. National Court Theatre. The pieces for it are as follows: 1) A grand symphony with trumpets and drums. 2) An aria sung by Herr Adamberger. 3) Herr Kapellmeister Mozart will play

a completely new concerto on the fortepiano. 4) A fairly new grand symphony. 5) An aria sung by Mlle Cavalieri. 6) Herr Kapellmeister Mozart will play a completely new grand quintet. 7) An aria sung by Herr Marchesi, senior. 8) Herr Kapellmeister Mozart will improvise entirely alone on the fortepiano. 9) To end, a symphony. Except for the three arias, everything is a composition of Herr Kapellmeister Mozart.[13]

Now for these wide-ranging programs he was writing concertos at an astonishing pace. In this he was a pioneer. Concertos had generally been played in a private setting; Mozart made them public.[14] In the relentless rush of composing and performing there would have been little time to practice or rehearse. He had to rely on his own fund of virtuosity and his orchestral players' sight-reading skill, which in Vienna was probably considerable because the musicians had to sight-read so much of the time.

In May he wrote to his father and sister about pieces he had sent them: "I find it impossible to choose between the two concertos—I think they are both concertos that make you sweat.—But as far as difficulty is concerned, the B-flat has the advantage over the D major. I'm actually quite curious to know which among the three concertos, the B-flat, the D, and the G, you and my sister like best . . . I am so interested to know whether your judgment is in accord with the <u>general</u> opinion here and also with <u>mine</u>."[15]

Of those he mentioned, from the four written between February and April, two were dedicated to student Barbara Ployer, one of three female virtuosos with whom he had productive encounters in 1784, the others being violinist Strinasacchi and pianist Maria Theresia von Paradis. When Mozart had an outstanding student, he tended to write for her. The Piano Concerto in E-flat, K. 449, would acquire the name *First Ployer*; the K. 453 in G Major, *Second Ployer*. Barbara, then eighteen, came from a wealthy family, her father, Franz Kajetan Ployer, a tax collector and timber seller. Mozart reported that Franz paid nicely for his daughter's first concerto. Some years later, Ployer wrote in an album of Mozart's that he was addressing the man "who surpasses all in divine Apollo's art."[16]

While as a performer Barbara essentially owned her concertos, Mo-

zart premiered the K. 449 in E-flat at a March 17 subscription concert. He reported the audience as "filled to the brim," and the concerto "won extraordinary applause." Apparently, he had begun the E-flat with a 170-bar sketch a couple of years earlier.[17] He described it as a concerto "of a special kind," meaning more intimate than extroverted. In regard to the difficulty of the solo part, he also sets it apart from the B-flat and D major, which "make you sweat." The ensemble has only horns and oboes plus strings. Like several concertos of this period it first offers some elegant gestures, then breaks out in a powerful tutti. The concerto's main glory is its slow movement, one of his sensual nocturnes: warm-hearted, songful, aria-like, the strings marked "Sotto voce." Call it an aria sung inwardly, or intimately to a lover, delicate emotional tinctures washing through the music. The finale starts off with a bit of a tease of an academic fugue and keeps returning to that mode in a generally mischievous mood.

Arguably, the E-flat is the first of Mozart's fully mature concertos, part of that being the more equal partnership of orchestra and soloist. In turn, that partnership would make possible a new depth of dialogue between solo and orchestra, one that could take Mozart into new places as with dialogue in drama or in company: agreeing, contesting, conflicting, joking, and on through the spectrum of conversation.[18] In turn, the more substantial role of the orchestra called for more weight and color in the ensemble, which Mozart addressed by expanding the number and significance of the winds—though his particular selection of winds and of brass would vary from piece to piece. Some of these choices were practical. Most clarinets in those days had five metal keys plus eight finger holes, and could play comfortably only in A, B-flat, and tonalities close to those. Valveless trumpets had, like horns, "crook" attachments, meaning extra tubing to change the instrument's tonality. Trumpets were commonly crooked only in B-flat, C, D, E-flat, and F, those being keys generally associated with grander and cheerier sentiments.[19]

Again, Mozart's concertos were becoming more substantial, bigger in sound with a full wind section, the orchestra no longer a simple and obedient accompanist to the soloist. That is also to say that his concertos were getting more nearly symphonic than any before, and richer in material. Themes are multiplying in the first-movement exposition,

longer and more searching developments becoming the norm. In his concertos the first entry of the soloist after the orchestral exposition has usually echoed the orchestra's first theme, but now the piano is beginning to break away toward entering on its own tack. Before long in his concertos, the soloist will be adding substantial new ideas to the dialogue, the conversation of orchestra and soloist getting more elaborate and varied.

The *Second Ployer* in G Major, K. 453, is a more lighthearted but also a more ambitious matter, starting with its scoring: pairs of flutes, oboes, bassoons, and horns. Like the E-flat, it starts lightly, quite galant, before breaking into a full-throated and expansive tutti. Next is a splendid movement in C major, usually a key in the cheerful or grand direction, but this one a minorish major, with lyrical solos from the winds in a long orchestral opening. The entrance of the piano brings some brooding shadows into the music by way of striking harmonic digressions, to which the winds add commentary. Mozart supplied a beautiful cadenza for the movement. The winds continue their importance in the finale: this movement with a theme and five variations does not begin with piano alone, as usual in a finale, but with piano and flute doubling on the chirpy tune. A long concluding section rounds out a playful outing.

Mozart premiered the G Major in the suburb of Döbling, at the house of Gottfried von Ployer, a cousin of Barbara's father with whom she lived. She and Mozart also played the Two-Piano Sonata K. 448. To show off his music and his student, Mozart brought with him to the concert Giovanni Paisiello, a wildly prolific composer of mostly vocal music, eventually including ninety-four operas. At the time, Paisiello was the darling of Vienna and most of Europe, making him and Mozart nominally rivals. But Mozart was not always rivalrous, he rather liked Paisiello's operas, and anyway the man was doing him no harm. The formation of the Italian opera company in Vienna was partly inspired by Paisiello's *The Barber of Seville*. That hilarious and wildly popular work defined where contemporary opera buffa stood in style and approach, and Paisiello's *Barber* would come in handy for Mozart as a source of ideas when he returned to buffa.

The finale of the G-Major Concerto entered history for a second delightful reason, beyond its effect. In May 1784 Mozart bought a pet starling, a bird that can mimic human noises. Probably via whistling,

he taught the little creature the theme of the finale. He wrote Leopold quoting the bird's version of the tune, with the observation "that was lovely." To be sure, he noted that the bird sang a G-sharp in the second bar instead of the concerto's G natural, and added a hold at the end of the first bar. But Mozart forgave these interpretive transgressions and was fond of the pet, who for the next years added his voice to the ruckus of people and animals in the house.

In April 1783 he finished K. 450 in B-flat and K. 451 in D—the concertos that he reported made the soloist sweat. The B-flat starts off with a wind solo on a drolly flippant theme whose slithering chromatic thirds will be an abiding motif in the piece. Yet again, as with some of its fellow concertos of the time, this opening leads to a big orchestral tutti that adds gravity to the scene. Some comically reeling syncopations mark the second theme. The soloist enters with a passage of streaming figuration before arriving at the orchestra's opening melody. The music remains wry to the end of a long movement, the piano adding bravura passages to the recapitulation. The strings begin the expansive Andante with a stately and songful theme that is decorated by the piano, who occupies herself for much of the movement with gentle tracery accompanying the strings. The Rondo finale is another ironic stretch, its leading theme swaggering and folklike.

D major is usually a bright and cheery key for Mozart, but K. 451 in D begins with a grand and stately passage, rather posh with its striding dotted rhythms. The piano enters on an echo of the orchestra's opening bold stride, then breaks into extended virtuosic roulades. Light-fingered figuration will be steadily required from the soloist. The central Andante is another of Mozart's concerto nocturnes, dreamily lyrical, before the folk tune finale that doesn't aspire to much more than being good fun.

He sent the D Major home, and Nannerl, preparing to play it, wrote to ask if there was something missing in the Andante. You're right, her brother replied, meaning it was too stripped down, and he sent her an ornamented version of a passage. (Most of his written cadenzas were for Nannerl and his students. He tended to improvise them in performances.) This is an indication not only of how Mozart played his concertos, improvising figuration on the written music, but how he expected they would be played by others. Knowing when these additions

were appropriate and when not was another factor in the good taste that he and Leopold usually cited when talking about performers.[20]

THE TRATTNERHOF FLAT ON THE GRABEN SERVED MOZART WELL enough for a while, the casino where he gave concerts conveniently downstairs, but still, in June 1784 he gave notice to his landlord. With his flourishing performing and composing schedule, he needed more space for rehearsals, copyists, servants, students, pets, the new baby on the way, and his pregnant wife, plus his piano and equally indispensable billiard table. Of all his leisure endeavors involving some degree of skill—*Bölzlschiessen*, bowling, horseback riding, and so on—billiards had ascended to first place in his affection. Among its other pleasures, as he played leisurely games punctuated by the crack of the billiard balls, he could assemble music in his head. After all, the business of lining up a shot was a process of calculating angles and foreseeing outcomes, and so in its way germane to matters of composing—say, the place and trajectory of a given piece of material in the unfolding of a form.

Significant things transpired in the middle of 1784, in Mozart's life and in the whole of Vienna. In August, Joseph II issued another of his stream of decrees, this one his new mandates for burials. In the past many deceased had been placed in church crypts and graveyards inside the city walls, which was an unhealthy and increasingly unworkable tradition in a cramped city with living space at a premium. With his usual obliviousness to human sensibilities, Joseph decreed that the deceased of all but the aristocracy were to be carted in temporary coffins well outside the city to sites where they would be sewn into sacks and tossed into communal graves, the corpses piled in three layers and sprinkled with quicklime to hasten decomposition. The remains were to be dug up after ten years and the bones discarded, so the graves could be reused. No headstones were allowed, memorial services limited, graveside ceremonies forbidden. Unsurprisingly to all but Joseph, the public was outraged and protests erupted. Joseph relented enough to allow regular coffins, if the relatives insisted on it,[21] but the regulations would survive long enough to have their impact on myths of Mozart's life and death.

In Salzburg that August, Nannerl got married, meaning Leopold

finally allowed her to. He had been holding out for a husband from at least the minor nobility, and he got it: one Johann Baptiste Franz Berchthold von Sonnenburg, a magistrate of St. Gilgen. By coincidence, Berchthold occupied the same position as Nannerl's grandfather and lived in the very house in which her mother grew up. Nannerl was thirty-three, her husband forty-seven and twice a widower. He came with five children, for whom Nannerl would be responsible.

"Holy smoke!" Wolfgang exclaimed when his sister wrote the news. "It's high time for me to write to you if I want my letter to still reach you as a virgin!" He offered congratulations and regrets that he could not make the wedding, and made an offhand suggestion that everybody should come to Vienna to live. The invitation was essentially rote; by then everybody knew it was not going to happen.

His sister's wedding called for one of his poetic effusions. It shows once again that his vision of wedlock placed the marital bed at the center of the matter:

> Wedlock will teach you things galore
> that seemed a mystery before;
> now you won't wonder anymore
> what knowledge Eve had to obtain
> before she could give birth to Cain.
> Marital duties are quite light,
> and if you do them with delight
> you need not have the least bit fright.
> But all things have at least two faces
> and though a marriage offers graces,
> it also brings you worries by-and-by.
> So, if your husband shows you cool reserve,
> which you feel you do not deserve,
> but he, with knitted brow, thinks he's right:
> just tell yourself, well it's his way, and say:
> yes, Master, thy will be done by day—
> but my will shall be done at night.[22]

Shortly after the marriage, Leopold wrote a much different letter to Nannerl: "I am utterly alone in a true death-like stillness amidst eight

rooms. During the day I am unaffected, but at night, as I write this it is rather painful. If only I could at least still hear the dog snore and bark . . . But none of this matters: as long as I know that you two are living in happiness, then I, too, am content." His live-in students, March- and brother and sister, had departed, and the family's beloved Bimperl had died.[23] While there were two or three servants in the house, they did not count as companionship. Leopold's hopes for his daughter's marriage were forlorn. This match with a minor aristocrat, which he had presumably arranged, seems to have turned out largely loveless, Berchthold distant, Nannerl sinking into a life of withdrawn desperation, running the house and seeing to her five stepchildren, whom Leopold described as "troublesome, evil-minded."[24] The marriage would choke off most of what was left of her performing and teaching.

Leopold wrote Nannerl voluminous letters of advice, trying to run her household at a distance as he had once tried to run Wolfgang's career. Eventually she had three children of her own. At Leopold's insistence, Nannerl went to Salzburg for her first lying-in and, also at his insistence, returned home leaving her son, named Leopold, with him to rear.[25] Until Leopold died he kept the child. From St. Gilgen, Nannerl and her husband visited Salzburg and their son exactly once, grudgingly.[26]

A few days after his sister's marriage, Wolfgang had another health crisis. At a Burgtheater performance of a new Paisiello opera, *King Theodore in Venice*, based on Voltaire's *Candide*, he found himself drenched in sweat and began vomiting violently. He was laid up for a month. Probably the cause was rheumatic fever, which he had suffered in childhood. His doctor was friend Sigmund Barisani, from a Salzburg family who were friends of the Mozarts, and later director of the Vienna General Hospital.[27] Mozart credited Barisani with saving his life.[28] In his report to Nannerl, Leopold wrote that rheumatic fever was going around Vienna. It was not the last time the disease went around town, and probably not Mozart's last encounter with it.[29]

IN AUGUST, WOLFGANG STILL SHAKY FROM THE ILLNESS AND CON- stanze close to giving birth again, the family moved into an apartment in Grosse Schulerstrasse, just behind St. Stephen's Cathedral. The rent

was an enormous 460 florins a year, some four times his rent at the Trattnerhof—about 40,000 in the dollars of 240 years later. At this point Mozart was making 3,000 florins a year and more—hardly the income of an aristocrat, but placing him in the comfortable upper middle class.[30] A week after they moved in, their son Karl Thomas was born, the first of their children to make it to adulthood.

Mozart had needed more living space, but he also wanted more luxury in keeping with his success. Not only was their new flat elegant, with its six rooms and vestibule, but it was expansive for a wall-circumscribed city where most people below the aristocracy lived in cramped quarters. There is no exact record which of the rooms was used for what. One small room had a sculptural faux-marble ceiling: the house had once been owned by a court stucco artist who decorated the room to show off his craft. The Mozarts may have used it for a cozy bedroom.

As there were generally two or three or servants in residence, sometimes a student living in the house, visiting guests, and assorted pets, the flat was generally busy and loud, which bothered Mozart not at all. Still, much of his work was done late at night after a concert or a theater performance, while he sat alone by candlelight, the only sound the scratch of his quill pen on music paper and the quiet notes of his clavichord, while his mind rang with orchestras or string quartets. Usually he slept only five or six hours.[31]

There was a lot of furniture in the house, enough to accommodate parties, rehearsals, private performances, and hired copyists. (Mozart kept a close eye on them so they would not pilfer his work and sell it to pirate publishers.) The main room had two large windows looking out on Schulerstrasse.[32] Here would have been the center of rehearsals and performances. A room nearly as large would have been his study, with the little clavichord. Perhaps in the main room sat his Walter piano, to which he had added a pedal attachment like that of an organ, to reinforce the bass and to facilitate playing Bach fugues and counterpoint in general. The pedal board was heavy, adding to the effort of hauling the clavier around town for performances.

The year 1785 would turn out the busiest of Mozart's performing life. The months after the move to Schulerstrasse saw a flurry of major works: two piano concertos; a Piano Sonata in C Minor to which the

next year he added a fantasy prelude; the last three of the set of six string quartets he had been working at for months; and small efforts eventually including studies written for Thomas Attwood, a young British composer who studied and lived with Mozart for a year and a half.

At the end of September, soon after Karl Thomas was born, Mozart finished the Piano Concerto no. 18 in B-flat, K. 456. This was written for a striking figure in the concert life of the day: Maria Theresia von Paradis, a young piano virtuoso, singer, and composer who had been blind since early childhood. She came from a bureaucratic family, and in the 1770s had been a patient of Franz Mesmer, who actually brought some of her sight back if only temporarily. When Paradis first encountered Mozart, apparently during his Salzburg visit of 1783, she was embarking on tours of Europe that went on for years, to considerable acclaim.[33]

The first movement of the Concerto in B-flat he wrote for Paradis is substantial in size, the wind section full (though he is not tending to use clarinets in these days), but the actual material of the outer movements is not particularly weighty. Call it post-galant. Paradis clearly had great dexterity at the keyboard; the piano part he wrote for her is brilliantly virtuosic in spots, with at times a youthful playfulness certainly charming, bordering on cute. Yet again in his concertos of these years, the middle movement is most memorable in its depth of expression. It's a theme and five variations in G minor, amounting to another angle on that tragic key: call the movement a kind of formal enactment of melancholy, like a character grieving in the midst of an opera buffa. The theme is given in a long orchestral prelude, after which the soloist delivers only gentle filigree, never the plain theme. In the middle of the movement comes a consoling passage in G major, but the music that follows is still more troubled. In short, here is a slow movement of great emotional force in the middle of a generally blithe outing.

The last piano concerto of that dazzling year is K. 459 in F Major, in his catalogue dated December 11. For Mozart F major tends to the genial and earnest, but that does not encompass the depth of material and richness of sound of the opening movement. The orchestral exposition begins with a row of themelets held together with his incomparable sense of continuity that enables him to go from anywhere to nearly

anywhere else with no apparent effort. Much of that continuity is un-
analyzable, but part of what holds the movement together is the steady
presence of the marchlike dotted rhythm from the first bar. So if the
tone of K. 459 is light, the variety is sumptuous. Rather than the usual
slow outing, the middle movement is an elegant dance in 6/8, marked
"Allegretto." The finale is a jovial and dashing Rondo, its main theme
bubbly, but with a twist: three episodes of fugato, imitative counter-
point in an ironically learned tone complete with pompous trills, all ef-
fortlessly integrated into the fun. When Mozart joined the breadth and
formal richness of this concerto to more substantial material, he would
move from writing good unto great concertos to writing historic ones.
That would begin to happen in the next year.

IN DECEMBER ARRIVED ANOTHER LANDMARK IN MOZART'S LIFE, AND
therefore a landmark in his art: he was initiated into the Masonic lodge
Zur Wohlthätigkeit, "Beneficence." What drew him to this burgeoning
progressive society he never explained—or if he did, the record was
erased. There is no question, though, of his commitment to Freema-
sonry, and so to its implications and agendas, which were at once a
symptom of the European Enlightenment and part of its vanguard.

What became a worldwide secret society promoting science and ra-
tionalism grew out of the medieval guilds of the stonemasons who built
the great cathedrals. The modern movement was not an association of
builders, but masonry remained a central symbol of an organization
that proposed to build something in the world. The first Grand Lodge
appeared in England in 1717; from there the order spread around Eu-
rope. As with the old guilds, there were degrees of membership: ap-
prentice, fellow, master. Members were addressed as "Brother"; every
fellow Mason, of whatever rank in society, was your brother.

The first Viennese lodge appeared in 1742. One of its founding
members was Franz von Lothringen, later husband of Empress Maria
Theresa and father of Joseph II.[34] Maria in fact was bitterly anti-
Masonic during the marriage, more so after Franz died, this in part
because she was fervently Catholic. Governments tended to despise the
Masons partly because they did not abide by borders but to a larger
ideal of the brotherhood of humanity. The Church condemned the

Masons for a row of reasons: they were international; they were secret; they preached not a religiously based but a secular and rational ethics; they accepted in theory members of any religion and level of society, as long as they professed some sort of deity; they promoted ideals of secular constitutional governments rather than Church-allied ones. For all the antagonism of Church and states, however, by the later eighteenth century Masonry was widespread in the Old World and the New, especially among the intelligentsia: Voltaire, Goethe, George Washington, Benjamin Franklin, all Masons. In Vienna by 1780, there were some two hundred brothers allied to six lodges.[35]

Regarding the goals of the order, the playwright Gotthold Ephraim Lessing wrote, "By the exercise of Brotherly Love we are taught to regard the whole human species as one family, the high and the low, the rich and the poor, created by one Almighty Being and sent into the world for the aid, support and protection of each other. On these principles, Masonry unites men of every country, sect and opinion, and by its dictates creates true friendship among those who might otherwise have remained at a distance."

All that noted, the spectrum of Freemasonry in the eighteenth century, its heyday, was a good deal more complicated. There were schisms, differing and sometimes contending rites. Membership included men from radical to conservative, religious to atheistic. The science-based, Enlightenment rationalism the Freemasons propounded was mixed oddly and erratically with mystical paraphernalia. There were fables about connections to ancient Egyptian mysteries, some of that rising from a current of Rosicrucianism with its exotic intimations of alchemy and occult wisdom. If universal brotherhood was the declared ideal, the actual membership was largely middle class and up. Women were not admitted, Jews often excluded. For many, the order was more a practical than an idealistic endeavor. Casanova wrote that it was useful to be a member for entirely social and economic reasons. In your lodge you had a collection of often influential acquaintances, and you were welcome among brother Masons everywhere: in theory at least, nowhere were you a stranger.

In Austria the Masons' core membership was the new bureaucratic class Joseph had created to professionalize his government. This class had a good deal of status in the society, but no real say in running

the country; it existed to realize the goals and dictates of the sovereign, whose power remained absolute. The same sense of powerlessness characterized the aristocracy old and new, but its privileges and often enormous wealth were still unassailable, except by the throne. The growth of the Masons in Austria had a great deal to do with that bureaucracy and the new, paid-for nobility wanting some degree of equality with the old nobility.[36] In the democratic context of the Brotherhood, all classes were equal, including artists like Mozart, most of them making their living as servants of courts.

There were more complexities, for well and ill. In 1738, Pope Clement XII issued a bull declaring an absolute ban on membership in Masonic lodges, on pain of excommunication—which, as dogma had it, assured one's destination in hell. But that bull was suppressed in Austria. Empress Maria Theresa finally banned the lodges, driving them underground, but when Joseph took the throne they were able to emerge and proliferate again.[37] Moreover, a certain amount of the membership comprised Catholic clergy and aristocrats of liberal persuasion. Mozart may have chosen the Beneficence lodge because it was the most Catholic-influenced one in Vienna.

In his lodge there was also a Rosicrucian streak and an influence of the Illuminati, the latter a still-more-esoteric and notorious offshoot of Masonry. This order proposed to form a secret cadre of morally enlightened souls to infiltrate governments everywhere and nudge them in progressive directions. Said the Illuminati: the Freemasons talk endlessly about changing the world; we intend to do something about it. In effect, the Illuminati politicized the Enlightenment, with the ultimate goal of eradicating sacred and secular absolutism. Otto von Gemmingen zu Hornberg, the grand master of Mozart's Beneficence lodge, was an Illuminatus, Mozart's surgeon friend Franz Gilowsky an Illuminati leader in Vienna.[38] Another initiate was Joseph von Sonnenfels, a close adviser to Joseph and an acquaintance and patron of Mozart, who had six volumes of Sonnenfels's writings in his library. (In Bonn, Germany, the head of the town's Illuminati lodge was composer, writer, and freethinker Christian Neefe, who would enter history as the teacher of the young Beethoven.)

The various currents of Masonry were not necessarily rivalrous. The Beneficence lodge was close to the leading one in town, Zur wahren

Eintracht, "True Concord," headed by scientist Ignaz von Born. Both lodges met in the same rooms. Born had been ennobled by Joseph for his invention of a revolutionary extraction process that the emperor had mandated for the metals industry in the kingdom. Born's True Concord aspired to be something on the order of an academy of arts and sciences; it distanced itself from the mythic and mystical side of the order. As one visitor described the lodge, which published a journal of progressive ideas and articles on ancient religions, "They make light of the whole idea of secrecy and have transformed the entire thing into a society of rational, unprejudiced men dedicated to Enlightenment."[39] Born was also an Illuminatus, thus more radical than the run of Freemasons.

A central strain of Masonic doctrine had to do with overcoming the fear of death and damnation, turning that terror long wielded by the Church into a conviction that death is what gives life meaning and value. At every meeting, after the brothers had donned their leather Masonic aprons and other accoutrements, there would be some ceremony and singing, then a warden would proclaim, "Our whole life is only a journey toward death!" and the master of the lodge would reply, "Be mindful of death!"[40] The text to one of Mozart's first Masonic songs ran, "Only a Mason can look calmly upon the work of death . . . in the midst of decay he sees burning the flame of the better life, and hopes for the light of Truth."[41] On a later day he would write in a letter, "death is the key which unlocks the door to our true happiness." The elaborate and deeply secret Masonic initiation ceremony amounted to a symbolic death and resurrection into wisdom.

Ignaz von Born was a genial and sociable sort, a natural leader, also fiercely anticlerical and perhaps an atheist, though he would have kept the latter quiet. Like most Masons in Vienna he was a devotee of Josephinism. The Austrian Masons looked at the emperor, in contrast to his mother, as their protector. Joseph for his part was divided. He was not the least interested in joining the order, but tolerated them because they supported his reforms. At the same time, it was ingrained in Joseph to be suspicious of secret organizations, especially ones that professed allegiance to a universal humanity more than to the Austrian state. Joseph had already made the Church a subordinate branch of his government and exercised absolute control over its assets. That he would bring the Freemasons to heel was only a matter of time.

When Mozart was initiated as an apprentice into the Benevolence lodge, the speaker addressed him, "Favorite of a guardian angel. Friend of the sweetest muse. Chosen by benevolent Nature to move our hearts through rare magical powers, and to pour consolation and comfort into our souls. You shall be embraced by all the warm feelings of mankind, which you so wonderfully express through your fingers, through which stream all the magnificent works of your ardent imagination!"[42] How Masonry influenced Mozart is partly manifest, partly obscure. In the next years he wrote a certain amount of music for Masonic services, most of it on the slight side. There is no hint that he had any interest in the esoteric part of the order or any variety of mysticism. Even if friends of his were Illuminati, the kind of sociopolitical commitment they demanded would not have been his style, and he would not have had time for it anyway—though he did rise quickly to the rank of master mason.

As has been noted, this was an era before artists were expected to celebrate themselves in their work, to express their own lives and egos. In the eighteenth century artists rather aspired to express universal feelings and qualities. All the same, inevitably, one drew from one's own feelings and experience. For Mozart that now included his engagement with Freemasonry, which may have led him to a connection with the larger sociopolitical world that he had never considered before. In any case, that is where his art was heading. Near the end, he would create arguably his greatest opera on a magical story decked out with a mythologic apparatus that echoed the order. There would be the legacy of Freemasonry on the history of music.

BY THE END OF 1784 A STILL MORE SIGNIFICANT TURNING POINT ARrived in Mozart's life and work: he had become close to Joseph Haydn. The record does not say exactly when the two men met—there is no mention of it in his letters—but Mozart had been aware of Haydn and his work for many years. On January 10, 1785, he introduced to Haydn three of the six string quartets he had been working on. In reading through the quartets, Haydn would have played violin and Mozart viola. It was in this set of pieces, written in a period when he was not composing symphonies, that Mozart definitively came to terms with

the influence of Haydn, whom history, in addition to "father of the
symphony," would also call "father of the string quartet." Probably
Mozart already intended to dedicate the set to the older master, then
fifty-two. Mozart was about to reach his twenty-ninth birthday. Before
this set he not written a quartet since 1773. The first of what came to be
called his "Haydn" set is No. 18 of his works in the genre. They mark
the first of his truly important quartets.

Haydn in those days was nearing the end of his active service as
Kapellmeister of the Hungarian house of Esterházy, which maintained
one of the most extravagant musical establishments of the Austro-
Hungarian aristocracy. Born in a small town in Lower Austria, in child-
hood Joseph and his younger brother Michael showed musical gifts that
landed them among the choirboys at St. Stephen's Cathedral in Vienna.
Dismissed from the choir when his voice changed, Joseph spent years
in poverty, studying and composing, sometimes playing fiddle on the
street for pennies, working his way up through various posts until he
landed a plum one, as vice-Kapellmeister of the Esterházy court. There
for the next three decades in that job and eventually as Kapellmeister,
he was a uniformed servant, composing to order and directing the or-
chestra and opera forces for a succession of princes.

Isolated in various palaces, Haydn wrote stacks of chamber works
and music for the Esterházy orchestra and opera theater. It was a tre-
mendous way to learn one's craft, the music generally played as soon as
the ink was dry, but it was also a backbreaking job. "I did not know,"
he said later, "if I was a *Kapelle*-master or a *Kapelle*-servant . . . It is
really sad always to be a slave." But Haydn, unlike Mozart, went along
and got along in the courtly milieu. Over the years his reputation made
its way around Europe, especially after he began publishing around
1774.[43] (Before then, his princes owned his works.) By the time Haydn
and Mozart met, around 1784, Haydn was generally viewed as the lead-
ing composer of his generation, and certainly the most influential. By
then he was also the most widely printed composer in France and En-
gland; in Vienna he was published by Artaria, the leading house.

With Haydn the symphony became a more public genre, while the
quartet remained mainly the concern of amateur performers and con-
noisseurs in private concerts. He had taken up the symphony when it
was a relatively minor form of *Hausmusik*, and over years and dozens

of efforts transformed it into the king of instrumental forms. Likewise he had begun writing string quartets when they were a popular but still routine genre, largely amounting to an accompanied first violin solo. Haydn made the quartet into the king of chamber genres. In symphony and quartet, he regularly included the optional fourth movement, the minuet, and for some quartets he invented a kind of sped-up and usually jolly version of a minuet he called a scherzo, meaning "joke" or "prank." He reinstated counterpoint—called "the learned style"—as a vital part of the musical discourse. Most important, Haydn turned the quartet into what came to be called a dialogue of four equal participants, and the supreme demonstration both of a composer's craft and his creative soul. On a larger scale, he refined into its classic outline the formal model the future would call sonata form, which composers used for first movements and often for others in a work. Because that outline could organize intensified contrasts and drama in a work, its influence spread into opera, concerto, nearly every kind of genre.

There was a caveat in Haydn's career: Vienna appreciated him less than most places did. For many years he wintered at the Esterházy palace in town, but the city remained relatively cool to him. In some quarters his music's rowdy humor and forays into folk and popular styles were declared undignified. Emperor Joseph was generally grumpy about Haydn.

Before they met, Mozart and Haydn would have known a good deal about each other; Mozart had known some Haydn symphonies and chamber music probably since he was a teenager. Their first encounter might have been at Vienna concerts in December 1783, where there were works by both Haydn brothers and a Mozart concert aria, and he played one of his concertos. They had mutual acquaintances, among them Mozart's student Barbara Ployer and his horn player friend Joseph Leutgeb. Possibly encouraged by Mozart, Haydn became a Mason a month after his young friend was initiated, though he did not stay active in the order as Mozart did.

The two men might easily have been fierce rivals, but both were too honest to indulge in rivalry for the sake of it. Mozart understood as well as anyone Haydn's worth. Haydn, on the whole a kindly and generous man but touchy about his position in the musical world, decided from the beginning that the younger composer was a phenomenon he himself

could not claim to be. Later Haydn observed guilelessly to the music historian Charles Burney, "I have often been flattered by my friends with having some genius, but [Mozart] was much my superior." Mozart never heard Haydn say this, but he had already responded in kind when a musician disparaged Haydn to him, probably expecting him to be pleased. Instead Mozart snapped back: "Listen, if the two of us were boiled down together, we would still not make one Haydn."[44]

Mozart may have produced his childhood quartets easily unto thoughtlessly, but the six pieces of the Haydn set took him over two years, starting with K. 387 in G, later dubbed the *Spring*, probably begun in late 1782.[45] The Haydns cost him many months of desultory and frustrating labor, some of the manuscripts showing sketching and revising and false starts far beyond what was usual for him. The sketches have mainly to do with working out contrapuntal passages, at times with an unaccustomed uncertainty about where he was heading. Only the last two quartets, the A Major and C Major, were written fairly quickly, probably because by then he had in hand a publishing contract from Artaria.

What he ended up with was the weightiest, most probing and original music of his life to that time. In a childhood letter he had written gaily to Nannerl that he composed as easily as a sow piddles. It was no longer so effortless, not because he was running low on ideas, but because he was no longer satisfied with what had always come so easily.

The main inspirations Mozart absorbed from his model seem to have been Haydn's Op. 33, *Russian* Quartets, from 1781, which the composer described in a preface as being written "in a new and special manner." What Haydn meant by this is not entirely clear, but likely it had to do with a new equality of the four instruments, including the cello occasionally being liberated from its traditional function of dispensing a simple bass line. This change implied a new emphasis on counterpoint, not by simply recalling Baroque style but integrating a contrapuntal voice into the High Classical style, even when fugues or fugal passages made appearances. It was then that connoisseurs began to speak of the quartet as a conversation among four equal members.

The steady presence of counterpoint in the discourse is one of the things that mark Mozart's *Haydn* Quartets, as they became known. Another is a new weightiness of tone. He had not entirely left behind

the preciousness of the galant in his music. That would always be a vein to draw on, sometimes to flesh out a routine piece, sometimes as a baseline to be transformed, sometimes to ironic effect. In these quartets, though, the galant is largely banished. Even in their light moods— say, the nimble dance that opens *The Hunt*—there is more substance than before, which is to say that Mozart was pushing himself in new directions. If he was using Haydn as a model, he remained himself absolutely. This is audible in the melodic beauty of his themes, warmer and more expansive than Haydn's generally pithy and straightforward ones. Nor did the effort these pieces cost Mozart show on their surface. There is a new tightness and focus, but the music flows with the same grace and inevitability he always possessed. Now that inevitability was more hard-won.

Like most quartets of the day published in sets, the Haydns were not expected to be performed as a group. Still, quartets were issued with an eye to contrast and variety of mood and key. Players would buy a set and often sit down and read through the pieces to get acquainted with them, and they did not want to hear redundant outings. As first in the set, Mozart placed No. 14 in G Major, K. 387. This was a usually genial key for him, and so it is here from its gentle and cordial opening. Part of its richness of sound is the counterpoint. Every part is melodic, and from the beginning the four instruments trade off ideas, the focus shifting from player to player. Here as in the other quartets, Mozart expanded the array of material presented in the exposition, but at the same time the forms are taut, and there is a deeper attention to motifs that unify movements and whole works. Most noticeable in the G Major is a little chromatic line first heard in the second bar, which will mark themes for the rest of the piece. Here and in the others of the set, developments are expanding, often involving wide harmonic exploration. At the end of a development, Mozart tends to slide easily back into the home key. Especially after a harmonically searching and intense stretch, most of his recapitulations mark a relaxation, not a point of drama or suspense but a reassuring return home.

The finale of the G Major is laid out in sonata form, but its opening theme is a fugue of playfully quasi-academic cast. Its leading motif sounds like a traditional cantus firmus used as the basis for a counterpoint exercise. (That motif has the same shape and, to a degree, the

same tone and function as the one in the finale of his last symphony.)
The second theme is another fugue; before long he combines the first
and second themes in a deft but still tongue-in-cheek double fugue. In
Mozart's earlier music, fugue and counterpoint often came off as self-
conscious, not entirely integral. Here he resolves this problem, weav-
ing counterpoint seamlessly into his voice.

Mozart chose the key for a piece partly in practical terms—how a
particular key sounded with a given ensemble—but no less in expres-
sive terms. He wanted one quartet in the Haydn set to be darker, in the
direction of tragic, so he chose D minor. That quartet, No. 2, K. 421,
begins sotto voce but with the urgency of that key for Mozart: an ag-
itated statement delivered in a whisper. Adding to the intensity is the
tightness of the form, with no subthemes in the exposition but with
each theme rich in material, transforming restlessly from bar to bar.
The leading motifs in the quartet will be the downward octave plunge
of the first measure and the D-C-sharp-D half-step figure of the sec-
ond, which will persist in the piece like a simmering trouble in mind.
Another aspect contributing to the first movement's unsettled quality
is that the phrases are unstable, many skirting the familiar four-bar
symmetry, some beginning in the middle of a bar. The development is
one of Mozart's most heated. It focuses on the opening theme like an
obsession, with explosive accents, the key shifts volatile: dark A-flat
minor, A minor, D minor, G minor, F major.

After a consoling second movement in F major, but with a shad-
owed middle section in F minor, comes a minuet far from the courtly
dance of its origin. If dance at all, it is a dance of the doomed, maybe
the most Sturm und Drang minuet written to that point, with a relent-
lessly falling chromatic bass line. A childishly skipping trio in G major
seems scant relief, like whistling in a graveyard. The finale is a theme
and variations, the theme a quietly fierce siciliano. It contains a piping
figure of repeated notes whose origin goes back to the end of the first
movement's exposition, echoed in the next movements. In the finale
the intensity persists through a spectrum of colors and textures in the
variations, each instrument given its moment in the foreground, the
repeated notes becoming more insistent. At the end the main theme
returns allegro, the repeated-note figure now obsessive. The final ca-
dence returns to the D-D octave plunge of the beginning of the quartet

and the half-step motif on A G-sharp A, completing the expansive and impassioned journey of which they were the harbingers.

So both in material and in expressive consistency Mozart is pulling his pieces more tightly together as a whole than he had before. Haydn showed the way in that process, and Mozart understood what Haydn was doing more deeply and creatively than anybody else. Still, the relationship of Mozart and Haydn was not a simple one of mentor and acolyte. The influence went both ways. The D-minor Quartet in Haydn's later Op. 76 set, called the *Quinten* for its relentless fifths motif, he surely wrote with Mozart's D-minor Quartet in his mind. They share the same kind of intensity, and some of Haydn's themes seem a distant echo of Mozart's.

The next quartet, No. 16 in E-flat, K. 428, is on the whole the most untroubled of the set, even if it begins with a twisting and aphoristic unison motto involving nine of the available twelve notes of the chromatic scale. It is answered by a lovingly engaging theme that defines the temper of the piece. The prevailing geniality is amplified in an exquisitely sighing second movement, one of those times that Mozart seems to conjure the languid glow after lovemaking. The minuet, in contrast to the D-minor one, is vigorously danceable, the skittering finale a specimen of its expressive indication: allegro vivace—*allegro* usually meaning "fast" in music, but the word actually meaning "bright and merry."

The first three *Haydn* Quartets laid out emotional climates from gracious to fierce. The next three are marked by their greater concentration, their enhanced counterpoint, the attention to developing their themes like a debate carried on at length.[46] The fourth of the *Haydn* Quartets, No. 17 in B-flat, came to be dubbed *The Hunt* because its opening theme evokes a horn's hunting call. This will not be an impassioned work, but it will be rich both in material—it begins with a capacious exposition—and at the same time in concentration: for one example, the little D-C-D bit in the second bar flowers into a trillish figure that dominates the long second theme and is further varied and developed in the development section and in a long coda. The following minuet recalls the traditional grace of that dance, yet it still has more substance than a galant outing, this partly because there is a steady contrapuntal undercurrent, something the galant usually avoids. A solemn

slow movement verges on hymnlike. It gives way to a dancing finale in sonata form: Mozart the dancer, in person and on the page. The sonata form means the finale will have more developmental depth than the usual blithe rondo.

A major was usually one of the cheery keys, partly because it sounds so bright in strings. No. 18 in A Major, K. 464, adds some contrapuntal depth and gravity to that mood, along with bold harmonic excursions—for one example, the second section of the first theme is in C major, far from the home key. Here as much as in any of the set is the realization of the idea of the quartet as conversation, the instruments steadily tossing material back and forth. The material here is more severely concentrated than in any of the quartets; the marvel is the variety Mozart gets out of that concentration. Again, the minuet movement comes second rather than in its usual third spot in a work, this one in a sort of minorish and pleading A major, everything developing a couple of succinct ideas. (Mozart never used Haydn's scherzo movement.) Third is an enormous set of variations on a simple and songful theme—again getting a lot out of a little—that in its course explores a range of textures, from lush to diaphanous. The finale is in a compact sonata form, so nominally with two theme sections, but it never gets far from the sighing chromatic slide of its opening, which evolves in myriad forms.

To finish the set Mozart unveiled one of the sui generis moments of his creative life, the Quartet in C Major, K. 465. It begins with a searching version of that usually polite key, its atmosphere even darker than C minor, the cello pulsing quietly on a low C. Rather than filling out the home chord as usual, over it the viola adds an A-flat, the second violin an E-flat, and then the first violin enters on an A natural—in the context of that era a cross-relation, a foul dissonance—to virtually uncanny effect. This moment would be fiercely debated by theorists into the next century; it gave the whole piece the nickname of *Dissonance*. (When somebody complained to Haydn about it, he replied testily: "If Mozart wrote it, he knew what he was doing.")[47] Harmonically, the A natural can be called an appoggiatura, an upper note out of the harmony that resolves into a proper consonant note, as the A-natural does—and likewise similar if less cryptic harmonies to follow. But that A natural is still wrong, intentionally wrong. This is one of Mozart's

moments of stunning harmonic daring, always memorable because so much of his harmony is straightforward. The point here is the strangeness, the troubled harmony of the whole introduction that keeps the key tantalizingly elusive.

Then the next surprise: that knotty opening introduces a warmly welcoming C-major Allegro. Years later, Haydn would surely remember the beginning of this quartet when he wrote his oratorio *The Creation*: after an introduction whose harmony evokes primal chaos, the music erupts unforgettably in a pure C major on the phrase "and there was *light*!" The implication is the same in the *Dissonance* Quartet: from darkness and uncertainty to light and certainty. It is perhaps germane that when he wrote the piece, Mozart had just become a Mason. In the future, some would see here an evocation of the order's initiation ceremony, which begins in blindfolded darkness. When the blindfold is torn away and the initiate is stunned by the light, he has symbolically journeyed from ignorance to enlightenment.[48] The rest of the C-major Quartet remains in the light, ending the set with calm equanimity. The slow movement is a long Andante cantabile, ABAB coda in form, that begins warmly on a lovely hymnlike theme, and journeys through territories of twilight intimacy, each theme varied and enlivened on its repeat. The B theme recalls the quietly pulsing cello notes of the quartet's opening, and its searching atmosphere. A movement as inward as any in Mozart ends with a passage of exquisite and consoling delicacy. Here is the completion of the thought that was left hanging at the end of the first movement's introduction.

In these works, with Haydn as his beacon, Mozart raised his string quartets to the level of his other music and in the process expanded all his art to a greater breadth and depth. Everything he did was grounded in a phenomenal inborn talent, but in the end what he accomplished was grounded in sustained labor, fueled by an implacable determination to reach higher. More than with many composers of his stature, his greatest works would come largely in his last years.

In his quartets Mozart was not aspiring to compete with Haydn. He knew he could not do that. No one could. Haydn had invented the very sense of what a quartet was. What Mozart wanted to do with these pieces was to honor and be worthy of Haydn, whom he admired more

than any composer alive, and who admired him likewise. When he published them, Mozart added a heartfelt dedication:

> A father, having decided to send his children out into the wide world, felt that he should entrust them to the protection and guidance of the famous Man who by good fortune also was his best Friend.—Here they are, distinguished Man and dearest Friend, my six children.—They are, to be truthful, the fruit of long and laborious efforts; however, the hope given to me by various Friends that my efforts will be at least somewhat rewarded encourages and flatters me to think that this offspring will be of comfort to me someday. You yourself, dearest friend, told me of your approbation of them during your last Visit here in our Capital . . . May it please you to welcome them kindly and to be for them a Father, Guide, and Friend![49]

Artaria gave Mozart a lavish 450 florins for the quartets, the same as he received for an opera at that point.[50] He was being published steadily, fifteen works and sets of works issued between 1781 and early 1786, but this hardly kept up with his production.[51] The importance of his work was now in effect a byword, as shown in Artaria's notice of the publication: "Mozart's works call for no special praise, so that it should be quite superfluous to go into details; it need only be affirmed that here is a masterpiece. This may be taken as the more certain since the author has dedicated this work to his friend Joseph Haydn, Kapellmeister to Prince Esterházy, who has honored it with all the approval of which a man of great genius is alone worthy."[52]

Mozart had been in Vienna only four years, but his name and influence were spreading widely. In November 1784 Leopold wrote his daughter that *Die Entführung* was done to great applause in Salzburg, and "the whole town is delighted with it. Even the archbishop was gracious enough to say 'Really it wasn't at all bad.' I hear that they took in 191 gulden." At a second performance, Michael Haydn sat in the middle of the orchestra, behind the clavier, taking it in with delight. He opined that it needed an orchestra of sixty or seventy to reach its full effect.[53]

Besides his finishing the *Haydn* Quartets and receiving their dedicatee's blessing for them, for Mozart the beginning of 1785 saw further

events of moment. He had applied for admission to the Tonkünstler-Societät, Vienna's benevolent organization for musicians, and they asked him for a new piece for one of their big charity benefits in Lent. With no time to write something new, Mozart reworked the Mass in C, added two new arias and a Terzetto, supplied the whole with an Italian text, and called the result *Davide penitente*. With the usual huge forces it was premiered in March, to a disappointing audience and little notice. Meanwhile, though Mozart appeared to be eager to be accepted into the society, for some reason he never got around to supplying the required birth certificate, so the attempt foundered.[54]

In January Emperor Joseph dispatched a letter to his censor: "I hear that the well-known comedy *Le mariage de Figaro* is said to have been proposed for the Kärntnertortheater in a German translation; since this piece contains much that is objectionable, I therefore expect that the Censor shall either reject it altogether, or at any rate have such alterations made in it that he shall be responsible for the performance of this play and for the impression it may make."[55] In other words, if the censor allowed the play to go forward, the repercussions would be on the censor's head. Of course, he shut down the performance.

With that the notorious French play was forbidden from the stage in Vienna just a few days before it was scheduled to be mounted by the new director at the theater, Emanuel Schikaneder. The actor and impresario had been a friend of the Mozart family since he brought his troupe to Salzburg in 1780. In November his first production in the new job had been *Die Entführung*. As for *Figaro*, whose reproaches against the nobility had perversely been embraced by the nobility in Paris, this seemed to end its chances in Vienna. Schikaneder probably vented his frustration to his friend Wolfgang. In any case Mozart knew all about the play, and as it turned out, this first failure of *Figaro* in Vienna was hardly the last word about it.

In February 1785, in the midst of Wolfgang's now accustomed torrent of work and with a new baby in the house, the family welcomed a distinguished visitor: Leopold Mozart.

Chapter 19

THE GREATEST COMPOSER

Leopold Mozart arrived at his son's flat in Vienna on February 11, 1785, a miserable traveler suffering from a bad cold in the middle of a howling winter. Soon after he arrived, so did heavy snow and temperatures that had some Viennese freezing to death.[1] Leopold was then sixty-five and not as apt for travel as he used to be. With him was teenage violinist Heinrich Marchand, who along with his singer sister had been a project of Leopold's. He hoped to make soloists out of them and thereby renew his fame as a pedagogue. The siblings' parents had paid for Leopold's carriage so he could show off their son in Vienna.[2] Heinrich would perform a couple of times during the visit, to no effect.

When Leopold appeared at his son's apartment, men were frantically copying out the orchestra parts of a concerto finale for a program that night. It would have to be sight-read at the performance. The cold and snow would not deter the servants, who had to haul Wolfgang's well-swaddled piano to the ballroom of the Mehlgrube restaurant. This was the first of six Lenten subscription concerts Wolfgang was to give on Fridays at the hall. That night, along with his son's symphonies and arias, it appears that Leopold heard the premiere of the D-minor Piano Concerto, among the most fiery, original, complex, challenging works his son ever wrote. Leopold, who for the whole of Wolfgang's musical life had preached to him a doctrine of keeping it simple and catering to the crowd, found the piece glorious. At the end of the concert, amid

thunderous applause, Emperor Joseph waved his hat and called out, "Bravo, Mozart!"[3]

The next night Joseph Haydn came to Wolfgang's house on Schulerstrasse. With Haydn and Leopold playing violin and Wolfgang on viola, they read through three of the string quartets that Wolfgang intended to dedicate to the old master. At the end, the most celebrated composer in the world said to Leopold: "Before God and as an honest man, I tell you that your son is the greatest composer known to me either in person or by name. He has taste and, what is more, the most profound knowledge of composition."

These extraordinary occasions were not lost on Leopold. Still, he was feeling his age, his energy was flagging, his cold was tenacious, and before long he began to suffer from arthritis.[4] But he was ready to be further impressed by Wolfgang's extravagant apartment and its cost. Leopold reported a rent of 460 florins; in fact it was 450, though the servants, food, wood, candles, and general upkeep added more. (In Salzburg, Leopold's rent for the much larger Tanzmeisterhaus flat was 90 florins.) Wolfgang's six Lenten concerts seem to have made a remarkable net profit of some 4,000 florins.[5] Leopold estimated his son's savings to be in the vicinity of 2,000. Otherwise Leopold found new baby Karl Thomas charming, the image of Wolfgang. The house he declared well-tended, this being a compliment to Constanze. One of their meals included roast pheasant, rare meats, oyster, glacé fruits, and several bottles of champagne. A meal at Constanze's mother Frau Weber's house Leopold would report as "neither too lavish nor too stingy . . . cooked to perfection."[6]

But as the weeks went on the surfeit of delights proved wearing. Wolfgang was frantically busy, performing nearly every night and composing steadily. After a month Leopold reported to Nannerl, "We never get to bed before 1 o'clock and I never get up before nine. We lunch at two or half past. The weather is horrible. Every day there are concerts; and the whole time is given up to teaching, music, composing and so forth. I feel rather out of it all. If only the concerts were over! It is impossible for me to describe the rush and bustle. Since my arrival your brother's fortepiano has been taken at least a dozen times to the theaters or to some other house."[7]

On one occasion Leopold listened with critical interest as Aloysia

Lange, his son's old flame and now one of the leading sopranos in town, privately sang for him. He wrote Nannerl, "Well, I have twice heard Mme. Lange sing five or six arias at the clavier in her own house, . . . That she sings with the greatest expression cannot be denied . . . I now understand why some said that she had a very weak voice and others that she had a very powerful one. Both statements are true. Her held notes and those she emphasizes are astonishingly loud, her tender phrases . . . very delicate, so that in my opinion there is too much discrepancy between the two."[8]

Leopold stayed in Vienna for two and a half months. It appears that Wolfgang talked up the Freemasons and his father was agreeable to joining, which suggests his liberal sympathies were running strong. He was put up for membership and initiated in early April. For the occasion, Mozart wrote a song, "Fellow Craft's Journey." On April 24, the day before Leopold left town, they attended a ceremony at the True Concord lodge in honor of its grand master, scientist Ignaz von Born, for which Mozart provided the cantata *Die Maurerfreude* (The Mason's Joy). (Like Haydn, who attended few to no Masonic meetings after he was initiated, Leopold did not pursue the craft.) The seven-minute cantata, routine like most of Mozart's Masonic music, was largely a solo written for his friend and fellow Mason, tenor Johann Adamberger. It ends with a chorus in praise of Emperor Joseph.

Before Leopold departed there was one more matter to see to. He wrote Nannerl: "The Baroness von Waldstätten is sending us her horses on Tuesday and we are to drive out to see her at Klosterneuberg, her present headquarters, lunch with her and return in the evening. I am very anxious to meet this woman of my heart, since I . . . have been the man of her heart." They had been exchanging warm letters—he complaining about his son, she reassuring him—and also confidences about their lives. This would be their only meeting. No record would survive of how it went, but there was no question of a deeper relationship. Leopold lived far away, and no matter how unconventional a noblewoman Waldstätten was, she was not likely to be so eccentric as to take up with an elderly commoner.

Leopold left Vienna on April 25. The visit had exhausted him, but otherwise it had gone well enough. He could only have been impressed by the acclaim his son was enjoying, his sumptuous income, his ex-

traordinary diligence: in March, Wolfgang completed another important piano concerto, No. 21 in C Major. Leopold had witnessed his son at the apex of his career. During the visit he may have become more nearly reconciled to Constanze, or not. As for the view from Salzburg, he had long overstayed his leave of absence, and Archbishop Colloredo responded as usual: "If Leopold Mozart is not hereby returned the second half of this month, his salary is to be stopped until further notice."[9] In keeping with his old style of excuses on the road, Leopold blamed his delay on the wind, the snow, the cold, and his illness. His official leave from his job had been six weeks; he was gone fifteen.[10]

After so many roads and so many years, this concluded Leopold's last journey involving his son. They had been one of the most remarkable teams in the history of their art, and they had written a substantial chapter of that history themselves. On his departure Wolfgang and his wife accompanied Papa as far as Purkersdorf, and there they parted forever.

WORKS OF MAY AND JUNE 1785 SHOW WHERE MOZART STOOD BY THIS time in his art: bursting with ideas in works pouring out of him. The year before he had finished one of his most imposing piano sonatas, K. 457 in C Minor, dedicated to his student and former landlord's wife, Maria Theresa von Trattner.[11] The next May he added to the sonata a Fantasy in C Minor, K. 475, to act as a prelude and to make the piece into a bigger and more sweeping statement. It is some of the most substantial of all his solo piano music. Nearly everything he turned his hand to in these days, even kinds of works he had not tended to take all that seriously, were touched by the high tide of his inspiration.

The idea of a fantasy or fantasia was a singular genre in the Enlightenment atmosphere that wanted to define and codify everything: the point was to present an atmosphere of freedom and improvisation. The idea went back to the sixteenth century. Earlier fantasias were so loose that they often omitted bar lines. By the eighteenth century, formal outlines like sonata form or rondo or ABA were still considered out of place in a fantasia. Ideas were expected to evolve steadily, harmony to be bold and searching. In general, then, what was not only allowed but expected in a fantasia was the kind of freedom considered inappropriate

to a sonata, where tightness of form and material and predictable repe-
titions of material were the rule.

Always mindful of genre and tradition, in the Fantasy no. 4 in C
Minor, K. 475, Mozart maintains the quasi-improvisatory atmosphere
of a fantasia but does not care to give up all sense of regularity. There
are clear contrasting episodes, and a concluding return to the open-
ing. When he decided to attach a fantasy to the C-minor Sonata, for its
opening idea he takes up motifs from the sonata's opening: the motto
that sinks on its repetition, its opening stride up a C-minor chord. Then
for the Fantasy's opening theme he adds chromatics that blur the tonal-
ity and set a more cryptic mood.

The Fantasy is a troubled journey of searching and not quite finding.
Significantly, Mozart first wrote a C-minor key signature at the top and
then erased it. The first bar is in a blurred C minor, but that key is not
heard from again until the end. The usual secondary key in a C-minor
work, E-flat major, is not heard from at all. So, the Fantasy is "in" no
clear key at all until the coda settles, a bit uneasily, into C minor. As
to motifs, the Fantasy and Sonata alike are unified by chromatic lines
and endlessly varying half-step figures that recall the second bar of the
piece. Tense silences play a role in both pieces.

The first section of the Fantasy is built around relentlessly sinking
chromatic bass lines. They take the music on a path of precariously
shifting harmonies while the left hand strides obsessively in echoes of
the opening motto. Here as in the whole movement, most of the music
is figuration with only fitful wisps of melody. The next episode settles
into a shadowed, rueful D major, answered by an urgent passage start-
ing in A minor—D major and A minor both being keys far removed
from C minor. A moment of cadenza-ish, rushing chromatic scale is
followed by a long Andantino in B-flat, more nearly melodic but un-
settled and troubled by silences. The music drifts off, then an agitated
passage breaks out with rattling thirty-seconds. Wandering harmonies
lead back to the opening motto and a coda that finally establishes C
minor. The Fantasy ends with a dizzying uprush of scale.

That stretch of uncertainty prepares the Sonata in C Minor, which
begins fiercely with its motto, a blunt stride up the home chord. Here in
contrast to the Fantasy the keys will be clear and stable, but the rhythm
is nervous and implacable, the intensity unrelenting. A quiet and ex-

pansive Adagio middle movement is not so much consoling as pensive, a broad journey of mood and texture. The Rondo finale begins quietly but already unsettled in the offbeat rhythm of the theme, which bursts into belligerent gestures punctuated by silences. Near the end, divided between high treble and deep bass, the opening figure of the Fantasy returns like the memory of a dream. In this movement especially, the boiling emotion of the music seems to stretch past the rather delicate pianos Mozart knew, to anticipate more robust instruments of the future with their expanded palette of volume, range, and color that opened new avenues of expression.

A small but touching product of June 1785 is the song "Das Veilchen" (The Violet), on a poem by Goethe. Over his career, Mozart wrote twenty-some songs for voice and piano, ranging in subject and style. "Das Veilchen" is among his most memorable. In contrast to his concert arias and scenes that tend to operatic-style drama, his songs are small-scale, intimate, belonging to small rooms and good friends. Like "Veilchen," some are closer to folk style than usual for him. In the two minutes of the song he creates a small world of expression allied to the poem. A little violet dreams fondly of being picked by a young shepherdess, but when she appears she obliviously tramples him, leaving him dying yet content to have been touched at all: "And if I die, then I die / Through her, through her, / At her feet, after all." The poem is, of course, a barbed parable of hopeless love. Mozart's setting paints in simple tones the ingenuous hopes of the opening. Then in a bit of recitative comes the piercing moment of being crushed, then the violet's pathetic and forsaken last thought, the music touched with irony. The manuscript of the song covers a single page and looks dashed off, as if to be sung on the spot, but his notation shows no crossing out, not the slightest uncertainty.

IN SUMMER 1785, A VISITING MUSIC PUBLISHER'S REPRESENTATIVE from London wrote a description of Mozart. The day was hot, the visitor reported, Mozart had been working intensively on a string quartet. He was formally dressed, but did not appear put out at being interrupted. In fact, as they talked, Mozart jotted down notes here and there.

I was surprised, when he rose to find him of not more than about 5 feet and 4 inches in height and a very slight build. His hand was cold but his grip was firm. His face was not particularly striking, rather melancholy until he spoke, when his expression became animated and amused and his eyes, which constantly darted from Klein to myself, were full of kind concern in our doings about which he inquired with obvious interest. He had not been to London since a boy but seemed to remember it well and spoke of his old friend Bach, who had died some three years past.[12]

There is Mozart in the flesh, his face solemn until a word brought out the twinkle in his eye, his unfeigned interest in a stranger's life, his nostalgia for London and his mentor and friend J. C. Bach. He was in a good mood. Creatively he was having a glorious year, and the worldly rewards were pleasant. He was playing constantly in public and private, sometimes making hundreds for a night's work; his music was being published steadily for generous fees. He had some well-paying students and a stream of commissions. In income this was one of his better years; he probably cleared over three thousand florins.[13]

Yet there is an ominous undercurrent. In November he wrote his publisher Franz Anton Hoffmeister asking for a loan, and the letter implies it wasn't the first time: "I turn to you in my hour of need, begging you to help me out with some money, which I need urgently at this moment.—Furthermore, I am asking you to give it your best effort in helping me with the matters we talked about.—Forgive me for bothering you so often, but since you know me and therefore also know that I am very interested in the welfare of your business, I am quite convinced that you won't take my intrusiveness amiss but rather want to be helpful to me just as I want to be helpful to you."[14] As he had shown in an earlier letter to Baroness Waldstätten, there is a studied tone of pleading, a tone he would amplify in future letters.

Why was he running low on cash? His flat at that point was expensive, but it probably did not cost him more than a thousand a year, even with related costs and two or three servants. His piano and billiard table were top of the line (the piano some nine hundred florins, the table around three hundred),[15] but they were one-time expenses. The only continuing drain on his funds was his extravagant wardrobe. Was he

gambling? Certainly he was: as noted, even when one was playing a simple game on the order of cards or billiards or bowling, there was generally money involved. There are varying reports of how good a billiard player Mozart actually was. At some point, he picked up the habit of searching out good players visiting in town, inviting them over, and trying his hand with them.[16] Possibly he was not as good with the cue as he thought he was, or as clever in card games. In any case, for all his father had taught him, there had been little to nothing about managing money. Papa had taken care of all that, and from beginning to end, funds tended to slide through Mozart's fingers.

At this point, at least, there was no crisis. Presumably he repaid Hoffmeister on time and with interest. Even if he was a freelancer and so money arrived erratically, it could still be counted on to arrive eventually. Later, when the cash flow became more erratic, Mozart himself became more anxious and erratic.

THE D-MINOR PIANO CONCERTO, K. 466, OF WHICH LEOPOLD PROBABLY heard the premiere in February 1785, can be called the work in which Mozart reaches a pinnacle where his last concertos would gather. In every respect, in depth and concentration and complexity and intensity, the D Minor is an advance over the splendid concertos of the previous year. Here begin the works that set the genre on the path it would pursue for the next hundred years and beyond. This one in particular, and the C Minor that followed it, were to be models and inspirations for a subsequent social and artistic era that prized the shadowed and demonic and called itself Romantic.

Again, D and G minor were Mozart's most fraught, most opera seria, most Sturm und Drang keys. The D-minor Concerto begins quietly, in a restless mood, the strings in nervous syncopations, the basses adding ominous drumbeats. With every device at his command—rising pitch, rising volume, increasing rhythmic energy, increasing harmonic turbulence, sudden furious explosions—Mozart ratchets the tension higher, step by step, until he arrives at a pounding figure on a high D that implacably repeats itself.[17] Call it "the demon." It climaxes an orchestral introduction in which lies a sense of lurking threat held uneasily at bay, but bursting out again and again. The demon shadows

all that follows, but it appears only once again—at the end of the movement, as if it has been waiting, as if the end confirms its sway.

There is more to the orchestral introduction than its foreboding. Mozart's classic outline of a concerto is fully in place: in the first movement a double exposition, both sections of the first exposition equipped with a subtheme. The second theme arrives in a quiet and lyrical F major that briefly calms the waters, but the demon rises again and builds to a climax. Yet within the variety of material in the orchestral exposition, there is a consistent economy of means: the central motif of the movement and the concerto is heard in the opening drumbeat, the four-note up-rips of the basses, A to D, answered by the inversion of that pattern in the violins: F E D C-sharp. That little bit of scale will preside in the thematic material like a hidden pointer to the agitations of the music.

In a concerto, the first solo defines or foreshadows the relationship that the solo and orchestra are going to have, whether they will be cooperative, competitive, at odds. The soloist is like the leading character in a play or an opera; as soon as he enters, he generates the action. The orchestral exposition builds tension and expectation for the appearance of that character. So the stage continues to inform much of what Mozart does in his instrumental music: a concerto's orchestral introduction works much like the introduction of an aria. The "first solo," meanwhile, was not generally the first notes the soloist played: the pianist was also the conductor and, partly to help hold things together, generally played under the orchestral sections. The solo part included a figured bass line from which the player improvised a harmonic accompaniment when he was not soloing.

In Mozart's concerto first movements to this point, the piano had first stepped forward repeating the orchestra's opening theme, even if it took a moment to get there. This implies a soloist and orchestra more or less in concord. In the D Minor, however, the piano enters quietly on a new idea (though it recalls the orchestra's gentle second theme). If the tone of the preceding had been stormy, the solo's shadowed but calm lyricism changes the equation, adding a note of gentleness and self-possession. There is going to be a dialogue between darkness and light, between fury and peace—at least a fraught peace, the possibility of peace.

This in turn requires a more intricate formal framework than any

concerto before. To make a broad generalization: music needs both simplicity, for coherence and expression, and complexity, for depth and durability. It does not so much matter where the simplicity and complexity lie. Bach's surface is often complex, a texture of dense counterpoint, but under the surface are simple formal outlines. Mozart's surface is often deceptively simple and direct. But often in his finest work, such as the D-minor Concerto, the material is richly varied in shape and rhythm and expression, and this variety is managed by subtle and complex form.

In the D Minor Mozart is juggling an unprecedented diversity of material. To that task he brought his incomparable skill in creating continuity among a heterogenous collection of ideas. One of his secrets, seen in the D Minor and over and over in his music, is to increase the rhythmic energy toward the end of a phrase or a section, which throws that energy into the beginning of the next phrase.

When the throbbing opening theme reappears in the solo exposition, the piano adds to it a commentary of running sixteenths that intensifies the passage and hastens it along. In place of the second theme of the orchestral exposition, the soloist presents another new idea in F, the most lyrical passage in the movement. The orchestra seconds that idea, and it leads to another feature of many solo expositions: a "display section," where the piano dispenses virtuosic passages that at once show off the soloist's dexterity and move the dialogue toward the development. What follows is one of the longest, most varied, most tumultuous developments of Mozart's music to this point. Its main material is the driving opening theme and versions of the piano's lyrical opening theme, the two elements contending. The orchestra never plays that lyrical theme, which is wielded by the piano like a frail talisman against the darkness. When the fury erupts, the soloist can't help being swept up in it.

Mozart's recapitulations tend to be a point of relative relaxation. This one is and isn't, because the surging syncopations of the opening theme sustain the stress. Mozart never wrote out a cadenza for this concerto. Whatever the soloist does in the cadenza, it has to continue the edgy dialogue of the driving opening theme and the piano's quieter themes, and lead into the climactic reappearance of the demon in the orchestral coda. The movement ends by sinking into exhaustion.

What then? Will the slow movement be consoling, angry, wounded, introspective, what? The answer is, none of those. The opening theme in B-flat major is elegantly galant, like a tea party after a storm, but in its course it blends serenity, grace, melancholy, and agitation. Secreted within it is the four-note motif from the beginning that hints of some clouds, and they appear: the middle of the movement breaks out furioso, the piano's virtuosity at the service of stress and strain. When the galant opening theme returns, the same music now feels uneasy. Within the tea party has lain an unspoken apprehension.

The finale starts fiercely, led by the piano. Tension rises and falls, a cheerier theme appears briefly, but the storm never abates but rather rages to the cadenza. Here the soloist has, within the convention of showing off their virtuosity, to prepare a transformation from darkness to light, from all the trouble that has come before to a D-major coda that begins with a certain nervous searching and moves to a final, if detectably fraught, reconciliation: the pealing final chords may be in D major rather than minor, but they are close enough to the gestures of the demon in the first movement to suggest that this is a victory bold but not final. Mozart did not much like sad endings to sorrowful stories, but he could not forget the sorrow either. Call the implication of the end of the D-minor Concerto a battle won, not a war. Two operas later, Mozart would again take up D minor on a big canvas, and the outcome would turn out still more ambiguous.

Less than a month after the D-minor Concerto, Mozart finished its riposte, the Concerto no. 21 in C Major, K. 467. He retained his gift for writing music manifestly lovely, sunny, elegant, and that mood is set from the beginning of the C Major. No clouds will trouble this concerto. But now he is presenting contentment at a higher level, from his pinnacle. This is partly because the ideas are less conventional, the touches of the galant less at face value, and the variety of material fleshing out the forms has increased radically. As an example, the mincing stride of the C Major's opening idea is answered by a crisp military fanfare, so we are presented with two contrasting characters who prepare the way for the entrance of the main character. The soloist enters with sprightly roulades before picking up a bit of the orchestral exposition and taking off on his own tack. The finale of the C Major will have a

similar direction as the first movement, starting with a rather galant theme, but in a more dashing and exhilarating direction.

The Romantics would care mainly about Mozart's darker moods and would brush aside his sunny ones as merely pleasant. But Mozart's bright outings are not necessarily less ambitious or less weighty than the proto-Romantic ones. Only in art is suffering called more interesting and worthwhile than good times. No artist made more of pleasure—made it deeper, more liberated, more sensual—than Mozart did. Yet again here, surrounded by dancing delight, the middle movement is the essence of the concerto, this time a sui generis music that would make this Andante an object of enchantment and veneration. The music is languid, veiled, at once singular yet in the line of his nocturnes, his night music. Over a gently striding bass and pulsing triplets in muted lower strings, the violins sing a sustained melody of enraptured beauty that seems to sway between pleasure and poignancy, like some essence of human love. Mozart was in love with love, and his sense of the marriage bond was whole: it was partnership, companionship, fun, and sexuality woven intimately together.

As one of its implications, call this Andante a distilled avatar of sexuality: desire, caress, piercing relief, languorous aftermath, sweet communion physical and spiritual. Who but Mozart could more beautifully encompass the subtle, the concise, and the voluptuous, could more exquisitely interweave the worldly and transcendent? Who else could revel so deeply and as if without boundary in the aura of what the world names *beauty* without asking what it is made of? Mozart stands as a rebuke to defining beauty, asking us to imbibe it as we imbibe the breath of a lover. We say of a lover that they walk in beauty. In these territories of his art Mozart walks in beauty, and he is the generous lover of everyone who knows him.

Mozart's beauty can be so overwhelming that it obscures the rest of his music that contains so much beyond simple pleasure, if pleasure is ever simple. Between life and the listener, he places his music as an intermediary. Call the Concertos in D Minor and C Major the antipodes of an art that contains the whole of life, but that places a mirror of life in a chalice: an exquisitely wrought chalice.[18]

IN LATER 1785 PUBLISHER HOFFMEISTER COMMISSIONED THREE WORKS
for piano quartet—piano plus violin, viola, and cello, a rare chamber
medium in those days. For whatever reason, perhaps because there was
no presence of Haydn in the picture with this kind of piece, Mozart
set to work on the commission eagerly and wrote a three-movement
Quartet in G Minor, next year adding another in E-flat. In ideas and
ambition, both works are at the top of his form. As it went with his
string quintets to come, Mozart seemed more unbound when he was
not writing for string quartet. But in the end the piano quartets did not
sell, the publisher lost interest, he never wrote the third. Artaria ended
up publishing the two completed ones.[19]

Surprisingly, given his strenuous schedule of composing, perform-
ing, and teaching, Mozart took on, in August, a live-in theory and
composition student, a young Englishman named Thomas Attwood.
The son of a coal seller who played the trumpet, Attwood was cham-
pioned by the Prince of Wales, who financed his studies in Naples and
Vienna. Mozart arranged the young aspirant's studies with particular
diligence, setting him to work on, among other things, Fux-style for-
mal counterpoint. (Attwood went on to a pleasant if in no way historic
career in London, as composer and organist for the Chapel Royal and
professor at the Royal Academy of Music.) Given that this student lived
in Mozart's flat around a year and a half, the young man probably made
himself useful as an adjunct servant and music copyist.

Attwood preserved the notebooks from his studies. They reveal his
teacher's fondness for him, partly because they show Mozart teasing
him. Most of the corrections on the assignments are in Italian, but some
are in English, including one note beside an egregious technical mis-
take: "You are an ass."[20] (Mozart was desultorily studying English, to-
ward a visit to England someday.) On a figured bass exercise he wrote
for Attwood, Mozart scribbled a wry portrait of his piano student Bar-
bara Ployer, her hairdo seeming to fall in musical notes. At one point in
his studies Attwood essayed a fugue that Mozart found so risible that he
later made use of it as part of an elaborate musical joke.

The Englishman left a sketch of his teacher as he knew him in the
later 1780s: "Mozart at the time I was with him, appeared to be of
cheerful habit, his health not very strong. In consequence of being so
much over the table when composing, he was obliged to have an up-

right Desk & stand when he wrote . . . He was so fond of Sebastian Bach's Preludes & Fugues that he had a separate Pianoforte with Pedals, fixed under the Other—was very kind to all of Talent to come to Vienna and generally played at their Benefit concerts."[21]

Mozart had suffered two serious illnesses in the years before Attwood appeared. The student's observation about his teacher's health surely related to the schedule Mozart was keeping, which had to wear on a constitution that had never been strong. People who met him tended to comment on how pale, small, and delicate Mozart looked. And his schedule would scarcely abate in these years. The results were predictable. In January 1786 he wrote a fellow Mason, begging off attending a ceremony, "Dear Brother. / It is now an hour since I arrived home—with terrible headaches and stomach cramps; I was hoping to get better—but when I noticed, to my dismay, that the contrary was true, I also realized that it was not possible for me to attend our first ceremony today; I therefore beg of you, dear Brother, to excuse me and give my apologies to everybody present.—Nobody loses more by my absence than I do."[22] Bouts of illness became part of his everyday life, the time he spent recovering a dreary but unavoidable necessity.

In November two aristocratic Freemasons died, and for their Lodge of Sorrows ceremony Mozart adapted an earlier piece into the *Masonic Funeral Music*, K. 477, a solemn dirge for winds and strings that aims toward an integration of ceremonies Masonic and Catholic. To that end he worked into the music an old church plainchant melody.[23] The original version of the piece had one basset horn; for a second performance he added two more, plus a contrabassoon, to further darken the color.[24] He liked that tenor version of a clarinet as much as the standard one, appearing to find in it a certain imposing dignity. Maybe for that reason he tended to use basset horns in Masonic or Masonic-related works.

The next month there was a concert at the Crowned Hope lodge in honor of its head Ignaz von Born, to which Mozart contributed a piano concerto and some improvisations, and the *Funeral Music* was heard again.[25] That concert could stand as the symbolic high-water mark of Freemasonry in Austria. For all its support of the throne, this international, secret, and resolutely independent order had been eating at Emperor Joseph, who wanted everybody and everything in his realm to serve, in one way or another, as an adjunct of the state.

On December 11, peremptorily and out of the blue, as with so many
of his decrees, came the Freemasonry Act: the eight lodges in Vienna
were directed to amalgamate into two or three. This was partly a
strike against the mystical side of the order, especially the Rosicru-
cian element, and against the secretive and suspiciously conspiratorial
Illuminati. Joseph was agreeable to the rationalist and progressive el-
ement of the order, not to its occult currents.[26] As much as anything,
though, the act was a means of consolidating the Masons to make it
easier to keep an eye on them. Joseph's spies were already busy in the
country; in the next years they would become more so.

In the decree Joseph wrote,

> The so-called Freemason societies, whose secrets are unknown
> to me and whose chicanery I have until now not taken seriously,
> continue to multiply and are now spreading to smaller cities.
> Their assemblies, if unsupervised and left entirely to themselves,
> can be a haven for profiteers and can have a corrupting effect on
> law and order, religion and morals, especially in cases where peo-
> ple holding positions of authority fanatically band together and
> show grave injustice toward their subordinates who are not mem-
> bers of these societies.

Having made his point that they have gotten too big and influential,
Joseph goes on to say that they also of course do good works and that
he will allow them to continue, only now under strict control.[27] So,
unlike his mother, he did not ban the lodges but rather put them under
state "protection," the police required to be informed about member-
ship and meetings.[28] Clearly, to some degree Joseph saw the Freema-
sons as a threat. There he proved mistaken: the ruinous challenge to
his reforms would rise not from progressives, but from conservatives.[29]

The reactions of Masons to the act were various. Some, including
Mozart, accepted the decree and joined one of the three new consoli-
dated lodges—in his case, one named "New Crowned Hope." A song
he wrote for the new lodge runs, "Today, beloved brothers, break /
into songs of rapture and jubilation, / Joseph's beneficence / Has
crowned anew our hopes / and in our hearts / a threefold flame now
burns with new hope."[30] Other Masons were not hopeful; in fact, they

were somewhere between disgusted and disillusioned; among many, Ignaz von Born quit the order. In the next year or so, Masonic membership in Vienna trickled away from up to eight hundred at the peak to some two hundred. Mozart's lodge stayed relatively active, but much of the clerical and aristocratic component departed, leaving it a largely bourgeois group of merchants, doctors, and the like.[31] After 1786 he would write no more music for ceremonies for five years, maybe a sign that he was less involved.[32] The remaining membership adapted to the Freemasonry Act and went their ways assuming the best. But the act was in fact a first shoe dropping. It would be a few years before the second fell.

FOR MOZART THERE WAS A FALLOFF OF MAJOR INSTRUMENTAL WORKS from later 1785 and into the New Year. The reason was that he was working on an opera, the most ambitious one of his life. But the occasional effort did emerge, one of them a little theatrical work commissioned by Joseph as one of two to be presented on the same program at the Orangery hall in Schönbrunn Palace. The royal occasion being celebrated was the visit of Joseph's sister Maria Christina and her husband, the governor-general of the Netherlands, both of whom were present for the grand banquet and performance.[33] As one of his austerities, the emperor had closed up most of his summer palace, but he maintained the big room for ceremonies and concerts. Besides, the Orangery had to be kept heated because it was full of exotic plants; occasions there were surrounded by a botanical spectacle.

The two composers commissioned were Mozart and Salieri. It can't be called a matter of Joseph wanting to put their rivalry on the boards together (to whatever extent they really were rivals), because the two productions were in themselves parodies of operatic rivalry. For the performances, small stages were set up at each end of the hall. After dinner for around eighty guests, who were serenaded at table by a wind group, everybody retired to one end of the hall to watch Mozart's contribution, *Der Schauspieldirektor* (*The Impresario*). It amounted to a miniature singspiel in German with an overture, four arias, and a good deal of dialogue. Then the audience moved to the other end of the Orangery

for Salieri's *First the Music, Then the Words*, in the direction of an Italian opera seria.

Both the pieces and the performances were a web of in-jokes that broadly sent up operas, managers, divas, and librettists alike. Their plots were suggested by Joseph himself.[34] The libretto for Mozart's *The Impresario* was by Johann Gottlieb Stephanie, who had written *Die Entführung*. In it, one Frank, an impresario (a speaking part handled by Stephanie), and a buffo bass named Buff audition two actresses for their company. Both ladies get a job, but they fall into hissy fits about who will be the prima donna and who will get paid more. The sopranos in question were none other than Aloysia Lange, with her long connection to Mozart and now his sister-in-law; and the mistress of Salieri and first Constanze in *Die Entführung* Caterina Cavalieri, who was in the process of being eclipsed by Aloysia.[35] Their rivalry in real life was no joke, but they were good sports enough to lampoon it on the stage.

The Impresario begins with a bubbly overture to set the scene. Soon it is decided that each soprano will sing an aria to show off her specialty. First, Aloysia as "Madame Herz" (Heart) provides a pseudo-mournful aria in seria mode ("The hour of parting has come"), not neglecting to end with some vocal pinwheels soaring up to high D. Next is the turn of Cavalieri as Madame Silberklang (Silvertone), whose specialty is buffa and whose aria ("My dear young man, I accept your love") is more upbeat. Finally comes the heart of the matter, a splendidly funny trio in which both sopranos relentlessly declaim, "I am the prima donna!" and tenor Monsieur Vogelsang (Birdsong) attempts without success to calm the waters. (That part was sung by Mozart's friend Johann Adamberger.) In contrast to Salieri's opera, finely done but much reliant on clowning, Mozart creates laughter by musical means, the battle of divas building to climaxes where the sopranos mount dizzying feats while the tenor protests impotently beneath. In the middle of the number, Madame Herz exhibits her soulfulness with a passage on the single word *adagio*, over and over; Silberklang answers with a strenuous stretch on *allegro allegrissimo*.

In the final number Buff makes his entrance to declare "I'm the leading buffo among singers!" which would have amused the audience because the singer, Weidemann, had a terrible voice. The sopranos contend to the end, where Mozart inserts a little joke and a bit of favoritism

for his old love: Aloysia as Madame Herz steps up to declare in solo, "Let the audience decide who gets the biggest praise!" in the process ascending to a boggling high F. The cast concludes the delirious mess with a moral deploring rivalries: "Every artist must strive for glory, yet to . . . place oneself above the others makes the greatest artist small."[36]

For Salieri's *First the Music* the cast included Nancy Storace, a bitter rival of Lange and Cavalieri. The book was supplied by Giovanni Battista Casti, a well-known poet and satirist and rival of new court librettist Lorenzo Da Ponte. Really, the hilarity of the evening was built in from the beginning, in the collection of artists assembled for the project. The music was the icing on the cake, a vehicle for a burlesque of famous local artists and artistic excess in general, every character an archetype of theatrical foolishness.

Salieri's pseudo-seria opera is around an hour long, for which he was paid twice what Mozart received. The plot concerns an opera that must be mounted in four days, a score already finished, and a librettist with writer's block who, in desperation, tries to fill in with old verses. There is again a battle of divas, one seria and one buffa. At the height of the fracas, the two sopranos belt out their arias simultaneously. One of the showstoppers was an aria in which Storace did a spot-on imitation of the celebrated castrato Marchesi, nailing both his voice and his mincing mannerisms—which by implication was a send-up of the whole institution of the seria castrato. Irish tenor Michael Kelly played the librettist role as a devastating impersonation of Lorenzo Da Ponte—his lisp, his pompous airs, and so on. (Every eye was on Da Ponte himself, who sat in the audience. Kelly said he took it in good spirit, but Da Ponte had his revenge on the tenor in his memoirs.)[37]

The Impresario would live beyond its occasion because it is by Mozart and is marvelously funny. Salieri's would age not as well because, if more uproarious, it is less memorable; in the end, after all, he was not a great melodist. All the same, out of their context in the rivalries and gossip of 1786 Vienna, both operas lose some of their original piquancy.

BY NOW THE MOZARTS WERE FIXTURES OF THE VIENNA BEAU MONDE, throwers of parties, habitués of ballrooms.[38] For a Carnival masked ball

a few years back, Mozart had produced a little theatrical with music. Now for one of 1786 he mounted a one-man show: dressed as an Oriental sage, he came to the ball equipped with a printed pamphlet of eight riddles and fourteen proverbs, headed *Excerpts from the Fragment of Zoroaster*, which he distributed to all and sundry. Zoroaster was an archetype for a mystical sage of the East; later he would be a source of a Mozart character named Sarastro. The first riddle began, "We are many sisters, it is painful for us to unite as well as to separate. We live in a palace, yet we could rather call it a prison," and so forth. The solution is "teeth." To what degree the riddles were serious or facetious is a good question, but they are pithy and evocative in their mordant fashion. Some of the proverbs:

(1) Talk much—talk badly; but the latter will follow of itself; all eyes and ears will be directed toward you. (4) I prefer an open vice to a doubtful virtue; at least I know what to expect. (5) A hypocrite who is trying to imitate nature can do so only with watercolors. (10) It is not suitable for everybody to be modest; but it is appropriate for great men. (11) If you are poor but clever, arm yourself with patience, and work hard. If you do not become rich, you will at least remain clever.—If you are an ass but rich, use your advantage, be lazy; if you do not become poorer, you will at least remain an ass. (12) One can give praise to a woman in the surest and tenderest way by telling her unkind things about a rival. How many men are not women in this respect?[39]

A draft of the riddles survives in Mozart's hand, a couple of them scratched out by Mozart's later biographer Nissen, probably because they were ribald. Wolfgang sent them to Leopold, who solved most of them and wrote Nannerl, "These fragments are *good* and *true*; I suppose they are for moral edification."[40] If so, they are edification with a dose of acid.

During this period, in the middle of composing piano concertos and a new opera and *The Impresario*, plus writing riddles and proverbs and performing constantly, Mozart made a revision of *Idomeneo*, adding new numbers on verses by Da Ponte and changing Idamante from a castrato to a tenor. He put it on as a performance in the private theater

of Prince Johann Adam Auersperg, who sometimes mounted lavish productions bordering on fully staged.[41] Mozart hoped the performance might take the opera to a court theater; he still believed in it as one of his best works. But Joseph and Vienna remained uninterested in opera seria. That was the last time *Idomeneo* was heard in Mozart's lifetime.

Three piano concertos of late 1785 and early the next year remained at the supreme level of the previous two, again building on the past but taking his art to a more exalted plane. Mozart's sense of a given key's personality remained fairly consistent. The Concerto no. 22 in E-flat Major, K. 482, has the spaciousness and stateliness that key usually represented to him, but the key has acquired a new richness. The winds here are flute and pairs of clarinets and bassoons, which give the wind section a mellow sheen. The opening starts with a princely figure, but on the first page this is followed by two contrasting ideas: a jaunty passage by the winds, picked up by the strings, and a more flowing theme passed around the orchestra. The soloist enters on a theme of his own, flowery gestures falling into racing roulades that are almost oblivious to the orchestra. When the princely theme reappears, the piano never plays it but rather comments on it in pealing arpeggios. Meanwhile the movement continues to veer in directions unexpected for what seemed an easygoing outing, including an episode in the then-esoteric key of B-flat minor that throws a sudden shadow over the music. That key returns to start a tense and dark-tinted development. It appears that solid and dependable E-flat major has become a setting for contending forces. At the recapitulation, music that before the development had seemed placid now seems ambiguous and compromised.

That tangle of expression continues in the Andante, in not a tragic but rather a deeply brooding C minor. A striking C-major interlude in the middle is dominated by wind solos, the piano silent. That moment lightens things briefly, but the music turns stern and foreboding, and a conclusion in C major does not lift the cloud. The Rondo finale begins in a racing 6/8 in a tone of almost childlike gaiety that largely hangs on to the end, though it is interrupted by a slow, elegant, lyrical interlude—a tone of, say, princely reassurance. The concerto's singular congregation of moods ends with the finale's return to the childlike main theme, but developed at considerable length and depth—this rather than the expected racing and gay conclusion that has been familiar in Mozart.

For an even greater surprise, the coda that follows the piano cadenza is not the usual brisk wrap-up but a varied and pensive ending of several pages, all of it adding further nuance and gravity to the original theme.

This is arguably one of the subtlest of the great Mozart concertos. It was followed by No. 23 in A Major, K. 488, more straightforward and one of his most delightful, but of a deeper kind than his delights of the past. It has the same winds as No. 22, with two clarinets. The strings begin with a stately theme that is echoed by the winds, setting up a dialogue that will continue throughout. The soloist's entrance on the orchestra's opening theme signals that in this outing, relations will be collaborative. The mood remains sunny, the development on the short side and involving mainly a conversation between piano and winds, the former glittering happily and the winds stolid. The middle movement, in a rare and shadowed F-sharp minor, is an achingly poignant siciliano that forms a single emotional unfolding. Here flowing lyrical lines are often doubled in strings and winds, creating a rich palette of color, and there is a wind interlude in the middle. This heart-tugging middle movement is forgotten in a laughing and airy finale.

The last of a remarkable trio of concertos is No. 24 in C Minor, K. 491, the second and last of Mozart's minor-key ones, finished in the same March 1786 as the A Major. Here is his C-minor mood at its most potent, the opening echoing the disquieted theme of the C-minor Fantasy. This is the only concerto in which he calls for the full contingent of winds—one flute and two each of clarinets, oboes, bassoons, and horns, plus trumpets and timpani. It makes for maximally rich wind scoring and a steady interchange of ideas between strings and winds.

The C Minor begins on its moaning theme in octaves, unsettled in its harmony—all twelve chromatic notes are heard on the first page. That theme will be the seed of the ones to come in the concerto, and its apprehensive mood will stamp the concerto as well. Soon the theme explodes into a fierce forte, and from that point in the movement the theme will continue to trouble the music in the same way. A second theme is quiet and flowing, yet still tensed. The soloist enters pensively, with a sense of being starkly alone. That is wiped out by another burst of the opening theme. In relation to the orchestra, the soloist will be defined as more individual, even confrontational, than in any other Mozart concerto.[42] The dialectic of the movement is that quiet, sometimes

hopeful phrases are sooner or later slapped down: again and again, the mood rises only to fall. The development is anxious, eruptive. As usual in Mozart's instrumental music, opera informs this work, but the tone is less operatic than something unique to instrumental music, having to do with the particular colors of piano and orchestra entangled in a drama.

The drama here is also more complicated than simply tragic, as heard in the opening theme of the second-movement Larghetto, an ingenuous and consoling little tune. Still, the B section of the ABA, mostly in winds, recalls the chromatic lines and the unease that marked the first movement. The finale is not in a hopeful C major but instead returns to C minor for an elaborate theme and variations. The theme echoes the cryptic opening of the concerto, but this C minor is not so much tragic or demonic as quietly driven, elusive. For most of the finale, the troubles of the first movement are neither picked up nor quite resolved. The racing coda seems to mingle bits of hope with breathless apprehension. The curt ending is a final explosion of C minor: the pall remains abroad.

Like most of Mozart's concertos the C Minor was not published in his lifetime, and the manuscript shows more uncertainty and ambiguity than with any other major work of his life. True, sketches for the A-major Concerto show three false starts, but nothing like the tumult of the C Minor autograph. If the pages are evidence, this piece had frustrated Mozart; in places, as so rarely for him, the ideas refused to settle down. In the opening movement he took a twenty-eight-bar segment from one spot and dropped it in another.[43] The solo staves were entered sketchily, some of the notes barely legible; sometimes there are so many revisions in the solo part that the final intention is impossible to discern. If the concerto had been published, Mozart would have resolved these matters, but in its disordered state, the manuscript reflects how he approached the solo parts of his concertos: he played them freely, every performance different, the written solo sometimes a point of departure for a performance that would often have the quality of an improvisation.[44]

Since his career blossomed in Vienna, piano concertos had been Mozart's main focus. Between 1782 and 1786 he wrote fifteen of them. In its power, weight, and intensity, the C-minor Concerto marked a point

of arrival and drew a line. If he did not want to repeat himself in his concertos, he had to reinvent.[45] From this point he would search for a new direction.

THERE WERE OTHER NOTABLE EVENTS IN THE SPRING OF 1786. ON APRIL 7 he may have premiered the C-minor Concerto at the Burgtheater. There a few days later he accompanied his old soprano friend Josepha Duschek in a program before an audience that included much of the nobility and Emperor Joseph.[46] For the first time in a while he had no subscription concerts in the offing. As it turned out, his feverish public performing schedule was finished. Actually he may have wanted to be done with it. The schedule had been punishing—now he had an opera to finish—and to say again, he was more engaged with composing than performing.

That spring Leopold caught up Nannerl on recent developments. "We had our concert yesterday. Marchand performed the concerto in D minor, which I sent to you the other day. As you have the clavier part, he played it from the score and [Michael] Haydn turned over the pages for him and at the same time had the pleasure of seeing with what art it is composed, how delightfully the parts are interwoven and what a difficult concerto it is."[47]

Leopold told Nannerl that her brother was about to premiere a new opera called *The Marriage of Figaro*. He was pessimistic about its chances. "It will be surprising if it is a success, for . . . Salieri and all his supporters will again try to move heaven and earth to drown his opera. Herr and Mme. Duschek told me recently that it is on account of the very great reputation which your brother's exceptional talent and ability have won for him that so many people are plotting against him."[48]

His son at that moment was bursting with creative juice but also riven with anxiety. Mozart had never put before the public something so risky as this opera based on a play notorious all over Europe. This time, for a change, he had chosen the story himself. He knew what he was doing, but he could hardly be certain of how it would turn out. If things went badly, he would share the blame with his librettist, Lorenzo Da Ponte. In fact this prodigal poet was well accustomed to scandals and fiascos around his work—and his life, for that matter. But Mozart was not so accustomed.

IF YOU WANT TO DANCE, MY LITTLE COUNT

S ometime in the middle of 1785, Mozart brought to Lorenzo Da Ponte the notorious French play *The Marriage of Figaro*, saying he wanted the new court librettist to turn it into an Italian opera buffa. Mozart would not have known yet what a resource he had in Da Ponte, who was about to prove himself one of the finest librettists opera ever saw. But at that point the poet had produced only four librettos since coming to Vienna, those also being the only ones of his life. The first had been *Rich Man for a Day*, for Salieri, which had been a spectacular flop, after which Salieri had said he would rather cut off his fingers than work with Da Ponte again. Added to that was Mozart's long-standing prejudice against Italians as untrustworthy charlatans. He probably knew little about Da Ponte's background, and if he had, it would only have buttressed his suspicions. The freshman librettist had landed in Vienna on the run from the law, with a prodigal history behind him. He had, for example, proved too much for Venice, perhaps the most dissolute city in Europe.

Da Ponte's penchant for shape-shifting began early. He was born Emmanuele Conegliano in March 1749, in the small Jewish ghetto of Ceneda, near Venice, son of a poor tanner. His father converted the family, and at fourteen the boy was baptized under the name of the lo-cal bishop, Lorenzo Da Ponte. His education had been neglected until his father hired a Latin tutor, after which Lorenzo began devouring Latin works he found in the attic. There followed intensive reading

and composition in Italian; he idolized Metastasio and claimed to have memorized Dante's entire *Inferno*. Whether or not this was true, his eventual command of Italian literature was profound and lifelong, and he began versifying at an early age.

Finally, it was decreed that Lorenzo and his two brothers would study for the priesthood. He proved to be so precocious a student that at twenty-three he became vice rector of the seminary; by the next year he was celebrating Mass.[1] Besides Latin, he mastered Greek and Hebrew.[2] There was, in short, no question of Lorenzo's intelligence, his talent, or his scholarship, which could take him far in a priestly career. But on a visit to Venice he fell for one Angela Tiepolo, a patrician woman who was beautiful, tempestuous, and married. He began slipping away from the school to see Angela, who around the time he was ordained as a priest gave birth to his child. (Her husband's response to all this was to enter the priesthood.) Soon Da Ponte left the seminary to join Angela in Venice.[3] In his memoirs he blamed his church vocation on pressure from his father, saying it violated "my true calling and my character."[4] Truer words he never wrote.

Venice suited Da Ponte well. Carnival with all its excesses was celebrated nearly half the year, citizens going about in masks behind which many carried on feats of carousing legendary in their time. Wrote a British traveler of the city, "Adorned with every excellence of human art, and pregnant with pleasure, expressed by intelligent countenances sparkling with every grace of nature; the sea washing its walls, the moonbeams dancing on its subjugated waves, sport and laughter resounding from the coffee-houses, girls with guitars skipping about the square, masks and merry makers singing as they pass you."[5] Fabled lover Casanova knew Venice intimately; there he and a local priest had shared the favors of a beautiful nun. Divines male and female partook of the city's pleasures and excesses. Everybody knew the story of the two Venetian nuns who fought a duel with knives over a local abbé. So, Da Ponte as a robed priest, a celebrant in services, engaging in a public affair with a married woman was nothing to remark on.[6]

He found a job tutoring some aristocratic children, which helped support the hard-partying life he and Angela enjoyed, replete with champagne and gambling and opera and bonbons and hothouse fruits and the delightful new concoction called ice cream.[7] For a while he served

as sort of the entertainment director of a brothel, which he pursued wearing his clerical robes.[8] Later, at a party he met the aging Casanova and they became longtime, if a bit bristly, friends. Da Ponte may have modeled himself to a degree on the famous rake, but unlike Casanova, who pursued romantic conquest for the sport of it, Da Ponte was not a true libertine but a man at the mercy of his passions for women, which were constant and consuming.

Da Ponte's life became a ragged chronicle of ups and downs, living in splendor at one period and destitute at another. He not only lived on a risky edge of excess, he tended to incite madness around him. One example: amid his affair with the fiery Angela, he fell in love with a beautiful and learned young girl named Matilda, daughter of a duke, who had fled a convent dressed as a man, the family's jewels sewn up in her clothes. Now Da Ponte took up with Matilda, and they lived and loved subsidized by her jewels and doubloons.[9] But he did not entirely give up Angela, even when on one visit she greeted him with a knife in hand.

At that moment he fled back to Matilda only to find that she had been abducted by the Inquisition. Undaunted, he persuaded Angela to take him back, and they resumed partying on a still more extravagant scale. He became addicted to gambling, particularly the popular card game faro.[10] At the same time he had been part of a hard-drinking literary group led by the brother of the fantasist playwright Carlo Gozzi. With his literary knowledge and his facile and witty poetry, Da Ponte shone among those artists and scholars, and he revealed a knack for improvising verses in public. Da Ponte did not know it, but with his literary bent, his fluency at versifying, and his jaundiced view of life and love that was founded on experience, he was preparing for a career that had not yet occurred to him.

As it transpired, it was literature, not debauchery, that finally brought his downfall in Venice. At a debate he read out his Latin elegy called "The American in Europe," which proclaimed that laws were the cause of unhappiness, thought should be free, and so forth in Voltairean and Rousseauian terms. Ran one verse: "Nature, inside my breast / Gave me the only law: / Not to do in action or in word / That which I do not like." This and a similar piece attracted the attention of the Inquisition. Da Ponte was arrested and tried before a jury of senators in crimson robes. The Inquisitor swore that such populist sentiments could only

come "from a Jew or an atheist." (Da Ponte may have been an atheist and had been born a Jew, but he did not advertise either fact.) In the end he was forbidden from teaching anywhere in Italian lands. This would not be his last fiasco resulting from failure to keep his mouth shut around the powerful.

Soon he found an influential patron and as a result regained his job as a tutor—but the patronage ended, it appears, when he tried to seduce his patron's wife. Fleeing a tide of accusations, he turned up at the door of his priest brother in Padua with nothing but the clothes on his back and fifty lire. As one of his patrons had observed: "Too many incidents, Abbate, too many incidents." Now Da Ponte found himself banished from Venice for fifteen years on pain of imprisonment, on the grounds of "libertinage, blasphemy, sacrilege, adultery, and public concubinage."[11] Incidentally he was accused of eating ham on Friday and disgracing Christianity in general.[12]

Then and later, if Da Ponte had a remarkable propensity for brewing trouble, he also had an inexplicable gift for promoting himself, finding admirers and patrons. One of those patrons from this period described him so: "A strange man; known for a scoundrel of mediocre caliber, but gifted with great talents for literature, and with physical attractions for which women love him ... A madman in every sense ... There can hardly be a worse individual." Yet in the end, he and that patron got along profitably.[13]

Da Ponte became an assistant to Caterino Mazzolà, a rising star as an opera librettist, among whose successes was *The School for Jealousy*, written for Salieri. Da Ponte may have introduced himself to Mazzolà with forged letters from Mozart and Beaumarchais.[14] He spent some ten months in Dresden with Mazzolà, helping him with his work and steeping himself in operas by Paisiello, Salieri, Martín, and other masters of the day. Finally he decided to try his chances in Vienna, with no idea what the direction of those chances might be. Mazzolà sent him off with an introduction to Salieri: "My beloved da Ponte will hand you these few lines. Do for him everything that you would do for me. His heart and his talents deserve everything." Actually, Mazzolà may have been so effusive because he thought Da Ponte might have designs on his job, and he was eager to see the last of him.[15]

Da Ponte arrived in Vienna late in 1781. His first initiative was to

visit the dying Metastasio and read him a poem of praise he had written. Still, nothing happened for a year or so. Then came the lucky moment: Emperor Joseph dissolved the German singspiel and formed an Italian opera troupe at the Burgtheater.[16] Somehow Da Ponte got to Joseph and convinced him that he was the man to be named the librettist for the new company. Again, Da Ponte was a brilliant if hardly profound poet, had written plays, and he had worked with librettos during his time with Mazzolà. But he had never, as it were, actually written one. Shooting from the hip as usual, Joseph appointed Da Ponte court librettist. His salary was a handsome if not extravagant twelve hundred florins a year, plus the proceeds from selling printed booklets of his librettos.[17]

Taking his new post in the same spirit as his teaching, Da Ponte made an intensive study of Italian librettos. One of his first discoveries was how terrible most of their poetry was. In that respect, at least, he knew he could excel. When the first project handed him was for Salieri, he gave the composer a selection of plots to consider. Salieri picked *Rich Man for a Day*, which Da Ponte considered the weakest story of the bunch, but he dutifully turned it out.[18] It was a doomed endeavor. As he recalled, "My dialogue felt dry, my arias labored, my sentiments trivial, the action languid, the scenes cold. In short, it seemed to me as though I'd never known how to write, . . . that I had undertaken to wield the club of Hercules with the hand of a child." When the opera landed with a thud, composer and librettist blamed each other.

But Joseph remained loyal and Da Ponte stayed on the job, learning as he went. A Shakespeare adaptation he did for Martín y Soler had a successful premiere in early 1786.[19] One of the skills he had to master was to survive in the Viennese atmosphere of gossip, cabals, and boiling rivalries. Wrote Vienna observer Pezzl, "Excesses, intrigues, frauds, hypocrisies and depravities exist cheek by jowl with wisdom, generosity, and bonhomie."[20] The Italian singers whose theater company Joseph had closed detested the German singers; each faction plotted against the other. Da Ponte had to learn how to play politics along with learning to write librettos, or he would find himself dead in the water.[21] He did his best to court Count Rosenberg, Joseph's theater director, with variable success.[22]

Otherwise, true to form, Da Ponte stole the affections of a girl beloved

by a surgeon named Doriguti, who seemed not particularly bothered about it, but who was in fact biding his time to get revenge. It came when Da Ponte went to Doriguti complaining of a tooth abscess. The good doctor gave him a bottle of some stuff assuring him of a cure. The concoction included nitric acid, which removed the abscess and also removed most of Da Ponte's teeth. He had always had a bit of a lisp; now he had a pronounced one.[23] Irish tenor Michael Kelly, not an admirer of the man, left a sardonic description of Da Ponte 's appearance: he had "a remarkably awkward gait, a habit of throwing himself (as he thought) into a graceful attitude, by putting his stock behind his back, and leaning on it; he had also a very peculiar, rather dandyish way of dressing; for in sooth, the Abbé stood mighty fine with himself, and had the character of a consummate coxcomb."[24]

So when Mozart presented Da Ponte with the idea of doing *Figaro* on speculation in 1785, it was not out of any particular admiration or trust. The poet had written verses for a couple of Mozart's insertion arias for other people's operas, and those had gone well enough.[25] But mostly it was the reality that Da Ponte was a favorite of Joseph, so he was whom you worked with if you hoped for a production by the court.

Da Ponte agreed to adapt the libretto from the Beaumarchais play. On one hand this French work was the most scandalous thing on the boards in those days, because of both its political and its sexual content, and so it had the makings of a sensation. If Mozart had not already known about the play, he was probably introduced to it by his old theater friend Schikaneder, who had recently staged it. The trouble was, Schikaneder's production in Vienna had just been squelched by Joseph as politically and morally offensive. Mozart had rarely come up with an idea for an opera himself, but for this one he was ready to stick his neck out. Da Ponte signed on to the project with enthusiasm. It was just his style.

THE AUTHOR OF *THE MARRIAGE OF FIGARO*, PIERRE-AUGUSTIN CARON de Beaumarchais, had a career that rivaled Da Ponte's in profligacy, though he was a piece of work on a grander stage both figuratively and literally. Born in Paris in 1732 the son of a poor watchmaker, Beaumarchais took up that trade and by age twenty-three was plying it for

the court of Louis XV. He taught harp to the daughters of the king and acquired the cryptic court title "Keeper of the Royal Warren."[26] Eventually he became sufficiently prosperous and well married to get himself a patent of nobility. By then he was already a notorious public figure, partly because he was prolific in mounting lawsuits that exposed the corruption of the courts. Eventually, when he had been twice widowed, rumor had it that he murdered both his wives. It only added to his charisma.

Beaumarchais ingratiated himself successively with Louis XV and Louis XVI. At one point, he was dispatched by the court to travel across Europe to suppress a pamphlet defaming Queen Marie Antoinette. It appears, actually, that Beaumarchais had written the pamphlet himself. During those travels he stayed in Vienna, but because of his excesses—among other things, on the way he tried to stage an attack on himself, complete with wound—he spent most of his time there in jail.[27] Really the stories about Beaumarchais are virtually endless. He extracted money from state funds to buy arms for the American Revolution. He founded a publishing house to print the complete works of Voltaire, many of which were banned at the time.[28] He joined the Périer brothers in their business of pumping water from the Seine and filtering it for sale to the public. He played the lead in Goethe's early play *Clavigo*, the plot based on an offer of marriage made to Beaumarchais's sister. While painting himself as a victim of persecution by the aristocracy, he pursued initiatives both for and against the ancien régime. Amid these assorted endeavors, including his marriages, Beaumarchais got very, very rich.

Mainly, he stood before the public as a writer. His reputation was secured by two of the great stage hits of the age, first *The Barber of Seville* and then its sequel, *The Crazy Day, or the Marriage of Figaro*. History would remember them because both became historic operas— and Beaumarchais was much involved in opera as well, working with Salieri among others. As for the plays, it was the sequel that raised the greatest storm. It took Beaumarchais six years of public campaigning to get the court to allow *Figaro* on the stage.[29] It was, after all, a bitter exposé of aristocratic decadence that nonetheless had to depend largely on the aristocracy for its success.

A central figure in both plays is Figaro, barber for the libidinous

Count Almaviva. The *Marriage* begins in the most mundane way:
Figaro is measuring a room, declaiming the numbers to his betrothed,
Susanna. What he is measuring for is their marital bed, which they will
occupy after their wedding. Which is to say that Beaumarchais's story
begins with a bed in the center of the story, and in fact, beds were cen-
tral in two plays telling the entangled story of five principals: Figaro,
servant to the philandering Count Almaviva; Susanna, the maidser-
vant of Countess Rosina; the page Cherubino, a girl-crazed pubescent
in whom the countess has a more-than-maternal interest. The setting is
Seville, perhaps assuming Spain to be more backward, more tradition-
ally absolutist, than elsewhere in Europe. In any case, Beaumarchais
placed the action of his stories safely away from Paris, where the plays
were written and first produced. But everybody knew that they were
about the aristocracy everywhere, about the ancien régime that had
occupied thrones across the Continent from time immemorial as ab-
solute rulers, free to tax, torture, execute, and likewise bed whomever
they pleased.

The first play of the eventual three that Beaumarchais produced
was *The Barber of Seville*, where the characters first appear. Rosine
(in the opera, Rosina) is locked up by her aged guardian Dr. Bartolo,
who intends to marry her whether she likes it or not. But young Count
Almaviva has fallen for Rosina and attempts various dodges to get to
her. Finally Figaro secures for him the key to her room. After vari-
ous contretemps resulting from the count's being in disguise, Rosina is
about to marry Bartolo when Figaro manages to substitute Almaviva
for the bridegroom, to Rosina's relief. The play was in fact originally
conceived as an opera and was quick to be adapted for that purpose.[30]
At the same time, in its plot and characters, the *Barber* recalls commedia
dell'arte, with Figaro in the role of Harlequin and Susanna standing for
Columbina.

In the next play, *The Crazy Day, or The Marriage of Figaro*, the char-
acters have nominally settled down. Figaro is about to marry Susanna,
and the Countess is married to the man who pursued her and whom she
loved. But nobody is happy. The play is an accurate picture of much of
the aristocracy, their often loveless marriages and routine affairs. The
Count is still restless, on the make. Rosina is miserable, remembering
the beautiful days of their first love. Cherubino is roiled by adolescent

yearnings. And Susanna, as she informs her innocent bridegroom, is under threat.

The threat is the Count, who lusts after this delicious servant of his wife. The trouble—here the crux of the plot—is that the Count has an aristocratic precedent on his side. It is called *le droit du seigneur*, the traditional right of the lord of the manor to deflower a new bride on her wedding night. This is, again, a potent symbol of enthroned tyranny: it certifies that the lord of the manor, who often also sees to the church in his domain, owns his subjects body and soul. Another way to put the story of *The Marriage of Figaro* is that the bed and what transpires in it is made into a symbol representing tyranny that goes beyond sex and into the whole of a society. In a word, the institution of absolutism.

So the dramatic situation extends to a social system under the rule of the ancien régime. The galvanizing element of *Figaro*'s plot probably came from a play by Voltaire centered on this traditional outrage, the setting of the play medieval and its title *Le droit du seigneur*.[31] This was a natural issue for the Enlightenment, which began for the first time seriously to critique the power structure that had existed for millennia without question and without redress. There must be, however, a large heavy asterisk concerning this plot element: le droit du seigneur did not actually exist in the eighteenth century, and as far as history can discover, the practice existed rarely if at all.[32] There were rumors and legends about it going back to ancient times, but no clear evidence. For his play, Voltaire in essence cooked up an atrocity, a sort of institutionalized rape, for his own political and dramatic purposes.

Did Mozart and Da Ponte know that their plot was founded on a fiction masquerading as a contemporary social evil? Surely they did, but anyway it makes no difference. Art is about reality in the long run, but in practice it has its license. Making the droit part of the plot is simply a means of putting a sharper point on a critique of the aristocracy, its power over body and soul, its commonplace sexual profligacy. The nobility, and for that matter the clergy much of the time, were not expected to conform to the moralities imposed on the common people. The common people were expected to play by the rules, but at the whim of the nobility, commoners were meanwhile their playthings. (As for the middle class, they essentially did not exist in Mozart operas.) So *Figaro* amounts to a study of power spiced with sex and comedy.

Besides their innate appeal, the fun and games allowed the nobility to take it all in good spirit—necessary because the nobility had to sanction one's work, whatever the medium, for it to reach the public at all.

For Mozart this was his first complete opera in Italian since *Idomeneo* in 1781 and his first complete opera buffa since *La finta giardiniera* in 1775. He had made great strides since those two—and, for that matter, since the *Abduction*. He had also lucked into a librettist who stirred his full capacity. In the end, he and Da Ponte were going to have three historic collaborations. In the guise of naughty sex comedies, all of them dig deep into the wounding realities of life. Everybody, high and low, upstairs and down, yearns for what they do not have. Central to two of the operas, *Figaro* and *Don Giovanni*, is a direct assault not on the existence of the aristocracy itself, but on its privileges and abuses. The assaults are served up as jolly confections, but few at the time missed their import.

It took Beaumarchais those six years to get King Louis XVI to allow *Figaro* on the stage in Paris. Once that happened, the play had the most unexpected kind of success: it was embraced by the aristocracy, who showed up in droves to giggle over this exposé of their foibles and their sins. Aristocratic women were particularly enamored of it, some of them having favorite lines inscribed on their fans and handkerchiefs. One of the play's admirers was Marie Antoinette, wife of Louis XVI, sister of Emperor Joseph II. A British visitor, neither French nor aristocratic, simply found it scandalous: "indecent merriment, and gross immorality; mixed, however, with much acrimonious satire."[33]

The most celebrated lines in the play, the central piece of nobility skewering, came in a bitter soliloquy of Figaro concerning Count Almaviva: "Because you are a great lord, you think that you are a great genius! You took the trouble to be born, that's all. You remain nothing but an ordinary man; while I . . . have had to use more science and calculation simply to survive than it has taken to govern Spain for the last hundred years!"[34] Perhaps the nobles of Paris chuckled over those lines too. It would not have occurred to them that in the not so distant future, these and related sentiments were going to cost many of them their heads. In the next generation, a military man sophisticated in politics named Napoleon Bonaparte would call *The Marriage of Figaro* the first shot of a French Revolution that was destined, as the saying goes, to

change the world.[35] Whether or not Napoleon was accurate about that, Beaumarchais's little comedy was a harbinger of titanic forces waiting to be unleashed.

In terms of politics, Da Ponte was likely more sophisticated than Mozart. He had, after all, been banished from Venice, among other things, for attacks on aristocratic privilege. Mozart was of some sort of progressive inclination—the evidence for this his membership in the Freemasons—but he had never been banished from anywhere and had no intention of being. The sociopolitical sentiments of the play likely suited him well enough; the evidence of that is his next operas. But he was not writing opera, or anything else, to make some sort of grand sociopolitical statement. He was producing a piece of work part of whose appeal was that it was already lodged in the minds of the public. He was taking up, in other words, a project with a built-in sensation, similar to what he had done in *The Abduction* with its fashionable Turkish subject.

At the same time, the play's notoriety threatened to be a barrier to realizing the project, because Emperor Joseph had banned it from the stage. Da Ponte in his memoirs was given to taking credit for nearly everything to do with his successes, though he was also forthcoming about his disasters. Still, he did admit that the *Figaro* idea came from Mozart—again, not long after the emperor squelched Schikaneder's production. Da Ponte agreed to write the libretto and promised Mozart he'd fix things with Joseph.

What Da Ponte told Joseph, or so he reported, was that he would take out all the overtly political stuff—for example, Figaro's "trouble to be born" soliloquy. What Da Ponte did not say is that nothing he did would change the significance of the story. The Count is still a libertine and a tyrant because there is nothing in law or custom to stop him. The Countess still has to enlist a servant to help rein in her husband. And the servants still have only one weapon to preserve their bodies and souls: their wits. They cannot challenge the nobility, but they can outsmart it. That element alone is part of the play's radicalism, even if the plot of a peasant outfoxing a nobleman was familiar in plays of those days.[36] In the exposing of enthroned evil lies some of *Figaro*'s ageless relevance. It was the job of Mozart and Da Ponte to flesh out that relevance with compelling characters and appealing tunes.

All the same, the notion that Joseph was snookered into allowing a

radical story to be produced gives the emperor too little credit. Joseph was often oblivious to the human effects of his actions, but the foundation of all his endeavors was progressive, sophisticated, and, in theory, rational. A central element of his agenda was to bring the nobility to heel, among other things to make them subject to the law and to pay taxes. In the name of fairness and rationality, Joseph was attempting to reduce the aristocracy to a position rather of window-dressing. All of which, of course, enhanced the power of the throne. The government was to be run entirely by the emperor and the bureaucracy, the latter beholden to no one but the emperor. This was Joseph's boldest move to power, and it proved ultimately the downfall of his ideals: most of the Viennese nobility hated him and his agenda, and finally the nobility won.

But in 1785 Joseph was at the height of his power and his program of reform. An opera about aristocratic excesses suited his program entirely.[37] So he approved it, and for that matter did not object to the original play being published in German translation. Believing the theater to be part of the moral and social education of his people, Joseph kept that medium under close control. Besides, most of the audience at the Court opera were going to be of the nobility anyway, so maybe he intended to give them a lesson on their behavior.[38] He made Da Ponte tone down the politics a bit, and he probably figured the sheer force of Mozart's music would mitigate much of the rest. In fact, in the end that was more or less how things worked out. There would be no apparent unrest sparked by the opera, not from the Josephinists or from the nobility. That is not to say, however, that the implicit message went unnoticed. Wrote one critic: "What is *not allowed* to be said these days, is sung."[39]

MORE TO THE POINT AS FAR AS *FIGARO* WAS CONCERNED, DA PONTE had a good deal of work to do to adapt a play of convoluted plot and complex characters into an opera libretto. Somehow this beginner managed it like a master who had been doing it all his life. The simple part was taking out Figaro's "trouble to be born" speech. Beyond that, opera uses words more sparingly than do plays: lines and scenes had to be cut, likewise characters for whom the music would have little use. Da

Ponte reduced the characters from sixteen to eleven and removed the Countess from the first act.[40] The characters were simplified; in comparison to plays there is less room in buffa for ambiguities of motivation and such. The characters became archetypes: Figaro the wily barber, Almaviva the tomcatting aristocrat, Rosina the wronged wife, Susanna the saucy and wise servant, and so on.[41] Cherubino meanwhile became a "pants" role, to be played by a soprano. The depth of these figures would have to come from the music.

In the play, the jealousy of the Count drives the Countess toward Cherubino—in the third play of the series they become lovers and she has his child. Da Ponte reduced Rosina's growing passion for the boy to hints, her pleasure in fussing over him and dressing him up as a girl. Beyond that he toned down the play's erotic elements, the Count not so rabid a libertine, the Countess more chaste. In Da Ponte's hands the characters became less ambiguous but also nimbler in the service of a plot that zips along briskly.[42] Unlike most dramatically static arias, especially in seria, Da Ponte wrote action numbers, each a dynamic part of the story. Only here and there are the arias soliloquys, mainly the two rueful ones of the Countess and Figaro's enraged brief against Susanna in particular and women in general. The influence of Mozart is seen in the fewer arias and more ensembles—ensembles nearly half the numbers, more than any of his other librettos of the time.[43] Mozart trimmed back the reflective, dramatically static arias of seria and most buffas; of the fourteen solo numbers in *Figaro*, only five are ruminative, the others addressed to someone onstage.[44]

Meanwhile Da Ponte had to fashion big finales, especially in the second act and the end of the opera. This was one of the distinctive features of up-to-date buffas, something Mozart did not invent but brought to a new peak of delight and intensity: each act reaches its climax as a symphony movement might end in a coda. Da Ponte mordantly summarized the requirements:

> This finale, which has to be closely connected with the rest of the opera, is a sort of little comedy in itself . . . This is the great occasion for showing off the genius of the composer, the ability of the singers, and the most effective "situation" of the drama. Recitative is excluded from it; everything is sung, and every style

of singing must find a place in it—adagio, allegro, andante, ama-
bile, armonioso, strepitoso, arcistrepitoso, strepitossissimo, and
with this the said finale generally ends . . . In this finale it is a
dogma of theatrical theology that all the singers should appear on
the stage, even if there were three hundred of them . . . and if the
plot of the play does not allow it, the poet must find some way of
making the plot allow it.[45]

There was another element in the background. Giovanni Paisiello
had set the first play in the cycle, *The Barber of Seville*, and its scintil-
lating music and rollicking comedy had made it one of the biggest hits
of the Viennese stage in the eighteenth century.[46] The *Barber* is a jolly
affair about a courtship that ends well. *Figaro* is about the threat of infi-
delity, which darkens the comedy.[47] Mozart was generally well disposed
to the prolific Paisiello and did not get particularly exercised about him
as a rival. He imbibed Paisiello's score and turned its relevant ideas to
his own purposes. There are echoes of Paisiello in "Porgi amor" and
"Se vuol ballare."[48]

Above all Da Ponte fleshed out the *Figaro* libretto with poetry both
natural and sparkling that made the points he wanted to make. For one
example: what in Beaumarchais's famous soliloquy had been a direct
assault on inherited power, those who had taken only the trouble to be
born, became in the hands of Mozart and Da Ponte Figaro's droll little
song with a message more dramatically relevant and no less trenchant:
"If you want to dance, my little Count, I'll play the tune."

As usual Mozart was composing for particular singers, Da Ponte no
less aware of them in writing the libretto—the strengths and weak-
nesses of each principal had to be factored in. This time they had at
their disposal some of the finest singers of the era, most of them buffa
specialists admired for their comedic skills. The part of Figaro was
written for Italian Francesco Benucci, the leading buffa bass of the day,
who had handled the character part of Bartolo in the Vienna premiere
of Paisiello's *Barber*. Mozart was among his admirers. Tenor Michael
Kelly reported that during a rehearsal, while the bass was holding forth
Mozart stood with a score muttering, "Bravo! Bravo! Benucci." Kelly
called Benucci's final peroration in the sardonic military march for
Cherubino "electricity itself."[49] In rehearsal the number got an ova-

tion for Mozart from cast and orchestra alike.[50] He shaped that march knowing what this performer would make out of it. As with the other roles, it is as if we hear Benucci's flair for physical comedy written into the libretto and the score. The bass would be singing more Mozart in the future.

Count Almaviva was written for baritone Stefano Mandini, who had played the same role in Paisiello's *Barber.* Dublin-born tenor Michael Kelly was destined for starring roles, but here he handled two secondary parts, the music director Don Basilio and notary Don Curzio. During studies in Italy, Kelly had become friends with soprano Nancy Storace, now singing in the cast with him.[51] Bass Francesco Bussani tended to character parts and doubled as Doctor Bartolo and the gardener Antonio. (In the Paisiello opera, Benucci and Bussani had been Bartolo and Figaro; now they switched roles.) Bussani's wife Dorothea put on breeches to play Cherubino. Anna Gottlieb, daughter of actors at the Burgtheater, at age twelve was given the part of Barbarina.[52]

Call soprano and comedienne Ann (Nancy) Storace the soul of the first production. Then twenty-one, she came from a musical family in London and finished her training in Italy. Michael Kelly reported that at age fifteen, Storace made such a sensation in a Florence production that the famous castrato Luigi Marchesi had her fired for upstaging him. (She had her revenge by doing the devastating impression of Marchesi in Salieri's *First the Music.*) She was one of the singers whom Joseph's scouts snapped up for the new Italian opera company. Unlucky in marriage—Joseph had her abusive husband thrown out of town—Storace and Benucci became involved for a while during the *Figaro* production. (There were rumors about her and Mozart, but no evidence for it.) The Viennese music fancier and diarist Count Johann Karl von Zinzendorf wrote of her appeal: "Pretty face, voluptuous, fine bosom, beautiful eyes, a white neck, a fresh mouth, delicate skin, the naïveté and petulance of youth, sings like an angel."[53]

This could be a template for the consummate Susanna. One could say that the whole genre of opera owes a debt to Nancy Storace in her capacity as a muse for Mozart. Her gift for comedy and for dominating the proceedings onstage made the resourceful, cheeky, worldly-wise Susanna arguably the true central character in *Figaro.* Unlike her betrothed, Susanna is involved in duets with every other major character.[54]

And in turn, though Storace left Vienna the next year before she could do any more Mozart roles, his propensity for memorable female characters may in part be her lasting legacy to his art. Storace amplified his sense of what could be made of operatic heroines.

FIGARO APPEARS TO HAVE BEEN COMPOSED LARGELY IN TWO SEGMENTS, in late fall 1785 and spring 1786, with some tinkering in between.[55] (In that same period, he wrote *Der Schauspieldirektor*, three piano concertos, the *Masonic Funeral Music*, and some eight other works.)[56] For the job, Mozart got 454 florins, Da Ponte 600 for the three operas he was working on in the period.[57] First scheduled for around Christmas 1785, *Figaro* was put off until the next May.[58] Da Ponte reported that as he wrote the libretto bit by bit, Mozart would set new text as soon as he got it and then wait for the next installment. This is not as arbitrary as it sounds: Mozart knew the play intimately, and he and Da Ponte probably collaborated on how it was going to be adapted. As usual, Mozart composed very fast, though not as straight-from-God as later legend had it. The most beautiful number in the opera, the Countess's aria "Dove sono," cost him a good deal of trouble as a number of sketches attest, and there were probably many sketches that would not survive.[59]

His manuscripts reveal much of his compositional method, different colors of ink showing what elements were put in first and what later. In opera and much of the time in instrumental music, Mozart worked in layers—though the final scores may have been preceded by any number of preliminary sketches. This is seen in Figaro and Susanna's opening duet, "Cinque, dieci, venti." In the instrumental introduction on the first page, written down first in darker ink, we see the two violin parts and the bass part; the winds were added later. Notes went down on the page not systematically but as they occurred to Mozart or as the music called for it: on the second page, a soli phrase for the wind section was written in first along with the bass, plus first violins; supporting second violins and violas were filled in later. On the next page Figaro enters, and from that point on, of course, the voices are always entered on the first pass, the bass line always present. Otherwise, in general on first pass, there is a changing assemblage of skeletal parts, the first violins included if they're playing at all, second violins coming and going

depending on how prominent their part is. The winds are notated only on the first pass if they are the substance of the phrase at that point. And there are exceptions to all this.

Part of the reason for the initial skeleton score was to give Mozart a sense of continuity, letting him write out a whole number start to finish without worrying over the background material in the scoring—much of which would have already been in his mind anyway. This was generally his process in writing instrumental music as well. For opera, there was another reason: the singers had to memorize a great deal of music and text, and he needed to get material to them as soon as he could. So the skeleton score would go to a copyist, who would write out a fair copy and give it to the singers. A competent keyboard player could fill in the harmony for rehearsal. The singers got the recitatives too, but that was a matter of two lines: voice and bass, which would be fleshed out by the clavier player.

As usual, the opera was not composed in chronological order but in the order of when Mozart got the text, what ideas he got first, the importance of the numbers, and so on. And as always, ideas and demands from the singers got into the score, though not all of them onto the page. For one example, in the act 3 sextet, Michael Kelly insisted on a stuttering delivery of his part. Mozart resisted the idea but finally gave in. After it got a big laugh, Mozart told Kelly he had been right.[60]

All the same, it remains astonishing how little compositional work is found on the *Figaro* score, given that Mozart looked at a manuscript as a practical matter and no sort of immaculate document. Nearly everything is clear, confident copy, even though a certain amount of it was worked out on the autograph. Again, there are exceptions. The tune to Figaro's defiant aria in regard to the Count, "Se vuol ballare," is so natural that one would imagine it came to him as a whole. In fact, the score shows that bars two, four, six, and eight of the tune were changed later—this implied because the same bars in the reprise are likewise revised. On a final score, making changes is a laborious process; in every relevant line—in this case, five lines—the rejected notes have to be scratched off with a knife, the staff lines redrawn because they vanish too, then the revisions entered. The results usually look scruffy, as they do here, in contrast to the concision of most of the score. Most of the time, what Mozart put on the autograph was final.

THE BURGTHEATER PREMIERE WAS SET FOR MAY 1, 1786. THE THEATER
was horseshoe-shaped, with four stories of seats, and held about thir-
teen hundred people including standing room, though more could al-
ways be packed in. In contrast to many European opera houses, the
décor was more subdued than showy, the boxes fairly plain; the hall
suited the conspicuously modest style of Joseph II. The house orchestra
was mid-size, around thirty-five, to which could be added trumpets
and drums and the like. The theater's lower boxes were rented by noble
families, some of whom had held them for generations. They tended
to treat the theater as a sort of second sitting room, a place to meet
and greet, see and be seen, so they often took in a given opera multi-
ple times. There were gaming rooms and tables for rent for those who
wanted to play cards during the performance. Of course, many would
be chatting during the music, and scouting the hall for striking rai-
ments and pretty faces.[61]

Michael Kelly remembered Mozart at a rehearsal conducting the or-
chestra in full regalia: a crimson cloak and a cocked hat with gold lace.
His impression of Mozart in the preparations was as generally agree-
able and generous with praise, but "touchy as gunpowder."[62] This was a
sort of description no one else seems to have reported in regard to Mo-
zart. Most of the recollections run to genial, friendly, sometimes silly,
that sort of thing. In his short time in Vienna, Kelly was friendly with
Mozart, and if you were a friend who played billiards, you played with
him. Kelly reported that Mozart beat him every time.

Mozart's touchiness in the *Figaro* rehearsals was probably a sign of
nerves before the premiere, and no wonder. This was a major effort
critical to his reputation in opera, the medium he cared most about,
and it was a far more serious and ambitious matter than *The Abduction*.
There were many questions on the line. Would the musicians be ready?
Would the audience like it? Most particularly, would Joseph like it?
Would the expected cabals allow the music to be heard at all? Would
politics get in the way, such as a rebellion of aristocrats not appreciating
how they were portrayed? For that matter, would the emperor have a
last-minute change of mind as he had with Schikaneder, and forbid the
production?

The dress rehearsal gave rise to a legend that Da Ponte reported,
or created, in his memoirs. Just before the rehearsal theater director

Count Rosenberg summoned the librettist and announced that the act 3 ballet had to be taken out, because they would have to pay extra to hire dancers, which may already have led Joseph to ban ballet in the court theater as an economic measure. Da Ponte wrote a sardonic account of the meeting, in which Rosenberg talked to him like a schoolchild, continually calling him *Signor poeta* in a tone that implied "Signor Jackass." With a grand gesture, Rosenberg demanded the libretto, ripped out the two pages calling for the ballet, and threw them in the fire.

Da Ponte hastened to tell Mozart, who naturally responded with consternation. Despite his myriad duties and concerns as emperor, Joseph was minutely involved in running the opera and often came to rehearsals. Da Ponte made sure the emperor came to the dress rehearsal. Joseph appeared with a retinue of nobility, including Rosenberg. At the moment of the ballet, the singers suddenly stood silently and gesticulated along with the music. "What's all this!" Joseph exclaimed. Da Ponte referred him to Rosenberg, who could only splutter. Joseph may have forbidden ballet in the theater, but they got their dancers.[63] On the other hand, Da Ponte approached his memoirs creatively, so maybe that happened and maybe not.

The premiere of *The Marriage of Figaro* was not without turmoil, not exactly a triumph, but nothing in the vicinity of a failure. Mozart conducted from the keyboard in the middle of the orchestra. There were indeed cabals: a review reported steady hissing from "uncouth louts" in the top balcony.[64] (Leopold had predicted Salieri would try to sabotage the performance. There is no evidence that he was involved, but he probably heard the premiere. In any case he was about to head for Paris and a collaboration with Beaumarchais.)[65] Singers and orchestra were still struggling with the difficult score. (It settled down by the third performance.)[66] All the same, the music was embraced excitedly by that first audience. Encores of numbers were common in those days; on the first performance five, and on the third performance no fewer than seven numbers and a duet were encored. (This annoyed Joseph; in the future he allowed encores only of solo numbers.)

What the audience was hearing was in essence not unprecedented. It was a recognizable buffa based on a famous play, with more or less familiar sorts of characters and situations. Mozart remained one of the great tunesmiths, and that is a rare gift. "Melody is the essence of music,"

he told Michael Kelly. "I compare a good melodist to a fine racer, and contrapuntalists to hack post horses."[67] But there were other tunesmiths around; you had to write appealing melodies to make any kind of career in opera. Mozart had all that, but in comparison to his contemporaries he also brought to music an unprecedented realism on the comic stage, a profound wisdom about people and their motivations, and in *Figaro* he animated a satire founded on the fiction of droit du seigneur that was as true to life as the day's newspaper and the gossip of the moment.

None of this was really needed to be popular and make money. Good singers, good tunes, interesting characters, a nice story, some laughs, some tears—these were the usual currency for opera. The composers more popular than Mozart in his lifetime—among them Salieri, Paisiello, and Martín—were maybe less concerned with deeper matters of story and character. Mozart liked applause, and he liked having money to live in a fine apartment and to buy the best piano and best billiard table and grandest clothes. He probably would have been more popular if he wrote fewer notes; listeners complained that his orchestra covered up the singers. But when he was spinning out music at the keyboard or in his head as he played billiards or rode his horse, what mattered to him was the integrity of the notes, the rightness of the forms, the implications of the notes for the characters and the story. Nobody else cared as much as Mozart did about the drama, and in music nobody inhabited and realized characters—*acted* characters—as he did. This is what made him incomparable in his time, and something of that order after his time.

THE OVERTURE TO *FIGARO* IS SCURRYING AND DROLL, ITS QUIETLY muttering opening leading to a quasi-grandiose Tutti fortissimo. This beginning establishes an unrelenting comic energy for the overture that will carry over into the opera. Significantly, this is a fun-and-games opening, with no hint of the darker undertones of the story. That is Mozart's game in *Figaro*: on the surface we have a merry sex comedy; those who want more are free to look for it. The overture is in bright D major, the home key of the opera. Its layout is also prophetic of the rest: a sort of sonata form, with a chattering second theme in the usual dominant key, A major. Many numbers in the opera are going to incorporate

sonata form without mechanically submitting to the symphonic version of it—in the overture and later, for one example, there is not much in the way of development sections. The overture has two themes, the second longer, a closing section, retransition, and we're back to the recapitulation plus a long coda, which raises the excitement to a breathless level to prepare the opening curtain. As a whole the overture has a quicksilver brightness in the orchestral sound and an indefatigable energy, the lower strings responsible for much of that energy with their incessant driving and chattering figures.

With the curtain the energy calms down, so we can start over again. We find Figaro counting off numbers as he measures the floor for the marital bed. With a quick change of direction, Susanna's theme appears in the orchestra as she admires in the mirror her homemade wedding bonnet. Besides doing its job of presenting the characters and establishing the general tone and approach of the opera, the opening scene speaks volumes about the level Mozart had reached after sixteen stage works finished or sketched and dozens of instrumental works. Recall that he is the only composer who was equally important in opera and concert music. This allowed his command of structure and orchestration to inform his music for opera, and also the reverse, his operatic sensibilities informing his concert music. Much of *Figaro*'s effect is going to rise from Mozart's sophistication in making the devices of instrumental music work for drama and comedy and characterization.

It's reasonably clear how words create meaning, character, situation, but how does music amplify those things? In speaking we articulate feelings partly by what we say and partly by how we say it. There's an interaction between those two things, the what and the how of words, and sometimes a deliberate contradiction. Take the word *fine*. It can be said in a businesslike way, somewhere between casual and involved, showing simple approval. It can be snapped out abruptly, meaning approval as if in passing, not important. Or it can be pronounced warmly or enthusiastically, conveying an involvement by the speaker: "That is fine!" The word can be stretched out with an upward inflection, *fiine*, meaning: "all very nice, but . . ." It can be said with a smile or a chuckle as an ironic quasi-approval. It can be barked angrily, *Fine!*, by which is meant the opposite of approval: "nothing is fine, and you are in for it." Each of these implications can have myriad shades. In an opera

the music provides the implications and the shades, implies mood and movement for every moment of the text. It is the job of the singers, while singing beautifully, to follow the cues of the music in their singing and acting and movement. As said before, the music has to *act the text*, and the singer has to project the implication of the music.

In the opening duet Figaro's counting theme is straightforward, striding, as he recites the numbers. In the middle of the orchestral texture the second violins provide energy with a babble of sixteenths; for much of the opera's arias and ensembles, the second fiddles are going to be the prime rhythmic engine in the middle of a rich orchestral texture. Then comes a shift to a more lyrical—call it feminine—idea, which is Susanna admiring her hat and not much caring about what Figaro is doing. In effect, her music functions as the second theme in sonata-like terms. The rest of the duet will be a development of these contrasting musical ideas, which represent the contrasting concerns of the two people onstage: the bed, the hat. It also stands for a contrast between a woman's attention to beauty and social presentation and the man's fixation on a practical task. But there is another undertone: Susanna knows what's really going on, and Figaro does not. She's going to have to tell him.

After Susanna's musical phrase (she has not sung yet), Figaro continues with his measuring music, which Mozart makes both straightforward and playful. At the mirror Susanna sings, to her theme, "Yes, now I'm pleased with it . . . Take a look, my darling Figaro. Look at my bonnet." He continues obliviously counting. A musical and dramatic development unfolds. After singing their phrases solo, they join in a duet, he still counting, she talking about her hat and their wedding. The second violins churn away, keeping the music moving. Then comes a telling phrase: Figaro finally notices, and taking up Susanna's tune he says, yes, the hat's nice. They're coming together, they trade off figures. In a little interlude they sing mellifluous thirds in duet, which amounts in sonata-form terms to a retransition back to the home key of D major, a quasi-recapitulation. From that point they're warmly together, the music based mainly on her theme, as if she has drawn her lover away from his mundane concerns and into her orbit, which is love and pleasure. There is the climax of the duet.

In accompanying the singers, Mozart's orchestra does not try here to paint their souls, but rather the flow of emotion and action.[68]

Here is Mozart's singular gift in opera: his ability to wed an incomparable command of "abstract" musical structure to a fine sense of drama and character that minutely pictures every turn of action and emotion and paints the psychology of characters like nothing before on the opera stage. He was able to marshal abstract form for the purpose of drama because the structure of sonata form in particular is innately dramatic: the two themes of an exposition can imply two contrasting characters or situations; the return to the home key in the recapitulation after a tonal journey, whether or not the tune is the same, can paint reconciliation, affirmation, certainty. The clear phrases of eighteenth-century style, founded on dance music, can feel like a train of events; the Classical art of rhythmic transition allowed for quick changes of direction without muddling the continuity.[69]

Mozart never uses full-scale sonata form in an operatic number—there is rarely anything like a full-blown development—but he echoes it often. So these pieces that are part of a story in action still have the solidity of something that sustains its weight in purely musical terms. Drama is conveyed in music that obeys the logic of music, and that music tells us how we are to receive the text in the same way that an actor tells us by his performance in a play. At the same time, Mozart's mastery of large-scale unfolding in multi-movement works informs his ability to keep the succession of pieces in a number opera moving forward both musically and dramatically—forward toward the cathartic act finales. Beyond all that, it was only a later generation that invented the idea of abstract music anyway; in the eighteenth century, all music dramatic or instrumental was considered a form of rhetoric, with emotional and extramusical associations involved as a matter of course.[70] Sonata form, for example, was compared to the structure of an essay, a sermon, a drama.

In the opening scene of *Figaro* the next step is for Susanna to enlighten her innocent lover with her practical wisdom. It begins with a recitative. Susanna asks what he's been doing. He says that he's measuring for the bed Count Almaviva is giving them. I don't like that, she says. But it's a nice bed in a room conveniently close to our masters,

he says—why aren't you happy? "Because," she informs him, "I am Susanna and you are a fool." He demands an explanation.

A new duet begins, one of the gayest and most scintillating in the opera, but its implications are not happy. Its most amusing musical and dramatic figure is a little rhythmic bit representing their masters' bell of summons: *Ding ding, dong dong*. That figure will be steadily developed as a musical motif, meanwhile becoming funnier and more fraught. What is our master ringing for, really? Susanna asks, "Suppose one morning / Your dear little master—*Ding ding!*—should send you / On an errand miles away . . . *Dong dong!*—wouldn't that devil / Just have his day!" She means the Count having his way with her.

Figaro is duly gobsmacked. In a recitative he learns the whole story from Susanna: "This is why he's being so kind to you and your bride." She cites "his 'privilege' as lord of the manor." She means le droit du seigneur. But, Figaro fumes, didn't he abolish that? He did, says Susanna, but in my case he regrets it.

In light of a situation they now both understand, another divide opens between them. Nothing about this surprises Susanna. It's the way of the world, and the way of men who wield power. For Figaro this is an outrage but also a summons to action. He will be the man, he will take charge of keeping Susanna out of the count's clutches. First, he'll hasten the marriage. Figaro is a wily sort, but as it turns out, he will not prove wily enough for the challenge. It will be mainly Susanna's cunning that preserves her integrity and that of their marriage.

There is another issue hanging in the background here: what exactly is a servant? Traditionally, servants of the aristocracy were virtual slaves, given room and board and little to no pay, subject to their lords body and soul, not even able to resign without permission—and a servant's request to resign could have unpleasant consequences. Most of the middle class, such as the Mozart family, had servants as well; they were also given room and board and little else, generally considered inferior beings in some degree. Servants of the aristocracy, such as Susanna as maid to a countess, were traditionally more repressed than servants of the middle class, but also higher in status as lackeys for the grand and great.

Part of the point in the play and opera *Figaro* is to mount an enlightened attack on the whole upstairs/downstairs situation. Figaro

and Susanna are not slaves to the Count and Countess; they are paid employees.[71] As such, they have a natural right to integrity and dignity, which includes moral dignity in their marriage.[72] (Among his reforms, Joseph made marriage for the first time a civil contract.)[73] In *Figaro*, the droit du seigneur represents the determination of the ruling class, acting on lust or for any other reason, to retain their feudal privileges over the bodies of their servants.

Figaro understands that he's going to have to outwit his employer. Now comes one of the legendary arias of the opera, legendary not because of sociopolitical implications but because it's an irresistible melody: "Se vuol ballare," "If you want to dance, little Count, I'll play the tune." The dance involved is three-beat, on the order of a minuet, which is to say an aristocratic dance.[74] "Sit for your lessons in my school," Figaro crows to the absent Almaviva, "And I'll teach you my rigadoon." I'll teach you, in other words, to dance like I do. Sure enough, the middle of the aria breaks into a lusty two-beat peasant contredanse tune with a fast-pattered text: "Here a parry, there a thrust—/ Oh, your quickstep will be over soon!"

The number ends with a recapitulation of the opening tune. These kind of sonata-like returns will happen in numbers throughout, but in a variety of ways: as here, a return of the opening thematic idea on the same text; sometimes the musical ideas repeating with a new text; sometimes the recapitulation effect a more subtle matter of return to the home key with new material and text. In dramatic terms, literal repeats of words and music have the effect of underlining an idea or an emotion. Here the repetition underlines Figaro's determination to wrap the Count around his finger and preserve his bride and himself, their integrity as human beings, their very lives.

So Figaro's scheme is afoot. It will not go as planned.

THE NEXT SCENE BRINGS A SECONDARY PLOT, INVOLVING TWO PEOPLE the Count will try to make use of for his own ends: Marcellina and Dr. Bartolo. Both are essentially clownish characters, Bartolo recalling the Doctor in commedia dell'arte. It seems that Figaro once borrowed money from Marcellina and agreed that if he did not pay her back, he had to marry her—and she is old enough to be his mother. Bartolo,

who is itching for revenge after Figaro took Rosina away from him
and secured her for the Count (in Beaumarchais's previous play), signs
on to Marcellina's plot to prevent his enemy's marriage to Susanna. He
sings a sanctimonious aria of vengeance, proclaiming his superiority:
"To forget an insult is a measure / Of the common man's stupidity. /
With obsession or discretion, / With my learning I'll confound him! /
Oh, believe me, I will hound him!" The key is D minor, Mozart's pre-
ferred tonality for the dark and threatening, here turned to ironic effect.
An ensuing scene between Susanna and Marcellina is a row of barely
stifled insults, but Susanna does not yet know what Marcellina is up to.

Enter the page Cherubino, whose name means "little cherub." As
that implies, Cherubino is a creature intoxicated by love, if you want
to call it that. He is mainly in love with the Countess, who is his god-
mother; meanwhile the gardener's daughter, Barbarina, is mad for
him. Cherubino is the "pants role," the reality of this boy being played
by a soprano manifest to the audience, that in itself used as a kind of
meta-joke: some of the plot will involve dressing Cherubino like a
girl, at which point the actress has to play a boy struggling with femi-
nine clothes and movements. The soprano's skill at this bit of physical
clowning can make for some fine comedy. Pants roles were common in
operas of the time; there was a lot of gender juggling, onstage and off. It
is perhaps relevant to recall Casanova's smirking recollection of a party
when a gaggle of beautiful pubescent girls and beautiful teenage castra-
tos lined up naked and guests were invited to guess which was which.

Really the adolescent Cherubino is crazy for love itself, burning
for any female he can get his hands on. Mozart's first aria for him is
a whirl of breathless, guileless sexual hunger, "Non so più cosa son":
"What is this feeling, this mysterious yearning, / One moment freez-
ing, the next moment burning? / Each woman I see makes me turn
pale . . . Gives my trembling heart a delicious fright." This is Lorenzo
Da Ponte writing from broad experience, Mozart from less experience
maybe, but no less fervent—he had his Bäsle period. The music gasps,
pounds, races. Sometimes in his adolescent excitement Cherubino's
voice breaks, jumping from a low register to high. It ends with his cry
that if nobody cares about his yearning for love, "If no one listens, well, /
I talk about love to myself!" Mozart gives a full stop on that last line,
leaving it hanging in the air. To taste, it can be played as an evocation

of teenage masturbation, or not—the sort of double-entendre-ish gag Mozart appreciated.

Cherubino tells Susanna that he has incurred the ire of Count Almaviva, who found him alone in a compromising situation with Barbarina and summarily fired him from his position as page. He wants the Countess to intercede to get his job back. At one point Susanna produces one of Rosina's ribbons, which Cherubino snatches, kisses, and refuses to give back. For all its jumbles, this is a nicely tight plot; the ribbon will figure later.

Suddenly the Count appears. "I'm done for!" Cherubino cries. He manages to hide behind an armchair as Almaviva enters and resumes his relentless pursuit of Susanna. Then the Count realizes that Don Basilio, once Rosina's music teacher and an old busybody, is approaching while he is trying to romance this maid. The Count hastens to hide behind the armchair where Cherubino crouches; Susanna deftly draws the boy around to the front of the chair and covers him with a dressing gown: now two characters are skulking around the same chair, for two different reasons. Basilio knows all about the Count's passion and urges Susanna to give in to it: "I would have thought you might prefer to take as a lover, like any other woman, a nobleman who is rich, sophisticated, discreet." Moreover, Basilio accuses her, disapprovingly, of fooling around with Cherubino. He notes that the page has been paying undue attention to the Countess—at which point the Count jumps from behind the chair in a fury. General consternation.

An elaborate trio takes shape, Mozart weaving into a musical whole a group of characters with differing texts and agendas and emotions. Basilio smirkingly declares that he has no suspicions, the Count rages, and Susanna is at the end of her wits. In painting the Count's first response to this muddle, Mozart does one of his deft bits of characterization. Almaviva enacts what actors call a "slow burn": "What's this? . . ." he blurts in shock to Basilio. "Get out of here . . . you seducer . . ." Then, in full voice, forte, "Get out of here!" The Count will be provided further opportunities for slow burns. During the trio there are two prophetic lines, in different directions. "Dove sono?" (Where am I?) moans a near-fainting Susanna. The line will be heard again, from the Countess. And later Basilio sings, "Così fan tutte le belle" (It's

what they all do, the women). The first of those latter words, and that sentiment, will be in the title of an opera to come.

In a recitative in the middle of the trio comes one of the famous moments in the play. Count Almaviva describes the scene of the day before, when he came into Barbarina's room. She acted suspiciously, and he raised a tablecloth to find Cherubino hiding under the table. To illustrate, and to Susanna's horror, he lifts the dressing gown on the chair and discovers Cherubino hiding yet again, in another woman's room. "All is lost!" Susanna groans to herself." "Better all the time!" Basilio cackles. "Ah, most virtuous of ladies!" cries the Count, "At last I see how things are!"

To summarize so far: Cherubino has been accused of scandalous attentions to Barbarina, the Countess, and now Susanna. Susanna has been accused of impropriety with Cherubino. Don Basilio is in his element, witnessing a scandal. Count Almaviva, who has been trying to seduce Susanna, reproaches her for being involved with Cherubino. The Count calls for Figaro to be summoned, to witness the shame of his bride. Then, talking with Cherubino, the Count realizes the boy has heard everything. "I tried not to listen," the teenager says helpfully. "Bloody hell!" the Count cries. His pursuit of Susanna, and/or revenge on her, has been thwarted for the moment.

Where is Figaro during all this? He has been pursuing his scheme. The act is approaching a close, and the action broadens. Figaro is going to hoist the Count by his own petard: he tells his employer that he has assembled a chorus of villagers to sing his praises for ending the practice of droit du seigneur. "Clever devil!" the Count mutters to himself, but he makes a show of thanks. The villagers sing a gay pastoral tune to their master "whose generous heart / Keeps honesty . . . as its reward." Cherubino appears and begs the Count for forgiveness, the advent of a mighty theme in the opera. The teenager does not omit to add, "I will never reveal . . . ," leaving unsaid what he heard in Susanna's room. Finding himself blackmailed, the Count hastily forgives the boy, but decrees that he must fill a vacancy as an officer in the regiment. This command is not good news for Cherubino or for Figaro's plans, but it seems for the moment inescapable. As for Almaviva, his hope of using droit du seigneur to force Susanna to submit to him has been crushed. He will have to rely on persuasion—and on Marcellina.

The conclusion of the act is a superb bit of verbal and musical whimsy: to a steadily mounting, mock-heroic military march, seeming to begin in the distance and advance toward us, Figaro says farewell to the little cherub in his new commission: "Non più andrai," "No more now will you flutter by / To bother the ladies night and day, / You preening, lovesick butterfly!" Now it's "Off to the wars, my young friend! / Long mustaches and socks to mend, / Musket to shoulder, saber in place, / Back like a ramrod, sneer on your face." The march rises to a brassy and sardonic climax as Figaro cries, "On to victory, Cherubino!" Really, though, he hopes to keep the boy around for a while, as part of his plan. This in fact is the last time Figaro will be confidently running the show.[75] The curtain falls as the terrified teenager tries to look brave.

THE ACT 2 CURTAIN RISES ON THE COUNTESS IN HER CHAMBERS. SHE sings "Porgi, amor": "Grant me, love, at last an end to my sorrow . . . Bring back the light of my life / Or have mercy and let me die!" It is Mozart at nearly his most beautiful and heartfelt. Rosina laments the faithlessness of the husband she once loved and who fought to get her (this being the substance of the *Barber* play). This is not a buffo aria but rather in seria style. The Countess is what the time called a *mezzo carattere*, usually a suffering woman who can be both serious and comic and who, unlike the stiff heroines of seria, takes an active part in the action. Early opera buffas were sheer comedy, but over the years, composers and librettists realized that they could enfold serious undertones and characters—to a degree on the model of Shakespeare, his comic scenes in the middle of tragedies, and vice versa.

Susanna enters. She has told the Countess about her husband's designs on her. "So he tried to seduce you?" Rosina says. "Oh," replies Susanna casually, "his lordship does not offer such compliments to a woman of my station. He came to offer me money"—which is to say that he offered her cash for her favors.[76] And indeed, without explanation, Susanna will soon turn up with a purse of money. Perhaps this paying-for-sex proposal is no more corrupt than the Count's interest in Susanna in the first place. Or at least the Countess does not seem particularly incensed by it, as such. Her response has to do with her feelings, not her servant's: "Ah, that cruel man no longer loves me!"

The Countess is sickened not only by her husband's faithlessness but by his jealousy of her. Figaro arrives and adds another element: he tells them the Count is working with Marcellina to prevent his marriage to Susanna. Now our barber has a further plan: a letter he gave to Basilio to forward will tell the Count that his wife is meeting a lover at the ball that night. While the Count is distracted by that, the marriage can be held without interference. Meanwhile Susanna will summon the Count to a rendezvous, but playing her part at the rendezvous will be Cherubino, dressed as Susanna. The ladies sign off on the plan, Figaro exits with a recall of his mocking "little Count" tune. Cherubino arrives.

This is one of the opera's farcical scenes. Cherubino is enticed to sing an ingenuous love song, more adolescent yearning if more restrained than before. He has with him his military commission, which has not been officially sealed. Figaro has told the teenager about the plot, but Cherubino is still boggled when the women start undressing him, putting women's clothes on him, arranging his hair, showing him how to walk like a girl. The Countess discovers the ribbon Cherubino stole; she is touched by his tears when she asks for it back.

Once again, an unwelcome intruder: the Count arrives outside, pounding on the door. Alarmed, Cherubino and Susanna hide in an inner room. Almaviva is let in, and outraged by Figaro's bogus letter, he demands to get into the locked inner room. Rosina refuses. He leaves to fetch a crowbar, dragging her with him. Susanna and Cherubino emerge, and in a panic the boy jumps out the window. Susanna looks down in alarm but sees that he's all right, up and running through the garden. When she hears the Count and his wife returning, she rushes back to the dressing room.

When they arrive, the second-act finale begins—the kind of finale Da Ponte wrote about, most of or all the principals involved, the characters in high dudgeon, tumultuous events in a chain of linked numbers of mounting tumult and confusion. Again, Mozart did not invent this kind of finale, but he took up the idea and brought it to an unprecedented plane of comic energy. Part of what these extended finales do is to eliminate recitative, moving away from number opera's traditional alternation of recitative and aria or ensemble and into continuous music and action—still in the discrete sections of number opera but with an

overarching pattern of keys, moods, tempos, all of it arranged toward maximum energy and excitement at the end.

So the more hubbub, the better. This finale unfolds in eight sections, each with its own tone, each with its own orchestral color, the tempos and meters changing. A sonata-like pattern of keys enfolds the whole: E-flat B-flat G C F B-flat E-flat. In other words, the keys in the sequence of sections work like a sonata even when the material does not. In the first Allegro, the Countess confesses to the Count that Cherubino is in the dressing room and, well, not completely dressed, but really it's all very innocent. In the Andante second section the Count throws open the door to find only Susanna, to the astonishment of both him and his wife. Susanna is unflappable, emerging serenely with "Your servant! / Why so amazed?" In an Allegro, the Countess tells Susanna she's about to faint, but the Count apologizes—the opera's second plea for forgiveness. Now the Countess puts on a show of outrage at her husband's suspicions. As Susanna observes to herself, "Confusion all around, / The stuff of comedy!" Indeed Da Ponte is poking fun at the genre of opera buffa itself, with its obligatory hyperbolic second-act finales.

This Allegro is another little piece in itself, held together by a couple of figures, one driving and the other gently surging, that keep the music moving ahead through the back-and-forth dialogue and patter, the vocal parts steady variations on a simple descending motif, the keys working again like sonata form: the home key, B-flat, going to the dominant F; then a development-like procession of keys mirroring the dialogue as it becomes more heated with the Countess's fake outrage, and then her fibs about why she had said Cherubino was in the locked room; and finally a return to B-flat. The orchestra is in its quicksilver mode, with a full complement of winds: flutes, oboes, clarinets, bassoons. (The Burgtheater orchestra had about a dozen violins, four violas, three each of cellos and basses, pairs of all four winds.)[77] Mozart has marshaled the full orchestra for this climactic finale; other numbers have a changing cast of winds and brass, the instrumental colors keyed to the expression of each piece: eleven numbers have the full complement, fourteen have ad hoc combinations.[78]

A lively Allegro brings a new scene and situation. With a jump to the distant key of G major, Figaro arrives to gather people for the

wedding. The Count confronts him with the letter about his wife meeting a lover; Figaro improvises a new flurry of misrepresentations. Everybody in the story is a virtuoso of mendacity, the plot a fabric of lies. Echoes of earlier melodic motifs and rhythmic figures are in play, along with carefully structured harmonic patterns, to hold together a kaleidoscopic succession of musical and dramatic twists and turns.

Susanna and the Countess tell Figaro he'd best confess the ruse of the letter. He refuses. With a new section comes another twist: the gardener Antonio enters and reports having witnessed an odd sight, a man jumping from that window. Thinking fast, Figaro claims it was he, but the gardener presents Cherubino's military commission, which the boy dropped in his flight. Oops. This segment is a quartet: the number of singers is rising along with the turmoil. The key is B-flat, dominant of the finale's home key, E-flat, preparing its return.

The situation gets yet more crazed when Marcellina, Bartolo, and Basilio turn up to press Marcellina's claim on Figaro: pay up or marry the lady. Now the principals are all onstage, battling away in a sextet. (Mozart said this was his favorite part of the opera.) Return to the home key of E-flat, a tempo of allegro assai, the orchestra providing a burst of energy. Soon comes a faster Allegro, everybody shouting at once, Susanna, the Countess, and Figaro crying, "All of them are mad!"; the Count, Basilio, and Bartolo crowing, "A run of luck, a masterstroke!" Prestissimo! Pandemonium! Curtain!

THE THIRD ACT STIRS UP MORE PLOT KINKS AND RESOLVES ONE ELEMENT so as to concentrate on the other. Schemes and disguises continue to proliferate. The Countess persuades Susanna to meet Almaviva in the garden—or rather she intends to meet him herself, disguised as her maid. Susanna, meanwhile will dress as the Countess. So servant and master switch clothes, which switches their roles—for the moment. The Count arrives and in a duet with Susanna continues his efforts at seduction. She agrees to meet him that night, as per the Countess's scheme.

Now the most downright delicious scene in the opera: Marcellina and Bartolo with Don Curzio corner Figaro over the debt and his agreement to marry Marcellina if he can't raise the money. It seems his

goose is cooked, but he refuses to go through with the marriage to Marcellina. He claims that he needs his parents' permission to marry and that he is actually of noble birth, which he could prove if he could only find his parents, which he hopes to do "in about ten years." It comes up that he has a birthmark. On the right arm? Marcellina exclaims. Who told you? says Figaro. Oh my god, says Marcellina, I've found my boy. And the father is none other than Bartolo.

Marcellina is not only old enough to be Figaro's mother, she *is* his mother. Some extravagant incest has been circumvented. Mozart is in his comic element in this scene. Beginning with a sappy tune, parents and son embrace. Susanna arrives, having secured the money (from the Count?) to pay Figaro's debt. Seeing him embracing Marcellina, she is livid, and it takes some doing to calm her down and explain to her the situation, which is done in a hilarious stretch of echoes: His mother? Yes, his mother! Your mother? Yes, my mother! His father? Yes, his father! And so on. Finally Susanna gets the idea, everybody is relieved, and that part of the plot winds up—except for the Count, who will not be pleased with the news. Marcelina and Bartolo decide to be married alongside Susanna and Figaro.

From this point everything turns on disguises, the coming night, the assignation in the garden. Alone, the Countess sings an accompanied recitative lamenting the "humiliating pass I have been brought by a cruel husband. Once he loved me, then he neglected me, and finally deceived me . . . And now he forces me to seek the help of my maid!" This, for an aristocrat, is humiliating indeed—for all her fondness for Susanna. She sings "Dove sono," the most affecting aria in the opera, one of the most affecting in any opera: "Where are they now, the vanished days, / The moments of pleasure's afterglow?" This sort of recitative and aria is another borrowing from seria. Recalling the sweet moments after making love, Rosina offers her gently sorrowful melody for all lost love, for all women who find love slipping from their grasp and see hope receding on the horizon.

But Rosina hasn't given up. The scheme goes forward. The Countess desperately needs her maid to help save her marriage. She dictates a letter for Susanna to write down, inviting her husband to a tryst, where the Countess will meet him in Susanna's clothes and expose his perfidy. It is a remarkable moment, Rosina speaking lines, each echoed by

Susanna as she copies them down, servant and master collaborating, for the moment, as equals. Significantly, their music is nearly the same.[79]

A choral scene follows, village girls holding flowers, Cherubino in disguise as one of them, his nominal girlfriend Barbarina on hand. His wedding on again, Figaro returns to gather the attendees, the girls sing. But a dissonance intrudes when Antonio the gardener exposes Cherubino in his women's disguise, and Figaro's lie about jumping out the window more or less falls apart. He concedes only that maybe both of them jumped. The Count's anger is countered by Barbarina, who notes archly that "you have so often said to me, when you hug and kiss me, 'Barbarina, if you love me, I will give you anything you want.'" An oops for the Count. She wants Cherubino for her husband, and if she gets him, she will love the Count "as I love my kitten."

In the midst of these squabbles, the Count feels he is going mad. Among other things he has been reduced by a young girl to the status of a small furry animal. As least he has the tryst with Susanna to look forward to, but that will turn out the worst muddle of all. There is a grand march and the ballet that Da Ponte saved for the premiere. The dance is critical to the plot, because during it, Susanna slips Almaviva the compromising letter his wife dictated. Opening it, Almaviva pricks his finger on a pin clipped to it. This is a prophecy of his coming fate. Seeing the exchange and ignorant of the Countess's scheme, Figaro becomes suspicious of Susanna. The stage is set for the final act, where everyone gets their deserts.

FOR THE BEGINNING OF THE FOURTH ACT MOZART WROTE AN ARIA FOR Barbarina: she has lost the pin that was in the letter, which the Count gave her to return to Susanna. That information could have been handled in a couple of lines of recitative; the aria is superfluous to the plot and impedes its progress. In future productions it would often be omitted. But the trouble is that it amounts to a lovely little number in a veiled F minor. Here is the Mozart whom Joseph and other cognoscenti complained about, who doesn't know when to turn it off, who writes too many notes—often too many beautiful notes. Anyway, Barbarina explains to Figaro that she's searching for the pin, and this reinforces his conviction that Susanna is about to betray him with the Count. In

an encounter with Marcellina, he tells her he is off "to avenge all hus-
bands!" He is a little overambitious. The tangles are complete. Now the
question is how they will untangle.

Further interludes put off the final confrontations. Mozart seems to
have felt he owed the principals one more solo each. Marcellina says she
will warn Susanna about Figaro and sings an aria about how women
are mistreated by men. Basilio cautions Figaro not to tangle with the
nobility, then gets an aria telling a tale about an ass's skin. Figaro gets
his rage aria indicting the whole species of women: "Enchantingly they
sing / A song that nags and mocks. / A siren song they sing / To drive
us on the rocks." Mozart ends Figaro's aria mockingly with whooping
horns, which for those in the know was an old musical symbol for the
horns of a cuckold. Figaro has invited Bartolo and Marcellina to wit-
ness his erstwhile bride's exposure. Meanwhile, unspoken, most of his
schemes have come to naught—though not for the reasons he thinks.
None of these arias is among the memorable ones of the opera; they
provide some nice solos for principals who had not gotten their due.

It all comes down to a dark garden. Who knows if Da Ponte had
something further in mind by placing his denouement in a garden,
other than its providing a handy place for people to hide and spy
on one another. But in that era gardens had a repute for beauty and
intimacy in a public place, even if they were usually tended by the
nobility. They also recalled one of the notorious dramas of the time,
Voltaire's *Candide*, in which that guileless character is led farcically
astray by a philosopher (modeled on Leibnitz) who assures him
that this is, come what may, the best of all possible worlds. At the
end, the bruised hero comes to a conclusion that became a byword:
"Candide, as he was returning home, made profound reflections on
the Turk's discourse," wrote Voltaire. "'This good old man,' said
he to Pangloss and Martin, 'appears to me to have chosen for him-
self a lot much preferable to that of the six kings with whom we had
the honor to sup . . . that we must take care of our garden.' 'Work
then without disputing," said Martin; "it is the only way to render
life supportable.'" Tend your garden, mind your business, Voltaire
says; don't place your fortune and self-regard in the hands of the
nobility, and life will go as well as it's going to. Voltaire's garden
may be lingering in the background of this one, which is the setting

of an intimate resolution: the place of forgiveness in holding life together.

The final act produces the most dizzying—maybe a better word is *absurd*—welter of incident yet: multiple spying, defiance, disguises, rage, reconciliation, slaps to the face. Bit by bit the cast assembles for the final hullaballoo. Susanna and the Countess, each disguised as the other, wait for the Count to appear and make love to the woman whom he thinks is Susanna but is actually his wife. Figaro is convinced his bride is having a tryst with the Count. Cherubino turns up in the darkness, ready to grab any female in sight.

The finale begins with Susanna. She has seen Figaro spying on her; to get his goat she sings an accompanied recitative and an airy song, "Deh, vieni non tardar," about meeting a lover. She knows that Figaro will recognize her voice. Having in the previous act given showy but dramatically extraneous songs to the other principals in the cast, now Mozart gives Nancy Storace her turn. Future productions would often cut those arias, but usually not this one because it's charming, an embodiment of its text: "Come, beloved, no more delay. Come, the moment will not stay." Moon, brook, breezes, flowers—the accompaniment recalls Cherubino's love song and also a bit of its formal quality: Susanna is singing out of feigned rather than real feeling, and the music is not an occasion for virtuosity but rather a celebration of the beauty of the singer's voice.

The interlude in this case does not impede the drama; it is a calm baseline from which the climax begins to gather. This finale is going to be more frantic in incident but musically less so than the second-act one. It begins relatively calmly, with Cherubino trying to make love to the Countess, whom he thinks is Susanna; she is furious, her scheme threatened. Almaviva turns up; because of the disguises, each man thinks his woman is with another man. The Count and Figaro are livid, Cherubino randy, Susanna and Rosina fearing the collapse of their plans, the five of them exclaiming and lamenting in various configurations, the music holding it all together and steadily ratcheting up the commotion. Finally the Count is pawing whom he thinks is Susanna but is actually the Countess, and he leads her to a bower.

Now Figaro get his comeuppance. "Tutto è tranquillo": "Suddenly so peaceful and still," he begins, the music echoing this sentiment. It

heats up with the appearance of Susanna dressed as the Countess. Soon he figures out that this is Susanna, and for revenge, he pretends he is courting the Countess. This ends in a torrent of slaps from a furious Susanna, which Figaro receives delightedly. It ends with laughter and forgiveness. "Peace, peace my dearest sweetheart!" he croons, and the music turns to a tender love song, interrupted by the Count looking for the fled Susanna, who is really Rosina. In this number there is a repeated motif between Figaro and Susanna that is one of Mozart's great throwaways, a little moment there and gone but as delicious as any composer has managed—the sort of thing, in other words, that drove other composers to distraction: fleeting glories they could never hope to equal.

For the final scene, everybody is on hand: all the above plus Antonio, Basilio, Marcellina, even Barbarina. It begins with the Count in the most hypocritical of jealous rages, calling for men with swords to apprehend his unfaithful wife. The music paints his rage, Figaro's feigned terror, the consternation of everybody else. Finally the Count has the disguised Susanna kneeling before him. "The adulteress is before you!" he cries. All plead, "Forgive her!" "No, no, no, no!" he bellows. Now the turning point: the real Countess emerges, triumphant but tender: "Then for others let me beg instead / A forgiveness that, for me, you will not show."

Here is the final forgiveness, the most profound one. The Count has been caught in his lies and corruption, humiliated before his servants. The music becomes something on the order of a sacred hymn. He pleads simply to Rosina, "My lady, forgive me." She replies simply, "What can I say but . . . yes." This is what Mozart brings, beyond Da Ponte 's understated finish: forgiveness is sacred. All join in the hymn that rises to a majestic peroration.

There remains only the quick, jolly wrap-up that has to conclude an opera buffa. The cast lines up and declaims, "Each and every one happy again! / A day of madness, / Of folly and sadness / Is now at an end . . . Night after night of happiness! / In the end there is only love!" So ends the crazy day, with two couples about to be wed and a married couple reconciled. The nights of love, the beds, remain in the center of the story, but now the beds have been restored to their proper occupants.

In the end there is only love. As it always did in the end for Mozart, love reigns, a love of hearts and minds and bodies. He never forgot the beds and the bodies, for all the trouble they cause. Just as the next play of Beaumarchais's trilogy turns from imagined to real infidelity, and just as Mozart recognized that the resolutions of love and sex were provisional, in his operas the celebrations of the final numbers tend, whether he intended it or not, to leave a sense of uncertainty. The resolution so cheerily proclaimed will not endure.

Taking into account the innately loose nature of number opera: in all its dimensions from inspired libretto to inspired score, in the harmony of character and action and musical realization, in its broad comedy and its bitter human wisdom, *Figaro* is as close to perfect as Mozart ever came, which is to say as close as opera ever came.

THIS TRUEST AND BEST FRIEND

There is no record of how Mozart felt about the premiere of *The Marriage of Figaro*. No surviving letter, for example, to Leopold. He was long past sending regular reports to Salzburg, or to Nannerl in St. Gilgen.

On its first run, *Figaro* had nine performances in the Burgtheater, a modest success for a new work. Still, in the four years before that premiere, Paisiello's *Barber of Seville* had enjoyed thirty-eight performances in Vienna,[1] and that was the composer's seventy-first opera. Martín y Soler's wildly popular buffa *Una cosa rara* (in English, *A Rare Thing, or Beauty and Honesty*), its book also by Da Ponte, soon crowded *Figaro* from the stage. It would not be heard in the city again for two years.[2] So there would be revivals of *Figaro* in Vienna, but nothing like the kind of repetitions seen for works of Paisiello, Martín, and Salieri. With everything he did, Mozart had to contend with his reputation for being difficult. All the same, over the next years *Figaro* found acclaimed performances around Europe and wild acclaim in Prague.

A review in the *Wiener Realzeitung* soon after the *Figaro* premiere was a study in where Mozart stood in those days with both enemies and admirers.

This piece, which was prohibited in Paris and not allowed to be performed here as a *comedy* either in a bad or a no good translation, we have at last had the felicity to see represented as an

opera . . . Herr Mozart's music was generally admired by connoisseurs already at the first performance, if I except only those whose self-love and conceit will not allow them to find merit in anything not written by themselves. The *public*, however . . . did not really know on the first day where it stood. It heard many a *bravo* from unbiased connoisseurs, but obstreperous louts in the uppermost story exerted their hired lungs with all their might to deafen singers and audience alike with their *St!* and *Pst* . . . Apart from that, it is true that the first performance was none of the best, owing to the difficulty of the composition. But now, after several performances, one would be subscribing either to the *cabal* or to *tastelessness* if one were to maintain that Herr *Mozart's* music is anything but a masterpiece of art. It contains so many beauties, and such a wealth of ideas, as can be drawn only from the source of innate genius. Some journalists like to tell that Herr Mozart's opera had not pleased at all . . . I believe it to be sufficiently well known that it was precisely the 3rd performance and the frequent demand for encores . . . that led to the *Imperial Decree* which a few days later publicly announced *that it would in future be forbidden to repeat in an opera any piece written for more than a single voice.*[3]

Perhaps Mozart was disappointed in the reception of *Figaro*, perhaps he grumbled, but there is no record of it. It appears that while he complained vigorously about overrated musicians and about cabals (real and/or imagined) at his operas, he was not in the habit of lamenting being misunderstood and unappreciated. He enjoyed the successes, absorbed the failures, and went on about his business. By June 1786, the month after the premiere of *Figaro*, he finished the Piano Quartet in E-flat, K. 493; five canons; the Rondo in F; K. 490, for piano; and the Horn Concerto in E-flat, K. 495.

Canons were an old musical discipline. There are canonic episodes in Mozart's larger works, but by and large he seems to have viewed freestanding ones as compositional muscle building, as gifts, or as jokes written for parties. Given that this was Mozart, the jokes could get rowdy, but the music is never less than expressive, whatever the sentiment. For example, his Ave Maria canon is gently lyrical. More vigorous ones setting his own doggerel, the canons of the 1780s range

from the relatively simple sentiment of "Leck mi im Arsch" (Kiss my ass) to the gaily loping "Let's go to the Prater," a more expansive poem about the Vienna park.

> Let's go to the Prater, let's go wild,
> let's go watch Punch.
> The puppet is sick, the bear is gone,
> How will we go wild?
> In the Prater there are gnats and heaps of filth,
> the bear is gone, the puppet is sick,
> and there are heaps of filth in the Prater,
> full of filth, full of filth.

A subtler study in canon was "Difficile lectu mihi Mars," written in semi-nonsense Latin for his tenor friend Johann Nepomuk Peyerl. The joke here is that Mozart knew that in Peyerl's thick Bavarian accent, "lectu mihi mars" would sound like the German "leck du mich im Arsch"—and we're back to "kiss my ass." Mozart also knew that the quickly repeated word *jonicu* at the end would, in Peyerl's rendition, sound like *cujoni*, Italian slang for "cojones."[4] The full cry of Mozartian earthiness, though, is displayed in the rhapsodic "O du eselhafter Martin," like many of his ribald outings, written in dialect, with its splendid internal rhyme in the third line, "du bist so faul als wie ein Gaul." The setting is suitably boisterous:

> O you miserable Martin!
> O you Martinian donkey!
> You're as lazy as a horse,
> who has neither head nor hocks.
> There's nothing you can do about it;
> I can still see you hanging from the gallows.
> You stupid horse, just shut up,
> I'll shit in your mouth, so hopefully I'll wake up.
> O dear Martin, I ask you very nicely
> O lick me quickly but quickly in the ass!
> O lick! O lick!
> Oh lick me quickly, quickly in the ass!

O, dear friend, forgive me,
the ass, I'll spank your ass.
Martin! Martin! Martin! forgive me![5]

The apparent subject is Mozart's impresario friend Phillip Jakob
Martin, and the depth of the teasing is an indication of Mozart's fond-
ness for him. (Actually, this is a revision of the original version, sub-
stituting Martin for tenor Peyerl, who may have particularly inspired
Mozart to effusions of bawdiness.)[6]

It was in this period that the writer, amateur musician, and salon
hostess Karoline Pichler, in whose home Mozart had played a number
of times, wrote in a memoir that Wolfgang had improvised variations
in "Non più andrai" for them, and afterward began jumping over tables
while howling like a cat. In general, both Haydn and Mozart, "whom
I knew well, were persons who displayed in their contact with others
absolutely no other extraordinary intellectual capacity and almost no
kind of intellectual training, of scientific or higher education. Everyday
character, silly jokes, and in the case of [Mozart] an irresponsible way
of life, were all that they displayed to their fellow man, yet . . . what
worlds of fantasy, harmony, melody and feeling lay hidden in that un-
likely outer shell."[7] So the two men appeared to this highly literary, also
highly musical woman. Perhaps because of her literary bent, Pichler
did not understand that these were artists who thought not in words but
in music. And Mozart actually was fairly well read, knew Shakespeare
and Goethe and Moses Mendelssohn, though he did not tend to show it
off. As for the "irresponsible way of life," this is suggestive but opaque.
One guess is that Mozart's financial woes had entered Viennese gossip.
Another guess is that he was womanizing, but there is no evidence for
that, neither now nor later. Besides his manifest loyalty to his wife, it is
hard to work out when he would have had the time for infidelity.

ALSO WRITTEN IN JUNE WAS A LITTLE F-MAJOR RONDO FOR PIANO
that Mozart later attached to a sonata. If that month's Piano Quartet
in E-flat Major, K. 493, is any indication, which it may be or not, in
the month after the *Figaro* premiere Mozart was in a cheerful frame of
mind. His previous entry in the uncommon medium of piano quartet

had been the G Minor, another of his darkly serious outings in that key. (These were toward the three piano quartets that publisher Hoffmeister had commissioned, but the G Minor did not sell, and he did not publish the E-flat Major. Mozart never wrote a third quartet.) But his musical high spirits were not as simple as they used to be. In his more ambitious works, at least, cheeriness is no longer taken at face value, but rather is inflected. The E-flat Major begins with an earnest introductory phrase that leads to a warmly pensive first theme proper. The mood stays essentially upbeat through the exposition, with an elaborate piano part leading the proceedings, somewhat in the direction of a solo-and-orchestra effect recalling his piano concertos.[8] The main qualification to the opening optimism is the development: an extensive one, following a chain of dark-toned minor keys far from the E-flat-major home: B-flat minor, E-flat minor, G minor, and so on. When the opening theme returns, it is like clouds opening to sunshine, but sun after clouds is a different matter than a sunny day.

An expansive second movement is in sonata form, indicating music more searching than the common ABA pattern. The opening theme is strikingly shaded, almost solemn for A-flat major. The long coda is a series of simple cadences to A-flat major, as if for reassurance after the shadows. Even the Rondo finale is more expressively broad than usual, starting with a jolly and ingenuous theme that is going to be tempered by weightier material. There is a long middle section starting in C minor that is not exactly Mozart's familiar agitated C minor, but intense all the same until it brightens into A-flat major. If the beginning of a work is the start of what may be a wide-ranging journey, a coda tends to suggest an overall emotional center for the whole. The ending of the quartet is a stretch of pure, untroubled E-flat major.

IN SEPTEMBER MOZART WROTE A LONG AND AFFECTIONATE LETTER to Sebastian Winter, the family servant who had been with them in the traveling days twenty years before. It was Winter who had drawn up the maps for the kids' *Königreich Rücken*, or Kingdom of Back, as Mozart recalled in the letter: "Well now, dearest friend!—Companion of my Youth! Naturally, I've been to 'Rücken' many times throughout these years and since I have never had the pleasure of seeing you there,

it would be my greatest wish that you would come to visit me in Vienna or that I visit you in Donaueschingen."[9]

In 1784 Winter had handled for Mozart the sale of copies of his symphonies and piano concertos to a prince.[10] But some pieces, presumably the newer concertos, Mozart wanted to keep for himself: "The compositions that I hold back for my own use, or for the use of a small circle of music lovers and connoisseurs (who promised not to share them with anyone), cannot possibly be known abroad, because they haven't been made public even here."[11] As noted before, the idea was to play a given concerto until the novelty ran out, only then to send it around or publish it, and then to write a new one—assuming you were performing regularly. Concertos, like other larger pieces that were not profitable to engrave, might be circulated in manuscript copies, and Mozart counted on getting income from that.

In October 1786 Constanze gave birth to another son, who lived a month. Did the Mozarts have any tears left for the second of their babies to die? They would lose two more in the next years. Meanwhile they did not know that in Salzburg, Leopold was failing. In November he wanted to visit his old students, Marchand brother and sister, in Munich and, once again enjoy Carnival there. He was still taking care of little Leopold, son of Nannerl and her husband Johann. While he was away in Munich, Leopold asked them to see to their son, but Nannerl's husband refused, saying he was too busy. This infuriated Leopold. After having her baby in Salzburg, Nannerl had returned to St. Gilgen and did not see the child for a year, when she and her husband condescended to visit. Replying to Johann, Leopold wrote, "That my son-in-law should make the excuse that he couldn't travel in because of the sheer amount of work is something I really couldn't tell anyone without going red myself . . . I salute my son-in-law and ask him what he believes all reasonable people must think of a man who is capable of holding out for a whole eight or nine months, and perhaps even longer, without seeing his child, or maybe, which God forbid, ever seeing him again, when he's only six hours away from him?"

Stuck in a loveless marriage and living in the backwater town of St. Gilgen with five stepchildren to tend to, and without a decent piano in the house, Nannerl had sunk into a dreary retirement. There is no clue as to why she seemed indifferent to her child. In the event, Leo-

pold went to Munich anyway and sent her reports of Carnival and his students. Nannerl had loved Carnival in Munich; now it was out of her reach.[12] She had always obeyed Papa and now obeyed her husband, never placing her own needs in the forefront as Wolfgang always had. St. Gilgen is where her submission landed her.

After that visit Leopold would also never again see Munich. In the fall of 1786 he had begun to have alarming medical problems, including humming in his ears, sometimes lasting all day. He kept up an extensive correspondence, but apparently not with Wolfgang, whom he no longer told anything significant.[13]

AFTER *FIGARO* MOZART KEPT TO HIS USUAL PACE. HE WAS NOW largely a composer rather than a composer-pianist. The major works of later 1786 began with a Trio in E-flat for Piano, Clarinet, and Viola that ended up being called the *Kegelstatt*. *Kegel* means "skittles alley," the title rising later from a story that Mozart wrote it during a session of the bowling game skittles. This is unlikely, given the scope of the work, but it does imply something significant: a piece for friends just as skittles in the yard was a game for friends and family. (Around that time Mozart said that he wrote the twelve horn duos of K. 487 "while playing skittles.")[14] Indeed the *Kegelstatt* glows with affection for the players and the instruments he wrote it for—which is to say that it is the distillation of what chamber music meant in those days: works played in private largely by and for friends.

The first performance was probably on August 9, during a party at the home of the Jacquin family. Its patriarch was Nikolaus, professor of botany and chemistry at the University of Vienna. His Wednesday soirées drew from a wide circle of people, including amateur and professional musicians, scientists, artists of all sorts, and Freemasons.[15] Mozart's singular choice of instruments for the *Kegelstatt* was not aesthetic, but social. The viola part he wrote for himself. After the piano, that was his favorite instrument to play; he liked being in the middle of the music. The piece was written for and dedicated to the teenage pianist Franziska von Jacquin, one of his most talented students and sister of his close friend Gottfried, who was an official of the court in Vienna and an amateur musician. In a letter to Gottfried from Prague, Mozart

declared that Franziska's name henceforth was to be Dinimininimi, but anyway, "I've never had a female pupil who has been as diligent and eager as she is."[16] He knew Franziska could handle the demanding piano part of the *Kegelstatt*. Mozart loved the clarinet beyond all winds, and naturally in the trio he wrote that part for his friend Anton Stadler, the finest player in Vienna, perhaps the finest anywhere. A critic wrote that Stadler had "so soft and lovely a tone that no one with a heart could resist it."[17] Stadler was a Freemason; he and Mozart were often together at Jacquin's house.[18]

If the selection of instruments was a function of those friends and that occasion, Mozart exploited the ensemble to fashion a palette of colors singular in his music. One imagines the party, the food and drink and laughter, everybody sitting down to what turned out to be one of the most affable of Mozart's chamber works, his gift for melody on display from start to finish. The clarinet tended to bring that out of him, and so did friendship. One imagines Franziska eager to show her teacher she could handle what he had written for her, Mozart intent over the viola part, Stadler showing off his lovely tone.

As Mozart tended to tease friends at the same time as he was affectionate, the opening sets a mood warm but also detectably teasing and ironic, presenting the first of the train of beguiling lyrical themes that will mark the piece. Not only are the colors singular; so are the forms. The first movement starts off like sonata form, with two theme sections, the second in the dominant key, both themes similarly lyrical and marked by the turn figure called a *grupetto*. What transpires in the movement comes off less like sonata form, with its development section and so on, than like an ongoing fantasia on the themes.

Next a minuet, also unusual in layout. For one thing it is as long as the first movement, starting with another lyrical clarinet line recalling the second theme of the first movement. Rather than the usual lighter and shorter trio section in the middle of a minuet, this trio is enormous, minor-key, chromatic in harmony, based on an obsessive motif. Here Mozart gave himself on viola some chattering triplets to keep the music moving ahead. The spacious finale begins with a long lyrical clarinet solo. Unusually for a rondo, the A theme comes back as expected, but everything else is unexpected: the B theme is a variant of the A theme in the dominant key; after the minor-key C section, the A theme re-

turns not more or less literal as usual, but varied, followed by a train of sort-of new themelets, and there is an usually long coda. In other words, like the first movement the finale approaches the effect of a fantasia, like an improvisation. So ends a trio written for friends, unflaggingly and affectionately songful.

MOZART'S MAIN FOCUS IN 1786–87 WAS CHAMBER MUSIC. WHETHER BY choice or necessity, his public performing was winding down, so likewise the production of concertos. He returned to one genre in which he had not finished a work for a decade: piano trio. This medium was rising in popularity among chamber music aficionados; Mozart may have written the trios of 1786 and the next year as vehicles for himself to play in soirées.

As the G Major and B-flat Major of this year show, he was not particularly ambitious with trios, though there are traces of exploration. Part of the issue has to do with his treatment of the cello. In the eighteenth century, it was an instrument still awaiting full emancipation as an equal partner in chamber and orchestral music. As yet it had no serious solo repertoire. (Bach's solo cello music was then unknown.) It was the young Beethoven who in the next decade would write the first ambitious cello sonatas. Traditionally the cello's role had been to play the bass part in one way or another—in orchestral music doubling the basses an octave above, in string quartets supplying the bass line that supported the harmony. But in piano trios the keyboard can readily handle the bass. Where does that leave the cello? In theory, more available for playing melody and providing a voice in counterpoint. But in common practice, the instrument still had a kind of second-tier reputation, and that was lodged in the minds of composers.

One sees these issues in play in Mozart's two trios of 1786. The G Major, K. 496, begins with a long piano solo that is a bit of a throwback, galant and impersonal in tone. The rest of the movement is attractive enough but never strays beyond that atmosphere, though there is a longish contrapuntal development. Then comes a striking Andante, in a pensive C major that becomes more ruminative as it goes. The middle is a stretch of far-ranging harmonic exploration and contrapuntal development, the cello fully involved in the dialogue. The finale, variations

on a quirky theme, is somewhere between the first two in ambition and freshness, one of the variations a suddenly brooding expanse of G minor.

In the B-flat Major Piano Trio, K. 502, the ideas feel generally fresher, the atmosphere of the opening perky, with only a touch of galant preciousness. All the same, the cello is largely relegated to its old role on the bass line. In its approach the first movement is in sonata form but essentially an ongoing development of the opening theme, taking it on a wide-ranging journey not particularly dramatic but steadily absorbing. The second movement starts with a long, affecting melody from the piano, echoed by the violin, the cello staying in the background. The same applies to the Rondo finale, though in the middle section the cello contributes to a contrapuntal discussion. In this end, these trios from 1786 are parlor music par excellence, not intending to be too challenging in the execution or in the deportment.

The single string quartet of this year, No. 20 in D Major, K. 499, is another matter. A rare freestanding quartet for Mozart, it was dedicated to his publisher friend Franz Anton Hoffmeister, and came to be called by his name. This was more or less Mozart's forty-first quartet, the first dozen or so of them products of his prodigyhood, and the first since his breakthrough with the *Haydn* Quartets. With its parade of compelling themes, the *Hoffmeister* confirms a sense that for him quartets are no longer the challenge they used to be, that they have settled comfortably into his creative consciousness. That does not necessarily mean that this one came easily to him, but unlike in the struggling manuscripts of the *Haydn* Quartets, the handwriting is impeccable.

It begins with a placid octave stride down a D-major chord, followed by a theme in the mellow low strings of the instruments, then a bit of imitation on a bit of the theme. This movement will be another monothematic one, developmental all the way, so the development section is short, the gentleness pervasive. But mature Mozart being gentle and unassuming is not like other composers; there is magic between the lines. The minuet, placed second, is short and unassuming, though it has a minor-key trio rather whispery and conspiratorial, after which the return of the minuet arrives like a new dawn. Call the Adagio a minorish major that seems to gather eloquence as it goes. Like the first movement, the finale is in sonata form but essentially monothematic.

The material is liquid, much of it featuring the first violin. Also, like the first movement, as the material is developing steadily, the development section is short. The recapitulation sneaks in, and its second theme, rather than staying in D, jumps to F major. The whole effect is another entry in the direction of a fantasia, the formal landmarks receding behind an impression of steady exploration.

Dated December 1786 in his catalogue is the completion of two larger works, the Piano Concerto in C Major, K. 503, and two days later the Symphony no. 38 in D Major, K. 504. Mozart seems to have begun the concerto a year or two before the completion date—one of those sketches and drafts that sat in his drawer until he needed it.[19] He probably pulled it together for use in a series of four subscription concerts he gave that December in his old stamping grounds, the Trattnerhof.[20] If C major was in those days considered the key of sentiments grand, even-tempered, spacious, and so on, this piece is another case in point. It begins with a magisterial proclamation answered by a little riposte in the winds. The grandness and good humor will essentially prevail through the piece. In its equanimity, this concerto is roughly the polar opposite of his last one, the C Minor, which is the epitome of the unsettled.

The C Major was the last of the concertos Mozart wrote for his concerts in Vienna, fifteen of them in four years.[21] It has all the thumbprints of his mature style—the profusion of themes, the piano entering with its own new theme, and so on. In an imposing introduction, the orchestral sound is full-bodied, the orchestra itself busier than usual, playing a role equal to the soloist's. That role is reinforced by the long orchestral opening of the second movement and by the Rondo finale, which begins with an extensive orchestral passage rather than with the soloist as usual. Solo and ensemble work in collaboration throughout—from first movement to last, the piano largely dispenses airy figuration that supports, accompanies, comments on the orchestra. The whole piece enfolds various kinds of echoes: flowery writing for the soloist, a tendency for the winds to answer the strings. As a whole this is not a piece striking for expressiveness so much as for an austere elegance of sound and effect. Maybe the most memorable movement is the fresh-faced middle one, unfolding like a placid summertime landscape.

THE NEW SYMPHONY, NO. 38 IN D MAJOR, WAS MOZART'S FIRST IN THREE years. Because he apparently premiered it in Prague, the symphony acquired the name of that city. The reason he traveled there in early 1787 had to do with *The Marriage of Figaro*. The opera had found a modest reception in Vienna, but a Prague production starting in November or early December was a triumph. Wrote a critic, "No piece . . . has ever caused such a sensation as the Italian opera *Die Hochzeit des Figaro*, which has already been given several times here with unlimited applause." As a result, Prague's Society of Great Connoisseurs and Amateurs invited Mozart to come and hear the production.[22]

Mozart was happy to accept. He left for Prague the second week of January 1787, the new symphony in his luggage. Taking along friends to admire his triumph, he traveled with an entourage in two coaches, starting with Constanze and their dog Gaukerl, a servant, a couple of violinists, a young violin prodigy with her aunt and chaperone, and clarinetist Anton Stadler.[23] The trip took three days, everybody in the gayest of moods. On a long coach journey there was always the question of how to occupy the time. Mozart was likely working in his head, humming to himself, at stops jotting down ideas on slips of paper. Otherwise there were stories, games, jokes. For the trip, Mozart gave everybody new names: Constanze became "Schabla Pumfa," Stadler "Natschibinitshibi," the dog, "Schamanuzsky," he "Pùnkitititi."

Figaro was in the middle of its run at Prague's National Theatre, and playing to packed crowds.[24] The night Mozart arrived he visited a ball and heard excerpts of *Figaro* arranged for dancing.[25] He soon discovered that he was going to be hearing his music everywhere he went. He stayed at the palace of Count Johann Joseph Thun und Hohenstein, patriarch of the Thun family, who were Mozart friends and patrons in Vienna and to whom the *Linz* Symphony was dedicated. The city's embrace put him in a euphoric mood, which generally rendered him a little ludicrous. It was reported that at parties he was conversing in recitative, which had to have been odd.[26]

Prague was the capital of Bohemia and the second-largest city in the Austrian Empire. All the same, on a tour Mozart's pupil Johann Nepomuk Hummel had found its streets narrow and dirty; a British traveler described it as a place of "ragged and half-ruined melancholy aspect," where everything seemed "at least five centuries behind-hand."

He observed that the aristocratic ladies in the opera boxes were wearing clothes recalling middle-class London women of a decade before.[27] It was, in short, a provincial town compared to Vienna, its instrumental and vocal forces limited even though Bohemians were famously musical.[28] The problem was that the best musicians tended to take their careers somewhere else that paid better. There was a strong Austrian influence; the main language in Prague was German[29] An earlier run of the *Abduction* had created a public for Mozart in the city. *Figaro* succeeded mainly because of the music, but the story also appealed to the locals, who saw it as a send-up of the pretentious Viennese aristocracy.[30]

In the middle of the stay Mozart wrote a long report of the visit to Gottfried von Jacquin in Vienna. Besides the lively account, the letter shows the tone Mozart used with a close friend in his maturity, far less boisterous than the letters of his youth. It remained true that with each correspondent he had a distinctive voice, in this case, genial and chatty.

> At last I find a moment to write to you . . . Immediately after we got here on Thursday, the 11th, at 12 o'clock noon, we had to run and rush to get ready for our luncheon at 1 o'clock. After table Count Thun the Elder regaled us with Musick performed by his own orchestra; it lasted about an hour and a half . . . At 6 o'clock I drove with Count Canal to the so-called Brietfeld Ball, where the crème de la crème of Prague's beauties gathers.—That would have been something for you, my friend!—I can see you now, running after all the pretty girls and women . . . Well, I didn't dance and didn't flirt.—The former because I was too tired, the latter because I am naturally bashful;—however, I watched with greatest pleasure how everyone was hopping around with sheer delight to the music of my "Figaro," which had been transformed into Contredanses and German dances; for here they talk of nothing but—"Figaro"; no opera is seen as much as—"Figaro"; nothing is played, blown, sung, and whistled but—"Figaro"; again and again it is—"Figaro"; it's all a great honor for me . . . As they put a pretty good Pianoforte in my room . . . , you can easily imagine that I couldn't just leave it standing there in the evening, untouched, without playing it; and from that it follows

quite logically that we played a little [piano] quartet . . . Anyway, it was time for the opera.—What we heard was "Le gare generosa" [by Paisiello].—As far as the performance of the opera is concerned, I cannot tell you anything special, because I was talking too much; but why I was talking so much, contrary to my habit? Well, perhaps that's the clue . . . Now farewell, my dearest friend, my dearest Hinketi Honky!—For that's your name and I want you to know that.[31]

In a grand musical academy on the nineteenth, Mozart conducted the premiere of the *Prague* Symphony, No. 38 in D Major, K. 504, and improvised keyboard variations on "Non più andrai" from *Figaro*.[32] Music critic and future Mozart biographer Franz Xaver Niemetschek recalled the event, reporting that the theater "had never been so full as on this occasion . . . We did not know which to admire most, the extraordinary compositions or his extraordinary playing; together they made such an overwhelming impression on us that we felt we had been bewitched. When Mozart finished the concert, he continued improvising for a half hour." The next night, he conducted *Figaro* at the theater.[33]

The *Prague* was only the fourth symphony Mozart had written since moving to Vienna in 1781, the last two of them from three years before. Instead of symphonies there had been the fifteen piano concertos he composed for his concerts. He wrote the *Prague* before he planned to go to that city, perhaps intended it for a planned trip to London, but that is not certain. Nor is there any indication of why he turned from the Viennese pattern of four-movement symphonies to the old-fashioned pattern of three, the middle a slow movement.

The *Prague* begins with an introduction, this being Viennese style and something Mozart had done in only two symphonies before. That opening is long, in tone solemn unto fateful; when it reaches D minor, it falls briefly into a foreboding prophecy of his next opera, which will be in that portentous key. What follows, though, is an entirely benevolent Allegro, the material simple and nearly ingenuous, in that respect recalling the A-major Symphony from his Salzburg days. That earlier symphony was written for a smallish music room orchestra; this one expects a bigger band, the winds being two each of flutes, oboes, and bassoons, plus horns and trumpets.

The first movement is enormous, nearly nineteen minutes if the second repeat at the end is taken and counting the three minutes of the introduction. Themes proliferate and tend to verge right away into development and recombinations of thematic scraps. There is a sense of a lovely and expansive musical landscape in a leisurely unfolding. Because the exposition extensively develops the material already, the development section turns to elaborate counterpoint, with ideas tossed back and forth around the orchestra. (Sketches show Mozart experimenting with thematic combinations.)[34] There is for him an unusually long retransition to the recapitulation that starts as a false recapitulation, meaning in the wrong key. Which is all to say that he is playing ever more elaborately with his inherited forms. Maybe the profusion of thematic material in his concertos has spilled over into his symphonies.

An enchanting second movement is also long, over ten minutes, and in sonata form. The tone is pastoral, untroubled at first, but some shadows appear—starting in D minor, recalling the first-movement introduction. The development is given to transformations of the first theme, some of it again summoning the stern tone of the introduction, the keys ranging widely. His recaps these days are less likely to be literal; this one keeps working over the material as if it were an extension of the development section. In terms of procedures, much of the above also applies to the finale: sonata form, tending to play with the material from the beginning (what a later age would call developing variation), and another false recapitulation in the development. The keys range further in the exposition than they used to with him; this D-major movement soon finds its way to distant F major. The tone is dashing and gay, the first theme chattery (the tune is lifted from the Susanna/Cherubino duet in *Figaro*), the second theme more flowing, the irrepressible first theme returning at the end of the exposition. As with the second movement, the development takes the playful first theme into more serious, mostly minor-key territory. For a final surprise—a logical one, given that we have heard so much from the first theme—the recapitulation starts on the second theme before returning to a varied version of the first.

This is to say that in this good-humored symphony, Mozart performed one of his more elaborate experiments with the forms he inherited, and he stretched his harmonic palette with more tonal variety. For the

listener the effect is of a captivating piece with a new richness animating it. Mozart had always been able to conjure delight; now he is doing it in deeper and more sweeping ways. And if he is taking gaiety less at face value, he is also taking conventional formal outlines less for granted.

Three days after that concert, he again conducted *Figaro* in the middle of its triumphant run in the National Theatre and was given the box office takings. He left Prague around February 8 with his entourage, with glorious memories, with the prospect of a commission for a new opera to be premiered at the National Theatre, and a thousand florins richer. He was headed, however, for two unwelcome matters. The first was a farewell concert for the splendid Nancy Storace, his first Susanna, who was returning to her native England along with tenor Michael Kelly and Mozart's British student of the past two years, Thomas Attwood. The other had to do with his father. He did not know about that yet, because nobody had told him anything.

THE STORACE FAREWELL CONCERT WAS AT THE KÄRNTNERTORTHEater on February 23, 1787, the hall full and Joseph bestowing no less than four thousand florins on the soprano. (So she made in one night what Mozart approached only in his best years.) In the concert a duet from Martín's *A Rare Thing* was encored twice.[35] For the occasion Mozart wrote a scena, "Ch'io mi scordi di te," with orchestra and piano obbligato, K. 505. Earlier he had set the same verses as an insertion for his revised *Idomeneo*. It's a thwarted lover text, probably chosen by Mozart for the relevance of its first lines: "That I will forget you? Do not fear it, beloved." He would not forget Nancy Storace, and he was going to miss her. Perhaps one or two of her replacements in Vienna had better voices, but none had her charisma or her comic brilliance on the stage. The scena is the usual accompanied recitative and aria; during the aria, Mozart created a duet for himself at the piano and his prima donna. If the text is bemoaning and the music follows it intimately, the effect is still spirited and warm, not virtuosic but rather a stage for Storace to project her acting and presence as well as her voice, while Mozart wove loving keyboard lacework around her.

After the concert Storace and entourage headed for London. There

waited her current lover, or one of them, the famed music historian
Charles Burney. Traveling in two grand four-horse coaches and with
a mountain of luggage, they stopped in Salzburg, where Leopold had
been alerted to their coming and played the host. He reported to Nan-
nerl that Storace sang for Archbishop Colloredo, who presented her
with a handsome gift.[36] Mozart had hoped to be traveling with them.
They had promised him opportunities and rich rewards in England,
and they were probably not exaggerating. He had been taking English
lessons to prepare for the trip and asked Leopold to take care of their
two young children (one of whom was soon to die). Leopold wrote
Nannerl,

> You can easily imagine that I had to express myself very emphati-
> cally, as your brother actually suggested that I should take charge
> of his two children, because he was proposing to undertake a
> journey through Germany to England in the middle of next Car-
> nival . . . Herr Muller, that good and honest maker of silhouettes,
> had said a lot of nice things about little Leopold to your brother,
> who heard in this way that the child is living with me. I had never
> told your brother. So that is how the brilliant idea occurred to
> him or perhaps to his wife. Not at all a bad arrangement! They
> could go off and travel—they might even die—or remain in
> England—and I should have to run off after them with the chil-
> dren . . . Basta! If he cares to do so, he will find my excuse very
> clear and instructive.[37]

This letter might be described as waspish, or as brutal. For one
thing, Leopold was set on going to Munich for Carnival, and babysit-
ting two children in addition to his grandson would upset his plans.
Then, he says, they might die in England, and what a mess that would
be. He had not told Wolfgang about Nannerl's son living with him be-
cause that might encourage Wolfgang to do what he had just done—
ask Leopold to look after *his* children. In a later, more "fatherly" letter
as he described it, Leopold gave his usual sort of advice: summer is not
a good time to make concerts in London anyway, you would need to
have two thousand florins in hand to finance the trip, and so on.[38] In
fact, what with a new opera, money troubles, and the lack of a solid

invitation, for Wolfgang at this point a trip to England was not in the cards in any case.

The greater significance of the letter is that it is one of Leopold's last surviving ones. Ailing in the spring of 1787, he went to his doctor and was diagnosed as having a "blockage of the spleen." He told the Marchand family in Munich that he did not expect to live to the end of summer. He did not tell Wolfgang, but finally somebody did.[39] On April 4, Mozart wrote his father the most extensive and heartfelt letter since he had told Leopold of his wife's death years before. That letter had been full of religious boilerplate, along with the tears. This one has little religious. He wrote from what he had encountered in books, in the Masonic lodge, in the Enlightenment atmosphere around him. In the letter, he had been venting complaints about his old colleague the oboist Friedrich Ramm, then:

> This very moment I've received some news that distresses me very much—this is all the more as I gathered from your last letter that you were doing very well;—but now I hear that you are really ill! I need not tell you how much I'm longing to hear some reassuring news from you yourself; and, indeed, I confidently expect such news—although I've made it a habit to imagine the worst in all situations—as Death, if we think about it soberly, is the true and ultimate purpose of our life, I have over the last several years formed such a knowing relationship with this true and best friend of humankind that his image holds nothing terrifying for me anymore; instead it holds much that is soothing and consoling! And I thank my God that he has blessed me with the insight, you know what I mean, which makes it possible for me to perceive death as the <u>key</u> to our ultimate happiness.—I never lie down at night without thinking that perhaps, as young as I am, I will not live to see another day—and yet no one who knows me can say that I am morose or dejected in company—and for this blessing I thank my Creator every day and sincerely wish the same blessing for All my fellow human beings . . . I beg you . . . do not keep it from me but tell me the whole truth or have someone write it to me, so I can be in your arms as quickly as humanly possible.[40]

Perhaps one need not dwell on the fact that Mozart expresses his sympathy here by talking about himself and his convictions. This is the self-involvement of the artist. The letter is also calm and rational. He and his father had been effectively estranged for some time. And Mozart was far more familiar with death than he had been with his mother those years ago in Paris; since then he had watched friends and children die. The essence of the letter, what he wants to impress on his father, is not to be afraid, but to embrace "this true and best friend of humankind." Of that ideal he says, "you know what I mean." Leopold would know what he meant because he was a Mason, and that is Masonic doctrine: rising above the fear of death and hell was central to the doctrine of the order. Bits of the letter are also drawn almost verbatim from the writings of Moses Mendelssohn, the philosopher (grandfather of Felix) whose work was widely read and integral to Enlightenment thought, influential well beyond its Jewish roots.

Most significant is what Mozart does not say, something he once wrote over and over in his letter after his mother died: the consolation of eternal life. For his part Leopold gave no recorded sign of being afraid of death. Conventionally Catholic, he believed fervently in the immortality of the soul, and there is no indication that he was anxious about finding a place in heaven. Whether or not Wolfgang still believed in the Catholic paradise, when he told his father that death is our best and truest friend, he was not talking about heaven. He was talking about life. He was saying that it is above all death that gives our life meaning and value, true joy and true love, and tragic grandeur. Love was Mozart's faith, and it was death that made love profound. To whatever extent that wisdom was borrowed or his own, it was authentic wisdom.

THAT SPRING OF 1787 WAS A ROUGH PATCH FOR MOZART. HIS FATHER was failing, and a dear friend had died—Count August von Hatzfeld, canon of the cathedral at Eichstädt and an accomplished violinist, who had played Mozart's quartets under his coaching.[41] And Mozart was sick. Whatever it was, perhaps kidney problems, it did not send him to bed but did keep him unsettled.[42] He was in his thirties now, when the effects of age begin to be felt in the body, partly in a depleted resistance to illness.

Meanwhile, even though he had just brought home a pile of cash from Prague, somehow there were still money worries. Constanze was involved in trying to secure a big loan, two thousand florins, to pay off and consolidate smaller debts; he was prepared to put up the house furnishings as security. It is not known whether that loan turned out, but he did use the furnishings for another loan of one thousand florins from a Viennese merchant, the furnishings as security.[43] Borrowing among friends was common in those days, and Mozart loaned as well as borrowed. He was owed, for example, three hundred florins by old friend Franz Anton Gilowsky, from a family the Mozarts had known in Salzburg. Owner of a small newspaper and chronically bankrupt, Gilowsky stiffed Mozart on the debt.[44] That would not be the last loan to a friend that ended unpaid. As usual his main solution, sick or not, was to sleep less and work harder. He was still performing here and there, had chamber pieces to write, and he needed to make progress on the new opera for Prague. Da Ponte had supplied the libretto, the subject an old yarn familiar to nearly everybody from plays and books and puppet shows: Don Juan, in Italian Don Giovanni, the libertine who defies God and gets his just deserts.

While Mozart was embroiled in all that, he had a visit from a teenage prodigy who wanted to study with him. The boy was sixteen, his name Ludwig van Beethoven. He was the musical wonder of his hometown of Bonn. As a pianist and composer he was largely self-taught; he had been financed by the Bonn court to go to Vienna and seek out Mozart for some further polish. There is no solid record of what happened at their meeting, or of whether they had further ones.

Of course, this encounter of the titan of one generation with the titan of the next eventually entered the realm of legend, which is not so concerned with what really happened. The story that evolved was roughly as follows: The teenager played and Mozart responded politely, but he was not all that impressed. At sixteen he had, after all, been one of the finest keyboard players alive. Beethoven was not that, not yet. So, the story goes, when Beethoven saw that the master was not all that excited by his playing, he asked if he could improvise. Of course, Mozart said, and the boy set off. It did not take long for Mozart to understand. He went into the next room and said to friends something on the order of

"Keep an eye on that one. He's going to make a name in the world."
And thus a torch was passed.

So goes the legend. What is more or less sure is that the one meeting aside, the studies never happened. Two weeks after he arrived in Vienna, Beethoven got an urgent letter that his mother was dying, and he left precipitously. He returned to Vienna only after Mozart had died. In later years, dishing on the competition as musicians tend to, Beethoven said he'd heard Mozart play several times and found him to be not truly a pianist at all. "No legato," he said, meaning that by his standards, Mozart still had the fastidious style of a harpsichordist. Actually from early on Mozart had talked about a singing style of playing, and he surely applied that to the piano. But unlike Mozart and Haydn, Beethoven had grown up playing piano from nearly the beginning, and so forged a keyboard technique of his own that emphasized songfulness. Later his student Czerny would write that Beethoven's "playing of adagio and legato . . . has yet to be excelled."[45] So it is with the generations in music as in most else: young and old speak different languages. Nonetheless, for Beethoven as a composer, Mozart was already his North Star and would remain so to the end.

There was one entirely pleasant element in the Mozart's life in those days. In 1786 he acquired as a student an eight-year-old prodigy in piano and composition named Johann Nepomuk Hummel, who lived with the family for a year or so and was treated like a son. He became Mozart's most famous student, his career starting with a European tour later in the decade.[46]

IN JANUARY 1787 THERE HAD BEEN A DIPLOMATIC EPISODE THAT proved prophetic of calamities that would soon affect everybody. Catherine the Great of Russia invited Emperor Joseph to join a tour on the Dnieper River that was designed to impress the Turks, Russia's old enemy, with the power of her navy. Field Marshal Grigory Potemkin had nondescript locations tarted up into what would be immortalized as "Potemkin villages." Though Joseph declared this show of power a "traveling circus," he agreed to come.[47] Hostilities were coming to a head between Turkey and Russia, and Catherine's ally Austria would

be drawn relentlessly into the conflict. Joseph considered himself a soldier king, and he was itching for a chance to exercise his country's military muscle.

In April 1787, the Mozarts moved from the deluxe Schulerstrasse flat behind the cathedral to one in the nearby suburb of Landstrasse, where they stayed seven months. It was a smaller and cheaper place, the rent around half of what he had been paying. This may have been a money-saving effort, but it was also a pleasant situation with a garden and without the heat and dust and racket of Vienna inside the walls. (Though he could have afforded it most of the time, Mozart never fled the city for summer vacation places in the country, as did most of the nobility and the wealthy. The dust and stink and commotion of the city did not seem to oppress him. Nor did the countryside seem to inspire him particularly.) Meanwhile he was not going to be performing regularly in Vienna anymore, so there was no practical reason to be in the middle of the city. He saved money in the new place, but it did not solve his chronic cashflow concerns. These seemed to persist no matter how much he earned in those days, and in 1787 he earned a lot—well over three thousand florins, one of his better years.[48] Among other things, Artaria in Vienna was busily issuing his symphonies, quartets, sonatas, and concertos, though his supply of works would always outstrip publishers' abilities to keep up.[49] One possible explanation for his shaky finances was that Mozart had a great many friends, thus many visitors, thus more opportunity to lose money at the card or billiard tables.

That spring, with much weighing on him, he decided to write three string quintets, two of them new and one an arrangement, and to rent them out in manuscript, which could make him significantly more money than selling a piece outright to a publisher.[50] The arrangement was of the Wind Band Serenade, K. 388. The two new quintets would be counted among his supreme chamber works: K. 515 in C Major, K. 516 in G Minor.

Clearly Mozart liked the quintet medium, choosing two violins and two violas rather than two cellos. He seemed to feel more comfortable with the richer possibilities of texture and color than he did with quartets—maybe because he did not have the challenge of Haydn hanging over him. Besides, Mozart simply liked the viola. With a quintet he could indulge in a broader palette of colors, more varied

doublings, call-and-response effects. Between the two new ones, he aimed for maximum contrast. Thus the choice of keys: C major, the key of the grand and even-tempered; and G minor, the key of strife, anger, anguish. Again, Mozart's sense of these keys' expression had been consistent since his childhood, with due variation in the nuances of how he wielded them. So if the String Quintet in C Major, K. 515, is a relatively placid outing, it still displays the extravagance of imagination he had reached by this time, the freedom he wielded in manipulating forms and key patterns. He was also turning to more varied and epigrammatic thematic material that could be transformed from the beginning.

Form is the bones of music, rhythm the muscle, melody and gesture the flesh, medium the color, genre the custom and heritage. A piece of music lays out its material, its themes and motifs, and feeds on itself as it goes. In the hands of a master these elements are forged into an integral object as intensely particular as the image of a loved one. The longest of Mozart's chamber pieces for strings, the C-major Quintet begins with a steady pulse of eighth notes under which, beginning unusually in the cello, he places the familiar opening arpeggio that starts a work by proclaiming the home key. This staccato arpeggio is stretched out as part of a slow unfolding, with a tender violin fillip as answer to the arpeggio. It takes pages for this idea to play out, mainly as a dialogue between first violin and cello, the keys involving a diversion to distant D-flat major. This beginning sidesteps the long-breathed melodious starts of so many of his works and instead uses snippets of ideas that can be manipulated and rearranged like a child's blocks.

The second theme is prepared not with the usual quick modulation to the new key but with an extended dominant preparation for what turns out a long second-theme section in three contrasting parts, lyrical to lilting to surging, then a long closing section mostly over a G pedal. The development is on the short side but rich all the same, climaxing with a double canon.[51] Written during one of the more troubled periods in Mozart's life, the first movement, even with a few passing clouds, has a mood that is largely as untroubled as a couple sipping wine under a tree on a sunny afternoon, an ineffable pleasure. There follows what would seem a muted and modestly graceful minuet, except that the middle trio section, usually lighter and shorter, is enormous, almost

a little movement in itself, first presenting three contrasting ideas that
are mulled over in the next section.

The slow movement is largely a songful duet between first violin and
first viola, stretching out in an ABAB outline. Imagine that after the
amorous interlude of the first movements, in the finale (a more or less
sonata-rondo form; the final return of the A theme is a development
of it), the couple have a walk around the landscape. Musically what is
striking is that so much of the finale is quiet, with only a few assertive
bits before the full-throated end.

By now it was to be expected that when Mozart took up G minor, it
would be special. Indeed, the Quintet in G Minor, K. 516, is more trou-
bled, deeper than Mozart had plunged before. In a way the motivation
for its atmosphere was musical, aiming for something opposite to its
partner, the relatively serene C-major Quintet. All the same, it is hard
not to imagine that the situation he found himself in—the contrapun-
tal stresses of his father's decline, his own shaky health, and anxieties
over money—contributed to driving him toward sorrow in his work.
(He was also working on *Don Giovanni*, his demonic opera.) Whether
personal or not in its impetus, this is in some ways the most tragic piece
Mozart ever wrote. G minor usually galvanized something in the di-
rection of demonic, something outside pressing in. This quintet is not
demonic from the outside, but rather anguished from within. Here as
in most of his instrumental music the influence of opera and its emotion
is felt, not so much in a sense of narrative, of implied storytelling, but
rather, as an emotional journey expressed in tones and abstract form,
but no less moving for that.

The quintet begins with simmering anxiety in the top three voices,
no bass line as a foundation in the low register, and uneasily shifting
harmonies. The opening theme will persist throughout the movement
like an obsession. There is an impression of fragments yawing this way
and that but unable to escape the obsession. The leading motif through
the whole piece is a half step in its mood of pathos, sometimes extended
into sliding chromatic scales like ground shifting under your feet. Each
first-movement theme has its rhythmic character, all of them nervous.
The colors shift constantly, variegated gestures turning around the
same obsession. Nothing is solid, everything unsettled. The develop-
ment section is short because the material has been restlessly searching

from the beginning. The coda presents the leading themes jammed together like a surge of pain and its aftermath.

The elegant minuet had rarely if ever been so troubled as the G-minor second movement, its quiet sorrow punctuated by offbeat jolts; a G-major trio provides provisional relief. There follows a slow movement almost hymnlike in tone that suggests an introspective solace, all the instruments muted and whispering.

In the first three movements of the G Minor we have had a drama from anguish to consolation. In the finale would Mozart leave us in light or in darkness? The movement begins with a throbbing Adagio introduction that is a naked song of woe. But in the end, he turns not back to sorrow but to the resolution of a tragic drama: pathos to joy, his usual inclination. It is an Allegro rondo in 6/8, dancing and untroubled, as if grieving has found, after the sorrowful song, a turn to hope, and sorrow is banished for good.[52] So this emotional drama, some of it the most desolate musical expanses of Mozart's life, ends like most of his darker stories, in reprieve. After all, in his worst moments, Mozart always predicted a turn for the better. But as in life, not all his stories end in light.

For example, light on his hopes that the three quintets would bring him some needed cash from manuscript copies: for whatever reason, perhaps the unusual depth of expression and the challenge of playing them, his plan to rent them out did not work. The most popular quintets of the day were the slight and mellifluous ones of Boccherini. So Mozart eventually sold two of the quintets to Artaria for what he could get.[53] At least he could enjoy playing them at home, covering the first viola part alongside Haydn on violin.[54]

IN LATE MAY THE NEWS ARRIVED: LEOPOLD HAD DIED ON THE twenty-eighth, at age sixty-eight. He had been long-lived for the time. Dominikus Hagenauer, son of the Mozarts' old patrons, wrote in his diary, "The father who died today was a man of much wit and sagacity, who would have been capable of rendering good service to the State even apart from music. He was the most correct violinist of his time . . . He was born in Augsburg and spent most of the days of his life in the service of the Court here, but had the misfortune of being always

persecuted here and was not as much favored by a long way as in other, larger places in Europe." Leopold had been persecuted—that is, by musicians he patently did not respect and an archbishop whom he despised.

Wolfgang did not get the news from Nannerl but from Franz d'Ippold, her onetime suitor, who had stayed close to Leopold. Mozart wrote immediately to her, his tone distant and businesslike. The death had been expected, and in any case they did not share the old warmth. His sister was no longer someone to whom he could unburden himself.

> Dearest Sister! / You can well imagine how Painful the sad news of our dear father's sudden death was for me, after all, our loss is equally great.—Because I cannot possibly leave Vienna at this time, which, even if I could, would be more to embrace you than for any other reason, since the estate of our dear late father hardly warrants it, I must confess that I share entirely your opinion regarding a public auction. I would, however, like to see an inventory before it takes place, so I could select a few items for myself;— . . . as Herr von d'Yppold says in his letter, I need to know what's in that disposition before I can decide about anything else.—Therefore, at this point, I simply expect to receive an accurate copy of that writ, and then, after a brief review, I will let you know what I think without delay.—Please, be so kind and give the enclosed letter to our true and good friend Herr von d'Yppold.—As he has shown such friendship toward our family on so many occasions, I hope you will do me yet another service of friendship and be my representative in all necessary proceedings.[55]

It appears from the letter that Wolfgang had no idea how much his father was actually worth. In any case Leopold had essentially left everything to his daughter. She informed her brother through a third party that contrary to his wishes, he would get none of Leopold's effects and have no claim on the sale of his estate. The sale came in September: 579 items offered and 314 sold. Among the effects were two microscopes from London and objects from the children's childhood tours, and it appears that Leopold left Nannerl some six thousand flo-

rins or more in cash.[56] Years before he had written that he was cutting his son loose, disinheriting him, and so he did. Wolfgang had no legal recourse. Maybe because he wanted to give his sister some solace or anyway give her no trouble, he asked Nannerl for a modest payment of one thousand florins. She agreed, and that was the end of it. Their exchanges were chilly, and they would have few further communications.

So ended the story of Leopold Mozart, who in his youth had been a brilliant student and resourceful careerist; who had married a handsome woman whom he loved deeply, in his fashion; who had written a good deal of well-received music and the most admired violin method of the era; who had engineered a years-long campaign that made his children famous around the globe; who had been the only teacher in music and life his incomparable son ever had. And a man who ended feeling neglected, bitter, and disappointed, lording over his daughter and distant with his son, for years keeping the wealth garnered from his children a closely held secret. That Wolfgang never got a solid job in Church or court never ceased to trouble Leopold. That his son no longer needed him was an insult he never forgave. Largely through his efforts and his skills in shaping a prodigious accident of heredity, Leopold Mozart had experienced a remarkable life. Only the remarkable part of it ended years before he did, leaving the bitterness and disappointment.

The letter just quoted is all that survived from whatever feelings Mozart might have had about his father's passing. But he did write about another death: his pet starling, age three, whom he loved, who could sing a tune from one of his piano concertos. The bird was buried with appropriate ceremonies, including the singing of hymns. Over the grave, Mozart declaimed a poem he had written for the occasion.

Here rests a bird called Starling,
A foolish little Darling.
He was still in his prime
When he ran out of time,
And my sweet little friend
Came to a bitter end,
Creating a terrible smart
Deep in my heart.

Gentle Reader! Shed a tear,
For he was dear,
Sometimes a bit too jolly
And, at times, quite a folly,
But nevermore
A bore.
I bet he is now up on high
Praising my friendship to the sky
Which I render
Without tender;
For when he took his sudden leave,
Which brought to me such grief,
He was not thinking of the man
Who writes and rhymes as no one can.[57]

To taste, there are two ways to take this bit of doggerel. One is that Mozart cared more about his starling's death than his father's. Another is that the poem, whether or not he realized it, was part of his mourning for Leopold, tongue partly in cheek though it may have been. There is no way to know exactly how Mozart viewed Leopold in the last years. Certainly he understood how much he owed his father. But he had made his break from the family years before, starting in Paris and culminating when he moved to Vienna over Leopold's protests. This break he made without hesitation, without inordinate distress, without looking back. By Leopold's death, what had his father become to him? A nuisance? An irrelevance? In the years after Leopold visited Vienna it appears that they barely corresponded at all (Wolfgang keeping none of his father's letters). Leopold followed his son's glittering career at second hand. This resolution as it lay when Leopold died—if it can be called a resolution given who each of them was, and as sad as it was— may have been the best available for both of them.

WHILE *DON GIOVANNI* WENT FORWARD, MOZART REMAINED PRODUC- tive in other genres in 1787. Around the beginning of that year he added to the flute quartets that he had begun in 1777, with the A Ma- jor, K. 298. It may have been another item intended for performance at

the Jacquin family soirées; family patriarch Nikolaus played the flute. All the movements are based on borrowed tunes, the most memorable the first-movement variations on a sweet folklike song by Franz Anton Hoffmeister. The finale, its theme a trifle by Paisiello, has an outlandish expressive indication that may indicate an ironic posture for the whole piece: "Rondo-meow / Allegretto grazioso but no too presto, but not too adagio, either. So-so—with much charm and expression."[58]

There is no doubt about the waggish intentions of another work from this year, *Ein musikalischer Spass*, (A Musical Joke), K. 522. In the form of a four-movement serenade, this is a satire not only on amateurs playing badly but also on composers composing badly. The jokes are both overt and subtle. Which is to say, as with Mozart's usual intention of providing something for everybody, there is nonsense in abundance for both the dilettante and the connoisseur. The scoring is for five solo strings, with a first violinist who likes to show off but shouldn't, and two regrettable horn players.

It begins with a vigorous and incomparably stupid tune. What follows is an orgy of insipid, digressive, clichéd, non-sequitured, inanely repetitious music full of bad voice leading, unresolved chords, wayward modulations, and the old bugbear of parallel fifths in the voice leading. For the delectation of the less sophisticated, there are gloriously missed notes in the horns, false endings, and at the end of the third movement, a quasi-improvised cadenza by a violinist with a short attention span whose fingers can't manage half steps in the high register, so plays a whole-tone scale. The finale incorporates an abortive fugue based on one that Mozart's pupil Thomas Attwood had perpetrated in an assignment. The piece ends with a chord incorporating five keys, the likes of which would not be heard again for over a hundred years.

Just before he left for Prague and the premiere of *Don Giovanni*, Mozart finished a serenade-like work for five strings he called *Eine kleine Nachtmusik* (A Little Nocturne). Here he returned to the jovial and celebratory mood of his Salzburg serenades, now from the perspective of his maturity, which translates to a work of untroubled delight. This piece of the sort he could write, figuratively speaking, with his left hand on a Sunday afternoon has the crystalline perfection that would dazzle and frustrate his musical contemporaries, who could scarcely approach it and knew it. Discovered sometime after Mozart died, the *Nachtmusik*

would become one of the most beloved pieces he ever wrote. Call the style post-galant: it has the uncomplicated lightness of that vein without the preciousness. It begins with a rumbustious leap up and down the main-key chord that had been done a thousand times. The blithe melody that follows is, in gesture, *like* something done a thousand times, but in practice it has not been, because this is Mozart at the height of his powers, providing a little profound fun for friends in parlor concerts. The second-movement *romanza* could be the accompaniment for a flirtation at a masked ball, a flirtation maybe more enchanting than one expected it to be. There follow a highly danceable Minuet and a sparkling Rondo.

In January 1787, Mozart turned thirty-one. For whatever it might indicate, or not indicate, about his feelings after a troublesome year in his life—though, he did have the opera premiere to look forward to—it can be noted that the aforementioned three pieces are all high-spirited unto hilarious.

On October 1 he and Constanze boarded the coach for Prague. As usual with his operas, *Don Giovanni* was largely finished by then, but there would be much to do at the last minute. And as usual when big things were afoot, Mozart was in a silly state of mind.

VIVA LA LIBERTÀ

When Lorenzo Da Ponte wrote the libretto for *Le nozze di Figaro* in 1786, he was a novice, new in his job at court. A year later, when Mozart came to him with *Don Giovanni*, Da Ponte was nearing the height of his influence and his game. Of the twenty-two operas presented in the Burgtheater that year, he wrote the librettos for six of the ten new ones.[1] His success was founded mainly, however, on his book for Martín y Soler's *A Rare Thing*, which pushed *Figaro* off the stage in Vienna and proved one of the great hits of the age.

That triumph secured for Da Ponte various perquisites—professionally, of course, but also in his leisure endeavors. "The ladies in particular," he reminisced, "who desired to see nothing but the *Cosa rara* and dress only in the styles of the *Cosa rara*, believed that Martini [*sic*] and I were in truth two 'rare things' ourselves. We might have had more amorous adventures than had all the Knights of the Round Table in twenty years . . . Invitations for walks, lunches, suppers, jaunts in the country, fishing parties; billets-doux, little gifts accompanied by enigmatic verses—it simply did not stop!" (Ladies dressing à la *Cosa rara* was not unique. There were also fashions in the style of *Figaro*, so fashionable Viennese women could impersonate Susanna or the Countess.)[2]

That year, Da Ponte wrote a mordant summary of his job:

You know—everyone knows—that for three years I have served, for better or worse, as theatrical poet; that is one of the

hardest, toughest jobs, which could have caused long-suffering Job to lose his patience. One must first satisfy the maestro di capella, into whose head always comes one trifle or another. Here he wants to change the meter or the rhyme, and to put an A where there is a U . . . Even worse for you if, to awaken the inspiration of the constipated maestro, you have to add . . . the singing of birds, the rushing of brooks, the beating of hammers, the ringing of bells, the wheel, the tambourine, the grindstone, the mill, the frog, the cicada . . . Even if the principal singers are reasonable, in their dealings with the composer and poet, there is the third man, the fourth buffa, who causes a commotion . . . one does not want these words, another does not want the music . . . And in the audience, which judges from what it sees and hears, only the poet comes to harm, he alone is considered an idiot.[3]

Da Ponte had three projects presented to him for 1787, Mozart's *Don Giovanni* and also Salieri's *Axur* and Martín's *The Arbor of Diana*, both of which would prove far bigger hits in Vienna than *Don Giovanni*. (*Diana*, a Gozzi-like fairy tale and one of Da Ponte's few non-adaptations, had fifty-nine performances in Vienna in its first four years.)[4] Rather than face the conundrum of choosing from among three of the leading opera composers of the day, Da Ponte accepted them all. "You won't succeed!" declared Emperor Joseph when Da Ponte told him. "Perhaps not," Da Ponte recalled his reply, "but I shall try." For models he cited his Italian literary heroes: "At night I shall write for Mozzart [*sic*] and imagine I'm reading Dante's *Inferno*. In the morning I shall write for Martini, and feel as if I'm studying Petrarch. In the evening it will be Salieri's turn, and that shall be my Tasso."

For this poetic marathon, Da Ponte recalled that he equipped himself with three items on his desk: a bottle of good Hungarian Tokay on the right, an inkwell in the middle, and a box of snuff on the left. To complete his writerly needs he secured a beautiful girl of sixteen who appeared at the ring of a bell, bringing him coffee, treats, and inspiration. As for the young lady, "I would have liked to love [her] simply as a daughter, but . . ." As he remembered, he rang the bell fairly often, the girl costing him some time in "amorous dallying, at which she was a perfect mistress."[5] This routine worked so nicely that he retained her

as a muse for the next six years. With her help, in two months of labor he finished the librettos of *Don Giovanni*, one other, and most of the third.[6] Or so he recounted, but again it must be remembered that he was creative in his memoirs. (In regard to his teenage muse, we should also recall that in an age when life expectancy was in the thirties, a girl of sixteen was considered marriageable.)

A matter not easy to resolve is why Mozart picked this project in the first place. For some two centuries, the Don Juan story had largely been a lowbrow theatrical cliché. It may have originated as a folktale, popular ballad, or the like. The first known written version is a Spanish one from the early seventeenth century, *The Trickster of Seville, or the Guest of Stone*, by Tirso de Molina.[7] From there, the story continued onstage, in street performances, in puppet theaters. There were assorted variations, but in essence it was a simple tale that provided some sexy thrills and a comfortably moral denouement, with a frisson of hellfire: Don Juan is a relentless seducer of women who defies morality and finally defies God, for which in the various productions he would be dragged down to theatrical hell by dusty-costumed demons amid the best fiery effects available. In some versions he has murdered the father of a woman he raped; some have a servant of the Don based on the Harlequin of commedia dell'arte.[8]

The story was familiar all over Europe. On a visit to Italy the inescapable renditions annoyed Goethe: "No one could bear to live without having fried Don Juan in hell."[9] Some versions, at least, were respectable. There had been a 1665 French version by Molière (from which Da Ponte cribbed) and a 1761 ballet pantomime by Gluck. (With his usual effortless interweaving of influences, Mozart lifted from Gluck for his finale, and likewise picked up ideas from Salieri's *Trofonio's Grotto*, which had twenty-two performances in Vienna in the two years before *Don Giovanni*.)[10] Most relevantly, Carlo Goldoni, one of Da Ponte's heroes and models, produced a libretto on the story. That celebrated Italian playwright wrote buffas on the side that were enormously influential. Seeking to move comedy away from the rowdy improvisation of street theater to something more scripted and elevated, Goldoni brought to the genre realistic dialogue, clashes of classes, and a seasoning of serious characters, all set in contemporary times.[11] He added the *mezza carattere*, between comic and serious, and pioneered the kind of

frantic act finales that Mozart and Da Ponte took up and perfected—
the "action finale" with the leading characters in a grand tizzy. The
result Goldoni called a *dramma giocoso*. Still, after he produced his ver-
sion of Don Giovanni he apologized for taking up this "wretched Span-
ish tragicomedy" that he viewed "with horror."[12]

Da Ponte was happy to take up a story in which the erotic had al-
ways been a constant presence, since the eponymous antihero chases
every woman in sight. It was inevitable that Da Ponte would make the
sex still more present and trenchant. One of his advantages was that he
had two exemplary life models for Don Giovanni: his friend Casanova,
and himself. Of the two, Casanova was the more pertinent, devoted to
seduction for the sake of it, and to kissing and (in later life) telling in
his memoirs. As it turned out, the past-his-prime Casanova in person
would directly, if tangentially, figure in the *Don Giovanni* project.

THE INCEPTION OF THE PROJECT CAME FROM PRAGUE AFTER THE WILD
success of *Figaro* at the National Theatre, which led to the new com-
mission. As for the story, there had recently been a one-act buffa of *Don
Giovanni* premiered in Venice, the music by one Giuseppe Gazzaniga,
the book by the city's leading librettist, Giovanni Bertati. The cast in-
cluded tenor Antonio Baglioni, who then moved to Prague and likely
brought the opera with him.[13] (Baglioni would become the first Don
Ottavio.)[14] Pasquale Bondini, impresario of Prague's National Theatre
and his successor, tenor Domenico Guardasoni, seem not to have been
attracted to the music but were interested in the story. In the last decade
there had actually been five Don Juan operas.[15] Guardasoni sent Mo-
zart the Bertati libretto, apparently expecting him to set it as was, but
Mozart persuaded Da Ponte to flesh it out into a full opera.[16]

This yarn was absolutely up Da Ponte's alley, and like Mozart he was
not troubled by its low-class reputation. The familiarity of the tale with
the public may have appealed to them—as it had with *Figaro*. Anyway,
opera buffa had always occupied a middle ground between art and pop-
ular entertainment. Da Ponte later claimed that Mozart wanted to make
it an entirely serious opera, but that he, Da Ponte, persuaded him to al-
low comic elements in. The result was a singular work, poised between
comedy and drama. Productions over time would emphasize differing

elements, but one thing remains constant: Don Giovanni, whose relentless lechery could easily have been written as comedy, is a figure fascinating but hardly funny. The two leading women are respectively fierce and pathetic, and the laughs are sparse.

The Bertati libretto Mozart gave Da Ponte was an opera within an opera, in which a traveling company, broke and desperate for material, decides to take up this "marvelous bit of filth" that will grab the crowd.[17] Da Ponte ended up using the Bertati as much as he could, in much of act 1 and the end of act 2, but the story had to be expanded to fill an evening.[18] Most likely he and Mozart sat around talking and laughing over wine and punch, trading ideas about story and characters and layout. Da Ponte would title his libretto emphasizing divine retribution: *The Libertine Punished, or Don Giovanni*. Mozart and history would reverse the title. In his memoirs, Da Ponte wrote remarkably little about Mozart, but late in life he recalled to a friend Mozart's impetuous energy and hard work, his quickness in decision, his adventurous intellect.[19]

Da Ponte discarded Bertati's opera-within-opera angle and placed the story in an unidentified Spanish town. He liked to start an opera in the middle of the action, and so created an electrifying opening scene in which a masked Don Giovanni tries to seduce Donna Anna, or failing that, to rape her, and kills her father in a duel. Da Ponte meanwhile, shaped the three female leads in a Goldonian mode: the traumatized Donna Anna a seria character; Donna Elvira a *mezza carattere*, seduced and abandoned by Giovanni and now torn between her drive for revenge and her passion for him; and a servant girl, the nubile Zerlina. Donna Anna was supplied with a seria-style suitor, Don Ottavio, Zerlina with her hapless fiancé Masetto. Don Giovanni was supplied with his servant Leporello, who amounts to the resident Hanswurst but is less clownish and more streetwise than the usual. If none of the women approaches the worldly wisdom of a Susanna, the opera still turns around Anna, Elvira, and Zerlina. Don Giovanni buzzes around each of them in capacities from scoundrel to seducer—or, to use the term of a later age, a Casanova.

Da Ponte continued inventing scenes and plot elements, but in the end the book is less integrated than most of his other librettos, more a series of episodes loosely strung together.[20] Perhaps Don Giovanni, doomed to be frustrated in his attempts at seduction and resorting to

elaborate ruses to avert disaster, allowed little room for a developmental plot. Da Ponte made sure to include a droll patter song for Leporello: a "catalogue aria," familiar in operas of the time, where the librettist could show off his nimble versification, the composer his tonal comedy, and the singer his physical and verbal dexterity.[21] These arias might have to do with people, food, dance steps, any subject that could trip off the tongue. Catalogues had long been a feature of Don Juan street performances. A servant might flourish to the crowd a roll listing the Don's conquests, and hint that some of the wives' names were on it.[22]

Of course, in this two-act play there needed to be a big finish for the first act; Da Ponte supplied a ballroom scene where, amid the dances, all the characters come together, each with an agenda of his and her own. It would have been Mozart who wanted three conjoined dances in the scene.[23] And once again, between them Mozart and Da Ponte created personalities that take familiar stereotypes of drama, character, and music into unprecedented territories. Each character has a fundamental disposition, but all of them—except Don Giovanni—take unexpected directions in one way or another. Don Giovanni, a cipher of an antihero, marches relentlessly toward the doom he brings on himself.

MOZART AND CONSTANZE ARRIVED IN PRAGUE ON OCTOBER 4, 1787, and took rooms at the Three Lions Inn. Da Ponte was expected soon; he would be needed not only for last-minute text adjustments but also for work on the staging. In that era the librettist largely served as what a later time would call a stage director, though Mozart would have been involved as well, dealing with the actors dramatically as well as musically.[24] There was a story that in rehearsal he extracted a proper stage scream from Caterina Bondini, his Zerlina—she was the theater impresario's wife—by pinching her vigorously. Exactly where he pinched her is unclear. "Mind you scream like that tonight!" he told her.[25] Many details, from the actor's gestures to their placement onstage, would be taken care of by long-standing conventions.

Years later Luigi Bassi, the first Don Giovanni, recalled, "Mr. Mozart was an extremely eccentric and absent-minded young man, but not without a certain spirit of pride. He was very popular with the ladies, in spite of his small size; but he had a most unusual face, and he could cast

a spell on any woman with his eyes." The last point implies that some flirting was observed. Probably there was, but Mozart was accompanied by Constanze, on whom not much would have been lost. Otherwise he seems to have been in his distracted and juvenile-unto-weird mode, as usual when a big project was weighing on him along with pre-premiere nerves. His brother-in-law Joseph Lange wrote, "Never was Mozart less recognizably a great man in his conversation and actions, than when he was busied with an important work. At such times he not only spoke confusedly and disconnectedly, but occasionally made jokes of a nature which one did not expect of him."[26] On his previous Prague visit, Mozart had been observed carrying on conversations in recitative. This time in gatherings he was apparently speaking in rhymed couplets.

Da Ponte had been delayed in Vienna by the premiere of his opera with Martín, *The Arbor of Diana*.[27] He arrived on the eighth and took a room across the street from Mozart, so they could shout at each other through the open windows. In practice, Mozart spent much of his stay at the Villa Bertramka of his old Czech soprano friend Josepha Duschek. There he could find a billiard table, ample supplies of punch, and pretty girls. (It's notable that Mozart was never reported to be particularly drunk, though that was probably part of the gossip that was rife in Vienna about him, also about everyone else of note.) He wrote the last bits of the opera in Duschek's pavilion. After the premiere she extracted from him a concert aria, "Bella mia fiamma," which she sang for the rest of her life. Years later, a story from Mozart's son related that having not gotten a long-promised aria, Duschek locked Mozart in her pavilion until he finished "Bella mia fiamma," and its intricate vocal difficulties were his revenge on her.[28]

Da Ponte also frequented the Duscheks' villa, and so did another visitor who was in town to see the opera: Giacomo Casanova. Besides being an old friend of Da Ponte, he surely took a professional interest in this production. In a mystery never resolved, there would survive a variant of an act 2 scene of *Don Giovanni* in his hand. Did he provide a draft of that scene? In any case, in those heady days in Prague there would have been lively dialogues among him, Da Ponte, and Mozart. Another visitor to the villa painted the three of them: "[Mozart] anticipated the day of the premiere as though it were a carnival. He

paid extravagant court to the ladies, played all kinds of tricks, talked in rhyme, . . . and everyone let him do anything he wanted as if he were a child." Of Da Ponte: "quicksilver movements and dark, fiery southern eyes . . . he seemed always to be watching what impression he was making." Casanova and Da Ponte "had much in common. Both of them had lived in Venice when they were young; both had traveled the world restlessly; in both there was an unmistakable vein of vanity. They both boasted of the honors that had been heaped upon them and took pleasure in talking about the potentates with whom they had had dealings." He noted that when Da Ponte mentioned his "uncle" the bishop, Casanova needled him about his Jewish birth, something Da Ponte was not given to talking about. The visitor also reported that Mozart was getting plump; in his later years he seemed to have resembled a fat little bird.[29]

What the visitor saw as a jolly time was veiling a good deal of pressure and anxiety. After he arrived in Prague Mozart had to write most of the recitatives, the act 2 finale, arias and ensembles involving Don Giovanni, and an aria for Masetto, plus assorted last-minute tweaks.[30] In the process, he added a couple of jokes of his own. Young Teresa Saporiti, who sang Donna Anna, was admired for her buxom figure as well as for her voice. In the final banquet scene, the Don exclaims over and over, "Ah che piatto saporito!"—What a tasty dish! Less naughty was Mozart's pun on the orchestra's harpsichord player, Jan Křtitel Kuchar, his last name meaning "cook." At the end of the supper scene with the Don and Leporello, the Italian version, *cuoco*, turns up as a nod to the orchestra pit. Of course, Mozart had to write the overture, generally the last thing to be done. Constanze recalled that he kept putting it off before finally writing it the night before the premiere while she kept him awake, and it was sight-read by the orchestra. It actually may have been read at the dress rehearsal; in any case, Mozart would have had the overture substantially in his head before he picked up his pen.[31] Staying up to finish something at the last minute was nothing unusual for him. Since childhood, he had pushed aside the claims of body and health when work was pressing.

The production created its own headaches. On his last visit to Prague, Mozart had seen *Figaro* in the middle of its run, after it had settled in. He may not have realized what a shaky operation the com-

pany amounted to. Money was scarce, no funds available for backup singers. If a principal got sick, the production had to be postponed. The Don, young Luigi Bassi, was reported as on the dense side but a decent actor, a compelling stage presence, and equipped with a beautiful voice.[32] He also seems to have been something of a prima donna, complaining about his lack of arias and making Mozart rework "Là ci darem la mano" over and over. When Da Ponte had to dash back to Vienna before the premiere to deal with the opening of his third opera of the season, Salieri's *Axur*, Casanova stepped in to make himself useful in various capacities. Mozart was to conduct the first performances.

The premiere was delayed ten days, then delayed again when one of the cast fell sick.[33] The original premiere date was given to a *Figaro* revival in honor of a visit by Emperor Joseph's niece and her new husband.[34] Mozart wrote friend Gottfried von Jacquin,

> You're probably thinking that my Opera has been performed by now—well—you were a bit mistaken there; first of all, the stage personnel here is not quite as capable as the personnel in Vienna when it comes to learning an opera like this one in so short a time. Second, I found on my arrival here that very few preparations and arrangements had been made for it, and it would have been totally impossible to have the opening on the 14th . . . so, they gave my "Figaro" instead, yesterday, in a fully illuminated theater, and I myself conducting . . . Everything here is quite a bit slower because the singers are too lazy to rehearse on opera days and the manager is too timid and fearful to push them.[35]

By the night of the premiere on October 29, Mozart was so anxious and overwrought that the head of the orchestra had to calm him down.[36] Mozart had taken up an all-too-familiar story and turned it into something singular impersonating an opera buffa. There was no way to know what people might make of it.

THE NATIONAL IN PRAGUE WAS ANOTHER OF THE TIME'S TALL THEATERS, with five balconies looking down steeply onto the stage, the top balcony mainly providing a view of the tops of the singers' heads. The

effect was intimate, the acoustics mellow. The story needed no fancy effects until the end, so scene changes could be handled with drops in the back and flats shuttled in and out from the sides.

At the premiere Mozart entered the pit to a storm of applause. He was loved in Prague. For the occasion he would have been wearing the grandest items in his wardrobe. Sitting down to the harpsichord, he looked over the orchestra and gave the first downbeat. Searing chords emerged: D minor, his demonic key, here raised to a new intensity. For the audience it was immediately clear that this was not the expected sparkling start to an opera buffa. It was, in fact, some of the most foreboding music ever heard. Nor could they know at first hearing that the introduction foreshadowed the music and drama at end of the opera, which is to say that from the beginning of the overture, Mozart intended to reach toward the denouement and draw the whole work together.

What follows that menacing opening is an Allegro in recognizable buffa-overture mode, capering and exuberant, in a brilliant D major. Those diverging temperaments enfold the drama and the comedy of the story. At the same time, with the opening bars Mozart created a lingering undercurrent that would never leave the opera, even in its friskiest moments. It is as if those ominous chords resonate under everything to follow. The overture also presents the orchestral sound of *Don Giovanni*. If the *Figaro* orchestra was light, silvery, darting, *Don Giovanni* is darker, not silver but old gold. If *Figaro* maintained a steady energy, in *Don Giovanni* the rhythmic flow is more measured, less frantic, until the ends of the acts. The orchestra in Prague was splendid, their sight-reading excellent, but the group surprisingly small: about twenty-five players, full winds (including clarinets) and brass, only twelve strings, three trombones added at the end of the opera. The wind playing in Prague was famously strong, so the wind music in *Don Giovanni*, including onstage ensembles, is particularly rich.[37]

In opera music there is feeling, movement, action, sometimes symbolism and commentary. The curtain rises to pacing music. Any number of buffas began with a servant complaining about his or her lot, and so it is here. Leporello, servant of Don Giovanni, is striding up and down talking to himself as he waits for his master to finish his assignation of the evening. "On the go from night to day, / And not a

word of gratitude," he grouses. "I've had enough of servitude. Oh, to be a gentleman!" As will be revealed, traveling in the wake of his epic womanizer of a master, Leporello has seen it all. But this night is different from most. In the shadows or in a mask, Don Giovanni has invaded the bedroom of Donna Anna to try his luck, whether she likes it or not. Suddenly the two of them burst from her room, she crying, "Do not think, unless you kill me, / That I will ever let you go!" In those two lines, shouted in the middle of action, Da Ponte painted Donna Anna: fierce, relentless, fearless. "Silly woman! You scream in vain," Don Giovanni jeers, "Who I am you will never know." (Exactly what has happened, a rape or attempted rape or successful seduction, is perhaps intentionally left unclear. This becomes part of the ambiguities of plot and character in the opera.)

There is a frantic struggle, Donna Anna grabbing at the intruder, he resisting, until she hears the approach of the Commendatore, her father. She rushes to him in fury, he draws his sword. "Fighting an old man is beneath my dignity!" the Don exclaims, but the old man comes for him and meets his death. In the music, the onset of the disaster interrupts Leporello's chatty aria. The music that follows for the duel and the murder is appropriately violent, but odd in one respect: it is not in a minor key but in B-flat major, which will be the other tonal pole of the opera, after D major and minor. The duel is tumultuous like a buffa ensemble, but the major key creates a distancing effect, as if poised between Donna Anna's rage and the Don's excitement and his anger at being frustrated. The tension is largely conveyed in the hectic rhythm, with Leporello babbling away in the background.

Donna Anna having for the moment fled and the Commendatore lifeless on the ground, Leporello asks sardonically, "Who's dead? You or the old man?" It is perhaps not a new situation for them. "Well done!" Leporello continues, "Two crimes and no bother. / Rape the daughter and murder the father." "He asked for it," Don Giovanni says, cleaning the blood from his sword. As for Leporello, the Don adds, if he knows what's good for him, he will keep his mouth shut. We see already that Don Giovanni feels no loyalty or responsibility to his servant or to anybody else.

Later commentators would sometimes try to make Don Giovanni into a force of nature, beyond good and evil, the most potent character

on the stage. There is something to be said for the last point, but in terms of the time and the logic of drama, there is no ambiguity. From the beginning of the story Don Giovanni is shown to be a rapist and a murderer utterly indifferent to his crimes, nothing but annoyed with the protests of his female victim and his servant. Simply put, Don Giovanni is a malignant character: brutal, indifferent, narcissistic, utterly self-serving in his relentless quest for women. At the same time he is no simple villain, even if in the future he was often going to be played that way.

Here "force of nature" becomes relevant. Call Don Giovanni an image of male sexuality amplified to an archetype: the male always on the hunt, never satisfied, consumed by desire itself and all but indifferent to its object. Beyond that, he is the primal force of sexuality embodied. As such, utterly without constraint, he sets in motion tides of passion that will corrupt nearly everyone around him. From the beginning in his attempted (or maybe successful) seduction or rape of Donna Anna and then the murder of her father, his obsession mounts relentlessly toward the denouement, steadily more intense and more destructive until the issue has transcended a character's obsession to become a tear in the moral fabric of the world.

Donna Anna returns to find her father lying in his blood, and laments. With her is her betrothed, Don Ottavio, who tries to console her with himself: "You must let go / Of these memories, this sorrow. / You have a father and husband in me." So an ardent lover she will not find in him. No, she cries. I want vengeance! Swear you will give it to me! "I swear it by our love!" he responds, and together they sing, "Death will be his just reward." In the future the tenor role of Don Ottavio would be played as a staunch partner in one production, a hapless figure in another. But in words and music, Mozart and Da Ponte paint him as an ineffectual character whom Donna Anna clings to and depends on, but for whom she patently feels no passion at all. Their relations are relentlessly chaste. Ottavio talks a fierce show sometimes, but he is not a man to wield a sword. In any case he is a figure out of opera seria, earnest to a fault, most of his music stolid and sometimes falling into seria-hero roulades. Which is to say that in his words and his music, Don Ottavio resembles a castrato.[38]

In the aftermath of the murder, Don Giovanni and Leporello con-

sult. You're leading the life of a scoundrel, Leporello declares. That doesn't divert the Don; there is a woman coming to his house. She's here now, he says, I can smell her. He does not know that the woman stepping on the scene is Donna Elvira, a prior conquest who is now raging at his deserting her: "I mean to destroy his miserable life, / To rip out his heart pitilessly!" As will become manifest, Elvira does, indeed, protest too much. Having anticipated what he hoped would be his next adventure, Don Giovanni is dismayed to find it is her. "Monster! Criminal! Filthy liar!" she shrieks. "All of his titles!" Leporello mutters. "She must know him well." Here, in fact, is the first touch of comedy in this nominal opera buffa. The ensuing touches will be scanty. The Don tries to placate Elvira as Leporello adds sardonic commentary in the background. Finally the servant is deputized to occupy her while the master makes his escape.

Leporello decides to give Donna Elvira a little lesson on the career of a professional Casanova. This is the catalogue aria, the catalogue a list of the women the Don has bedded. With a Leporello gifted in comedy, the effect of the aria is on the surface uproarious if under the surface alarming. In comic intensity, nothing else in the opera approaches it.

Leporello has a fancy for numbers and categories. In this aspect at least, he betrays a certain admiration for the monumentality of his master's achievements. In the verse Da Ponte is in his poetic element, dropping pithy and mellifluous lines: "In Italy, six hundred and forty. / In Germany, two hundred thirty-one . . . There are your country girls, / Maidservants and ladies in pearls. / Countesses, baronesses / Princesses, marchionesses . . . With blondes, it is his way / To praise their sweetness. / Dark ones, their bouquet. / Pale ones, their neatness. / In winter he likes them plumper / But then thinner come summer." The music cackles and crackles along with the verse. In a tone of wonder, Leporello returns to the refrain: "But in Spain, a thousand and three! A thousand and three! A thousand and three!" The grand total of the Don's conquests comes to 2,064, Leporello concludes, satisfied at his presentation. "If she wears a dress, he's game. / He knows which end is which." He advises Donna Elvira, "the square is not round!" He's saying that in Don Giovanni, she's dealing with something inevitable, a force of nature.[39] Sitting in the audience, Casanova himself could have

been howling with glee. Maybe he saw it as a testament to himself, a little exaggerated for effect, but still.

Donna Elvira is duly horrified. "I hear in my breast only the voice of vengeance, of rage and hate," she grieves in a recitative. Too much, too much. She will change her tune. Surprisingly, for all the talk of rage and revenge in the opera, for all the fury and villainy, there is no full-scale, conventional furioso aria in which a character vows revenge. Even in a buffa, an example being Dr. Bartolo in *Figaro*, a figure will often swear vengeance at length. Not here. That is one of several ways Don Giovanni diverts the usual courses of good and evil. For himself, in his pursuit of pleasure he has no time for revenge. Everyone else is busy responding to him.

Enter a chorus of villagers celebrating the coming nuptials of Zerlina and Masetto. Those two being peasants, they are buffa characters, and being a male peasant, Masetto is a buffoon. As with most operatic buffoons, things will go hard on him, starting with his fiancée. Zerlina is on the face of it another stock character, a cheeky young servant girl, if with none of the experienced cunning of a Susanna. She does know something about men, though, at least about men like Masetto. Beyond that Zerlina is helpless, so she is vulnerable. As she is delectable and wears a skirt, she attracts the keen attention of Don Giovanni.

Finding an occasion at hand, he puts on a show of magnanimity. Go on, have your fun, he tells them. Ah, here is a bride and groom. "At your service, sir," says Masetto with a bow. This is how one addresses a don. "Spoken like a gentleman," the Don says reassuringly, his eye on Zerlina. As he figures out how to detach her from her fiancée, he offers friendship and protection to the young couple. Leporello is ordered to take everybody to the Don's palazzo to wine and dine—everybody but Zerlina. Masetto heatedly objects. Here emerges another theme, an irreplaceable element of Don Giovanni's arsenal: his title. "His Excellency will take your place," Leporello tells Masetto. "Your Zerlina is in the hands of a nobleman," the Don adds, "you should have no doubts." When Masetto is outraged, reassurance turns to threat: "Go immediately, no questions asked," Don Giovanni snaps, his hand on his sword. "Watch your step, Masetto, or you'll regret it."

Don Giovanni is not as directly a social critique as *Figaro*, the Don a far more imposing character than Count Almaviva, but this scene

creates another resonance that endures in the opera. It is essential to the Don's agenda that he is an aristocrat. In that he is in some degree above the law and, in any case, beyond the demands of conventional morality. The peasantry is his playground. His means are a practiced mingling of seduction, intimidation, and if necessary, violence. Masetto understands this with brutal clarity: "I must bow and slip away . . . I dare not disobey. / A nobleman, yes indeed." He knows what's coming, and his own helplessness to stop it. "Little rogue, little flirt," he hisses to Zerlina. "My downfall lies under your skirt." And more cruelly: "Maybe our nobleman / will make a lady of you at last." In comparison to *Figaro*, where most of the sexuality is handled by innuendo, in *Don Giovanni* it is front and center. And the very word *nobleman* is a synonym for a debaucher. Still, if some productions in the future would make Don Giovanni a simple aristocratic oppressor, that underestimates him.

Now we see the Don in action as a Casanova. Wasn't I clever in how I got rid of Masetto? he asks Zerlina. He's my husband, she responds, with an attempt at resistance. The Don plays the class card: "That boor? Do you think an honest man, indeed a nobleman, could suffer such a lovely face, such a delicious face, to be ill-treated by that ham-fisted peasant?" It won't take long. To seal the deal, he sings a serenade for Zerlina: "Là ci darem la mano" (There you'll give me your hand).

Here Mozart indulged his melodic potency generously. Likely he hoped for this to be a hit played and sung everywhere, a sweetly seductive melody of love. In the context of the opera, it is nothing but a fraud. It would not be the only hit in the show, but like the others it is wedded to the characters and the situation. Otherwise, in this opera more than in *Figaro*, Mozart is going to make use of musical genres to dramatic and symbolic effect. The object of Don Giovanni's desire is an ingenuous servant girl, so he sings her an ingenuous folk tune. Here we see Don Giovanni the cipher: again and again he sings in the style of the person he is manipulating—which is to say, in the mode of their class.[40] That is the symbolism of "Là ci darem." In other words, the Don has no terms of his own to sing in, only the terms of his desire. Zerlina wavers—"I want to and yet I don't." Briefly she worries about Masetto, then she capitulates: "Come to me!" They both sigh. United, they sing Da Ponte's cynical last verse: "Only an innocent love can

give / Us both the life we want to live." Zerlina is the first corruption Don Giovanni has orchestrated before our eyes.

Their duet that concludes "Là ci darem" returns to the opening melody, as numbers often will in the opera, in sonata or sonata-like patterns. Again. Mozart weaves seamless shapes of conjoined music and drama. A recapitulation of the opening melody and key is a fundamental musical pattern; in dramatic terms, a return tends to create a sense of affirmation and intensification of a feeling or an idea, especially if the aria returns to the same words. Here the words of the tune's first hearing are "give me your hand." On the tune's return, "an innocent love." It is anything but innocent. In the duet reprise, the leading theme cinches a seduction.

So far for Don Giovanni things are going nicely with Zerlina, but it is his destiny never in the opera to achieve his object. Enter Donna Elvira, who will make a habit of spoiling his game. Still in histrionic mode, she works herself into a fury and into an aria, addressed to Zerlina: "Oh, flee from this traitor!" Here and elsewhere her vocal lines tend to be jumpy and jagged, with abrupt changes of volume.[41] Elvira is the only female in the opera who never has a tender aria. This one is in the direction of a furioso number, but Mozart keeps it low-key because Elvira, whether or not she knows it, is concerned mainly with getting Zerlina out of the way.

"It's the devil who is amusing himself today, ruining my plans," groans Don Giovanni, prophetically. Donna Anna and Don Ottavio appear. Not realizing that the Don is the author of their misery, they beg for his help. "Has the devil told her something?" he asks himself. Reassured, he declares himself at their service. So far, the solutions to his setbacks have proved easily at hand. But here comes Donna Elvira again, telling Anna, "Poor woman, do not trust / In that deceitful heart!" She's crazy, the Don says to Anna and Ottavio, thinking fast; let me take care of her. Blistering words are flung around: *guilty, traitor, liar, totally mad*. Anna and Ottavio begin to suspect Elvira is telling the truth. So she is, but she is also trying to eliminate another potential rival.

When the Don leaves with Elvira, saying he must calm her down, Donna Anna collapses. She has recognized his voice. He is the rapist

and murderer she seeks. She tells Ottavio the story of that night, claiming that at first she thought the man in her room was he, Ottavio. She prods him to vengeance. After she leaves, Ottavio vents forlorn sentiments: "My peace of mind / Depends on hers as well . . . I cannot be happy, oh, / If she is not." Mozart makes this a gentle song of heartache that brings Ottavio closer to us as a feeling character. At least this time he is not vowing a revenge of which he is not capable.

From Leporello Don Giovanni gets a report of the doings at his palazzo. Donna Elvira and Zerlina turned up, Leporello says, and Elvira "went right on shouting." Finally he locked her out of the house. "Clever rascal!" says the Don. "Well done!" He has a new plan to secure Zerlina, in the midst of a ball he's going to throw. In a lusty and vibrant aria that he knows will suit Leporello, he calls for wine and food and girls. Gather all the women you can find, he commands, even if you get them from the street—in other words, streetwalkers welcome. Get everybody drunk and get them dancing. "Ten more will be kissed. / By tomorrow, / Ten more for my list!" His ambitions are mounting, but as a prospect Zerlina remains for the moment at the top of the list.

Now arrives the reckoning between Masetto and Zerlina. Nothing happened, she says. He doesn't believe her; she deserted him on their wedding day. But her feminine wisdom, and her charms, come to the rescue. Zerlina makes a show of prostrating herself. "Beat me, beat me, dear Masetto / Your poor Zerlina awaits." If her words are masochistic, the music is a crooning folk song, another tune from the opera that history would not forget. (One later incarnation would be as a church hymn.) By the aria's end, Zerlina has placed Masetto's hand on her heart and she has him back, as she knew she would, and he probably did too: "Look how this witch enchants me! Men just go soft in the head." So they do in this story, men and women both.

So arrives the act 1 finale. Wine, food, revelers, the principals gathering, Don Giovanni working the crowd. Mozart flexes his muscles, the music a mosaic shifting to follow the action. No longer under Don Giovanni's spell, Zerlina tries to hide, but he finds her; to his dismay, he also finds Masetto lurking. How to deal with this now? Let's dance! the Don proclaims. He will extract Zerlina when he gets the chance.

Anna, Elvira, and Ottavio turn up in masks, hoping to expose their prey. The musical atmosphere is tense and heated, the principals with their conflicting agendas, everybody talking at once.

The Don raises his glass for a toast: "Viva la libertà!" Here's to liberty! Everybody, including the disguised trio, joins in: Here's to liberty! they cry over and over, full-throated. But all of them mean different things by it. For Don Giovanni it means his liberty to act as he wishes on the bodies of women; liberty means license, aristocratic license.[42] For Leporello, it means his hoped-for release from his debauched and treacherous master. For Anna, Elvira, and Ottavio, it means relief from the anguish the demon has inflicted on their lives.

Everybody dance! decrees the Don. His guests and, for that matter, all the world must dance at his order and to his tune. He will partner Zerlina, who now wants nothing but to escape. Something remarkable begins: three dances on three parts of the stage, played onstage by costumed musicians. Anna and Ottavio begin a minuet; a contradance strikes up for Don Giovanni and a frantic Zerlina; as ordered, to distract Masetto, Leporello drags him into a *Deutscher*, which on the score Mozart dubs in dialect as a Teitsch. Here is the symbolism of dance: the elegant minuet done by the seria characters; the middle-class contredanse, its little hops so different from the aristocratic minuet; and the vigorous Teitsch a peasant dance in which the partners hold on to each other—the most overtly erotic of the dances.[43] In practice all these styles could be seen at a Viennese ball, danced by everybody, but the associations remained.[44]

On the score the dances are not sequential but simultaneous. In a wild quasi-collage, Mozart superimposes the 3/4 minuet, 2/4 contradance, and 3/8 Teitsch. The effect is strange, almost hallucinatory. In the midst of it Masetto is trying to break away, Leporello senses impending disaster, the masked trio hope for a revelation of the Don's perfidy. At the moment he is occupied with spiriting Zerlina offstage.

Soon the trance of the overlaid dances is broken with a scream. It is Zerlina crying for help. Figuratively, this time, all hell breaks loose. Frenzy, shouts. Once again the Don improvises a solution. He drags Leporello into the room and tries to pin the outrage on him: "Here's the villain who attacked you . . . Die, you filthy wretch!" He is prepared, in quite literal terms, to sacrifice his servant to protect himself. It doesn't

work. The trio unmask themselves, accuse him, Don Ottavio produces a pistol, everybody cries for blood and revenge.

The finale is a musical and dramatic coup. Mozart and Da Ponte likely planned together how text and music would interact. The music reaches a frenzy, rhythm and harmony spilling over bounds: in three bars the tonality jumps C D E F C while the strings chatter crazily. Over and over there is a pealing chromatic line, the opera's abiding symbol of things sliding into chaos. Here the frantic second-act finales of opera buffa are taken to a new height of intensity, but to alarming rather than comic effect. Da Ponte said he convinced Mozart to make this a buffa rather than a serious opera, and Mozart nominally agreed, but in most of it he keeps close at hand the drama, the demonic undertone lingering from the overture's opening chords. With that he creates a powerful, darkly dramatic opera full of incipient violence that is not exactly a buffa and not at all an opera seria, with its static apparatus of style and outline. For all the conventions, Mozart has created a new kind of spectacle with a new kind of central character, who spreads social and moral chaos with everything he touches.

The end of the act is crazed, and prophetic. "My head must be on fire!" Don Giovanni cries. "Tempests are storming through. / But my courage will not fail me . . . Though the powers of hell assail me, / I will live to see another day!" He is wrong. Before it is over this day will be the end of him, in flames.

MOST OF THE SECOND ACT AMOUNTS TO DON GIOVANNI'S ATTEMPTS to restore things to normal, in his terms. Having seen that his master does not give a fig for his life, Leporello declares that he is fed up and leaving. "It was supposed to be fun!" Don Giovanni gaily declares of his servant's brush with death. He produces a more convincing argument for Leporello to stay, which is four gold pieces. Another problem solved. But promise you'll leave the women alone, Leporello demands, pocketing the money. This is of course absurd. Don Giovanni puts forth a philosophy that seems to him reasonable, even generous: "I do it because I love them. Who is faithful to one is cruel to the others. I am a man whose heart is so large that I love all of them. Women simply don't understand me. They think that my natural generosity is some

sort of deceit." Leporello knows what that's worth. "I certainly have never seen a greater or more natural generosity," he responds sardonically. As for Da Ponte, it is not exactly that those words express his career with women, though they may approach the outlook of Casanova, listening in the audience at the premiere. But they still came from Da Ponte's life and experience: sex and the bedlam and misery it can engender was a territory he knew intimately. In that respect too, his life had prepared him for his job.

The Don has found a new plan: because he seems to be persona non grata for the moment, he and his servant will exchange costumes. He has his eye on a chambermaid of Donna Elvira's, and "aristocratic clothes don't have much of an effect on girls of her class." Leporello resists, the Don turns from persuasion to threat, and the exchange is made.

The tide of corruption has reached Donna Elvira. She appears in a window, her resolve weakening: "He is a criminal, a traitor. / To pity him is a sin." She is finding pity for Don Giovanni in her heart, or interprets it as that. Interprets her desire, in other words, as the virtue of pity. In the darkness the Don appears; standing behind Leporello, who is dressed in his clothes, he begs Elvira's forgiveness, declaring his love. "God, what a strange passion / Stirs again in my heart!" she moans. "Look at that crazy woman!" Leporello whispers, "She's still willing to believe him!" The Don goes on with her, but this is a plan of escape, not seduction. Soon Elvira has descended, and in the darkness, under the Don's approving gaze, the disguised Leporello romances her. I'll never leave you again, he assures her. "Dearest of men!" she exclaims. Donna Elvira's real agenda has emerged. She wants him back. She is duped because she wants to be. If the Leporello in the cast is a good physical comedian the scene is amusing enough, if we are ready for betrayal to be played as comedy.

In his disguise as Leporello, the Don jumps in to chase them away. He has another serenade in mind, directed to Donna Elvira's chambermaid in a window. This is "Deh, vieni alla finestra," "Oh, come to the window," another irresistible confection, this time accompanied by the twitter of a mandolin. The words are a row of clichés to make a servant girl swoon: "Your delicate mouth is sweet as honey," and so on. In terms of the drama the serenade is irrelevant, but a pretty tune is

a pretty tune—it is distinctly similar to "Là ci darem"—and anyway, the *primo uomo* needed another aria.

The Don's latest attempt runs off the tracks when Masetto appears with musket and pistol, leading a group of villagers searching for him. Impersonating Leporello and thinking ahead, Don Giovanni steps in to direct the expedition, sending detachments around town but keeping Masetto with him. (For the purpose he uses Leporello's patter; a change of costume involves a change of style, too, as if the master is imitating the servant's voice.) You mean to kill the Don? the Don asks Masetto when they are alone. "I want to tear him into a hundred pieces!" cries Masetto. After extracting the guns from the youth, the Don turns nasty and roughs him up, accompanying the last kick with "You dog-faced peasant! You bastard!"

Wounded Masetto is found by Zerlina, who pulls him together in a surprisingly warmhearted, almost hymnlike aria on an essentially libidinous verse: "You'll soon see . . . the remedy I have / Especially for you . . . I can give it to you, / If you want to know / Where it is on me." Again she puts his hand on her breast. Masetto feels better by the minute. And Mozart writes a little throwaway hymn to the healing power of love and lovemaking.

Meanwhile Leporello as Don Giovanni is trying to shake a clinging Donna Elvira. He makes his escape from her but is discovered by Anna, Ottavio, Zerlina, and Masetto. They think, of course, that he is the Don. He has the hat and the robe. While a distraught Donna Elvira cries, "He is my husband . . . Have mercy!" they propose to kill him on the spot. In the ensemble, Mozart makes use of material earlier associated with the characters, adding to it a descending chromatic fourth, chromatic lines again representing things falling apart.[45]

For a second time Leporello faces a fate earned by his master. In desperation, he unmasks himself. In the ensuing confusion, Elvira is naturally the most outraged. Once again her hope is squashed; rage is all she has left. They propose to take out their fury on Leporello. With comic pathos he begs for mercy, meanwhile edging toward his escape. Here the servant shows himself most fully: he is a servant for pay, hoping for a little wine and a little fun in the process, but he is no real accomplice for the Don. Leporello is the eternal survivor, the man on the bottom of the social ladder twisting and turning to preserve

himself and make a few shekels and, when things go bad, running away or hiding under a table.

After Leporello has fled, Don Ottavio tells the others that he will go to the authorities about the Don. He sings an aria of clichéd words to clichéd music, though Mozart made it all quite pretty. Ottavio is thawing still more as a character, but he ends with a futile vow: "I will soon return / As a herald of blood and slaughter." Ottavio will never be anything but a herald of the forlorn. After his aria is one by Donna Elvira, who is once again feeling seduced and abandoned and now doubly deceived, back to spitting fire: "It is only revenge I desire!" Mozart makes her music not furioso, however, but almost formal in tone, a showpiece for the singer. (Often included in later productions, this aria was added for the Vienna premiere, among a number of changes.) In her intensity Donna Elvira is a powerful character, but the music suggests that we can no longer trust her to have any constancy in either passion or revenge. Her histrionics have molded into a mask.

Now the critical scene. Don Giovanni and Leporello reunite, in a cemetery. The Don is much amused by what he has wrought. He is, after all, still in one piece and ready as ever for adventure. "Thanks to you, I was nearly killed," Leporello snaps. "Well," replies the Don, grinning, "that would have been quite an honor." And all the same to him. He tells an amusing story about a girl who accosted him in the street, taking his hand, thinking he was Leporello. With that he crows about stealing his servant's conquests.

Don Giovanni is laughing over his story when a sepulchral voice rings out, accompanied by somber trombones: "You will laugh your last by dawn." Who's this? The voice and trombones speak again: "Audacious villain! Leave the dead in peace." They discover the grave of the Commendatore, Donna Anna's father, whom Don Giovanni murdered. The inscription on his statue above it reads, "Struck down by a traitor, I await here my revenge." So a new addition to the Don's row of victims wanting revenge, but this one of another order. We have a scene recalling Shakespeare, the ghost of Hamlet's father wailing for vengeance in an uncanny atmosphere. (A critic of the time wrote of the scene that Mozart seemed to have "learned the language of ghosts from Shakespeare.")[46]

The Don does not like to be mocked, but he is still unconvinced, and

much amused. On a whim he orders terrified Leporello to invite the statue to dinner. A stunned Leporello can't get the words out; the statue seems to be looking at him. In his stammering terror there is a singular mingling of comedy, fear, and strangeness. Finally, Leporello gasps out, "Great sir, my master here . . . / It's his decision . . . not mine . . . / Invites you now to dine . . ."

The statue nods assent. Leporello recoils, horrorstruck. Don Giovanni is . . . what? Intrigued. "Will you dine with me?" he coolly inquires of the statue. "Yes," intones the stone Commendatore. All right, then. The Don finds a new situation, perhaps a new adventure calling for his attention. As Leporello gibbers in terror, he says, "The old man's coming to my table. There's a meal to prepare, I believe." End of scene.

We have seen that when it comes to women, Don Giovanni has a surface of velvet and a heart of ice. Here we learn that nothing on heaven or earth can break the ice in his heart. His courage has not failed him. It never will, if courage is the name for it. At this point in the story he rises beyond a callous manipulator and narcissist and into something on a higher level in the ranks of demons. Don Giovanni has become an adversary of God, though that hardly saved Lucifer and it will not save him.

Fateful harmonies in D minor are waiting for their appointed return. The grave scene is the first appearance of trombones in the opera. Again, the instruments were most familiar in church services and funerals, occasionally heard in opera. The flipside of the holy is the demonic: more in terms of ensembles than solo instruments, trombone choirs, with their solemn throaty timbre, had a long-standing association with death, the uncanny, the underworld.[47] They had played that role in opera long before Mozart. For the scene he recalled the atmosphere and the trombones in the Oracle scene of Gluck's *Alceste*.[48] Which is to say that the moment the trombones speak with the Commendatore, the audience feels a shiver of the infernal.

BEFORE THE FINAL SCENE COMES ONE BETWEEN DONNA ANNA AND Don Ottavio. He tells her that they will have their vengeance and so on, but . . . She rebukes him for speaking of love at such a time. He pulls

away; she calms him: "It pains me to postpone that happy hour we have both desired." As it will prove, she does not desire that hour and it does not pain her at all. She sings an aria: "Never say, my love, my own, / that I am cruel to you. / You know my heart is always true." Da Ponte would not have intended her words to be taken as entirely genuine, but Mozart appears to take them that way; the aria is earnest and touching. Yet Anna's heart is not true to Ottavio, not in the way he wants it to be. Again and again she has pushed him away, and she is by no means done with tormenting her long-suffering protector. Here is Anna's corruption: it is as if after the upheaval of her encounter with Don Giovanni, the conventional consolation and security Ottavio offers are entirely inadequate. Donna Anna is stringing him along.

Mozart's old Salzburg friend, the musician and writer Johann Andreas Schachtner, later said something striking about him: "I think that if he had not had the advantageously good education which he enjoyed, he might have become the most wicked villain, so susceptible was he to every attraction, the goodness or badness of which he was not yet able to imagine."[49] In life Mozart tended to receive things at face value, give himself to them in those terms, and so it was with his characters in opera. On the whole he does not make musical judgments or prophecies for a character, does not contradict them. (The last scene of *Don Giovanni* is an exception.) Again: Mozart acts the text, giving himself to the reality of the moment, evoking the emotion at hand, which is what an actor does from moment to moment in a drama. An actor playing Iago, Shakespeare's monstrous villain, will find the truth of that role, his human rhymes and reasons. At this moment in *Don Giovanni*, it may be that Donna Anna thinks she means what she says. In the aria Mozart does not neglect to give her a florid, seria-soprano finish, as if to underline a declaration of devotion to Ottavio that, as it will soon prove, she does not remotely feel.[50]

The banquet. Brass fanfares, D major. The guests gather, among them a wind band. Don Giovanni feels elated: "I've spent as much as I can. / I want to amuse myself. / More music, you lads in the band!" As he tears into his food, the band begins to play. What follows is a series of ironies. The first number is from Mozart's friendly rival Martín, a tune from *A Rare Thing*. Leporello approves, calls bravo. The next tune arrives, from a Sarti opera that, like Martín's *Cosa rara*, was more

popular in Vienna than anything of Mozart's. Finally there is "Non più andrai" from *Figaro*, at which Leporello groans, "This one I know only too well." Leporello sneaks some food from the table; the Don has a laugh that makes him speak with his mouth full. If he expects his invited guest from the graveyard to appear, he shows no sign of it. (Luigi Bassi, the first Don, recalled that "we never sang this [scene] the same way twice. We did not keep the time very strictly, but made a joke of it . . . everything *parlando* and nearly improvised, as Mozart wished it.")[51]

Enter Donna Elvira, having upended her emotions again, once again hungering for him: "One last time / I come to you / To prove myself / Eternally true." He makes a show of humbling himself, she demands he change his ways, he turns cold: "Let me finish my meal." Here is his second refusal to change. The first refusal was to Leporello, done with a show of philosophy. Here it is done cruelly, but it is his last betrayal. Says Leporello as his master sits down to eat again, "If he's not moved now / By the depth of her sorrow, / He has a heart of stone." "You foul man!" Elvira sobs. "Wallow in your crimes!" "Long live the ladies!" the Don exclaims, ignoring her anguish. "Here's to fine old wines!" Elvira flees the room, a scream is heard, she returns on the run to vanish out the other side. Don Giovanni sends Leporello to see what's up. At the door, he screams in turn.

The stone guest has arrived. His thunderous tread approaches, his heavy fist pounds the door. Leporello refuses to open it, so the Don does it himself while his servant scuttles under a table. A big diminished chord, recalling the one that announced the Commendatore's mortal wound in the duel. The music sinks into the opera's fraught home key, D minor. "Don Giovanni!" the statue intones in sepulchral tones, "You invited me / To dine and I have come." The Commendatore is, so far, an effigy of few words, but he will have more to say. The music paints Don Giovanni as rattled but unbowed. I didn't really think you'd come, he says, "but I'll do what I can. Leporello, set another place."

The Don is defiant, battling as always to control the situation, turn it to his advantage. But he no longer controls the music, which remains in D minor at its most foreboding. As his music throughout has tended to slip into the vein of the person he is addressing, here the Don echoes the statue's fateful tone. Soon return the vertiginous chromatic lines first

heard in the beginning of the overture and returning periodically as an echo and a prophecy, streaming as relentlessly as fate. "Stop where you are!" the statue orders. "He who dines under heaven's portals / Has no need for the food of mortals." There is nothing of heaven in the music, rather a rising portent of doom.

Will you come and dine with me? asks the Commendatore, meaning at the table of paradise. "He doesn't have the time!" Leporello cries from under the table. "Say no!" During what ensues he continues to jabber, like a trespasser from an opera buffa. As for Don Giovanni, he cannot see his ruin at hand, that he is facing a situation he cannot lie his way out of. His narcissism has reached a point of madness. "My heart and my hand are steady," he declares. "I have no fear. I will go!" The music rises to his proclamation, but it is not given as a heroic declaration but a portentous one. His defiance of God remains in his words but not in the music, because he is no longer in control of his fate. But that is something he cannot acknowledge.

The Commendatore asks for his hand. With a heedless gesture the Don gives it. Here is the moment of truth. He is in the grip of his doom, his last illusion of control extinguished. Yet with catastrophe before him, he still will not submit. Now comes the opera's third and last offer for redemption. "Change your ways!" the Commendatore cries. Five times the statue demands repentance, five times the Don refuses, even as ice fills his veins. Flames shoot from the stage, the earth shakes. The irrevocable choice has been made. "Your time is up!" the Commendatore cries.

At that moment, Don Giovanni, for the first and last time in his life, understands an inescapable truth. "A tremor seizes my body, / I feel . . . my life assailed. / Fiery whirlwinds flail . . . / Where are these horrors from!" From inside the earth rises a demonic choir, chanting over trombones and pounding drums: "These are for your sins, and not enough. / There is worse from where these come!" It is a scene of damnation taken straight from the source Da Ponte cited, Dante's *Inferno*. Even invoking the fires of hell, he remained a scholar of the Italian classics. It is the sort of damnation the Enlightenment did not tend to believe in, nor the Freemasons, and likely neither did Mozart nor Da Ponte. But this story known to all demanded its denouement, so they provided it in full demonic array. To plunging minor scales, Don

Giovanni sinks screaming into the flames. Tutti final chords, D minor, trombones blaring. True to the old title, the libertine, the unrepentant Casanova, has been punished. At the premiere Casanova himself might have joined in the cheers, but maybe alone in the audience he would have been laughing too.

THE RECORD SUGGESTS IT IS POSSIBLE THAT WHEN MOZART BROUGHT *Don Giovanni* to Vienna he ended the opera there, with the flames and glowering chords.[52] If so, that means he decided that the more sophisticated Viennese audience would not put up with the Prague conclusion, which is an opera buffa one. At that point, what did he think of it all? What did he expect people to think? Of course, what to think of *Don Giovanni* at the end of a given evening, as in all shows in the theater, has everything to do with how it is sung and played. In the future many productions would lean to the buffa side, in which the Don is a used-up, impotent rake unable to attain any of his desires, Anna and Elvira are stock characters bemoaning their fate, and Elvira reels pathetically from rage to lust. Arguably, those productions underestimate the characters, underestimate Mozart, underestimate the libretto.

Again, what the text and the music say is unequivocal: Don Giovanni is a rapist, murderer, and an uncontrollable libertine who corrupts nearly everyone around him. But his magnetism is irresistible. He seduces Elvira and Zerlina; even Donna Anna cannot escape him and resign herself to hapless Ottavio. Neither can Leporello, the survivor who sees it all with clear-eyed cynicism, break free of his master's sway.

So the end, with its infernal flames that Mozart and Da Ponte probably did not believe in. But besides being a theatrical coup highly amenable to music, besides being the finish everybody expected, the damnation has an insistent moral logic: God has to stop Don Giovanni because nobody else can. He is the primal and ungovernable power of sexuality embodied. He precipitates a crisis in the moral order, and only God can restore the balance. If the Don is played at the full implication of what he is in the music and the libretto, including his practiced skill in seduction, he not only sullies nearly everyone on the stage in one way or another, but also sullies us, the audience. On the stage

at least, we like seeing a rogue get away with it. Our own complicity becomes part of the story: we want Don Giovanni to win.[53] His antagonists are Donna Elvira, who beneath her rage is besotted with him; Donna Anna, who is helpless to carry out revenge; Don Ottavio, who is conventional and clueless; and Masetto who is useless. Don Giovanni is the most vital character on the stage, the only one who has absolute integrity and fearlessly acts on it, even if that integrity is demonic. Here is what allies him with Lucifer. In that sense he is the fallen angel of the human, the demonic destroyer. Hell is where he belongs because he has been living in it all along.

But in Prague and most theaters to come wherever the opera would be mounted, the rules of buffa still reigned. In the libretto, Da Ponte called the work a *dramma giocoso* à la Goldoni; in his thematic catalogue Mozart simply called it an opera buffa, and it had to have the happy ending that resolves everything, even if in practice it resolves nothing.

The remaining principals gather onstage. Leporello explains what has happened; they accept it with a shrug. "Now that heaven / Has granted us our revenge," entreats Don Ottavio to Donna Anna, "May I at last be given / The reward of vows exchanged?" She's tired of hearing this stuff from him. Wait a year for me to heal, she declares, then we'll see. Ottavio submits, nobody objects. With her customary sense of drama, Donna Elvira vows to enter a convent, which is to say that she believes her passionate life is over. Zerlina and Masetto are hungry for dinner. Leporello looks forward to, first, a stiff drink, and then to a new and less harrowing master.

All six join in the jolly final number that proclaims a chain of platitudes. Mozart provides dashing and giddy music, with an interesting quirk: it begins with a theme like an old contrapuntal figure, a cantus firmus, or perhaps a fugue theme, but the chorus is not going to be a fugue. So even though the text starts with "Let the villain rot, / Tied in Plato's knot!" and ends with "A sorry fate awaits each sinner. / He suffers life, and ends up dead," the music has not just a vivacious but also a formal quality, grounded in D major with no chromatics or ambiguities. In the music and the sentiments, convention and D major win. Like so many dramas on the stage, it's a quick windup with no looking back.

Yet to the extent that one takes *Don Giovanni* seriously as drama

and not merely a spicy comedy, the story is not over, not at all. No one is the same or ever will be. For years Mozart's operas had ended with forgiveness or reconciliation, and a triumph of love.[54] Not this time. Nearly all the characters were touched by corruption, in one way or another Don Giovanni's accomplices. This leaves a shadow over their lives that gaiety, piety, dinner, a stiff drink will not enlighten. So ends an opera that like so much Mozart and, for that matter, so much Da Ponte, rose from a fabric of tradition and convention yet still managed to be like none other. The demon gets his deserts, but we have seen the demon and he is us.

Chapter 23

WITH NOTHING YOU CAN CREATE NOTHING

At the beginning of November 1787, with a manifest air of relief after the anxieties of a premiere, Mozart wrote his Vienna friend Gottfried von Jacquin:

My opera "Don Giovanni" was performed on October 29, with the greatest of applause.—Yesterday it was given for the fourth time—for my own Benefit.—I think I'll be leaving here on the 12th or 13th . . . Maybe my opera will be performed in Vienna after all?—I certainly hope so.—They're doing their best here to persuade me to stay a few months and write another Opera,— but I can't accept the offer, no matter how flattering it is . . . I'm sure you are not lacking in pleasant distractions, dearest friend, because you have everything that you at <u>your age</u> and in <u>your situation</u> could possibly wish for!—All the more as you seem to be leaving behind your previous somewhat <u>restless lifestyle</u>;—aren't you persuaded a little more each day by the Truth of my little lectures to you?—Don't you think that the pleasures of unstable and capricious love affairs don't even come close to the blessings of true affection?—I am sure that deep in your heart you are often grateful for my edifying lectures!—Indeed, you have it in you to make me proud;—but all joking aside.—You do owe me some thanks if you prove yourself worthy to Mme. N_____, after all, I played a not so insignificant role in your moral im-

provement and conversion.—My great-grandfather used to say to his wife, my great-grandmother, who said to her daughter, my grandmother, who in turn said to her daughter, my mother, who told her daughter, my sister, that to speak agreeably and beautifully was a high form of art, but to cease talking at the right moment was perhaps no less a high form of art—I, therefore, will follow the advice of my sister, who derives her wisdom from our mother, grandmother, and great-grandmother and will come to an end not only with my moral ramblings but with my entire letter.

Here is one of few surviving Mozart letters from his maturity written at leisure for no other reason than affection. To a close friend of more or less his own age, he pens a newsy and droll letter that does not verge into naughty (as he could do anytime, mostly when there was a woman involved), but rather eases into an ironic yet earnest little sermon about the virtues of marriage and fidelity—what he calls "true affection" as distinct from the transitory pleasures of affairs. It is surely no coincidence that these sentiments follow in the wake of *Don Giovanni*. Marriage had been good to Mozart and Constanze. He had entered into matrimony with that hope, as when he wrote to Leopold about marrying for love and for companionship emotional and sexual.

Jacquin, a chancellery official with a good bass voice, studied composition informally with Mozart, who wrote a number of pieces for him. Some of them were jokes, some of them intended for Jacquin to put his own name on and use for the purpose of impressing a girl. As was seen, Gottfried's teenage sister was one of Mozart's most gifted piano students and the inspiration for and dedicatee of the *Kegelstatt* Trio. Of the pieces Mozart wrote for fun with Jacquin, the most elaborate is called "Liebes Mandel, wo ist's Bandel?" (Dearest Almond, Where's the Ribbon?). It was based on an incident when Constanze could not find a ribbon her husband had given her. After a frantic search around the house by the trio, Jacquin found it and held it high in the air, making the Mozarts and their delirious dog jump for it.[1] Warm and memorable silliness among friends, life spilling into art.

The letter to Jacquin shows Mozart happy with the Prague reception of *Don Giovanni* and hopeful about bringing it to Vienna, though in the letter he does not take that for granted. After the premiere the critical

reception tended to be respectful but put off by the density of the music and the tenor of the story. Despite the familiar tale, audiences were dealing with a lusty exploration of Don Giovanni's depravity like nothing seen before on an opera stage—that genre that was supposed, no matter how racy, to be ultimately uplifting and moral. One Hamburg critic was profusely offended while paying the usual pro forma tribute to Mozart's skill and imagination.

> [Mozart] is a real virtuoso, whose intellect is never crippled by his powers of imagination. His enthusiasm is guided by reason, his portrayals by careful consideration . . . Don Juan combines in himself all that is irrational, bizarre, unnatural, and contradictory, and only poetic nonsense from a human hand could raise him to the level of an operatic hero . . . The most vile, miserable, and dastardly fellow, whose life is an unbroken chain of infamies, seductions, and murderous deeds . . . A stone statue sings, is invited to dinner, accepts the invitation, climbs down from its horse, and arrives safely at the appointed hour. How charming! What a shame it does not eat as well—then the fun would be complete . . . Herr Mozart may be an excellent composer, but he will never be so for our ordinary opera patrons, for he would first have to instill in them a quality that they understand as poorly as a blind man understands color—sensibility.[2]

In other words, too many notes; he's over the heads of the average operagoer, who is a bit of an oaf. A Berlin reviewer stretched the extremes further:

> I went full of high expectations and heard an opera which, in my opinion, satisfies the eye, charms the ear, offends reason, insults morality, and treads wickedly upon virtue and feeling . . . [On the other hand] if every nation could take pride in one of her sons, so Germany must be proud of Mozart, the composer of this opera. Never, indeed never before, was the greatness of the human spirit so tangible, and never has the art of composition been raised to such heights! Melodies that an angel might have invented are here accompanied by celestial harmonies, and anyone whose soul is

the least bit receptive to the truly beautiful will surely pardon my saying *our ears are enchanted*.[3]

This critic ended by calling *Don Giovanni* a wicked story that "will make honest maidens blush for shame." Mozart had reached a point in his career in which even his mixed-to-bad reviews called him the greatest composer who ever lived. Maybe the article got a mordant chuckle out of him and Da Ponte.

Mozart returned from Prague in mid-November to find bad and good news. After a long decline, Gluck had died at seventy-three. Joseph appointed Mozart the great man's successor as imperial and royal chamber musician. Later history would make much of the discrepancy in salary: Gluck had been paid two thousand florins a year, Mozart received eight hundred. But Gluck's salary had really been a pension and reward for a long life's labor, and it involved essentially no work. Mozart was hoping for more, but not unduly offended. From that point, he often signed himself as "I&R Chamber Musician" (variously *Kammermusicus* or *Kammer-Kompositeur*) and sometimes as Kapellmeister, though strictly speaking, he was not—Salieri was appointed court Kapellmeister, his duties including managing and conducting the court orchestra.

When Gluck died, Salieri was actually holding the *Kammermusicus* position; he got moved up and Mozart took his place, which made him the second most important figure in the court musical hierarchy. This was no small thing, and in any case it would have been unimaginable for Salieri, who had long been a leading musician in town, to be passed over as Kapellmeister for the younger Mozart—who meanwhile had never run a musical establishment, while Salieri had. The eight-hundred-florin starting salary for Mozart was far more than most people made in a year, nearly a third of his income thereafter, and for the time being it required nothing but writing dances for court balls. It was also implied in the contract that his salary would be raised in due course—for example, when he began actually to work for it.[4] He would write dozens of dances in the next years, mostly German dances and minuets for orchestra that were used for public balls in the Hofburg. He could turn out these things by the yard. Within the confines of a functional genre, his dances show a remarkable variety of material, from

folksy to magisterial and everything in between, all of them marked by well-honed melodies that stick in the ear. And the dances had legs: most of them were published during his lifetime.[5]

The reason for the appointment was simply that Joseph wanted to keep Mozart in Vienna and hoped the job and associated prestige would do the trick. As usual, he paid the minimum to get what he wanted. Besides, if Mozart may have been the most respected composer in town, he was not the most beloved. Of the most popular operas in Vienna in this period, two were by Martín y Soler, one by Salieri, and two by Paisiello (one of them *The Barber of Seville*).[6] Among connoisseurs Mozart was still deemed exceptional but problematical. Again: certainly he is a great master, ran the usual critical line, but he cannot restrain his overweening imagination, his chilly intellectualism, his too many notes. An April 1787 article in the influential *Cramer's Music Magazine* is another case in point. It begins with a rumor that presumably represented Mozart's plans at the beginning of the year, none of which happened until sometime later:

> Mozart started a few weeks ago a musical tour to Prague, Berlin, and, it is said, even London. I hope it will turn out to his advantage and pleasure. He is the most skillful and best keyboard player I've ever heard; the pity is only that he aims too high in his artful and truly beautiful compositions . . . whereby it must be said that feeling and heart profit little; his new Quartets . . . which he has dedicated to Haydn, may be called too highly seasoned—and whose palate can endure this for long?[7]

Part of Mozart's problem with critics and public was that, on the face of it, his music did not lie outside the familiar. He wrote the usual sorts of pieces, the usual kinds of operas with the usual sorts of plots, wielded the traditional forms in instrumental music. But in every dimension he searched deeper than his contemporaries, took more care, bent expectations. That is why some of his rivals, such as Paisiello and Salieri, wrote a dozen or more operas in the time that he wrote five. What needed to happen in the critical response was for his complexity to be embraced for its richness. He was setting the bar higher in nearly everything he touched, and it took years for that to sink in. Another

article of the same time at least shows signs of a critical turn from the usual hedged and grudging admiration:

> Mozart has now arrived in Vienna as Imperial Chapel Master . . .
> A little while ago, there appeared a single [quartet] . . . which is
> very intricate, requiring the greatest precision in all four parts . . .
> Many another piece can sustain a mediocre performance; this
> product of Mozart's is, however, scarcely bearable if it is per-
> formed by mediocre dilettante hands and carelessly presented . . .
> What a difference, when this much discussed work of art was
> played in a quiet room by four skilled musicians who have studied
> it well, where the effect of each and every note did not escape the
> attentive listeners here, and which was played with the greatest
> precision in the presence of only two or three attentive persons.[8]

Beyond suggesting a warming in the critical reception of Mozart, the article foreshadows a larger evolution. From his childhood on, chamber music had been a matter of private performances by amateurs of varying abilities ranging from slight to expert, often played with little to no rehearsal. The pieces did not come from a standing reper-toire but were expected to be more or less new. The music was com-posed for that milieu, which limited its difficulty—though, it should be noted, not its quality. But now critics were beginning to talk about pieces whose difficulties were not a failing but rather something worth grappling with, in carefully prepared performances by skillful players. The audience for the performance the critic cited was "two or three attentive persons." The context was still private, intimate, but now the listeners were expected to be connoisseurs if the work was to make its point. The end of that evolution in the history of chamber music would be professional performances for paying audiences, but that would not evolve for years to come.

The months around the advent of 1789 were eventful ones for Mozart, for his musical milieu, for his country. In December 1788 he moved the family back into town, to the corner of Tuchlauben and Schultergasse, where they stayed for some seven months. The place was comfortable though not as grand as the flat they had when he was writing *Figaro*. As it turned out, they never again lived in a place quite that luxurious.

In December, Joseph made a long-anticipated move and dissolved the faltering German opera company that had been mounting singspiels in the Burgtheater, and formed a troupe there to mount Italian opera buffas. It had been Joseph's pet project to establish a popular theater in German, but even an autocrat like him could buck public taste for only so long.

The following February Joseph made more than news; he made history when he declared war on Turkey. This declaration rose from an alliance going back to 1781 with Catherine the Great's Russia, which had long-standing tensions with the Ottoman Empire. After some Turkish provocations, Russia declared war. This by treaty brought Austria into the conflict. In theory, Joseph was backing up the Russians, but in fact, for some time Catherine let Austria do most of the fighting. The war broke out at an inauspicious moment: Joseph was having trouble with his territory in Belgium and with his northern neighbor Prussia. Still, he had always considered himself a soldier, and now he had his war. He left Vienna to lead the army, which he did to ruinous effect.

Behind him the emperor left a city unsettled and a musical scene decimated. Performances and commissions and publications flagged. War taxes took a devastating toll on the economy, as much as anything on art and artists. The Austrian national debt would reach four hundred million florins. There were bread riots, presaging ones in France that would trigger the Revolution. Joseph's popularity with the public was overtaken by disillusion. In the perspective of history, the Austro-Turkish War began Austria's decades-long decline into reaction, totalitarianism, and political irrelevance.

THROUGH IT ALL, MOZART WORKED AT WHITE HEAT EVEN THOUGH there were fewer performances available, and this went hard on his income. As for the war, he did his bit with "A German War Song" for voice and orchestra and a contradance called "The Battle."[9] His solution to the financial crunch was to borrow money and try to compose his way out of debt. That was a hopeless ambition, even if his creativity was boiling.

Sometime perhaps early in 1788 he pulled together a new piano sonata, in F major, K. 533, as finale, using a rondo finale he had written

earlier. On the one hand he had never been as ambitious and bold in his piano sonatas as in some of his chamber music; on the other hand, he was full of juice, and it showed in nearly everything he wrote. The sonata is an exercise in subtlety in the guise of a pretty little piece. It begins with a perky tune alone, as if posing the question "What shall I do with this?" That opening might have been written for a sonata of his ten years before; the continuation would not have been. The phrasing at the beginning is ambiguous. The second part of the theme is joined by the left hand in a babbling Alberti pattern, of which Mozart had been availing himself since childhood, but this is the last Alberti that will be heard until the recapitulation. The second page establishes that this is going to be a contrapuntal work, expressed in a duet between the hands, with much tossing back and forth of figures. Meanwhile the exposition is about twice long as his usual. The development jumps into C minor and the counterpoint becomes more heated, with steady running triplets, though nothing disturbs the essential tranquility. This development is not just longer than his used to be; now, like this one, developments in his major works are true quasi-improvisations on the themes.

In keeping with the equanimity of the first movement, the sonata-form middle movement does not slip into sorrow, but rather has a mood in the direction of quiet yearning, until the development takes the ideas into a stern dialogue of contrasting characters between the hands. When the duet gets into thirds in each hand, the harmonies stretch achingly. As in the first movement, here Mozart is interested in counterpoint that inverts, bottom and top switching places. Not all counterpoint works for inversion; it has to be composed that way. Soon he will explore the idea of invertible counterpoint unforgettably in a symphony. All the same, even though this kind of inversion is an old device of the learned style, the sonata has no archaic atmosphere but has its own timbral and expressive world. After two movements of music that takes attractive material deeper than it would appear to go, the old finale he imported into the piece has a more ingenuous effect, jaunty and charming, maybe too much so, and without the contrapuntal disposition of the earlier movements. Noting this, Mozart added a new section before the coda, starting low on the keyboard and working upward to the top in imitative counterpoint, reaching for a sense of gravitas that looks back to the earlier movements.

Along with the F Major, he produced the mellifluous little C-major piece dubbed "easy sonata," K. 545, that would test the capacities of beginning pianists in perpetuity. Call it an exercise in studied naïveté from a composer at the height of his powers. On the one hand it has the kind of effortless perfection of which Mozart was the incomparable master. On the other hand, its future ubiquity would give it some of the responsibility for convincing many listeners, even musicians who should have known better, that Mozart was a china doll composer of pretty but hardly momentous works existing in some sort of eternal sunshine.

If the F-major Sonata had an exploratory vein that it did not wear on its sleeve, the three piano trios of this year, K. 542 in E Major, K. 548 in C Major, and K. 564 in G Major, his last in the genre, do not on the whole propose to expand on the generally light and unambitious norm of piano trios in those days. They are all good-humored, largely piano-centric works, the cello parts mostly relegated to the bass line, the dynamic indications ranging from skimpy to nonexistent. Clearly the trios are aimed toward the genial and sociable atmosphere of salon concerts in homes and at court, when things returned to normal. (As it turned out, they never did.) Haydn had increased the depth and seriousness of string quartets exponentially, and Mozart followed him in that direction. Haydn had not done the same with piano trios, and Mozart followed him in that too. It may be relevant that these trios were commissioned by Artaria, and Mozart needed the money urgently.

Dated February 24, 1788, in his works list—he probably began the piece a year before—is the Piano Concerto, K. 537. It's a large and varied work if expressively not an aspiring one, in D major, no clarinets in the winds but with trumpets, and lush in sonority. There is an abundance of material and much brilliant piano writing, also signs of haste and post-performance neglect: stretches of the outer movements and the entire middle movement have no left-hand part. Mozart would have supplied the left hand in performance, of course, but the missing music implies that he made no effort to get the piece published. (There are incomplete solo parts in the manuscripts of earlier concertos, but not nearly to this degree.) He may have premiered it during a spring tour the next year; after he played it at a royal occasion in 1790, the concerto acquired the name *Coronation*. The name is about as apt as most applied

by others, which is not very, but it does convey the generally impos-
ing, good-humored, sometimes ingenuous atmosphere of the piece. He
wrote more imaginative works in D major, but in any case that was not
a key one mourned in.

THE MOST REMARKABLE EFFORTS AROUND THE SUMMER OF 1788 WERE
three symphonies that Mozart produced in some six weeks: K. 543 in
E-flat Major, K. 550 in G Minor, K. 551 in C Major. He had written
moving and momentous symphonies before; these are not just his
greatest, but arguably his first that can be called historic. As seen, when
he and Haydn started writing symphonies, they had been relatively
modest pieces designed to enliven programs in salons and palaces, to
be played by orchestras numbering twenty or fewer, no conductor re-
quired. What direction might be needed was supplied by the first vio-
linist or by the harpsichord player presiding in the middle of the group.
When Haydn began working for the Esterházy princes, he had at his
command one of the finest musical establishments anywhere, so his
ambitions for symphonies burgeoned steadily through dozens of works
that climaxed in the ones he wrote for London in the 1790s. By that
point Haydn had certified the symphony as the king of instrumental
genres and earned his title of "father of the symphony."

None of this had to do entirely with artistic ambitions; it also re-
sulted from a change in venue. Earlier symphonies were written mainly
for private music rooms. But in Paris and London a tradition of pub-
lic performances by large orchestras in large halls had grown up, and
in the travels of his youth Mozart had heard orchestras in both cit-
ies. Haydn's London sets were written for that kind of venue, as was
Mozart's *Paris* Symphony, which was larger in scale and forces than
his earlier ones. As he had done with string quartets, Mozart studied
Haydn's symphonies on the way to finding his own path. With these
last three, written years before Haydn's *Londons*, Mozart returned his
mentor's favor: these symphonies' depth and ambition became an inspi-
ration to the older man. And in turn, above all Mozart's last three and
Haydn's last dozen put the genre of symphony in the place where the
young Beethoven picked it up and did what he generally did, which was
to absorb models and take them further in scope and ambition.

First came Symphony no. 39 in E-flat Major, K. 543, noted in Mo-
zart's works list as finished on June 26, 1788. For him that key generally
implied something in the direction of imposing, expansive, Elysian in
tone—he often used it in Masonic-related pieces. In the orchestra the
key of E-flat has a less bright but also more sumptuous sonority than
tonalities such as D and A major. The symphony begins in grand style
with a spacious introduction that mounts in intensity until it leads into
a graceful Allegro in a flowing 3/4. The winds are a single flute, pairs
of clarinets and bassoons; the rare omission of oboes contributes, along
with the key, to a mellow orchestral sound. In all three of these sym-
phonies the winds are going to be more present and engaged in the
musical dialogue than perhaps in any symphony by anybody before.
An enlarged presence of winds was as much as anything what Haydn
learned from Mozart. (Although while Haydn began including clari-
nets in his orchestra, he never quite settled on what to do with them.)
The new prominence of winds was also one of the things for which
critics scolded Mozart. An article reported that one experienced pro-
fessional opined that in his opera scoring, Mozart was "too loquacious
with the wind instruments. Instead of only reinforcing the melody . . .
and supporting the harmony . . . , they often darken the former and
confuse the latter, prevent simple, beautiful singing and disturb the
singers' delivery."[10]

The E-flat and the other two symphonies are fairly straightforward
in form compared to other works of his at the time; all of them have,
for Mozart, extensive developments that range, sometimes strikingly,
in a variety of keys. At the same time, a developmental approach to the
material is now often a feature of Mozart's expositions too, which is to
say again that in his work the idea of development is spreading out of
the development section.

Of the final three, the E-flat is the shortest. In contrast to its more ve-
hement and elaborate fellows, call its personality gently good-humored
and mostly cloudless. The first movement has another feature that will
mark all three symphonies: the bass/cello group sometimes departs
from the bass line to become melody, sometimes the leading melody.
When the bass moves melodically, putting the foundation in motion, it
can tend to unsettle or blur the harmony. That is part of a tendency in
the last symphonies to put off strong cadences more than Mozart had

tended to. To use a literary metaphor, he is writing longer sentences, using more commas and dashes, waiting longer to arrive at a period. This kind of harmony can be turned to various effects—here a kind of Arcadian reverie, in the next symphony to a sense of anxious searching.

The second movement is something of a deliberate throwback, starting with a gently galant tune recalling ones of Mozart's youth and of his mentor J. C. Bach. Here that familiar trope is a point of departure for a procession of moods, starting after the A-flat-major opening theme with a sudden protest in F minor. The galant theme itself gets richer on its return, mainly by the addition of winds to the original string phrases. Mozart's orchestra is becoming more of a republic, the strings still in charge, but everybody else contributing not just color but substance, a new paradigm that had evolved in his operas and concertos. It is clear that Mozart is thinking in terms of a larger group than the usual modest band. The genre has moved out of the music room to become the public instrumental genre par excellence. That is also a matter of style. In Mozart's youth the styles of, say, serenade, concerto, and symphony were not radically distinct; now symphonies had a voice of their own, richer and more dramatic than their ancestors.

The minuet of the E-flat is genial and robust, heartier than the usual elegant dance, Mozart often scoring all the violins in unison to give weight to vigorous gestures. A flowing trio is led by the winds, the second clarinet providing a scampering accompaniment. The finale begins quietly in the violins on a gay tune that bursts into a forte with ebullient horns. Another element of the last symphonies is going to be a tendency to present a theme and immediately vary and develop it; in this movement, the second theme is a variant of the first. As said, the ending of pieces in these days often provides a sort of retrospective certification of the essential mood. This conclusion is ironic, beginning on the top of the main theme, which cuts off in mid-stride. Which is to say that the E-flat-major Symphony ends with a chuckle.

The three symphonies were written as a set, though that does not mean they were expected to be performed together. A set of pieces was always going to have a variety of keys and moods, usually a minor-key one involved. For No. 40, K. 550, Mozart chose fraught G minor. In this symphony he takes up the key for the last time in a major work and brings to it a piercing ferocity learned from his operas and, perhaps,

spurred by his troubles at that moment: his country at war, his royal patron away on the battlefield from which he would return a broken man, musical life at a low ebb in the war economy, Constanze struggling with almost constant pregnancies, his own fortunes drifting. He was primed for a work that was searching and apprehensive.

The G Minor begins in medias res, the violas appearing with a nervous chattering accompaniment that seems already to have been in progress and with a theme in the violins that sounds like a song of grief over unsteady ground. The essential vehicles of an atmosphere of alarm are the headlong, relentless rhythm and a single obsessive interval: the half step, which can have any mood but had long been linked particularly with suffering and tragedy. In this symphony technique and expression are going to be wedded indelibly. Mozart had always been concerned with motivic connections and with a central question of any work: what makes this piece absolutely *this piece* and no other? In his earlier works there is a general if sometimes hard-to-pin-down sense of unity, but that sense had been consolidating, which is to say that for the listener he is more overtly drawing works together as a whole in their material and their import. Maybe from Haydn, Mozart learned to use small motifs to pull a work together: simple bits of material, often two or three notes, that function like seeds to grow themes. (An example is Haydn's String Quartet Op. 76, no. 2, called *The Fifths* for the relentless presence of that interval in the first movement and echoes of it in the later ones.) From beginning to end of the G Minor, there is a sense of unity in every dimension, emotional and technical. Mozart's earlier G-minor symphony, No. 25, written at age seventeen, was manifestly Sturm und Drang, as is this new one, now with incomparably more variety and passion. The "Little" G-minor Symphony is strong but rhetorical, striking postures of fury and sorrow; this G Minor seems lamentation and wrath themselves. And in musical terms, much of the symphony's melodic material will turn around half steps, that interval at its most heated.

Here half steps trouble the music in myriad guises. The opening statement begins by repeating it three times; then a leap up of a sixth, then the step is strung together in a descending scale, then the whole statement is repeated a step lower. (The leap of a sixth in the viola accompaniment is echoed by the sixth in the theme, which

becomes a secondary motif.) The climax of the first section is expressed in half steps slashing up and down. The harmonic sentences are long and restless, with few firm cadences. The opening theme in its forthright anxiety is repeated, worked into an explosion. A sighing second theme in E-flat major provides a glimmer of relief, but it is overwhelmed by new fury that sinks into exhaustion, half steps nakedly wailing.

What follows is the longest, most impassioned and variegated development section of Mozart's life. It begins with the opening theme in the rare key, for his time, of F-sharp minor. From that point the keys progress in a falling pattern: E minor, D minor, C major, B-flat major, finally a long preparation, in chains of half steps, for the recapitulation and the return of G minor. There is much diminished harmony, the most unsettled chord in Mozart's arsenal. There is no solid cadence. Twisting variations of the opening theme are constant, the intensity unrelenting, until the recapitulation almost seems a relief. The recapitulation rages down to the final chords in G minor, with no hint of a hopeful turn to major. As a portrait of anguish, nothing by others in Mozart's time equals this movement. Whether he knew it or not, one would have to go back to Bach at his most tragic to find its like—though Handel also explored those regions, especially in *Messiah*, a work Mozart knew intimately.

After that portrait of despair, what next, in a work he was determined to make an expressive whole perhaps more faithfully than he ever had before? The second movement is an Andante in E-flat major and in sonata form, meaning it is going to have more contrast and development, more weight, than an ABA movement. The music is gentle, quietly surging, a shelter from the storm. But there is an undercurrent of unease from the second bar, when the basses slide up in chromatic half steps to a piercing out-of-key C-flat. The theme features accented chromatic dissonances called appoggiaturas, the sort of thing familiar in galant themes, but in this case the sighing half steps sound poignant rather than decorative. The music becomes a duet between violins and basses, rendering the harmony ungrounded and tenuous. Over the themes the winds add chirping stepwise figures, which would usually come off as jaunty but here seem troubled. After the exposition ends on a note of yearning, the development takes the opening theme

and the chirping figure through various paces, fraught half steps finally overwhelming the music.

Unrest unto despair returns in the Minuet. Haydn had led the way in breaking the old courtly dance from its roots into far-ranging directions, to the door of tragedy. Here Mozart continues that evolution, his Minuet taking on the grave temper of the symphony. The theme is a stark duet between the violin and bass lines. (The violin theme's outline of D-B-flat recalls that rising sixth in the third bar of the first movement.) In the middle a gentle Trio provides a stretch of emotional relief. The Sonata-form finale ratchets up the Sturm und Drang energy. It erupts with a dash up a G-minor chord that was a familiar melodic feature of the Mannheim orchestra that Mozart heard in his youth, called the "Mannheim rocket." If the first movement began with nervous anxiety, the finale is a declaration of rage. The leading motifs are still in place as the opening rockets up from D to B-flat (again echoing the third bar of the piece) and drops a half step to A. Through the symphony, Mozart has wielded these two motifs in myriad forms. Their presence becomes part of its sense of inescapable pain.

If the finale's second theme is shot through with half steps, it is still in a contrastingly lyrical B-flat major, but there is a shadow: the theme is in three high parts, with no bass line, which is to say that there is no stable harmonic ground. Soon the ferocity returns, rampant and implacable. The development begins with a tutti stretch in no definable key before arriving at D minor. In nervously jumping harmonies, it involves scraps of the first theme flying back and forth in imitative counterpoint, all of it sustaining a driving intensity. After that fragmented development, the recapitulation has the effect of the opening theme assembled back into a whole. The development had ratcheted the ferocity to a maximum, so the return of the opening is like putting a seal on the rage. The regularity of the sonata form in first and last movements, combined with development sections of Haydnesque breadth, contributes to the effect: it is as if the forms as a whole are ruthless and inescapable. So the structure of the piece is an integral part of its character, a joining of form and content that would not be lost on the next generations of composers, led by Beethoven.

The Romantic nineteenth century, wanting to see art as rising directly from the soul and the suffering of the artist, would call the

G-minor Symphony a symptom of Mozart's despair at that moment in his life. But Mozart did not subscribe to the Romantic cult of genius, and he did not create art for art's sake. He chose the rage and despair of the G Minor as an artistic matter and brought to it his seasoned mastery as a symphonist and his acquaintance as a human being with rage and despair, just as an actor can embody a Shakespearian tragedy one night and a courtly comedy the next. But in these months, Mozart's expression of the dark side of life was direct and immediate.

In fact the C-major Symphony, K. 551, his last symphony, has a courtly air, grand and expansive, putting forth an almost operatic expanse of the imposing and gracious that would eventually earn it the title *Jupiter*, that being the Roman king of the gods. Again Mozart is working within the familiar temperament of C major, which tends to exclude passion and grief but can involve the imperious and stirring, as does the *Jupiter* in myriad ways. The wind section has one flute and pairs of oboes and bassoons, and full brass with timpani.

It begins with big forte octave up-rips, answered by a quiet phrase in lilting rhythm, the tune built on a scaffolding of four notes that will have great resonance in the piece: C D G F. It is a figure familiar in textbook studies as a cantus firmus, a simple given theme on which to weave counterpoint. That connection foreshadows a steadily contrapuntal symphony that works toward a singular climax in the finale. The quiet answering phrase is used to extend the first theme, turning that figure into a towering proclamation. The phrase on C D G F is the essential motif not just of the opening movement, but of the entire symphony. It underlies the second theme, a gracious rising figure that takes shape as an imitative dialogue between violins and basses, until the phrase rises again to a ringing assertion that seems some essence of aspiration and nobility—not courtly nobility but rather personal, spiritual. Maybe the most unusual element of the exposition is an extended closing section that introduces a new theme and once again rises to a soaring conclusion.

That new theme becomes the first subject of the development, which is also marked by the lilting rhythm of the opening answer phrase. Another long development, it first involves a stern imitative dialogue between violins and basses, the texture two parts, the winds doubling the strings but breaking out on their own for an interlude before a false

recapitulation in the middle, the opening theme in F major. This becomes the basis for more development, which arrives at a fierce segment in A minor. The recapitulation adds more development of the ideas.

The second movement is marked "Andante cantabile," meaning a singing slow movement, its opening theme suitable, say, for a gently triste aria by a melancholy soprano in an opera seria, or a *mezzo carattere* in a buffa. An operatic soprano might be expected to ornament the theme on her own; here ornaments to the theme are written in as the melody spins, finally coming to rest in the basses. Once again sonata form, the whole movement having a dreamy, veiled, nocturnal quality. After a passionate phrase in C minor, the second theme, in C major, is still a touch melancholy, similar to the first theme but lacier. A short development is dominated by the passionate phrase; the recapitulation acquires more elaborate ornamentation, again recalling a seria aria, where the return of a theme calls for expressive virtuosity. The Minuet starts with a breezy theme that, unlike the last symphony's minuet, is more nearly courtly and elegant. Its third and fourth bar evoke the third and fourth bars of the first movement, the cantus firmus motif, now B C E D. That recall is not fortuitous: the second part of the central trio declaims the motif in the high parts, G-sharp A C B.

Those echoes of the symphony's opening cantus motif prepare the opening of the finale, in which the motif reappears but with an important difference. In the beginning of the symphony it was C D G F, which in the key of C is harmonically open; in the finale the same shape is C D F E, which is harmonically closed. In other words, the motif enfolds the whole of the symphony in a single harmonic pattern, open to closed. This beginning is followed by some down-rips that echo the up-ripping figures of the opening.

In its material and in its formal layout, this finale is maybe the most unusual movement Mozart ever produced. This is a result of its fundamental conception, a contrapuntal idea that is easy to explain but not easy to bring off: he will present a series of themelets, one after the other, each with a distinctive melodic and rhythmic profile. They are presented in a steady, brisk dialogue bouncing around the orchestra.[11] In the course of the movement he will rearrange and recombine them until, in a vertiginous coda, he stacks up five themelets at once.

This sort of contrapuntal extravagance doesn't happen by accident.

Mozart had to have written the five-theme climax first, then he separated out the bits and started from the beginning, presenting them individually in the exposition. While the finale is nominally in sonata form, the effect is a kaleidoscopic progression of themes within a context of a steady kinetic energy that occasionally recedes only to flare up again. Here is Mozart the musical athlete, echoing the physical energy of his pastimes: riding, bowling, dancing. Another way to put it is that the finale is a sort of big development, joyously restless and striving, steadily contrapuntal. In that spirit, the recapitulation returns to the cantus theme, but now with added winds and a bass echo that overlaps the theme.

There has been a sense of the music dashing toward something. The coda is the destination not only of the movement but of the whole symphony: the grand combination of motifs, the passage that had to have been created first. So in a way, the movement has been surging toward its essential inception and inspiration First, quietly in strings we hear the cantus theme upside down, then right side up. Suddenly the theme is picked up forte in the horns and bassoons, now to be interwoven with four more of the themelets we have been hearing all along, each of them with answering imitations, each of them cycling up and down in the texture in a dazzling display of invertible counterpoint. The audible effect is a kind of breathtaking bricolage, the elements racing past just beyond our ability to grasp them, finally resolving to a rhythmic unison that brings the symphony to a triumphant close. The finale as a whole is prophetic of the future, which is to say of Beethoven: the onetime light "last dance" of a symphonic finale has been raised to the force of an apotheosis.[12] At the same time, in the history of the genre this movement would remain sui generis.[13]

Because the last three symphonies were not commissioned and there is no firm record of their being performed in Mozart's lifetime, the Romantic century, with its cult of the visionary genius, would have Mozart writing them for himself and addressing them to God and posterity. Generations of biographers would paint it as a tragedy that he never got to hear the most prophetic symphonies of his life. Those notions would take their place in a hoary corpus of myths about Mozart. But he did not address his music to posterity. He wrote these pieces with an eye to upcoming concerts, perhaps ones Swieten was

organizing, and he surely heard them. One sign of this is that after the first version of No. 40, he added clarinets to the winds, revising the piece for a concert; performance parts for the symphony would survive, with corrections in Mozart's hand.[14] Salieri may have conducted one of the last three symphonies at a Tonkünstler charity concert for which musicians donated their services, so there was a massive orchestra.[15] The record is hazy about hearings because programs did not survive, and there was generally no mention of concerts in the papers unless a given piece was reviewed. True, the Austro-Turkish War had led to a decline of performances public and private, likewise commissions. But there was still a good deal of music around, and the symphonies had opportunities to be heard.

So it would be these three symphonies and the ones Haydn wrote for London in the next decade that raised the genre to the commanding position it would occupy from that point on. In the end, Haydn considered large choral pieces to be his most important works; Mozart felt the same about his operas. Beethoven, who was eighteen in 1788, would come to maturity considering symphonies to be his leading works. But for Mozart, meanwhile, the *Jupiter* confirms a new turn in his music after the appointment as imperial court composer, his subsequent pieces showing an intensified ambition, rich textures, streamlined melodies, and more overt and complex counterpoint: call it his imperial style.[16]

With these works Mozart closed his career as a symphonist, though it would not have occurred to him that they were an end point. For him they were a new beginning. With what he had achieved, it would have appeared to him that there was plenty of time for more symphonies. Plenty of time.

IN MARCH 1788 JOSEPH II ARRIVED AT THE FRONT TO TAKE OVER COM-mand of the war. As yet he had gotten no help from his ally, Russia. The war soon slipped toward disaster: bad supply lines, bad roads, bad weather, raging epidemics that killed thousands of soldiers and finally claimed Joseph too. Matters would take a positive turn eventually, but by then it was too late for the emperor.[17] In Vienna, the economy faltered and the arts took a hit—though theater performers, including

musicians, were exempt from the war tax.[18] Concerts dwindled, and with fewer opportunities to perform, Mozart needed no new concertos. In 1788 he gave more than thirty-seven concerts public and private; the next year it was sixteen; in 1790, seven.[19] But in his creative life that was probably fine with him. If his new position as court chamber composer at the moment required writing only dances, he expected to be writing chamber works when the war was over and Joseph returned, so he turned his attention to those. Creatively, this year would be busy in a number of directions.

One new source of income followed from an acclaimed concert when Mozart conducted C. P. E. Bach's Resurrection cantata for Baron van Swieten, with massive forces—the orchestra numbered eighty-six. There followed commissions from Swieten for arrangements of other Handel choral works: *Acis and Galatea*, *Alexander's Feast*, *Ode for St. Cecilia's Day*, and *Messiah*.[20] In Leipzig Swieten had studied with Kirnberger, who had studied with J. S. Bach, and so acquired a passion for "old" music (most of it actually less than a century old) centered on Bach and Handel. (Swieten had first learned of Bach decades before, from the aged Frederick the Great, who whistled for him the king's theme that Bach made into *A Musical Offering*. Frederick assured Swieten that as great as was his court composer C. P. E. Bach, his father was greater.)[21] Mozart was a staple of Swieten's Sunday noontime soirées, presiding at the piano usually reading from a full orchestral score, while a group of men including Swieten and Salieri sang the choral parts of works leaning to J. S. and C. P. E. Bach and to Handel.[22] The main point of Mozart's arrangements, for public concerts Swieten was producing, was to update Handel by turning his Baroque orchestra into a Classical one, with modern expressive marks and a bigger band, including a full wind section in pairs, plus trombones. (Swieten and Mozart also made cuts in the pieces, reassigned solo parts, and the like.)[23] Mozart's *Messiah* version would circulate from then on, in itself and as the basis for further adaptations.

These revivals were epochal. Handel was about to become the central influence on oratorio and sacred music for the next century and beyond. Mozart got involved with these endeavors because it was a welcome paying job and he was interested in the music, but whether he knew it yet

or not, he was preparing himself to be a church Kapellmeister, in which capacity he would be expected to write sacred music regularly for the first time since Salzburg.

For Mozart the big public event of 1788 was the Vienna premiere of *Don Giovanni* at the Burgtheater on May 7, 1788, the production decreed by Joseph II. The emperor would not be around to hear it, but from the battlefront he had been keeping up with how opera was going in Vienna. For the performance, he paid Da Ponte 100 florins and Mozart 225, generous for an adaptation. Aloysia Lange was cast as Donna Anna, the Donna Elvira her rival Caterina Cavalieri, who insisted that Mozart write a new aria for her. He dutifully produced the effervescent "Mi tradi." Aloysia at the time was five months pregnant. In the Vienna run the new Zerlina was Adriana Ferrarese del Bene, who became a sensation with the public and also became Da Ponte's lover.[24] There was a row of other changes in the opera from the Prague version, some felicitous and some not; on the plus side of the equation was "Dalla sua pace," where Don Ottavio got something beautiful to his vocal credit. It appears that Mozart cut the jolly final sextet, instead ending with the Don descending in flames, as arguably is more fitting all around. (He may have restored the sextet later.)[25] For the times, this new finish would have been controversial in some degree, because buffas were supposed to end with forgiveness, reconciliation, a cheery moral, and a few clichés about love and its delights. But *Don Giovanni*, even if the story rose from theatrical convention and cliché, was never a normal buffa. As for the disparities between the Prague and Vienna versions of the opera, the future would have to work that out for itself.

A number of letters about *Don Giovanni* went back and forth between Count Rosenberg, manager of the court opera, and distant Joseph. When Rosenberg admitted the music was splendid, Joseph replied that "your taste is beginning to become reasonable." Joseph was back in town before the last of the performances, but he was too sick to attend.[26] In fact, after a shaky start, *Don Giovanni* was, like *Figaro*, another modest success; there were four additional performances in May and more over the summer, for a total of fifteen. Once again the most cogent response came from Joseph Haydn, who heard the Vienna premiere. He attended a party afterward where cognoscenti were delivering their verdicts. Everybody agreed that the work was a product

of great genius and imagination and so forth, but one said the orchestra was too elaborate, another declared the whole thing chaotic, another bemoaned it as unmelodic. They turned to Haydn, who in some heat declared, "I can't settle the argument. But one thing I do know and that is that Mozart is the greatest composer the world now has." The progress of Mozart's music in the next years would be a matter of the judgment of those most sensitive ears in the art trickling down to the critics and cognoscenti and from there to the public.

If Emperor Joseph was not able to see *Don Giovanni* on the stage, he seems to have looked at the score, maybe played and sang it over. He told Da Ponte, "The opera is divine; possibly, just possibly even more beautiful than *Figaro*. But such music is not meat for the teeth of my Viennese." He meant, in effect, that it was over their heads. When Da Ponte relayed to Mozart the emperor's crack about the town's teeth, Mozart replied only, "Give them time to chew on it."[27] Joseph's critique was the usual, and as usual, Mozart was right. By the time he died, *Don Giovanni* and *Figaro* were selling out across Europe—though neither of them rose to the popularity of *Die Entführung*, which he had written to be a hit and never took particularly seriously.

IN THE MIDDLE OF JUNE 1788, MOZART MOVED THE FAMILY TO THE suburb of Alsergrund. There they had a spacious and cheaper apartment looking out over a garden.[28] Performances having gotten sporadic, there was no need to live in the middle of town. The peace in Alsergrund suited him. After the move, he wrote Masonic brother Johann Michael von Puchberg, a wealthy textile merchant, that in the first ten days he had gotten more work done than in two months in his town flat. Over the next three months he would finish seven major chamber and orchestral pieces, which amounted to over four hours of music including the three symphonies. Apparently none of them was a commission.[29]

All the same, he was feeling low: "If such black thoughts did not come to me so often, thoughts that I banish by a tremendous effort, things would be even better." Likely part of what was bothering him was Constanze, who was showing the effect of multiple pregnancies. (A six-month-old daughter died in June.) But the immediate problem remained

money. Here began a series of letters to Puchberg. Every one of Mozart's surviving letters to him are pleas for cash. The tone in this one is scrupulous and relatively calm. The ensuing letters to Puchberg, nineteen of them in total, would get steadily more agitated over the next years.

> Most Honorable Brother of the Order, / dearest and best friend!—/ The firm conviction that you are my true friend and that you know me as a man of honor encourages me to open my heart to you . . . I shall come right to the point, with my usual frankness and without any pretenses.—/ If you would have the kindness and friendship to support me for one or two years with one or 2000 gulden at a suitable rate of interest, you would help me keep my field and plow! You probably know yourself as a matter of experience and truth how . . . without a certain minimum capital, it is impossible to keep one's affairs in order.—With nothing you can create nothing.[30]

As would become his custom, Puchberg responded to the plea, but not with the requested extravagant loan. He probably sent around 200 florins, but he was not going to countenance supporting his friend for one or two years. Here the question arises, and will arise over and over, of what was going on. After all, if Mozart was not the most popular of living composers, he was among the most respected and best paid. The more sophisticated his listeners, the more the respect. He was not having his best year in earnings, but they were not dramatically worse than usual; in 1788 he made 2000 florins or more, an entirely comfortable income when Viennese clerks lived on 200 or less.[31] He was getting publication fees and there were still occasional performances, which could be profitable. Much of his problem, when performances and publications and commissions became more erratic because of the war, was not a question of total earnings but of cash flow, the perennial bane of the freelancer, in a time when there were no royalties for performances or sales of one's work. He got his money from commissions, publications, and performances, but it came in dollops and tended to leach away in the interims.

So in one way and another money was falling through his fingers.

His father had never taught him to handle finances, and he was still helpless at it. Added to his expensive habits and wardrobe, it may be that the more anxious he felt about his situation, the more reckless he became at billiards and cards. In any case he was starting to worry, and the more he worried, the more he borrowed. In the late 1780s he got loans from several people but mostly from Puchberg, who proved a loyal and generous friend if not a bottomless well of cash.

ONE ITEM FROM THIS PERIOD WAS SOMETHING UNACCUSTOMED FOR Mozart in this decade, a letter to his sister. In their celebrated childhood tours he and Nannerl had reigned as sovereigns in the imaginary Kingdom of Back. In his teens they had traded jokey and affectionate, sometimes startlingly affectionate, letters, and he had written naughty and parodistic entries in her diary. Now his tone with Nannerl is chilly, the affection rhetorical. He begins by apologizing for not having written, probably not since Leopold died.

> You have every right to be angry with me!—But will you still be angry after receiving my newest piano pieces with this mail coach?—Oh, not really!—Well, I do hope my package will make up for everything.—/ I'm sure you know that I wish you well every single day, so I hope you will forgive me that I am limping in with my late congratulations for your Name Day, Dearest Sister—I wish you from the bottom of my heart and from the depth of my soul all the things you wish for yourself . . . Now I have a favor to ask of you;—I would appreciate it very much if [Michael] Haydn could lend me for a little while the two *Tutti-masses* and the *Graduali* he composed;—I would return them with gratitude.—It's now a year since I wrote to him and invited him to come and stay with me, but he has never answered me; so, as far as answering letters is concerned, he seems to have a lot in common with me, don't you agree?—It would be a real help to me if you could do the following: invite him out to your place in St. Gilgen and play some of my New pieces for him—he can't possibly dislike the Trio and Quartet.[32]

Writing on Nannerl's name day was a transparent excuse, sending her new piano pieces a dodge. Mainly he wanted to see some sacred works of Michael Haydn, whom he had respected and studied since childhood. Because he had not completed a sacred work for years and had no occasion to write one now, this is an interesting request. One guess: he had taken note that the Kapellmeister of St. Stephen's Cathedral was getting old, so the man's position, the most coveted and best-paying musical job in town, might come open before long. As it transpired, Mozart wanted to be first in line to succeed him. So the real point of his letter to Nannerl was practical: he still regarded Michael Haydn's sacred music as a model to be studied. Mozart did not otherwise have much practical use for his sister, which is why on a trip to Frankfurt in 1790, he did not take a short detour to visit her, and why, it appears, the next pressing word she had about her brother was the news of his death.

Also in these months there was a shake-up in the musical life of Vienna. Away on the battlefield, Joseph stopped managing the opera in August 1788. To save money, there were only two commissions for new work that year—for Salieri and for his student Joseph Weigl. In another budget-slashing move, Joseph had already transferred German opera from the Kärntnertortheater back to the Burgtheater, ending the dominance of Italian opera there. He closed the Kärntnertortheater for what turned out to be two and a half years, though special productions were allowed.

Having moved out to the Alsergrund suburb in search of peace and a lower rent, at the beginning of 1789 the Mozarts moved back into town to a flat called Zur Mutter Gottes (The Mother of God), on the Judenplatz. The reason for this move is more obscure than for the previous one. Was he expecting some performances to materialize? Was he concerned about Constanze's health? She was pregnant again, and he was planning to be out of town for a while without her for the first time since their wedding. In March he asked for another loan from a friend, this time from legal clerk Franz Hofdemel in Vienna:

I am taking the liberty of asking you without much ceremony for a favor.—If you could or would lend me 100 gulden until the 20th of next month, I would feel much obliged.—On the 20th I

will receive the quarterly installment of my salary and shall be able to repay my loan, with many thanks.—/ I relied too much on the sum of 100 ducats due to me from abroad [his payment for *Don Giovanni* from the Prague National Theatre]—Since I haven't received the sum yet . . . I have left myself a bit short of cash and need some money right at this moment . . . / We shall soon be able to call each other by a more beautiful name! For your proceedings are nearing their end. [The more beautiful name was "brother": Hofdemel was about to be initiated as a Mason.][33]

Mozart did not mention the real purpose of the loan: he needed it for a tour of northern Germany that he and his patron and lodge brother Prince Karl Lichnowsky were about to undertake.

There is no record of when Mozart and Lichnowsky got acquainted. The prince was highly musical, a good pianist, and may have studied with Mozart. In any case they would have encountered each other at the Zur Wohltätigkeit lodge.[34] Lichnowsky had previously studied in Leipzig with a student of J. S. Bach's, and he had an extensive collection of Bach manuscripts that he would have shared with Mozart.[35] But if he was a lavish patron of music in general and of Mozart in particular, Lichnowsky was also an imperious aristocrat who did not appreciate dissension from commoners, an attitude he would exhibit with Mozart and with his later protégé Beethoven.

Why Lichnowsky proposed the tour is not entirely clear, though he had business interests in Berlin and may have brought Mozart along as a favor.[36] He probably covered Mozart's travel and accommodation, but Mozart still had to borrow money for the trip.[37] For Lichnowsky, the tour may also have been something of a vacation, visits with aristocratic friends, some scouting for romance. He was a relentless womanizer; his marriage to Princess Caroline—one of the celebrated beauties of Vienna, a daughter of the Thun family who were Mozart patrons, and a very fine pianist—would not temper his restlessness. Mozart's motivation for the tour was of course money, probably that entirely and not hopes for a court position. He had no reason to leave Vienna, especially as things might be looking up there. The war had to end sometime, and he assumed the musical scene would revive.

Before Mozart left on the tour, he composed some farewell doggerel for Constanze, which she began by laying out the last word of each line:

When I travel to Berlin in Style
I hope to gain honor and Fame,
yet the applause will not make me—smile,
for you, my dear, cannot enjoy the same;
But at our wiedersehen I already know,
we'll be hugging and kissing with burning Desire!
Meantime, though, tears of sorrow will flow
splitting our hearts into patience and Fire.[38]

The tour lasted from early April to early June 1789, with significant gaps in the record. In April Mozart and Lichnowsky saw Prague, Dresden, Leipzig, and the Prussian court at Potsdam; in May Mozart returned to Leipzig and then headed for Berlin. For him there seems to have been no overarching plan beyond looking for promising patrons. In Prague he had a reunion with Domenico Guardasoni, who had commissioned *Don Giovanni*. The impresario offered him nine hundred florins plus generous expenses for a new opera, but there was no contract and nothing came of it.[39]

The Dresden stay included an intriguing social visit. It was with Christian Gottfried Körner, a playwright and celebrated *saloniste*, also an Illuminatus and a friend of Friedrich Schiller. Körner seems to have nudged Schiller in Illuminist and Masonic directions in the poet's legendary "Ode to Joy," from 1785. In other words, he was politically progressive unto radical, and something of a mystic. To what extent that interested or influenced Mozart is impossible to say, but he was soon to write a Masonic opera, and Körner could not have been more relevant to that.

During the Dresden visit, Körner's sister-in-law Dora Stock did a drawing of Mozart, silverpoint on an ivory board. It is one of the most straightforward of his portraits; Stock was interested in capturing his likeness, not his soul. The portrait is in profile, showing him as an ordinary-looking man getting toward a fleshy middle age, eyes protruding a bit, his lush hair—he had stopped wearing wigs years before—arranged to cover his deformed earlobe.[40] This was probably

the last portrait of Mozart from life. The date of the more celebrated
one by his brother-in-law Joseph Lange is unclear, but likely dates from
earlier in the decade. (Originally a head portrait, it was grafted onto a
larger canvas that remained unfinished.) Those two are the only like-
nesses done from life in Mozart's maturity.

During the tour Constanze lived sometimes alone in the flat with
son Karl, but mostly stayed with the Puchbergs. Mozart wrote her[41]
often, the letters a mixture of news and jokes and affection, giving
occasional glimpses into their private language and intimate nick-
names.

> Dearest little Wife! / While the prince is off bargaining for fresh
> horses, I am seizing this opportunity with great pleasure to write
> you, dearest little wife of my heart, a few quick words.—How
> are you?—Are you thinking of me as often as I'm thinking of
> you?—I look at your portrait every few minutes—and cry—
> half out of joy, half out of sorrow! . . . And don't worry on my
> account, because I'm suffering no hardships on this trip—no
> adversities—except your *absence*—which, as it can't be helped,
> simply must be endured.—I am writing this with tears in my
> eyes;— . . . I kiss you most tenderly a Million times and remain
> Forever your / stu-stu Mozart.[42]

By Dresden he was missing her more poignantly:

> If I wrote you all the things I'm doing with your *portrait* you would
> certainly laugh.—For example when I take it out of its prison,
> I say: Grüß dich, Gott, Stanzerl!—grüss dich gott, grüss dich
> gott;—Spitzbub:—knaller-baller;—Spitzignas—bagateller—
> schluck und druck!—And when I put it back in its case, I slide
> it in very slowly saying all the while: Stu!—Stu!—Stu!—but
> with a certain emphasis that is appropriate for such a meaningful
> word . . . Well, I think what I've written here is pretty stupid, at
> least as far as the outside world is concerned.—But for the two
> of us, who love each other dearly, it's not stupid at all.—Today is
> the 6th day I've been away from you, and, Heavens, it seems like
> a year to me.[43]

The *stu-stu-stu* that came up again in this letter might indicate a sexual rhythm, and the implications of *schluck and druck*, "slurp and squeeze," are to the point as well. (He wrote a vocal quartet on that text for Constanze.)[44] His letters home would get only more heated as the trip went on. At the same time, the couple's separation raised his concerns about her health and also raised a simmering jealously that had emerged from time to time since before they were married:

> Dearest Little wife, I have a number of requests to make:—first I beg you not to be sad; 2nd that you take good care of your health and be careful when you go out into those spring breezes. 3rd that you don't go out walking by yourself—but best of all—don't go out walking at all. 4th that you feel completely assured of my love.—I haven't written you a letter yet without putting your portrait before me. 6th et ultimo, I'm asking you to please be a little more detailed in your letters.— . . . 5th I beg you to think not only of your and my honor in your conduct. But even of just the appearance of it.—Please don't be annoyed by this request.— You should love me all the more for being so concerned about honor. / Now farewell, dearest, my truly beloved!—Remember that every night before going to bed I talk to your portrait for a good half hour, and when I wake up I do the same. . . . Oh, stru! stri!—I kiss you and squeeze you 1095060437082 times; this will help you to practice your pronunciation.[45]

As in childhood, he moved from one small triumph to another. At a stopover in Leipzig, he improvised for an hour on J. S. Bach's organ at St. Thomas Church. A newspaper report said that an old student of Bach's had raved that his master had been resurrected. Mozart toured the school where Bach used to teach and heard a motet performed, perhaps "Singet dem Herrn."[46] At the end of April he and Lichnowsky arrived in Potsdam, eighteen miles from Berlin, in the hope of meeting Prussian king Frederick William II, who was a musical enthusiast and a fine cellist. Otherwise the king was notoriously attentive to the ladies, one of his nicknames among his subjects being "the fat scallywag."

Mozart stayed in Potsdam for seventeen days, his doings there a mystery. He had not announced his imminent arrival, as Leopold would

invariably have done on a tour. Records show that the court had no idea he was coming to town.[47] He was received by the director of court chamber music, the famed cellist Jean-Pierre Duport, whom Mozart had met in Paris when he was eight.[48] As a tip of the hat to his host, Mozart wrote some variations on a Duport minuet.[49] If he made the usual rounds of aristocratic salons, there is no record of it. Another version of the visit, an unlikely one, has him being received by the king and Queen Friederike, playing for them over several days and receiving an offer from Frederick William for a well-paying job, which he did not accept.[50] Whether or not that happened, Mozart appears to have gotten one hundred friedrichs d'or from the king as commission for a set of six string quartets and also six piano sonatas for the royal daughter.

May 8 found the travelers back in Leipzig, where the mysteries of the trip took a new turn. The most puzzling of them: Prince Lichnowsky headed home, leaving Mozart to finish the tour alone. Just before his patron left, Mozart borrowed from him Prussian thalers amounting to some fourteen hundred florins, at 4 percent interest. In turn, Lichnowsky borrowed back one hundred thalers in cash for his journey home.[51] Why would the lavishly rich Lichnowsky be strapped for cash? There the matter stood until two years later, at which point things became still stranger.

On this second Leipzig visit Mozart mounted a concert of his music on May 12 at the legendary Gewandhaus hall, the kind of dedicated music venue that Vienna had never possessed. This was a gala program with orchestra, the music including the concertos K. 456 in B-flat and K. 503 in C, and two symphonies in part or in whole, probably drawn from his recent three. Josepha Duschek sang two of his scenas, including "Bella mia fiamma," which he had written for her, and he soloed in the C-minor Fantasy and some improvised variations.[52] In rehearsal he found the orchestra players aged and obdurate; at one point, he was stamping his foot so hard to mark the beat that he broke a shoe buckle.[53]

The take from the Leipzig concert was disappointing, partly because he had to hire an orchestra, partly because he was competing with himself—*Figaro* was being played in town that night.[54] As interesting as anything he did in Leipzig was a little Gigue in G Major for Keyboard, K. 574, that on the eve of his departure he wrote in

the friendship album of organist Carl Immanuel Engel. Intricately contrapuntal, the piece is a vertiginous harmonic labyrinth based on chromatic lines spidering up and down, its tonal nebulousness matched by ambiguities of pulse and meter. The first five beats, for example, enfold ten of the twelve chromatic notes.[55] He must have worked out the piece earlier; even Mozart could not produce something that esoteric on the spot.

Near the end of the Berlin stay he wrote a final yearning letter to Constanze. He begins in fussy fashion by citing the dates and places of his eleven letters to her, and her six replies (one of her letters perhaps lost in the mail). He cautions, "When I return, you'll have to be content with seeing me rather than money."[56] This is strange. He had been paid quite a bit during the tour—it added up to a thousand florins or more, maybe a lot more, and he had also borrowed from Lichnowsky.[57] By way of explanation, in the letter to Constanze he cites the high costs of staying in Leipzig and the poor receipts from his Gewandhaus concert. (He also underestimated the value of the one hundred friedrichs d'or he had gleaned from the Berlin commission, which equaled some eight hundred florins. In the event, he would not finish the pieces.)[58] Apparently money was still dribbling away at card tables or elsewhere.

More to the point, in the letter he makes a husbandly request of his wife. He is missing her terribly, or wants to assure her he is. As always, for him love and lovemaking were one. He tells her he'll be home on June 4, and out of amatory desperation he has to resort to taking himself in hand. Soon, he sighs,

> I'll be sleeping with my dear little wife;—Spruce up your sweet little nest because my little rascal here really deserves it, he has been very well behaved but now he's itching to possess your sweet . . . [sic] Just imagine that little sneak, while I am writing he has secretly crept up on the table and now looks at me questioningly; but I without much ado, give him a little slap . . . Well, he is almost out of control—the scoundrel. I hope you will take a carriage and come out to meet me at the first postal station?[59]

After an eventful tour with curiously ambiguous results, when Mozart arrived back in Vienna his reunion with his wife was not as sweet

as he had hoped. Constanze was pregnant and ailing, soon to be bed-ridden; with Mozart she delivered six children in nine years. He had made good money on the trip, but the cash he was going to need for doctors seemed to have evaporated. He was not seriously in debt, not yet, but he was getting worryingly behind. Meanwhile the war was still on, musical life still constrained by war taxes. The nobility who were not commanding in the field had fled the turmoil of the city to their country estates.[60] Now the town's chief patron, Emperor Joseph, was suffering both from tuberculosis and malaria. Vienna blamed the em-peror for everything: the losses on the battlefield, the faltering econ-omy. And public blame of Joseph the war leader spread into blame of his social and political agenda.

In one way or another, all of it came down on Mozart. He had suf-fered his share of hard times before, which he had always met with stoic hopefulness. Now, maybe for the first time in his life, he felt cornered and desperate. He owed a fair amount of money and needed more, and he was beginning to be afraid he might lose his wife, which he could only view with dread. He panicked.

THE TRUTH OF THE MOMENT

C all the letter Mozart wrote to friend Michael Puchberg on July 12, 1789, as much a sign of his state of mind as of his financial condition:

Dearest and best friend! / And Most Honorable Brother. / Oh, God! The situation I'm in, I wouldn't wish it on my worst enemy; and if you, my best friend and brother, forsake me, I, <u>helpless and blameless as I am</u>, will be lost together with my poor, sick wife and child.—I had wished to pour out my heart to you last time I was at your house—but I didn't have the heart to do it! And I would not have the courage even now—indeed, I can do it only with a trembling hand in writing—and I wouldn't even dare to put it in writing—if I didn't know that you know me well, know about my circumstances, and are completely convinced of my <u>innocence</u> in this wretched and most distressing situation. Oh, God! Instead of thanking you, I come to you with new requests!—Instead of paying off my debts, I come asking for more. If you can see into my heart, you know how anguished I am about this. I probably won't need to tell you once again that this unfortunate illness is slowing me down with my earnings, but I will tell you that in spite of my miserable situation I had decided to go ahead and give subscription concerts at my house so that I can at least take care of my expenses, which are considerable and frequent, for I was sure of receiving your friendly help and support; but this plan isn't

working either; fate is against me, <u>but only in Vienna</u>, I cannot earn any money even when I want to; for two weeks now I've sent around a list for subscriptions and there is only one name on it: <u>Swieten!</u>— . . . In the meantime I'm composing six easy piano sonatas for Princess Friederike and six quartets for the King . . . Besides, in a couple of months my fate will be decided in <u>other things</u> as well, therefore, you are not risking anything.

He asks Puchberg for five hundred florins, and adds a postscript:

I can hardly make up my mind to send this letter!—But I must!—If it weren't for this illness, I wouldn't be forced to be so shameless before my one and only friend;—yet, I hope for your forgiveness, for you know both the good and <u>the bad of my situation</u>. The bad is only temporary, the Good, however, will endure once the Bad has been overcome.—Adieu!—Forgive me, for God's sake, do forgive me![1]

The tone of the letter is notable partly because it is so consistent, even polished, in its desperation. It is not without rhetorical flourishes: "wouldn't wish it on my worst enemy," "pour out my heart," "my one and only friend." It is on the order of a beseeching aria by a grieving prince in an opera seria, though in the actual world it is still remarkable for the anguish so nakedly revealed. Mozart did not feel, that is to say, that such nakedness was beneath him. It is what you do when you are laying your plight at the feet of a friend. The beginning of the letter shows the essential reason for his despair: Constanze had developed a foot infection that in those days, in that state of medicine, was truly dangerous. The infection soon ulcerated, and she was also afflicted with bedsores, which means that she had been in bed for a while.

A doctor sent her for a cure to the spa at Baden, where she would spend much of the next year and a half. Doctors, a spa—all of it expensive, and nearly useless to treat her condition. Mozart still had money coming in and his work would go on undisturbed, though in 1789 he did more sketching than finishing. But payments were haphazard, and Constanze's illness was relentless. He would write only two of the piano sonatas and three of the quartets commissioned by the Prussian king.

He was still making fairly good money, but Constanze's illness was going to consume more than he was making. For what hope cost, he had to rely on friends. When Puchberg did not respond to the letter Mozart sent him a second one, equally abject but more specific: "She is astonishingly resigned to her fate, and is awaiting improvement or death with true philosophical equanimity; I'm writing this with tears in my eyes." These were not rhetorical flourishes. For over a year he and Constanze would live with death hovering over them. They had buried four children by now, and that was not out of the ordinary. No sensible person in those days felt themselves far from the grave. He had asked for 500 florins; finally Puchberg sent 150. Mozart thanked him profusely.[2]

IN PARIS ON JULY 14, 1789, TWO DAYS AFTER HE WROTE THE LETTER TO Puchberg, a mob of citizens who had lived for months in fear of starvation stormed the fortress of the Bastille, which had become a symbol of royal tyranny. King Louis XVI and his wife Marie Antoinette, sister of Joseph II, tried to calm the waters by donning the tricolor cockade of the rebels. It did no good. The king and his queen, their thrones, the whole of the French nobility, were about to be inundated by a tide of history. Vienna newspapers would be headlining events in France for years to come.

Hearing the news, Joseph II—back in Vienna and desperately ill—was livid; he feared for his sister and expected worse to come. Joseph had always been prone to snap decisions. Now, virtually in a moment, determined to stamp out any hint of revolution that might be simmering in Austria, he began to rescind his treasured reforms. He ordered the head of police to begin a ruthless censorship of books and the press. Soon a network of spies would arise to keep a close eye on the citizenry. Viennese chronicler Johann Pezzl wrote that the atmosphere became so charged that "one never speaks openly, and never about matters of importance. It is known that walls have ears."[3] Joseph, who had dreamed of creating the most rational and liberal state in Europe, was transforming his country into a police state that would broaden and intensify for decades to come. Now it would be the French who would enact much

of Joseph's abandoned program: dissolution of monasteries, a national church, religious tolerance, equality before the law, and so on.[4] But as it played out, while proclaiming the rule of reason, the French Revolution would cascade into a bloodbath of unreason.

History would have no idea how Mozart felt about what was taking shape in France then or in the next two years, because he did not tend to write letters about it. What letters he may have written with any political content were, in the growing climate of repression, destroyed by his wife after he died, along with any compromising literature he owned.[5] What Mozart may have said in person about political matters was said to trusted friends in private, because suddenly the walls had ears. Only three pieces of evidence would endure concerning Mozart's sociopolitical leanings: he had been in some degree and fashion a supporter of Joseph and of his reforms; he was a Freemason, which places him somewhere on the progressive spectrum; and his last completed opera is a paean to Enlightenment.

In September 1789, the family moved to the Kleines Kauserhaus on Rauhensteingasse in the inner city. It was a high-ceilinged flat of over fifteen hundred square feet. Besides the essentials of pedal piano and billiard table, their furnishings crammed the place: four sofas, eighteen armchairs, five wardrobes, a secretary and manuscript cabinet, five tables, two bookcases, four beds, one of them double. There was an attached stable for his horse, and they kept three servants, who slept wherever there was room.[6] They were still living high on the hog, Mozart still dressing like an aristocrat. For some performances he sported a white suit, and there were outfits in silk and satin.

In the summer of 1789, Constanze languished in Baden, struggling with her ulcerated foot and six months pregnant. (The baby would be a daughter who survived for one hour.) Mozart was frantic. Maybe because of that state of mind, his simmering jealousy boiled up again. Set in beautiful hills and valleys and with waters celebrated (for no good reason) for their healthful benefits, Baden was an oasis for those who could afford it. With its spirited social scene and mixed bathing it was also a place for entertainment and romantic adventure. In August Mozart wrote a letter to Constanze that attempted to be newsy and consoling but quickly turned worrying.

I was overjoyed to get your dear letter—and I hope you received
my second one yesterday with the decoctum, the electuary,
and the ant's eggs I sent along [home remedies, and the ants'
eggs maybe for bird feed]—I myself shall set sail tomorrow at
5 o'clock to visit you;—if it weren't for the joy of seeing you and
holding you in my arms, I wouldn't come out to Baden just now,
because "Figaro" is going to be staged again soon, and since
I'm to make some changes, I'll need to be here for the rehears-
als . . . dearest little wife!—Let me talk candidly:—you have
no reason whatever to be sad—you have a husband who loves
you, who does everything he possibly can for you—and as far
as your foot is concerned—all you need is to be patient and I'm
sure everything will be fine;—and, you know, I am glad when
you are having fun—I truly am—I only wished you wouldn't
lower yourself so much at times—you are a bit too familiar with
N.N. [unknown] . . . A Woman has to always behave properly—
otherwise people will talk—Dearest!—Forgive me for being
so frank, but it is necessary for my peace of mind as well as our
happiness together—just remember that you yourself confessed
to me once that you give in too easily—and you know what
the consequences are—so do remember the promise you gave
me—Oh, dear God!—Make an effort, my love!—Be merry and
happy and loving with me—and don't torture yourself and me
with unfounded jealousy—trust in my love, for you do have full
proof of it! And you'll see how happy we will be together and,
believe me, only a woman's proper conduct can tie a man firmly to
her –adjeu [*sic*]—tomorrow I shall be kissing you most tenderly.[7]

Really neither of them was in good shape. A visitor recalled Mozart
in those days as "a small man with a large head and fleshy hands . . .
gaunt and pale."[8] He had always been described as small, pale, and or-
dinary looking; the "gaunt" is a new factor. Reported as getting plump
during the *Don Giovanni* premiere, he had apparently been losing
weight. Since childhood he had been capable of marathon feats of work
when necessary. Much of the time in these years he worked late into the
night and slept four or five hours. He maintained that discipline, some-
times turning out music at an all-but-superhuman clip, but his ability

to withstand his relentless schedule was not keeping pace. If Mozart's creative juices were running high, the body that had to contain them was faltering.

At least the critical zeitgeist was turning in his direction. A leading critic of the day wrote a long article based on *Don Giovanni*. He fumes for a while about what a foolish and detestable character the Don is, but when he gets to the music:

> *Mozart* is no ordinary composer. He is not content with light, pleasing melodies written down at random. His music is carefully planned, profoundly felt work, suited to the personalities, situations and sentiments of his characters. It shows study of the language, which he treats musically, and just knowledge of prosody . . . He never applies runs and trills to syllables which are unable to bear them . . . With him every note proceeds from feeling and generates feeling. His expression is glowing, vivid and picturesque, yet without becoming fulsome and excessive. He has the richest and yet the most restrained imagination. He is the true virtuoso who never lets imagination run away with intelligence. Reason guides his enthusiasm and calm judgment his presentation.[9]

In September 1789 Mozart was busy with a new opera, but he took time to write a singular and loving Clarinet Quintet (clarinet and string quartet) for his friend Anton Stadler. The first performance may have been private or at a December court concert for the Society of Musicians. Despite its name, the piece was written for something called the "basset clarinet," a little larger than the usual instrument, a specialty of Stadler's. It remained rare, never catching on with orchestras. (Because the piece was rarely played on the basset clarinet, early publications moved its low notes up to the range of the usual instrument.) In any avatar, call this Quintet the essence of Mozart's feeling for the clarinet and for Stadler: from beginning to end it is largely a procession of warmly songful themes, which is to say that for Mozart the clarinet was a sister of the female voice. This is a work in his most summery mood (as are most of his clarinet pieces), recalling what the aforementioned critic wrote, "Every note proceeds from feeling and

generates feeling." Also appropriate: "reason guides his enthusiasm." In its material the quintet is not only ravishing but also concise and tightly woven.

It begins with a few gentle bars that will recur like a motto in the first movement. In a phrase of sighing lyricism, the motto lays out the essential melodic germs for the whole of the piece: the opening interval of a third is the central motif, but also the opening line E C-sharp B A, and the three-note rise of the next bar will be central. The last two beats of the third bar and the next bar provide a motif for the end of the first section. After the motto the clarinet enters quietly in the rich-flavored bottom of its range and soars up to the high range: this is going to be another piece not just *for* the clarinet, but also *about* this richest of the wind instruments, in the colors of its ranges and the varieties of its articulation from sharp staccato to flowing legato.

There are four themes in the exposition, all of them exquisitely lyrical. After citing the motto, the development is mostly given to the strings working over the clarinet roulades of the eighth bar, while the clarinet falls into a staccato accompaniment dancing through the whole of its range. Beyond its singing themes, of the sort the clarinet generally drew out of Mozart, the first movement has a quality of floating reverie. Some of that comes from the freedom of its phrasing: in most of the piece Mozart studiously avoids the usual four-bar phrases characteristic of eighteenth-century dance music. This contributes to the rhapsodic mood, each phrase finding its own length, winsome melodies ambling freely around the musical landscape.

The Larghetto second movement is laid out in an ABA pattern, which in its simplicity emphasizes the unfolding of the melodic lines. In its motivic details the opening melody recalls the motto of the first movement, its mood like an operatic love song. In the first movement the clarinet was not the lead voice much of the time, more like an honored guest among the strings. Here the clarinet sings from the beginning, most of the movement an affectionate duet between clarinet and first violin. Another forthright tune based on the opening motto begins an easygoing minuet, again mostly a dialogue of clarinet and violin. It is unusual in having two trio sections, the first a wry stretch as if a bit breathless, the second a lilting and gracious dance. The finale is a variation movement on an impish staccato theme whose irony is partly

due to its phrasing: after three movements with few four-bar phrases, the finale is relentlessly regular. The music is mostly lighthearted, with a poignant Adagio in the middle. There are assorted references to earlier moments: the Quintet's opening motto still resonates in the background, the first variation recalls the second trio of the minuet, the third variation recalls the second theme of the first movement, and so on. After a short coda the final bars are curt and pert, as if to say: so long, my friends, have to run, it was fun.

IN DECEMBER MOZART WROTE ANOTHER LETTER TO PUCHBERG, ASKING for money as usual, this one less frantic in tone. He begins with a reassurance that the money is all but in hand, the only problem cash flow.

> Don't be alarmed about the content of this letter;—only to you my best friend, because you know my circumstances intimately, do I have the courage to open my heart completely.—Next month I will receive 200 ducats for my opera from the theater management . . . If you could lend me 400 gulden until then, you would be rescuing your friend from the greatest embarrassment . . . I would've been able to stretch my money until then, in spite of the big expenses I have every day, if it weren't for the fact that New Year is upon us and I have to pay off the Apothecaries and the Doctors (whom we don't need any more) in full if I don't want to lose my credit . . . I'm inviting you (and you alone) on Thursday at 10 o'clock in the morning to my place for a small opera rehearsal;—I'm inviting only you and Haydn.—I will tell you in person about some of Salieri's intrigues, which, however, have already misfired.[10]

If he is not fibbing or had not been misled, the court had promised him some 900 florins for the new opera, *Così fan tutte*, which was twice the going rate. In the end, though, it appears that he received 450, the usual for an opera.[11] In the letter he implies that Constanze is getting better. Maybe she was, but it would not last; she would be back in Baden soon. He brings up his by now virtually ritualistic suspicions of Salieri. If there is any reality behind his accusations this time, there may have

been a discernible reason. Since late 1788 there had been a new diva in town, Adriana Ferrarese del Bene. Now she was supposed to sing both in a Salieri opera and in the premiere of *Così*, and this created frictions in scheduling the two works.[12] The frictions were resolved, the rancor maybe not. As per the sometime-incestuous opera scene in Vienna, Ferrarese was Lorenzo Da Ponte's current lover. She was said to be on the homely side and hopeless as an actress, but she had a splendid voice and, Da Ponte recalled, beautiful eyes and an enchanting mouth. At the same time, he admitted to her "somewhat violent character that tended to provoke malevolence rather than inspire friendship." Mozart was not one of Ferrarese's admirers, but she was a popular diva with whom he had to deal. In *Così*, he wrote for her a tormented character who may have been beyond her dramatic skills: Fiordiligi.[13]

The premiere of *Così fan tutte* fell on January 26, 1790, at the Burgtheater. It was the day before Mozart's thirty-fourth birthday. The house was packed, the biggest audience of the season. The success of the early performances was immediate, as far as fate allowed, but the ensuing record of the opera was going to be volatile.

OTHER THAN ITS BEING COMMISSIONED BY THE COURT, NEARLY EVerything about the inception of *Così fan tutte* would remain a mystery. Joseph II was ill and sequestered, and it is not clear if he had anything to do with it. Da Ponte seems to have written the libretto for Salieri, who made some sketches toward it and then for some reason, uncharacteristically for him, he dropped it, whereupon Da Ponte took it to Mozart. At this point the title was *The School for Lovers*, one of a collection of *School* librettos of the time, including Salieri's *School of Jealousy*. There is no record of when in 1789 Mozart began work on *Così*, but as the invitation to Puchberg shows, by December it was in rehearsal and he invited Haydn to hear it. The singers slated for the premiere were a collection of stars: the old philosopher Don Alfonso written for Francesco Bussani, near the end of a celebrated thirty-year career in buffa, where he sang both bass and tenor roles; Bussani's wife Dorothea, the first Cherubino, sang the chambermaid Despina; baritone Francesco Benucci, Mozart's first Figaro, was Guglielmo; the leading buffa tenor Vincenzo Calvesi took Ferrando;

young rising star Louise Villeneuve was the flighty Dorabella; Ferrarese had the meaty role of Fiordiligi.

These were good unto superb singers, some of them admired as well for their acting. At the same time, the cast was a distilled demonstration of the rivalries and tumults of Viennese operatic life: who hated whom. In early 1789 Da Ponte had premiered a pasticcio called *The Musical Bee*, installing his lover Ferrarese as prima donna rather than her rival (and Salieri's lover) Caterina Cavalieri. This ruptured the friendship between the two men. Louise Villeneuve, meanwhile, was bitter about not getting a part in the *Bee* and so was generally hostile to Da Ponte. For his part, Da Ponte considered Dorothea Bussani a minimally talented singer who got her reputation by shameless clowning. Da Ponte and her husband Francesco did not get on either, because Da Ponte felt Bussani had horned in on casting decisions in the Italian company. (Francesco Bussani was much older than his wife, so Da Ponte had her sing to him as Despina to Don Alfonso: "an old man like you can't do anything for a girl.")[14] Ferrarese was the touchiest prima donna in town. As a result of all this, rehearsals for *Così* must have been tense.

The main mysteries, ambiguities, puzzles about *Così* have to do with the story and characters. This was one of the few librettos that Da Ponte fashioned from the ground up; his other works for Mozart were adaptations. The book shows Da Ponte indulging his scholarly passions: elements of Metastasio, including limiting the characters to six; ideas lifted from Goldoni the father of opera buffa, such as arias in which characters excoriate the opposite sex; bits of plot lifted from popular buffas, such as the test of faithfulness by disguised lovers.[15] Echoes of Boccaccio and Ovid enter in, along with a recent and notorious Parisian marital scandal in which Beaumarchais took a public stand in favor of the wife.[16] There is a steady influence of one of Da Ponte's touchstones, the classic Italian tales of Ariosto's epic poem *Orlando Furioso*, with its ironical examination of sensual love. But the gist, the flavor, the provocation, of the story came from Da Ponte. He was not only writing the words; he was also drawing on a lifetime of passions emotional and literary with which his collaborator had nothing to do. The opera's lampoon of Mozart's childhood patron Franz Mesmer may have been Mozart's idea, at least; maybe not coincidentally, the husband in the Paris scandal was a well-known devotee of Mesmer.

Otherwise Mozart presumably did his usual cutting and shaping to

make the book more musical, but that does not involve the content of the story, and again, that is the puzzle. A lingering query hangs over the opera: what did Da Ponte have in mind with this not-all-that-funny, finally traumatic, soi-disant opera buffa, and to what extent was Mozart of the same mind about it as his librettist?

TO BEGIN WITH THE TITLE. *COSÌ FAN TUTTE*, TRANSLATED AS "THEY [women] All Do It" or "Women Are Like That." If that sounds misogynistic, it is, though not in a simple way. The story is a prime demonstration that the later eighteenth century was not prudish about sex being critically examined in art. (What could not be examined critically, in the new atmosphere, was politics.) Unlike *Figaro*, where the classes of the characters are manifest and are the essence of the plot, *Così* exists in a bubble: other than the servant girl Despina, a familiar buffa character, we are not told the class of the other principals, or whether the place in Naples where sisters Fiordiligi and Dorabella live is a palace or a middle-class domicile. Their beaux, Ferrando and Guglielmo, are as much seria as buffa characters, and so is Fiordiligi.

In *Figaro* the story involves disguises and confusions of identity; in *Così*, disguise and confusion are the motor of the plot. *Figaro* is a High Enlightenment study of the nature of classes and of love; *Così* verges on a polemic against reason, against romantic love, against the Enlightenment itself. It does share one major element with *Figaro*: it ends in forgiveness and a nominal return to decency and normality. But with these four principals the forgiveness goes in every direction, and what sort of return to what sort of normality is an open question. By the curtain, four lives have ended up in a nasty mess, and we're left wondering what's so funny about it all. If anything has triumphed, really, it is not goodness and logic but the supreme power of desire and deception.

The opera begins with an argument between two friends, Ferrando and Guglielmo. They are disputing about their fiancées, Dorabella and Fiordiligi. Both declare the sisters to be incomparable specimens of their sex and beyond reproach in their fidelity: "her constancy equals her beauty," boasts Guglielmo of Fiordiligi. This debate is making the older Don Alfonso tired. A self-proclaimed philosopher of reality as opposed to the delusion and sentimentality of these lads, he has ad-

vised them that there is no such thing as perfect fidelity among women. Now, after a lot of guff from the boys, he proposes a bet that will reveal whether their lovers are goddesses or actual women. He has a scheme on which he will give them instructions that must be strictly followed. The men blithely accept the bet, certain they'll win.

Don Alfonso's scheme is for the two men to pretend to be called off to war, then to return in disguise as Albanians and attempt to seduce each other's girl. If they succeed, they will certify the wisdom of Alfonso and lose the bet. If their loves prove true, they will win the bet. But most significantly, as it gradually sinks in, they have wagered their faith in their lovers—beyond that, their faith in love itself; beyond that, faith in human constancy and reason. For the men, to win the seduction is to lose everything.

It all unravels in a wedding scene of unpleasant revelations. Having won the bet, Don Alfonso benevolently counsels forgiveness all around, because that is to be guided by reason, because, after all, *così fan tutte*.

THIS IS DA PONTE'S STORY FROM THE INCEPTION, SO IT IS HARD TO SEE the libretto as other than, in some degree, his brief against love and marriage as conceived by enlightened sorts: a romantic and sexual partnership more or less made in heaven. Da Ponte's life had revolved around two passions: literature and his ungovernable appetite for women. He tended to fall for tempestuous lovers, such as his current one Adriana Ferrarese del Bene. For Da Ponte and for the opera, when it comes to love heaven has nothing to do with it. Love is a secular and provisional matter ruled by the inconstancy of humans in general and of women in particular, everybody helpless in the grip of desire. The only solution is mutual understanding and forgiveness. The men in their murderous rage will be restrained by a more fundamental fact: in spite of everything their woman have done, as they see it, to betray them, they still love. In essence, that was Da Ponte's own experience with women. At the same time, the opera involves an exploration of women's sexuality surely unprecedented on the opera stage, one that would shock generations to come.

What Mozart thought of all this is contained in the music, but there

his attitude is still ambiguous. In his life and in his other mature operas, love would seem to be a supreme value and a source of high wisdom. Here he is collaborating on as jaundiced a portrayal of love as was ever seen on the stage (though this was also the decade of the contest of seduction in Choderlos de Laclos's novel *Les liaisons dangereuses*).

So the opera raises a tangle of questions. To repeat: were Mozart and Da Ponte on the same page about the meaning and direction of the story? This is maybe not possible to say. What can be said is that they didn't really have to be on the same page. Mozart did not feel obliged to choose librettos to suit his sociopolitical convictions—though in *Figaro* and particularly in the next opera, he probably was very much in tune with the story. He wanted a libretto that worked, that was interesting, that provided a solid framework for music, that might go over well with the public. That *Così* dealt with sex in some ways even more heated than *Don Giovanni* probably appealed to him.

Mozart took what Da Ponte brought him, he absorbed the libretto as he always did, and he made decisions about the music that both integrated and transcended the conventions of the buffa genre. The gist of his decisions was again that of an actor: in the music he would usually portray the emotions at hand, expressing the truth of the moment and not necessarily what was in the hearts of the characters, who in the case of the men much of the time, are lying. On the whole, Mozart will present the feigned truth the characters are projecting in their web of disguises and lies. Sometimes this will entail a quartet where the men are dissembling about their feelings and the women are not. Much of the time, there is the overall truth of the music—say, tender or anguished—in counterpoint to the underlying cynical if not brutal realities of forced seduction and deception, deceivers and deceived often singing tenderly together. This is essentially why *Così* is most unsettling when it is most beautiful. And some of it is beautiful indeed.

On the surface, *Così* is an opera buffa. It has the frantic buffa first-act finale, the saucy servant girl, the familiar plot of a test of love. It has none of the apparatus of an opera seria. But as a buffa it is even more eccentric than *Don Giovanni*. If Mozart's earlier operas involved disguises and lies, here those things are going to be central. Earlier his librettos integrated seria music and characters into buffa. This nominally comic opera is going to be an ongoing dialectic between seria and buffa in its

music and in its feelings, in the frivolity and the suffering of the characters. All this is to say that, once again, Mozart is taking up convention and bending it to his purposes. He is also taking up Da Ponte's libretto, with its own bendings of convention, and handling them to suit himself.

Future generations would often hold all this against Mozart, the beauty of *Così fan tutte*'s music seeming to exalt disguising, feigning, *acting*. But Mozart instinctively understood the truth of Shakespeare's words (maybe he had actually read those words): "the truest poetry is the most feigning." Art is a disguise, an as-if, a game of lies that asks to be believed in. The truth of art is not required to be the same as the truth of the world, and that is among the truths of *Così fan tutte*, in its unreal bubble.

Another truth of art is that any philosophy a piece may contain justifies nothing in itself. The thing has to *work*. If Mozart had decided to make his music follow the inner reality of every moment, the lying and hypocrisy, he could have ended up with a bitter pill of a score. There had to be room for beauty, for earnest emotions even when they are an act—beauty being a truth in itself, and the beauty of music independent of the sentiments it may be presenting in a lyric. So the solution, maybe the only solution open to him, was what he crafted: a dialectic between the apparent truth of the sometimes exquisite surface and the usually acrid genuine truth beneath it: the troubling reality behind the jeweled mask.

THE OVERTURE IS A CURTAIN-RAISER FAIRLY SIMPLE IN MATERIAL, most of it ringing chords with pouncing syncopations, a skittering, conspiratorial theme in strings, twisting woodwind figures. The orchestra has a full wind section, and the winds in general and clarinets in particular will figure more centrally in this than in any other of Mozart's operas. Most articulate in the overture is the introduction, a tutti proclamation followed by a tender oboe solo, ending with some big chords prophesying the eponymous motto that will later be sung to those same chords: "Co-sì fan tuuut-te." If the oboe is the voice of love, that proclamation of inevitable inconstancy is its answer. The "Così fan tutte" phrase is presented in the manner of a credo, and so it will be sung near the end of the opera.

In the overture there is another, more esoteric reflection of the motto, one likely only Mozart and Da Ponte would have known about. The phrase "Così fan tutte" is in fact lifted from *Figaro*, where it is intoned by Basilio after the Count finds Cherubino hiding in the chair: "They [women] all do that; it's nothing new." He sings the phrase to a trill figure followed by a descending scale. In the dashing wind figures of the *Così* overture's Presto, Bartolo's figure is introduced by the flute as one of the twining woodwind phrases that dominate the music.[17] The "Così" phrase returns in the course of the opera, and trills will be a recurring motif, evoking the sour sentiment of the motto. Otherwise the overture foreshadows the orchestral color to come. Call the *Figaro* orchestra burnished silver, *Don Giovanni* old gold; the orchestra of *Così* is going to be light, vernal, kaleidoscopic, with lavish writing for the winds.

So the opening scene begins in the middle of an argument, and in buffa territory, Ferrando and Guglielmo defending the honor of their ladies. The first words, from Ferrando: "Betray me? Dorabella? You're out of your mind!" Meticulously, old philosopher of life Don Alfonso brings these innocents around to his bet and scheme, the test of love. Within a trio he declares his credo: "The fidelity of women / Is like the Arabian phoenix: / Everyone says it exists / But where it is, nobody knows." (The line is in quotes in *Così*'s book because it is lifted from Metastasio.)[18] From the beginning all is exaggerated, unreal, everything happening in a rush: the argument, the pact, later the schemes and betrayals, a lifetime of laughter and sorrow and sad wisdom jammed into the course of a day. In the opening scenes it's a jolly story, the men confident that they will win the bet, their fiancées will stay true. The music follows suit, light and tripping, with moments of ear-filling dazzle from the orchestra.

Then the parallel scene with the sisters, Dorabella and Fiordiligi cooing girlishly over locket portraits of their men. The music is warm, the sentiments hyperbolic: "Oh but look here! / His fiery glance! / Flames and arrows / Enhance his grace." In their vocal lines, the ladies are going to get a certain amount of flowery music, appropriate to their gushiness and to the sopranos for whom the parts were written. When singing together they tend to spin out roulades in parallel thirds, which in the course of the opera is going to be a symbol of unanimity in thought and feeling.

Whether the sisters are aristocratic or middle class never comes up. The teenage servant Despina will be much involved in the action, but even if she is a buffa staple, this is not going to be a drama in which class much figures. In a way, the characters are abstractions. Though Mozart and Da Ponte gave them touches of individuality, there is no woman with the strength and knowing wisdom of a Susanna, the anguished ambiguity of a Donna Elvira. The young men are neither as antic and tough as Leporello or as wily as Figaro. Don Alfonso, Despina, and Fiordiligi are more individual as characters, but if Don Alfonso fancies himself a philosopher and functions as the trickster of the story, he is no Don Giovanni. Fifteen-year-old Despina vaunts her experience with men, but she has no man on whom to exercise her wiles.

Figaro had sustained an unprecedented realism within the traditions of opera buffa. *Don Giovanni* had gone in darker directions, but the reality of servant and master was still central to the plot in both its comic and dramatic elements. Those operas involve a row of absorbing characters bustling through the plot, each the center of one scene or another. Here it is all a matter of two couples, a man and a woman who conspire to overturn their illusions, and a few appearances of a modest chorus. The feelings of the four victims are going to be simmering throughout, in terms less and less comic, more and more disconcerting. One thing that can be said as the opera unfolds, though, is that the operative characters are the besieged sisters. Around these women the men circle like pleading and calculating satellites, but as the women's feelings go, so goes the story.

Don Alfonso enters to break the sisters' reverie with his first lie: their men have been called off to war. His announcement of the boys' imminent shipping off, "Vorrei dir," Mozart sets as agitated and breathless, an archetypal agitato aria in archetypal C minor. The conventional aria type is a subtle indication that Alfonso is putting it on.[19] His news is an act, but a vehement one. The boys arrive to bid farewell, and a quintet begins, "Sento, o Dio," that lays out the situation of the ensembles to come: the men are dissembling, the women earnestly stricken. In a way this is the general situation of a Mozart ensemble number, each character with their own agenda and that expressed in the music. But here the differences are more stark than usual, and by and large, the agendas are not individual but shared: the duplicitous beaux on one side, the

suffering girls on the other, Don Alfonso and Despina with their manipulations on the periphery. More than in any other Mozart opera, this story will be carried by ensembles.

The quintet is a solemn Andante in E-flat Major. The response of the sisters to the news is melodramatic: "Steel yourselves," they cry together, "and plunge your swords / Deep, deep into both our hearts!" Really, this sort of thing would be over the top even in an opera seria. The number ends with all five declaiming together: "Thus harshest destiny, alas, / Mocks all our human hopes. / Amidst dark despair we grope, / And which of us would want to live?" In musical terms, the quintet sets the method noted for much of the opera: Mozart does not evoke the inner emotions of the dissembling characters, which here would be a wrenching divide between real and feigned feelings, but rather the surface of what is being said and done, leaving the audience to supply the subtext. Again, this is nothing new in his operas, but in this case the dichotomy of reality and expression is sharply pointed.

So in the quintet the women's despair is real while the men are reciting lines and barely containing their laughter. Which is to say that the story is not intended by Mozart and Da Ponte to be taken as a mirror of reality, but rather, as embodied in Don Alfonso, a kind of philosophical/dramatic discourse on the nature of love and sexuality—a discourse, of course, in the form of a sexy and entertaining show.

Declarations of anguish and eternal love and devotion all around. The men make a show of departing to the strains of a military march and a chorus waxing lyrical about the pleasures of battle. Don Alfonso sings an exquisite trio of farewell with the girls: "Soave sia il vento," "May the winds be soft, / and the waves be calm," the gently babbling violins playing the part of the breeze. This is one of the more beautiful numbers Mozart ever wrote in an opera, and it is at the service of deception, though the girls' emotion is no lie. The beauty of the music is their sorrow and devotion; Don Alfonso's role as a fox is well hidden.

After the girls leave, Don Alfonso crows in a recitative, "I'm not such a bad actor after all!" He quotes an old song: "The man . . . who tries to catch the wind as it races through his hands is the same who trusts a woman. One day he'll understand." Now the violins impersonate the blustering winds. (The line echoes the Renaissance poet Sannazaro.[20] Da Ponte steadily slips in these kinds of quotes and echoes

from classic Italian sources, for his own amusement and for the cognoscenti who might notice.)

Enter Despina, grousing at the lot of a servant, which is what buffa servants tend to do. She's sneaking a sip of her mistresses' chocolate when they arrive. The sisters are grieving histrionically, their music in a mock-seria vein. An accompanied recitative and tragic aria from Dorabella evoke the Furies: "For them is my last breath." Hearing the reason for their despair, Despina is not impressed. The men will be back, and anyway, so what? Even if they're killed, there are a lot more boys out there. "One's worth as much as the next, because they're all worth nothing." Despina is quite the knowing and mordant fifteen-year-old. The sisters are shocked and offended—so far. Despina gets her aria, a chirpy case against men and the swindles of sex:

> Their two-timing sighs, and treacherous caresses!
> These are a man's upstanding qualities?
> They only love us while having their fun.
> Then they despise us and the game is done . . .
> O women, we must pay them back in kind,
> These cruel, dim-witted masterminds!

Despina does not know it yet, but she is already part of Don Alfonso's scheme. The two sides of the equation are established: the sisters on the side of love deep, eternal, exalted, and real; Despina and Don Alfonso on the side of love fickle, uncertain, irrational, and duplicitous—but no less real, in the same way that desire is real. Desire the engine of love, its potency and its imposture.

Now Don Alfonso directly enlists Despina in his plot, with the help of a gold coin that catches her fancy. He wants her to help her mistresses welcome "two charming gentlemen." Despina does not yet know that these are Ferrando and Guglielmo, disguised with moustaches and exotic getups as Albanians, their assignments to attempt to seduce the other's girl. Soon they appear, flirting with Despina to her amusement. Enter Fiordiligi and Dorabella, furious at their servant for letting men into the house. Don Alfonso presents the strangers as old friends, decent sorts and, by the way, quite well-to-do. The boys pounce on their prey, enjoying the game, entertained and reassured by their lovers'

outrage: "This whole scene is so delicious," they whisper to each other, "Just what a lover's heart requires." So it begins, the men basking in their beloveds' rejection of their advances and, soon, basking in the girls' suffering.

In a sextet of finale-esque elaboration, the men are relentless: "love, the all-powerful god, led us to you here!" The women are equally staunch: "Come scoglio,"—"Like a rocky fortress I stand," Fiordiligi decrees in a showpiece aria, "No wind or wave may command." Her solo is a parody of an accompanied recitative and aria from an opera seria heroine. "Only Death can now release / Us from our vows to heaven above," she concludes mightily. It is an old-fashioned sentiment voiced in an old-fashioned idiom.[21] From their positions of certainty (behind the disguises of the men), all the lovers are utterly sure of themselves. Don Alfonso and Despina are only amused. The men are intentionally ridiculous in their feigned avowals of love, the women earnestly ridiculous in their high-minded rebuffs. "We're two mad fools," Guglielmo avows to a swaggering tune, "As strong as mules . . . Look at these feet, / These eyes, this nose . . . / Yes, very fine feet, / And beautiful eyes."

At that the ladies storm off. Guglielmo and Ferrando break out in laughter at their own absurdity. With a little dexterous hamming up from the principals, the audience is amused too. So far. But something ominous is brewing: the men acting in masks like Harlequin, watching warily from behind the mustaches and costumes, acting for a purpose and gradually coming to dread the success of their masquerade.

So far this is buffa territory, disguise endemic to comic opera. In *Figaro*, the Countess acts as Susanna, and vice versa. Leporello acts the part of Don Giovanni, and vice versa. Again: in those operas the disguises were elements of a larger story; in *Così* the essence of the story is disguise and acting and what that does to the actors. Characters in opera assume identities and the music that goes with those identities. *Così* is acting about acting, putting masks on masks. The actors inhabiting their characters know they are acting and try to get away with it, and acting is a form of lying that we sanction and love because it can move us profoundly. We regularly confuse the actor with the role, like the Salzburg audiences of Mozart's youth who would chase

the villain home from the theater. In all this there is something primal, fundamentally human: acting as ritual. As *Così* demonstrates, however, the truth of the beautiful lie is a double-edged sword.

MORE CONFABULATION WITH DON ALFONSO; THE BOYS AGREE TO carry on. Ferrando gets an aria, not to Fiordiligi but to the other two men: "Un'aura amorosa," "A breath of love / From our sweethearts / restores our strength." His faith in love is earnest and so is the music, which is simple and beguiling—tenderer than anything Figaro sang to Susanna, on the order of what in the next opera a hero named Tamino will sing to a portrait of his beloved. It is another of *Così*'s effusions of beauty that creates a dreamlike spell outside the turmoil of the story.[22] Here the music defines an exalted and radiant vision of love that is about to be undone.

A scene between Despina and Don Alfonso. He tells her who the Albanians really are. The teenager is a hedonist, it's all the same to her, the old philosopher doesn't have to work to get her involved in his scheme. "What's love after all?" Despina ordains. "Pleasure, convenience, enjoyment, bliss, diversion, pastime, fun . . . When it doesn't please, it torments." Leave the girls to me, she tells him, they'll fall soon enough. For her, breaking the sisters' resistance has become a matter of pride: "They'll have the pleasure, and I the glory." She means inciting the sisters' betrayal for the sake of having fun with somebody new, or anyway somebody close at hand.

Behind the scenes, in terms of the real puppet masters, who is Despina speaking for? Can she be speaking for Mozart, happily married as far as the record knows, shaper of some of the wisest, strongest, most steadfast and heroic of operatic heroines? Is Despina speaking for Lorenzo Da Ponte? He was a man helpless before love and lust and the beauty of women and, for that reason, a man much wounded by love and lust and beauty and romantic adventure. Da Ponte was never so adept at making his escape as were Casanova and Don Giovanni. He had been knocked around plenty, losing most of his teeth to a man whose girlfriend he stole. Maybe the libretto of *Così fan tutte* is Da Ponte's chance to stand back and mock his own passions and the causes of

more than one near downfall. But Mozart . . . did he need that kind of revenge? There are no answers to that question.

The first-act finale is at once nearly the last gasp of anything resembling a normal opera buffa and at the same time a high point of the opera's perversity. It is over eighteen minutes long, traveling from relative peace to a frenzied climax. It begins with the girls, in a pastoral mode in warm D major, flutes supplying birdlike fluttering. The sisters bemoan how their lives have changed in a moment to "a sea of torment." Their mellifluous melancholy is shattered when the pseudo-Albanians charge in and announce that in their despair they are going to poison themselves. Before the horrified girls, they down vials of ersatz arsenic while in a tumultuous G minor the music acts a show of violence. Now the plotters have added the threat of death to the game of seduction, all presented as comedy. The girls are duly horrified, Despina runs to find a doctor while the boys theatrically pass out. While they wait, the girls step closer to admire the men's handsome faces as they lie in their comas.

Despina arrives in disguise as a doctor, the music vigorous and sardonic for this echt-buffa scene. The doctor boasts and preens for a while before pulling out his medical secret: a "Mesmeric stone," i.e., a large magnet, famous in France! With it he proposes to extract the poison magnetically from the sufferer's bodies. Miraculously, it works; the boys begin to writhe impressively. Here the most antic music in the opera provides a vehicle for the comedic talents of the cast. This gives way to an Andante as the Albanians awake, making a show of confusion. However horrified the girls are, the boys are grandly enjoying themselves. Immediately they resume their efforts, in crooning tones asking the sisters for a kiss.

The concluding sextet is a Presto pandemonium, the sisters sending the others to the devil in a fury of vocal virtuosity, the plotters laughing up their sleeves: "The world could not reveal / A more amusing situation! I don't know if it's feigned or real, / All this frenzy and all this rage." There Da Ponte defines a central question of the opera: When does the boundary between acting and reality begin to collapse? Or rather, when does acting create a new reality that is utterly unwelcome? With tutti D-major chords. the first-act curtain falls on nearly the last laugh to arrive in this professed comic opera.

THE SECOND ACT BEGINS WITH DESPINA CONTINUING HER ASSAULT on the sisters' fidelity. "Act like women!" she says. "Treat love like a bauble. . . . Since these strangers so adore you, let yourselves be worshipped. They are rich, handsome, noble, and generous . . . They even had the courage to die for you!" You can survive without love, she adds, but not without lovers. She finishes with an aria:

> At the age of, say, fifteen
> A woman should know what's what . . .
> She should know the little tricks
> To make a lover swoon,
> How to feign a smile or tears,
> How to blame things on the moon . . .
> She must know how to live
> Without a blush or a pause.

Despina is if anything more cynical about love than Don Alfonso, seeing it as a masquerade in pursuit of pleasure. Bat your eyes, make him swoon, blame your temper on your monthly. This is Despina's big solo, and Mozart made it first a lilting Adagio siciliano, folksy as befits a chambermaid. This gives way to a perky Allegro, highly tuneful, not detectably ironic. It's the airy credo of a teenager who likes sex but who doesn't think much of men; they deserve nothing better than to be fooled. But again, beyond that it's a performance. Despina has invested her ambitions in furthering Don Alfonso's plot—not for his pseudo-philosophical reasons but for her own amusement, and for pay. The music voices this in its lightness of touch, its winking ingenuousness.

On Despina's exit Fiordiligi calls her presumptuous, which is to say that she is acting above her station. Fiordiligi remains resolute, but Dorabella has come upon an idea: "If we amuse ourselves a little, to keep from dying of melancholy, that is not being unfaithful, dear sister." She proposes, just for fun, that they each pick their favorite Albanian, which they do in a flowery duet. As expected, each of them picks the other's actual beau. At this point Fiordiligi considers it all an innocent game, but maybe Dorabella is no longer playing a game.

The suitors arrive and continue their pursuit in one of the artlessly

fetching numbers in the opera, a duet with a choir turning up to join
in: "Secondate, auretta amiche." It begins with winds and horns, evok-
ing the wind band called a *harmonie*, but mellow, with no oboes. The
clarinets lead in their meltingly lyrical mode. The music is a sweetly
innocent serenade, the text all gentle breezes echoing the sighs of lov-
ers. Croons the chorus in response, "Help them, gentle zephyrs, help /
Speed the wishes of two brave hearts." For the moment there is an at-
mosphere of an artless midsummer love song, an Arcadian trance with
no hint of dissembling. The sisters are falling into Don Alfonso's trap
as into a waiting boudoir, and so is the music. Dorabella, the flightier
sister, will lead the way.

Now the music is largely on the side of pleasure and seduction, and
it is irresistible. To a bouncy tune, Don Alfonso declares that the boys
are giving up their pursuit and will suffer in silence. Then he and De-
spina discreetly withdraw, leaving the four lovers to a recitative. Fer-
rando whispers to Guglielmo that this will be the moment of truth. The
two pairs agree to take little walks on their own. When they are alone,
Guglielmo pours on the passion, giving Dorabella a heart locket that,
if she accepts it, will be her capitulation.

His friend's girl resists, wavers, gives way. "Unhappy Ferrando!"
Guglielmo mutters to himself. "Oh what bliss!" he cries to Dorabella.
As Shakespeare's Iago says: "I am not what I am." They join in a ten-
der duet, "Il core vi dono, / bell'idol mio," "I give you my heart, /
You for whom I yearn." Hesitant and sighing at first, the music gathers
momentum until their hearts are beating in unison in something on the
order of a shared erotic trance. And then off to bed with doubled-edged
words: "What new delight now starts, / And what sweet new pain!"

This leaves the matter of Fiordiligi and Ferrando, together in the
next scene. Fiordiligi is more serious, more thoughtful than her sis-
ter, which means that she is more self-torturing, still torn between her
loyalty to Guglielmo and her rising passion for Ferrando. She rebukes
him, orders him out. He is undaunted. Now comes his song of love:
"Ah, now I see that your sweet soul / Cannot resist my tears." This is
no serenade, though, rather, a rhetorical and flowery Allegretto, smell-
ing more of a favor to the tenor than a plea to Fiordiligi. (A note on the
autograph directs that the aria should be left out.)

Ferrando exits, leaving Fiordiligi to her misery. "You justly punish

my heart, O remorseless Love?" she cries in a recitative. "I burn, but no longer with a virtuous passion. It is madness, suffering, remorse, regret, fickleness, deceit, and betrayal!" Another concise summary of the opera itself. In a long, mournful aria, Fiordiligi declares her shame at her uncontrollable desire for the Albanian stranger and begs forgiveness from her absent lover. Horns are prominent in the accompaniment; for all their gentle, almost sorrowful lines, they remain symbols of cuckoldry. By the end of the aria the horns are hooting in triumph.

The boys join in a wrenching scene. As far as Ferrando knows, Guglielmo's fiancée is still loyal: "Fiordiligi is chastity itself" he declares cheerily to his friend. Guglielmo is nervous and evasive, having just come from his tryst with his friend's girl. Bit by bit the truth comes out. Ferrando erupts in murderous rage, Guglielmo tries to calm him down: "Do you want to ruin your life for a worthless woman?" Now we get a rueful aria from Guglielmo, "Donne mie, la fate a tanti," "Dear ladies, you deceive so many men." Which is to say, another of those buffa arias excoriating the opposite sex, the music boisterous and dashing, heavy on the horns. Guglielmo can't help confessing, though, his admiration for feminine charms: "From head to toe a delicious pleasure. / But then you deceive so many men, / It's quite impossible to measure." The words and music strive to make a joke of it all, but it's not so amusing. At this point things are an imbroglio that for its final confusion awaits only the story's final capitulation.

First the raging Ferrando gets a little aria that, in its words and music, encapsulates the central dilemma of the opera and its school for lovers: "Tradito, schernito," Betrayed and scorned, he declares himself, yet: "I feel my soul / Adores only her, / Only hears / Love's beckoning voice." Now he is sincere in a story where that is a rare quality. Dorabella has crushed him, yet still he is drawn to her helplessly. Ferrando is saying that Don Alfonso is right: love is irrational and treacherous, but in our hearts it prevails all the same. Here is the foundation of what will become forgiveness, but a forgiveness rising from a new and bitter wisdom. Entering, Don Alfonso hears Ferrando and cries, "Bravo! That's true love indeed!" Wiping away their resistance, Don Alfonso enlists the boys in a continuation of the game. After all, poor fool Guglielmo still thinks his lover is going to be faithful, which he believes certifies his manly superiority over his friend.

With the change of scene comes a recitative. Despina congratulates Dorabella on becoming a woman of the world. "That little devil is so sly," Dorabella replies complacently. "He could make a stone melt." In the music there is perhaps a sense of postcoital glow. Fiordiligi enters in a fluster, but not for the apparent reason: "You'll be horrified," she confesses, "I'm in love. And that love is not only for Guglielmo." Despina and Dorabella offer congratulations, but Fiordiligi is still struggling with her passion. Now she's getting pushed, effectively seduced, not only by Despina but by her sister, who sings, "È amore un ladroncello," "Love is a little thief, / And acts as a little snake." The music is a cheeky folk song, beginning with a wind *harmonie* that will be around in this act, clarinets tending to be the leading voice. Her tune begins with a horn call, though horns are not playing it—maybe recalling the horns of cuckoldry, but they have made their point already. The aria is on the order of a rondo, A B A C A coda, giving the whole a certain formal quality.

From here the story becomes steadily more contrived. The main thing that needs to happen is for Ferrando to complete his seduction of Fiordiligi, who still has some scruples and has put up a more passionate resistance than her sister. She will fall harder, but fall all the same. To escape temptation, to her sister Fiordiligi proposes another preposterous disguise: they will put on soldiers' uniforms and join their lovers on the battlefield. But she is caught with disguise and sword by Ferrando, who for his last stab at seduction resorts to a still-more-poisonous life-or-death ploy than the earlier fake poison: he demands that Fiordiligi run him through with the sword. There is a subtext here, another one in an opera rich in subtexts: he will stop at nothing to get even with Guglielmo for seducing his girl, so he inflicts a brutal pressure on Fiordiligi. It works. "You are cruel and have conquered," she moans. "Do with me what you will." Her line is accompanied by a twining oboe solo recalling the ones at the beginning of the overture. Things are coming full circle. They sing a poignant and florid duet, united in longing and in parallel thirds, and exit to the bedroom.

Guglielmo has overheard his love's capitulation. It is his turn for murderous rage. He is the counterpart of Fiordiligi, the last holdout, having been foolishly convinced that his masculine puissance will keep his fiancée true. He demands revenge. All right, says Don Alfonso to

both the boys: as revenge, marry them in your disguises. This is of course absurd, but it fits the nature of the story. After all, says Don Alfonso, if you find new lovers they'll be just as fickle. Besides, "Deep down you love them, these plucked crows of yours." So make a show of marriage and await the consequences. In any case, the old philosopher has won the bet and the day. Solemnly, the music reaching back to the overture, he has the boys repeat after him: "Co-sì fan tuuut-te!" The corollary: contra the illusions of the Enlightenment, there is no absolute moral truth, and beauty can be as much snare as revelation.[23] When it comes to relations between men and women, matches are made on earth, not in heaven, and the truth of love is found not in faith but in the body.

That climactic gesture raises a point. To repeat: it's not possible to tell how much Mozart actually subscribed to the libretto's mocking portrait of love. As noted too, Mozart did not have to agree with the story, he just had to make it work as a piece of musical theater. As also noted, the philosophy of love in the opera seems to clash with the strong women characters in Mozart's other mature operas. But recall that Da Ponte's name for this libretto was *The School for Lovers*. It was Mozart who insisted on the title *Così fan tutte*, relegating Da Ponte's notion to the subtitle. Does that reveal Mozart believing so coldly about women? No answer to that question. If he did, there is no other evidence of it, unless you count the jealousy that flared sometimes in his letters to Constanze. But mainly in this period he was concerned about his wife's health, and that had nothing to do with "women are like that." His next opera is going to have a similar situation, an older man sitting schooling a pair of young lovers, but to profoundly different ends.

The boys' disenchanted capitulation and Don Alfonso's philosophical victory usher in the finale, where somehow this shambles has to be resolved into something resembling an upbeat conclusion. It helps that the characters in their duplicities and their sufferings have acquired a sense of weight they did not have at the beginning. Their feelings count more now, though that hardly makes the situation cheerier. At over twenty minutes, this finale will be perhaps Mozart's most complex in its music and in its circumstance.

The scene is a wedding feast, the brides ready to marry their imagined lovers with, it appears, the same fervor they had for their real beaux

that very morning. It begins in C major, the home key of the opera and here the key of love and betrayal. Within bustling music, Despina and the chorus sing praises of the table and the musicians. Don Alfonso arrives. "Here's a comedy you'll never forget," he and Despina declare, "or find one, old or new, that is any better." For them fine indeed, because they are the winners in this exercise in equivocal enlightenment.

Enter the two couples, the sisters with their Albanians. The music jumps startlingly from a C-major Allegro to an E-flat-major Andante. "Blessed be these grooms / And their lovely brides!" the chorus declaims to brass fanfares. "May heaven smile on them!" Everything appears just so delightful, the principals declaring, "How everything here promises / A perfect joy and love!" The contrast of surface and subtext is becoming more wrenching by the minute. The girls appear happy as can be; the men are confused and enraged, but they join in the song: "Everything, everything, oh my beloved, / Now fulfills my desires." The music is in the moment, the joyous wedding feast. You are so beautiful, cry the grooms; you are so handsome, cry the brides. If it were not for the undercurrent, the music here might be serviceable for a normal wedding scene, if a little routine in its gaiety. Perhaps that is the point.

In a warmly lyrical slow section, three of the lovers join in a toast, "Let every care be drowned," their voices twining in a canon, the most musically compelling part of the finale. Again, the women's joy is unfeigned, Ferrando's ambiguous: in some degree, Fiordiligi has reached him. Under his breath, in the midst of the rhapsodic counterpoint, Guglielmo snarls, "Ah, if only it were poison they drank. / Those shameless little tarts!" His chattering line shatters the lyrical tenderness of the music. The others warble on obliviously.

Another big harmonic jump, A-flat major to E major. Don Alfonso enters with the required notary public, that being Despina in another disguise, singing through her nose. Here and in her earlier mask of doctor, Despina is in commedia dell'arte territory, stylized and exaggerated, with clever physical comedy required. The marriage contract is signed, but only by the ladies; it will not be binding when things hit the fan. Suddenly the scene goes up in smoke with the sound of offstage drums and the chorus singing a brisk military march about the soldier's splendid lot. Don Alfonso goes out to see what's up, which is of course

not news to him: Ferrando and Guglielmo have returned from their deployment!

Consternation! The music jolts from D major to E-flat major. The girls hide the Albanians in an adjoining room, from where the boys make their escape to be reborn into themselves. Finally, the beaux are about to be what they are, and reckoning is at hand. The rhythms are jumpy and dissociated; the keys reel vertiginously: E-flat major, C minor, G minor, F and G minor again, a jump to E-flat, and so on until the fiancées arrive in B-flat, where the music will stay for a while in a sustained scene.

Ferrando and Guglielmo now themselves, the music underlines their show of pleasure at being reunited with their loves and their show of wondering why their fiancées are so pale. This has been an opera about disguises and acting that are at first fun, then devastating. Here is the final act, the women exposed in their betrayal and fearing for their lives, all within a musical fabric of studied graciousness troubled only by some odd silences. Then Despina turns up, and Don Alfonso produces the marriage contract that he says he happened on. Uh-oh.

In music surging and crashing, the men make a show of rage: "Let's get to the bottom of this—/ And then torrents, rivers, whole seas / Of blood will flow!" The ladies tumble out a confession, call for the men to dispatch them with their swords, try to stop them from going into the room where their Albanians are hidden. The music here, though, is pleading more than terrified, almost seductive, the sisters singing in their accustomed parallel thirds. Which is to say that now Mozart wants to tamp down the confusion as things move toward resolution.

Don Alfonso opens the door to the room, the boys enter it, and then, to the girls' astonishment, instead of two Albanians and two fiancées, Ferrando and Guglielmo return sporting their disguises, and without moustaches. They are smiling and joking: "The knight of Albania," Ferrando declaims sarcastically, "Now bows before you, fair lady!" Their phrases recall music of their Albanian incarnations. Despina's impersonations are exposed. Distraught and disbelieving, the women blame Don Alfonso. In G major, preparing the final return to C, Don Alfonso confesses, "I deceived you, yes, but the deception / Was meant to undeceive your lovers / And result in a little self-perception." He counsels reconciliation, with the stimulant of a good chuckle: "The

four of you should laugh at my guile, / As I have laughed and will laugh the night away."

As the whole story has been the tumult of a day, the conclusion is brisk, perhaps because, after all, the whole business has been a flight of fancy. The music arrives back home in C major; deception and distress fall away. The couples embrace with declarations of love from the sisters and a tentative response from the men: "I believe it, my darling girl, / But don't want to test it straightway." Only Despina seems to be unhappy, a bit ashamed of herself, but after all, "With plenty of others I've had my way." In some productions she will be consoled with a coin from Don Alfonso. But every sorrow and illusion is to evaporate in laughter onstage and, in the theater, to be erased with applause. It has all been such stuff as dreams are made on—bad dreams.

We arrive at the concluding opera buffa tutti, in C major, gay and brilliant as it must be. The text draws the requisite moral, but with an unavoidably acrid undertone.

> Happy is the man who looks
> On the bright side of everything,
> And in all circumstances and trials
> Lets himself be guided by reason.
> What only makes the others weep
> Will be for him a source of joy,
> And amid the storms of this world
> He will find his peace in every season.

Cue the most improbable conclusion of a Mozart opera. These sentiments should not be parsed too finely. They say that the road to happiness is through reason about unreason, or maybe what they mean is not reason but realism. Nothing in this story has been rational, though that is what Don Alfonso declares himself to be. All has been deception, desire, rage, and regret, the portrait of love a systematic rebuke of Enlightenment optimism and rationalism: the power and the triumph of bad faith. In the end, is it only the women who are "like that"? What about the men?[24] Acknowledging the inconstancy of the human heart is called the road to joy and peace, but that is, to say the least, uncompelling as a moral. What we are left with is one of Mozart's abiding

themes, one that perhaps Lorenzo Da Ponte signed on to as well: it is forgiveness that heals the wounds of life and love.

It's hard to say that love has been well served in *Così fan tutte*. Love has been abused in the process of being disabused. It's hard to say that marriage has triumphed, that each character has returned to the proper mate as in *Figaro*. It appears that for Fiordiligi and Dorabella, one man is as good as another, just as Despina says, and it is hard to picture these matches flourishing into the future. Likely we are not meant to imagine this because the opera exists in an unreal territory, a demonstration of a precept about women rather than, like *Figaro* and *Don Giovanni*, a stylization of real people and the realities both beautiful and grim of living in society.

It is hard to say that women have been well served, either, that some degree of misogyny is not in play. Women's alleged fickleness, their innate unreliability, end up being blamed for the whole hullaballoo, even though the behavior of the two beaux has been no less foolish and far more manipulative. Ferrando and Guglielmo are foolish in a more heedless, laddish way. Don Alfonso, the "old philosopher" of the story, is colluding with a fifteen-year-old girl who is more or less the embodiment of his philosophy. Though Mozart has complicated matters with Fiodiligi's genuine anguish, her touching aria "Per Pieta," the characters begin as types, and if they acquire some individuality and gravitas by the end, there is no one as individual as a Figaro, Susanna, Leporello, or Don Giovanni. Putting all that aside, it is not unfair to question if the opera fails to do the first thing comedy is supposed to do whatever its subtexts, which is to keep us laughing.

The real old philosopher was Lorenzo Da Ponte, who in his last libretto for Mozart arguably takes his revenge on women for what they have done to him, in his own foolishness, and for which he forgives the darlings in his fashion because, after all, *così fan tutte*. Here Da Ponte was aiming for a great surgical truth, cutting open the human heart to see what was inside. Mozart was more interested in the human truth of the moment, the truth of emotion in its Harlequin colors, the truth of an act, which may be independent of if not contradictory to logical or philosophical truth.

How Mozart might respond to these questions is, once again, impossible to say. He never had to in life. One possibility is this: don't

take opera as your philosophy. Just note that the story works as a piece of theater, and in case you didn't notice, the music is splendid. What more do you need? Perhaps relevant also is that this was a libretto at which Antonio Salieri had a try and gave up, and it would not have been unlike Mozart to take it over and demonstrate, with a vengeance, what could be done with it. That is in effect what Constanze said in later years, and she opined that Salieri never forgave him for it—this idea possible but unlikely.[25]

What is certain amid all this uncertainty is that Mozart was not done with love on the stage. He would be involved in his next opera from the ground up, and love in that story would be another matter: exalted and transformative.

ENDINGS AND BEGINNINGS

A nguished in body and soul, Holy Roman emperor Joseph II died on February 20, 1790. As bells rang out across Vienna many wept, some celebrated. Joseph had returned to his city to die having badly led a war unwisely started, and of which, among its thousands of pointless dead, he himself was a casualty. Dying of tuberculosis he caught at the front, he lay in bed covered with suppurating sores.[1] To his brother and heir to the throne Leopold, he wrote, "I am unfortunate in everything I undertake, the appalling ingratitude with which my arrangements are received and I am treated—for there is now no conceivable insolence or curse that people do not allow themselves to utter about me publicly . . . I no longer dare to have an opinion and put it into effect."[2]

By that point, under a new commander, the Austro-Turkish War had turned in Austria's favor, but in the end Austria would get essentially nothing out of it. Meanwhile the war had blighted the economy, Belgium (goaded by Prussia) had rebelled against Austrian rule and proclaimed autonomy, the Netherlands was in open revolt, Hungary was militant. It appeared the Austrian Empire was on the brink of collapse. Joseph's enemies, mainly the aristocracy whose power he had challenged, had gained the upper hand. The freedom he had bestowed on the press had been manipulated by the voices of reaction, who were more clamorous than the progressives.[3] At the same time, in his rage over the uprisings in France—though in public he maintained

neutrality—Joseph had begun to rescind his cherished reforms and clamp down on free speech.

A degree of censorship had been in place throughout his reign, but now it would become relentless, aided by the bureaucracy that he had built to improve government efficiency. In the next decades, that bureaucracy would serve repression as well as it had served the cause of Enlightenment. There was a rising fear in the government that the Jacobin unrest in France, which had widespread sympathy among Viennese progressives even among the aristocracy and clergy, was going to bleed into Austria. In particular there came finally to be something on the order of an official hysteria about secret societies. The Freemasons were suddenly suspect, even more so the intensely secretive Illuminati. A note to Joseph read, "We know for a fact that many of the secret societies . . . are not, as they claim, dedicated solely to rational enlightenment and practical humanity. Rather, their intention is nothing less than to undermine the power and prestige of the monarchs, encourage liberation movements, and sway the people's opinion by means of a secret ruling elite."[4]

Joseph still had fervent admirers. Upon his death there was a tide of pamphlets, many of them extolling him. The recent successes in the war had revived much of his public support. His institutions educational and medical and his renewal of Vienna's parks and streets were still in place. But by 1790 a historic turn of events was truly in the making in German lands: a turn to the dark side. Partly because of the French Revolution and its bloody aftermath, the progressive movement, Enlightenment itself, was losing the debate about the future of societies. In the glow of his youthful ideals, Joseph had once written, "All men are equal from birth: we inherit only animal life from our parents and in that there is not the slightest difference between King, count, burgher, and peasant." Now a police secretary wrote to Joseph, "Your Majesty will have noticed how greatly the tone in the capital is changed in the past few years. They are no longer the long-suffering people . . . who blindly obey the law without arguing, looked up to their superiors with respect, and were proud of the honor to be subjects of the German Emperor . . . One looks in vain now for these . . . loyal and contented people."

This was going to be the new model for the Austrian citizen: a paci-

fied, blindly obedient, unthinking mediocrity. The walls had ears, and every written word was to be subject to relentless censorship by an all-powerful state. Eventually one was free to talk only at home, among trusted family and friends, and among artists only composers of instrumental music would be uncensored, though even they would be under perennial suspicion of subversion in their notes. If thought itself could have been censored, the Austrian state would have done it.

That is what Joseph's great dream came to in the next decades. He did not foresee all of it, but he understood how profoundly he had failed. Shortly before he died, he declared that his gravestone should read: "Here lies a Prince whose intentions were pure, but who had the sorrow of seeing all his plans collapse." Wrote the contemporary philosopher of history Johann Gottfried von Herder:

> Nine years ago, when he came to the throne, he was worshiped like a tutelary deity, and the greatest things were expected of him, the most useful, well-nigh impossible things . . . Was there ever an Emperor, was there ever a mortal, I should say, who made more strenuous efforts, who worked with greater zeal? And what a fate was that monarch's, who, confronted with death, was forced not only to renounce the aim he had set himself during his noblest years, but also to disavow, formally, the whole of his life's work, to annul it solemnly, and then to die.[5]

What Mozart thought of Joseph's death and the collapse of his ideals would not survive in the record. Most likely he had been an admirer of the emperor; most likely he had, on the whole, applauded the reforms; most likely he mourned. Heir to the throne Archduke Leopold had ruled Tuscany ably and had a reputation as a progressive, but nobody knew what he would do in light of the contrapuntal threats to the throne and the empire. Regarding his court, there would be some shake-up in the theater and music, as usual on the death of a monarch, and the theaters in Vienna would be closed for several months as part of the official mourning for Joseph.[6] Mozart was hopeful he would come out ahead in any restructuring, but there was no way to know. Meanwhile, in 1790 he was by his standards unproductive, Constanze was still ailing, he still had to be concerned about money. "I am standing at

the threshold of my fortune," he wrote hopefully to Michael Puchberg in April, before asking him for another loan. Soon he was sick himself. In May he wrote Puchberg with a mingling of misery and optimism:

> I am so sorry that I am unable to go out and talk with you myself; but my toothache and headache are still too painful and, generally speaking, I feel rather out of sorts. What you are saying about accepting a few good pupils is exactly what I've been thinking myself, but I wanted to wait until we are in our new apartment because I would like to give my lessons at home ... What worries me most right now is a debt I have at a fashion shop at the Stock am Eisen; the owner ... is making serious and impatient demands for the money I owe him; the sum is 100 gulden.[7]

Puchberg sent the money. Mozart would acquire new pupils at some point, but there would be no move in Vienna until September. Four months later, asking for another loan, Mozart wrote Puchberg that he was still sick and could not sleep for the pain.[8]

Still, he remained one of the most famous musicians in Europe and as respected as any, so when he got wind that Kapellmeister Hofmann of St. Stephen's was ailing and apparently on his last legs, Mozart was quick to apply for a position as his deputy. If he secured it, he would be next in line for the most distinguished and best-paying musical job in town, with a lavish salary of two thousand florins (though some of that would have to go to upkeep of the choirboys[9]). This, when added to his salary as court chamber composer, then 800 florins and expected to rise, would give him a quite agreeable regular income, to which would be added fees for playing and publishing that could equal that total or surpass it. The job would also, if he wanted and he probably did, relieve him of the need to take on pupils.

The City Council first turned him down for the job, then reconsidered, and in May 1791 it appointed him assistant.[10] He probably began to conduct some services at the cathedral and began also to think about what sort of music he would want to write for services. Among his sketches and drafts is a spacious Kyrie in D Major, apparently from this period, which he may have intended to begin a new Mass.[11] If he had managed to take over as Kapellmeister, however, there is a good

question as to what he would have done with it. He would have started, certainly, full of plans and enthusiasm. But Mozart had never run a musical institution, had never functioned happily within one, and had little respect for the sort of workaday musicians he would have to oversee. There is no telling how he might have done as a Kapellmeister at St. Stephen's or anywhere else.

Writing music for his own use was another matter. To that he would have devoted everything he had. For all his admiration for his old Salzburg mentor and colleague Michael Haydn, Mozart had no intention of turning out the sort of impersonal and archaic sacred work that he had produced in Salzburg. Meanwhile the expansive style of his earlier, unfinished Mass in C Minor would not work for the more stripped-down, sacred style Joseph had mandated in Austrian churches (though Leopold would relax those rules). As he showed in these years, Mozart imagined a sacred style on a more intimate scale.

IF 1790 WAS NOT NOTABLY PRODUCTIVE, HE STILL TURNED OUT SUB-stantial works. In June he finished the first three of six string quartets commissioned by the Prussian court, K. 575 in D, K. 589 in B-flat, and K. 590 in F. All are in major keys. Though eventually dubbed the *Prussian* Quartets, they would end up with no dedication and would not see print in his lifetime. Mozart had always shown a certain amount of resistance to writing instrumental works on commission if he was not interested in the genre at the moment. He preferred to be writing what he wanted when he wanted, usually in relation to some upcoming concert or to his positions at church or court. Compare that to the career of Joseph Haydn, who in his three decades as a court servant wrote entirely to order, and who in his pensioner years wrote nothing but commissioned works. Mozart spent his life scouting for a court position, but once again there is a question: Would he have been able to endure it? The knockaround life of the freelancer, with its perennial uncertainties, really suited him better.

Given that they are largely in Mozart's most genial mood, it is notable that he described the *Prussians* to friend Puchberg as "troublesome." Part of the trouble may have been for whom he was writing them: the cello-playing king Friedrich Wilhelm II of Prussia, who

would expect to play them with his palace quartet and hand them on to his two celebrated cellist employees, the Duport brothers. To say it again: Mozart did not think of himself as writing music for the ages; he was writing for a situation at hand. Here the situation was a court where, if he pleased the king with some charming pieces with conspicuous cello parts, he might get a job. Strictly speaking, he was not obliged to write elaborate cello parts for the king, but clearly he felt determined to do that. The result was three works with the cello in a featured role beyond anything done in a quartet by Haydn or probably anybody else.

They all are appealing in their material, riding on that more than on the sort of nuances of counterpoint and form and expression that he reached in the *Haydn* Quartets. And in general, these are works with sociable musical evenings in somebody's house in mind. This is not to criticize the quartets: many notable works of art were created to impress and exalt the people who paid for them. (The artist Tintoretto, who worked in Venice, made a painting of Christ introducing the Doge of Venice to the Virgin Mary, a pleasant social scene set in heaven.)

So in writing the quartets with an eye to the cello part, Mozart had to rethink how he handled all the parts. For one example, the first sketch for the finale of the first quartet, the D Major, began with the theme in violin, as was customary. He quickly dropped that and started over with the theme high on the top string of the cello, the viola accompanying underneath. It's as if he began the finale and thought, *Ahem, don't forget the king*. All the quartets are notably, often galantly tuneful, though the galant tone in Mozart's maturity is more substantial than the weightless themes of his youth. Mozart was as facile a melodist as ever, but even there these manuscripts show he had some trouble. Most of his autographs reveal a particular compositional process, beginning with the melodic lines and bass lines, with bits of accompaniment here and there, then he would go back and fill in the middle parts—which may have been in his head all along, but he wanted to settle first the melody and harmony (represented by the bass). Evidence on the page of the D Major Quartet, the ink colors and alignment of the parts, imply that here he wrote out stretches of the melody alone before going back and adding the rest. This may imply that he was having some trouble keeping a tune straight in his mind, and/or that he wanted these quartets to be particularly appealing in their themes.[12]

In a way the opening of the first *Prussian*, the D Major, sets the essential mood of the set: a simple elegant tune with galant ornaments, in a modest sotto voce, the accompaniment equally simple with an Alberti murmur in second violin and a pulsing D in viola. The movement will end as gently as it began. On the third line the cello stretches into the high register to present a new figure that is echoed by the first violin. The lyrical second theme picks up that idea, led by high cello. Little counterpoint is in residence, rather a lot of call-and-response among the instruments. The music is straightforward, without strong contrasts but with a great subtlety of color and texture. Part of that, again, will be the prominence of the cello. The handling of form in the *Prussian*s will turn up little surprising, but still in these works Mozart develops his material from the beginning, in the exposition. A darting figure in the first theme turns up in a new guise in the second theme. That figure will be transformed further in a short development section.

Next in the D Major is an intimate and untroubled nocturne with a beautiful spacious theme, call it a scene of lovers, laid out as a train of accompanied duets. Everybody, but especially first violin and cello, gets to show off how meltingly expressively they can play. After a serviceable and entirely danceable minuet, with the cello elaborately featured in the Trio, the finale begins with a recall of the quartet's opening theme in cello, and goes on with a movement livelier than the first, but equally lyrical.

The B-flat Quartet could be described in much the same terms: elegant, pithy, lots of cello. The last of the three quartets, the F Major, is the most expansive and richest of the set in material and range of expression. Call the opening theme elegantly neutral in tone, but its layout is striking: the "theme" is essentially a series of variants of the opening three bars. (In this piece, phrases will tend to the uneven.) This goes on for much of the first page, with an added little fillip that will also be turned around in dialogue among the instruments. The second theme begins in high cello with a variant of the second bar of the opening. So even when, as here, the material is not strongly spiced, subtleties of thematic handling are in play, the themes in effect more a matter of a shifting mosaic than of sustained melody. Where the closing section of an exposition is traditionally a short noisy bit to confirm the secondary key, this one returns to another variant of the opening. After

the recapitulation the coda begins like the development, appearing to be a return to it. As distinct from novelties in overall formal outline, these are novelties of melodic handling within the conventional form, the kind of thing that in the next decade would catch the attention of Beethoven.

Now a graceful Andante dance, expansive and in sonata form but essentially all made from the opening theme, around which the players weave dainty tracery. Compactness of material again: the robustly dancing *Minuetto* begins with a theme recalling the rhythm of the Andante, and its Trio recalls both that rhythm and the tracery of the previous movement (all of them distantly recalling the second bar of the piece). Even in this dancelike Minuet the phrases are still free: the opening theme is in two seven-bar segments. The last movement, in sonata form, is a gaily dashing affair, much of it first-violin-centric and sticking close to the main theme, with lots of melodic dialogue among the instruments. There are moments of contrapuntal and antiphonal intensity, but nothing questions the good spirits of the movement, or of the quartet as a whole. The coda is short, wry, and quiet. Certainly, Mozart did not intend the F Major to be his last quartet, but as fate would have it, it was. And so he unknowingly took his leave of a genre that may have cost him more trouble than any other.

Earlier, sometime around mid-1789, he wrote his first and last mature entry in another medium with a work as ambitious and compelling as the *Prussian* Quartets: the Divertimento for Violin, Viola, and Cello in E-flat, K. 563. It was written for his generous friend Michael Puchberg. Mozart wrote to Constanze during his German tour of that year that he and two others played it in Dresden "at a little musicale."[13] The trio's connection to someone in his circle may explain why he wrote in the light and ear-pleasing tradition of the divertimento, but made it, rather than the usual public kind of work, an intimate one, an affable document of a friendship to be played with and among friends.

Writing for string trio is a tricky matter. Compared to a quartet, a trio has one fewer instrument for dialogue and for fleshing out the texture. Unless one resorts to double stops, which Mozart does only here and there, it is going to be a lithe and limber medium; the challenge is not to let it get scrawny. Earlier in the century the occasional string trios tended to be for two violins and cello, and in three movements.

Haydn may have been the first to write for violin, viola, and cello, but he still stuck to three movements and works of no great aspiration. Mozart laid out this Divertimento in six movements, and as usual in the genre they range in moods and tempos. As his Salzburg divertimentos demonstrate, this sort of piece was supposed to be light and ear-pleasing, often written for a single performance and not expected to be published.[14] Those conditions don't apply at all to this work. On his first outing with a string trio, Mozart crafted something that would rarely be equaled in its medium, a worthy compatriot of his string quartets and quintets.

Like the last *Prussian* Quartet, the Divertimento begins sotto voce, this time with a simple descent down the home chord and a warmly flowing theme on the low strings of the violin, and the movement does not depart far from that atmosphere. The second theme arrives with striking color: high cello and violin on a caressing melody an octave and a third apart, the viola pulsing a B-flat in the middle. Mozart was not trying for anything searching in this piece, but he treated this medium new to him with effortless sensitivity, part of it an understanding that in a trio, the three instruments need to be treated nearly equally.

The next two movements are a slow movement and minuet, the following two another relatively slow movement and another minuet. The minuets are light and ingenuous, the slow movements more introspective—first a warm Andante that finds some affecting passages, the second almost childlike in its slow little dance and unshowy variations on it. The finale is a playful Rondo in a "hunting- style" 6/8, the main theme ingenuously winsome. Really, describing the Divertimento is like trying to conjure the feeling of lying under the sun on a summer day, drifting from one tranquil thought to another.

If the tone and style of the *Prussian* Quartets appears to be tempered largely by who commissioned them, there is one more element that applies to them and to the other chamber works of this period, the string trio Divertimento and the two string quintets that he wrote later in 1790. Mozart was still the court chamber music composer, but since taking the post he had not been asked to write anything other than orchestral dances for court balls. But when the Austro-Turkish War was finally done and things returned to normal under a new emperor, he expected to be asked for chamber pieces, so in the works of 1789–90 he

was thinking ahead, getting a leg up on that prospect. In the same way, after some years of finishing no sacred pieces, he would begin writing them again toward his coming job as Kapellmeister of St. Stephens. All this music shares a simplicity and plainspokenness new to his work. So do his last piano concerto and his next opera.

In the summer of 1790, he did some more Handel arrangements for Gottfried van Swieten, adapting Handel's *Alexander's Feast* and *Ode for St. Cecilia's Day*. Another more or less relaxed endeavor came from his actor and impresario friend from his Salzburg days, Emanuel Schikaneder. He was running a suburban stage called the Theater auf der Weiden (aka Freihaus Theater), where he was mounting extravaganzas. Mozart was clearly fond of Schikaneder and knew some of his company, one of them his sister-in-law Josepha. He took to visiting the theater and here and there over a glass of wine dashing off a song for a production. The first, apparently, was a "cat" duet, "Now, Dear Wife," for a Schikaneder-written opera called *The Philosopher's Stone*. At some point, something began to brew. Mozart hoped for the best from the new regime at court, but those prospects were all up in the air. He liked what his friend was doing at the Weiden; they edged toward a collaboration. Schikaneder had earlier mounted *The Abduction* in Vienna, but on the whole his current productions tended toward shows with elaborate stage effects and magical story lines. For Mozart to enter that world, he would have to write something unlike anything he had done before, in the direction of Schikaneder's style. So it would transpire. One of the models for that collaboration would be *The Philosopher's Stone*.

THROUGH 1790, NOT MUCH CHANGED. THE CASH FLOW REMAINED UN-steady, Constanze chronically sick, Mozart not doing so well either. His concern for his wife is shown in an anecdote her sister Sophie related years later. He had become reconciled with mother-in-law Cäcilia, who had made their lives miserable during their courtship. Cäcilia had mellowed, no longer needing to scheme with regard to her four daughters. Three of them were now leading singers in Vienna (Aloysia, Sophie, and Josepha), three were married (Constanze and Josepha happily, Aloysia not), and they probably helped support their mother.[15]

With Constanze bedridden, Sophie and Cäcilia began coming over

to help out, Cäcilia staying out of sight because "we did not want Constanze to realize how sick she was." Mozart was often at his wife's bedside. One day while she was taking a hard-won nap he sat by her composing, then got up from the chair. He had a penknife in his hand, perhaps to make corrections on the page. As he rose he dropped the knife, it landed on the chair, and somehow the blade sank into his thigh up to the handle. Sophie remembered that he who "usually made such a fuss" stayed quiet so as not to wake his wife, motioned to Sophie to follow him, and tiptoed from the room. Cäcilia bandaged him up, and he limped for a while. Sophie was touched by the scene.[16]

Mozart hoped for favor from new emperor Leopold II as strong or better than what he had received from Joseph. Leopold was aware of Mozart; in his teens the prodigy had performed for him in Italy. But for the moment the coronations had to be seen to. To show his commitment to the whole of the empire, Leopold had decreed three coronations, in October 1790 as Holy Roman emperor in Frankfurt and then, to take his other crowns, in Hungary and the next year in Prague. In deliberate contrast to Joseph's austerities, these were to be maximally lavish occasions.[17] A huge retinue would be required, court musicians naturally involved.

But for some reason Mozart was not invited to the Frankfurt revels, even though he held a court position. Kapellmeister Salieri would, of course, be part of the retinue. Mozart surely felt slighted, for good reason, but he was determined not to miss the opportunity to show off himself and his wares. He decided to travel to Frankfurt on his own, even though to manage it he had to pawn some furniture. (Some accounts say his silver.)[18] On September 23 he, a driver/servant, and brother-in-law Franz Hofer, husband of Josepha, left Vienna in grand style in his own new coach, his best finery along with the music in his trunk. While he was gone Constanze moved into their posh new flat on Rauhensteingasse.[19]

For Mozart the excursion to Frankfurt turned out to be an exercise in futility, producing neither any significant excitement nor any money. Everybody else had a royal time. The emperor's entourage involved 100 carriages, 1,493 mounted cavalry, 1,336 infantry in sparkling regalia—and just 15 musicians.[20] After the caravanserai in the streets, the coronation was to take place in the Cathedral of St. Bartholomew,

where imperial coronations had been held since 1562.[21] For his part, when he arrived Mozart found cheap lodgings in town with a friend.

The journey had taken six days on the road. In Mozart's childhood this would have been routine, but not anymore. His first report to Constanze is bright and hopeful. "What a wonderful life we're going to have," he crowed. "I want to work—indeed work very hard—so that we'll never again get into such dreadful straits." He suggested that Constanze find somebody to lend them a thousand florins and consolidate his debt. If that was more or less what he owed at that point—he had likely paid back Puchberg some of those loans—it is not a small sum but hardly a crushing one given his income. Constanze did as asked.

The main plan for Frankfurt was to give a big concert, for which he would have to scrape together an orchestra. His letter to Constanze just before the concert is full of hope and shows that his imagination is working busily on all fronts, including in assuring his ailing wife of his affection. This time there is no rhetoric, no sense of putting on. He says he needs her, and he means it.

> I intend to give my concert on Wednesday or Thursday and then on Friday—tschiri tschitschi—I will be out of here in a hurry.— Dearest wife! I hope you have attended to the business I wrote to you about—and are still working on it; I am pretty certain that I will make enough money here to be in a position to repay 800 or 1000 gulden right after I return . . . If you could only see into my heart—there is a struggle going on between my wish, my desire, to see you soon and hold you in my arms and, on the other hand, the wish to bring home a lot of money . . . I've become so accustomed to you—and I love you too much to be able to endure a lengthy separation . . . To be sure, I am famous, admired, and popular, but people here are even greater skinflints than the Viennese.—If my concert will have any kind of success, it'll be thanks to my <u>name</u> . . . If I work hard in Vienna and take more pupils, we'll be able to live quite comfortably; nothing can persuade me to think otherwise, except perhaps a <u>good appointment</u> at some court.[22]

In the middle of the myriad competing festivities around the coronation, his concert came off on October 15 between eleven in the morning

and two in the afternoon. For the affair he wore a navy-blue embroidered satin outfit and played a piano by Johann Stein of Augsburg, whom he had met in his early travels and whose pianos he had always admired.[23] It proved something of a dismal event, the audience small and the orchestra likewise, it appears with no more than five or six violins. On the program he played the K. 459 and K. 537 piano concertos, and there was a symphony; another planned symphony, possibly the *Jupiter*, was cut because the program was going on too long. Afterward he described the concert to Constanze as "a splendid success from the point of view of acclaim but rather meager in terms of money." He wrote that he was weeping onto the page. It was because he missed her, he said, but they may also have been tears for another dashed hope.[24] His salvation, the comfortable life he had long prophesied, was actually close at hand, but he would have to have had a working crystal ball to discern it.

A count who was an admirer of his gave an enthusiastic account of the concert.

There was a grand <u>concert by Mozart</u> in the auditorium of the National Playhouse. It began with that fine (1) <u>Symphony</u> by Mozart which I have long possessed, (2) Then came a superb Italian scena, "Non so di chi," which Madame <u>Shick</u> sang with infinite expressiveness. (3) <u>Mozart</u> played a <u>concerto</u> composed by him which was of an <u>extraordinary prettiness and charm</u> . . . Monsieur Mozart is a small man of rather pleasant appearance, he had a coat of Brown Marine satin nicely embroidered . . . (4) The [castrato] <u>Cecarelli</u> [*sic*] sang a beautiful scena and rondeau, for bravura airs do not appear to be his forte; he has grace and a perfect method, an excellent singer but his tone is a little on the decline, that and his ugly Physiognomy . . . / <u>In the 2nd Act</u>, No. 5, another concerto by Mozart, which however did not please me like the first. (6) A duet which we possess . . . (7) A <u>fantasy</u> [improvised] by <u>Mozart</u> very charming <u>in which he was shown infinitely exhibiting all the power of his talent</u>. (8) The last Symphony was not given for it was almost 2 o'clock and everybody was signed for dinner. The music thus lasted 3 hours which was due to the fact that between all the Pieces there were very long

pauses. The orchestra was no more than rather weak, with 5 or 6 violins but apart from that very accurate.[25]

This might stand as a description of many of his concerts over the years. It is notable that one of the soloists was his old and admired Salzburg castrato friend Francesco Ceccarelli, then thirty-eight, with much of his career ahead of him.

After the performance Mozart wanted to bolt for home, but given the disappointment in Frankfurt he made a slow return to Vienna, visiting friends and picking up performances where he could. He appeared in a concert at the royal palace in Mainz, then continued to Mannheim, where he discovered an upcoming performance of *Figaro*. The cast entreated him to stay for a few days and come to a rehearsal, to which he was agreeable. When he showed up at the theater, though, apparently not gotten up to any impressive degree, he almost did not get in. The diary of a theater official noted, "Kapellmeister Motzard [*sic*] was here on the 23rd and gave numerous tempos at the rehearsal of Figaro. I embarrassed myself with Motzard. I took him for a journeyman tailor. I was standing at the door during the rehearsal. He came and asked me if one could listen to the rehearsal. I sent him away: 'But surely you would let Kapellmeister Motzard listen,' he said. Then I was more embarrassed than ever."[26]

Then to Munich, where he had a reunion with old friends going back to his teens. He wrote Constanze, "I'm having a great time here with the Cannabich[e]s, La Bonne, Ramm, Marchand and Brochard; and of course, I'm telling them a lot about you and how much I love you.—I am so looking forward to seeing you, for we have lots to talk about; I am thinking that next summer I'd like to come here with you, my love, so you could try out different Baths and, besides, be entertained and get some exercise; a change of air would do you good, just as it agrees with me very much."[27]

While he was gone, an opera impresario in London sent an invitation offering him a commission to come for six months, starting in December, and to compose two Italian operas, either comic or serious. The offer was 2,400 florins, and he would be free to compose and perform for anyone else.[28] The deal had probably been initiated by Mozart's old British student Thomas Attwood, who was close to the Prince of

Wales. Soprano Nancy Storace, now in London, may also have been involved.[29] It was an appealing offer, a sign of his burgeoning international reputation, but when he got home Mozart turned it down. The reasons seem plain enough: Constanze was sick, his own health uncertain; he was trying to get the attention of the new emperor; and there was a project with Schikaneder in the offing. Certainly he wanted to visit London, scene of his early childhood triumphs, but there appeared to be plenty of time to visit the city later.

There was more brewing in London. Haydn, now pensioned off from his job with the Esterházy court, was about to leave for a sojourn there that proved to be hugely profitable for him and historic in its results: for two visits he produced the epochal *London* Symphonies, numbers 93 through 104, the summit of his decades of work in the genre. In the middle of December there was a farewell dinner for Haydn on the day he was to set out for England with Salomon. The story, true or not, has Mozart waxing skeptical, telling Haydn, "You won't stand it for long and will soon return, because you're not young anymore." Haydn protested that he was in perfectly good health. Haydn recalled Mozart going on, "Papa! You have no education for the great world, and you speak too few languages." To which Haydn recalled his riposte: "My language is understood all over the world."

Mozart accompanied Haydn to his carriage. Haydn reported that as they parted, Mozart said, "We're probably saying our last adieu in this life."[30] If he really said that, who was he talking about? Haydn said he took it for Mozart's concern about his surviving the trip, and he was touched by it. History assumes Mozart was talking about himself, that he had a premonition that he didn't have long to go in his own journey. This is the vote of myth, that Mozart foresaw his death, and as in a drama on a stage he was shortly to be commissioned for a requiem Mass that he would see as his own swan song. Is that possible? Certainly possible, only there is no evidence for it, and quite a bit of evidence that Mozart had no intention of dying.

THE YEAR 1791 WAS MOMENTOUS FOR MOZART IN EVERY DIRECTION, likewise in the arts and in the Western world in general. In June in France, Louis XVI and Marie Antoinette attempted to flee from their

detention in the Tuileries, hoping to reach the royalist town of Mont-médy and there organize a counterrevolution. But they did a woeful job of escaping and were captured and returned to Paris. Their flight intensified popular sentiment against them and drove another nail in their coffins. This year the guillotine was introduced in France. There were two portents for the future of society: in America, Washington, DC, was founded, and Samuel F. B. Morse, inventor of the telegraph, was born. In the arts appeared Boswell's *Life of Samuel Johnson* and Herder's *Ideas for the Philosophy of the History of Mankind*. In Paris, Luigi Cherubini premiered *Lodoïska*, which sparked a fashion for the genre called "rescue opera" that would eventually challenge Mozart on the stage, contribute to Salieri's retirement from the stage, and provide a route for Beethoven to escape from Mozart's influence on the stage. Rescue opera would prove to be the dominant serious opera mode of the generation after Mozart.

On January 5 Mozart entered in his thematic catalogue a new piano concerto, No. 27 in B-flat, K. 595, another work hardly intended to be his last word in a genre, but which proved to be. He wrote it for a concert of clarinetist friend Anton Stadler and soloed in it for the premiere in Vienna on March 4, 1791. It turned out to be his last appearance as a concerto soloist, his last time to bask in applause.

Possibly the first two movements of the B-flat had been drafted some time earlier.[31] If the concerto is low-key and nostalgic rather than a look backward, it is a testament to a composer still in motion and setting out in a new direction. In it Mozart combines a refined simplicity with some of the most searching harmony of his life. To its fluid treatment of keys he joined a fluid approach to the material: each movement states a straightforward theme, and from that point theme and harmony are constantly in development. There are hardly any "second themes" proper in the work. This steadily developmental quality is not exploited for drama or passion, but rather conjures a domain serene and sometimes wonderfully affecting.

All this is laid out in the spacious first movement, which begins and ends softly. The winds are one flute, oboes and bassoons, no clarinets and no trumpets. The woodwinds in general are as consequential as usual in Mozart's orchestra, but the flute in particular—an instrument quite basic in his time and which he once claimed to dislike—has a

bouquet of winsome solos. While the concerto gets full-throated here and there, from its galant opening theme gentleness prevails. Solo and orchestra are not at odds but rather carry on the discourse together, and there is little virtuosity in the solo part.[32] In the piano the old Alberti bass turns up. The opening phrase is interrupted by a little fanfare that renders things a bit off-kilter; that militant phrase will periodically add a dose of energy.

After two pages of straightforward harmony that never strays from B-flat major, a chromatic phrase intrudes. Much harmonic searching will come of that phrase. After a sudden and quietly surprising interlude in rare B-flat minor, the soloist enters on the ingenuous opening theme. From that point things get explorative. There are long stretches where the harmony is in flux, never cadencing. The development section begins in B minor, about as far from the main key of B-flat major as one can get; from there it drifts into a still-more-exotic E-flat minor. Harmonically, this is one of the most kaleidoscopic development sections of Mozart's life. The effect is of simplicity traversing into unexpected places. Its aura of being candid and artless, free of irony or rhetoric, enfolds something new in the guise of something old. As far as Mozart was concerned, he was not finishing with concertos; he was looking to the next ones.[33]

A theme at once modest and touching starts the second movement, and from there the movement gets only more heart-tugging, one of his trances of beauty. Mozart is heading toward the sublime late style of his next opera, in which guileless simplicity is made magical. All that carries into the finale, in outline a rondo, but barely: the B section has no very defined theme. The loping opening is more or less another "hunting" tune, its tone naïve, like a boy out roaming the fields. One would expect here some Mozartian gaiety, exuberant fun, or glittering virtuosity, but all that is kept under wraps in a movement that once more combines the artless and the searching.

Call the B-flat Concerto perhaps the most reticent of the major works from Mozart's last year. In that parade of special pieces, this one has its quiet place. Later history would try to gin up the biographical drama by making K. 595 a valedictory work. Again, there's no solid evidence that Mozart was having premonitions. If anything he was expecting good news, and for a while he got it: he was entering his

most prosperous period. In this concerto he was not saying farewell but rather the opposite, moving toward a new chapter in his art. In trying to find a way to encompass this elusive work, it's relevant that a few days after its completion he used the tune of the finale for the song "Longing for Spring," which begins, "Come, sweet May, and turn the trees green again, / and make the little violets bloom for me by the brook."[34] It's a song about yearning and expectation, about the future.

AT THE ANNUAL LENT BENEFIT CONCERT OF THE TONKÜNSTLER SOCI-ety in March 1791, those concerts usually involving massive forces, Salieri conducted an orchestra of more than 180 players, the program apparently including Mozart's G-minor Symphony. (Again, parts would survive, with corrections in his hand). There would be no record of how the piece was received.[35] Among his small works in this fruitful year were the thirty-five assorted dances he produced at the beginning, the second of two commissioned pieces for a musical clock, and an Adagio and Rondo for a quintet including Benjamin Franklin's glass armonica (that contraption of glass bowls turning in water and played with the fingertips). The latter was written for the blind armonica player Marianne Kirchgässner, whom Mozart heard in Vienna during her first tour as a virtuoso. Mozart had known the instrument since his teens and had written for it before. He produced a work first wistful, exploring the ethereal sound of the instrument, then trippingly lively.

In April Mozart finished the second in a set of two string quintets, the first dated the previous December. Both have in common with the *Prussian* Quartets major keys and a genial atmosphere, maybe written with Vienna court performance in mind, though new emperor Leopold II would not prove to be a chamber music aficionado like Joseph. The D Major, K. 593, in keeping with its bright personality on strings, is light; the E-flat, K. 614, less in keeping with Mozart's usual weighty mood in that key, is lighter. Both have a pastoral, outdoorsy feel, especially the E-flat, and both have the newfound economy of material, their movements turning around two or three ideas treated something like a development from the beginning. Both luxuriate in the rich sonority of two violas, Mozart feeling the viola music in his fingers.

The D-major Quintet begins with a pensive introduction drifting through keys, starting with a jump from D to F major, then B-flat, keys a third on each side of the home key. Both keys will be relevant to the development section. The Allegro that follows is perky and a bit folksy, with an imitation of open-horn harmony that is a sign for the outdoors. No real clouds trouble this or either of the quintets. As an illustration of economy of material: the dotted figure in the second phrase of the main theme is reworked to begin the second-theme section in A major; the subtheme of that section is a development of the main theme. The development section takes the ideas in more elaborate directions. In both quintets there are few surprises in the handling of formal outlines, but still there is a striking episode in this movement: the pensive introduction material returns near the end, followed by what seems to be a second recapitulation back to the opening Allegro theme, but is in fact the coda.

The mood and motifs of the first-movement introduction are taken up in the big Adagio that follows, an exquisite slow movement that hovers between wistful and plaintive, perhaps amorous, a diaphanous silkiness of emotion singular to Mozart. This movement is the glory of the last two quintets. The minuet is gentle but wry, its main idea a kind of battle of downbeats among the parts, the minuet section ending with vigorous canons at one beat's distance—echoing the opening sense of downbeats a beat apart. The finale is a skittering romp, more or less monothematic.

If there are outdoorsy moments in the D Major, the E-flat-major Quintet goes further into the pastoral, beginning with an evocation of hunting horns, and in the first movement a steady presence of trills suggests birdcalls. Those two ideas will never be far away in a generally jolly movement. The Andante is manifestly galant in tone, even archaically so, and nearly monothematic until the appearance of a lush new theme in E-flat. After a *minuetto* best described as serviceable, the finale is a sprightly foursquare dance, again sticking close to the main theme, the whole a bit first-violin-centric, like a pre-Haydn string quartet. The E-flat Quintet, in other words, is a bit of a look backward in general, perhaps a tip of the hat to friend and mentor Haydn. In both quintets one can find a vivid sense of Mozart at work, the music flowing from his mind to his pen with a delicious sense of discovery. That

profound delight of discovery, when he was lost in his art, is more than anything else what Mozart lived for.

By the turn of 1791 Constanze had begun to be of more direct service to her husband's career, taking over matters he was not so good at and, as it turned out, she was: finances. While he was in Frankfurt she had arranged at his request the loan with merchant Heinrich Lackenbacher, one thousand florins to consolidate their assorted debts, two years at 5 percent interest, apparently their furniture for security. Mozart signed the promissory note before witnesses when he got home. Constanze would oversee servicing the loans in 1791, which turned out to be the best earning year of his life. It appears that Lackenbacher got his money back in half the agreed time.[36]

Constanze also found the spacious place on Rauhensteingasse that they had moved into the previous September. They laid out an impressive 208 florins for new wallpaper. It was a flat appropriate for a prosperous and celebrated artist, comfortable and well suited to giving lessons and house concerts. Among other things it saw a reading of one of his new quintets with Haydn and Mozart on violas.[37] Constanze was still not well and was now eight months pregnant. In early June 1791 she and Karl, now six, headed again for Baden for rest and recovery. A week later Mozart came out for three days; Constanze and the boy came back to Vienna with him for her lying-in. Franz Xaver Wolfgang, their last of six children in eight years and only the second to survive, was born on the twenty-sixth.

That summer was going to be critical in Mozart's life and in the chronicle of music. While he was in Baden he connected with friend Anton Stoll, who was a local schoolteacher and choirmaster. For him Mozart produced a little motet for choir, strings, and organ on the old Eucharistic chant "Ave verum corpus," once sung in churches at the elevation of the Host. The piece is not quite four pages in manuscript, dated June 17, 1791, the writing clear and with no touch of hesitation or correction. It lasts three minutes, might have been the product of a morning. In its humble way, it is one of the most original works of his life and one of the most ineffably beautiful. Like so much of his greatest music it has a sense of perfection unique to Mozart—an ideal object impeccable to the last

note. He had reached a place inside himself where his inspiration assembled technique and tradition into a sense of revelation, like a familiar face becoming a beloved one.

"Ave verum corpus" was written to celebrate the upcoming feast of Corpus Christi, with its traditional street procession that Joseph had banned but Leopold reinstated. As to the beauty of this work, there are no adequate words. The radiance of the music is joined to a singular prayerful introspection in setting the text that hails the true body of Catholic doctrine, recalls Christ's suffering on the Cross, and ends with an evocation of paradise. Call it a study in what concentrated restraint can achieve. After a couple of measures of introduction, the choir begins with a modest melody in modest rhythms for the sopranos, marked "Sotto voce," which is the only volume marking in the piece. The lower voices begin with four bars of half notes laying out the simplest of harmonic progressions. Yet that opening is unforgettable, and from there the work flows like a warm twilight breeze to its conclusion, almost childlike in the simplicity of its prayer, yet touching chords in the heart as deep as anything Mozart wrote.

If there is a comparison, it is to the transcendent refinement of Palestrina, in its crystalline transparency and its subtle expression of *cuius latus perforatum* (whose pierced side), which brings a poignant chromatic phrase in a flowing rhythm. Here Mozart escaped the Baroque rhetoric of his Salzburg church works and created a sacred music new in its time: inward, humbly spiritual. In fact it is a work that realizes Joseph II's hopes about sacred music, putting away outward show and creating a consecrated space.[38] In that sense "Ave verum corpus" amounts to a study toward what Mozart wanted to do when he became Kapellmeister of St. Stephen's in Vienna: a sacred music that goes straight to the heart of common humanity. It was in essence the same kind of populist expression that he was creating for the stage that summer with his and Schikaneder's new opera, to be called *Die Zauberflöte* (*The Magic Flute*).

Choirmaster Stoll premiered "Ave verum corpus" at the St. Stephan parish church in Baden on June 23. Mozart had for this friend no particular sublime feelings, as shown in the opening doggerel of a letter he wrote him in July:

Dearest Stoll
Good old troll!
You sit in your hole
Drunk as a Mole!
But you're touched in your soul
By music's sweet flow.

The practical point of the letter is that he wanted Stoll to return the score of his Salzburg-period Missa brevis in B-flat and a Michael Haydn *Pax vobiscum*, which they had also performed in Baden. Mozart presumably wanted to study the Haydn and to make use of the Missa at St. Stephen's in Vienna. On the opposite side of the letter he scrawled in an imitation of his student Süssmayr's handwriting, "Don't let us down or we'll be sitting in scheiss," and signs it, "Franz Süssmayer [*sic*], Shithead."[39]

That student, who served him as a copyist and general amanuensis, was destined to play a singular role in the history of Mozart's music, even though he was a talent of modest dimensions whom his teacher teased mercilessly. There was, for example, a row of nicknames Mozart bestowed on the long-suffering Franz Xaver Süssmayr, mostly based on the fact that *süss* means "sweet": *Snai*, *Sauerbier* (sour beer), *Sauermeier* (sour farmer), and so on. At this point Süssmayr was with Constanze in Baden, helping her out and working on turning Mozart's drafts for *Die Zauberflöte*, apparently, into short scores, perhaps for the singers. Mozart wrote Constanze, "Please tell Süssmayer, that knucklehead, to send me the score of the first act . . . so I can orchestrate it . . . A couple of Englishmen just called on me . . . [T]hey really wanted to get to know Süssmayer, the famous Man . . . for they had heard I was fortunate enough to enjoy his favor . . . They want to honor him as a lamp cleaner."[40] For all his needling of Süssmayr, it's possible that they named their new son Franz Xaver after him. Mozart was one of those sorts for whom teasing can be a sign of affection. On the whole the letters of this summer seem to show him in a jovial mood, but in fact he was up and down.

By that point he and Schikaneder were steeped in *Die Zauberflöte*, the first opera Mozart was to write for a theater outside a court and the first to be a thorough collaboration from conception onward. In June,

after he got back from Baden, he and the impresario took in a new show called *Kaspar der Fagottist, oder die Zauberzither*. It was a fashionable yarn of the time, with magical elements. Mozart and Schikaneder were not much impressed with it, though they were ready to pick up anything useful.[41] Here again myth would germinate in later times, to the effect that with this zither story they had been scooped and felt obliged to change the direction of *Die Zauberflöte* in midstream. This myth has no more purchase than others that grew from this year. In those days everybody stole from everybody else all the time, and in general artists have always stolen whatever they've found useful.[42] In a later age, with the advent of copyright, the pilfering simply got more circumspect.

One story element that they may have lifted from *Kaspar* for their project was a balloon ascent, a matter perfect for the stage of the time because it was a modern miracle highly apropos in Vienna. The pioneering hot-air balloonist Jean-Pierre Blanchard, who among other things had made the first air journey across the English Channel, had after a couple of failures mounted a successful ascent in Vienna in July, he and his balloon rising majestically from the Prater park before thousands of spectators.[43]

In early July Mozart was feeling down, stuck at home with work and missing Constanze terribly.

> I can't describe to you what I feel, but there's a sort of emptiness, which hurts somehow, a certain longing that is never fulfilled and therefore never stops, it's always there . . . when I think of how merry we were and how much like children when we were in Baden together—and what sad and tedious hours I'm spending here now,—not even my work gives me joy anymore, because I'm so used to taking a break now and then and have a little chat with you; but this kind of pleasure is unfortunately denied to me right now—and when I go to the piano and sing something from my opera, I have to stop at once—it makes me too emotional— Basta![44]

This may be the most heartfelt letter he ever wrote his wife. He is swamped and ailing, he needs her love to support him, needs somebody on whom to lavish his love.

There was more on his mind that summer than *Die Zauberflöte*. In June a stranger showed up with a commission for a big sacred piece, a requiem Mass for choir and orchestra. The commission itself was nothing unusual, but its source was: the person paying for the piece was not to be disclosed. History would seize on this mystery and milk it for all it was worth, but in fact it was worth little. The source of the commission came to light in due course, and Mozart may have known who it was anyway. All that didn't matter. It was good money for a piece he wanted to write. While myth would claim that he came to feel the commission was fateful and that he was writing the Requiem for himself, there is no solid evidence for this, and in fact he seemed to be pleased with the commission, probably for two reasons. First, he had written a good deal of sacred music but never a requiem, which is an invitation for one's most searching and tragic imagination. Second, it was another chance to warm up for his job at the cathedral with a piece that would come in handy there. Now between the opera and the Requiem, he had two works to fan the flames and fill the coffers. He had told Constanze that he wanted to work very hard and get them out of debt. Between the ongoing opera for Schikaneder and the new Requiem commission, his plate was full. But soon arrived another opportunity—one too many, as it played out.

PRAGUE IMPRESARIO DOMENICO GUARDASONI, WHO HAD OVERSEEN the premiere of *Don Giovanni* in 1787 and had recently returned to the National Theatre, had been assigned by the Bohemian Estates to commission and produce an opera seria for Leopold II's third coronation in Prague, part of the sprawling circus of events that would be involved. The opera would have to be, as usual for these things, a rush job. As it turned out, it became still more of a rush. Guardasoni was particularly concerned about getting a leading castrato, because after two centuries of dominance in opera seria, the fashion for castratos was fading, the infamy of their existence overtaking their popularity. The agreement with the Estates was to commission a new book, if there was time, otherwise to resurrect an old one. Guardasoni promised to find *un célèbre maestro* to write the music. His choice was Salieri.

In July 1791, the impresario traveled to Vienna to make the offer.

Salieri declined, saying he was too busy running the Burgtheater, filling in on the job for one of his students.[45] Desperate, Guardasoni made further efforts to try and convince him, five trips by one report, eating up valuable time, but Salieri remained adamant. Meanwhile the impresario consulted in Vienna with celebrated librettist Caterino Mazzolà, who among other things had written the book for Salieri's perennial hit from 1779, *The School of Jealousy*. With time running out, they agreed that he would adapt the classic Metastasio libretto *La clemenza di Tito*, first produced in 1734. The libretto had been set some forty times since by composers including Gluck, though apparently no major composer had used it since 1774.[46] Voltaire had praised the book as a model exposition of the ideal of enlightened absolutism.[47] It was understood that the text could be refurbished to taste, as it always had been.

Having failed to get Salieri, Guardasoni took the commission to Mozart. In order to accept it, Mozart would have to put aside *Die Zauberflöte*, which was nearly but not quite done, and put aside the Requiem that he had not yet begun, but which had a firm deadline. He would have only a matter of weeks to pull *Tito* together. It was meanwhile a seria, and even though Mozart took the genre seriously, his main successes had been in buffa. It was all too much, even given his ability to mount marathons of work. His health had been tenuous to bad all summer, while Constanze was still in potentially dangerous shape and had just given birth.

Which is all to say that he should not have taken the commission. But it was not in him to turn it down. There were too many enticements, not least the prestige of writing an opera for a royal coronation after having been snubbed in the Frankfurt coronation. There was also the situation at court, where opera seria was being revived, something he would have wanted to be involved with.[48] Even more, the commission and travel fees amounted to an extravagant 1,125 florins, which would go far to getting him out of debt. Anyway, he had never turned down an offer that was prestigious and well paying, and he had his old confidence that no matter what the pressures, he could manage it. So he always had and so he did, up to a point.

Mozart got to work with Mazzolà to turn the *Tito* libretto into what he called "a real opera." What that mainly meant was transposing buffa elements into seria. Classic seria librettos did not have ensembles, and

Mozart required them. Metastasio's original *Tito* had twenty-five arias and four choruses. When they were done, the book had been cut from three acts to two and had eleven arias, eight duets and ensembles, and five choruses.[49] Many of the arias and ensembles were buffa-style action numbers, in contrast to the static arias of traditional seria, in which one character after another stood alone onstage and emoted.[50] All of which, the premiere date being more or less set in stone because of its connection with the coronation, had to be written in a few weeks along with a pile of recitatives.

Mozart and Mazzolà seem to have collaborated easily, and in any case Mozart would not have expected to be working again with Lorenzo Da Ponte. The court librettist was out of Vienna and out of the picture, having largely, for the last time, contrived another of his own downfalls. (Ironically, Mazzolà had once been a mentor and champion of Da Ponte and recommended him to Salieri in Vienna.) After Joseph II died, everybody knew there would be the usual shake-up at court when Leopold II took over, but as usual, Da Ponte and everybody else had hoped in one way or another to keep their job.

In twenty-five years as Grand Duke of Tuscany, Leopold had proven a shrewd and progressive administrator. He modernized the state, protected the peasants, and drew up a widely influential criminal code.[51] Many hoped that when he took the throne in Vienna he would maintain what was left of Joseph's reforms, even reinstate some. That would not happen, because Leopold had to deal with the revolts in Hungary, Bohemia, and the Netherlands, and a resurgent Austrian aristocracy who loathed Joseph's attacks on their privileges. In France, Leopold's sister Queen Marie Antoinette and King Louis XVI were imprisoned by the Revolution and in mortal danger. In the two years before he died, Leopold would skillfully deal with these matters and preserve the Holy Roman Empire. Often he did it by making strategic concessions to one faction or another.[52] Among other things, he relieved the Austrian aristocracy from the taxes Joseph had imposed on them.[53]

When it came to music, Leopold was not the kind of enthusiast Joseph had been and deferred to his wife's taste, which was the opposite of Joseph's: while his predecessor had all but banished opera seria and limited ballet, Leopold and his wife considered opera buffa rather vulgar. They organized a new ballet troupe and formed a company to

produce opera seria.[54] Da Ponte had at that point been court librettist for eight years. In the process he had done splendid work, historic in his collaborations with Mozart, and Joseph had been his protector. But he had also made enemies, the most powerful of whom was Salieri, despite their five collaborations.

With Joseph gone, Salieri was fed up with this preening librettist. But clearly some of his enmity had to do with Salieri's soprano lover Caterina Cavalieri, who was the rancorous rival of Adriana Ferrarese del Bene, Da Ponte's live-in girlfriend. Del Bene's diva shenanigans had been a byword since before she arrived in Vienna. In December Da Ponte wrote a long letter to court theater director Count Rosenberg declaring that if the Italian opera let del Bene go it would ruin the company. When the emperor was informed of the relationship between Da Ponte and the singer, he exploded, "To the devil with this disturber of the peace!" By the end of the year she and Da Ponte had both been booted. Soon after that Rosenberg was gone as well, and before long Salieri stepped down as Kapellmeister.[55] Salieri had a long career ahead of him and would eventually acquire pupils named Beethoven, Schubert, and Liszt, but his glory years as an opera composer were essentially over. For whatever reason, Mozart, meanwhile, retained his position as court chamber composer. Leopold seems to have had little use for Mozart's music, but he did not cut him loose.

Da Ponte retired to nearby Mödling to scheme about getting his job back. The form this took were two initiatives with Leopold, both of them disastrous. One was an audience with the emperor, during which Da Ponte railed against his rivals and Leopold strung him along without any intention of conceding. Then came a letter. Years before, Da Ponte had sealed his fate in Venice with a couple of screeds attacking the ruling class. Now he sent Leopold a defiant letter saying, among other things, "My destiny does not depend on you, because all your power and that of all possible kings have no rights over my soul . . . I cannot fear you." In the letter he used the familiar *tu* for "you," which was an unbelievable lèse-majesté. Leopold was duly outraged. Da Ponte was definitively canned in March 1791.[56] He tried to persuade Mozart to go to London with him right away. Mozart was tempted but put him off, saying he had *Die Zauberflöte* to finish.[57] (From that point, deserted by del Bene, Da Ponte wandered to London and finally America. There,

picaresque and resourceful as always, for a while he ran a grocery store with a little bootlegging on the side, and as an honorary professor he founded the Italian department at Columbia University.)

Mozart got to work with frenzied intensity on *The Clemency of Titus*. As usual he wrote the bigger numbers first, the ensembles and most of the solos, leaving some things to be done when he got to Prague. For the moment there was no question of tailoring the music to the singers because these had not been named yet. Perhaps that left some of the arias with a certain generic quality. Meanwhile, to get it finished, he had to take whatever shortcuts he could, including assigning the simple recitatives to his amanuensis Süssmayr. It appears that he left the accompanied recitatives to do in Prague, where the singers were going to have to learn the music with the same kind of urgency with which he'd written it. One guess is that most of it was done between the end of July and his departure for Prague near the end of August.[58] Other accounts, less likely, have the bulk of the opera composed in eighteen days. The situation was in any case a mess that he and the principals held together barely. Still, despite the killing pressure he was under, Mozart's sense of humor did not flag. On one page of the *Tito* manuscript, there is a thick black cross of ink, in the middle of it the remains of a fly. It appears Mozart used the page to swat the insect, and took the time to inscribe around it a memorial cross.[59]

On August 25 he, Constanze, and Süssmayr left for Prague. Waiting for him back home was the completion of *Die Zauberflöte*, the whole of the Requiem to do, and a clarinet concerto he intended to write for Anton Stadler, who was going to play in the *Tito* orchestra in Prague. Ailing Constanze should not have come, but Mozart wanted her beside him. They journeyed four days through a beautiful autumn landscape, but he would have had little time to notice. Constanze recalled that in carriage journeys, he tended to be thinking, humming, at stops jotting down ideas on slips of paper. They arrived on the twenty-eighth, at which point Mozart had ten days to get the opera finished and rehearsed.

THEY ARRIVED IN A CITY SWARMING WITH PREPARATIONS FOR THE coronation. There were to be parties, banquets, fireworks, fairs, masked

balls, plays, operas. There was a magic show with automata who answered questions posed by the audience. Balloonist Blanchard took off from a field. A two-story building sported a "Persian Fair" with a hundred boutiques and performances involving hundreds of children and adults and around a hundred horses, some of them disguised as camels.[60] Among the emperor's retinue, Salieri was responsible for the sacred music. In Prague he would conduct three Mozart Masses, including the *Coronation* and one of the *Thamos* choruses fitted with Latin words. The royals were serenaded at table with music from *Don Giovanni* played by winds; the whole opera was also mounted, Leopold and his wife in attendance. A writer caught sight of Mozart and described him as "a little man in a green coat, whose eye proclaims what his modest appearance would conceal . . . whose joy it is to see for himself with what delight his beautiful harmonies fill the hearts of the public." On September 12, there was a gala involving five orchestras playing music for dancing in various rooms, some of the dances surely by Mozart.[61]

Hard at work as he was, he took hours off here and there, apparently several times visiting the local Truth and Unity Masonic lodge. On his last visit he was given a surprise: a performance of his cantata *Die Maurerfreude*. It was said that he daily dropped by a billiard parlor in town. People noted him singing to himself as he lined up shots, and jotting things in a notebook. At the Duscheks' he sat down and played the result, an ensemble for *Die Zauberflöte*.[62] Observers also noted that he was visibly ill and being seen to by doctors, though his high spirits still flared up with friends.[63]

As always, he waited until the end to write the overture to *Tito*. This gave rise to a story that may as well be true. He was staying at the Duscheks' Villa Bertramka. Josepha Duschek and the orchestra concertmaster came in the day before the premiere to find Mozart pacing up and down in his room in a sweat. Flummoxed and exhausted, he groaned that he could not come up with a single idea for the overture. Duschek cried, "Then for heaven's sake begin it with a cavalry march!" Mozart went to the piano and started to improvise vigorous music, and the overture fell into place.[64] If the orchestra sight-read it at the premiere, it would not have been the first time for a Mozart opera.

At the coronation ceremony, tradition dictated the show. The arch-bishop bared Emperor Leopold's left shoulder and anointed it with holy oil, which after a blessing was rubbed off with bread and salt. The Crown of Saint Wenceslas was placed on the emperor's head, he was handed the scepter and the Golden Apple of the Empire, and a ceremo-nial sword was strapped around his waist. He took his oath of office to the accompaniment of trumpets and drums and cannons. That night, September 6, was the premiere of *The Clemency of Titus*. The emperor and retinue arrived late, and of course the house waited for them.

The opera seria they saw belonged to a genre in the middle of a long slide into obsolescence but still popular in Italy and in England, still preferred by royals who liked to be reminded of their powers and who did not mind being lectured about their responsibilities, as long as it came from a stage. To countenance the operas' calls for clemency made them look clement. Mozart was much loved in Prague, and when the performance finally began he entered to cheers and perhaps fanfares, as he had before in the city. He seated himself at the harpsichord (old-fashioned by then, but still used in opera and orchestral music). He was sick and exhausted and would have to rely on the nervous excitement of performance to get him through the evening—that and the prod-igal fund of energy he had possessed since childhood. The orchestra and singers had gotten their parts at the last minute and were probably highly on edge, Mozart more so. It could not have been any sort of secure performance.

Metastasio's original libretto for *Tito* was based on the Roman em-peror Titus. From his time onward this emperor was known for his benevolence and mercy, at least when compared to the madness and ferocity of other Roman sovereigns. He ended prosecutions for treason and official spying on the populace; meanwhile, to amuse the citizenry he built the Colosseum, a mixed blessing.[65] This libretto was one of Metastasio's most vital, even if Titus is the least interesting of the three main characters, to a large extent because, in dramatic terms, benevo-lence and forgiveness are less entertaining than scheming and evil.

The central character is a fascinating woman: Vitellia, daughter of the late emperor Vitellius. She hates Titus for dethroning her father, and using her beauty as weapon she has persuaded her lover Sextus to assassinate Titus after setting fire to Rome as a diversion. At the same

time Vitellia is ambitious, ready to put aside her drive to revenge if Titus makes her his empress. But he has declared it will be Berenice, a foreigner. That choice has only stoked the rage for revenge in Vitellia. If she does not reach the searing fury of Electra in *Idomeneo*, she is a more riven and complex character. Sextus, equally compelling in his way, is helpless to resist her even though he is close to the emperor. He is overwhelmed by love, tortured by it to the point of betraying the emperor and himself. The story turns around the passion, rage, regret, and guilt of these two. There is another pair of lovers, Sextus's sister, Servilia, and his friend Annius, the latter a pants role for a soprano

The plot is tangled but engrossing. Though Titus loves Berenice, he nobly sends her away in favor of a Roman woman, and he chooses Servilia as his empress. This of course enrages Vitellia, and she demands that Sextus immediately murder Titus. But when Servilia tells the emperor that she loves Annius, he again nobly pulls back. His choice for empress now falls on Vitellia. This being her fondest hope, now she is riven by regret and uncertainty, Sextus no less so. After various contretemps—the city burns, Titus is reported as killed but is not— Sextus's plot is exposed, and he is condemned to be devoured by wild beasts in the arena. In a powerful scene, Titus confronts Sextus, who confesses his guilt, but out of his desperate love for Vitellia, he will not reveal her part in the plot. He takes all the blame on himself, saying he deserves death. Alone and anguished, Tito signs the death warrant for his friend, then tears it up. He declares that if he is to be condemned as weak, he wants it to be for showing mercy. But he tells no one of his decision, and preparations for the execution go forward.

Stricken by guilt at what she has done and expecting Sextus to be executed, Vitellia rushes to the arena where the lions await their meal and Sextus awaits his end, and she confesses all to Titus. Stunned by her revelation, Titus nonetheless declares clemency for all, and the opera ends with the chorus singing his praises. The choice of this story was the expected sort of show to decorate a coronation, its plot of a ruler's clemency archetypal for opera seria. At the same time, choosing this tale of an emperor famous in history for his mildness and forgiveness was a tribute to Leopold II, who had shown himself a progressive and benevolent ruler in Tuscany. After he died he was called "a latter-day Titus."[66]

WHAT TO MAKE OF THE OPERA IS A COMPLEX QUESTION. WHEN HE took it on, Mozart was at the unsurpassable height of his powers, his music taking a turn into a new dimension. He had the libretto he wanted, and it had compelling leading characters torn by love, revenge, and regret. He liked writing seria at least as much as buffa. At the same time, the opera was put together at furious speed by an ailing composer who had to hand off some of the duties to his competent but hardly inspired student Süssmayr. Some of the scenes left in simple recitative, like the confrontation between Titus and Sextus, could, if fully composed, have been powerful passages on the stage. (To Metastasio a seria was first of all a drama, and for him recitatives were as important as arias.[67] The operagoing public did not concur.) On the whole the music is up to Mozart's standard, with a singular voice because it was the first seria of his full maturity. Call *Tito* a stride toward remaking and intensifying opera seria that did not entirely reach its goal because there was no time, no time, no time.

The orchestra is full, with two each of winds, plus trumpets, drums, and horns. Given that Mozart's friend Anton Stadler was in the orchestra, there is going to be a lot of clarinet and some contribution from the tenor clarinet called a basset horn. The overture is a brisk affair. Whether Mozart really considered the opening to be in the manner of a cavalry march is hard to say, but the music is pompous and imperial for a story of royal doings, with plenty of trumpets and drums. It sets out the home key of C major in its magisterial mood.

Among the opera's highlights is the spacious first-act aria in which Sextus submits to his murderous lover. What makes this number distinctive is a long clarinet obbligato, much of it a duet of tenor and clarinet; with the two of them, Mozart shapes a touching piece. He seems to have been inspired, as he generally was, by that instrument and that friend, clarinetist Stadler. Here Sextus becomes a striking if almost powerless character, driven by a helpless love to betray his friend Titus in spite of all his best instincts: "Oh, what power, dear gods / Have you given beauty to inspire!" Here in a quite different story is another case of what we find in *Così fan tutte*: characters at the mercy of passions that drive them to betrayals they could hardly have imagined. In *Tito* at its best, the music has an unalloyed dignity that suits the traditions of opera seria but slips past seria's usual artificiality of character and music.

There is a sense of genuine feeling stretching beyond familiar rhetoric.

The finale of act 1 is the glory of *Tito*. Mozart was a master of buffa finales, and he was invested in this one. It is of course not going to be the farce of a buffa finale, all the characters in a frenzy, but matters have still come to a pass: as Sextus laments and Vitellia is frantically trying to call off the assassination, the fire that he and accomplices set to cover the assassination has broken out in Rome. Everyone is stricken, for varying reasons. The screams of the people punctuate the music in searing harmonies. The scene sustains a blistering intensity, as if the raging flames are a punishment to Sextus and Vitellia. As a climax, word comes that Titus has been killed in the tumult. The two conspirators realize that for their treachery they are going to get nothing but regret and infamy. The end of the act is not tumultuous, however; rather there a sense of black despair, somehow conveyed in E-flat major. *Tito* proved to be Constanze's favorite opera by her husband, this finale one of her favorite things he ever created.

So Mozart overfilled his plate and yet brought it off, even if *Tito* could have been far more developed if he had only had the time. He might have used the musty and obsolescent foundation of opera seria to create a new kind of music drama. That with so much else would not happen.

The premiere of *Tito* was essentially a failure, probably mainly due to a scrappy performance. The royal family was not entertained. Empress Maria Luisa wrote in a letter, "In the evening to the theater. The grand opera not so grand, and the music very bad, so that almost all of us fell asleep. The coronation went splendidly."[68] The ubiquitous chronicler Count Zinzendorf noted in his diary, "a very tedious opera."[69]

In the next weeks the music would settle in with the company and the opera would find an audience in Prague. For his part, Mozart badly needed a break. Most of *Die Zauberflöte* he had written more or less at leisure. With *Tito* had come weeks of relentless work late into the night, with little sleep. But he could not take a break; he had to dash back to Vienna to finish and premiere *Die Zauberflöte*. The last months had amounted to the most sustained and remarkable creative marathon of his life, and he was still in the middle of it. But it cost him too much. It cost him everything.

AN ETERNAL CROWN

The name on the libretto of *Die Zauberflöte* is Emanuel Schikaneder. The words are his, it is his kind of show: a fable that plays to the galleries with lavish stage effects, broad humor, mystical malarkey, and a lavish role for himself. But Mozart was involved from the beginning, and surely for that reason, *Zauberflöte* turned out to be the only historic project Schikaneder was ever involved with in his long career as actor, librettist, playwright, composer, and theatrical entrepreneur. It was also the biggest and most enduring hit of his life. Impossible to know exactly what elements each of the two creators contributed, but the result has thumbprints of both. Schikaneder recalled long talks between the two of them as the project took shape. When it came to the overall approach, Mozart was ready to meet Schikaneder more than halfway, or maybe it was simply that he liked what the impresario was doing in the Freihaus Theater and wanted to be part of it.

Mozart had been hanging around Schikaneder's theater for a while, writing the odd aria for a production. Meanwhile he had long wanted to write German opera again, and he had nothing in hand from Emperor Leopold's new Italian troupe. A collaboration was a natural step for these old friends. Between them they created something familiar in Schikaneder's output, but in Mozart's case something new for him, neither opera buffa nor seria, and not a conventional singspiel either. Here he escaped the traditions and rigmaroles of court opera and connected

to the rough theater of the streets, to farce and fantasy and fairy tale and the antics of Hanswurst and his brethren.

Mozart was lucky that, once again, a great librettist had fallen into his lap. But where Lorenzo Da Ponte was a poet and litterateur, Schikaneder was in all his capacities a servant of his audience, one of the foremost theatrical figures of his time and prodigally theatrical in his temperament as well. He was born in 1751 to a family of domestic servants. His father died a couple of years after he was born; his mother got by selling religious articles at the Regensburg Cathedral. Early on he seems to have struck out on his own playing the fiddle in village taverns.[1] At eighteen he joined an itinerant theatrical troupe working out of Augsburg and imbibed the requisite skills: acting, singing, dancing, directing, writing tunes for productions. He also imbibed theatrical genres from comedy to tragedy to opera and singspiel and became acquainted with the range of theatrical classics: Germans including Lessing, Schiller, and Goethe, and Shakespeare. The role that made Schikaneder famous was Hamlet; he also appeared as Othello and in other classic roles.[2]

Already a budding star, in 1777 he married the company's leading actress, Eleonore Arth, who was a singer and dancer. Three years later he took over the troupe, supporting it at his own expense. He would have known, or soon learned, that Goethe and Shakespeare were not going to pay the bills, whereas singspiel and other, broader offerings could. Schikaneder never entirely left serious drama, but his repertoire gravitated to more popular offerings.

For six months in 1780–81, the Schikaneder troupe was resident in Salzburg, appearing at the theater across the square from the Mozarts' house. The family being steady theatergoers and socializers, they took Schikaneder into their circle. The record shows him as part of the family's Sunday afternoon *Bölzlschiessen* matches; one of the homemade targets poked fun at his womanizing, showing him flirting with one girl while another waits for him.

Emperor Joseph II saw Schikaneder onstage in Pressburg and on the spot offered him a job at the Kärntnertortheater in Vienna. Schikaneder came to the theater at the end of 1784, his first production *Die Entführung aus dem Serail*. It was there that his production of Beaumarchais's

Marriage of Figaro was scotched by Joseph at the last minute. Before long, that job fell apart when a star of the company, his wife, Eleonore, got fed up with his habitual infidelity and left him. She took up with an entrepreneur named Johann Friedel, who ran the suburban stage called the Theater im Freihaus auf der Wieden, the last being a river that ran alongside Vienna.

After some wandering in the wake of their separation, Schikaneder put together a new company in Regensburg, where he mounted open-air spectacles including Sturm und Drang plays by Goethe and Schiller, complete with companies of soldiers spread around the landscape. In Regensburg he joined a Freemason lodge, probably less out of idealism than professional interest; wherever a member went in Europe in those days, he found useful contacts among fellow Masons. But this undertaking didn't turn out any better than the Kärntnertor did, and for a similar reason: within six months, some scandalous incident or incidents, probably having to do with a woman or women, got him ejected from the craft.

Schikaneder's place in history came by way of his ex-wife, who had been managing the Freihaus Theater with her partner Friedel. He died suddenly in 1789 and bequeathed her the theater. At that point she summoned Schikaneder, they reconciled, and the two began running the theater together. The repertoire would be all German, its foundation singspiel. "My sole aim," Schikaneder proclaimed, "is to work for the box office and to see what is most effective on the stage, so as to fill both the house and the cash-box."[3] His first production was his own comedy, *The Dumb Gardener from the Mountains*. It featured him as Stupid Anton, his avatar of Hanswurst. The play was a smash; six sequels followed. Schikaneder remained a star of the troupe, but by then he was getting too stout to be playing leading roles. He would tend to comic parts, to which when singing was required he brought a strong if untrained baritone, not up to virtuoso arias but good enough for popular numbers. Mozart would have made note of all this and filed it away for the purpose.

In those days there were a number of suburban theaters outside Vienna. The Freihaus was part of a sprawling complex of buildings that included 225 flats, 6 large courtyards, a church, an apothecary, and a mill. (The word *Freihaus* reflected that the theater was freed from

taxes.)[4] The main courtyard had a garden with a wooden pavilion, where after shows Schikaneder and the company often celebrated noisily into the night. The theater was a stone building with a tile roof that he expanded to hold around a thousand people. There was a double row of boxes; the stage was some forty feet deep and included the elaborate machinery Schikaneder required for his effects.

Most of the theater company lived in the complex, alongside a mélange of working people, craftsmen, servants, and the like, who were also the core audience for the productions. The aristocracy turned up as well, so in contrast to the court theaters, the audiences represented a singular mingling of classes. Schikaneder's house orchestra had about twenty-three but could be expanded as needed. The company was not as well paid as the court troupes, but they were still leading players, among them Josepha Hofer, Mozart's sister-in-law, the eldest of the singing Weber girls.[5] Her virtuosity rivaled that of her sister Aloysia, and she was particularly admired for a sensational high register.

Soon after Schikaneder started with the company, Mozart wrote Josepha an insert aria for a production of Paisiello's *Barber of Seville*.[6] He became friends with the company's leading tenor, Benedikt Schack. An old story has Mozart dashing off songs for Schack while waiting for him to get out of costume after a show.[7] Another of the company was Anna Gottlieb, who had created the first Barbarina at age twelve and was now a seasoned veteran of seventeen. Vienna rumors had a liaison between her and Mozart. This would have been no surprise, but there is no evidence for it. Still, if ever Mozart was surrounded by temptations to stray, it would have been amid this theater company full of roisterous joie de vivre. The sexual exploits of stage people were as much a byword as those of the aristocracy, the subject of endless delicious gossip.

SO IN THE SPRING OF 1791 THE TWO MEN SAT AND TALKED, PLANNED and sketched. With this project Mozart could be leisurely, probably working on it for some six months, off and on.[8] To keep his composer close at hand, Schikaneder gave him the use of the wooden pavilion in one of the Freihaus courtyards.[9] The two men were supreme professionals at the height of their careers. Depending on how they are

counted, this would be more or less Mozart's twenty-second opera finished or planned. For his part Schikaneder had written dozens of plays and librettos. He had no ambitions toward depth, but he knew what worked on the stage, knew about shaping action and pacing and character. If he was hardly a fine poet, he was a capable versifier.

Mozart would have been humming as they worked, imagining melodies and formal outlines, but he would also have been adding story and character ideas. It was going to be what Schikaneder probably considered a singspiel; in his catalogue, Mozart simply called it a German opera. A current term for what they were planning was a "machine comedy," meaning one involving extravagant stage effects: characters flying around, thunder, lightning, fire and waterfalls, plus sumptuous sets and costumes and often involving fairy tales and some exotic and fanciful locale.[10] This sort of show was hardly new to Mozart. As a devout theatergoer, he had seen plenty of it from Schikaneder and others. Around 1786 he had tried his hand at a couple of spoken comedies in the Hanswurst vein: *A Salzburg Rube in Vienna* and some sketches toward a play called *The Test of Love*. His characters included "Wurstl" (short for "Hanswurst") and "Herr von Dummkopf."[11]

At some point they decided that this was going to be a machine comedy in fairytale mode—but a fairy tale for adults more than children. Rather than the usual pseudo-mystical humbug of these stories, the mountain spirits and all that, there would be something real behind the flimflam. The opera was going to be an allegory of Freemasonry: the ideals, the ceremonies, the symbolic words and actions, the initiation into wisdom. This seems like Mozart's thumbprint on the work; in any case, it was central to the whole. Schikaneder had been a Mason only briefly and badly. Mozart had been an initiate in the craft for nearly a decade, he was devoted to it, and he had written music for its ceremonies (though none of it was ambitious and none since 1786).

Beyond that, Mozart had already written music related to the 1731 novel *Sethos*, by the French abbé Jean Terrasson. The book was well known to Masons, who took it as an authority on Egyptian mysteries, which was hardly the case: Terrasson invented the whole apparatus.[12] *Sethos* had been the basis of the play *Thamos*, for which Mozart years before wrote choruses and arias toward an opera. The book and play are about the education of an Egyptian prince and his initiation into

ancient mysteries.[13] For Mozart, that incomplete project based on *Sethos* turned out to be something of a study for *Die Zauberflöte*.

But that was only a general superstructure for what took shape. From his decades of theatrical experience and apparently wide reading, Schikaneder put together the story like a mosaic, cobbling together bits and pieces from an array of sources. Christoph Martin Wieland's epic poem *Oberon* was popular and broadly influential; Schikaneder had recently premiered an operatic version with music by Paul Wranitzky. From that, it appears, came the ideas of the trial of a pair of lovers and of a magical instrument. In regard to the action, it is relevant that Schikaneder had written music and libretto for an operetta based on Blanchard's balloon ascents.[14] Another prime source was a book of stories written and collected by Wieland called *Dschinnistan*, all of them tales of a mythical "Oriental" domain. Its last story is *Lulu, or the Magic Flute*. In that book there is also a version of *Oberon* in which the hero plays his horn and makes some rogues dance.[15] All this played into a vogue in German countries for exotic tales. Egyptiana was equally fashionable, influencing fiction and theater plots as well as design and fashion. Ancient priests, Eastern magi, djinns, and the fanciful occult were all over the books and stages of the time. There was a long-standing element of them in Masonic lodges as well.

Another prime source of *Die Zauberflöte* was a long essay by Ignaz von Born, acclaimed scientist and Vienna's most famous Masonic leader—before he quit the order in the wake of Joseph's clampdown. Published in a Freemason journal, his essay was called "On the Mysteries of the Egyptians." It amounted to a summary of the ancient religion, its gods and rites and priests. (Given the state of historical knowledge at the time, the facts and esoterica would have been largely fictitious, much of it based on *Sethos*.)

For the *Zauberflöte* libretto, Schikaneder lifted stretches of prose from the essay, also some of its ideas and ideals. Everything in the Egyptian mysteries, Born wrote, had a threefold purpose, "a moral, and historical, and a mystical meaning." The number three itself was a central symbol of Freemasonry, this so for a row of reasons, including the three main Abrahamic religions, the three degrees of the Masonic order, the three columns that stood in every temple, the three knocks of a second-degree Mason at the door of a lodge.[16] Born describes the

Egyptian initiation into the mysteries, in which a candidate is led into
the temple so that "in darkened chambers he may be faced with the
terror of death and brought back . . . so that he might see bright light
at midnight."[17] This element of the supposed ancient mysteries he
presented as a precursor to the Masonic initiation. Because the lodge
he led was rationalistic and scientific in outlook, scorning the mystical
hocus-pocus of many lodges, Born ended the essay, "May superstition
and fanaticism never desecrate our lodges!"

The essay includes this passage about women, purporting to explain
why they were not accepted into the order: "The Egyptian priests be-
lieved women to be incapable of the higher knowledge that was the
priests' task, and doubted their discretion." So women were not capa-
ble of the intellectual understanding required of a Mason. Beyond that,
their very beauty made them unsuitable: women should not be pres-
ent at ceremonies "lest they disturb the Brothers in their work by their
charms." Women, in short, could be guided to the light only by men,
with their superior understanding. This was general Masonic doctrine
relating to women, echoing common assumptions of the era. That too
would be part, an ignoble part, of *Die Zauberflöte*.

But the question of women was not simple either in the Masonic or-
der or in the opera. Not all Masons agreed that women should not be
accepted in lodges. There was an ongoing debate about this—and also
about allowing Jews. One of the requirements for a Mason was to be-
lieve in a higher being, though which particular one was not stipulated.
All the same, Jews were excluded. If the opera's dismal pontifications
about women come from Schikaneder or his echoing of Masonic doc-
trine, the rejection of that doctrine in the opera has Mozart's finger-
prints on it. He was not interested in submissive women. All his leading
women are vibrant characters, and even in scathing *Così* they are the
center of the story.

There is one more significant influence on *Zauberflöte* and other ex-
otica of the time: to set a tale in an imaginary country permeated with
magic was a way to avoid the increasingly imperative presence of the
censor in everything to do with Austrian life, not least in art. After
full censorship was revived by the dying and disillusioned Joseph II's
patent of January 1790, every play, every opera, every book and poem,
had to be approved by the authorities.[18] Eventually all improvisation

onstage would be forbidden for fear of subversive ideas expressed outside the approved script. At every performance of every play, a policeman would be in the audience following the script; with any deviation, the guilty performer would be arrested on the spot. Creating allegories and works about other times and places, preferably entirely imaginary, has been through history a way of eluding the hand of tyranny. In Vienna in 1791, at least, that hard necessity was aided by the fact that exotica and machine shows appealed to the crowds and filled the coffers. Also, private suburban theaters in these years were not so relentlessly policed. In any case, it appears there was nothing in the storybook territory of *Die Zauberflöte* to arouse the attention of the censors.

So the essence of *Die Zauberflöte* coalesced from these elements and more, forged into a unity by Schikaneder. The story as it took shape is set in a land ruled by what amount to sorcerers and sorceresses. Prince Tamino—the libretto says he is wearing a Japanese hunting costume—is saved from a serpent-monster by three women who declare themselves servants of the Queen of the Night. The Prince is of course young and handsome. He encounters the clownish Papageno, a sort of natural man covered with feathers, whose job is catching birds for the Queen. She appears and tells them a distressing story: her daughter Pamina—the echoing names Tamino and Pamina are portents of destiny—has been abducted by an evil wizard named Sarastro, who heads some kind of brotherhood. The Queen tells Tamino that if he can rescue her daughter, Pamina will be his. She gives him the girl's portrait. Gazing at her face, Tamino falls instantly in love. He accepts the Queen's quest. Papageno will come with him; he will prove an erratic sidekick. The Queen also bestows on them enchanted accompaniments: Three Boys, who appear flying in a balloon and who will be their spirit guides; and two magical instruments, a flute for Tamino and a set of bells for Papageno, which can be wielded when trouble arises. The Boys are benevolent djinns, wise as elders, who will appear at critical moments to point the way. These sorts of guiding figures were familiar in magic plays and operas of the day.[19] The flute and bells are emblems of the power of music to bewitch, to enlighten, to transform.

The rest can be quickly summarized. Tamino and Papageno come to Sarastro's territory only to learn that he is not an evil wizard but the reverse, a wise and benevolent leader of a spiritual band—who are, in all

but name, a representation of a Masonic brotherhood and lodge. Hero and villain switch places: it becomes clear that the Queen of the Night is a malevolent woman whose ambitions challenge the supremacy of men. She represents the night of vengeance and fanaticism, Sarastro the light of wisdom and tolerance. In the future much confusion would rise from this switching of hero and villain. The Queen of the Night, after all, provides the heroes with the Three Boys and the magical instruments that will preserve them. In a fairy tale, a bad character cannot bestow boons.[20] But this is not an actual fairy tale; it is an opera in the mode of one. And characters' switching from good to bad was a familiar plot twist in stories of the time.[21] Eventually, of course, this being a comedy, after assorted contretemps the lovers are united and initiated into the Brotherhood, and the Queen's rebellion is put down.

As Ignaz von Born wrote of the religion of ancient Egypt, in Masonry and in this opera, things have one aspect on the surface, others underneath. The Masonic allegory dominates. Even if she turns out not to be what she pretends to be, the "Star-Flaming Queen" echoes the Masonic symbol of a flaming star; she has three servants, the Masons' favorite number, and supplies the Three Boys as guides.[22] She seems to have been based to a degree on the fairy Perifirime in *Sethos* and on another character in the book who tries to get rid of men who stand in her way to gaining supremacy at court.[23]

One aspect on the surface, another below. The Queen of the Night is a representative of the past and its fanaticism and superstition; allied to darkness, she is the enemy of the light of Enlightenment. In that respect she recalls a real queen: Holy Roman empress Maria Theresa, mother of Joseph II, who after the death of her Freemason husband began to repress the order, raiding lodges and arresting members.[24] This connection may have escaped most audiences of the time, and has escaped most since; for that matter, likely only initiated Masons would have grasped the allegory of the craft underlying the whole. Though the connection is plain, and the cover engraving of the first publication of the opera's libretto was full of Masonic symbols, including the flaming star (the cover was made by a member of Mozart's lodge[25]), the relation of the story to Masonry was apparently not noted in print for decades.[26] Mozart was playing the game he did in *Figaro* and *Don Giovanni*: those who wanted to see in them a critique of the aristocracy were welcome

to; those who saw the aristocrats in the plot as just a vehicle of an amusing story were equally welcome. The rigmarole and balderdash of *Die Zauberflöte* are like those in a lot of magic-based plots of the time; nobody was required to think them any more than that.

Each of the characters has their own sources and implications. The debauched slave Monostatos is black not for racist reasons, at least not entirely so, but rather because he ends up allied with the Queen, and so with the night. Papageno, an avatar of Hanswurst devoted to wine, women, food, and song, proves entirely unqualified for the role of hero's sidekick he is asked to play. The name for this garrulous clown likely and appropriately came from *Papagei*, a German word for parrot.

What about Sarastro? His name comes, in part, from the mythical sage Zoroaster, aka Zarathustra. Recall that for a party years before, Mozart produced a collection of Zoroastrian riddles. The prophet was a familiar figure rising from the Enlightenment's interest in ancient mysteries and religions. In the simplest dimension, Sarastro is a representation of the grand master of a Masonic Lodge. But there are two other connections well known to Mozart and Schikaneder that may have inflected him as a character. One again brings up the formidable Ignaz von Born, whose humanistic and science-oriented lodge in Vienna Mozart sometimes attended. Born was lauded for his wisdom and integrity—and also noted, like Sarastro, for a volatile temper. There was another figure, literary this time, who may have contributed to Sarastro's name and temperament: Shakespeare's sage Prospero in *The Tempest*, who also has a temper and also has a dark-skinned slave with designs on someone's daughter. Monostatos is Sarastro's Caliban, and both lustful exotics come to well-deserved grief at the hands of their masters. Which is to say that, like Prospero, Sarastro is fundamentally a wise and benevolent sage, but with a vengeful side.

All the characters are part of a web of symmetrical pairings in the story. At the same time, plot and characters are connected to the earth and the cosmos. The Brotherhood worships the holy couple of Egyptian mythology, Isis and her husband Osiris (who figured heavily in Masonic lore). The Queen is of night and the moon, Sarastro of daylight and the sun; he wears on his chest the potent solar emblem. Papageno the bird catcher is allied with light and air; the barbaric Monostatos is a creature of the earth. Tamino is allied to melody and song, Papageno

to dance and its physicality.[27] Tamino is fire; Pamina, water; in their initiation they pass through trials of fire and water.[28]

THE PREMIERE ARRIVED ON SEPTEMBER 30, 1791. THE FREIHAUS WAS sold out, anticipation buzzing in the hall as Mozart took his bow and sat at the harpsichord. Beside him was his pupil Süssmayr, to turn the pages of the score. Mozart would have been nervous, excited, exhausted. He had been in some degree ill for months, and this was his second opera premiere in three weeks. As often with big projects, he had been pushing his body to its limit and beyond. The final numbers, the Priests' march and the overture, he had written in the last few days.[29] There were varying reports about the skills of the Freihaus orchestra, and he may have tempered the scoring for them, but there was no doubt about the excellence of the cast. All were first-rate singers and actors, playing parts meticulously written not only for their voices but also their particular comic and dramatic skills. In the same way, the story and the music were tailored to the stage, to the acoustics of the Freihaus, and to the theatrical style of Schikaneder and what his audience expected from him. This was the most elaborate and ambitious production the impresario had ever mounted in his theater.

Naturally the role of Papageno was tailored to Schikaneder, his sturdy baritone reflected in the folk style of his arias, his movement incorporated in the rhythms of his music. (It is entirely possible that he wrote some of his own tunes for the show and Mozart arranged them.) Tamino was tenor Benedikt Schack, who was also a composer of singspiels and a flute player, so he probably played Tamino's flute solos himself. Schack must have been a particularly bright tenor, because that is what the part implies. The Queen of the Night was Mozart's sister-in-law Josepha Hofer, with her dazzling high register. Sarastro was written for the rich bass of a staple of Schikaneder's companies, Franz Xaver Gerl, twenty-four; he had Osmin in his repertoire. (His acting skills must have been considerable, because his later career included spoken drama.) Gerl's wife Barbara took Papagena. Soprano Anna Gottlieb was at seventeen experienced and able to handle the part of Pamina. Monostatos was given to character player Johann Joseph Nouseul, then fifty and more an actor than singer. There were other

familiar faces: Schack's wife one of the Three Ladies, a daughter of Schikaneder singing one of the Three Boys, his older brother one of the Priests.[30]

For this variegated collection of characters, and unburdened by the traditions and expectations of court opera, Mozart created the most colorful score of his life, from the childlike folksongs of Papageno to the exalted arias of Sarastro and the Baroque chorale prelude of the Men in Armor. Hardly a number in the opera is routine, and in its style it is neither quite buffa nor seria. The musical forms are the freest in Mozart's operas, often having little of sonata form beyond a return to the home key at the end. It was his task meanwhile to project throughout an aura of magic, and to that end much of the music has a singular ethereal beauty, not only in the material itself but also in the orchestral sonorities, some of them never heard before in Mozart's or anyone else's music.

THE ORCHESTRA FOR *DIE ZAUBERFLÖTE* IS THE FULL CLASSICAL CONtingent of doubled winds, trumpets and drums, plus three trombones. Unlike in *Don Giovanni* where the latter are introduced for their demonic associations, here they will be used partly in an echo of their churchly tradition and as sonic icons of gravitas.

Like any number of overtures, this one begins with ceremonial chords. But these three chords have a particular significance in this opera: they represent the threefold knock of a Fellow Craft Mason at the door of the temple before a ceremony. The chords, each with a sixteenth-note upbeat, recur at the beginning of the overture's development section. The key is E-flat major, for Mozart and many of the time a key of serious and exalted import. At the same time, the order considered it a Masonic key, because it has three flats. Chords and key presage a collection of threes in the opera, in both plot and music, and the opening chords will return.

The overture is in the usual sonata form, with a solemn and searching introduction followed by an Allegro with a nimbly chattering theme. This is singspiel style, but the music sounds more substantial than that. For one thing, the Allegro begins with an elaborate fugal treatment of the theme. As it proves, the whole of the overture is made from permutations of that theme. Its feature, as in so many Mozart themes going

back to his early years, is a series of repeated notes. The effect is distinctive to him. Fast repeated notes generate forward-driving momentum: we wait for what will break out of them. But in Mozart, repeated notes can also have a quality of arch insistence, driving in, in this case a manic energy like a doll being shaken. In the course of the overture the theme is put through paces, here soft and conspiratorial, there pealing and loud, here comic, there earnest, the pattering repeated notes relentless.

The curtain rises to a scene of action and spectacle. Prince Tamino runs onstage fleeing a serpent-monster, to the rigging of which Schikaneder would have paid particular attention. Beginning with the hero running onstage crying "Help!" while pursued by a monster is of course a rip-roaring way to start a show. The key is C minor, the tonality of tragedy and fear, but here the fear is contained, almost ceremonial. This is not the devouring monster rising from the sea of *Idomeneo*. This is fear in a fairy tale, the gingerbread house of the witch, the wolf disguised as Grandma.

Tamino theatrically faints away. On cue the Three Ladies appear, spears in hand, and to a fanfare dispatch the serpent. For the time, there is already something strange in all this: for that moment, things are upside down: the man collapsing helpless in the face of danger, having to be saved by women. As it turns out, though, this situation is also prophetic in the opera. In militant tones the Ladies tout their bravery in their usual close harmony, which places a sort of aura around their music. Here the opera's voice of magic appears, in female voices accompanied with airy wind scoring, often floating with no anchoring basses underneath. The Ladies are servants of the Queen of the Night, who will turn out to be not what she seems. Are the Ladies also tainted? This is something never entirely addressed, one of the loose ends in the plot. But as Schikaneder might have rejoined to this charge: fairy tales are not required to make sense.

With the opera not two minutes in, sex makes its appearance. The Ladies split into contending voices, each fawning over this handsome stranger as he lies in faint. They fall to bickering about who will go tell the Queen and who will stay by him. Finally they all depart, in a huff. Enter Papageno, who sings a ditty about catching birds for the Queen. Punctuated by runs on his panpipes, the music is a nimble dance match-

ing the naïve temper of the verse: "A jolly trapper of birds am I / And tra-la-la is what I cry. / The birdcatcher is how I'm known / In every corner, by child and crone." The crowd would have been chuckling in delight before he opened his mouth, by the silliness of the music and by his feathery costume, and by seeing Schikaneder again prancing about as some sort of Hanswurst figure.

Die Zauberflöte is a German singspiel, so there is no simple recitative but rather spoken dialogue and occasional accompanied recitative. Tamino awakens and sees the monster lying dead. In some spoken patter, Papageno introduces himself as a servant of the star-shimmering Queen of the Night, tales of whom Tamino's father has told him. Tamino boasts that he is a prince, his father "a king who rules over many lands and peoples." Here are established central elements of their characters. One is that Papageno, the man of the woods who catches birds, has no idea who his parents were or where he came from, no idea of a world and people beyond the mountains. He is a birdman from nowhere and nobody. Meanwhile Prince Tamino has no idea how he came to be in this land. Here is more fairytale logic, never really explained or needing to be. As in dream and fairytale, in this story things simply happen of their own inscrutable logic. Has he seen the star-shimmering Queen? Tamino asks Papageno. "What mere mortal can claim to have seen her?" the birdman cries. "What human eye could see through her inky veil of darkness?" The Queen is beyond everyday life, a figure of fable and myth.

For Tamino, Papageno takes credit for killing the monster because— why not? But the Three Ladies appear, expose his lie, and affix a lock to his mouth. Here arises the issue of silence, a theme in the opera and also in Masonic ceremonies, where silence was a way of putting the world aside in contemplating the light. Now the ladies give Tamino a portrait of the Queen's daughter Pamina, promising, "If you find yourself not unmoved by her features, then you are destined for happiness, honor, and glory!" Another case of threefold qualities being summoned in the opera.

Now the first great turning point. In a fairy tale you can fall in love with an image. Gazing at the portrait of Pamina, Tamino is smitten: "The picture is bewitchingly beautiful, / Like nothing my eyes have ever seen." It is the awakening of love, which is also a summons to

adventure, to heroism, to glory.[31] Though he does not realize it yet, Tamino has been called to a quest in the world of djinns and wizards and, as it will transpire, to a journey toward wisdom. The form the call takes is not through the understanding but through the eyes, the revelation of beauty, which is the threshold of love. Mozart's music for this moment is unlike either a buffa or seria aria, instead a sort of stream of consciousness, at first recitative-like as Tamino takes in the portrait, then warming and filling with yearning as the revelation overcomes him: "Can this feeling be love? / Yes, yes, it is truly love!" Seeing that the picture has done its job, the Three Ladies tell him of Pamina's abduction by Sarastro. As his fate has decreed, he vows to rescue her: "Pamina will be saved! I swear it by my love, by my heart!" He has accepted the call to a hero's journey, which is to say that he recognizes his fate, and in so doing he puts his old life behind him.

Thunder proclaims the coming of the Queen of the Night. The stage transforms from a wood to a splendid room. Says the stage direction: "The Queen is seated on a throne which is blazoned with transparent stars." The music swells to a lofty peroration. "O tremble not, my son," she proclaims in accompanied recitative, "for you are innocent, pure, and wise." More threefold virtues. The Queen is sorrowful but no less proud and commanding. Unlike any other aria in the opera, this one is in seria style, a mother's lament. As such it is mournful and touching yet detectably rhetorical, not tinted with magic or with the sort of authenticity heard in Tamino's passion or in Papageno's ingenuousness.

She ends, "Now you shall go to set her free / Now you can life and love restore. / And when you've won your victory / She will be yours forevermore!" If Tamino frees her daughter, she promises him Pamina's hand. This promise is a double-edged sword. On the one hand it is the kind of promise that queens make in fairy tales. On the other hand there is something ruthless in it, and indeed the Queen will prove interested less in her daughter's freedom than in striking a blow at Sarastro. Her proposal is sung in soaring roulades that reach to high D and to one high F near the end, a foretaste of her next aria. Here the virtuosity is made to seem overblown, the rhetoric of opera seria indicting its sincerity. But that is not clear to an audience seeing the opera for the first time. To those viewers, the Queen is a supernatural figure surrounded by stars, a wronged woman, her daughter the captive of a tyrant.

As the Queen sweeps off to fanfares from the orchestra, comedy returns with a jolt. Papageno still has his mouth locked shut and, garrulous even now, is forced to hum pitifully as the Three Ladies taunt him. They remove the lock and extract his promise never to lie again, a promise nobody believes. For the first but not last time, the cast dispenses a serving of platitude: "If lies and envy could be banished / And truth alone were understood, / Then hatred, slander, all would vanish. / And mankind live in brotherhood." The sentiments are bland but sincere—sincerely Masonic, in whose doctrine the words *brother* and *brotherhood* had a fundamental place.

Time for Tamino and Papageno to depart on their quest to save Pamina. To that end, two magical talismans are presented to them, gifts from the Queen. First, for Tamino, a golden flute. (Later in the opera, it has perhaps inadvertently been turned into a wooden one.) "With this you can do anything / Beasts will come and rocks will sing / The grieving heart forget its pain." Which is to say that the flute is an Orphic instrument with the capability to bewitch and assuage. Papageno is given a set of bells possessing the same potency. "With magic flute and silver bells," Papageno and the Three Ladies declaim, "a lad can cast enchanted spells."

Mozart sets the quintet in dancing comic vein, though the ladies' close harmony has the enchanted air. The music follows the action, yet it is no antic buffa ensemble but rather has a sense of steady musical and dramatic unfolding. Papageno is uninterested in heroic quests and not excited to be Tamino's sidekick: Sarastro, he says, is sure to "have me plucked and roasted / And feed me to his snarling hounds." Of course, in the end, Papageno will accompany Tamino, even if under protest and resolutely resistant to the tasks expected of him.

Now the voice of magic appears: a bass line absent, there is a radiant floating texture of clarinets, bassoon, and plucked strings. It is the Three Boys, descending from the sky as if from a balloon. They will guide the hero on his journey. Accompanied by their talismans and protectors, Tamino and Papageno set out to free Pamina.

ANOTHER SWITCH OF MUSIC, MOOD, AND SET. WE FIND "A RESPLENDENT Egyptian room; two slaves carry in beautiful cushions and an inlaid

Turkish table and spread out carpets." A long stretch of spoken dialogue. The slaves are gloating over the news: Pamina has escaped. Their overseer, the Moor Monostatos, "that fat-headed fleshpot," is going to be blamed for it by Sarastro, whose punishments can be grisly. Monostatos had been on the point of ravishing Pamina when she cried out for Sarastro, and in his ensuing confusion she ran to a canal, commandeered a gondola, and rowed away. We meet Pamina as a brave and resourceful young woman. But it has not worked; Monostatos enters dragging her and calling for chains.

The Moor is a descendant of Osmin in *The Abduction*: an exotic buffoon, ridiculous but in this case far from funny. In a breathless duet, roughly "Turkish" in style, he demands Pamina submit to him. If she refuses he is prepared to have her bound and rape her. Sex in *Die Zauberflöte* is not as central to the plot as in other Mozart comedies; here it is only overt when it is degraded. Pamina cries that she'd rather he killed her. The scene jumps outside, where Papageno has just arrived and is peering in the window. He sees Pamina, and in a reprise of his first song, now scored in the airy tone of magic, he describes "a maiden young and fine." He goes inside, and there follows a bit that is quite funny if the comic skills of the singers are up to it: feathered Papageno and black Monostatos come face-to-face, and each terrifies the other. Together they gasp, "Aaagh! . . . that is . . . the dev . . . il . . . surely!" The Moor flees the scene.

With him out of the way, Pamina and Papageno have a confabulation. He comes from her mother, he says. She recognizes his name. He tells her that a prince who loves her is coming to her rescue. Now it is her turn to be smitten by somebody she has never met: "He loves me? Oh, say that again! I love to hear the word love." As both Pamina and Tamino show, love in *Die Zauberflöte* is not fallen into as a corollary of desire. It is a consecrated force that is imbibed, like the potion in the story of Tristan and Isolde. As such it is a different and more exalted matter than the love of Figaro and Susanna, which is sensual and playful, or love in *Così*, which is manifestly sexual. With its story by the roué Da Ponte, *Così* has its foundation in an abiding cynicism concerning the evanescent relations between the sexes. *Die Zauberflöte*, with its story by Schikaneder and Mozart, has an ethos of lofty devotion between lovers.

Pamina and Papageno join in a duet, which is sweetly lyrical, gently beautiful, but with a formal quality, an ode to love sung almost as a recitation: "The greatest joy that each may own—/ To live by love, by love alone." Love lightens sorrow, it is part of nature's circle. "Man and wife, and wife and man, / Ascend to the Godhead." Here Mozart changed Schikaneder's text from man and wife reaching for the gods to their union attaining a kind of divinity.[32] He thereby made the duet into what amounts to the credo of *Die Zauberflöte*. In Mozart's prior operas love was internal, emotional, erotic. Here it is transcendent, joined to the order of society and of the cosmos.

This duet is one of the elevated numbers in the opera, all of them sharing a tone beyond comedy and tragedy alike. It is followed by one of the moments that approach the sublime. The Three Boys lead Tamino to the place where he is to free Pamina and join her, which will complete a sacred circle. Onstage are three temples. Inscribed on the right lies the Temple of Reason; on the left, the Temple of Nature; in the middle stands the Temple of Wisdom: three more qualities. The Boys' music is a slow march beginning with the solemn voices of trombones and strokes of timpani, which will supply the only bass part in their trio. The music defines this as a consecrated moment in an exalted place. Here as in much of the opera, Mozart wields an absolute simplicity of melody and harmony to remarkable ends. Like the Three Ladies, the guides largely sing in close harmony, but their music is not the voice of magic, not an evocation of grandeur, but rather a quality of unadorned nobility founded on the seraphic voices of boys.

Two things in regard to this and later sanctified moments in the opera: In these years, Immanuel Kant defined the sublime as something deeper than beauty. The latter he called a matter of the transfixing property of some surfaces as they strike us: indefinable, beyond understanding. The sublime is more mysterious, lifting our imagination toward the inconceivable. "I meet, I *find* the Beautiful," wrote Samuel Taylor Coleridge also in these years. "The circle is a beautiful figure in itself; it becomes sublime, when I contemplate eternity under that figure." In musical terms, the Boys' number is yet another voice in a work full of voices from peasants to princes to djinns and sorcerers. Call the trio *the voice of ethos*. These are weighty notions to hang on a little hymnlike march, but this is the place Mozart has reached in his

art: to reduce music to an essence of itself, which reveals its elemental power. The second matter is that this sounding image of the holy does not evoke common religion at all, but rises from an imaginary panoply of ancient-named gods. There is no Christianity in *Die Zauberflöte*. Rather the opera evokes an essence of religion itself, humanistic and celestial at the same time. It conjures the presence of the sanctified.

The finale of act 1 will be nothing like the farcical and frantic finales of a buffa or a singspiel. Much of it is accompanied recitative unlike any other in Mozart, in contrast to the usual accompanied recitative that precedes an aria. In order to fulfil his quest, Tamino has come to a place that he must understand, but the nature of which he has no idea, though he senses its potency. How and why does he sense it? Again, because this is a fairy tale. He has left the everyday world and entered the realm of myth.

An expanse of nearly a half hour, the finale is full of event and dialogue and contrast. Opera influenced Mozart's instrumental music, and the reverse influence gave his operatic scenes a sense of expansive freedom, also of unity underlying sometimes broad contrasts, never broader than here where they enfold multiple styles. This symphonic quality, and this scene in particular, was going to be much noted by future generations of opera composers, as a way of escaping number opera and integrating the music into a continuous flow.[33] Here the tones range over the stylistic map of the opera from accompanied recitative to stretches of arioso to full-blown duet and aria.

The Boys give Tamino a threefold injunction that must guide his quest to free Pamina: "Be silent, patient, and steadfast!" These are disciplines of a hero. There follows rhyming verse for Tamino that would ordinarily be set as an aria, but Mozart makes it an accompanied recitative, the most dramatic one of his life. Crying, "To save Pamina is my duty!" Tamino pounds on the door of the Temple of Reason. From inside the temple men's voices command, *"Go back!"* Stunned, he tries the Temple of Nature, with the same result. Finally he knocks on the Temple of Wisdom, which summons an old priest. There follows a long dialogue in recitative with bits of arioso. The Priest is impressed with this youth in search of wisdom, Tamino shocked to discover that this man is a servant of the despised Sarastro, who kidnapped Pamina. Indeed Sarastro did, the Priest replies, but I am sworn to silence concern-

ing the temple's secrets; you can find these things only if you become part of the sacred band.

The Priest leaves a despairing Tamino alone. "Oh endless night! When will you depart?" he cries. "When will my eyes find the Light?" Again from within the temple rise the mysterious voices: "*Soon, young man, or never!*" This will be the sole opportunity fate will give him. Is Pamina alive? he begs the voices. *Pamina lives,* they reply. The voices are nominally priests of the temple, but really they are not of this world. They are the voice of the numinous. Relieved, Tamino takes up his flute and begins to play. "How strong are your magical tones!" he marvels, "Even wild animals feel it!" Animals duly emerge from the wood, summoned by the Orphic flute, entranced. The music is an ingenuous folksong with a nimble melody. Tamino hopes it will summon Pamina. Instead he hears Papageno's panpipes in the distance.

Quick change of scene as Papageno and Pamina dash toward Tamino and freedom. But they run into Monostatos, who cries for chains to bind them. Now the other magical talisman shows its power: Papageno's bells. He begins to play, and as the animals were drawn by Tamino's flute, the bells entrance Monostatos and the other slaves into dancing and singing a giddy tra-la-la tune. After they dance off comes another verse of bromide from Papageno and Pamina: "Music gladdens every soul / In perfect harmony!"

Suddenly a fanfare and more offstage voices, hailing Sarastro. He is coming! As Papageno trembles in fear, to a sturdy march Sarastro makes his entrance in a triumphant chariot drawn by six lions, while the chorus sings his praises. These are the appurtenances of a supreme wizard—but like one of the models for his character, Prospero in *The Tempest*, he is not a simple one.

Sarastro is quick to demonstrate both his magnanimity and his dark side. In a number somewhere between a duet and accompanied recitative, Pamina apologizes for her escape attempt, but explains that she was trying to escape from Monostatos. We first hear Sarastro's rich bass as he forgives her and continues to a more serious matter. If the usual sorts of dramatic logic and motivation do not apply in this kind of story, there is still the lingering question of why he abducted Pamina in the first place. Here an explanation comes, if a bit curt and hazy. I know your heart, Sarastro says. "You greatly love another, / I won't press

you to love me. / I give you your freedom." He implies that he wanted
her for himself, so he is another abductor for love like Pasha Selim. But
in the same breath he removes himself from between Pamina and her
destiny.

I'm not just pleading for myself, Pamina entreats him, but also for
my mother, who—"

"Is in my power!" Sarastro interrupts. She is free to love Tamino,
he says, but not to return to the Queen. "My mother's name is sweet to
me!" Pamina cries. "She is—"

"A proud woman!" he interrupts again. Here rises Sarastro's wrath-
ful side, and the dark side of Masonry with regard to women. "A man
must guide your heart," he instructs her, "because any woman with-
out his care / will lose her way." That sentiment, so far from anything
expressed in his other operas or any known statement of Mozart about
women, is left dangling. (In another place, he cut a line of Schikaned-
er's text where the Boys tell Papagena she will be her husband's prop-
erty.)[34]

With a change of musical gears, Monostatos leaps back into the
scene, dragging Tamino after him. His and Pamina's eyes meet, with
instant recognition. They must embrace, they cry together, even if it
is their last embrace. Monostatos demands that Tamino be punished
and he rewarded for catching him. Your reward, declares Sarastro, will
be seventy-seven lashes. The Moor is thunderstruck, the chorus hails
Sarastro's wisdom. As it transpires, the sentence will not be carried out,
and Monostatos is not averted from his designs on Pamina.

There things lie at the end of act 1. Pamina and Tamino have con-
firmed their love, but they are still virtual prisoners. In a grand conclu-
sion to end the act, the chorus proclaims one more platitude: "When
Justice is a certainty, / And Virtue triumphs over Vice, / Then man-
kind will be truly free / And earth become a paradise!" Again the
sort of abstract moralizing that Masons were given to, likewise the
Brotherhood—never named—in *Die Zauberflöte*. But the path toward
that enlightenment, in its metaphorical journey from darkness to light,
will be led not by Sarastro or the Brotherhood, but in another, utterly
Mozartian way.

The second-act curtain rises to a scene of a palm grove with trees of
silver and leaves of gold. We are inside the Temple of Wisdom, among

the Brotherhood, who are priests of Isis and Osiris. There are seats with pyramids; in the center, a large pyramid. To a solemn march the Priests make their first appearance in the opera, filing in holding palm fronds: they are servants of gods of the desert. The music is in the vein established by the Three Boys, the voice of ethos. An audience seeing the opera for the first time is likely going to be dazzled by the music and spectacle, and also puzzled. At this point Sarastro still appears to be Pamina's abductor and the bitter enemy of her mother, who seems a wronged and magnanimous character. For his part, Sarastro has so far evinced kindness and forgiveness but also misogynistic wrath. The music, meanwhile, has painted him and the Brotherhood in lofty terms.

At the end of the march the Priests are seated and, so labeled in the score, we hear "the threefold chord." It is the same one from the overture, now beginning the august deliberation regarding an initiation. In those days Freemasons were recommended for membership by a friend or family member, who was their champion. Now Sarastro is going to put forth Tamino for membership in the Brotherhood. Here again is something that makes only fairytale sense, because up to this point Tamino has no understanding of the Brotherhood or of Sarastro and considers him an enemy. But Sarastro understands that here is an exalted couple whose union is fated, but this can be realized only through initiation.

A long spoken stretch. "This youth," Sarastro tells the Brotherhood, "wants to tear the dark veil from his eyes and gaze on the holiness of the sacred light." This evokes the moment in a Masonic initiation when the blindfold of an initiate is torn away, revealing a light that symbolizes wisdom—the wisdom bestowed by the craft, the victory of knowledge over ignorance.[35] He concludes, "It is our solemn duty now to watch over this high-minded youth and extend to him the hand of friendship." Friendship being a proxy for the Masonic hand of brotherhood.

The Priests ask a series of ritual questions. Is he virtuous? Can he keep silent? Is he good-hearted? Finally they nod assent. Sarastro thanks them and adds, "Pamina, a pure and gentle maiden, has been designated by the gods for this young man. This was the reason I separated her from her arrogant mother [well, not entirely]. That woman . . . hopes by superstition and delusion to bewitch people and undermine the very foundations of our temple . . . As a brother among

us, he will be the champion of Virtue and the scourge of Evil." Three more qualities cited: virtue, silence, and benevolence. A deeper question follows. The threefold chord sounds again. A brother voices his concern that Tamino may not survive the ordeals of initiation. "After all, he is merely a prince!" Sarastro's reply is epochal: "No, he is more than that. He is a man!"

By no means, this time, does Sarastro mean a man as superior to a woman. He means a true, strong, honorable person, a hero in potential. To be such a man, according to Sarastro and to Masonry, is of more consequence than to be a prince. So much of the Enlightenment bears on this declaration. The Masons were founded as a brotherhood of enlightened men in that sense, nominally irrespective of rank or religion—which was in part why thrones and the Church denounced the craft as subversive of the social and sacred order. But Mozart (probably he rather than Schikaneder) has added an element Masonry had not yet attained: as it transpires, Pamina will be initiated into the Brotherhood as well.

The Priests give assent to Tamino's initiation, and Sarastro completes the ritual with a hymn to Isis and Osiris, the text based on the opera's prime source, the ancient-Egypt novel *Sethos*.[36] It evokes the primal divine couple, the wife Isis assembling the pieces of her murdered husband Osiris. This sacred couple is the essence of the other dualisms in the mythos of *Die Zauberflöte*: moon and sun, water and fire, night and day, Pamina and Tamino—and the Queen and Sarastro. In a sense, the goal is to reconcile these polarities, but again, more in theory than in practice: Sarastro and the Queen are oil and water and cannot be reconciled.

So Sarastro's aria "O Isis und Osiris" is a pre-Christian hymn, an evocation of primeval gods. The style of the music is not Christian either, nor like any traditional sacred music. Yet it is unmistakably sacred because it evokes an essence of the spiritual, yet an essence not removed from the world but profoundly human and humanistic. Which is to say that the hymn is not addressed to any gods worshipped in the actual world, but to a sense of the numinous. To that end, it is again music with the kind of chaste simplicity unique to Mozart that has a quality of elemental rightness, as if it grew from something eternal rising from the inner nature of music itself.

Part of the hymn's effect is the organ-like sonority that accompanies Sarastro's bass voice: dark-toned basset horns, bassoons, trombones, divided violas, and cellos—and again no basses, so the music seems to hang in midair. If there is anything in Mozart that "O Isis und Osiris" resembles, it is the "Ave verum corpus" he had just written, and parts of the Requiem he was about to write. The hymn ends with "Grant they may conquer death [in the initiation], / But if they fail the final test, / Find for them in heaven's breadth / A final peace, eternal rest." This again not about the Christian afterlife and, in a way, not entirely about immortality at all. Part of the wisdom Masonry wanted to impart to the initiated was to transcend the fear of death and of hell. The journey of initiation through the presence of death, the fire and water, was an image of that transcendence.[37]

In a Masonic meeting the master of the lodge would proclaim, "Be mindful of Death!" and, later, "Early acquaintance with death is the best schooling in life."[38] Mozart echoed this in the letter he wrote his father near the end: "Death . . . is the true and ultimate purpose of our life, I have over the last several years formed such a knowing relationship with this truest and best friend of humankind that his image holds nothing terrifying for me anymore; instead it holds much that is soothing and consoling!" *Die Zauberflöte* is a comedy, but one with, at its center, a spiritual yet non-Christian transcendence of mortal fear. It is relevant that Mozart had recently visited Schiller's friend Christian Körner, a Mason and Illuminatus whose High Enlightenment ideals inflected Schiller's "Ode to Joy," which in its original version contained the declaration, "All sinners shall be forgiven, and hell shall be no more."

Again the opera follows serious matters with comic ones. Papageno has been put forward to accompany Tamino in the initiation, a prospect he views with a mingling of dread and indifference. A priest appears to ask if they are prepared to face death. "Wisdom is my goal," declares Tamino, "the fair maid Pamina, my reward." A ritual answer to a ritual question. To the same question, Papageno replies, "To tell the truth, I don't much care for wisdom. I'm a simple man. A little sleep, a little food and drink—that's enough for me. And if only I could catch myself a pretty little wife . . ." If the mythos of the opera, like Masonry, puts aside the aristocracy of birth, it maintains an aristocracy of mind and

spirit. Tamino is a prince, an honorable man, an aspirant, maybe a pro-
spective Sarastro, but he has not yet ascended to that level. Papageno
is a kind of ur-peasant, a natural man, but the opera does not patronize
him for that. A clown is also part of nature's and heaven's plan. It was
also an essential part of Mozart's nature.

But now, as the Queen had promised her daughter's hand to Tamino
if he succeeded, the Priest dangles the prospect of a girl before Papa-
geno: "What if Sarastro has already destined a bride for you, a maiden
who looks just like you, down to the last feather?" Her name, as it hap-
pens, is Papagena. Do I have to die to get to see her? Papageno groans.
All you have to do, the Priest replies wearily, is shut up. Keep silent
alongside Tamino—even if the ladies are present. This, of course,
is not going to go so well for Papageno. Two Priests sing a curt duet
about the dangerous wiles of women, the music giving it a blandly di-
dactic tone.

Soon Papageno, enjoined to silence, proceeds to babble away. He
is interrupted by the appearance of the Three Ladies, the Queen's ser-
vants, who beseech them to flee for their lives from Sarastro and his
minions. This quintet of the Ladies and Tamino and Papageno is in
some respects odd. They are servants of an evil queen giving false ad-
vice, but the tone of the Ladies' music, along with their close harmony,
is light and luminous. Which is to say that their number sounds like
music for the Three Boys, and so is enchanted with an airy little flute-
violin refrain. Once again there is ambiguity in the music, as in the
plot, between good characters and bad.

The orchestration is viscerally involved with the effect of this num-
ber. Two generations later, doubling orchestral instruments on a line—
clarinet and oboe, flute and clarinet, violin and flute, and the like—would
be done for coloristic and expressive effects. But in the eighteenth cen-
tury doublings were generally for practical reasons: the routine dou-
bling of bassoon and bass to strengthen the harmonic foundation, or
doubling woodwinds to balance with strings. Here and elsewhere in
Die Zauberflöte, Mozart comes up with singular instrumental doublings
to paint mood and character. In the past he had done that more often
with rhythm; now he is doing it equally with color.

The expostulations of the Ladies are interspersed with Tamino turn-
ing their threats away—he has learned the perfidy of women—and

Papageno's terrified gibbering. Suddenly Priests of the Brotherhood appear and cry, "These women are to be reviled! / The Brotherhood is defiled!" and condemn the Ladies to perdition, or at least to falling through a trapdoor onstage. A terrified Papageno faints dead away. Two Priests pull him together. He wonders why, if this Papagena is already destined for him, he has to go through all this stuff. "Be a man!" the Priests entreat him. In this ruckus, he sighs, "a man could fall out of love forever."

The scene changes to a "charming garden." As Pamina sleeps, Monostatos creeps up on her, having escaped the lash and still lusting for her. He breaks into a patter song in folk-Turkish style whose sentiment seems to be lifted from Shakespeare's *Merchant of Venice*: I am black, but does my heart not beat like others, don't I deserve love too? The song, in two strophes—repeated music with two verses—and just over a minute long, has no reason to be more than serviceable, but it is unforgettable, one of Mozart's great throwaways. It raises a chuckle in the soul.

But Monostatos is interrupted yet again, this time by the Queen of the Night, who enters in thunder. What ensues is a scene destined for legend in opera, again because it is like nothing else. After waking her daughter and shooing Monostatos away, in a spoken dialogue the Queen unmasks herself. Where is that boy I sent for you? she demands. He has joined the Brotherhood, Pamina tells her. That means I can no longer protect you, her mother replies coldly. She tells the story of Pamina's father, who gave the Brotherhood the seven-pointed Circle of the Sun that Sarastro now wears at his breast and which is his power. Her husband told her: "Do not try to understand a matter not meant for a woman's mind. It is your duty to place yourself and your daughter under the leadership of wise men." With that the story deepens, likewise the misogyny. The Queen says Tamino must choose between her and the Brotherhood. "Dear Mother," Pamina sobs, "could I not love him just as tenderly if he were part of the Brotherhood?" "How dare you!" she cries.

The reversal of hero and villain is complete, the Queen's true malevolence revealed. Here is a knife, sharpened for Sarastro, she tells her daughter, forcing the blade on her. You will kill him and bring back to me the Circle of the Sun. This will be her means of wresting power

from the Brotherhood, which is to say, from the rule of men. When Pamina protests, the Queen silences her and begins an aria hardly of this world—like so much music in the opera, but in this case, raging with fire. There had been any number of characters in opera more or less from hell, including the demons in *Don Giovanni* with their infernal trombones, but none so singularly infernal as the Queen of the Night. This Queen is an anti-heroine swelling larger than life before our eyes and ears.

"Hell's vengeance boils in my veins," she cries. "Death and despair flame around me!" There was the old convention of the furioso aria, sung usually in a seria by an evil character vowing revenge. Mozart had written his share of these, including blistering ones for Electra in *Idomeneo* and a parody of one for Bartolo in *Figaro*. "Der Hölle Rache" rises from that tradition, but it does not sound like it. In musical terms, "Der Hölle Rache" can be defined partly by what it does not do. It begins and ends in D minor, in tradition an appropriate key for proclaiming death and despair, but there are no trombones and no conventional sulfurousness. The Queen is boiling with fury, but she is still a queen—a queen out of myth who distributes magical instruments and has in her voice a magical instrument of her own, which never rages out of control. That is the daring and the strangeness of this aria destined for legend.

It begins with quivering strings as the Queen looms over her terrified daughter. The operative words are issued in a series of proclamations like a row of lashes: *vengeance, despair, death, outcast,* and finally, *a mother's curse.* After the opening in D minor, as she orders her daughter to plunge the knife in her enemy, the music moves to F major and stays there. The range climbs to normal soprano top notes, B-flat, C, as she tells Pamina that if she fails to kill Sarastro, she will be her daughter no more. On that threat, the music ascends into the empyrean and unreal: high-C leaps to repeated high Fs.

That note had rarely been heard from a soprano onstage, but it was heard often from Josepha Hofer, Mozart's sister-in-law. Those top notes, a kind of resonant squeak, were her specialty, and to them she owed much of her fame. Of course Mozart was going to write those notes for her. But what would ordinarily have been a virtuoso vehicle he made not into a portrait of a stage villain but into the medium of nightmare. One sign of a nightmare is that it is not what you expect,

least of all coming from the mother who is supposed to be your protector. This height of an evil mother's rage continues in that unexpected F major, usually associated with cheery and pastoral moods, and the figure reaching to high F is like a fanfare, staccato notes ringing in a supernatural register like thrusts of a dagger. The precision required for that figure is a sign of the Queen's poise in the midst of conjuring death and despair. Finally she is spitting threats at her daughter on a high A for six bars, as if driving each word into her soul: you will be turned out forever, the bonds of nature shattered, unless Sarastro pales in death. She ends in a howl: "Hear, vengeful gods! Hear a mother's oath!" She sweeps off, leaving the dagger in Pamina's hand.

As shattered Pamina clutches the blade, Monostatos appears. He has overheard everything. He tells her that if he only says the word to Sarastro, the Queen will be drowned in the Brotherhood's water of initiation. The price for his telling Sarastro is Pamina's body. When she falls to her knees to plead with him, he snatches the knife and cries, "Love me or die!" Several people need rescuing in this opera, and in this case the savior is Sarastro, who enters to stay the Moor's hand. "I know your heart is as black as your face," Sarastro tells him, but he will let him go, apparently because he is not as bad as the Queen. Monostatos departs, vowing to find her and betray his master.

Pamina begs Sarastro for mercy for her mother. He says only that if Tamino makes it through the initiation they will be united, and her mother "will grovel back to her castle in shame." There follows his second heart-filling aria, "In diesen heil'en Hallen," ("Within These Sacred Walls"), this time not hymnlike in style but as imposing as his first aria, and with the same sublime directness. It is on the order of a gentle folksong in two strophes. Here and elsewhere in the opera Mozart is more generous than usual with flute solos in the orchestra, for obvious reasons. In these sacred halls, Sarastro says, "Revenge remains unknown. / And if a man should fall, / His way by love is shown." Friendship and brotherhood are the guides to a better place. The opera's credo is sounded again: "Within these sacred walls / Where man loves mankind, / No traitor lies in wait, / Because one forgives one's enemies."

These are high sentiments, true to their Masonic roots and unforgettably evoked in the music. But they are not strictly true: Sarastro has a

vengeful side, he and the Queen remain sworn enemies, and his slave
has just turned traitor.

NOW PAPAGENO ENTERS AGAIN TO PROVIDE SOME FUN. HE AND TAMINO
are brought to a hall to await initiation and are sternly enjoined to si-
lence. As soon as the Priests are gone Papageno begins chattering,
Tamino trying to shush him. An old lady appears and begins to tease
Papageno, calling him "my angel" and her sweetheart. When he asks
her name, she hobbles away. We know, of course, who she is. Now
the Three Boys appear to cheer on Tamino and Papageno, counsel-
ing them to keep flute and bells handy in case of need, and providing
some snacks. Again their music floats in midair, but this time the tone is
perky and playful. But be quiet! the Boys remind them. Let's eat! says
Papageno as soon as they leave.

Tamino plays his flute. This draws Pamina, who enters to find that
Tamino inexplicably won't speak to her, nor will Papageno. Conclud-
ing that Tamino no longer loves her, she sings a devastated aria, ending
with "If your love were to disappear / The friend who's left is Death
alone." Once again, working outside the formulas of opera seria and
buffa, not restrained by singspiel expectations, Mozart writes a sorrow-
ful song free of rhetoric and filled with pain—but the pain of a fairy
tale, where hero and heroine grieve but are destined to triumph. In that
world, as in this song, grief can be delicately beautiful. The last line,
"rest in Death," is piercing to the heart. In the orchestra the novelty of
colors continues: there is a wind response to Pamina's phrases, some of
it scored memorably for flute and oboe in unison. The flute smooths the
sharpness of the oboe, the oboe gives poignance to the flute.

After more banter from Papageno to silent Tamino, the Priests enter
and sing a prelude to the initiation. The music has the tone of Sarastro's
hymn to the gods, this time in the vibrant sonority of a men's choir
accompanied by trombones. Again, the aura of this music recalls "Ave
verum corpus" in its exalted simplicity. Here it is a sounding image of
the Enlightenment dream of a new humanity, an age of reason, peace,
and justice, which appeared to have actually begun in these months
with the rise of revolution in France. Progressive circles in Vienna were
awash with excitement as astonishing news arrived by the day from

Paris. In these weeks Louis XVI, still nominally king but a prisoner after he and Marie Antoinette were dragged back from their escape attempt, formally acknowledged the new civil constitution. But if the Enlightenment was the greatest period of hope in human history, and the Revolution seemed to be its fulfilment, around those bright hopes twilight was already gathering as murderous forces gained momentum in France and repression and reaction in Austria.

Sarastro steps forward to wish Tamino well on the perilous journey of initiation. Pamina had been stricken by Tamino's silence, afraid that she had lost his love. In a trio the lovers say farewell. Sarastro reassures them and hurries Tamino on.

In a long dialogue scene Papageno—that is to say, Schikaneder— gets to strut his stuff. For Schikaneder who was more actor than singer, this amounts to a virtuoso turn in the opera. Papageno is scared and hungry, and he can't follow Tamino. A priest appears to announce without regret that, after all, he's not up to being initiated. That's fine with Papageno, who is consoled with a glass of wine. It is delicious and inspires him to a song accompanied by his bells: "A sweetheart or a bride / Is Papageno's wish. / A cute and curvy, moon-eyed / Turtle-dove's his dish!" It is a folksong in four repeated strophes, the bell part more elaborate with each verse. (The bells were played in the pit, on a keyed glockenspiel nimbler than one played as usual with mallets.)

Here in comic form is a moment that cinches an essential premise of the opera, concerning its principals. *Die Zauberflöte* is a parable of love, from earthly to cosmic. In his theatrical progeny Papageno is Hanswurst, a peasant in society, a natural man of the woods in the mythology of the story. What he wants out of life is food, wine, song, and a pretty little wife with whom to make babies. Part of his simplicity is that simple vision of love founded on an earthy sexuality. (The other overt desire is from Monostatos, which is degraded sexuality, simple lust.) The love of Tamino and Pamina is at a higher level, including sexuality but beyond it, exalted. Finally there is the love of Sarastro, who is an avatar of divine love, pure and disinterested. To be sure, there was a hint of his interest in Pamina, but that was perhaps a case of Schikaneder making a stab at motivating the abduction. The abiding reason that Sarastro abducted Pamina was to remove her from the presence of an evil mother and join her to her destined partner. In the

story and in the music, none of these principals is scorned. All these manifestations of love are part of the earthly and cosmic order. And all of them were part of Mozart.

After Papageno's song the crone appears again. Now he makes a joke of flirting with this old lady until suddenly she reveals herself to him as a winsome teenager dressed just like him. But as he rushes to embrace her, a priest drags her away and she is gone like a mirage.

Finale. It begins with the Three Boys descending in their balloon and hailing the sun as the light of justice, reason, and wisdom:

> Soon the glorious sun will take
> Its golden course across the sky!
> The foes of superstition wake
> And wisdom is enthroned on high.
> Soon peace will bring its remedies.
> Enlightenment will bless the wise.
> Then mankind will be truly free
> And earth become a paradise!

This is another summary of the Masonic foundation of the opera: a vision of Elysium that would be part of Beethoven's inspiration when he came to write his last symphony. The poem that he would quote in that work, Schiller's "Ode to Joy," rose from the Enlightenment spirit of the 1780s. And a cantata the young Beethoven wrote on the death of Joseph II began by summoning the specter of fanaticism, which is to say superstition, which Joseph went down fighting (in theory, at least).

If the chorus of priests reflected Enlightenment spirit directly in the music, the music for the Boys reaches it by a route lighter and more indirect. Their number begins with clarinets, bassoons, and horns making up a *harmonie*. The melody is childlike, the key E-flat, the home tonality of the opera and the key of nobility and inspiration. This beginning, though, is ceremonial. Now the story intrudes: the Boys discover Pamina despairing at her loss of Tamino, brandishing a dagger, ready to kill herself over Tamino. The Boys move from being guides to saviors: they stay her hand, assure her that Tamino loves her, prepare to bring her to him.

The stage transforms to an epic scene of the sort that was Schika-

neder's specialty. In the distance loom two towering mountains, from one of which gushes a waterfall while the other spits fire. In the foreground are two rocks with iron doors. These are the gates of initiation. Tamino is led to his ordeal by two Men in Armor, their helmets crowned in flames. They read to him the inscription on a pyramid in the center of the stage. This is another of the opera's tremendous moments, when sound becomes the gateway to the uncanny. It is also another style in an opera kaleidoscopic in its voices. In form the song of the Men in Armor is a Baroque chorale prelude, meaning the melody of a Lutheran chorale declaimed with counterpoint woven around it. The words are exhortations to the initiate:

> He who walks this path full of pain
> Will remain pure through fire, water, wind and earth.
> If he can overcome the fear of death,
> He rises up from the earth!
> Enlightened, he will be capable
> Of consecration to the Mysteries of Isis.

Taken almost verbatim from the novel *Sethos*, this verse has its own tincture of the occult.[39] It is the music that raises this number toward the sublime. The strings quietly carry on imitative four-part counterpoint in style as close to J. S. Bach's as Mozart ever came in a major work. The strings' gently skipping music goes on almost in a separate plane as the chorale melody sung by the Men in Armor, who are doubled by winds and trombones. As in a Bach chorale prelude, they declaim the chorale melody phrase by phrase over the counterpoint of the strings. The orchestral sound is singular in total, but what drives the music into the heart is the voices: they sing their line in octaves throughout, uniting rich low bass and pealing high tenor, a riveting sonority maybe never heard in opera before. The total effect is of something at once ceremonial and ineffable.

The Men's number slips into accompanied recitative. Tamino declares himself ready to go alone into the ordeals, but now Pamina appears. In a moment it is understood that she must go into the trial with him, not behind him but leading him: "The woman who fears not night and death / Is worthy of initiation," sing the Men in Armor.

Those words are pealed out over and over: "The woman who fears not death is worthy! Is worthy!" Here Mozart—surely he is shaping the work—annuls the Masonic misogyny of the rest of the opera and makes the guide toward the light a woman. She is woman as an image of the power and wisdom of love. As he did in the Count's final plea for forgiveness in *Figaro*, Mozart handles the moment without embellishment, in the music as in the words: "Tamino mine! O what joy!" Pamina cries. Tamino echoes her words. The destined couple is truly united. Now, together, they will enter the gate in the rock.

Taking his hand, Pamina sings to him,

Whatever we walk through
When I am by your side,
I myself will lead you
And Love shall be my guide.

Tamino, Pamina, Papageno—none of them can reach fulfilment without help, without magic, without guides. In *Die Zauberflöte*, the guides toward salvation and wisdom have been Sarastro, the Boys, and music. Now Pamina becomes a guide, conducting both of them through emblems of death and resurrection and into the light. Tamino raises his flute. When the Queen bestowed it on him it was of gold. Now it is of wood, carved of unsullied oak by Pamina's wizard father. Imbued by the power of music, they sing with the Men in Armor, "we go joyfully into death's dark night."

The door into the rock closes behind Pamina and Tamino. We see them walking, hear wind and thunder and the crackle of fire. Tamino is playing his flute. When the great master of the next generation, Beethoven, wanted to be imposing and profound, he tended to get long and loud. As often as not, especially in this work, Mozart got soft and simple. Tamino's melody is a little dancing tune, accompanied by trombones and horns, modestly conveying a great transformation taking place.

Pamina and Tamino come through the fire; they embrace. Now they must brave the water. They walk downward. He plays the flute again, the same little tune. Suddenly the doors of the Temple of Wisdom are thrown open to reveal a blaze of light. Trumpets and drums sound, a

chorus cries, "Triumph! Triumph! Thou noble pair!" Together, Pamina and Tamino are conveyed into the temple.

After their triumph a question remains: What about Papageno? No girl for him? He is back in the garden alone, slumped in a clown's despair, playing his panpipes in the desperate hope that they will summon his Papagena. He sings a despondent aria about his yearning for this beloved who has appeared only as a phantom. Finally he too decides to end it all. The music is a darkened version of his usual ingenuous style. He throws a rope over a tree limb and counts to three on his pipes, hoping for the best. Nothing. Oh well, the rope then. This is the cue for the Three Boys, who appear to remind silly Papageno that he has magic bells for occasions like this. Of course! He had forgotten! So he plays them, in a music box tinkle: "Ring, little bells, ring out, / Bring my sweetheart here!"

And so the power of music saves Papageno too. His destined love Papagena appears, conjured by the bells, introduced by the Three Boys: their final task. In wonder and delight, at first the two can do nothing but stutter: Pa—Pa—Pa . . . Then they embrace, crooning to each other visions of nights of love and little Papagenos and Papagenas. Our birdcatcher has reached his fulfilment in echo of Tamino, but on his own artless terms.

This leaves a final matter to be disposed of, which is quickly done. Emerging from the earth via trapdoors, Monostatos appears leading the torch-bearing Queen of the Night and Three Ladies into the sacred precinct. He reminds the Queen that she has promised Pamina to him. "I'll keep my word," she declares. A roar from the orchestra: thunder, a waterfall. As the stage is transformed by sunlight, the intruders cry, "Shattered, ruined is our might, / All plunged into endless night!" The Queen and her minions sink back whence they came, the night of fanaticism and superstition: the past. The light is the future.

Now the joyous final chorus of a buffa or a singspiel. But this is far more than rejoicing over a rescue or the fall of a villain or the reunion of lovers. Tamino and Pamina enter wearing priestly robes. Beside them are the Priests of the Temple and the Three Boys, holding flowers. "The sun's golden splendor has banished the night," Sarastro declares. "The forces of evil are vanquished by right." Proclaims the chorus, "Strength has won victory, and its reward / An eternal crown

to Beauty and Wisdom!" Strength, Beauty, Wisdom—these were the names of the three pillars that stood in every Masonic temple.[40] The couple is elevated to a transcendent nobility, united with the cosmos. They are the Crowned Lovers. Their love is Wisdom enthroned, herald of a new age: the Reign of Love.

SO FROM A PATCHWORK OF SOURCES MOZART AND SCHIKANEDER WOVE their great fairy tale for children and grown-ups, full of comedy and profundity, silliness and wisdom, misogyny and feminism, and joined them to the starry cosmos and to a vision of a better world. With *Die Zauberflöte* Mozart arrived at the furthest reach of his art, the terminus of a journey that began soon after he left the cradle, at the moment he first miraculously played a tune on harpsichord.

An artist's talent and his personality are two different things, but they inflect each other. From childhood Mozart was an actor by nature; in maturity he acted his characters in his music. And he was all of them. Tamino, Pamina, Papageno, Sarastro—they all were him, in music he lived all of them, and in his life he and Constanze were the Crowned Lovers. He suffered and laughed and spoke the truth and lied along with all of them. His tears were their tears. His characters came to him in sound, and he shaped what they said, living it in that moment. *Die Zauberflöte* is the distillation of Mozart's journey through convention and into his own dominion. From there he promised to continue that journey into unimaginable discoveries. But a man's art is one thing, and his fate is another.

ET LUX PERPETUA LUCEAT EIS

After the premiere of *Die Zauberflöte* in September 1791, a year in which Mozart had premiered two operas in three weeks, written more music than at any comparable period in his life, earned more money likewise, and also, starting the year before, suffered his worst stretch of health in a long time, it would seem that he would have given himself a rest and enjoyed the situation a bit. After a dicey premiere, *La clemenza di Tito* was turning into a modest success in Prague, and *Die Zauberflöte* was proving a sensation in Vienna. He had the commission for a requiem. He was paying off his debts, and prosperity was imminent as soon as the postwar economy revived and the ailing Kapellmeister of St. Stephen's got around to dying, so Mozart could take over that plum job.

But for some reason he did not rest on his new laurels and his new prosperity. He continued in a kind of madness of work, composing late into the night and sleeping little.[1] In October he completed a clarinet concerto for his friend Anton Stadler, and the next month he dashed off a cantata for a Masonic ceremony. Otherwise after conducting the first performances of *Die Zauberflöte*, he returned to the theater repeatedly to bask in the applause and show off the opera to friends and family.

As far as the record knows, what sort of mood he was in during these weeks is ambiguous. Reports from Prague had him visibly unwell and consulting a doctor. On his return he may still have been ill but not bedridden. His letters of the period are resolutely cheerful, as he had

every reason to be. But Constanze was still in and out of Baden, he regularly making the hours-long coach ride to visit her. Years later she remembered him in these weeks as feeling shaky and depressed. She told an early biographer that he had said to her, "I know I must die, someone has given me acqua toffana and has calculated the precise time of my death—for which they have ordered a Requiem, it is for myself I am writing this."[2]

That he felt exhausted needs no explanation, but that he believed he was poisoned is puzzling and vexing. One possibility is that he never said it. Memory plays tricks, more of them as the years pass, and in general, Constanze is not the most reliable witness in the record—and least reliable concerning this period. She was given to dressing up a story, for one reason or another. If he did say he felt like he had been poisoned, it could have been a matter of feeling sick, perhaps sick in an unfamiliar way. But if he did feel that way, who could he possibly have imagined was responsible? The future would indulge in endless speculation on these matters, without evidence for any of it. His surviving letters of the time are, again, entirely in his high-spirited mode.

A lot of the high spirits have to do with *Die Zauberflöte*. In the first week of October he wrote Constanze in Baden:

> I've just come back from the opera;—it was full as ever.—The Duetto Man and Wife and the Glockenspiel in the first act had to be repeated as usual—the same was true of the boys' trio in the second act, but what really makes me happy is the Silent applause!—One can feel how this opera is rising and rising. But now to my daily life: right after you sailed off I played two games of billiards with Herr von Mozart; he's the guy who wrote the opera for Schikaneder's theater. Then I sold my old nag for 14 ducats,—after that I had Joseph get Primus to fetch me some black coffee, with that I smoked a glorious pipe of tobacco. Then I orchestrated almost the entire Rondó of the Stadler concerto . . . But hold on, what do I see?—What do I smell?—It's Don Primus with the Cutlets!—che gusto! I am now eating to your health.[3]

"Primus" was his nickname for a waiter at a local inn who did odd jobs for him.[4] Perhaps some of this was put on to cheer up Constanze,

but it has a ring of the old Mozart joie de vivre, a tumult of games, food, fooling, music, and pleasure in all of it. And why not? Constanze was still a worry but was, it appears, out of the woods at least. He was maybe feeling better, reporting to his wife a good appetite, and otherwise all going well: the opera, the concerto, the Requiem. *Die Zauberflöte* in particular was a kind of success he had never enjoyed on the stage before; the audience that packed the Freihaus cut broadly across class lines from top to bottom, from the aristocrats in the boxes to the working people in the top-level paradise.

The anxious tone of his worrying and borrowing letters of the last few years had not been heard for a while. A couple of days later he wrote Constanze that he had run into Mama, meaning her mama, and planned to take her to the opera, though he's skeptical she's up to it: he "will probably have to say: she is seeing the opera, but she's not hearing it." He wrote after returning from that night's performance, where he had been a little naughty—

Had a box this evening and applauded everything vigorously; but He, that Know-it-all, proved to be a real Bavarian; I couldn't stay with him or I would've been tempted to call him an ass;—unfortunately I just happened to be in their box when the second act started, and it begins with a solemn scene.—He laughed at everything; at first I was patient enough to draw his attention to some of the lines, but—he just laughed;—well, it was too much for me—I called him a real Papageno and left the box;—but I don't think this Nitwit understood what I meant—so I went to another loge, occupied by Herr Flamm and his wife, and there I could enjoy the opera fully, and I stayed to the end;—except when Papageno's aria with the Glockenspiel came on, at that moment I went backstage because today I had a kind of urge to play the Glockenspiel myself.—So I played this joke: just when Schikaneder came to a pause, I played an arpeggio—he was startled—looked into the scenery and saw me—the second time he came to that spot, I didn't play—and this time he stopped as well and did not go on singing—I guessed what he was thinking and played another chord—at that he gave his Glockenspiel a slap and shouted "shut up!"—Everybody laughed. I think through

this joke many in the audience became aware for the first time that Papageno doesn't play the Glockenspiel himself.—By the way, you can't imagine how charming the music sounds when you hear it from a box close to the orchestra—it sounds so much better from there than from the balcony.—As soon as you come back, you'll have to try it out.

No record of who was the thick-headed Bavarian who laughed at the wrong places. Mozart's joke on Schikaneder is a good indication of the easy friendship the two enjoyed. There would have been a certain amount of extemporizing in the show in any case, including topical humor on what was transpiring in the world outside the theater. This included the developing French Revolution, in which priests had just been ordered to swear an oath of fealty to the revolutionary government. (In the coming months some interpretations of *Die Zauberflöte* would paint it as a covert endorsement of the Revolution, others as antirevolutionary. None would call it a Masonic allegory.)

Another few days and another visit to the opera and report to Constanze. This one was particularly poignant. He had brought with him mother-in-law Cäcilia, his son Karl—and Antonio Salieri along with his lover, the diva Caterina Cavalieri. The letter reveals a manifest reconciliation of Salieri and Mozart, who since he arrived in Vienna had largely viewed the older man as an enemy and an obstacle. Yet in those same years they had also been in some degree colleagues, and now they seemed to have reached a mutually respecting friendship. Salieri, who was rarely heard to praise anybody, was lavish on this occasion.

You can't believe how sweet they both [Cavalieri and Salieri] were—and how much they enjoyed not only my music but the libretto and everything.—Both of them told me it was an op-era fit to be played at the grandest festivity, before the greatest monarch—and they would certainly go and see it more often because they had never seen a more beautiful and more pleasant spectacle.—Salieri listened and watched with great attention, and from the overture all the way through to the final chorus there was not a single number that did not elicit from him a "bravo" or

"bello." He and Cavalieri went on and on thanking me for doing them such a great favor.

Son Karl (aka Carl) was then seven and not a particularly diligent student. Mozart had put him in a school and then regretted it, doing some politicking to get him accepted in a better one run by the Piarists, a Catholic educational order. After the opera they had dinner, and,

> Carl was so delighted that I had taken him to the opera.—He looks great;—he couldn't be at a better place for his health, but everything else is unfortunately pretty bad out there!—The [school] is probably all right for producing some fine peasants for the world! . . . I don't believe that his education will go down the drain if he stays out of school for a month,—and in the meantime, maybe something will come of my talks with the Piarists; they are considering his acceptance.—Apart from all that, Carl is neither worse nor better than he was before; he has the same bad manners, likes to get attention as always, enjoys learning <u>even less</u> than before because all he does out there is to go walking in the garden . . . In other words the children are not doing anything, except eating, drinking, sleeping, and going for walks.[5]

Thus the letters of these weeks to Constanze: Mozart happy for a change, sanguine about how things are going, basking in praise received, enjoying being a papa.

THE CLARINET CONCERTO K. 622, WRITTEN FOR OLD FRIEND ANTON Stadler, was finished in the first week or so of October 1791 and dispatched to Prague, where Stadler probably premiered it.[6] Stadler had the advantage of being a virtuoso on an instrument just coming into its own and equally the advantage of having a composer friend who loved the instrument. The man himself appears to have been something of a rogue, having at the beginning of the '80s ditched his family to take up with a seamstress, and he tended to live on the edge.[7] Apparently Mozart did not hold a grudge that Stadler had once stiffed him on money given him to redeem a pawn ticket, or that he had so far not made good

on another loan of five hundred florins—which in fact Stadler never did repay.[8]

One of Stadler's specialties was that singular instrument lying in range between the usual clarinets in B-flat and A and the basset horn, with its range down to nearly an octave lower. This middle-register creature was dubbed the basset clarinet. Mozart's Clarinet Concerto seems to have been written for an instrument that added four notes to the bottom of the usual range, down to an octave below middle C. The instrument's larger size also gave it a slightly darker sound that inspired Mozart to lyrical effusions that make steady use of its over three-octave span. Meanwhile, like all clarinets it had the varied range of articulations from biting staccato to velvety lyricism and four registers each distinct in color. All this is woven into the concerto. Mozart sketched it in G major for basset clarinet. But the instrument never caught on, so when the concerto was published in the next decade it came out in A major for A clarinet, the original notes below its range transposed up.

The inception of the piece was one of those often-extensive sketches of a first movement that Mozart dashed off as they struck him and kept handy in case of need. This time it was the 199-measure draft of a basset clarinet concerto he put down in 1787 or sometime after.[9] The piece joins his accustomed lyricism in writing for the clarinet to a profusion of material that unfolds from a tiny central motif: the drop of a third that begins the lilting first theme will be echoed in themes throughout the concerto that are based on a foundation of descending thirds. (This pattern of notes underlies the theme of the first eight bars: G-sharp E C-sharp A F-sharp D B and finally G-sharp at bar 8.) The steady presence of thirds in the melodic language of the concerto gives it a distinctively sweet aura.

The orchestral sound throughout is lush, a dialogue of solo and ensemble with few patches of routine orchestral accompaniment. In the winds there are no oboes but rather the mellow sound of two flutes and two bassoons, whom the soloist joins at times in chorus. One way to view the first part of the movement is that it seems to be proceeding like a normal concerto, with a substantial orchestral exposition before the solo enters. But that exposition, and the rest of the movement, are not laid out conventionally. Where the second theme is expected, there is instead a contrapuntal development of the opening theme, starting with

a three-part canon that extends for a while before the second theme proper.

The solo enters on an amiable opening melody and soon takes it into dashing roulades. From that point, there flows a profusion of lyrical themes introduced by the clarinet that expands the exposition enormously. The development is likewise extensive, taking up several of the earlier ideas. There are stretches of exuberant clarinet virtuosity that ripple through the registers and their colors from bottom to top— the colors deepen when the piece is actually played on a basset clarinet, with its notes reaching down into the baritone range. Given that the soloist is showing off much of the time, there is no real cadenza.

The second movement reminds a listener that this is the Mozart who has just written *Die Zauberflöte* and "Ave verum corpus," where he found a touching and profound simplicity. The orchestra creates a warm atmosphere around exquisite singing and sighing solo lines. In the middle section of the ABA outline, the orchestra pulls back to reveal something of a clarinet soliloquy that becomes steadily more flowery toward a sort of mini-cadenza. Here is one of those Mozartian movements whose chief quality is not cleverness or contrast or virtuosity but rather a kind of candid elegance. Future generations would find a valedictory poignance in this movement. A touch of pathos is present, lying under the serene beauty, but Mozart himself did not appear to be feeling valedictory. He had reached a new plateau in his work that seemed to be driving him to go beyond anything he had attained before.

The finale of the concerto is a chirpy rondo on a folklike theme in something like Papageno mood, in which the clarinet proves nimbler and even more dashing than before. As in the first movement, the impression of simplicity is deceptive: this is an expansive movement with a large middle section in the A B A C B A outline, the C section developmental but also with new thematic material. So like the first movement, the finale has a sense of new themes appearing through its course—all of them turning around descending thirds. The final A section keeps extending and developing the theme, as if Mozart doesn't want the piece to finish, doesn't want to let it go. On the order of his finest piano concertos, this one would stand in perpetuity as the greatest of clarinet concertos—written just after his arguably greatest opera

and during the creation of a work that would stand at the summit of his sacred music.

MOZART PROBABLY STARTED INTENSIVE WORK ON THE REQUIEM JUST after the premiere of *Die Zauberflöte*. After he died, a prattling parade of myth and obfuscation would accumulate around the piece, and those stories would career happily on over the centuries: the commission from a mysterious stranger, Mozart's conviction that he was writing the Requiem for himself, and so on and so forth. But there was no mystery at all, only intentional mystification.

The commission brought by the stranger who appeared shortly before Mozart went to the Frankfurt coronation came from an eccentric, rich, and musical count named Franz von Walsegg. At his castle in Stuppach, the count gave regular house concerts in which he played cello and flute. The performances were never done from printed music, only from scores the count had paid to have copied or had copied himself, and which never included the name of the composer. This was because the count liked to play a little game: after each work was heard, he would coyly ask the company and players to guess the composer. Most of the time, recalled one regular visitor, "we suggested it was the Count himself, because from time to time he actually composed some small things. He smiled and was pleased that we (as he thought) had been mystified; but we were amused that he took us for such simpletons. We were all young, and thought this an innocent pleasure that we gave to our lord."

This foolery had been going on for years when Walsegg's young wife died in February 1791. The grieving count determined to commission two things as tribute: for her tomb an epitaph carved by a prominent Viennese sculptor; and in her memory a requiem Mass, for which he chose Mozart.[10] Walsegg paid more than 3,000 florins to his sculptor, around 225 to his composer. Despite the count's sad memorial, it may still have been his intention to have his usual fun over guessing the composer at the premiere. Thus the anonymous commission and the mystification around it. Constanze always said that Mozart had no idea who commissioned the Requiem, but that may not be true. Walsegg had owned a mansion in Vienna, one of whose tenants was Mozart's

generous friend Michael Puchberg. The latter may have suggested Mozart to the count in the first place, and it is entirely possible that Puchberg told Mozart what was going on.[11] Equally possible that he kept his mouth shut.

After the *Zauberflöte* premiere Mozart apparently began the work with the opening movement: "Requiem aeternam dona eis, Domine" ("Give them eternal rest, O Lord"). He had never set that text before, but he had been familiar with it nearly since the cradle. It is what is chanted and sung in church with every death, and Mozart had seen his share of death. The first choice to be made, as always, was the key and the forces. He chose the most common key for sorrow and tragedy, D minor, the key of *Don Giovanni* and one of his darkest piano concertos.

The instrumentation and scope of the piece are allied to the character of a compact Mass as it was defined in the time of Joseph: relatively small forces and mostly short movements. Mozart had already shown in "Ave verum corpus" how moving that kind of restraint could be. So if the Clarinet Concerto is marked by a profusion of instrumental color and expansiveness of material, the Requiem is going to be more or less the opposite: a restricted orchestral palette, the instruments mostly doubling the choir, each of its short movements developing a small range of ideas. Doubling the choir is the main task of three trombones, who play with the lower voices most of the time and have only occasional moments to themselves. Otherwise in this Mass for the dead, Mozart wanted only somber colors: in the winds no horns, no oboes, instead only two basset horns and two bassoons, with trumpets and timpani not for a festal effect as usual, but for incisive punctuation. As with most instruments made to emphasize their lower range, basset horns in their higher notes are more fragile than regular clarinets in the same range, and it is that high range that Mozart exploits more than the dark, woody low range. All this will be part of the particular aura of the Requiem.

In composing the "Requiem aeternam," he proceeded as he usually did with a vocal score. From the colors of the ink, it appears that he put the first page down in full, then after that defining section wrote down mainly the bass and chorus parts, plus some of the first violin and an occasional string interlude. Then he went back and filled in the winds and lower strings. In any case, most of the time the instruments double

the choir. Which is to say that in this piece he was not going to be much interested in orchestral color for its own sake. Rather the focus is largely on the choir and on the imagery and emotion of the text.

Like so much of his music in the last year or so, the Requiem begins with quiet modesty. It is going to be a work largely restrained throughout, not always quiet, but immense in its effect. The beginning is prayerful, a striding bass and answering strings over which the bassoons and basset horns intone gentle waves of lines in imitation. Then the trombones, trumpets, and timpani break the spell with a brassy forte, ushering in a chorus that, after the quiet opening, seems like a wail of lamentation. As in "Ave verum corpus," Mozart is aiming straight to the heart of listeners, here to the universal sense of loss, loss inescapable. Even the close imitation in the voices has an air not of contrapuntal richness but rather of something stern and relentless. It is music as if voicing the emotion of standing at an open grave. It is large tragedy on an intimate scale.

As noted, Mozart's time had not produced all that much powerful sacred music, partly because the mood of tragedy did not suit the optimistic atmosphere of the Enlightenment, partly because the sacred music of the time was mostly founded on operatic style, which tended to dramatic and showy rather than inward and spiritual. Mozart's first movement has nothing to do with opera, nor with the backward-looking sacred music of his youth. This is a musical world that seems not just to evoke mourning but to emerge out of the shadow of death itself. In effect Mozart had rediscovered a tragic voice in sacred music that had largely been missing since the Baroque. No less here than elsewhere, he wields tradition to his own ends. Part of the foundation is Handel, whose music he had been studying and arranging in Vienna, whose influence is felt from the opening that recalls the mournful first chorus from Handel's *Anthem for the Funeral of Queen Caroline*.[12]

Consolation will have its place in this Requiem, but not in this movement. Mozart is attuned to every turn of the text. At "et lux perpetua," ("let eternal light shine on them"), the mourning is suspended into a proclamation, but one still suffused with sorrow. With the entrance of a soprano—in church it would have been the clarion voice of a boy—on the words "a hymn becometh Thee," the music warms without departing from the domain of tragedy. This is music not for the concert hall

but rather aimed at services for the dead, so while there is an abiding depth of musical tradition behind the music, there is nothing rhetorical in it. The music keeps its focus on real mourners in a real church, who hope to be consoled and uplifted by these words and this music. Again, every nuance of the text finds its expression: "Hear my prayer" enters striding and urgent, though not loud, not demanding. Then the words "Requiem aeternam," return with the opening music intensified, combined with the gentle flowing codetta figure that wreaths the soprano solo, and extends to a climax at "et lux perpetua luceat eis" ("let the eternal light shine on them"). That line ends the movement not in triumph but in quiet submission.

So Mozart began this strange commission, in the middle of the most heated and exhausting period of his creative life, at the height of his inspiration.

A STILL-STRANGER MATTER AROSE IN THESE WEEKS OF AUTUMN. OUT of the blue his old friend, patron, lodge brother, and perhaps onetime student Prince Karl Lichnowsky mounted a suit against him for 1,435 florins. Where that debt came from would remain a mystery, why the prince demanded it still more of one. Lichnowsky was a lavishly wealthy man; this sum was barely pocket change for him. In 1789 they had started a tour of Germany together, the prince probably paying some of the expenses. Another puzzle is that when Lichnowsky abruptly left for home from Berlin, he borrowed 100 florins from Mozart.[13]

There may have been some sort of friction between them. They both were prideful men, Lichnowsky even more so than Mozart, with the power of the aristocracy to amplify his pride. Wherever the sum named in the suit came from, it may have been that Lichnowsky wanted for some reason to put this puffed-up commoner in his place. And in the court of the aristocracy—which was not the same as the court for commoners and tended to respond accordingly—the judgment went in Lichnowsky's favor. Half Mozart's court salary was ordered to be withheld until the debt was satisfied. As fate would prove, even if Mozart's earnings were on the rise, the prince would never get his money. In the end the origins of the debt would vanish from the record like a wisp of smoke from an unknown source.

AFTER THE OPENING MOVEMENT OF THE REQUIEM, MOZART DRAFTED a fugue on Kyrie eleison, "Lord have mercy on us." Again his main model was Handel: for the beginning of the subject he quoted the tune of "And with his stripes we are healed" from *Messiah*, and joined it with a countersubject from Handel's *Dettingen Anthem*. The fugue is vigorous, the main subject stoutly striding and the countersubject made from dashing sixteenths. This is a prayer for mercy assertive rather than submissive, worked out at length in a style flavored with Handel but with a Mozartian driving intensity. It comes down to a big Handelian drum-pounding climax that ends in an incomplete chord: archaic open fifths, which have an elemental power. As for the manuscript, it is beginning to dissolve. The score is only the choral parts with no instruments noted, though it is clear that they would largely have doubled the voice parts, because there was to be little in the scoring but support for the choir.

If the fugue has a good deal of intensity but still a certain formal quality, the next section is usually one of the most intense and colorful in any requiem: Dies irae ("Day of wrath"). This is an evocation of the final judgment, a matter of fear and trembling, in which the music needs to be good demonic fun. Here Mozart wrote out the first phrase for choir and strings and from there continued with only choir, bass, and bits of a rattling violin part that was to be duplicated in all the strings, with support from the winds. The chorus declaims the fire-and-brimstone imprecations of the text in block chords, no counterpoint at all, while the strings to be added later were to keep up a steady barrage of flame punctuated by stabbing brass. Here Mozart, whose Masonic teachings strove to subdue the fear of death and hell, went for the fire-breathing words full-tilt. If hell and damnation were not part of his own credo, he intended to portray the text and its tradition as they stood.

After that comes the "Tuba mirum," the last trumpet that announces the Day of Judgment. Here Mozart did not want more fear and trembling but, rather contrast and meditation. He set it as a placid vocal quartet, accompanied in the first section by an elaborate obbligato for solo trombone (standing in for the trumpet). After a striding, fanfarish opening figure, the trombone part is entirely singing. On the manuscript, Mozart noted only the voices, bass line, and trombone. (He

would have returned to add strings.) At the end the chorus enters with "when the just need mercy," where he added bits of string parts to be fleshed out later. As he had been doing all his career, at this stage he was aiming to get down the leading parts and the gist and flow of the whole, then go back and add the inner voices. As always, he figured there would be plenty of time for that when the basic material was settled.

Then another matter intruded. His Freemason lodge, New Crowned Hope, was inaugurating a new temple. That ceremony called for music, and Mozart would have been the composer of choice. In a time of increasing official suspicion of Masonry, he remained loyal to the craft. He broke off work on the Requiem to write the *Little Masonic Cantata* for male choir, two soloists, and small orchestra. It was the sort of occasional piece he could turn out in two or three days, and he probably did. It begins and ends with a stalwart male chorus, beginning: "Joyful instruments proclaim our joy, every brother feels these walls echo, because today we inaugurate this site to our temple." Later Constanze wrote that the cantata was well received and quickened Mozart's enthusiasm for the Requiem, to which he returned with zest.

So Mozart was not appearing to be depressed, except that his wife was ailing and away, and he missed her. He was about to become Kapellmeister of the cathedral, the best and best-paying job in town, and he still had his job at court. With the new religious works he planned for the cathedral, publication would probably accelerate. His thematic catalogue had sixteen empty pages waiting to be filled with new pieces.[14] If he was still not the most popular composer in Vienna, after the furor over *Die Zauberflöte* he might be before long, as indeed he was. Moreover he was paying off his debts and able, for the first time perhaps, to contemplate a future where he did not have to worry about money. He had always claimed, as he asked for a loan, that prosperity was around the corner. Now it actually was.

On or around November 20, 1791, days after he conducted the premiere of the *Little Masonic Cantata*, Mozart was stricken with illness and took to bed.

IT REQUIRED SOMETHING FAIRLY SERIOUS TO PUT MOZART IN BED. Even while ailing in Prague he had reportedly been going to Masonic

meetings, playing billiards daily, and of course rehearsing and performing a major opera. For months of 1790 he had been sick off and on, sometimes prostrate but mostly working at his usual hectic pace. Now as he took to bed he was probably more annoyed than worried. He had been stricken before, how many times, such as those terrible weeks in childhood when he had gone blind, his lips turned black, his tongue was like wood. Since those childhood illnesses he had endured assorted maladies, some of them life-threatening. But no matter how far he had gone, he had always come back, always rose from his sickbed and took up his pen as if death's knock on the door had never happened.

He may have been feeling better in the weeks since Prague, but probably not really well. That he was driven to his bed means that he was feeling helplessly weak and miserable. He would have kept working as best he could on the Requiem. There is no way to know exactly what of its music Mozart wrote after he collapsed.[15] Given his obsession with work in those days, if he could move his mind and his pen, he was surely, regardless of the pain, doing something on it. As he worked he showed drafts and sketches of the piece to his student and amanuensis Franz Süssmayr, telling him the directions he was headed.

In the Requiem, after the Tuba mirum comes the Rex tremendae: "King of majesty, tremendous, / Who dost free salvation send us." Here Mozart seized on that image of majesty tremendous, the chorus beginning with threefold cries of "King!" as if they stood before the throne of God. The chorus is surrounded by massive strings in octaves playing a swaggering dotted rhythm long associated in music with pomp and thrones. As in the first number, three blasts of trombones usher in the chorus. In these sorts of movements one sees the reason Mozart was excited to be taking up this genre: he had always been supremely apt at portraying action, emotion, character, but here he needs to express qualities unique to a sacred work—in this case, the supreme majesty of God. He projected that in a movement short like most of them in the work, but large in impact. The score he finished for the Rex tremendae was a basic draft of choir, bass line, and first violin line.

Next came the gently wafting Recordare for a solo vocal quartet, the longest movement in the Requiem. He wrote out the introduction, a falling line in basses, the basset horns singing lyrically arching lines

to each other. The text is addressed to Jesus and rejoices in His incarnation, which brings salvation to humanity. Mozart conveys this as a stretch of radiant serenity. On the manuscript the score begins with just basset horns and bass, then a string passage, after that the vocal part with a few sketches toward the string parts.

That lofty movement is matched in the next, "Confutatis," which joins two opposing qualities: "While the wicked are confounded," and a prayer, "Low I kneel with heart-submission." The first words are set as a pounding theme for the men in imitation. Then, like a curtain parting, come soft, heart-rending phrases for the women, without bass line, hanging in air like the boys in *Die Zauberflöte*. This dichotomy continues to the end. Every movement Mozart drafted for the Requiem is unforgettable, a kind of sacred music that reaches for the spirit of a listener with a vision of what the holy is most essentially about, in its most intimate terms. Again in the Confutatis, the score is sketchy, the voice parts complete. His hand on the page is as firm and clear as always.

For some reason, for the time being, he appears to have skipped the seventh movement, the Lacrymosa, or only noted the beginning, and went on to movements eight and nine. First a bustling and benevolent Domine Jesu entreating deliverance from the fiery pit, the expression not fearful but full of hope. It ends with a vigorous fugue on Quam olim Abrahae promisisti ("As Thou didst promise Abraham"). The movement is worked out in elaborate counterpoint that, like all the polyphony in the Requiem, is utterly natural, with no hint of what the time called, with a tinge of disdain, the "learned" style. Mozart was finding a new voice in sacred music and a new kind of counterpoint, founded on Bach and Handel but still his own, with an expressive immediacy hardly imagined before.

The luminous gentleness associated with Christ in the Requiem returns in the Hostias, the text with its prayers and sacrifices. If the Requiem begins in tragedy beside the grave, the keynote that Mozart arrived at in the work is not fear or pity or suffering, but the kind of peace and resignation about which he had once written to his father, when he said that death is our best and truest friend. He had learned that from the Masons: only when you know death can you truly live.

We can't know when, but at some point in the midst of putting down

these thoughts as numinous as ever conceived in music, Mozart would have sensed that what he was suffering was not like his other illnesses, from which he had virtually leapt out of bed and plunged back into work. Not this time. There came the moment when he realized that he was never going to direct his Requiem at St. Stephen's; that his letters to Constanze a few weeks before, so full of life and love, were his last letters; that his *Little Masonic Cantata* was the last thing he was going to complete on this earth. Now he was putting on the page his last notes. He was writing this Requiem for himself. He was going to die.

IN THE NEXT GENERATION, AS MUCH BECAUSE OF MOZART AS ANY-body, a famous composer's life would flow into the record in detail, even if much of the record would be fleshed out with myths and fabrications. In Mozart's day the death of a composer was not yet something to be much examined in the papers. The events of his deathbed and the day of his death would endure largely as matters of hearsay and legend. Most of the first-person accounts, mainly from Constanze and her sister Sophie, were made years later, subject to the vagaries of memory and of assorted agendas. Given the state of medicine at the time, there is equally little certainty about what was killing Mozart in those two weeks of November and December. On November 28, doctors Thomas Franz Closset and Matthias von Sallaba consulted about his condition. Then or soon after, they concluded that there was nothing to be done. One certainty, as it played out, was that a major factor in what killed Mozart was his doctors.

What is also certain is that he did not have an easy end. He journeyed from misery to worse. But his sojourn on the deathbed was sociable as his life had always been. In the big flat on Rauhensteingasse, they moved his bed into the larger study. People were in and out, among them Constanze's sister Sophie, Süssmayr, mother-in-law Cäcilia, and various friends, perhaps including Salieri. In one story, with friends near the end, he took out his watch and timed the performance of *Die Zauberflöte* playing across town: now Papageno sings his song, now the Queen of the Night reaches for her high notes. This, in fact, sounds like him. He fixed on Süssmayr to finish the Requiem if he died, even though he seemingly had little confidence in this student's talent. Con-

stanze recalled him telling Süssmayr about his understanding: "Ey—there you stand like a duck in a thunderstorm; you won't understand that for a long time." This even as, Constanze said, he was writing down ideas on slips of paper for Süssmayr to use in finishing the piece. If those slips of paper were real they did not survive, but real or not, they became part of Constanze's strategy to paint Mozart as completely responsible for the work.

Like most deaths that are not sudden, the end was tangled up in pain and confusion. Much of the account, many years later, came from Sophie. As they do, hopes went up and down. Sophie recalled that they made him a jacket to put on frontways, because his hands and feet were so swollen that it was painful to turn in bed, and also made a quilted dressing gown in case he was able to get up.[16] Likely he never managed to get to his feet. The reality of serious illness in those days was harrowing, the misery of the treatments rivaling that of the disease. At best, physicians accomplished little; at worst, they aggravated suffering and hastened decline. His doctors bled him profusely, maybe liters of blood drawn, which only weakened him. There were the usual purgatives and emetics, which made him worse.[17] He was nauseated; there were bouts of vomiting; he needed help to sit up. His son Karl recalled that his father was so swollen he could hardly move and that he began to give off an alarming smell, as if he were already decomposing.[18]

For a final and brutal irony, shortly before he took sick, word had arrived that patrons who were strangers to him, one a group of Hungarian noblemen and the other an aristocrat in Amsterdam, were each prepared to give him a yearly stipend of a thousand or more florins for life.[19] That would have been added to an already lavish income from court and cathedral, plus performing and publications. Mozart was dying at the very moment when the world began to pay him his worth in more than fine words.

One of the stories, all of them possible, none of them certain, says that on the day before he died, Mozart assembled a little group—himself, Süssmayr, Constanze, and three of Schikaneder's soloists from the Freihaus—to sing over the Requiem movements with him. Apparently he had just started the Lacrymosa: "Ah, that day of tears and mourning!" For it he wrote down two quiet bars of introduction in strings, then six bars for the chorus, an unfolding that is a little world

in itself: two bars of a mournful fragility, two bars as if quietly sobbing, then a rise to a peak of sorrow. But as they sang this music Mozart burst into tears and said he couldn't go on. And he put it aside for the last time. On that page of the Lacrymosa may lie the last of the rivers of notes he had written between age five and now. On the page his hand is clear and unshaken. So is the sibylline beauty of the music, a little phrase that goes to the heart. As an artist Mozart lived in beauty, and he ended in beauty.

Sophie recalled that on December 3 he sent her to her mother to report that he was feeling better and hopeful, that he expected to be congratulating Cäcilia on her name day. At home, after making her mother a cup of coffee, Sophie was staring at an oil lamp by the fire, worrying about him, when the lamp suddenly extinguished itself. Alarmed, she rushed to Rauhensteingasse and found Constanze crying, "Last night he was so ill that I thought he would not be alive this morning. Do stay with me today. If he has another bad turn, he will pass tonight. Go in with him for a little while and see how he is." This sounds like Constanze was coping, but she was not.

As Sophie recalled it, when she went in to him he said, "Ah, dear Sophie, how glad I am that you've come. You must stay here tonight and watch me die." When she tried to demur, he waved it aside: "Why, I already have the taste of death on my tongue. And if you don't stay, who will support my dearest Constanze when I'm gone?" This sounds at once too formal, too pat, but at the same time, in its gist it is like him—if in fact he could think and talk at all by that point. Constanze told Sophie urgently to find a priest to give him the last rites. She went to St. Peter's to find one, but "I had a great deal of trouble to persuade one of those clerical brutes to go to him." At length a priest was secured for final unction.

Sophie ran back to Constanze and found Süssmayr by the bed, the score of the Requiem lying on the covers, Mozart still trying to tell him what to do with it. There was a frantic search for his doctor, Closset, who was finally found in a theater but would not come until the opera was done. When he arrived he ordered, over Sophie's protest, cold compresses to be placed on Mozart's feverish brow. This served only to finish him. He gave a shudder and fell unconscious. Sophie said the last sound he made was trying to sing the timpani part from the Requiem. Decades later, she said she could still hear that sound in her mind.

But Constanze had a different memory of the end, one that sounds too real to be wholly invented. She said people were stopping in the street under the windows and waving handkerchiefs. Near the final moment, Mozart asked her what Dr. Closset had said. She was reassuring. "That's not true," he said. "Now I have to die, when I could care for you and the children. *Ach*, now I leave you unprovided for." Then he convulsed, sprayed a stream of vomit, and fell back dead.[20] It was five minutes to 1 a.m., December 5, 1791.

Thirty years before, when Leopold Mozart saw what his son was capable of, he determined to show the world what he declared a miracle of God, thereby to turn the world's thoughts to God's miracles, also thereby to profit from this one. Now Leopold's son was dead at not quite thirty-six years old, having surpassed nearly all men in his art and on the brink of surpassing himself in unimaginable ways. He had been named Theophilus, "beloved of God." But it turns out that the gods do not care. They do not care. The gods, nature, whatever it was that made Mozart, had indifferently created a miracle, and indifferently let it be erased long before its time. Ah, that day of tears and mourning!

WITH MOZART AT THE MOMENT HE DIED WERE SOPHIE, THE DOCTOR, and Constanze. Gottfried van Swieten arrived in the middle of the night and found a despairing Constanze lying beside her husband's body, trying to catch whatever killed him and so die with him.[21] The illness that attacked Mozart on November 20 had been a galloping malady that carried him away in two weeks.

To say again, medical science in those days had no idea of the actual sources of disease. The death certificate listed "acute miliary fever," that being a general name for an illness marked by lesions shaped like millet seeds. Centuries after, when medicine had actually become a science, one guess, based on his swelling, skin eruptions, and fever, would be that what claimed Mozart was a recurrence of an illness he had suffered in childhood, probably more than once, and which tends to recur: rheumatic fever. In fact, his doctors concluded it was that. One who reviewed the records sometime after, and knew Dr. Closset personally, said, "He fell sick in the late autumn of a rheumatic and

inflammatory fever, which being fairly general among us at that time, attacked many people."[22] They called it miliary fever to put it in layman's terms.[23] Eventually the description in books was corrupted to "military fever," which had no meaning at all.

Constanze wrote later that her husband had simply worked himself to death. She was probably right. He had been debilitated by overwork, and that opened the door to illness of a kind he had survived before but no longer had the strength to. Later myth would say that the overwork was because of neglect and poverty and desperation. None of that was true. He took on too much work because he wanted to. Everything appeared to him an opportunity not to be passed up. He had rarely said no to anybody, no matter how much it cost him. This time, his body couldn't pay the cost.

When epochal figures die they become in some ways more human, more ordinary than they have ever been. Their tragedy is, in essence, the same as everybody's. They become objects of medical curiosity, of legal and bureaucratic processes. With Mozart the first matter was the burial, which had to be done according to Emperor Joseph's decrees. It needed to be done soon, because whatever disease killed him, it deteriorated his body horrifically. Michael Puchberg helped with the business of burial; there was help from Gottfried van Swieten and Mozart's old patron Countess Thun; his Masonic lodge took up a collection for Constanze.[24] The day after he died, the new regime dismissed Swieten from his post as president of the Court Commission for Education.[25] His public career was finished; he had been too liberal for the police state that was taking shape in Vienna. That did not deter him from helping the family.

In London during his sojourn there, Haydn wrote a friend, "I long to be home again to embrace my good friends, only regretting that I cannot do this to the great Mozart . . . Posterity will not have such a talent again in 100 years."[26] Afterward Haydn wrote to Michael Puchberg, "For some time I was quite beside myself over his death, and could not believe that Providence should so quickly have called away an irreplaceable man into the next world." Friends said that after Mozart's death, Haydn's grief amounted to a crisis of faith in God. He recovered, but after that pulled noticeably into himself, became a harder man.[27]

Count Joseph Deym arrived at the flat to take a plaster death mask of Mozart to be exhibited atop a dummy in his wax museum. A brief notice appeared in the paper: "Mozart is—dead. He returned home from Prague a sick man, and continued to get worse; he was said to be dropsical . . . Because his body swelled up after death, some people believe that he was poisoned." Other than the first sentence, possibly none of this is true. But it shows that rumors of poison were in the air from the beginning. The Romantic generation with its cult of genius would take up that rumor with gusto: a demigod had to die a death from legend. At some point the blame fell on Salieri, who at the sad end of his life was anguished by the story that he had poisoned Mozart out of rivalrous jealousy. Salieri's name would live over the years in undeserved infamy. At worst, he had been a vigorous and powerful rival of Mozart's, but at least by the end, Salieri had been a friend.

Baron van Swieten took care of the funeral arrangements.[28] First, Constanze was hysterical and had to be gotten out of the house.[29] Mourning and funerals in Vienna were ceremonial affairs, but the town's fondness for extravagant funerals had been suppressed by Joseph's burial decrees. Founded on sound Enlightenment principles, to get graves out of the inner city in Vienna, the rules were despised by nearly everybody. The nobility, of course, were exempt, but they were usually interred in family vaults. Part of Joseph's decree ran, "The only objective in burial is to promote decomposition as soon as possible . . . Thus it is recommended for the present that all bodies be sewn unclothed into linen sacks, placed in coffins, and so brought to the cemetery."[30] The bodies were removed from the coffin and thrown into a common grave, sprinkled with lime, and covered over. After much public outrage, Joseph allowed burial in coffins if requested, but still in common graves. After a service at a church, mourners were not allowed to follow the coffin; nor were graveside memorials permitted.[31] All of it was a demonstration of Joseph's obsessive pursuit of rational policy combined with a ruthless insensitivity to human feelings and values.

A visitor to the house before the body was taken out recalled, "I saw the dead Master on the bier, lying in a coffin, in a black suit with a cowl down over his forehead . . . with his hands folded over his breast."[32] Constanze, facing the uncertainty of sudden widowhood, was persuaded

to pay for a third-class funeral. A first-class one cost 110 florins, second-class 40, third-class, just over 8 florins, plus about the same to pay the priests and a little more for the cart.[33] The least expensive burial was the way most Viennese were interred. It was when history forgot Joseph's short-lived ordinances that the myth of a pauper's burial for Mozart sprang up.

Legend would make December 6, the day of Mozart's funeral, rainy and cold. It was in fact mild and misty. In the early afternoon his body was taken in procession from the house on Rauhensteingasse the few blocks to St. Stephen's. A bell tolled, a cross bearer walked at the head; four men in long cloaks carried the coffin, which was covered in a pall. It is not certain who followed the coffin, but apparently Constanze had not been up to it.[34] Rites for the few mourners were held at a little chapel built against the wall outside the cathedral. At some point after six o'clock, or possibly the next day, the coffin was loaded onto a cart for the three-mile drive out to the grave near the village of Landstrasse, the only attendants the cart driver and two horses. The accompaniment to Mozart's burial was the thud of the coffin into the grave, the trills of the dirt thrown onto it. It appears, at least, that he was granted a grave to himself rather than the usual communal ones mandated by Joseph.[35] Its location would be lost to history.

So came to rest the miracle of God that Leopold Mozart had proclaimed to the world. Mozart had begun his career at age five with that myth, and after he died everything to do with him ascended into fable. His death was fashioned into a tragedy of poverty and neglect and envy. Poison, the pauper's grave, his last works addressed not to his time but to posterity—in effect, his legacy was refashioned into a precursor to the man who arrived in Vienna the next year to begin a meteoric career: Beethoven. He founded everything he did on the past, Mozart above all others, and Beethoven did not care about the myths. As the style of his craftsmanship shows, he understood Mozart better than anyone else. With the public Mozart would be Beethoven's main rival to get past, because the composer who in his lifetime had raised admiration and resistance in more or less equal measure, who was hailed for his gifts while being regretted for his too many notes, soon after he died ascended to the panoply of immortals as among the supreme composers

and a primal model for the future. There, with the inevitable ebbs and flows, Mozart would abide.

Probably he never imagined anything like that. He thought in terms of the friends and family he could make happy with his notes, the audiences he was going to be seeing in front of him, the distant strangers who would buy his music in print, the patrons who admired him enough to open their pockets. In the end, much of what sets Mozart apart from Beethoven and those who followed was the amity of his music, the art of a sociable man intended for a circle of friends and for small groups of listeners. That inflected even his monumental last two symphonies, which would become central to how Beethoven conceived the genre. Lonely, deaf, and misanthropic, Beethoven came to address his music to the world at large, to concert halls, to posterity. Beethoven wrote for Humanity, Mozart for people. What we hear in Mozart, even in the last symphonies, is a gift given to us intimately as friend to friend, lover to lover.

Sometimes in the future it would be said that Mozart had come full circle, completed his lifework with the Requiem, a work addressed to the heart of our spirituality. No. The Requiem was unfinished, and he was far from done. He worked himself to an early death in service of an uncanny closeness to perfection that he held in his hands from early on, but about which he was never complacent and never satisfied, and he imagined a long road ahead of him.

The quintessential artist, Mozart served the great human simplicities and shaped his great lies to show us the truth. From childhood, music was his native language and his mode of being. He thought deeply but in tones, felt mainly in tones, loved in tones, and steeped himself in the worlds he was creating with tones. From a life made of music he wove his music into the fabric of our lives. More and more toward the end, as he reached toward new territories, his art found a consecrated beauty that rose from love: love of music, love of his wife, love of humanity in all its gnarled splendor, love of the eternal yearning for God in the human heart. His work served all that. Whatever his image of God by the time he reached the Requiem, it was taken up in his humanity, and his humanity was for all time, and it was exalted in his art.

EPILOGUE

Death at any age surprised no one in those days, but the mourning for Mozart was no less profound for that. There were memorials in Vienna, Prague, Kassel, and Berlin. There was none in Salzburg. The largest memorial, attended by some four thousand people, was in Prague, where Mozart was beloved perhaps more than anywhere else. The overflowing crowd at St. Nicolai Church heard a Requiem by a local composer, conducted by Mozart's old soprano friend Josepha Duschek. Said the account in the paper, "There was a profound silence during the ceremony, and a thousand tears flowed for our Mozart, whose heavenly harmonies so often moved and filled our hearts . . . His loss is irreplaceable. There are . . . masters of music, but to bring forth a master above all others—for this Nature needs centuries."[1] Obsequies in Vienna were held on the tenth, supervised by Schikaneder, the music being the performable parts of the Requiem hastily assembled and rehearsed.

The last entry in Mozart's funeral guest book was from Constanze: "Dearly beloved husband! Mozart, unforgettable to me and to the whole of Europe—/ Now you are well—well forever! Eight years long we were joined in the most tender and in this world inseparable bond. O! Would I were soon joined to you forever."[2] Constanze would outlive him by fifty-one years.

If he had lived to be seventy-one, as his sister and his wife did and longer, he would have died the same year as Beethoven. When he lay down on his deathbed, he had been working on, besides the Requiem, a horn concerto, a violin sonata, a string trio and string quintet, a Mass, and various other pieces.[3] All in all, he left in his papers some 140 works in various states of completion.[4] At the time of his death, his library

had fiction and books on music, philosophy, drama, poetry, geography, history, mathematics, travel, natural science, and religion.[5]

In his last year Mozart had earned more than in any other year of his life, upward of 6,000 florins. The official figure for his estate was 826 florins. When he died the family had 60 in hand and more than 800 uncollected in loans to friends.[6] Constanze paid off his remaining debts fairly quickly, including 1,000 to Michael Puchberg. For comparison and in contrast, years later Haydn died leaving an estate of over 10,000 florins; Salieri's estate was over 20,000.[7] But Constanze had her husband's manuscripts, and that would be her fortune.

Devastated by his passing, Constanze was quick to pull herself together. As a widow with no earnings of her own, she had to be quick. Now she revealed a considerable gift for managing her husband's legacy and her own affairs. First of all it was imperative to get the Requiem to whoever had commissioned it—she said she never knew—or she would not only miss the final installment of the money, but would also have had to return the advance. It was critical for her to present it essentially as a work of Mozart's. She would, in other words, have to arrange a systematic fabrication with the score and in the account. The stories she told, then and later, muddied the question of who did what in the final Requiem, leaving a mystery on which many tales would be spun.

So somebody had to finish it. It had appeared that Mozart expected that person to be his student Franz Süssmayr, for all that young composer's limitations. Among other things, Süssmayr could expertly copy Mozart's hand on the page and likewise forge his signature—which he did, at the end of the manuscript that was presented to Count Walsegg. He recopied it, signed it himself, and two years later had it performed in Wiener Neustadt, presumably as his own, as he had intended. It would not be long before the work was known under Mozart's name; when Walsegg heard that the true composer had been revealed, he professed mortification and briefly made noises about legal action.[8]

Years later Constanze recalled that she was angry with Süssmayr at the time, she could not remember why, and so (after some hand not known to history finished the Kyrie[9]) she asked another and probably more expert Mozart pupil, Joseph Eybler, to complete the whole. Writing on Mozart's manuscript, Eybler did a certain amount of work

and then, for some reason, maybe balking at the immensity of the task, gave up and returned the manuscript to Constanze. Only then did she give it to Süssmayr, who finished it to the end, including writing new final movements. His contribution would be flawed in technique and in imagination, but the radiance of what Mozart had bequeathed left the Requiem still one of his greatest works. Süssmayr did not stand in its way. Among the Requiem's admirers were Haydn and Beethoven, neither of whom was interested in hearing about the contribution of Süssmayr. Haydn said that if Mozart had written nothing but the Requiem, he would have been a great composer.

Meanwhile there was the matter of how Constanze was to live in the long term. She took her case to Emperor Leopold, writing him and citing the Vienna rumor machine: "Your Majesty, everybody has enemies . . . but nobody has been more strenuously and continuously attacked and slandered by his enemies than my husband, merely because he had such great talent! People have had the audacity to tell Your Majesty many lies about him; the debts he left behind him have been exaggerated tenfold. I vouch with my life that 3000 florins would liquidate all his debts." The figure of 3,000 was probably inflated. In her desolation she likely had help with this commanding petition, perhaps from Swieten. Finally she received from the court a lifetime pension of around 266 florins. An all-Mozart concert in Vienna on December 23, sponsored by the court, brought her a much-needed 1,500 florins.[10]

Constanze went on to make a good deal of money selling her husband's manuscripts, those including a number of works that had never been published. For the sake of his legacy she revived her abortive singing career. In the years after his death she and Aloysia Lange, Mozart's first love, toured Germany performing his works. In Vienna around the turn of the century, Constanze's soirées were attended by leading musicians, Beethoven among them. At some point she destroyed any number of her husband's letters that had political sympathies dangerous in a police state, and she also threw out risky books in his library. She did not destroy letters critical of her, and astonishingly, in later years she handed over to biographers his naughty letters she had apparently gotten from the Bäsle, noting that they were "clearly tasteless, but nevertheless very witty."[11] It probably never occurred to her that they might end up in print. No censor of the time would have allowed it.

In 1797 philosophy professor Franz Xaver Niemetschek produced an important early biography of Mozart, to which Constanze contributed with her usual varying reliability. The next year she connected with a Danish diplomat named Georg Nikolaus Nissen, who took over her business affairs. He lived with her for years before they married in 1809, finally settling in Salzburg. After Nissen retired he began collecting material for a biography, but he died in 1826 with the book unfinished. (His gravestone in Salzburg reads, "Here lies Mozart's widow's second husband.") Constanze had the book completed. It amounted to a sprawling and often inaccurate affair, partly due to her own faulty memories and mythologizing. Still, if it was a shaky foundation for future Mozart biographies, it was full of firsthand information and a foundation all the same.

Constanze lived comfortably to age eighty, dying in 1842, the year a Mozart statue was finally unveiled in Salzburg. She left her sons nearly thirty thousand florins, most of it gained from her husband's music.[12] With her in town in the later years was Aloysia Lange, who left husband Joseph in 1795 and lived as best she could on a small stipend from him. After a glittering career, she finished her life in poverty, regretting turning Mozart down in her youth and insisting he had loved her until the day he died.[13]

Constanze changed the name of her younger son, Franz Xaver, to Wolfgang Amadeus. With her sanction, he had a modestly successful career as a pianist and composer, his teachers including Hummel and Salieri. He played at the ceremonies around the unveiling of the Salzburg memorial. His brother Karl Thomas, whom Constanze had discouraged from pursuing a musical career because his talent did not appear up to it, was also present at that belated hometown recognition of his father. Franz Xaver inherited the ear deformity that Mozart had kept covered with hair.[14]

When Mozart died, Emanuel Schikaneder was found walking around crying, "His spirit follows me everywhere! He stands constantly before my eyes!"[15] For the rest of the decade he ran the Freihaus Theater as actor, director, producer, writer, and composer. He had his share of successes, but nothing comparable to Die Zauberflöte, which he mounted in dozens of performances. In 1801 a backer gave him a new theater inside the city walls, the grand Theater an der Wien. Over

the entrance of the theater, Schikaneder installed a statue of himself as Papageno. Among those he worked with was Beethoven, who however gave up on an ancient-Rome libretto the impresario had pressed on him. Schikaneder's reign at the Theater an der Wein lasted less than five years, after which he drifted until, on the way to Budapest in 1812, he suddenly lost his mind. He spent his last days mad and penniless in Vienna.[16]

Antonio Salieri coasted to a halt as an opera composer in the decade after Mozart died. His last opera premiered in 1804, with little success, a relic of the past. His work vanished from the stage well before he died. But Salieri remained a respected teacher, his students including Beethoven, Schubert, and Liszt. It was said that Salieri always spoke respectfully of Mozart. The rumor that he poisoned his rival hovered about him in his last years. When Rossini came to Vienna in 1822, the two joked about it. But after Salieri had a mental breakdown the next year, he was heard raving that he had done it. In a lucid moment before he died in 1825, he told composer and pianist Ignaz Moscheles, "I can in all good faith swear that there is no truth to the absurd rumor; you know—I'm supposed to have poisoned Mozart."[17]

In her dreary and unhappy marriage in St. Gilgen, Nannerl Mozart bore three children to her magistrate husband, also rearing his five children from an earlier marriage. After he died in 1801 she returned to Salzburg, where she gave piano lessons and when asked responded generously to questions about her brother. Visitors in 1829 found her "blind, languid, exhausted, feeble and nearly speechless." They thought she was impoverished, but in fact she left an estate of 7,837 florins.[18] Most of it was the residue of her and her brother's early fame and travels.

In childhood and into her teens, Nannerl had shared her brother's glory and their father's love. Wolfgang's affection for her was perhaps more intense, certainly less fraught, than for their father. In their travels they had both been heavenly creatures to the public; in their own world, king and queen of the Kingdom of Back. But at the point Wolfgang made his break from their father, Nannerl had a choice to make and she made it: she stayed with Papa and under his thumb. Her fame withered away and, after she married, so did her performing, which would only have been in house music in any case. Nannerl could have

married someone she loved, could have left Salzburg and gone to Vienna to be beside her brother as he entreated her to do, to play in salons along with him so they would have remained a team. But he broke away and she stayed home, the high-strung daughter who always took Papa's side, and so finally her relations with Wolfgang withered away. They had no communication in his last years.

Like her father, Nannerl never really forgave her brother the marriage to Constanze. Still, she was forthcoming in matters concerning him. When he died she was asked by a Friedrich von Schlichtegroll to contribute to a necrology. He asked her what she considered to be her brother's faults. She replied that he had only "a single one . . . he had too soft a heart, and did not know how to handle money." Nannerl did know how to handle money, and she had long before hardened her own heart. She apparently told Schlichtegroll that she had no idea how many children her brother had or how many had survived.[19] (Constanze, already thinking about how to manage her husband's legacy, was outraged by the necrology. She bought up all six hundred copies of a reprint and destroyed them.)[20] Later, when Nissen was collecting material for his biography, Nannerl gave him some four hundred family letters, including the correspondence between Leopold and Wolfgang. In their last Salzburg years, she and Constanze remained at least cordial. When all was said and done, she remained proud of her brother to the end.

Nannerl died in Salzburg in 1829, at age seventy-eight. At first her will stipulated that, naturally, she wanted to be buried next to her father and one of her daughters in the St. Sebastian graveyard. Then in 1826, Constanze's second husband Nissen died and was interred beside Leopold, as therefore Constanze expected to be when she died. That year, in a codicil to her will, Nannerl declared that she now wanted to be buried in a community vault in St. Peter's. This was, in other words, her final rebuff of her brother's wife. Aloysia and her sister Sophie, who had come to live with her, were buried in St. Sebastian's Cemetery. So Leopold Mozart, who had despised the Weber family as gold diggers, ended up surrounded by Webers for all eternity.[21]

It is hard to conclude whether to call Nannerl Mozart a tragic woman. She is the sort of figure who tends to live in the orbit of a legend, obscured in the whirlwind raised by his energy. In her prime she

was more or less her brother's equal as a performer, but she did not have his imagination, his tenacity, his fierce attention to his own path. In the end, Nannerl looked backward to her glory, while her brother never looked in any direction but forward. So he was looking when he died, in midstride.

Et lux perpetua luceat eis.

APPENDIX:
MUSICAL FORMS IN
MOZART'S TIME

Sonata form. This is the formal outline par excellence of the Classical period because it is a comprehensive yet endlessly flexible means of organizing long stretches of often contrasting material. It is usually used for the first movements of multi-movement pieces, but it could also turn up in any other movement. For the purposes of this book, I'll lay out a simple version, which I suspect is close to how composers of Mozart's time thought of it. The overall idea is a pattern of keys, starting in the home key, going on a journey away from that key and into other keys, and then returning to the home key. That is to say that it involves a journey away from the home tonality, which increases the harmonic tension, and finally resolves back to the opening key.

In terms of formal divisions there is an overall outline in three parts, called exposition, development, and recapitulation. The exposition is in two parts, the first in the home key and the second typically in a closely related key, meaning one with one fewer flat or one more sharp. These are usually called the first and second theme sections. The melodic material may be all based on the opening theme, or there may be a distinct second theme (often softer and more lyrical, for contrast); further subthemes and more keys may be involved. The exposition is usually repeated.

The idea of the development is, first of all, to bring in some more keys to provide harmonic variety in the movement. In his earlier music Mozart tended toward short developments with not many new keys, a sort of palate cleanser before returning to the home key. In his later

pieces, following the model of Haydn, he tended to write longer developments that amounted to a sort of a quasi-improvisation on the themes of the exposition, and which might involve a number of keys and a good deal of drama and intensity.

The recapitulation returns to the home key and the opening material, either fairly literally or varied in some degree. Here, though, the second-theme section is also in the home key, creating a sense of stability and resolution. In practice, however, this would be harmonically dull, so there are usually some other keys involved too, though the general feeling is of everything returning to the home key. (In Mozart and other composers of the time there is usually another repeat at the end back to the beginning of the development. Often as not, modern performances don't take that second repeat.)

To this pattern may be added an introduction if desired (usually slower) at the beginning, and a coda if desired at the end, to create a stronger sense of conclusion.

To summarize the overall course of sonata form in its basic outline:

[Introduction] first theme section in home key / second theme section in another key [repeat] // development // recapitulation more or less in the home key [coda]. Vary ad libitum.

Really the outline of sonata form is that simple, but it is so powerful in being able to control widely contrasting material, and its sense of departure from and return to home had such a satisfying and innately dramatic quality—so it is so *useful*—that in the later eighteenth century sonata form invaded other genres, turning up, for example, in concertos and opera numbers.

Thus, concerto sonata form, used for the first movement of concertos. This involves a double exposition, which mimics the repeat of the exposition in regular sonata form. In a concerto, the orchestra plays the first exposition, laying out the main themes of the movement and sticking mostly to the home key. (This is that long opening where the soloist sits staring into the air.) Then the solo enters to begin a second exposition, either with the orchestra's opening theme or a new one of its own. In general, the second exposition will have new material added

by the solo, and there will be a new key or keys. There follows the usual sort of development and recapitulation.

SONATA-RONDO FORM IS OFTEN USED FOR LAST MOVEMENTS, AND IS usually fast and generally lively unto jokey. It is based on the old idea of a rondo, which is simply a tune that keeps coming back, alternating with other contrasting ideas: e.g., A B A C A D A and so on, for as long as you like. Sonata-rondo makes the A idea equivalent to a sonata-form first theme and the B idea equivalent to a second theme, thus in a new key. The C idea can be either new material, a development section à la sonata form, or something in between. So the standard outline of sonata-rondo is this:

A (home key) B (new idea, new key) A (home key) // C (new key[s] and material, or a development) // A (home key) B (home key) A.

In practice there are all kinds of variations on this pattern, especially in the order of themes following the C section, but the sense of the A repeatedly coming around (thus the name "rondo") is always emphasized.

SLOW MOVEMENTS OF WORKS IN THE CLASSICAL PERIOD USUALLY come second and are often simply ABA or variants of that, such as ABABA. Often the return of the A material and home key is ornamented, either on the page or by performers on the spot.

Minuets, based on the dance, usually come third in a four-movement piece. They are a large three-part form made up of two smaller three-part forms: e.g., ABA / CDC / ABA. Usually the first ABA section includes repeats, which are omitted when it returns. The middle CDC section is called the **trio**, and is usually lighter in texture.

Theme **and variati**ons refers to a theme, usually in two parts, that is then treated to a series of variations: e.g., A A1 A2 A3 A4 and so on, for as long as you like. The basis of the variations can be the melody, the harmony, the bass line, or a combination of them. The general idea is to

get maximum variety of texture and expression among the variations, making a series of contrasting segments with a general sense of overall progression, commonly a matter of the rhythm getting steadily faster.

FINALLY THERE ARE TWO SIGNIFICANT **CONTRAPUNTAL PROCEDURES**. Counterpoint, remember, is a musical texture made up of two or more superimposed melodies, as distinct from the more familiar texture of a single melody supported by accompaniment—such as a melody in the right hand of the piano and accompaniment in the left hand. Fugue is an old idea in which a little theme is stated, then picked up in imitation in one part (called a voice in counterpoint) after another. As the piece progresses, the keys change, and there is a return to the home key at the end. Most fugues are in two to four voices. Bach and other composers of the Baroque period wrote lots of freestanding fugues, but Mozart rarely did. Rather, following the model of Haydn, he used fugue-like imitation in sections of larger movements, or extended fugues as movements of a sacred work.

Canon we can think of as a grown-up version of "Row, row, row your boat"—a single melody with staggered entrances (two to four of them) that, when all get going, create good harmony. They take a lot of skill to write, to make the melody appealing while also making sure the harmony works out. Again, Bach and others wrote freestanding canons, but Mozart tended to use canonic passages as part of larger movements.

NOTES

PROLOGUE

1. Glover, *Mozart's Women*, Location 170.
2. Gutman, *Mozart*, 54.
3. Deutsch, *Documentary Biography*, 12–13.
4. Einstein, *Mozart*, 24.

CHAPTER 1: LEOPOLD

1. Davies, *Mozart in Person*, 4.
2. Davies, *Mozart in Person*, 4.
3. Solomon, *Mozart*, 23.
4. Braunbehrens, "'Fatherly Friend,' 'Most Obedient Son,'" 3.
5. Eisen, "Mozart and Salzburg," 1.
6. Solomon, *Mozart*, 97.
7. Salzburg city museum.
8. Sadie, *The Early Years*, 3–4.
9. Eisen, "Salzburg Under Church Rule," 165.
10. Eisen, "Mozart and Salzburg," 2.
11. Einstein, *Mozart*, 12.
12. Gutman, *Mozart*, 11n13.
13. Glover, *Mozart's Women*, Location 84.
14. From the Salzburg Residenz and its displays.
15. Eisen and Keefe, *Cambridge Mozart Encyclopedia*, 433.
16. Eisen, "Salzburg Under Church Rule," 169.
17. Glover, *Mozart's Women*, Location 113.
18. Solomon, *Mozart*, 36.
19. Halliwell, *The Mozart Family*, 5.
20. Glover, *Mozart's Women*, Location 84.
21. Gutman, *Mozart*, 10–11.
22. Sadie, *The Early Years*, 13.
23. Halliwell, *The Mozart Family*, 6–8.
24. Sadie, *The Early Years*, 7.
25. Sadie, *The Early Years*, 8.
26. Gutman, *Mozart*, 16.
27. From the Mozart Geburtshaus, Salzburg.
28. Glover, *Mozart's Women*, Location 137.
29. "Leopold Mozart," in Sadie, ed., *The New Grove Book of Operas*.
30. Some of Leopold's library is displayed in the Salzburg Mozarthaus.
31. Solomon, *Mozart*, 29.
32. Gutman, *Mozart*, 35.
33. Solomon, *Mozart*, 29.
34. Anderson, Complete, no. 23.
35. Till, *Mozart and the Enlightenment*, 182.
36. Fubini, *Music and Culture in Eighteenth-Century Europe*, 134.
37. Schroeder, *Late Eighteenth Century*, 49.
38. This drawing or engraving hangs in the Mozart Geburtshaus in Salzburg.

CHAPTER 2: PAPA

1. Glover, *Mozart's Women*, Location 144.
2. Deutsch, *Documentary Biography*, 10.
3. Schroeder, *Late Eighteenth Century*, 54. Leopold's letter to Gellert does not survive.
4. Wolff, *Gateway*, 55. Mozart's left ear lacked an earlobe, tragus, antitragus, and conch.
5. Oscar Wilde famously and facetiously observed, "Talent borrows, genius steals."

6. Stafford, "Mozart and Genius," 16.
7. Sadie, *The Early Years*, 22.
8. Solomon, *Mozart*, 40.
9. Gutman, *Mozart*, 63.
10. Eisen and Keefe, *Cambridge Mozart Encyclopedia*, 511.
11. From the Mozart Geburtshaus.
12. Gutman, *Mozart*, 64.
13. Anderson, Complete, no. 1.
14. Anderson, Complete, no. 2.
15. Landon, *Mozart and Vienna*, 58.
16. Bolt, *Librettist*, 84–86.
17. Steptoe, *The Mozart–Da Ponte Operas*, 14.
18. Rice, *Antonio Salieri*, 32.
19. From Johann Pezzl's sketches of Vienna in Landon, *Mozart and Vienna*, 65–66.
20. Landon, *Mozart and Vienna*, 10.
21. Gutman, *Mozart*, 66.
22. Sadie, *The Early Years*, 24–25.
23. Anderson, Complete, no. 2.
24. Sadie, *The Early Years*, 26–27.
25. Landon, *Mozart in Vienna*, 16.
26. Davies, *Mozart in Person*, 12.
27. Anderson, Complete, no. 4.
28. Solomon, *Mozart*, 57.
29. Davies, *Mozart in Person*, 13.
30. Sadie, *The Early Years*, 28.
31. Gutman, *Mozart*, 70.
32. Deutsch, Documentary Biography, 21.
33. Eisen and Keefe, *Cambridge Mozart Encyclopedia*, 445.
34. Sadie, *The Early Years*, 29–31.
35. Küster, *Mozart*, 15.
36. Davies, "Manic-Depressive," 1, 125.

CHAPTER 3: DAS KÖNIGREICH RÜCKEN
1. Sadie, *The Early Years*, 33–34.
2. Deutsch, *Documentary Biography*, 23.
3. Anderson, Complete, no. 17.
4. Museum of the Mozart Geburtshaus.
5. Gutman, *Mozart*, 175.
6. Anderson, Complete, no. 10.
7. Anderson, Complete, no. 12.
8. Sadie, *The Early Years*, 38.
9. Anderson, Complete, no. 12.
10. Halliwell, "Visit to Vienna," 2.
11. Anderson, Complete, no. 12.
12. Gutman, *Mozart*, 104.

13. Anderson, Complete, no. 16.
14. Anderson, Complete, no. 17.
15. Deutsch, *Documentary Biography*, 24–25.
16. Sadie, *The Early Years*, 36.
17. Sadie, *The Early Years*, 44–45.
18. Anderson, Complete, no. 18.
19. Steptoe, *The Mozart–Da Ponte Operas*, 37.
20. Sadie, *The Early Years*, 45.
21. Gutman, *Mozart*, 109.
22. Gutman, *Mozart*, 160; Deutsch, *Documentary Biography*, 25; Anderson, Complete, no. 18.
23. Anderson, Complete, no. 18.
24. Sadie, *The Early Years*, 46–77.
25. Gutman, *Mozart*, 162.
26. Gutman, *Mozart*, 176–77.
27. Sadie, *The Early Years*, 47.
28. 1911 *Britannica* article on Grimm.
29. Schroeder, *Mozart in Revolt*, 97.
30. Gutman, *Mozart*, 165.
31. Deutsch, *Documentary Biography*, 26–27.
32. Sadie, *The Early Years*, 34.
33. Anderson, Complete, no. 22.
34. Dimond, *Mozart Diary*, 16–17.
35. Sadie, *The Early Years*, 49.
36. Gutman, *Mozart*, 163.
37. Anderson, Complete, no. 20.
38. Anderson, Complete, no. 22.
39. Dimond, *Mozart Diary*, 18.
40. Anderson, Complete, no. 25.
41. Deutsch, *Documentary Biography*, 29.
42. Sadie, *The Early Years*, 54–57.
43. See Keefe, "Wolfgang Amadeus Mozart the Child Performer–Composer," *passim*.
44. Eisen and Keefe, *Cambridge Mozart Encyclopedia*, 450.
45. Anderson, Complete, no. 22.
46. Sadie, *The Early Years*, 49.
47. Anderson, Complete, no. 23.
48. Dimond, *Mozart Diary*, 18.
49. Gutman, *Mozart*, 165.
50. Anderson, Complete, no. 25.
51. Deutsch, *Documentary Biography*, 32.

CHAPTER 4: AN INSTRUMENT AT THE COMMAND OF MUSIC
1. Gutman, *Mozart*, 180–81; Anderson, Complete, no. 26.

2. Gutman, *Mozart*, 187.
3. Gutman, *Mozart*, 182.
4. Sadie, *The Early Years*, 60.
5. Anderson, Complete, no. 28.
6. Sadie, *The Early Years*, 63.
7. Sadie, *The Early Years*, 61.
8. Eisen and Keefe, *Cambridge Mozart Encyclopedia*, 257.
9. Gutman, *Mozart*, 194–95.
10. Sadie, *The Early Years*, 69.
11. Gutman, *Mozart*, 186.
12. Anderson, Complete, no. 28.
13. Sadie, *The Early Years*, 63.
14. Anderson, Complete, no. 30.
15. Gutman, *Mozart*, 192.
16. Zaslaw, *Mozart's Symphonies*, 17–18.
17. Deutsch, *Documentary Biography*, 38–39.
18. Sadie, *The Early Years*, 80.
19. Zaslaw, *Mozart's Symphonies*, 19.
20. Sadie, *The Early Years*, 66.
21. From notes for the Cecilia Bartoli recording of music written for castratos, aptly titled *Sacrificium*.
22. Sadie, *The Early Years*, 75.
23. Deutsch, *Documentary Biography*, 95–100.
24. Sadie, *The Early Years*, 68.
25. Landon, *Mozart Compendium*, 14.
26. Sadie, *The Early Years*, 69.
27. Sadie, *The Early Years*, 84.
28. Woodfield, "New Light on the Mozarts' London Visit," 195.
29. Deutsch, *Documentary Biography*, 45–46.
30. Landon, *Mozart Compendium*, 14.
31. Davies, *Mozart in Person*, 91.
32. Anderson, Complete, no. 39.
33. Gutman, *Mozart*, 207.
34. Anderson, Complete, no. 40.
35. "Chronology," The Mozart Project, http://www.mozartproject.org/chronology/index.html.
36. Glover, *Mozart's Women*, Location 291.
37. Eisen, *New Mozart Documents*, 13–24.
38. Deutsch, *Documentary Biography*, 56.
39. Deutsch, *Documentary Biography*, 59.
40. Deutsch, *Documentary Biography*, 60–61.
41. Gutman, *Mozart*, 218.
42. Deutsch, *Documentary Biography*, 61–64.
43. Deutsch, *Documentary Biography*, 61–65.
44. Gutman, *Mozart*, 219.
45. Sadie, *The Early Years*, 102–3.
46. Anderson, Complete, no. 45.
47. Neumayr, "What Actually Caused Mozart's Death?," 5.
48. Solomon, *Mozart*, 45.

CHAPTER 5: LIARS, SLANDERERS, AND ENVIOUS CREATURES

1. Deutsch, *Documentary Biography*, 70–71.
2. Solomon, *Mozart*, 60.
3. Deutsch, *Documentary Biography*, 67.
4. Gianturco, *Mozart's Early Operas*, 24.
5. Deutsch, *Documentary Biography*, 73.
6. Dimond, *Mozart Diary*, 36.
7. Sadie, *The Early Years*, 118.
8. Hunter, *Mozart's Operas*, 170–71.
9. Gianturco, *Mozart's Early Operas*, 38.
10. Gutman, *Mozart*, 222. The importance of Fux's *Gradus* survives to the present; he is still fundamental to the study of counterpoint, though it is usually studied in adaptations that are easier to deal with than the original Latin text. Both Mozart and Haydn used their own adaptations of Fux in their teaching.
11. Gianturco, *Mozart's Early Operas*, 49.
12. Glover, *Mozart's Women*, Location 375.
13. Gutman, *Mozart*, 228–31. This was the second Habsburg daughter to whom Ferdinand I had been betrothed. After both of them died before the weddings, he married the next Habsburg archduchess in line.
14. Anderson, Complete, no. 51.
15. Gutman, *Mozart*, 232–33.
16. Chailly, *The "Magic Flute" Unveiled*, 66–67.
17. Anderson, Complete, no. 52.
18. Sadie, *The Early Years*, 134.
19. Gutman, *Mozart*, 234.
20. Sadie, *The Early Years*, 146.
21. Anderson, Complete, no. 55.
22. Eisen and Keefe, *Cambridge Mozart Encyclopedia*, 5.
23. Landon, *Mozart and Vienna*, 31.

24. Anderson, Complete, no. 62.
25. Sadie, *The Early Years*, 137–38.
26. Gianturco, *Mozart's Early Operas*, 51.
27. Deutsch, *Documentary Biography*, 82.
28. Anderson, Complete, no. 62.
29. Anderson, Complete, no. 62.
30. Sadie, *The Early Years*, 141.
31. Sadie, *The Early Years*, 140.
32. Tyler, "'Zaide' in the Development of Mozart's Operatic Language," 532.
33. Gutman, *Mozart*, 246–47.
34. Gutman, *Mozart*, 247.
35. Anderson, Complete, no. 70.
36. Deutsch, *Documentary Biography*, 88.
37. Eisen and Keefe, *Cambridge Mozart Encyclopedia*, 206.
38. Landon, *Mozart, the Golden Years, 1781–1791*, 13–14.
39. Anderson, Complete, no. 59.
40. Sadie, *The Early Years*, 176–77.

CHAPTER 6: TRALALIERA
1. Sadie, *The Early Years*, 176–77.
2. Sadie, *The Early Years*, 179.
3. Anderson, Complete, no. 71.
4. Spaethling, *Mozart's Letters, Mozart's Life*, 5.
5. Spaethling, *Mozart's Letters, Mozart's Life*, 13–14.
6. Gutman, *Mozart*, 258.
7. Sadie, *The Early Years*, 181–82.
8. Anderson, Complete, no. 75.
9. Anderson, Complete, no. 76.
10. Anderson, Complete, no. 77.
11. Gutman, *Mozart*, 260.
12. Gutman, *Mozart*, 261.
13. Anderson, Complete, no. 80.
14. Spaethling, *Mozart's Letters, Mozart's Life*, 7.
15. Spaethling, *Mozart's Letters, Mozart's Life*, 8–9.
16. Spaethling, *Mozart's Letters, Mozart's Life*, 10.
17. Gutman, *Mozart*, 263.
18. Zaslaw, *Mozart's Symphonies*, notes that K. 74 was traditionally attributed to the Milan stay, but Alan Tyson notes that the paper used implies it was written later, in Rome. There is some doubt that K. 84 is actually Mozart's, but Zaslaw thinks it is and assigns its first version to Milan.

19. Sadie, *The Early Years*, 187–88.
20. Clive, *Mozart and His Circle*, 52.
21. Anderson, Complete, no. 80.
22. "History of the Carnival in Venice," Visit Venice Italy, https://www.visit-venice-italy.com/history_of_the_carnival_in_venice_masks_pleasures.htm.
23. Anderson, Complete, 151.
24. Gutman, *Mozart*, 265–66.
25. Eisen and Keefe, *Cambridge Mozart Encyclopedia*, 269–70.
26. Anderson, Complete, no. 84–85.
27. Deutsch, *Documentary Biography*, 113.
28. Anderson, Complete, no. 86.
29. Dimond, *Mozart Diary*, 53.
30. Clive, *Mozart and His Circle*, 91.
31. Deutsch, *Documentary Biography*, 108.
32. Gutman, *Mozart*, 270.
33. Anderson, Complete, no. 87.
34. "Miserere," Classical Net, http://www.classical.net/music/comp.lst/works/allegri/miserere.php.
35. Anderson, Complete, no. 87.
36. Gutman, *Mozart*, 274.
37. Anderson, Complete, no. 87.
38. Solomon, *Mozart*, 86–94.
39. Spaethling, *Mozart's Letters, Mozart's Life*, 13.
40. Gutman, *Mozart*, 275.
41. Anderson, *Mozart's Letters*, 17.
42. Anderson, Complete, no. 92.
43. Gutman, *Mozart*, 277–78.
44. Anderson, Complete, no. 92.
45. Sadie, *The Early Years*, 198.
46. Gutman, *Mozart*, 278–79.
47. Spaethling, *Mozart's Letters, Mozart's Life*, 16.
48. Anderson, Complete, no. 97.
49. Anderson, Complete, no. 100.
50. Anderson, Complete, no. 99.
51. Deutsch, *Documentary Biography*, 123–24.
52. "Order of the Golden Spur," Wikipedia, https://en.wikipedia.org/wiki/Order_of_the_Golden_Spur.
53. Spaethling, *Mozart's Letters, Mozart's Life*, 17–18.
54. Anderson, *Mozart's Letters*, 21.
55. Spaethling, *Mozart's Letters, Mozart's Life*, 20.
56. Freeman, *Josef Mysliveček*, 229–35.

57. Anderson, Complete, no. 109.
58. Anderson, *Mozart's Letters*, 22–23.
59. Sadie notes that there is no specific evidence that Mozart took lessons with Martini, but there is an old assumption that he did.
60. Sadie, *The Early Years*, 211.
61. Gutman, *Mozart*, 283–84.
62. Einstein, *Mozart*, 146–47.
63. Spaethling, *Mozart's Letters, Mozart's Life*, 23.
64. Hunter, *Mozart's Operas*, 26.
65. Berry, "Thoughts on Mozart as Dramatist and Symphonist," 1.
66. Nagel, *Autonomy and Mercy*, 13.
67. Libby, "Italy: Two Opera Centers," 24–25.
68. Hunter, *Mozart's Operas*, 190–92.
69. Bauman, "Simple Recitative," 126–27.
70. Hunter, *Mozart's Operas*, 186–87.
71. Rice, *Mozart on the Stage*, 198–99.
72. Libby, "Italy: Two Opera Centers," 27.
73. Sadie, *The Early Years*, 214–15.
74. Anderson, Complete, no. 125.
75. Sadie, *The Early Years*, 215.
76. Anderson, Complete, no. 125.
77. Anderson, Complete, no. 127.
78. Anderson, Complete, no. 126.
79. Anderson, Complete, no. 128.
80. Landon, *Mozart Compendium*, 18.
81. Anderson, Complete, no. 130.
82. Gutman, *Mozart*, 288.
83. Spaethling, *Mozart's Letters, Mozart's Life*, 25.
84. Deutsch, *Documentary Biography*, 134.

CHAPTER 7: *EXSULTATE, JUBILATE*
1. Sadie, "Mozart's 'Betulia liberata,'" *passim*.
2. Sadie, *The Early Years*, 234.
3. Hunter, *Mozart's Operas*, 38.
4. Glover, *Mozart's Women*, Location 570.
5. Spaethling, *Mozart's Letters, Mozart's Life*, 30.
6. Anderson, Complete, no. 141.
7. Anderson, Complete, no. 151.
8. Spaethling, *Mozart's Letters, Mozart's Life*, 30.
9. Anderson, Complete, no. 143.
10. Anderson, Complete, no. 144.

11. Eisen, *New Mozart Documents*, 20–21.
12. Sadie, *The Early Years*, 241.
13. Gutman, *Mozart*, 297.
14. Spaethling, *Mozart's Letters, Mozart's Life*, 33.
15. Anderson, *Mozart's Letters*, 27.
16. Anderson, Complete, no. 148.
17. Sadie, *The Early Years*, 243–44.
18. Deutsch, *Documentary Biography*, 138.
19. Dimond, *Mozart Diary*, 70.
20. Eisen and Keefe, *Cambridge Mozart Encyclopedia*, 462–63.
21. Sadie, *The Early Years*, 259–60.
22. Eisen and Keefe, *Cambridge Mozart Encyclopedia*, 331.
23. Spaethling, *Mozart's Letters, Mozart's Life*, 38.
24. Sadie, *The Early Years*, 278.
25. Anderson, Complete, no. 161.
26. Spaethling, *Mozart's Letters, Mozart's Life*, 41–42.
27. Gianturco, *Mozart's Early Operas*, 132–33.
28. Anderson, Complete, no. 167.
29. Warburton, "Lucio Silla," 726.
30. Gianturco, *Mozart's Early Operas*, 144.
31. Anderson, Complete, no. 168.
32. Anderson, Complete, no. 171.
33. Sadie, *The Early Years*, 291.
34. Solomon, *Mozart*, 98.

CHAPTER 8: INERTIA
1. Sadie, *The Early Years*, 323.
2. Clive, *Mozart and His Circle*, 39.
3. Solomon, *Mozart*, 99.
4. Braunbehrens, *Mozart in Vienna*, 26.
5. Einstein, *Mozart*, 34.
6. Eisen and Keefe, *Cambridge Mozart Encyclopedia*, 98.
7. Braunbehrens, *Mozart in Vienna*, 24.
8. Gutman, *Mozart*, 360.
9. Landon, *Mozart Compendium*, 97.
10. Solomon, *Mozart*, 103.
11. Gutman, *Mozart*, 311.
12. Sadie, *The Early Years*, 314.
13. Anderson, Complete, no. 178.
14. Anderson, Complete, no. 177.
15. Anderson, Complete, no. 178.
16. Spaethling, *Mozart's Letters, Mozart's Life*, 46.
17. Spaethling, *Mozart's Letters, Mozart's Life*, 46–47.

18. Sadie, *The Early Years*, 315.
19. Landon, *Mozart and Vienna*, 45.
20. Wolff, *Mozart at the Gateway to His Fortune*, 35.
21. Sadie, *The Early Years*, 317.
22. Sadie, *The Early Years*, 315.
23. Note in the Salzburg Mozarthaus.
24. Sadie, *The Early Years*, 323.
25. Mozarthaus exhibit.
26. Bauer, "W. A. Mozart: The True Airgun Shooting Enthusiast," *passim*.
27. Heartz and Bauman, *Viennese School*, 674.
28. Marie Anna Mozart [Nannerl], *Meine Tag Ordnungen*, 30.
29. Marie Anna Mozart [Nannerl], *Meine Tag Ordnungen*, 40.
30. Sadie, *The Early Years*, 330.
31. Landon, in *Mozart and Vienna*, 45, says that some of the music Mozart encountered in Vienna was Sturm und Drang in style—possible, but again, this was 1773, before the movement had gathered steam.
32. Sadie, *The Early Years*, 329.
33. Gutman, *Mozart*, 330.
34. Gutman, *Mozart*, 302.
35. Anderson, Complete, no. 191.
36. Anderson, *Mozart's Letters*, 30.
37. Anderson, Complete, no. 193.
38. Spaethling, *Mozart's Letters, Mozart's Life*, 50.
39. Anderson, Complete, no. 201.
40. Spaethling, *Mozart's Letters, Mozart's Life*, 51.
41. Anderson, Complete, no. 190.
42. Gutman, *Mozart*, 341.
43. Deutsch, *Documentary Biography*, 153.
44. Anderson, Complete, no. 198.
45. Anderson, Complete, no. 199.

CHAPTER 9: BREAKING
1. Sadie, *The Early Years*, 378.
2. Gutman, *Mozart*, 347.
3. Sadie, *The Early Years*, 377.
4. Gutman, *Mozart*, 349n6.
5. The K. 207 Violin Concerto was long dated 1775, but recent studies based on the paper suggest that it was 1773. See Sadie, *The Early Years*, 306.
6. Sadie, *The Early Years*, 372.
7. Sadie, *The Early Years*, 332.

8. Eisen and Keefe, *Cambridge Mozart Encyclopedia*, 112.
9. Sadie, *The Early Years*, 409.
10. Sadie, *The Early Years*, 410.
11. Küster, *Mozart*, 60–61.
12. "Serenade," in Sadie, ed., *The New Grove Book of Operas*.
13. Solomon, *Mozart*, 130.
14. Anderson, *Mozart's Letters*, 34.
15. Deutsch, *Documentary Biography*, 158.
16. Glover, *Mozart's Women*, Location 789.
17. Spaethling, *Mozart's Letters, Mozart's Life*, 58–59.
18. Deutsch, *Documentary Biography*, 163.
19. Glover, *Mozart's Women*, Location 789.
20. Sadie, *The Early Years*, 414.
21. Gutman, *Mozart*, 367n38.

CHAPTER 10: NO VACANCY HERE
1. Anderson, Complete, no. 215.
2. Anderson, Complete, no. 211.
3. Sadie, *The Early Years*, 420.
4. Anderson, Complete, no. 211.
5. Anderson, Complete, no. 262.
6. Sadie, *The Early Years*, 421.
7. Gutman, *Mozart*, 342.
8. Clive, *Mozart and His Circle*, 135.
9. Spaethling, *Mozart's Letters, Mozart's Life*, 63.
10. Glover, *Mozart's Women*, Location 884.
11. Glover, *Mozart's Women*, Location 868.
12. Gutman, *Mozart*, 379.
13. Anderson, Complete, no. 213.
14. Gutman, *Mozart*, 373.
15. Anderson, *Mozart's Letters*, 38–39.
16. Solomon, *Mozart*, 138.
17. Spaethling, *Mozart's Letters, Mozart's Life*, 66.
18. Anderson, Complete, 215a.
19. Spaethling, *Mozart's Letters, Mozart's Life*, 70.
20. Spaethling, *Mozart's Letters, Mozart's Life*, 116–17.
21. Gutman, *Mozart*, 370n3.
22. Anderson, *Mozart's Letters*, 45–46; Spaethling, *Mozart's Letters, Mozart's Life*, 70.
23. Gutman, *Mozart*, 376.

24. Anderson, *Mozart's Letters*, 47.
25. Anderson, *Mozart's Letters*, 48.
26. Gutman, *Mozart*, 377.
27. Komlós, "Performer," 6.
28. Spaethling, *Mozart's Letters, Mozart's Life*, 77.
29. Spaethling, *Mozart's Letters, Mozart's Life*, 73.
30. Anderson, Complete, no. 222.
31. Anderson, Complete, no. 226.
32. Sadie, *The Early Years*, 431.
33. Anderson, *Mozart's Letters*, 46–48.
34. Gutman, *Mozart*, 376.
35. Spaethling, *Mozart's Letters, Mozart's Life*, 76.
36. Clive, *Mozart and His Circle*, 109.
37. Deutsch, *Documentary Biography*, 166–67.
38. Komlós, "Performer," 219.
39. Gutman, *Mozart*, 378.
40. Deutsch, *Documentary Biography*, 168.
41. Gutman, *Mozart*, 378n17.
42. Anderson, *Mozart's Letters*, 54.
43. Spaethling, *Mozart's Letters, Mozart's Life*, 80–81.
44. Anderson, Complete, no. 231.

CHAPTER 11: LOVE AND MONEY

1. Clive, *Mozart and His Circle*, 81.
2. Braunbehrens, *Mozart in Vienna*, 126–27.
3. Wolff, "The Mannheim Court," 225–26.
4. Wolff, "The Mannheim Court," 222–23.
5. Gardiner, "Mozart's Operas," 301.
6. Wolff, "The Mannheim Court," 222–23.
7. Wolff, "The Mannheim Court," 218–19.
8. Wolff, "The Mannheim Court," 220.
9. Küster, *Mozart*, 91.
10. Sadie, *The Early Years*, 368.
11. Spaethling, *Mozart's Letters, Mozart's Life*, 86–88.
12. Gutman, *Mozart*, 379n22. The *schicken/ficken* connection is a speculation of Gutman's, to which I subscribe.
13. Gutman, *Mozart*, 387.
14. Gutman, *Mozart*, 390.
15. Anderson, *Mozart's Letters*, 58.

16. Anderson, *Mozart's Letters*, 65.
17. Spaethling, *Mozart's Letters, Mozart's Life*, 96.
18. Eisen and Keefe, *Cambridge Mozart Encyclopedia*, 404.
19. Küster, *Mozart*, 75.
20. Spaethling, *Mozart's Letters, Mozart's Life*, 130.
21. Bowers, "Mozart and the Flute," *passim*.
22. A third flute quartet attributed to Mozart in this period is probably bogus.
23. Spaethling, *Mozart's Letters, Mozart's Life*, 122–23.
24. Anderson, *Mozart's Letters*, 67.
25. Anderson, *Mozart's Letters*, 66.
26. Spaethling, *Mozart's Letters, Mozart's Life*, 94–96.
27. Gutman, *Mozart*, 388–89.
28. Spaethling, *Mozart's Letters, Mozart's Life*, 110.
29. Spaethling, *Mozart's Letters, Mozart's Life*, 111.
30. Anderson, Complete, no. 255.
31. Heartz and Bauman, *Viennese School*, 492.
32. Gutman, *Mozart*, 405n36–37.
33. Spaethling, *Mozart's Letters, Mozart's Life*, 93–94.
34. Gutman, *Mozart*, 398.
35. Spaethling, *Mozart's Letters, Mozart's Life*, 120.
36. Clive, *Mozart and His Circle*, 170.
37. Clive, *Mozart and His Circle*, 165.
38. Küster, *Mozart*, 90.
39. Anderson, Complete, no. 282.
40. Again, it was Solomon, in *Mozart*, who added up convincing evidence that Leopold was hiding his real resources in the later years of his life. Gutman concurs, and so do I. My reader Simon Keefe, I should mention, is skeptical.
41. Spaethling, *Mozart's Letters, Mozart's Life*, 124–26.
42. Anderson, *Mozart's Letters*, 73–74.
43. Spaethling, *Mozart's Letters, Mozart's Life*, 125.
44. Gutman, *Mozart*, 394.
45. Spaethling, *Mozart's Letters, Mozart's Life*, 127–28.

46. Steptoe, *The Mozart–Da Ponte Operas*, 88.
47. Anderson, Complete, no. 285.
48. Gutman, *Mozart*, 390.
49. Anderson, *Mozart's Letters*, 75.
50. Spaethling, *Mozart's Letters, Mozart's Life*, 132.
51. Spaethling, *Mozart's Letters, Mozart's Life*, 133.
52. Anderson, Complete, no. 288–89a.
53. Anderson, Complete, no. 290.
54. Heartz and Bauman, *Mozart's Operas*, 16.
55. Anderson, *Mozart's Letters*, 78–79.
56. Spaethling, *Mozart's Letters, Mozart's Life*, 130–31.
57. Schroeder, *Mozart in Revolt*, 128.
58. Spaethling, *Mozart's Letters, Mozart's Life*, 139–40.
59. Deutsch, *Documentary Biography*, 173.
60. Anderson, Complete, no. 287.
61. Anderson, Complete, no. 277.
62. Gutman, *Mozart*, 405.
63. Gutman, *Mozart*, 380.

CHAPTER 12: ASHES

1. Gutman, *Mozart*, 406.
2. Anderson, *Mozart's Letters*, 82.
3. Anderson, Complete, no. 301.
4. *Britannica* article on "Paris History."
5. Zaslaw, *The Classical Era*, 64.
6. "Paris music history," in Sadie, ed., *The New Grove Book of Operas*.
7. Heartz, *European Capitals*, 611.
8. Spaethling, *Mozart's Letters, Mozart's Life*, 141.
9. Gutman, *Mozart*, 429.
10. Anderson, *Mozart's Letters*, 88.
11. Gutman, *Mozart*, 416.
12. Spaethling, *Mozart's Letters, Mozart's Life*, 152.
13. Anderson, *Mozart's Letters*, 86.
14. Anderson, Complete, no. 304.
15. Gutman, *Mozart*, 424n2.
16. Glover, *Mozart's Women*.
17. Anderson, Complete, no. 305.
18. Anderson, Complete, no. 306.
19. Anderson, Complete, no. 305a.
20. Keefe, "Stuck in Music," 44.
21. Spaethling, *Mozart's Letters, Mozart's Life*, 177. He notes that while the Mozarts called Guînes *Duc*, he was actually a count.
22. Gutman, *Mozart*, 445.
23. Spaethling, *Mozart's Letters, Mozart's Life*, 169.
24. Glover, *Mozart's Women*, Location 1246.
25. Heartz, *Viennese School*, 595.
26. Sadie, *The Early Years*, 472–73.
27. Landon, *Mozart Compendium*, 22.
28. Spaethling, *Mozart's Letters, Mozart's Life*, 160.
29. Sadie, *The Early Years*, 474.
30. Zaslaw, *Mozart's Symphonies*, 319. Zaslaw notes that there did not seem to be a continuo player in the middle of the orchestra, as was usual in German lands.
31. Anderson, *Mozart's Letters*, 93.
32. Davies, *Mozart in Person*, 49.
33. Spaethling, *Mozart's Letters, Mozart's Life*, 176.
34. Davies, *Mozart in Person*, 49.
35. Spaethling, *Mozart's Letters, Mozart's Life*, 158–60.
36. Spaethling, *Mozart's Letters, Mozart's Life*, 161.
37. Gutman, *Mozart*, 407n1.
38. Spaethling, *Mozart's Letters, Mozart's Life*, 162–63.
39. The autograph of Mozart's letter to Bullinger is on display at the Mozarthaus in Salzburg.
40. Anderson, Complete, no. 314.
41. Glover, *Mozart's Women*, Location 1273.
42. Spaethling, *Mozart's Letters, Mozart's Life*, 164–65.
43. Spaethling, *Mozart's Letters, Mozart's Life*, 165.
44. There is a history of uncertainty over which of the slow movements of the D-major Symphony are the first and second ones. See Zaslaw, *Mozart's Symphonies*, 323–29.
45. Spaethling, *Mozart's Letters, Mozart's Life*, 168.
46. Keefe, "Stuck in Music," 33.
47. Anderson, Complete, no. 301.
48. Heartz, "Mozart, His Father, and 'Idomeneo,'" 230.
49. Anderson, Complete, no. 308.

50. Clive, *Mozart and His Circle*, 166.
51. Spaethling, *Mozart's Letters, Mozart's Life*, 172.
52. Anderson, Complete, no. 320.
53. Spaethling, *Mozart's Letters, Mozart's Life*, 175–76.
54. Gutman, *Mozart*, 437–38n4.
55. Tyson, "Mozart's Truthfulness," 938.
56. Zaslaw, *Mozart's Symphonies*, 322.
57. Keefe, "Stuck in Music," 53.
58. Sadie, *The Early Years*, 480.
59. Spaethling, *Mozart's Letters, Mozart's Life*, 176–78.
60. Deutsch, *Documentary Biography*, 177.
61. Schroeder, *Mozart in Revolt*, 97.
62. Spaethling, *Mozart's Letters, Mozart's Life*, 183.
63. Eisen and Keefe, *Cambridge Mozart Encyclopedia*, 254.
64. Solomon, *Mozart*, 152.
65. Spaethling, *Mozart's Letters, Mozart's Life*, 181–82.
66. Eisen and Keefe, *Cambridge Mozart Encyclopedia*, 61.
67. Anderson, *Mozart's Letters*, 119.
68. Spaethling, *Mozart's Letters, Mozart's Life*, 186.
69. Sadie, *The Early Years*, 482.
70. Anderson, Complete, no. 333.
71. Anderson, *Mozart's Letters*, 122–23.
72. Anderson, Complete, no. 337.
73. Sadie, *The Early Years*, 482.
74. Anderson, *Mozart's Letters*, 124.
75. Anderson, Complete, no. 340.
76. Anderson, Complete, no. 341.
77. Spaethling, *Mozart's Letters, Mozart's Life*, 198–99.
78. The image is borrowed from Robert Frost's image of writing a poem.
79. Sadie, *The Early Years*, 484.
80. Spaethling, *Mozart's Letters, Mozart's Life*, 200.
81. Spaethling, *Mozart's Letters, Mozart's Life*, 200.
82. Anderson, Complete, no. 349.

CHAPTER 13: A SCOUNDREL, A LOUSY ROGUE
1. Sadie, *The Early Years*, 490.
2. Gutman, *Mozart*, 484.
3. Gutman, *Mozart*, 485.
4. Sadie, *The Early Years*, 494.
5. Gutman, *Mozart*, 476.
6. Solomon, *Mozart*, 224.
7. Deutsch, *Documentary Biography*, 182.
8. Landon, *Mozart Compendium*, 22.
9. Einstein, *Mozart*, 147.
10. Marie Anna Mozart [Nannerl], *Meine Tag Ordnungen*, 70.
11. Marie Anna Mozart [Nannerl], *Meine Tag Ordnungen*, 86.
12. Solomon, *Mozart*, 223.
13. Spaethling, *Mozart's Letters, Mozart's Life*, 203–5.
14. Picture of the letter with drawing of the Bäsle, in Sadie, *The Early Years*, 426.
15. Glover, *Mozart's Women*, Location 1659.
16. Sadie, *The Early Years*, 499.
17. Zaslaw, *Mozart's Symphonies*, 348.
18. It's long been noted that the soprano solo at the beginning of the Agnus Dei in the *Coronation* Mass foreshadows "Dove sono" in *Figaro*.
19. Tyler, "'Zaide' in the Development of Mozart's Operatic Language," 214.
20. Tyler, "'Zaide' in the Development of Mozart's Operatic Language," 215–16.
21. Sadie, *The Early Years*, 513.
22. Deutsch, "Some Fallacies," 148.
23. My sense of art from the outside in and inside out came originally from acting. Actors of the past created characters from the outside in: the look, the voice, the mannerisms, the movement, the costume. The character was in effect built from objective elements. After Stanislavsky and what came to be called the Method, most modern actors work from the inside out, finding the personality and emotions of their characters inside themselves, subjectively from their own experience. So modern actors are in effect expressing themselves, whatever the character may be. In Mozart's day, acting was thoroughly stylized.
24. Sadie, *The Early Years*, 493.
25. Solomon, *Mozart*, 227–28.
26. Bauer, "Mozart's High Costs for Light and Heat," 5–6.
27. Eisen and Keefe, *Cambridge Mozart Encyclopedia*, 516.
28. Gutman, *Mozart*, 493.

29. Rushton, *W. A. Mozart: "Idomeneo,"* 27.
30. Cairns, *Mozart and His Operas*, 33.
31. Till, *Mozart and the Enlightenment*, 73.
32. Spaethling, *Mozart's Letters, Mozart's Life*, 211.
33. Cairns, *Mozart and His Operas*, 46.
34. Spaethling, *Mozart's Letters, Mozart's Life*, 211.
35. Rushton, *W. A. Mozart: "Idomeneo,"* 56.
36. Spaethling, *Mozart's Letters, Mozart's Life*, 157.
37. Eisen and Keefe, *Cambridge Mozart Encyclopedia*, 402.
38. Davies, *Mozart in Person*, 42.
39. Rushton, *W. A. Mozart: "Idomeneo,"* 58–59.
40. Rushton, *W. A. Mozart: "Idomeneo,"* 40.
41. Spaethling, *Mozart's Letters, Mozart's Life*, 212.
42. Spaethling, *Mozart's Letters, Mozart's Life*, 218.
43. Spaethling, *Mozart's Letters, Mozart's Life*, 224–25.
44. Gutman, *Mozart*, 492.
45. Anderson, *Mozart's Letters*, 133.
46. Heartz, *European Capitals*, 504.
47. Anderson, *Mozart's Letters*, 131.
48. Rushton, *W. A. Mozart: "Idomeneo,"* 39.
49. Gutman, *Mozart*, 503–4.
50. Anderson, Complete, no. 360.
51. Spaethling, *Mozart's Letters, Mozart's Life*, 217.
52. Anderson, Complete, no. 373.
53. Anderson, Complete, no. 382.
54. Pestelli, *The Age of Mozart and Beethoven*, 153.
55. Gutman, *Mozart*, 528.
56. Spaethling, *Mozart's Letters, Mozart's Life*, 226.
57. Anderson, Complete, no. 392.
58. Glover, *Mozart's Women*, Location 1426.
59. Gutman, *Mozart*, 506.
60. The Cuvilliés Theatre was bombed out during World War II, though much of the ornamentation had been removed and stored. The present theater is a restoration to its former grandeur.
61. Hunter, *Mozart's Operas*, 186–87. He estimates that two hundred theater candles would provide about the illumination of a modern 150-watt lightbulb.
62. Hunter, *Mozart's Operas*, 193–94.
63. Hunter, *Mozart's Operas*, 186–87.
64. Rushton, *W. A. Mozart: "Idomeneo,"* 5.
65. Rushton, *W. A. Mozart: "Idomeneo,"* 11.
66. Rushton, "Buffo Roles in Mozart's Vienna," 130.
67. Sadie, *The Early Years*, 534.
68. Gutman, *Mozart*, 526.
69. Gutman, *Mozart*, 531–32.
70. Braunbehrens, *Mozart in Vienna*, 15.
71. Landon, *Mozart Compendium*, 23–24.
72. Spaethling, *Mozart's Letters, Mozart's Life*, 234–35.
73. Spaethling, *Mozart's Letters, Mozart's Life*, 237.
74. Gutman, *Mozart*, 534.
75. Spaethling, *Mozart's Letters, Mozart's Life*, 240.
76. Gutman, *Mozart*, 537.
77. Anderson, *Mozart's Letters*, 148.
78. Anderson, *Mozart's Letters*, 398.
79. Braunbehrens, *Mozart in Vienna*, 19.
80. Gutman, *Mozart*, 545.
81. Spaethling, *Mozart's Letters, Mozart's Life*, 243–44.
82. Gutman, *Mozart*, 546.
83. Glover, *Mozart's Women*, Location 1410.
84. Spaethling, *Mozart's Letters, Mozart's Life*, 246–47.
85. Clive, *Mozart and His Circle*, 15.
86. Eisen and Keefe, *Cambridge Mozart Encyclopedia*, 10.
87. Spaethling, *Mozart's Letters, Mozart's Life*, 249.
88. Spaethling, *Mozart's Letters, Mozart's Life*, 251.
89. Spaethling, *Mozart's Letters, Mozart's Life*, 258–59.
90. Anderson, Complete, no. 404.
91. Spaethling, *Mozart's Letters, Mozart's Life*, 252.
92. Gutman, *Mozart*, 538.

CHAPTER 14: RETURN

1. Wheatcroft, *The Enemy at the Gate*, 525.
2. Cairns, *Mozart and His Operas*, 70.
3. Gutman, *Mozart*, 569.
4. Spaethling, *Mozart's Letters, Mozart's Life*, 260–63.
5. Spaethling, *Mozart's Letters, Mozart's Life*, 269.
6. Braunbehrens, *Mozart in Vienna*, 47.
7. Steptoe, *The Mozart–Da Ponte Operas*, 13.
8. Gutman, *Mozart*, 563.
9. Braunbehrens, *Mozart in Vienna*, 436n2.
10. Landon, *Mozart and Vienna*, 58. This part of the Landon is given to the vivid and extensive descriptions of 1780s Vienna by Johann Pezzl, one of the prime sources of information on the life of the city in that period.
11. Landon, *Mozart and Vienna*, 160.
12. Landon, *Mozart and Vienna*, 77–78.
13. Landon, *Mozart and Vienna*, 68–69.
14. Landon, *Mozart and Vienna*, 151.
15. Steptoe, *The Mozart–Da Ponte Operas*, 23.
16. Landon, *Mozart and Vienna*, 81–84.
17. Hunter, *Mozart's Operas*, 183.
18. Spaethling, *Mozart's Letters, Mozart's Life*, 260.
19. Rice, *Antonio Salieri*, 39.
20. Edge, "Mozart's Viennese Orchestras," 67.
21. Gutman, *Mozart*, 611.
22. Steptoe, *The Mozart–Da Ponte Operas*, 26.
23. Bolt, *Librettist*, 101.
24. Blanning, *Joseph II*, 66.
25. From Casanova memoirs, at https://ebooks.adelaide.edu.au/c/casanova/c33m/book2.10.html.
26. Blanning, *Joseph II*, 67.
27. Blanning, *Joseph II*, 63.
28. Gutman, *Mozart*, 564n4.
29. Blanning, *Joseph II*, 165.
30. Wheatcroft, *The Enemy at the Gate*, 385.
31. Eisen and Keefe, *Cambridge Mozart Encyclopedia*, 235.
32. Blanning, *Joseph II*, 98.
33. Beales, "Mozart and the Hapsburgs," 8.
34. Steptoe, *The Mozart–Da Ponte Operas*, 16.
35. "Vienna's Criminal Museum (Kriminalmuseum)," Britannica Blog, http://blogs.britannica.com/2009/09/viennas-criminal-museum-kriminalmuseum/.
36. Blanning, *Joseph II*, 56.
37. Brauneis, "Mozart's Appointment to the Imperial Court in Vienna," 3.
38. Beales, *Joseph II*, 456.
39. Beales, *Joseph II*, 463.
40. Beales, "Mozart and the Habsburgs," 96.
41. Bolt, *Librettist*, 93; Davies, "Manic-Depressive," 194.

CHAPTER 15: GNAGFLOW AND ZNATSNOC

1. Anderson, *Mozart's Letters*, 155.
2. Eisen and Keefe, *Cambridge Mozart Encyclopedia*, 492.
3. Gutman, *Mozart*, 591.
4. Anderson, *Mozart's Letters*, 153–54.
5. Spaethling, *Mozart's Letters, Mozart's Life*, 264.
6. Spaethling, *Mozart's Letters, Mozart's Life*, 270–71.
7. Anderson, *Mozart's Letters*, 158–59.
8. Eisen and Keefe, *Cambridge Mozart Encyclopedia*, 28.
9. Braunbehrens, *Mozart in Vienna*, 58.
10. Spaethling, *Mozart's Letters, Mozart's Life*, 273.
11. Spaethling, *Mozart's Letters, Mozart's Life*, 273.
12. Clive, *Mozart and His Circle*, 78.
13. Gutman, *Mozart*, 602.
14. Gutman, *Mozart*, 554.
15. Spaethling, *Mozart's Letters, Mozart's Life*, 274–75.
16. Gutman, *Mozart*, 555.
17. Solomon, *Mozart*, 255.
18. Spaethling, *Mozart's Letters, Mozart's Life*, 276–77.
19. Küster, *Mozart*, 141.
20. Gutman, *Mozart*, 560–61.
21. Gutman, *Mozart*, 562.
22. Braunbehrens, *Mozart in Vienna*, 65–66.
23. Gutman, *Mozart*, 600–601.
24. Spaethling, *Mozart's Letters, Mozart's Life*, 281.

25. Braunbehrens, *Mozart in Vienna*, 48.
26. Anderson, *Mozart's Letters*, 160–63.
27. Fubini, *Music and Culture in Eighteenth-Century Europe*, 364–65.
28. Anderson, *Mozart's Letters*, 163.
29. Spaethling, *Mozart's Letters, Mozart's Life*, 290–91.
30. Einstein, *Mozart*, 62.
31. Clive, *Mozart and His Circle*, 108–9.
32. Küster, *Mozart*, 134.
33. Zaslaw and Cowdery, *Compleat Mozart*, 301.
34. Keefe, *Mozart in Vienna*, 40.
35. Gutman, *Mozart*, 593–94.
36. Gutman, *Mozart*, 588–90.
37. Landon, *Mozart Compendium*, 292.
38. Keefe, *Mozart in Vienna*, 56.
39. Zaslaw and Cowdery, *Compleat Mozart*, 292.
40. Spaethling, *Mozart's Letters, Mozart's Life*, 294–97.
41. Spaethling, *Mozart's Letters, Mozart's Life*, 298–99.
42. Braunbehrens, *Mozart in Vienna*, 69–70.
43. Braunbehrens, *Mozart in Vienna*, 64.
44. Spaethling, *Mozart's Letters, Mozart's Life*, 301–3.
45. Solomon, *Mozart*, 259.
46. Spaethling, *Mozart's Letters, Mozart's Life*, 319.
47. Landon, *Mozart, the Golden Years, 1781–1791*, 72.
48. Eisen and Keefe, *Cambridge Mozart Encyclopedia*, 89; Gutman, *Mozart*, 581.
49. Spaethling, *Mozart's Letters, Mozart's Life*, 301.
50. Gutman, *Mozart*, 581.
51. Gutman, *Mozart*, 582–83.
52. Spaethling, *Mozart's Letters, Mozart's Life*, 301.
53. Spaethling, *Mozart's Letters, Mozart's Life*, 353.
54. Spaethling, *Mozart's Letters, Mozart's Life*, 307–8.
55. Anderson, Complete, no. 447a.
56. Olleson, "Swieten," 64.
57. Glover, *Mozart's Women*, Location 1861.
58. Spaethling, *Mozart's Letters, Mozart's Life*, 309–10.
59. Spaethling, *Mozart's Letters, Mozart's Life*, 303–4.
60. Spaethling, *Mozart's Letters, Mozart's Life*, 305.
61. Spaethling, *Mozart's Letters, Mozart's Life*, 313–14.
62. Anderson, Complete, no. 460.
63. Spaethling, *Mozart's Letters, Mozart's Life*, 317.
64. Spaethling, *Mozart's Letters, Mozart's Life*, 320–21.
65. Solomon, *Mozart*, 262.

CHAPTER 16: MONSTROUS MANY NOTES

1. Cairns, *Mozart and His Operas*, 97.
2. "Janissary music," in Sadie, ed., *The New Grove Book of Operas*.
3. Anderson, *Selected Letters*, 162.
4. Deutsch, *Documentary Biography*, 194.
5. Heartz, *Mozart's Operas*, 77.
6. Rumph, "Mozart's Archaic Endings," 177.
7. Cairns, *Mozart and His Operas*, 84–85.
8. Cairns, *Mozart and His Operas*, 76.
9. Wolff, *Mozart at the Gateway to His Fortune*, 36.
10. Hunter, *Mozart's Operas*, 81.
11. Keefe, *Mozart in Vienna*, 73.
12. Deutsch, *Documentary Biography*, 206–7.
13. Einstein, *Mozart*, 57.
14. Spaethling, *Mozart's Letters, Mozart's Life*, 314–15.
15. Bolt, *Librettist*, 104.
16. Braunbehrens, *Maligned Master*, 14–24.
17. Braunbehrens, *Maligned Master*, 42–43.
18. Braunbehrens, *Maligned Master*, 30.
19. For a sample of Salieri at his most brilliant, see *The Salieri Album* of Cecilia Bartoli.
20. Rice, *Antonio Salieri*, 26.
21. Rice, *Antonio Salieri*, 29.
22. Wolff, *Mozart at the Gateway to His Fortune*, 24.
23. Wolff, *Mozart at the Gateway to His Fortune*, 36.
24. Anderson, Complete, no. 460.
25. Gutman, *Mozart*, 610n9.
26. Gutman, *Mozart*, 634.

27. Spaethling, *Mozart's Letters, Mozart's Life*, 330–31.
28. Spaethling, *Mozart's Letters, Mozart's Life*, 331–32.
29. Landon, *Mozart and Vienna*, 15.
30. Spaethling, *Mozart's Letters, Mozart's Life*, 326–27.
31. Spaethling, *Mozart's Letters, Mozart's Life*, 336.
32. Landon, *Compendium*, 24.
33. Zaslaw, *Mozart's Symphonies*, 377–79.
34. Spaethling, *Mozart's Letters, Mozart's Life*, 321.
35. Keefe, *Mozart in Vienna*, 152.
36. Keefe, *Mozart in Vienna*, 162–63.
37. Braunbehrens, *Mozart in Vienna*, 183.
38. Solomon, *Mozart*, 291.
39. Kerman, "Mozart's Piano Concertos and Their Audience," 152.
40. Spaethling, *Mozart's Letters, Mozart's Life*, 336.
41. Derr, "Some Thoughts on the Design of Mozart's Opus 4," 202–3.
42. Forman, *Mozart's Concerto Form*, 92.
43. Spaethling, *Mozart's Letters, Mozart's Life*, 338.
44. Braunbehrens, "Hier ist doch gewis das Clavierland!" 8.

CHAPTER 17: LAST RETURN, LAST DEPARTURE

1. Allanbrook, "Dance Rhythms," 144.
2. Spaethling, *Mozart's Letters, Mozart's Life*, 339–40.
3. Deutsch, *Documentary Biography*, 213.
4. Spaethling, *Mozart's Letters, Mozart's Life*, 344–45.
5. Spaethling, *Mozart's Letters, Mozart's Life*, 351–52.
6. Spaethling, *Mozart's Letters, Mozart's Life*, 360.
7. Spaethling, *Mozart's Letters, Mozart's Life*, 347.
8. Steptoe, *The Mozart–Da Ponte Operas*, 42.
9. Rice, *Antonio Salieri*, 343.
10. Rice, *Antonio Salieri*, 331.
11. Eisen and Keefe, *Cambridge Mozart Encyclopedia*, 245.
12. Bolt, *Librettist*, 113.
13. Landon, *Mozart, the Golden Years, 1781–1791*, 172–73.
14. Steptoe, *The Mozart–Da Ponte Operas*, 46.
15. Steptoe, *The Mozart–Da Ponte Operas*, 49.
16. Spaethling, *Mozart's Letters, Mozart's Life*, 342.
17. Gutman, *Mozart*, 620.
18. Spaethling, *Mozart's Letters, Mozart's Life*, 350–51.
19. Spaethling, *Mozart's Letters, Mozart's Life*, 344.
20. Solomon, *Mozart*, 265.
21. Eisen and Keefe, *Cambridge Mozart Encyclopedia*, 331.
22. Spaethling, *Mozart's Letters, Mozart's Life*, 353.
23. Gutman, *Mozart*, 625–26.
24. Spaethling, *Mozart's Letters, Mozart's Life*, 354–56.
25. Solomon, *Mozart*, 274.
26. Eisen and Keefe, *Cambridge Mozart Encyclopedia*, 247.
27. Eisen and Keefe, *Cambridge Mozart Encyclopedia*, 356.
28. Keefe, *Mozart in Vienna*, 284.
29. Braunbehrens, "The Mozart-Salieri Connection," 5; and Keefe, *Mozart in Vienna*, 284.
30. Gutman, *Mozart*, 627.
31. Davies, *Mozart in Person*, 39.
32. Glover, *Mozart's Women*, Location 1985.
33. Spaethling, *Mozart's Letters, Mozart's Life*, 361.
34. Glover, *Mozart's Women*, Location 2069.
35. Clive, *Mozart and His Circle*, 96.
36. Glover, *Mozart's Women*, Location 2061.
37. Anderson, Complete, no. 414.
38. Glover, *Mozart's Women*, Location 2081.
39. Kinderman, *Mozart's Piano Music*, 48. Traditionally, the sonatas K. 330–33 were thought to be composed earlier, but Tyson noted that they are written on distinctive Salzburg staff paper, so, likely date from the 1783 visit.
40. Keefe, *Mozart in Vienna*, 140.
41. Wates, "Mozart's Mass in C Minor," 2.
42. Wates, "Mozart's Mass in C Minor," 4.
43. Gutman, *Mozart*, 628–29.

44. Keefe, *Mozart in Vienna*, 149.
45. Spaethling, *Mozart's Letters, Mozart's Life*, 362–63.
46. Zaslaw, *Mozart's Symphonies*, 384.
47. Zaslaw, *Mozart's Symphonies*, 388.
48. Gutman, *Mozart*, 631.
49. Glover, *Mozart's Women*, Location 2110.
50. Dimond, *Mozart Diary*, 155.
51. Cairns, *Mozart and His Operas*, 105.

CHAPTER 18: LONG AND LABORIOUS EFFORTS

1. Braunbehrens, *Mozart in Vienna*, 114–15.
2. Bauer, "Mozart's High Costs for Light and Heat," 15–16.
3. Wolff, "The Challenge of Blank Paper," 127.
4. Solomon, *Mozart*, 357.
5. https://www.swarthmore.edu /Humanities/pschmidl/essays /pynchon/vaucanson.html.
6. Komlós, "Performer," 222.
7. Eisen and Keefe, *Cambridge Mozart Encyclopedia*, 494.
8. Keefe, *Mozart in Vienna*, 256.
9. Eisen and Keefe, *Cambridge Mozart Encyclopedia*, 474.
10. Keefe, *Mozart in Vienna*, 258.
11. Keefe, *Mozart's Viennese Instrumental Music*, 169.
12. Keefe, *Mozart in Vienna*, 200.
13. Keefe, *Mozart in Vienna*, 200.
14. Kerman, "Mozart's Piano Concertos and Their Audience," 152.
15. Spaethling, *Mozart's Letters, Mozart's Life*, 369–70.
16. Clive, *Mozart and His Circle*, 120.
17. Tyson, "Proposed New Dates," 220.
18. Keefe, "A Complementary Pair," 561 and 580.
19. Küster, *Mozart*, 178.
20. Pianist and scholar Robert Levin has promoted the necessity of adding ornaments and the like to Mozart's concertos. See Levin, "Improvised Embellishments in Mozart's Keyboard Music."
21. Davies, *Mozart in Person*, 169.
22. Spaethling, *Mozart's Letters, Mozart's Life*, 372–73.
23. Gutman, *Mozart*, 640.
24. Glover, *Mozart's Women*, Location 2297.
25. Gutman, *Mozart*, 648.
26. Spaethling, *Mozart's Letters, Mozart's Life*, 371–72.
27. Clive, *Mozart and His Circle*, 19–20.
28. Cairns, *Mozart and His Operas*, 112–13.
29. Eisen and Keefe, *Cambridge Mozart Encyclopedia*, 331.
30. Solomon, *Mozart*, 297.
31. Solomon, *Mozart*, 309.
32. From the museum in the Vienna "Figarohaus."
33. Clive, *Mozart and His Circle*, 117–18.
34. McGregor, Martin I., "Mozart and the Austrian Freemasons: His Life, Works, and Masonic Tradition," paper delivered to the Research Lodge of Southland No. 415, New Zealand, August 7, 2016, http://www .freemasons-freemasonry.com /mozart_freemasonry.html.
35. Braunbehrens, *Mozart in Vienna*, 233.
36. Braunbehrens, *Mozart in Vienna*, 236.
37. http://www.freemasons-freemasonry .com/mozart_freemasonry.html.
38. Thomson, "Mozart and Freemasonry," 27.
39. Braunbehrens, *Mozart in Vienna*, 237.
40. Braunbehrens, *Mozart in Vienna*, 229–31.
41. Eisen, *New Mozart Documents*, 38.
42. Solomon, *Mozart*, 321.
43. Eisen and Keefe, *Cambridge Mozart Encyclopedia*, 212.
44. Landon, *Essays on the Viennese Classical Style*, 17.
45. Tyson, *Studies of the Autograph Scores*, 103.
46. Zaslaw, *Compleat Mozart*, 266.
47. Landon, *Essays on the Viennese Classical Style*, 17.
48. Chailley, *The "Magic Flute" Unveiled*, 84–87.
49. Spaethling, *Mozart's Letters, Mozart's Life*, 375.
50. Solomon, *Mozart*, 294.
51. Keefe, *Mozart in Vienna*, 221.
52. Deutsch, *Documentary Biography*, 252.
53. Anderson, Complete, nos. 520 and 521.

54. Deutsch, *Documentary Biography*, 236.
55. Deutsch, *Documentary Biography*, 235.

CHAPTER 19: THE GREATEST COMPOSER
1. Braunbehrens, *Mozart in Vienna*, 199.
2. Landon, *Mozart, the Golden Years, 1781–1791*, 123.
3. Anderson, Complete, no. 523.
4. Anderson, Complete, no. 524.
5. Bauer, "Mozart's High Costs for Light and Heat," 17–18.
6. Anderson, Complete, no. 524.
7. Anderson, Complete, no. 525.
8. Anderson, Complete, no. 526.
9. Landon, *Mozart, the Golden Years, 1781–1791*, 129.
10. Gutman, *Mozart*, 647 and 648n.
11. Clive, *Mozart and His Circle*, 159.
12. Eisen, *New Mozart Documents*, 37.
13. Solomon, *Mozart*, 522.
14. Spaethling, *Mozart's Letters, Mozart's Life*, 376.
15. Davies, *Mozart in Person*, 100.
16. Pesic, "The Child and the Daemon: Mozart and Deep Play," 93.
17. The classic analysis of the D-minor Concerto's first movement is in Charles Rosen's *The Classical Style: Haydn, Mozart, and Beethoven*.
18. This image comes from William Faulkner, who once said that you can present the truth straight or in a chalice.
19. Zaslaw, *Compleat Mozart*, 280.
20. Branscombe, "Mozart the Arch-Englishman," 12.
21. Eisen, *New Mozart Documents*, 39.
22. Spaethling, *Mozart's Letters, Mozart's Life*, 377.
23. Landon, *Mozart, the Golden Years, 1781–1791*, 139.
24. Zaslaw, *Compleat Mozart*, 38.
25. Heartz, *Mozart's Operas*, 257.
26. Solomon, *Mozart*, 322.
27. Braunbehrens, *Mozart in Vienna*, 242–43.
28. Blanning, *Joseph II*, 165.
29. Blanning, *Joseph II*, 170.
30. Till, *Mozart and the Enlightenment*, 196.
31. Braunbehrens, *Mozart in Vienna*, 245–50.
32. Branscombe, *W. A. Mozart: "Die Zauberflöte,"* 43.

33. Glover, *Mozart's Women*, Location 2300.
34. Gutman, *Mozart*, 652.
35. Glover, *Mozart's Women*, Location 2364.
36. Eisen and Keefe, *Cambridge Mozart Encyclopedia*, 447–48.
37. Bolt, *Librettist*, 151.
38. Solomon, *Mozart*, 311.
39. Spaethling, *Mozart's Letters, Mozart's Life*, 377–78.
40. Spaethling, *Mozart's Letters, Mozart's Life*, 377.
41. Keefe, *Mozart in Vienna*, 311.
42. Kerman, "Mozart's Piano Concertos and Their Audience," 162,
43. Cairns, *Mozart and His Operas*, 15.
44. Levin, "Mozart's Working Methods in the Keyboard Concertos," *passim*.
45. See Keefe, *Mozart's Viennese Instrumental Music, passim*.
46. Deutsch, *Documentary Biography*, 271.
47. Anderson, Complete, no. 538. The Marchand who played the concerto was Leopold's violin student Heinrich, who was apparently also an able soloist on piano.
48. Anderson, Complete, no. 539.

CHAPTER 20: IF YOU WANT TO DANCE, MY LITTLE COUNT
1. Bolt, *Librettist*, 17.
2. Steptoe, *The Mozart–Da Ponte Operas*, 98.
3. Bolt, *Librettist*, 18.
4. Braunbehrens, *Mozart in Vienna*, 203.
5. Bolt, *Librettist*, 20.
6. Bolt, *Librettist*, 22.
7. Bolt, *Librettist*, 25.
8. Steptoe, *The Mozart–Da Ponte Operas*, 100.
9. Bolt, *Librettist*, 31–32.
10. Bolt, *Librettist*, 33.
11. Gutman, *Mozart*, 618.
12. Cohen, *The Politics of Opera*, 300.
13. Bolt, *Librettist*, 54.
14. Gutman, *Mozart*, 618.
15. Gutman, *Mozart*, 619.
16. Bolt, *Librettist*, 99.
17. Braunbehrens, *Mozart in Vienna*, 206.
18. Rice, *Salieri*, 110.

19. Glover, *Mozart's Women*, Location 3731.
20. Bolt, *Librettist*, 129.
21. Bolt, *Librettist*, 114.
22. "Da Ponte," in Sadie, ed., *The New Grove Book of Operas*.
23. Bolt, *Librettist*, 127–28.
24. Steptoe, *The Mozart–Da Ponte Operas*, 103–4.
25. Eisen and Keefe, *Cambridge Mozart Encyclopedia*, 356.
26. Cohen, *The Politics of Opera*, 302.
27. Heartz, *Mozart's Operas*, 107–8.
28. Braunbehrens, *Maligned Master*, 131.
29. Braunbehrens, *Maligned Master*, 132–34.
30. Eisen and Keefe, *Cambridge Mozart Encyclopedia*, 46.
31. Till, *Mozart and the Enlightenment*, 148.
32. *Britannica* article on *Le Droit de Seigneur*.
33. Heartz, *Mozart's Operas*, 131,
34. Eisen and Keefe, *Cambridge Mozart Encyclopedia*, 361.
35. Till, *Mozart and the Enlightenment*, 145.
36. Hunter, *Mozart's Operas*, 139.
37. Cairns, *Mozart and His Operas*, 117.
38. Till, *Mozart and the Enlightenment*, 149.
39. Deutsch, *Documentary Biography*, 278.
40. Heartz, *Mozart's Operas*, 110.
41. Steptoe, *The Mozart–Da Ponte Operas*, 111.
42. Steptoe, *The Mozart–Da Ponte Operas*, 113.
43. Steptoe, *The Mozart–Da Ponte Operas*, 109.
44. Steptoe, *The Mozart–Da Ponte Operas*, 172.
45. Steptoe, *The Mozart–Da Ponte Operas*, 173.
46. Landon, *Mozart, the Golden Years, 1781–1791*, 157.
47. Robinson, *Opera and Ideas*, 9.
48. Landon, *Mozart, the Golden Years, 1781–1791*, 158; Hunter, *Mozart's Operas*, 136; Eisen and Keefe, *Cambridge Mozart Encyclopedia*, 360.
49. Eisen and Keefe, *Cambridge Mozart Encyclopedia*, 50.
50. Keefe, *Mozart and Vienna*, 341.
51. Clive, *Mozart and His Circle*, 82.
52. Glover, *Mozart's Women*, Location 3784.
53. Landon, *Mozart, the Golden Years, 1781–1791*, 243n17.
54. Eisen and Keefe, *Cambridge Mozart Encyclopedia*, 364.
55. Keefe, *Mozart in Vienna*, 336.
56. Braunbehrens, "The Mozart-Salieri Connection," 9.
57. Deutsch, *Documentary Biography*, 74.
58. Heartz, *Mozart's Operas*, 13
59. Heartz, *Mozart's Operas*, 152.
60. Keefe, *Mozart in Vienna*, 340.
61. Hunter, *Mozart's Operas*, 217.
62. Ross, "The Storm of Style," 1.
63. Rice, *Mozart on the Stage*, 148–50.
64. Eisen and Keefe, *Cambridge Mozart Encyclopedia*, 358.
65. Braunbehrens, "The Mozart-Salieri Connection," 9.
66. Cairns, *Mozart and His Operas*, 135.
67. Kelly, "Mozart in Social Life," 18.
68. Hunter, *Mozart's Operas*, 23.
69. Rosen, *The Classical Style: Haydn, Mozart, and Beethoven*, 289.
70. Webster, "Mozart's Arias," 102.
71. Till, *Mozart and the Enlightenment*, 144.
72. Till, *Mozart and the Enlightenment*, 149–50.
73. Till, *Mozart and the Enlightenment*, 152.
74. Cohen, *The Politics of Opera*, 304.
75. Robinson, *Opera and Ideas*, 23.
76. Till, *Mozart and the Enlightenment*, 162.
77. Rice, *Mozart on the Stage*, 142.
78. Cairns, *Mozart and His Operas*, 129.
79. Eisen and Keefe, *Cambridge Mozart Encyclopedia*, 363.

CHAPTER 21: THIS TRUEST AND BEST FRIEND

1. Eisen and Keefe, *Cambridge Mozart Encyclopedia*, 358.
2. Gutman, *Mozart*, 657.
3. Deutsch, *Documentary Biography*, 278.
4. Lucas Reilly, "Mozart Wrote Dirty Songs, Too." *Mental Floss*, February 26, 2014, http://mentalfloss.com/article/55247/3-dirty-songs-mozart.

5. Thanks to novelist friend Ralph Glöckler for help with the translations. In all his prose, but especially in his verse, Mozart is heavy in dialect, slang, and sometimes arcane obscenity.

6. Eisen and Keefe, *Cambridge Mozart Encyclopedia*, 268 and 59.

7. Landon, *1791: Mozart's Last Year*, 38.

8. Eisen and Keefe, *Cambridge Mozart Encyclopedia*, 83.

9. Spaethling, *Mozart's Letters, Mozart's Life*, 378–79.

10. Eisen and Keefe, *Cambridge Mozart Encyclopedia*, 536.

11. Spaethling, *Mozart's Letters, Mozart's Life*, 378–79.

12. Glover, *Mozart's Women*, Location 2320.

13. Solomon, *Mozart*, 392–93.

14. Lawson, "A Winning Strike: The Miracle of Mozart's 'Kegelstatt.'"

15. Lawson, "A Winning Strike: The Miracle of Mozart's 'Kegelstatt.'"

16. Spaethling, *Mozart's Letters, Mozart's Life*, 386.

17. Lawson, "A Winning Strike: The Miracle of Mozart's 'Kegelstatt.'"

18. Küster, *Mozart*, 324–25.

19. Tyson, *Studies of the Autograph Scores*, 19.

20. Zaslaw, *Compleat Mozart*, 133.

21. Keefe, "Complementary Pair," 658.

22. Solomon, *Mozart*, 417–19.

23. Gutman, *Mozart*, 659–60.

24. Glover, *Mozart's Women*, Location 4014.

25. Deutsch, *Documentary Biography*, 284.

26. Solomon, *Mozart*, 419–20.

27. Bolt, *Librettist*, 168.

28. Solomon, *Mozart*, 422–23.

29. Eisen and Keefe, *Cambridge Mozart Encyclopedia*, 397–98.

30. Gutman, *Mozart*, 659.

31. Spaethling, *Mozart's Letters, Mozart's Life*, 384–87.

32. Eisen and Keefe, *Cambridge Mozart Encyclopedia*, 400.

33. Cairns, *Mozart and His Operas*, 137.

34. http://www.allsenmusic.com /NOTES.

35. Landon, *Mozart, the Golden Years, 1781–1791*, 187.

36. Anderson, Complete, no. 545.

37. Anderson, Complete, no. 542.

38. Anderson, Complete, no. 545.

39. Solomon, *Mozart*, 392–93.

40. Spaethling, *Mozart's Letters, Mozart's Life*, 388–90.

41. Clive, *Mozart and His Circle*, 69–70.

42. Wolff, *Mozart at the Gateway to His Fortune*, 199n9.

43. Braunbehrens, *Mozart in Vienna*, 359–60.

44. Deutsch, *Documentary Biography*, 291.

45. Czerny, "Recollections from My Life," 16.

46. Clive, *Mozart and His Circle*, 77–78.

47. Gutman, *Mozart*, 677–78.

48. Solomon, *Mozart*, 522–23.

49. Dimond, *Mozart Diary*, 179.

50. Zaslaw, *Compleat Mozart*, 254.

51. Rosen, *The Classical Style: Haydn, Mozart, and Beethoven*, 272.

52. Burnham, *Mozart's Grace*, 157–58.

53. Zaslaw, *Compleat Mozart*, 254.

54. Keefe, *Mozart in Vienna*, 455.

55. Spaethling, *Mozart's Letters, Mozart's Life*, 390–91.

56. Deutsch, *Documentary Biography*, 296; and Solomon, *Mozart*, 412–13.

57. Spaethling, *Mozart's Letters, Mozart's Life*, 391–92.

58. Zaslaw, *Compleat Mozart*, 263.

CHAPTER 22: *VIVA LA LIBERTÀ*

1. Bolt, *Librettist*, 162.

2. From illustrations in the Figarohaus in Vienna.

3. Rice, *Mozart on the Stage*, 74.

4. Bolt, *Librettist*, 165–67.

5. Bolt, *Librettist*, 164.

6. Hodges, *Lorenzo Da Ponte*, 80–81.

7. Rushton, *W. A. Mozart: "Don Giovanni,"* 29.

8. Hunter, *Mozart's Operas*, 149.

9. Bolt, *Librettist*, 169.

10. Rice, *Mozart and Salieri*, 11.

11. Goehring, "Sentimental Muse," 131–32.

12. Steptoe, *The Mozart–Da Ponte Operas*, 115.

13. Gutman, *Mozart*, 664.

14. Keefe, *Mozart in Vienna*, 383.

15. Steptoe, *The Mozart–Da Ponte Operas*, 116.

16. Eisen and Keefe, *Cambridge Mozart Encyclopedia*, 139; and Keefe, *Mozart in Vienna*, 370.
17. Bolt, *Librettist*, 170.
18. Heartz, *Mozart's Operas*, 164.
19. Rice, *Mozart on the Stage*, 89.
20. Gutman, *Mozart*, 664–65.
21. Cairns, *Mozart and His Operas*, 157.
22. Rushton, *W. A. Mozart: "Don Giovanni,"* 28.
23. Heartz, *Mozart's Operas*, 165.
24. Rice, *Mozart on the Stage*, 73.
25. Rushton *W. A. Mozart: "Don Giovanni,"* 126.
26. Davies, *Mozart in Person*, 150.
27. Heartz, *Mozart's Operas*, 102.
28. Wignall, *In Mozart's Footsteps*, 73.
29. Bolt, *Librettist*, 176–78.
30. Keefe, *Mozart in Vienna*, 374.
31. Cairns, *Mozart and His Operas*, 166–67.
32. Keefe, *Mozart in Vienna*, 374.
33. Glover, *Mozart's Women*, Location 4074.
34. Keefe, *Mozart in Vienna*, 370.
35. Spaethling, *Mozart's Letters, Mozart's Life*, 393–94.
36. Bolt, *Librettist*, 181.
37. Keefe, *Mozart in Vienna*, 378.
38. Heartz, "Dramma giocoso," 997
39. Singer, *Mozart and Beethoven: The Concept of Love in Their Operas*, 48.
40. Cairns, *Mozart and His Operas*, 158.
41. Steptoe, *The Mozart–Da Ponte Operas*, 196.
42. Till, *Mozart and the Enlightenment*, 212.
43. Heartz, *Mozart's Operas*, 182–90.
44. Steptoe, *The Mozart–Da Ponte Operas*, 26.
45. Heartz, *Mozart's Operas*, 210.
46. Cairns, *Mozart and His Operas*, 150.
47. Berry, "Thoughts on Mozart as Dramatist and Symphonist," 3.
48. Cairns, *Mozart and His Operas*, 150.
49. Till, *Mozart and the Enlightenment*, 226–27.
50. As I get toward the end of *Don Giovanni* I am framing particular interpretations of the characters based equally on the libretto and the music. But the more interpretation I or anybody offers, the less it has to do with the variety of ways the characters and the stories have been played onstage. For example, the Furtwängler version from the 1954 Salzburg Festival plays the end of this scene as if Anna and Ottavio were feeling happy and resolved. But Ottavio's words at the end are forlorn: "I must follow her. Her sorrows are my own. With me beside her, her anguish will be eased." He may be willing to stay beside Anna, but in the opera and the foreseeable future he will never truly be *with* her as lover or husband. This issue of text versus how something is played will come up again in my sense of the end.
51. Heartz, *Mozart's Operas*, 172.
52. Cairns, *Mozart and His Operas*, 164.
53. My contention is that in an ideal production true to the actual seriousness and violence of the story, we still want Don Giovanni to win— which is to say that we are like Donna Elvira, seeing his malevolence but not able to resist. I think this reading makes Don Giovanni a more potent and interesting character than a simple villain in comtemplating whom we can sit back, fold our arms, and feel superior.
54. Nagel, *Autonomy and Mercy*, 41.

CHAPTER 23: WITH NOTHING YOU CAN CREATE NOTHING

1. Gutman, *Mozart*, 668–69.
2. Braunbehrens, *Mozart in Vienna*, 306–7.
3. Braunbehrens, *Mozart in Vienna*, 309.
4. Gutman, *Mozart*, 676.
5. Wolff, *Mozart at the Gateway to His Fortune*, 94.
6. Heartz, *Mozart's Operas*, 124–25.
7. Deutsch, *Documentary Biography*, 290.
8. Landon, *Mozart, the Golden Years, 1781–1791*, 194.
9. Solomon, *Mozart*, 432.
10. Deutsch, *Documentary Biography*, 327.
11. Keefe, "Jupiter," 30.
12. Keefe, "Jupiter," 21.
13. Keefe, "Jupiter," 43.

14. Wolff, *Mozart at the Gateway to His Fortune*, 89.
15. Landon, *1791: Mozart's Last Year*, 34.
16. Wolff, *Mozart at the Gateway to His Fortune*, 179.
17. Blanning, *Joseph II*, 177.
18. Brauneis, "Mozart's Appointment to the Imperial Court in Vienna," 2.
19. Solomon, *Mozart*, 434.
20. Gutman, *Mozart*, 682–83.
21. Einstein, *Mozart*, 150.
22. Woodfield, "Symphony of Light," 28.
23. https://search.yahoo.com/yhs /search?hspart=pty&hsimp=yhs -pty_packages¶m2=9f1108d3 -01da-40dd-9d30-a571610c2ee8&par am3=packages_~US~appfocus1&pa ram4=g-lp0-usps-dsf_packages—bb 8~Chrome~mozart%27s+handel+m essiah~99C5A0EF08E175E6A883C CA0D8E0429E¶m1=20190408 &p=mozart%27s+handel+messiah& type=pa_appfocus1_cr.
24. Glover, *Mozart's Women*, Location 4257.
25. Landon, *Mozart, the Golden Years, 1781–1791*, 171.
26. Bolt, *Librettist*, 187.
27. Bolt, *Librettist*, 187.
28. Küster, *Mozart*, 289.
29. Wolff, *Mozart at the Gateway to His Fortune*, 87.
30. Spaethling, *Mozart's Letters, Mozart's Life*, 398–99.
31. Solomon, *Mozart*, 523.
32. Spaethling, *Mozart's Letters, Mozart's Life*, 401.
33. Spaethling, *Mozart's Letters, Mozart's Life*, 402.
34. Eisen and Keefe, *Cambridge Mozart Encyclopedia*, 247.
35. Wolff, *Mozart at the Gateway to His Fortune*, 61.
36. Clarke, *The Prince Lichnowsky Newsletter*, no. 2.
37. Gutman, *Mozart*, 690.
38. Spaethling, *Mozart's Letters, Mozart's Life*, 403.
39. Braunbehrens, *Mozart in Vienna*, 327.
40. Wolfe, *Mozart at the Gateway to His Fortune*, 55.
41. Bauer, "Mozart's High Costs for Light and Heat," 26.

42. Spaethling, *Mozart's Letters, Mozart's Life*, 403.
43. Spaethling, *Mozart's Letters, Mozart's Life*, 405–6.
44. Singer, *Mozart and Beethoven: The Concept of Love in Their Operas*, 19.
45. Spaethling, *Mozart's Letters, Mozart's Life*, 405–6.
46. Eisen, *New Mozart Documents*, 58–59
47. Solomon, "Mozart's Journey," 78. Solomon puts forth a theory that Mozart was having an affair on the tour, maybe with Josepha Duschek, but there is no evidence for it beyond his doings being a mystery. Solomon does note (*Mozart*, 451) that the Niemetschek biography, to which Constanze contributed and which she sanctioned, observed that Mozart "was a man, therefore as liable to human failings as anyone else."
48. Gutman, *Mozart*, 693.
49. Wolff, *Mozart at the Gateway*, 56.
50. Landon, *Mozart, the Golden Years, 1781–1791*, 207.
51. Clarke, *The Prince Lichnowsky Newsletter*, no. 2.
52. Deutsch, *Documentary Biography*, 342; and Wolff, *Mozart at the Gateway to His Fortune*, 66. These two accounts differ in details.
53. Landon, *Mozart, the Golden Years, 1781–1791*, 205.
54. Gutman, *Mozart*, 694.
55. Landon, *Mozart, the Golden Years, 1781–1791*, 206.
56. Spaethling, *Mozart's Letters, Mozart's Life*, 411.
57. Clarke, *The Prince Lichnowsky Newsletter*, no. 2.
58. Braunbehrens, *Mozart in Vienna*, 331.
59. Spaethling, *Mozart's Letters, Mozart's Life*, 410–11.
60. Gutman, *Mozart*, 679.

CHAPTER 24: THE TRUTH OF THE MOMENT
1. Spaethling, *Mozart's Letters, Mozart's Life*, 412–13.
2. Spaethling, *Mozart's Letters, Mozart's Life*, 414.
3. Bolt, *Librettist*, 196–97.
4. Till, *Mozart and the Enlightenment*, 232.

5. Braunbehrens, *Mozart in Vienna*, 433n9.
6. Davies, *Mozart in Person*, 105; and Braunbehrens, *Mozart in Vienna*, 120.
7. Spaethling, *Mozart's Letters, Mozart's Life*, 414–15.
8. Braunbehrens, *Mozart in Vienna*, 122.
9. Deutsch, *Documentary Biography*, 355.
10. Spaethling, *Mozart's Letters, Mozart's Life*, 416.
11. Eisen, *New Mozart Documents*, 62.
12. Braunbehrens, *Maligned Master*, 167.
13. Clive, *Mozart and His Circle*, 56.
14. Brown, *W. A. Mozart:* Così fan tutte.
15. Eisen and Keefe, *Cambridge Mozart Encyclopedia*, 119.
16. Polzonetti, "Mesmerizing Adultery," 265.
17. Brown, *W. A. Mozart: "Così fan tutte,"* 3–4.
18. Brown, *W. A. Mozart: "Così fan tutte,"* 28.
19. Hunter, *Culture of Opera Buffa*, 280.
20. Brown, *W. A. Mozart: "Così fan tutte,"* 32.
21. Ballantine, "Social and Philosophical Outlook in Mozart's Operas," 511.
22. Hunter, *Culture of Opera Buffa*, 296.
23. Till, *Mozart and the Enlightenment*, 230.
24. Thanks to Raphael Atlas for these thoughts.
25. Hunter, *Culture of Opera Buffa*, 257.

CHAPTER 25: ENDINGS AND BEGINNINGS
1. Blanning, *Joseph II*, 189.
2. Bolt, *Librettist*, 183.
3. Blanning, *Joseph II*, 169.
4. Braunbehrens, *Mozart in Vienna*, 254.
5. Steptoe, *The Mozart–Da Ponte Operas*, 30.
6. Landon, *1791: Mozart's Last Year*, 12.
7. Spaethling, *Mozart's Letters, Mozart's Life*, 418.
8. Spaethling, *Mozart's Letters, Mozart's Life*, 421.
9. Keefe, *Mozart in Vienna*, 549.
10. Spaethling, *Mozart's Letters, Mozart's Life*, 430.
11. Wolff, *Mozart at the Gateway to His Fortune*, 143.
12. Eisen and Keefe, *Cambridge Mozart Encyclopedia*, 72.
13. Spaethling, *Mozart's Letters, Mozart's Life*, 407.
14. Keefe, *Mozart in Vienna*, 468.
15. Solomon, *Mozart*, 274.
16. Glover, *Mozart's Women*, Location 2607.
17. Gutman, *Mozart*, 726.
18. Braunbehrens, *Mozart in Vienna*, 355.
19. Wolff, *Mozart at the Gateway to His Fortune*, 47.
20. Braunbehrens, *Mozart in Vienna*, 355; Gutman, *Mozart*, 714.
21. Wignall, *In Mozart's Footsteps*, 166.
22. Spaethling, *Mozart's Letters, Mozart's Life*, 424–25.
23. Gutman, *Mozart*, 715.
24. Spaethling, *Mozart's Letters, Mozart's Life*, 426–27.
25. Deutsch, *Documentary Biography*, 375.
26. Eisen, *New Mozart Documents*, 65.
27. Spaethling, *Mozart's Letters, Mozart's Life*, 428–29.
28. Landon, *Mozart and Vienna*, 196.
29. Braunbehrens, *Mozart in Vienna*, 362.
30. Landon, *1791: Mozart's Last Year*, 18–19.
31. Solomon, *Mozart*, 473.
32. Keefe, *Instrumental Music*, 66.
33. Keefe, *Instrumental Music*, 85.
34. Solomon, *Mozart*, 473.
35. Braunbehrens, *Maligned Master*, 114.
36. Glover, *Mozart's Women*, Location 2672; Dimond, *Mozart Diary*, 204.
37. Gutman, *Mozart*, 716.
38. Landon, *1791: Mozart's Last Year*, 54.
39. Spaethling, *Mozart's Letters, Mozart's Life*, 438–39.
40. Spaethling, *Mozart's Letters, Mozart's Life*, 435.
41. Branscombe, *Die Zauberflöte*, 29–32.
42. Branscombe, *Die Zauberflöte*, 206.
43. Braunbehrens, *Mozart in Vienna*, 384.
44. Spaethling, *Mozart's Letters, Mozart's Life*, 437.
45. Wolff, *Mozart at the Gateway to His Fortune*, 229.
46. Rice, *W. A. Mozart: "La clemenza di Tito,"* 10.
47. Till, *Mozart and the Enlightenment*, 260.

48. Rice, *W. A. Mozart, "La clemenza di Tito,"* 46.
49. Küster, *Mozart,* 350.
50. Rice, *W. A. Mozart, "La clemenza di Tito,"* 37.
51. Braunbehrens, *Mozart in Vienna,* 350.
52. Rice, *W. A. Mozart, "La clemenza di Tito,"* 1.
53. Till, *Mozart and the Enlightenment,* 266.
54. Bolt, *Librettist,* 206.
55. Bolt, *Librettist,* 210–11.
56. Bolt, *Librettist,* 212–13.
57. Bolt, *Librettist,* 214.
58. Durante, "The Chronology of Mozart's 'La clemenza di Tito' Reconsidered," 588–89.
59. Durante, "The Chronology of Mozart's 'La clemenza di Tito' Reconsidered," 574.
60. Landon, *1791: Mozart's Last Year,* 103–5.
61. Cairns, *Mozart and His Operas,* 240–41.
62. Landon, *1791: Mozart's Last Year,* 106–7.
63. Solomon, *Mozart,* 487.
64. Rice, *Mozart on the Stage,* 103.
65. Rice, *W. A. Mozart, "La clemenza di Tito,"* 19.
66. Cairns, *Mozart and His Operas,* 232.
67. Rice, *W. A. Mozart, "La clemenza di Tito,"* 27.
68. Cairns, *Mozart and His Operas,* 238.
69. Braunbehrens, *Mozart in Vienna,* 387.

CHAPTER 26: AN ETERNAL CROWN
1. Dent, "Emanuel Schikaneder," 16.
2. Braunbehrens, *Mozart in Vienna,* 373.
3. Brion, *Daily Life in the Vienna of Mozart and Schubert,* 83.
4. Landon, *1791: Mozart's Last Year,* 137.
5. Braunbehrens, *Mozart in Vienna,* 376.
6. Cairns, *Mozart and His Operas,* 200.
7. Rice, *Mozart on the Stage,* 128.
8. Wolff, *Gateway,* 12; and Branscombe, *W. A. Mozart: "Die Zauberflöte,"* 101.
9. Chailley, *The "Magic Flute" Unveiled,* 41.
10. Eisen and Keefe, *Cambridge Mozart Encyclopedia,* 541.
11. Branscombe *W. A. Mozart: "Die Zauberflöte,"* 6–7.
12. Chailley, *The "Magic Flute" Unveiled,* 35.
13. Gutman, *Mozart,* 316–17.
14. Dent, "Emanuel Schikaneder," 19.
15. Chailley, *The "Magic Flute" Unveiled,* 29–30.
16. Landon, *1791: Mozart's Last Year,* 128.
17. Branscombe, *W. A. Mozart: "Die Zauberflöte,"* 23.
18. Branscombe, *W. A. Mozart: "Die Zauberflöte,"* 37.
19. Branscombe, *W. A. Mozart: "Die Zauberflöte,"* 214.
20. That in a fairy tale bad characters cannot bestow boons is a principal argument of Brigid Brophy in *Mozart the Dramatist,* where she votes for a midcourse plot switch in the creation of *Die Zauberflöte.* That theory has been around for a long time. I think Brophy's book is quite fine in many respects, and for years I accepted her argument, but for a row of reasons as noted in the text, her conclusion does not stand up.
21. Brown, *W. A. Mozart: "Così fan tutte,"* 2.
22. Küster, *Mozart,* 357.
23. Chailley, *The 'Magic Flute' Unveiled,* 37. Chailley's book is thorough and useful, but he is an extreme among the writers who have taken the undoubted Masonic symbolism of *Die Zauberflöte* into connecting many details of the music to the craft. As is clear in the text, I'm sticking to the obvious connections. To fill his music with cabalistic symbolism seems to me foreign to Mozart's creative style. He was a fervent Mason but not of the esoteric variety, though he would have been cognizant of that side of the craft. Still, modest symbolism, such as the representation of the threefold Masonic door knocks in the music, is something most composers would do in a similar situation. As a rhythm it's an entirely musical symbolism.
24. Herbert Hönigsmann, "Freemasonry Around the World: Austria." Grand Lodge of Washington, November 5, 2018, https://freemason-wa.org /2018/11/05/freemasonry-around -the-world-austria.

25. Landon, *1791: Mozart's Last Year*, 127.
26. Chailley, *The 'Magic Flute' Unveiled*, 47–48. I assume that any Mason who saw *Die Zauberflöte* would have seen the connection, but the fact that it was not really cited in public until 1857 is a piece of evidence against another old myth concerning the opera: the Freemasons were outraged that it revealed their secrets. Some have gone so far as to claim that the Masons murdered Mozart for his treachery. As is clear in the text, I don't buy this line of thought.
27. Till, *Mozart and the Enlightenment*, 318.
28. Chailley, *The 'Magic Flute' Unveiled*, 87.
29. Küster, *Mozart*, 375.
30. Branscombe, *W. A. Mozart: "Die Zauberflöte,"* 147–50.
31. These ideas about the journey of the hero are taken from Joseph Campbell's *The Hero with a Thousand Faces, passim*.
32. Till, *Mozart and the Enlightenment*, 286.
33. Eric Smith in Branscombe, *W. A. Mozart: Die Zauberflöte,"* 118–20.
34. Cairns, *Mozart and His Operas*, 209.
35. Chailley, *The "Magic Flute" Unveiled*, 84–85.
36. Branscombe, *W. A. Mozart: "Die Zauberflöte,"* 12–13.
37. This is one of Brophy's steady points.
38. Braunbehrens, *Mozart in Vienna*, 230–31.
39. Chailley, *The 'Magic Flute' Unveiled*, 143.
40. Chailley, *The 'Magic Flute' Unveiled*, 116.

CHAPTER 27: ET LUX PERPETUA LUCEAT EIS
1. Glover, *Mozart's Women*, Location 2787.
2. Solomon, *Mozart*, 490.
3. Spaethling, *Mozart's Letters, Mozart's Life*, 439–40.
4. Gutman, *Mozart*, 738n9.
5. Spaethling, *Mozart's Letters, Mozart's Life*, 442–43.
6. Keefe, *Mozart in Vienna*, 559.

7. Clive, *Mozart and His Circle*, 141.
8. Steptoe, *The Mozart–Da Ponte Operas*, 158.
9. Tyson, *Studies of the Autograph Scores*, 35.
10. Landon, *1791: Mozart's Last Year*, 77.
11. Brauneis, "Dies irae, dies illa—Day of Wrath, Day of Wailing," 4.
12. Keefe, *Mozart's Requiem*, 58.
13. Eisen and Keefe, *Cambridge Mozart Encyclopedia*, 247–48.
14. Cairns, *Mozart and His Operas*, 250.
15. Keefe, *Mozart's Requiem*, 62.
16. Landon, *Mozart's Last Year*, 165–66.
17. Neumayr, "What Actually Caused Mozart's Death?" 10.
18. Solomon, *Mozart*, 493.
19. Wolff, *Mozart at the Gateway to His Fortune*, 32.
20. Landon, *1791: Mozart's Last Year*, 166–68.
21. Solomon, *Mozart*, 494.
22. Davies, *Mozart in Person*, 183.
23. Neumayr, "What Actually Caused Mozart's Death?" 1–10. It has to be noted that the diagnosis of rheumatic fever is anything but certain, only arguably the most likely. I don't go through the various other theories, of which there are many, including the one that is almost certainly not true: poison.
24. Glover, *Mozart's Women*, Location 4897.
25. Landon, *1791: Mozart's Last Year*, 169.
26. Deutsch, *Documentary Biography*, 426.
27. Schmid and Sanders, "Mozart and Haydn," 32.
28. Gutman, *Mozart*, 745.
29. Solomon, *Mozart*, 494.
30. Braunbehrens, *Mozart in Vienna*, 415.
31. Davies, *Mozart in Person*, 169.
32. Landon, *1791: Mozart's Last Year*, 168.
33. Solomon, *Mozart*, 496.
34. Solomon, *Mozart*, 496.
35. Gutman, *Mozart*, 745.

EPILOGUE
1. Eisen, *New Mozart Documents*, 123.
2. Landon, *1791: Mozart's Last Year*, 171.
3. Cairns, *Mozart and His Operas*, 171.

4. Wolff, *Mozart at the Gateway to His Fortune*, 167.

5. Sadie, *The Early Years*, 156–57.

6. Solomon, *Mozart*, 430–31.

7. Landon, *Mozart and Vienna*, 199,

8. Solomon, *Mozart*, 485.

9. Keefe, *Mozart's Requiem*, 87.

10. Landon, *1791: Mozart's Last Year*, 184–85.

11. Konrad, "Mozart the Letter Writer and His Language," 2.

12. Wolff, *Mozart at the Gateway to His Fortune*, 8.

13. Glover, *Mozart's Women*, Location 5631.

14. Stafford, "Mozart and Women," 8.

15. Solomon, *Mozart*, 494.

16. Clive, *Mozart and His Circle*, 136.

17. Braunbehrens, *Maligned Master*, 5.

18. "Nannerl," in Sadie, ed., *The New Grove Book of Operas*.

19. Solomon, *Mozart*, 402.

20. Glover, *Mozart's Women*, Location 5010.

21. Solomon, *Mozart*, 501–2.

WORKS CITED

Allanbrook, Wye J., and Wendy Hilton. "Dance Rhythms in Mozart's Arias." *Early Music* 20, no. 1 (1992): 142–49.

Anderson, Emily. *The Letters of Mozart and His Family*. 1st ed. of 1985 rev. ed. New York: W. W. Norton & Co., 1989. Called "Anderson Complete" in the notes.

———. *Mozart's Letters: An Illustrated Selection*. Boston, Toronto, and London: Little, Brown and Company, 1990.

Ballantine, Christopher. "Social and Philosophical Outlook in Mozart's Operas." *The Musical Quarterly* 67, no. 4 (1981): 507–26.

Bauer, Günther G. Transl. anon. "Mozart's High Costs for Light and Heat." *Mitteilungen der Gesellschaft für Salzburger Landeskunde*. Salzburg: n.p., 2008: 147–86.

———. "W. A. Mozart: The True Airgun Shooting Enthusiast." *Salzburg News*, January 22, 2005.

Bauman, Thomas. "Benda, the Germans, and Simple Recitative." *Journal of the American Musicological Society* 34, no. 1 (1981).

———. *Die Entführung aus dem Serail*. Cambridge Opera Handbooks. Cambridge: Cambridge University Press, 1988.

Beales, Derek. *Joseph II*. Vol. 2 of *Against the World, 1780–1790*. Cambridge: Cambridge University Press, 2009.

———. "Mozart and the Habsburgs." In *Enlightenment and Reform in Eighteenth-Century Europe*. London: I.B. Tauris and Company Ltd., 2005, 90–116.

Berry, Mark. "Thoughts on Mozart as Dramatist and Symphonist." Program note from the Royal Opera House, Covent Garden, 2012.

Blanning, T. *The Pursuit of Glory: Europe, 1648–1815*. 1st ed., Penguin History of Europe. New York: Viking, 2007.

Blanning, T. C. W. *Joseph II*. 1st edition. London ; New York: Routledge, 1994.

Bolt, Rodney. *The Librettist of Venice: The Remarkable Life of Lorenzo Da Ponte*. New York and London: Bloomsbury Publishing, 2006.

Bowers, Jane. "Mozart and the Flute." *Early Music* 20, no. 1 (1992): 31–42.

Branscombe, Peter. "Mozart the Arch-Englishman." Article read at Mozart Symposium at the Institute of Germanic Studies, University of London, 1991.

———. *W. A. Mozart: "Die Zauberflöte."* Cambridge Opera Handbooks. Cambridge [UK] and New York: Cambridge University Press, 1991.

Braunbehrens, Volkmar. "Cherubino in Mannheim." Keynote speech at the 56th Deutsches Mozartfest 2007 der Deutschen Mozart-Gesellschaft, Manheim.

———. "'Fatherly Friend,' 'Most Obedient Son': Leopold and Wolfgang Mozart." *Väter und Söhne*. Berlin: Rowohlt, 1996.

———. "Hier ist doch gewis das Clavierland!—Mozart in Vienna." Talk at the Konzarthaus in Vienna, June 2008.

———. *Maligned Master: The Real Story of Antonio Salieri*. Repr. ed. New York: Fromm International, 1994.

————. *Mozart in Vienna, 1781–1791.*
1st ed. New York: Grove Weidenfeld,
1990.

————. Trans. Eveline L. Kanes. "The
Mozart-Salieri Connection." In
Volkmar Braunbehrens. *Maligned
Master.*

Brauneis, Walther. "Dies irae, dies illa—
Day of Wrath, Day of Wailing: Notes
on the Commissioning, Origin, and
Completion of Mozart's Requiem."
Originally in the *Jahrbuch des Vereins
für Geschichte der Stadt Wien*, Band
⁴/8, 1991.

————. Trans. anon. "Mozart's
Appointment to the Imperial Court
in Vienna: Facts and Speculations—
Was Mozart in Fact Kapellmeister
to Archduke Franz?" Wien, *Mozart,
Experiment Aufklärung im Wein des
Ausgehenden 18. Jahrhunderts*, 2006.

Brion, Marcel. *Daily Life in the Vienna
of Mozart and Schubert*. New York:
Macmillan, 1962.

Brown, Bruce Allen. "Salieri's 'Così fan
tutte.'" *Cambridge Opera Journal* 8, no.
1 (1996).

————. *W. A. Mozart: "Così fan tutte."*
Cambridge Opera Handbooks.
Cambridge: Cambridge University
Press, 1995.

Burnham, Scott G. *Mozart's Grace.*
Princeton, NJ: Princeton University
Press, 2013.

Cairns, David. *Mozart and His Operas.* 1st
ed. London: Penguin UK/Cambridge
University Press, 2007.

Campbell, Joseph. *The Hero with a
Thousand Faces.* Princeton, NJ:
Princeton University Press, 1973.

Chailley, Jacques. *"The Magic Flute"
Unveiled: Esoteric Symbolism in
Mozart's Masonic Opera.* Reissue. N.p.:
Inner Traditions, 1992.

Clarke, Bruce Cooper. *The Prince
Lichnowsky Newsletter.* Vols. 1–8
(1991–2011).

Clive, Peter. *Mozart and His Circle: A
Biographical Dictionary.* New Haven,
CT: Yale University Press, 1994.

Cohen, Mitchell. *The Politics of Opera:
A History from Monteverdi to Mozart.*

Princeton, NJ: Princeton University
Press, 2017.

Czerny, Carl, and Ernest Sanders.
"Recollections from My Life." *The
Musical Quarterly* 42, no. 3 (1956).

Davies, Peter J. *Mozart in Person: His
Character and Health.* New York:
Praeger, 1989.

————. "Mozart's Manic-Depressive
Tendencies." *The Musical Times* 128,
no. 1730 (April 1987).

Dent, Edward. J. "Emanuel Schikaneder."
Music and Letters 37, no. 1 (January 1956).

Derr, Elwood. "*Basso Continuo*
in Mozart's Piano Concertos:
Dimensions of Compositional
Completion and Performance
Practice." In Zaslaw, *Mozart's Piano
Concertos.*

————. "Some Thoughts on the Design
of Mozart's Opus 4, the 'Subscription
Concertos' (K. 414, 413, and 415)." In
Zaslaw, *Mozart's Piano Concertos.*

Deutsch, Otto Erich. *Mozart: A
Documentary Biography.* New ed.
London: Simon and Schuster, 1990.

————. "Some Fallacies in Mozart
Biography." *The Musical Quarterly*
vol. 42, no. 2 (April 1956).

Dimond, Peter. *A Mozart Diary: A
Chronological Reconstruction of the
Composer's Life, 1761–1791.* Westport,
CT: Greenwood, 1997.

Durante, Sergio. "Analysis and
Dramaturgy: Reflections Towards
a Theory of Opera." In Hunter and
Webster, *Opera Buffa in Mozart's
Vienna.*

————. "The Chronology of Mozart's
'La clemenza di Tito' Reconsidered."
Music and Letters 80, no. 4 (November
1999).

Edge, Dexter. "Mozart's Viennese
Orchestras." *Early Music* 20, no. 1
(1992): 64–88.

Einstein, Alfred. *Mozart: His Character,
His Work.* Trans. Arthur Mendel and
Nathan Broder. Reprint. New York:
Oxford University Press, 1965.

Eisen, Cliff. "Mozart and Salzburg."
From *The Cambridge Companion to
Mozart*, ed. Simon P. Keefe, 7–21.

———, ed. *Mozart Studies*. Oxford: Clarendon Press, 1991.

———. *New Mozart Documents: A Supplement to O. E. Deutsch's Documentary Biography*. Stanford, CA.: Stanford University Press, 1991.

———. "Salzburg Under Church Rule." In Zaslaw, *The Classical Era*.

Eisen, Cliff, and Simon P. Keefe, eds. *The Cambridge Mozart Encyclopedia*. Cambridge, UK: Cambridge University Press, 2007.

Forman, Denis. *Mozart's Concerto Form: The First Movements of the Piano Concertos*. New York and Washington, DC: Praeger Publishers, 1971

Freeman, Daniel E. *Josef Mysliveček, "Il Boemo."* Sterling Heights, MI: Harmonie Park Press, 2009.

Fubini, Enrico. *Music and Culture in Eighteenth-Century Europe: A Source Book*. Trans. Wolfgang Freis, Lisa Gasbarrone, and Michael Louis Leone. 1st ed. Chicago: University of Chicago Press, 1994.

Gallagher, Sean, and Thomas Forrest Kelly. *The Century of Bach and Mozart: Perspectives on Historiography, Composition, Theory, and Performance*. Cambridge and London: Harvard University Press, 2008.

Gardiner, John Eliot. "Reappraising Mozart's Operas in the 1990's. The Case of Idomeneo." *Musical Times* 131, no. 1768 (1990).

Gianturco, Carolyn. *Mozart's Early Operas*. London: B. T. Batsford Ltd., 1981.

Glover, Jane. *Mozart's Women: His Family, His Friends, His Music*. Amazon Kindle ebook. New York: Picador, 2013.

Goehring, Edmund J., "The Sentimental Muse of Opera Buffa." In Hunter, Mary, and James Webster, eds., *Opera Buffa in Mozart's Vienna*. Cambridge, UK: Cambridge University Press, 1997.

Gutman, Robert W. *Mozart: A Cultural Biography*. 1st ed. New York: Houghton Mifflin Harcourt, 1999.

Halliwell, Ruth. "The Bridal Visit to Salzburg in 1783." From Halliwell, *The Mozart Family*.

———. *The Mozart Family*. Oxford: Clarendon Press, 1998.

———. "Wolfgang as Linchpin: The Visit to Vienna in 1762." In Halliwell, *The Mozart Family*.

Heartz, Daniel, and Thomas Bauman, "Goldoni, Don Giovanni and the Dramma Giocoso." *Musical Times* 120, no. 1642 (1979).

———. *Haydn, Mozart and the Viennese School: 1740–1780*. New York: W. W. Norton & Co., 1995.

———. *Mozart's Operas*. Berkeley: University of California Press, 1992.

———. *Music in European Capitals: The Galant Style, 1720–1780*. New York: W. W. Norton & Co., 2003.

———. "Mozart, His Father and 'Idomeneo.'" *Musical Times* 119, no. 1621 (1978).

Hodges, Sheila. *Lorenzo Da Ponte: The Life and Times of Mozart's Librettist*. London: Grafton Books, 1985.

Hunter, Mary. *The Culture of Opera Buffa in Mozart's Vienna*. Princeton, NJ: Princeton University Press, 1999.

———. *Mozart's Operas: A Companion*. 1st ed. New Haven, CT: Yale University Press, 2008.

Hunter, Mary, and James Webster, eds., *Opera Buffa in Mozart's Vienna*. Cambridge, UK: Cambridge University Press, 1997.

Irving, John. *Mozart: The "Haydn" Quartets*. Cambridge and New York: Cambridge University Press, 1998.

———. *Mozart's Piano Sonatas: Contexts, Sources, Style*. Reissue. Cambridge, UK: Cambridge University Press, 2006.

Jenkins, John S. "Mozart and the Castrati." *The Musical Times* 151, no. 1913 (2010).

Keefe, Simon P., ed. *The Cambridge Companion to Mozart*. Cambridge and New York: Cambridge University Press, 2003.

Keefe, Simon P. "A Complementary Pair: Stylistic Experimentation in Mozart's Final Piano Concertos, K. 537 in D and K. 595 in B-Flat." *The Journal of Musicology* 18, no. 4 (2001).

———. "The 'Jupiter' Symphony in C, K. 551: New Perspectives on the Dramatic Finale and Its Stylistic Significance in Mozart's Orchestral Oeuvre." *Acta Musicologica* 75, Fasc. 1 (2003).

———. *Mozart in Vienna*. Amazon Kindle ebook. Cambridge, UK: Cambridge University Press, 2017.

———. "Mozart 'Stuck in Music' in Paris (1778): Towards a New Biographical Paradigm." In Keefe, Simon, ed. *Mozart Studies 2*. Cambridge Composer Studies. Cambridge: Cambridge University Press, 2015, 23–54, http: doi. org/10.1017/CBO9781107360051.003.

———. *Mozart's Requiem*. Amazon Kindle ebook. Cambridge, UK: Cambridge University Press, 2012.

———. *Mozart's Viennese Instrumental Music: A Study of Stylistic Re-invention*. Woodbridge, UK, and Rochester, NY: The Boydell Press, 2007.

———. "Wolfgang Amadeus Mozart the Child Performer–Composer: New Musical-Biographical Perspectives on the Early Years to 1766." In Gary E. McPherson, ed., *Musical Prodigies: Interpretations from Psychology, Education, Musicology, and Ethnomusicology*. Oxford: Oxford University Press, 2016.

Kelly, Michael. "Mozart in Social Life." *The Musical Times and Singing Class Circular* 32, Mozart Supplement (1891).

Kerman, Joseph. "Mozart's Piano Concertos and Their Audience." In Morris, *On Mozart*.

Kinderman, William. *Mozart's Piano Music*. 1st ed. Oxford and New York: Oxford University Press, 2006.

Komlós, Katalin, "Mozart the Performer." In Eisen and Keefe, eds. *The Cambridge Companion*.

Konrad, Ulrich. "Mozart the Letter Writer and His Language." In Keefe, Simon, ed. *Mozart Studies 2*. Cambridge Composer Studies. Cambridge: Cambridge University Press, 2015,

1–22, http: doi.org/10.1017 /CBO9781107360051.002.

Küster, Konrad. *Mozart: A Musical Biography*. Trans. Mary Whittall. Reprint. Oxford and New York: Clarendon Press, 1996.

Landon, H. C. Robbins. *Essays on the Viennese Classical Style: Gluck, Haydn, Mozart, Beethoven*. New York: Macmillan, 1970.

———. *Mozart, the Golden Years, 1781–1791*. 1st American ed. New York: Schirmer Books, 1989.

———. *Mozart and Vienna*. Reprint. New York: Schirmer Reference, 1994.

———. *The Mozart Compendium: A Guide to Mozart's Life and Music*. New York: Schirmer Books, 1990.

———. *1791: Mozart's Last Year, 1791*. 1st American ed. New York: Schirmer Books, 1988.

Landon, H. C. Robbins, and Donald Mitchell, eds. *The Mozart Companion: A Symposium by Leading Mozart Scholars*. London: W. W. Norton & Co., 1969.

Lawson, Colin, "A Winning Strike: The Miracle of Mozart's 'Kegelstatt.'" In *Mozart's Chamber Music with Keyboard*. Amazon Kindle ebook. Cambridge, UK: Cambridge University Press, 2012.

Levin, Robert D. "Improvised Embellishments in Mozart's Keyboard Music." *Early Music* 20, no. 2 (1992): 221–33.

———. "Mozart's Working Methods in the Keyboard Concertos." In Gallagher, *Century of Bach and Mozart*.

Libby, Denis. "Italy: Two Opera Centers." In Zaslaw, *The Classical Era*.

Link, Dorothea. "Mozart in Vienna." In Keefe, *The Cambridge Companion*.

Link, Dorothea, and Judith Nagley, eds. *Words About Mozart: Essays in Honour of Stanley Sadie*. Woodbridge and Suffolk: Boydell Press, 2005.

McClatchy, J. D. *Seven Mozart Librettos: A Verse Translation*. New York and London: W. W. Norton & Company, 2011.

Mongrédien, Jean. "Les mystères d'Isis [1801] and Reflections on Mozart from the Parisian Press at the Beginning of the Nineteenth Century." In Zaslaw, *The Classical Era*.

Morris, James M., ed. *On Mozart*. Washington, DC, and Cambridge, New York: Cambridge University Press, 1994.

Mozart, Marie Anna [Nannerl]. Edited by Geneviève Geffray. *Meine Tag Ordnungen*. Bad Honnef: Verlag Karl Heinrich Bock, 1998.

Nagel, Ivan. *Autonomy and Mercy: Reflections on Mozart's Operas*. Trans Marion Faber. 1st ed. Cambridge, MA: Harvard University Press, 1991.

Neumayr, Dr. Anton. "What Actually Caused Mozart's Death?" Transl. Bruce Cooper Clark. *"Wiener Klinische Wochenschrift" Heft* 23–24.

Olleson, Edward. "Gottfried van Swieten: Patron of Haydn and Mozart." *Proceedings of the Royal Musical Association* 89 (1962).

Pesic, Peter. "The Child and the Daemon: Mozart and Deep Play." *19th-Century Music* 24, no. 2–3 (Fall/Spring 2001–2).

Pestelli, G. *The Age of Mozart and Beethoven*. Cambridge [Cambridgeshire] and New York: Cambridge University Press, 1984.

Platoff, John. "Operatic Ensembles and the Problem of the *Don Giovanni* Sextet." In Hunter and Webster, *Opera Buffa in Mozart's Vienna*.

Polzonetti, Pierpaolo. "Mesmerizing Adultery: 'Così fan tutte' and the Kornman Scandal." *Cambridge Opera Journal* 14, no. 3 (2002).

Ratner, Leonard G. *Classic Music: Expression, Form, and Style*. New York: Schirmer Books, 1980.

Rice, John A. *Antonio Salieri and Viennese Opera*. Chicago: University of Chicago Press, 1999.

———. "Mozart and Salieri." From Rice, *Antonio Salieri*.

———. *Mozart on the Stage*. Cambridge, UK: Cambridge University Press, 2009.

———. *W. A. Mozart: "La clemenza di Tito."* 1st ed. Cambridge, UK, and New York: Cambridge University Press, 1991.

Robinson, Michael F. "The Alternative Endings of Mozart's 'Don Giovanni.'" In Hunter and Webster, *Opera Buffa in Mozart's Vienna*.

Robinson, Paul. *Opera and Ideas: From Mozart to Strauss*. Reprint. Ithaca, NY: Cornell University Press, 1986.

Rosen, Charles. *The Classical Style: Haydn, Mozart, Beethoven*. Expanded ed. New York: W. W. Norton & Company, 1997.

Ross, Alex. "The Storm of Style: Listening to the Complete Mozart." *The New Yorker*, July 24, 2006.

Rumph, Stephen. "Mozart's Archaic Endings: A Linguistic Critique." *Journal of the Royal Musical Association* 130, no. 2 (2005).

Rushton, Julian. "Buffo Roles in Mozart's Vienna: Tessitura and Tonality as Signs of Characterization." In Hunter and Webster, *Opera Buffa in Mozart's Vienna*.

———. *W. A. Mozart: "Don Giovanni."* Cambridge Opera Handbooks. 1st edition. Cambridge, UK, and New York: Cambridge University Press, 1981.

———. *W.A. Mozart: "Idomeneo."* Cambridge Opera Handbooks. Cambridge, UK, and New York: Cambridge University Press, 1993.

Sadie, Stanley. *Mozart: The Early Years, 1756–1781*. Oxford: Oxford University Press, 2006.

———. "Mozart's 'Betulia liberata.'" *Musical Times* 109, no. 1509 (November 1968).

———, ed. *The New Grove Book of Operas*. New York: St. Martin's Press, 1996.

———, ed. *Wolfgang Amadè Mozart: Essays on His Life and His Music*. 1st ed. Oxford and New York: Clarendon Press, 1996.

Schmid, Ernst Fritz, and Ernest Sanders. "Mozart and Haydn." *Musical Quarterly* 42, no. 2 (April 1956).

Schroeder, David. *Mozart in Revolt: Strategies of Resistance, Mischief and Deception*. New Haven, CT: Yale University Press, 1999.

———. *Mozart and Late Eighteenth-Century Aesthetics*. Ed. Simon P. Keefe. Cambridge, Cambridge University Press, 2003.

Singer, Irving. *Mozart and Beethoven: The Concept of Love in Their Operas*. Cambridge, MA: MIT Press, 2010.

Smith, Erik. "[*Die Zauberflöte*] The Music." In Branscombe, *W. A. Mozart: "Die Zauberflöte."*

Smithers, Don L. "Mozart's Orchestral Brass." *Early Music* 20, no. 2 (1992).

Solomon, Maynard. *Mozart: A Life*. 1st ed. New York: HarperCollins, 1995.

———. "Mozart's Journey to Berlin." *Journal of Musicology* 23, no. 1 (Winter 1994).

Spaethling, Robert. *Mozart's Letters, Mozart's Life*. New York and London: W. W. Norton & Company, 2000.

Stafford, William. "Mozart and Genius." Based on article in *The Cambridge Mozart Encyclopedia*. Cambridge, UK: Cambridge University Press, 2006.

Steptoe, Andrew. *The Mozart–Da Ponte Operas: The Cultural and Musical Background to "Le Nozze di Figaro," "Don Giovanni," and "Così fan tutte."* Oxford and New York: Clarendon Press, 1990.

Thomson, Katharine. "Mozart and Freemasonry." *Music and Letters* 57, no. 1 (1976).

Till, Nicholas. *Mozart and the Enlightenment: Truth, Virtue, and Beauty in Mozart's Operas*. New York and London: W. W. Norton & Company, 1996.

Tyler, Linda L. "'Zaide' in the Development of Mozart's Operatic Language." *Music and Letters* 72, no. 2 (1991): 214–35.

Tyson, Alan. *Mozart: Studies of the Autograph Scores*. Cambridge, MA: Harvard University Press, 1987.

———. "Mozart's Truthfulness." *Musical Times* 119, no. 1629 (1978).

———. "Proposed New Dates for Many Works and Fragments Written by Mozart from 1781 to December 1791." In Eisen, *Mozart Studies*.

Waldoff, Jessica. "'Don Giovanni': Recognition Denied." In Hunter and Webster, *Opera Buffa in Mozart's Vienna*.

Warburton, Ernest. "Lucio silla: By Mozart and J. C. Bach." *Musical Times* vol. 126, no. 1714 (1985).

Wates, Roy E. *Mozart: An Introduction to the Music, the Man and the Myths*. New York: Amadeus Press/Rowman and Littlefield, 2010.

———. "Mozart's Mass in C Minor, K. 427/417a (unfinished)." From Wates, *Mozart*.

Weber, William. "The Myth of Mozart, the Revolutionary." *The Musical Quarterly* 78, no. 1 (1994): 34–47.

Webster, James, "The Analysis of Mozart's Arias." In Eisen, *Mozart Studies*.

Wheatcroft, Andrew. *The Enemy at the Gate: Habsburgs, Ottomans, and the Battle for Europe*. New York: Basic Books, 2009.

Wignall, Harrison James. *In Mozart's Footsteps*. 1st ed. Universal Sales and Marketing, 1991.

Wolff, Christoph. "The Challenge of Blank Paper: Mozart the Composer." In Morris, *On Mozart*.

———. *Mozart at the Gateway to His Fortune: Serving the Emperor, 1788–1791*. 1st ed., New York: W. W. Norton & Company, 2012.

Wolff, Eugene K. "The Mannheim Court." In Zaslaw, *The Classical Era*.

Woodfield, Ian. "Mozart's Compositional Methods: Writing for His Singers." In Eisen and Keefe, *The Cambridge Companion*, chap. 23, p. 16.

———."Mozart's 'Jupiter': A Symphony of Light?" *The Musical Times* 147, no. 1897 (2006).

———. "New Light on the Mozarts' London Visit: A Private Concert with Manzuoli." *Music and Letters* 76, no. 2 (1995): 187–208.

Zaslaw, Neal. *The Classical Era: From the 1740s to the End of the 18th Century*. London: Macmillan, 1989.

———. "Mozart as Working Stiff." From *On Mozart*, James M. Morris ed. Washington, DC: Woodrow Wilson Center Press; and New York: Cambridge University Press, 1994.

———, ed. *Mozart's Piano Concertos: Text, Context, Interpretation*. 1st ed. Ann Arbor: University of Michigan Press, 1997.

———. *Mozart's Symphonies: Context, Performance Practice, Reception*. Oxford, UK: Clarendon Press, 1991.

Zaslaw, Neal, ed., with William Cowdery. *The Compleat Mozart*. New York and London: W.W. Norton & Co., 1990.

INDEX OF MUSICAL COMPOSITIONS

The first section lists works by Mozart. The second lists works by other artists.

GENERAL INDEX

Aachen, 60
Abel, Carl Friedrich, 73, 78
absolutism, 447, 491
Adamberger, Johann Valentin, 322, 356, 358, 361, 394, 403, 407, 411, 416–17, 435, 462, 476
Adlgasser, Anton Cajetan, 16, 95, 232
Affligion, Giuseppe, 105–6, 108, 120
Albert, Franz Joseph, 204, 208
Alberti bass, 68, 76, 231, 587, 649, 659
Alexander the Great, 95, 186–87
Allegri, Gregorio, 127
Almaviva, Count (character), 490, 491–93, 495, 497, 505, 507–16, 518–19, 564, 626, 708
Amalia, Princess of Prussia, 60
"American in Europe, The" (Da Ponte), 485
American Revolution, 183, 254, 310
Amicis, Anna Lucia de, 131, 156, 158–59, 233
Amsterdam, 87
Anfossi, Pasquale, 180, 416–17
Antwerp Cathedral, 86
appoggiatura, defined, 456
Arco, Count Karl Joseph Felix von, 324–26, 328, 333–35
arias, 27
 catalogue, 556, 563
 da capo, 96
 furioso, 702
 Mozart's development as composer and, 97–98
 opera seria and, 138–40
 sonata form and, 386
Ariosto, 621
aristocracy, 13–14, 22–23, 42–43, 53, 89, 238–39, 251, 447
 Don Giovanni, 492, 564–65, 684

Figaro, 491–94, 506–7, 684
 Joseph II and, 344, 494, 643
 new nobility and, 346–47
 Zauberflöte and, 684–85, 699–700
Arnstein, Adam Isaac, 358
Arnstein, Fanny, 358
Arnstein, Nathan, 358
Artaria publishers, 366, 450, 458, 472, 542, 545, 588
Arth, Eleonore, 677–78
Aste, Madame d', 143
Atlas, Raphael, xv
Attwood, Thomas, 444, 472–73, 536, 549, 656–57
Auernhammer, Josepha Barbara, 352–54, 358, 364–66, 378, 399–400
Auersperg, Prince Johann Adam, 479
Aufklärung (German Enlightenment), 22, 24, 38, 64, 301–2, 340, 344
Augsburg, 7–9, 49–50, 363–64, 677
 tour of 1763, 56
 tour of 1777, 203–4, 210–18, 241, 246
Augsburg, Peace of (1555), 9
Austria
 Bavarian Succession and, 244, 254
 bread riots, 586
 composition of, 345–46
 Freemasonry and, 446–48
 reforms of Joseph II and, 340–47
 repression in, 643–45, 682–83, 705
Austro-Turkish War, 541–42, 586, 592, 598–99, 602, 643–44, 651
automatons, 432

Bach, Carl Philipp Emanuel, 78, 99–100, 404–5, 599
Bach, Johann Christian, 73–74, 77–79, 83, 135, 148, 157, 234, 251, 273–74

788

Frederick William II, King of Prussia, 608–9, 613, 647–48
Freemasonry Act (1785), 474–75
Freemasons, 22, 102, 198, 293, 576, 601, 605–6, 644
 death and, 448, 699
 death of Mozart and, 730
 Haydn and, 451
 Joseph II and, 343, 473–75, 681
 Leopold and, 462
 Maria Theresa and, 340, 343, 445, 684
 Mozart and, 445–49, 462, 473, 493, 528, 538–39, 590, 615, 723
 Mozart cantata for, 711, 723
 number three and, 681, 693
 Requiem and, 722
 Schikaneder and, 678
 women and, 696, 698, 708
 Zauberflöte and, 680–82, 684–85, 687, 689, 697–700, 703, 706, 708, 710, 714
French opéra comique, 61
French opera seria, or, *tragédie lyrique*, 301
Friedel, Johann, 678
Friederike, Princess, 613
Friederike, Queen of Prussia, 609
Fugger concert hall, 216–17
Fugger family, 9
fugue, 23, 37, 454
 defined, 744
Fürstenberg, Prince Joseph Wenzel von, 91
Fux, Johann Joseph, 22, 35, 99, 125, 407, 472

galant, 83, 178, 189, 453, 648
 defined, 78
Galiani, Abbé Fernandino, 130
Galileo, 20
Gallitzin, Prince Dimitri Alexievich, 332–33, 405
Gamerra, Giovanni de, 154
Gasparini, Abbate, 143
Gassmann, Florian Leopold, 168, 395
Gatti, Luigi, 398
Gazzaniga, Giuseppe, 554
Gelber, Tobias Philipp, Baron von, 198
Gellert, Christian Fürchtegott, 24, 30, 64, 121, 246, 349
Gemmingen zu Hornberg, Otto von, 447
Geneva, 89
George Augustus, Prince of Wales (*later* George IV), 472, 657
George III, King of England, 72–73, 76

Gerl, Barbara, 686
Gerl, Franz Xaver, 686
German National Theater. *See also* singspiel, 347, 392–93, 410–12, 604
 Abduction and, 357, 381–82, 392
German opera, form favored by, 23
Gershwin, George, ix
Gessner, Salomon, 89–90
Gilowsky, Franz Anton, 358–59, 379, 407, 447, 540
Gilowsky, Kathrl, 287
Gilowsky, Maria, 174
Giuseppe Ximenes, Prince of Aragona, 147
glass armonica, 169, 660
glockenspiel, 713–14
Gluck, Christoph Willibald, 23, 36, 38, 45, 77, 106–7, 113, 123, 132, 141, 186, 250, 365, 403, 409, 553, 573, 667
 death of, 583
 operatic reforms, 41, 157, 250, 304, 309, 312–14, 318, 361–62, 395
Goethe, Johann Wolfgang von, 57, 177, 206, 246, 313, 411, 446, 465, 489, 524, 553, 677–78
Golden Spur Cross, 132, 201, 214
Goldoni, Carlo, 107, 412, 553–55, 578, 621
 Servant of Two Masters and, 412
Gottlieb, Anna, 679, 686
Gozzi, Carlo, 299–300, 485
Gradus ad Parnassum (*Steps to Parnassus*) (Fux), 22, 99, 125
Graf, Friedrich Hartmann, 212–13
Great Hall of Spring Gardens (London) concert of 1764, 73–74
Greek Orthodox Church, 343
Greek Revival, 301
Grimm, Friedrich Melchior, Baron von, 62–64, 66, 69–71, 74, 88–89, 137, 166, 217, 247–50, 253–54, 261, 262–65, 272
 letters to Leopold, 273–74
 Mozart's falling-out with, 273–74, 276–77
 violin sonatas and, 281
Guardasoni, Domenico, 554, 606, 666–67
Gudenus, Mademoiselle de, 47
Guglielmo (character), 620, 622, 626, 629–30, 632, 634–39, 641
Guînes, Adrien-Louis de Bonnières, Duc de, 255–57, 272–73
Guînes, Marie-Louise-Philippine de Bonnières de, 255–57, 277

correspondence with Mozart, acquired
by Nissen, 739
correspondence with Mozart, from
Vienna, 351–54, 378, 401–2, 405–8,
410, 412–13, 433–34
daily life in Salzburg and, 146, 173–75,
285–87
death of, 538–39, 545–48
death of, and estate, 546–47
death of father, 10
death of Mama and, 202, 260–64,
269–70, 278
Die Schuldigkeit and, 96
disdain for everyday musicians, 19
disinherits Mozart, 398, 547
drawing ability of, 9
dry wit and, 232
early life and education of, 7–11, 14–15,
19–20
early tours with children, 24
Eckardt and, 69
European tour with children, of 1763–
66, 51–53, 55, 57, 60–66, 69–71,
73–75, 79, 84–85, 93
expectations for children, 380
Figaro and, 501
finances, 48, 461
finances, and demands on Mozart, 187,
267, 277, 285, 289, 307, 319–23, 327,
331, 335, 414, 419–20
finances, and lies about poverty,
235–36, 240–41, 247, 267
finances, and profits from children's
travels, 46, 48, 57, 66, 70, 73, 93–94,
146, 235, 277, 331, 399, 419
finances, and salary, 56, 94, 112, 220,
235, 274
Gellert as literary hero of, 24, 30, 64
Grimm and, 62–64, 70–71, 217, 247–48,
272–73, 277
Haffner symphony and, 402
Hasse and, 149
health problems of, 60, 74–75, 85–86,
149, 152, 299, 526–28
homes of, 17–18, 165, 172–73
household shrine of, 20
Idomeneo and, 302–10, 314, 318–19
Italian tours and, 113–14, 117, 119–33,
143, 144, 146, 149–52, 154, 156, 161, 165
Jenamy and, 194
Kapellmeister ambitions of, 19, 28, 38,
167, 179, 200, 273–74, 398–99

La finta giardiniera and, 182–85
La finta semplice and, 105–8
last visit to Mozart in Vienna, 1785,
459–63
last years of, 399
letters, and wide interests, 19
letters, last surviving, 538
letters, not kept by Mozart, 332
letters to Hagenauer, 41, 46, 49, 56,
65–66, 104, 108
letters to Mama in Paris with Mozart,
254–55
letters to Mozart dwindle by 1786, 527
letters to Salzburg, coded, 160–61,
321–22
letters written with history in mind, 120
library of, 173
Linz concert by Mozart and Nannerl of
1762, 40–41
Mannheim court orchestra and, 57
marriage to Anna Maria Pertl "Mama,"
10, 15–19, 201–2
meets George III in England, 72–73
Mitridate and, 142, 143
mother and, 18, 56
Mozart D Minor concerto and *Figaro*,
482
Mozart goes beyond as composer, by
1769, 113
Mozart letters to, as submissive,
reassuring, and bland, 245
Mozart letters to, on music and
composition, 198–99, 404, 436, 439
Mozart letter to, on marriage for love,
581
Mozart rash in Vienna and, 48
Mozart's discussion of taste with, 440
Mozart's early violin playing and, 50
Mozart's future, as concern of, 161
Mozart's gift recognized by, 32
Mozart sings tune and kisses on nose, as
child going to bed, 51
Mozart's marriage to Constanze and,
358–59, 368–72, 379–80, 397–99,
422
Mozart's organ playing as child and, 55
Mozart's relationship with, 8, 267
Mozart's romance with Aloysia Weber
and, 239–43, 279, 282–84
Mozart's sale of Mama's wedding ring
and, 268
Mozart's sexuality and, 215

Mozart, Leopold (father) (*continued*)
Mozart's sight-reading vs., 81
Mozart's smallpox illness of 1767, 102
Mozart's talent nurtured by, 1–2, 7–8, 28, 35
Mozart's tour of 1777–78 without, 201–10, 213–16, 218, 223, 226–33, 235–36, 239–43, 246–48, 250, 253, 255, 259–64, 269–70, 272–79, 332–35
Mozart's visits, with Constanze, in 1783, 417–19, 422–23, 426
Munich Carnival of 1786 and, 526–27
Munich visit with children of 1762, 39–40
Nannerl and, 1, 32, 38, 47–48, 175, 526–27, 738–39
Nannerl's marriage and, 440–42
Nannerl's son Leopold adopted by, 442, 526, 526–27, 537
Nannerl's suitors and, 117, 355
niece Maria Anna Thekla and, 215–16
"Non so d'onde viene" and, 245
personality of, 10, 18–20, 48, 214
plays Mozart's string quartets with Haydn, 461
publication of Mozart's compositions and, 310
publicity on tours, 58–59, 85
religion and, 9–10, 19–20, 24, 64, 232
resentment of Mozart, after flight to Vienna, 397–98, 402
resourcefulness of, 420
riddles sent by Mozart and, 478
Salzburg and, 165, 179
Salzburg and, as vice Kapellmeister, 49, 95
Schobert and, 69
Storace hosted by, 537
students Heinrich and Gretl Marchand, 318–19, 418, 460, 526
teaches Mozart counterpoint, 99–100
teaches Mozart graded pieces, 1–2
teaches Mozart sonata and symphony forms, 76–77, 148
teaching and advice to Mozart on composing, 30–34, 37, 36–37, 51, 83, 113, 136, 420
teaching style of, 32–33
tensions with Mozart, after Paris, 280–81
Tissot on Mozart as prodigy and, 90–91
Vienna smallpox epidemic and, 101–2

Vienna tours with children, 40–49, 100–101, 104–5, 168–69, 172
violinist, 25–26
violin method by, 28–30, 87, 114
Waisenhausmesse Missa solemnis and, 110–11
Waldstätten and, 333, 397–99
Weber family and, 333–34
writes of children's accomplishments, not favoring Mozart over Nannerl, 38
Mozart, Maria Anna Thekla (cousin, *die Bäsle*), 56, 211, 215–16, 224, 229, 232, 234, 248, 318, 508
fate of, 363–64
Mozart's letters to, 224–26, 232, 245–46, 268, 279–80, 287–88, 363
with Mozart in Munich, 280, 283 or 284
with Mozart in Salzburg, 1779, 286
Mozart, Maria Anna Walburga "Nannerl" (sister), 40, 245
assessment of life of, 739–40
Bäsle and
birth of, 1751, 17
birth of brother Mozart and, 7
bolt shooting and, 173
career as clavier player and teacher, 115
Carmontelle portrait and, 70–71
children of, 442
communications with Mozart decline, 547
composing attempts and, 37–38, 132
Concerto for Two Pianos written for, 364
Constanze and, 375, 739
correspondence with Mozart, in Italy, 117, 121–22, 128–31, 143–44, 149–51, 154–55
correspondence with Mozart, of 1777–78, 205–6, 208, 210
cousin Maria Anna Thekla and, 215–16, 248
daily life in Salzburg, 174–75, 286–87, 419–20
death of, 739
death of Leopold and, 546–47
death of Mama in Paris and, 264–65
death of Mozart and, 604
diary of, 38, 72, 175, 287, 418
education of, 54
estate of, 738
European tour as child, 51, 55, 60, 63, 70–71, 74–76, 78–79, 88–89, 91–92
family living quarters and, 146
fashion and, 46, 323

Reale Accademia di Scienze, Belle Lettere
ed Arti (Mantua), 120
recapitulation, defined, 741, 742
recitative, 98, 157
simple or "dry," defined, 138, 140
Renaissance, 22, 99, 125
rescue opera genre, 658, 703
rheumatic fever, 49, 91, 442, 729–30
Ritter, Georg Wenzel, 252, 303
Robbers, The (Schiller), 177, 310, 313
Romantics, x, xii-xiii, 149, 239, 287, 467,
471, 594–95
Rome, 124, 126–34
rondo, 190–92, 196
Rosenberg, Count Franz Xaver von
Orsini-, 335, 347–48, 350, 405–6,
416–17, 487, 501, 600, 669
Rosicrucianism, 446–47, 474
Rosina, Countess (character), 490, 493,
495, 498, 508–9, 511–16, 518–19, 630
Rossini, Gioachino, 738
Rousseau, Jean-Jacques, 20, 62, 108–9,
113, 143, 166, 176, 273, 485
Royal Society, 81
Rubens, Peter Paul, 60
Rumbeke, Countess Marie Thiennes de,
333
Russia, 541–42, 586, 598

Salieri, Antonio, 358, 604
affair with Cavalieri, 389, 476, 621, 669
appearance and personality of, 396
background of, 395–96
Beaumarchais and, 489, 501
Beethoven, Schubert, and Liszt as
students of, 669, 738
Da Ponte and, 366, 483, 486–87, 552,
642
Da Ponte's break with, 621, 669
Da Ponte's *Rich Man for a Day* and, 412
death of Mozart and, 726, 731, 738
estate of, 735
Figaro and, 501
Franz Xaver Mozart as student of,
737
Guardasoni commission and, 666–67
Joseph II and, 349, 583
later life of, 738
Leopold II and, 653, 671
Mozart borrowing from, 553
Mozart first sees opera of, 170
Mozart's *Abduction* and, 394–95

Mozart's last three symphonies and, 598
Mozart's reconciliation with, 714–15
Mozart's rivalry vs., 395–97, 416–17,
482, 619–20, 642
Mozart succeeds, as *Kammermusicus*,
583
operas by, 395–97, 410–11
Orangery concert with Mozart, 475–76
popularity of, 502, 584
resigns as Kapellmeister, 658, 669
Swieten soirées and, 599
Tonkünstler Society concerts and, 660
Sallaba, Matthias von, 726
Salzburg, 11–16
Anna Maria moves to, 16
Colloredo elected to, 152, 165–67
Constanze's and Nannerl's later years
in, 739
death of Mozart and, 734
Finalmusik and, 25
Il re pastore premieres at, 187
Leopold and children return to, after
European tours, 49, 52–53, 91–93
Leopold and Mozart return from Italian
trips, 144, 146, 161, 165
Leopold's early life in, 10–20, 24–25, 28
Mozart and Constanze visit, in 1783,
417–26
Mozart as Konzertmeister in, 153,
274–77, 283–300
Mozart family daily life in, 172–75, 422
Mozart family moves to
Tanzmeisterhaus, 172–74
Mozart leaves Leopold in, for tour to
Paris of 1777–78, 201–2
Mozart returns to, from Vienna in 1769,
111–12
Mozart's decision of 1781, not to return
to, 319–28
Mozart's frustration with Colloredo
and, 165–66, 172
Mozart statue in, 737
orchestras and, 16–17
Schikaneder troupe and, 677
symhonies and, 25
theater and, 174, 285
Salzburg Cathedral, 10, 11, 13, 290
Salzburg Residenz, 11–13
Salzburg rube in Vienna, A (Mozart
comedy), 680
Salzburg serenade, 25
defined, 197